This edition of the book has a companion website: thelightroombook.com. It contains additional resource material in the form of Lightroom movie tutorials, templates, and PDF downloads. I know a lot of readers like having access to the images that appear in the book. Therefore, I have created a downloadable Lightroom catalog that contains nearly all the photos that appear here. Full instructions on how to install the catalog once you have downloaded it are contained on the website.

Overall, I am still as excited about Lightroom as I was at the beginning of the program's development, and I hope the book provides the inspiration and insights to help you get the most out of the program, too.

Martin Evening, October 2017

Lightroom book updates

Adobe has been known to release interim updates for the Lightroom program in which new features are added. To keep readers updated, I aim to keep the book website updated, adding PDFs or movies whenever significant new features are added. So when this happens, do remember to check the book website. I also have a Facebook page where readers can be kept up-to-date: facebook.com/MartinEveningPhotoshopAndPhotography.

Acknowledgments

I would like to thank Pamela Pfiffner, for prompting me to get started on this project and for her advice and help during the planning stage of this book series. For this particular edition, my editor, Nancy Davis has done an excellent job making sure everything has come together smoothly. Other members of the publishing team included the production editor, Tracey Croom; copyeditor, Linda Laflamme; proofreader, Patricia J. Pane; indexer, James Minkin; and additional compositing and corrections by David Van Ness. I would also like to thank Charlene Charles-Will for the original cover design, as well as the Adobe Press marketing team.

Lightroom is really the brainchild of Mark Hamburg, without whom none of this would have happened. Since the inception of Lightroom, I have been helped a lot by the various Lightroom engineers and other members of the team. It is all thanks to them that I have managed to gather the background technical knowledge required to write this book. In particular, I would like to thank Thomas Knoll, Eric Chan, Max Wendt, and Joshua Bury (who work on the Camera Raw engineering). I would also like to thank Benjamin Warde, product managers Sharad Mangalick and Tom Hogarty, plus product evangelist Julieanne Kost, for the support and help they have given me over the years. I would especially like to thank lan Lyons, who tech edited the book. Thank you, lan, for clarifying all the many technical points and providing additional insights. Thanks also go to Sean McCormack, who provided me with valuable feedback and assistance.

A number of photographic shoots have been carried out specifically for this book. I would like to thank the models, Lucy Edwards and Veronica at M&P and Kelly from Zone; Camilla Pascucci for makeup; Terry Calvert, James Pearce, and Nadia Foster for hair; Harriet Cotterill for the clothes styling; Stuart Weston and Neil Soni for the use of their studios; and Harry Dutton and Rob Cadman for assisting me. Also a big thank-you to Jeff Schewe and George Jardine for documenting the shoots with stills and video.

It has been an interesting experience to see a new program emerge from scratch and has been a pleasure to share the development process in the company of a great group of Lightroom experts and fellow authors, who were all willing to share their knowledge about the program with one another. You will notice that this book is dedicated to the memory of Bruce Fraser, who sadly passed away in December 2006. Bruce was one of the original core group of Lightroom experts who helped shaped the program. The Lightroom capture and output sharpening features are both based on Bruce's original work on Photoshop sharpening techniques. Bruce was a true genius and is deeply missed by all those who knew and worked with him.

A book like this would be rather boring to read through without having some decent photographs to illustrate it with. For supplementing my own photography, I would, therefore, like to thank Sean McCormack, Eric Richmond, and Jeff Schewe, all of whom are individually credited throughout this book. And lastly, I would like to thank my wife, Camilla, and daughter, Angelica, for yet again being so understanding and patient while I was glued to the computer!

Contents

1	Introducing	Adobe	Photoshop	Lightroom	1
---	-------------	-------	------------------	-----------	---

 What is Lightroom?
 2

 Keeping things simple
 2

 Modular design
 2

Lightroom performance
Lightroom performance
Adobe Camera Raw processing
Color controls
Managing the image library
Where does Photoshop fit in?
Integrating Lightroom with Photoshop
If your Lightroom subscription should come to an end 8
What you need
Installing Lightroom
Sleep protection
Upgrading from an older Lightroom catalog
Using Lightroom for the first time
Lightroom preferences
Performance preferences
Graphics card compatibility
Smart previews option
Lightroom CC (mobile) preferences
History panel
Customizing the identity plate and interface 20
Getting help
The Lightroom interface
Working through the book
Importing photos 27
The main Import dialog28
Copy as DNG, Copy, Move, or Add?
DNG benefits
Converting to DNG after import
Import and Library module previews
Import options preferences
Importing files from a card
Activity Center
Source panel
Content area
Content area segmenting options

	File Handling panel	
	Build Smart Previews	43
	Suspect duplicates	
	Add to collection	43
	Embedded Previews after import	
	File format compatibility	
	Why files may fail to be imported	47
	Making backup copies of imported files	47
	Photos shot as raw + JPEG	48
	File Renaming panel	48
	Renaming catalog files later	50
	Apply During Import panel	50
	Destination panel	52
	Planning where to store your imported photos	52
	Importing to a selected destination folder	54
	Import Presets menu	54
	Importing video files	55
	Adding photos to the catalog	56
	Importing photos via drag and drop	57
	Importing photos from another application	58
	Auto Imports	
	Importing photos directly from the camera	
	Tethered shooting connections	
	Lightroom-tethered shooting	62
	Lightroom-tethered shooting	62
3	The Library module	
3		. 67
3	The Library module	. 67
3	The Library module About Lightroom catalogs	. 67 68 70
3	The Library module About Lightroom catalogs	. 67 68 70 71 72
3	The Library module About Lightroom catalogs	. 67 68 70 71 72
3	The Library module About Lightroom catalogs	68 70 71 72 72
3	The Library module About Lightroom catalogs	68 70 71 72 72 72
3	The Library module About Lightroom catalogs	. 67 68 70 71 72 72 72 73 74
3	The Library module About Lightroom catalogs	. 67 68 70 71 72 72 73 74
3	The Library module About Lightroom catalogs Backing up the catalog file Backup strategies Backup software Time Machine and the Lightroom catalog Catalog corruption Sync catalog disaster recovery Creating and opening catalogs Creating a new catalog Opening an existing catalog	. 67 68 70 71 72 72 72 73 74 74
3	The Library module About Lightroom catalogs Backing up the catalog file Backup strategies Backup software Time Machine and the Lightroom catalog Catalog corruption Sync catalog disaster recovery Creating and opening catalogs Creating a new catalog Opening an existing catalog The Library Module panels	. 67 68 70 71 72 72 72 73 74 75 76
3	The Library module About Lightroom catalogs Backing up the catalog file Backup strategies Backup software Time Machine and the Lightroom catalog Catalog corruption Sync catalog disaster recovery Creating and opening catalogs Creating a new catalog Opening an existing catalog The Library Module panels Making the interface more compact	. 67 68 70 71 72 72 72 73 74 75 76 78
3	The Library module About Lightroom catalogs Backing up the catalog file Backup strategies Backup software Time Machine and the Lightroom catalog Catalog corruption Sync catalog disaster recovery Creating and opening catalogs Creating a new catalog Opening an existing catalog The Library Module panels Making the interface more compact The Navigator panel	. 67 68 70 71 72 72 73 74 75 76 78
3	The Library module About Lightroom catalogs Backing up the catalog file Backup strategies Backup software Time Machine and the Lightroom catalog Catalog corruption Sync catalog disaster recovery Creating and opening catalogs Creating a new catalog Opening an existing catalog The Library Module panels Making the interface more compact The Navigator panel The Catalog panel	. 67 68 70 71 72 72 73 74 75 76 78 78
3	The Library module About Lightroom catalogs Backing up the catalog file Backup strategies Backup software Time Machine and the Lightroom catalog Catalog corruption Sync catalog disaster recovery Creating and opening catalogs Creating a new catalog Opening an existing catalog The Library Module panels Making the interface more compact The Navigator panel The Catalog panel The Library module Toolbar	. 67 68 70 71 72 72 73 74 74 75 76 78 78
3	The Library module About Lightroom catalogs Backing up the catalog file Backup strategies Backup software Time Machine and the Lightroom catalog Catalog corruption Sync catalog disaster recovery Creating and opening catalogs Creating a new catalog Opening an existing catalog The Library Module panels Making the interface more compact The Navigator panel The Catalog panel The Library module Toolbar The Folders panel	. 67 68 70 71 72 72 74 74 75 76 78 78 78
3	The Library module About Lightroom catalogs Backing up the catalog file Backup strategies Backup software Time Machine and the Lightroom catalog Catalog corruption Sync catalog disaster recovery Creating and opening catalogs Creating a new catalog Opening an existing catalog The Library Module panels Making the interface more compact The Navigator panel The Catalog panel The Library module Toolbar	. 67 68 70 71 72 72 73 74 75 76 78 78 78 78 79

Locating a folder at the system level	82
The Folders panel/system folders relationship	84
Maintaining folder links	84
Maintaining volume links	85
Synchronizing folders	86
Finding the link from the catalog to a folder	88
How to organize your folders	90
The Filter bar	92
Exploring the Library module	93
Grid view options	93
Library Grid navigation	95
Working in Loupe view	97
Loupe view options	98
Draw face region overlay	99
Working with photos in both Grid and Loupe views	100
Loupe view navigation	102
Loupe zoom views	103
Loupe view shortcuts	103
Loupe Overlay view	104
Grid and Guides	104
Layout Image	106
The Layout Overlay feature in use	106
Previews and preview appearance	108
Initial Import Photos dialog preview-building options . 1	108
How Lightroom previews are generated	109
Camera-embedded previews vs. Lightroom previews	110
Missing previews	111
Preview size and quality	111
Working in Survey view	112
Working in Compare view 1	114
Compare view mode in action	116
Navigating photos via the Filmstrip 1	118
Working with a dual-display setup 1	120
How to get the most out of working with two displays	122
Rating images using flags 1	
Refine Photos command 1	
Rating images using numbered star ratings	
Rating images using color labels	
Color label sets 1	
Other ways you can use color labels	
Grouping photos into stacks	
Automatic stacking	
Making image selections	
Quick Collections	

	Collections	134
	Module collections	135
	Collection badge icons	137
	The module collections in use	138
	Editing collections	138
	Target collection	139
	Collection sets	140
	Smart Collections	140
	Removing and deleting photos	142
	Exporting catalogs	143
	Exporting with negatives	143
	Exporting without negatives	144
	Including Smart Previews	144
	Including available previews	145
	Opening and importing catalogs	145
	New photos section	146
	Changed Existing Photos section	146
	Limitations when excluding negatives	147
	Export and import summary	147
	Working with Smart Previews	147
	How to create Smart Previews	148
	Making the catalog portable	149
4	Develop module image editing	
4	Smarter image processing	154
4	Smarter image processing Steps for getting accurate color	154
4	Smarter image processing Steps for getting accurate color Choosing a display	154 155 155
4	Smarter image processing Steps for getting accurate color Choosing a display Calibrating and profiling the display	154 155 155
4	Smarter image processing Steps for getting accurate color Choosing a display Calibrating and profiling the display White point and gamma	
4	Smarter image processing Steps for getting accurate color Choosing a display Calibrating and profiling the display White point and gamma Matching white balances	
4	Smarter image processing Steps for getting accurate color Choosing a display Calibrating and profiling the display White point and gamma Matching white balances Steps to successful calibration and profiling	
4	Smarter image processing Steps for getting accurate color Choosing a display Calibrating and profiling the display White point and gamma Matching white balances Steps to successful calibration and profiling Process versions	
4	Smarter image processing Steps for getting accurate color Choosing a display Calibrating and profiling the display White point and gamma Matching white balances Steps to successful calibration and profiling Process versions Upgrading to Version 4	
4	Smarter image processing Steps for getting accurate color Choosing a display Calibrating and profiling the display White point and gamma Matching white balances Steps to successful calibration and profiling Process versions Upgrading to Version 4 Process version mismatches	
4	Smarter image processing Steps for getting accurate color Choosing a display Calibrating and profiling the display White point and gamma Matching white balances Steps to successful calibration and profiling Process versions Upgrading to Version 4 Process version mismatches Camera Raw compatibility	
4	Smarter image processing Steps for getting accurate color Choosing a display Calibrating and profiling the display White point and gamma Matching white balances Steps to successful calibration and profiling Process versions Upgrading to Version 4 Process version mismatches Camera Raw compatibility Editing CMYK images in Develop	
4	Smarter image processing Steps for getting accurate color Choosing a display Calibrating and profiling the display White point and gamma Matching white balances Steps to successful calibration and profiling Process versions Upgrading to Version 4 Process version mismatches Camera Raw compatibility Editing CMYK images in Develop The Develop module interface	
4	Smarter image processing Steps for getting accurate color Choosing a display Calibrating and profiling the display White point and gamma Matching white balances Steps to successful calibration and profiling Process versions Upgrading to Version 4 Process version mismatches Camera Raw compatibility Editing CMYK images in Develop The Develop module interface View options in Develop	
4	Smarter image processing Steps for getting accurate color Choosing a display Calibrating and profiling the display White point and gamma Matching white balances Steps to successful calibration and profiling Process versions Upgrading to Version 4 Process version mismatches Camera Raw compatibility Editing CMYK images in Develop The Develop module interface View options in Develop Develop module cropping	
4	Smarter image processing Steps for getting accurate color Choosing a display Calibrating and profiling the display White point and gamma Matching white balances Steps to successful calibration and profiling Process versions Upgrading to Version 4 Process version mismatches Camera Raw compatibility Editing CMYK images in Develop The Develop module interface View options in Develop Develop module cropping Rotating a crop	
4	Smarter image processing Steps for getting accurate color Choosing a display Calibrating and profiling the display White point and gamma Matching white balances Steps to successful calibration and profiling Process versions Upgrading to Version 4 Process version mismatches Camera Raw compatibility Editing CMYK images in Develop The Develop module interface View options in Develop Develop module cropping Rotating a crop Constrain to image cropping	
4	Smarter image processing Steps for getting accurate color Choosing a display Calibrating and profiling the display White point and gamma Matching white balances Steps to successful calibration and profiling Process versions Upgrading to Version 4 Process version mismatches Camera Raw compatibility Editing CMYK images in Develop The Develop module interface View options in Develop Develop module cropping Rotating a crop Constrain to image cropping Auto straightening	
4	Smarter image processing Steps for getting accurate color Choosing a display Calibrating and profiling the display White point and gamma Matching white balances Steps to successful calibration and profiling Process versions Upgrading to Version 4 Process version mismatches Camera Raw compatibility Editing CMYK images in Develop The Develop module interface View options in Develop Develop module cropping Rotating a crop Constrain to image cropping Auto straightening Crop aspect ratios	
4	Smarter image processing Steps for getting accurate color Choosing a display Calibrating and profiling the display White point and gamma Matching white balances Steps to successful calibration and profiling Process versions Upgrading to Version 4 Process version mismatches Camera Raw compatibility Editing CMYK images in Develop The Develop module interface View options in Develop Develop module cropping Rotating a crop Constrain to image cropping Auto straightening	

	Canceling a crop	172
	Tool Overlay menu	172
	The Tool Overlay options	172
	Quick Develop cropping	173
The Ba	asic panel	174
	White Balance tool	174
	White Balance corrections	176
	Creative white balance adjustments	177
	White balance and localized adjustments	178
	Independent auto white balance adjustments	179
	The Basic panel tone-editing controls	180
	Exposure	180
	Contrast	181
	Highlights and Shadows	181
	Whites and Blacks	182
	Auto Whites and Blacks adjustments	182
	General Auto Tone adjustments	184
	Basic panel adjustments workflow	185
	Histogram panel	188
	The Histogram panel and image adjustments	190
	Navigating the Basic panel via the keyboard	191
	Correcting overexposed images	192
	Correcting underexposed images	194
	Match Total Exposures	196
	Highlight clipping and Exposure settings	198
	Clipping the blacks	198
	Creating HDR photos using Photo Merge	200
	Deghost Amount options	201
	Creating panorama photos using Photo Merge	204
	Panorama projection options	205
	Panorama Photo Merge performance	208
	Boundary Warp slider	208
	Clarity slider	210
	Images that benefit from adding Clarity	211
	Negative Clarity adjustments	212
	Vibrance and Saturation	214
	Quick Develop panel tone adjustments	216
	Process version conflicts	217
	The other tone controls	217
	A typical Quick Develop workflow	218
	Editing video files in Quick Develop	221
	Loupe view video-editing options	221
The To	one Curve panel	
	Point Curve editing mode	
	RGB curves	
	The Tone Curve regions	232

	Combining Basic and Tone Curve adjustments	234
	Tone range split point adjustments	238
	Refining the tone curve contrast	239
	HSL / Color / B&W panel	240
	Selective color darkening	242
	False color hue adjustments	243
	Using the HSL controls to reduce gamut clipping	244
	Lens Corrections panel Profile mode	246
	Lens profile corrections	246
	Accessing and creating custom camera lens profiles .	247
	Profile lens corrections in use	247
	In-camera lens corrections	250
	Removing chromatic aberration	250
	Lens Corrections panel Manual mode	252
	Defringe adjustments	252
	The Defringe controls in use	253
	Eyedropper tool	
	Applying a global Defringe adjustment	254
	Applying a localized Defringe adjustment	
	Vignetting sliders	257
	Transform panel	
	Upright adjustments	
	How Upright adjustments work	
	Suggested order for Upright adjustments	260
	Synchronizing Upright settings	
	How to apply an Upright adjustment	
	Guided Upright adjustments	
	The Transform sliders	
	Effects panel	
	Post-Crop vignettes	
	Post-Crop vignette options	
	Adding Grain	
	Dehaze adjustments	
	Dehaze as a localized adjustment	
	Camera Calibration panel	
	Camera profiles	
	sing your images	
	Comparing before and after versions	
	Managing the Before and After previews	
	Reference View	
Image	e retouching	
	Spot Removal tool	
	Visualizing spots	
	Creating brush spots	
	Retouching example using brush spots	
	Editing circle and brush spots	291

	Tool Overlay options	291
	Undoing/deleting spots	291
	Auto-calculate behavior	292
Spo	t Removal tool feathering	292
Synd	chronized spotting	292
	Synchronized settings spot removal	293
	Auto Sync spot removal	294
	Red Eye Correction tool	295
	Pet Eye mode	
Loca	alized adjustments	
	Initial Adjustment Brush options	298
	Editing the Adjustment Brush strokes	
	Saving effect settings	
	Localized adjustment position and editing	
	Exposure dodging with the Adjustment Brush	
	Auto Mask	
	Previewing the brush stroke areas	
	Beauty retouching using negative clarity	
	Hand-coloring using a Color effect	
	Localized Temperature slider adjustments	
	Localized Shadows adjustments	
	Clarity and Sharpness adjustments	
Gra	duated Filter tool	
-	Brush editing a Graduated Filter effect	
Rad	ial Filter tool	
	Correcting edge sharpness with the Radial Filter	
Ran	ge Masking	
	Range Masking and process versions	
	Color Range Masking	
	Luminance Range Masking	
Hist	ory panel	
	pshots panel	
5.15	How to synchronize snapshots	
Easing the	workflow	
_	king virtual copies	
	Making a virtual copy the new master	
Syne	chronizing Develop settings	
٠,	Auto Sync mode	
Con	ying and pasting Develop settings	
COP	Applying a previous Develop setting	
Liah	ntroom and Camera Raw compatibility	
Ligi	Making Camera Raw edits accessible in Lightroom	
	Making Lightroom edits accessible in Camera Raw	
	Keeping Lightroom edits in sync	
	Synchronizing Lightroom with Camera Raw	
Savi	ing Develop settings as presets	
Javi	ing Develop settings as presets	

	Auto Tone preset adjustments	345
	The art of creating Develop presets	345
	Creating a new Develop preset	346
	Understanding how presets work	347
	How to prevent preset contamination	348
	Creating default Develop camera settings	352
5	The art of black and white	355
	Black-and-white conversions	356
	Black-and-white conversion options	358
	How not to convert	
	Temperature slider conversions	360
	Manual black-and-white adjustments	362
	Black-and-white infrared effect	365
	Refining black-and-white conversions	368
	Split Toning panel	368
	Split-toning a color image	
	HSL panel: Desaturated color adjustments	
	The HSL black-and-white method in detail	
	Camera Calibration adjustments	373
6	Sharpening and noise reduction	377
6		
6	Capture sharpen for a sharp start	378
6	Capture sharpen for a sharp start	378
6	Capture sharpen for a sharp start	378 378 380
6	Capture sharpen for a sharp start	378 378 380
6	Capture sharpen for a sharp start	378 378 380 381
6	Capture sharpen for a sharp start	378 378 380 381 382
6	Capture sharpen for a sharp start Improved Lightroom raw image processing Output sharpening Default Detail panel settings Sharpen preset settings Sharpen – Faces	378 378 380 381 382 383
6	Capture sharpen for a sharp start Improved Lightroom raw image processing Output sharpening Default Detail panel settings Sharpen preset settings Sharpen – Faces Sharpen – Scenic	378 378 380 381 382 383 384
6	Capture sharpen for a sharp start Improved Lightroom raw image processing Output sharpening Default Detail panel settings Sharpen preset settings Sharpen – Faces Sharpen – Scenic Sample sharpening image Evaluate at a 1:1 view	
6	Capture sharpen for a sharp start Improved Lightroom raw image processing Output sharpening Default Detail panel settings Sharpen preset settings Sharpen – Faces Sharpen – Scenic Sample sharpening image	
6	Capture sharpen for a sharp start Improved Lightroom raw image processing Output sharpening Default Detail panel settings Sharpen preset settings Sharpen – Faces Sharpen – Scenic Sample sharpening image Evaluate at a 1:1 view Luminance targeted sharpening	
6	Capture sharpen for a sharp start Improved Lightroom raw image processing Output sharpening Default Detail panel settings Sharpen preset settings Sharpen – Faces Sharpen – Scenic Sample sharpening image Evaluate at a 1:1 view Luminance targeted sharpening The sharpening effect sliders	
6	Capture sharpen for a sharp start Improved Lightroom raw image processing Output sharpening Default Detail panel settings Sharpen preset settings Sharpen – Faces Sharpen – Scenic Sample sharpening image Evaluate at a 1:1 view Luminance targeted sharpening The sharpening effect sliders Amount slider	
6	Capture sharpen for a sharp start Improved Lightroom raw image processing Output sharpening Default Detail panel settings Sharpen preset settings Sharpen – Faces Sharpen – Scenic Sample sharpening image Evaluate at a 1:1 view Luminance targeted sharpening The sharpening effect sliders Amount slider Radius slider	
6	Capture sharpen for a sharp start Improved Lightroom raw image processing Output sharpening Default Detail panel settings Sharpen preset settings Sharpen – Faces Sharpen – Scenic Sample sharpening image Evaluate at a 1:1 view Luminance targeted sharpening The sharpening effect sliders Amount slider Radius slider The modifying controls	
6	Capture sharpen for a sharp start Improved Lightroom raw image processing Output sharpening Default Detail panel settings Sharpen preset settings Sharpen – Faces Sharpen – Scenic Sample sharpening image Evaluate at a 1:1 view Luminance targeted sharpening The sharpening effect sliders Amount slider Radius slider The modifying controls Detail slider	
6	Capture sharpen for a sharp start Improved Lightroom raw image processing Output sharpening Default Detail panel settings Sharpen preset settings Sharpen – Faces Sharpen – Scenic Sample sharpening image Evaluate at a 1:1 view Luminance targeted sharpening The sharpening effect sliders Amount slider Radius slider The modifying controls Detail slider Interpreting the grayscale sharpening preview	
6	Capture sharpen for a sharp start Improved Lightroom raw image processing Output sharpening Default Detail panel settings Sharpen preset settings Sharpen – Faces Sharpen – Scenic Sample sharpening image Evaluate at a 1:1 view Luminance targeted sharpening The sharpening effect sliders Amount slider Radius slider The modifying controls Detail slider Interpreting the grayscale sharpening preview Masking slider	378 378 380 380 381 382 383 384 385 385 386 389 390 393 393
6	Capture sharpen for a sharp start Improved Lightroom raw image processing Output sharpening Default Detail panel settings Sharpen preset settings Sharpen – Faces Sharpen – Scenic Sample sharpening image Evaluate at a 1:1 view Luminance targeted sharpening The sharpening effect sliders Amount slider Radius slider The modifying controls Detail slider Interpreting the grayscale sharpening preview Masking slider Masking slider preview mode	

Noise reduction	402
Luminance noise reduction	402
Color noise reduction	404
Noise-reduction tips	404
Color noise corrections	405
Color Smoothness slider	406
Selective noise reduction	408
Selective moiré reduction	409
Moiré removal on non-raw images	411
Exporting from Lightroom	413
Opening images in Photoshop	414
The External editing options	414
Edit in Adobe Photoshop	415
Edit in additional external editing program	416
Opening non-raw images in an external	
editing program	417
Creating additional external editor presets	417
External editing file-naming options	418
The file format and other file settings options	418
Camera Raw compatibility	419
How to use the external edit feature	420
Going from Lightroom to Photoshop to Lightroom	422
Extended editing in Photoshop	426
Linking Lightroom photos as Smart Objects	429
Exporting from Lightroom	431
Export presets	431
Export Location	431
Exporting to the same folder	432
File Naming	434
File Settings	434
DNG export options	436
Image Sizing	437
When to interpolate	437
Output Sharpening	438
Metadata	438
Watermarking	439
Creating new watermark settings	440
Post-Processing	441
Adding export actions in Lightroom	
Exporting catalog images to a CD or DVD	445
Exporting catalog images as email attachments	446
Third-party Export plug-ins	448
Exporting video files	449

Printing	451
The Print module	453
Layout Style panel	454
Image Settings panel	
Layout panel	
Margins and Page Grid	
Guides panel	
Multiple cell printing	
Page panel	
Adding a photographic border to a print .	462
Page Options	
Photo Info	
Picture Package	466
Image Settings panel	466
Rulers, Grid & Guides panel	466
Cells panel	466
Custom Package	468
Picture Package/Custom Package Page pane	el 469
Page Setup	470
Print resolution	471
Print Job panel	472
Print job color management	472
The Lightroom printing procedure	472
Managed by Printer print settings (Mac)	473
Managed by Printer print settings (PC)	474
Printer profiles	475
Print Adjustment controls	475
Print	476
Printing modes	477
Print sharpening	477
16-bit output	478
Print to JPEG File	478
Custom profile printing	479
Managed by Lightroom print settings (Mac	.) 480
Managed by Lightroom print settings (PC)	481
Rendering intent	482
Soft proofing for print output	483
Why what you see isn't always what you g	et 483
Soft proofing in practice	485
Before and Proof preview	
Before state options	
Saving a custom template	491

Pre	senting your work	493
The Bo	ook module	494
	Creating a new book	495
	Book Settings panel	496
	PDF and JPEG book export	497
	Preview panel	497
	Toolbar	498
	Auto Layout panel	498
	Auto Layout Preset Editor	498
	Editing the book pages	500
	Editing the cover pages	502
	Page panel	504
	Marking page layouts as favorites	504
	Adding page numbers to a layout	504
	Saving custom page layouts	504
	Guides panel	505
	Cell panel	506
	Text panel	506
	Text box layouts	506
	Adding auto text	507
	Type panel	508
	Type panel Character controls	508
	Target Adjustment tool options	510
	Type panel Frame controls	510
	Background panel	510
	Publishing your book	511
The SI	ideshow module	512
	The Slide Editor view	514
	Layout panel	
	Options panel	516
	Overlays panel	
	Creating a custom identity plate	
	Adding custom text overlays	
	Backdrop panel	
	Titles panel	524
	Music panel	
	Playback panel	
	Pan and zoom options	
	Manual mode	
	Playback screen and quality settings	
	Play and preview	
	Navigating slideshow photos	
	Impromptu slideshows	
	Slideshows and selections	528

Exporting a slideshow	530
Exporting slideshows to PDF	530
Exporting slideshows to JPEG	
Exporting slideshows to video	532
Exporting a timelapse video	532
Licensing audio tracks	533
The Web module	534
Layout Style panel	
The Lightroom HTML and HTML5 galleries	
Lightroom HTML gallery (default) layout	
Lightroom Grid (HTML5) Gallery layout	538
Third-party gallery styles	539
Site Info panel	540
Color Palette panel	541
Choosing a color theme	541
Appearance panel	
Appearance settings for the HTML gallery	
Appearance panel settings for the HTML5 Gallery \dots	543
Image Info panel	
Adding titles and captions	
Customizing the title and caption information	
Creating a custom Text template	
Output Settings panel	
Previewing web galleries	
Image appearance in the Slideshow and Web modules	
Upload Settings	
Exporting a web gallery	550
Uploading a web gallery	
Managing your uploads	
Template Browser panel	
Creating a web collection	553
Managing your photos in Lightroom	555
Working with metadata	
The different types of metadata	
A quick image search using metadata	
Metadata panel	
Metadata panel view modes	
General and EXIF metadata items	
File Name	
Sidecar Files	563

Template Browser panel 528 Creating a Slideshow collection 529

	Copy Name	563
	Metadata Status	564
	Cropped photos	564
	Date representation	565
	Capture time editing	565
	Camera model and serial number	566
	Artist EXIF metadata	566
Custor	m information metadata	567
	Metadata presets	568
	Editing and deleting metadata presets	570
	IPTC metadata	570
	IPTC Extension metadata	572
	A more efficient way to add metadata	573
Metac	lata editing and target photos	574
	Mail and web links	576
	Copyright status	576
Keywo	ording and Keyword List panels	577
	Keeping metadata private	580
	Synonyms: The hidden keywords	580
	Applying and managing existing keywords	583
	Auto-complete options	583
	Removing keywords	584
	Keyword hierarchy	584
	Keyword filtering	585
	Importing and exporting keyword hierarchies	586
	Implied keywords	586
	Keyword suggestions	587
	Keyword sets	588
	Creating your own custom keyword sets	589
The Pa	ainter tool	590
People	e view mode	590
	Single Person view mode	596
	Expanding and collapsing stacks	597
	People view mode Toolbar	597
	Person keywords	598
	Exporting Person keywords	600
Photo filterin	ng and searches	600
Filteri	ng photos in the catalog	600
	Three ways you can filter the catalog	602
	Filtering photos via the Filmstrip	603
	Adding folders as favorites	604
	Flagged photos filter options	604
	Star rating filter options	604
	Creating refined selections via the Filmstrip $\ldots \ldots$	604
	Color label filter options	605

	Virtual copy and master copy filtering	607
S	ubfolder filtering	608
N	Making filtered image selections	609
F	ilter bar	610
	The Filter bar layout	611
Te	ext filter searches	611
	Search rules	612
	Combined search rules	613
	Fine-tuned text searches	613
А	ttribute filter searches	614
N	Netadata filter searches	614
	Metadata filter options	615
	Metadata filter categories	616
	ocating missing photos	
C	ustom filter settings	618
	Empty field searches	618
	Advanced searches	
	ublishing photos via Lightroom	
S	aving and reading metadata	
	Saving metadata to the file	
	Tracking metadata changes	627
	XMP read/write options	
	Where is the truth?	632
	Synchronizing metadata settings	633
S	orting images	634
	Sort functions	635
	Color label sorting	635
Geotag	ging images	636
	iPS devices	
Е	mbedding GPS metadata in a photo	
	Reverse-geocoding	638
Т	he Map module	
	Navigation	639
	Location filter bar	
	Loading GPX tracklogs	640
	Editing pins	
	Matching photos to a recorded tracklog	
	Manually geotagging photos in the Map module	
	Saved Locations panel	
	Exporting GPS-encoded files	646
	Filtering geocoded images	647

Lightroom CC/mobile6	49
Lightroom CC/mobile workflow	650
What Lightroom CC/mobile can and cannot do	652
Lightroom CC for Apple TV	652
Setting up Lightroom CC/mobile	
How Lightroom CC/mobile edits are synchronized	655
Where Lightroom CC/mobile photos are kept	
Creating a synchronized collection from Lightroom Classic CC	
Working with Lightroom CC for mobile	
Single image view	659
Lightroom CC for mobile preferences	
Album/folder options	663
Adding photos directly via a device	664
Lightroom CC for mobile camera	664
Lightroom CC for mobile searches	665
Lightroom CC for web view	666
Lightroom CC for web	668
Auto tone	670
Uploading files via Lightroom CC for web	671
Managing photos via Lightroom CC for web	673
Lightroom CC program	674
Migrating from Lightroom Classic CC	675
Lightroom CC program layout	677
Importing files via the Lightroom CC program	678
Editing photos in the Lightroom CC program	680
Stacking photos	683
Edit Settings options	684
Managing photos in the Lightroom CC program	684
Selecting and rating images	685
Creating copies	685
Keywording	685
Lightroom CC program file sharing	686
Removing/deleting photos	686
Lightroom CC program preferences	687
Lightroom preferences and settings 6	89
General preferences	690
Show splash screen	
Check for updates	
Catalog selection	
Import options	
Completion sounds and prompts	

Presets preferences	. 692
Camera-linked settings	. 693
Location section	
Lightroom Defaults section	. 693
External Editing preferences	
File Handling preferences	. 694
Import DNG Creation	. 694
Convert and export DNG options	. 697
DNG compression	. 697
DNG with lossy compression	
Updating DNG previews for third-party viewing	
Validating DNG files	
Checking DNG metadata status	
Reading Metadata options	
Filename generation options	
Interface preferences	
Panel end mark	
Custom panel end marks	
Creating a custom splash screen	
Panel font size	
Lights Out	
Background	
Keyword entry	
Filmstrip options	
Interface tweaks	
Performance preferences	
Camera Raw and video cache settings	
Lightroom CC preferences	
Lightroom Network preferences	
Lightroom settings and templates	
Accessing saved template settings	
Customizing the Lightroom contents	
Hacking the Lightroom contents	
Lightroom previews data	
System information	
The ideal computer for Lightroom	
RAM	
Graphics card	
Hard drives	
Drive configurations	
Just a bunch of disks	
Just a Bullett of ulsks	. / 14
Index	715

Introducing Adobe Photoshop Lightroom

An introduction to the main features in Lightroom, showing an example of a typical studio shoot workflow

Welcome to the Adobe® Photoshop® Lightroom® system, which is designed to meet the needs of digital photographers everywhere. Lightroom now consists of two components: Lightroom Classic CC, which is the desktop version of Lightroom; and Lightroom CC, which now refers to all things mobile, but in particular, the Lightroom CC computer application. Because this book is predominantly about working with Lightroom Classic CC, the main focus is on how you can best work with the Lightroom Classic CC desktop program. Some Lightroom Classic CC users may also be subscribed to Lightroom CC, in which case there is a whole chapter at the end of the book dedicated to discussing Lightroom CC mobile workflows and how these integrate with Lightroom Classic CC. With this in mind, and for the sake of simplicity, I mostly refer to Lightroom Classic CC as "Lightroom" throughout the book. However, in the Lightroom Mobile chapter I make a clearer distinction between Lightroom Classic CC and Lightroom CC/mobile.

Lightroom was designed from the ground up to provide today's digital photographers with the tools they most need. This is reflected in the way Lightroom separates the various tasks into individual modules, is able to process large numbers of images at once, and lets you archive and retrieve your images quickly. But before I get into too much detail, let me begin by explaining a little about the basic concepts of Lightroom, the essential preference settings, and the Lightroom interface.

NOTE

You can use the following Mac shortcuts when switching between individual modules (PC users should use Ctri Alt plus the number):

Alt −1 to select Library

Alt −3 to select Map

Alt −4 to select Book

Alt −6 to select Print

₩Alt -7 to select Web

In addition, (a) selects the Library module in Grid mode, (E) selects the Library module in Loupe mode, and (b) selects the Develop module.

What is Lightroom?

Lightroom is a high-quality image processor and image database management system rolled into one. Although, as I mentioned in the introduction, Lightroom now consists of the Lightroom Classic CC desktop application and a Lightroom CC mobile system and streamlined Lightroom application. Lightroom is designed with photographers in mind, giving them powerful image-editing tools to process their photographs and manage large numbers of digital images. Lightroom provides a suite of application modules that provide an ideal workflow for digital photographers.

Keeping things simple

Lightroom's tools are designed to streamline the image management and editing process and make the user experience as smooth and simple as possible. The program aims to provide photographers with the tools they need most and eliminates the call for complicated workarounds. For the most part, Lightroom has succeeded in doing this. It does not have too many complicated preference dialogs, nor does it demand you do anything special to optimize the program settings before you get started. For example, there are no color management settings dialogs to configure. This is because color management in Lightroom is carried out automatically without needing any user input. The Lightroom print workflow is very logical and, once set up, is easy to work with.

Modular design

Lightroom is comprised of individual, self-contained modules built around a central core that contains the image processing and image database engines. Each module can be thought of as offering a unique set of functions, and in Lightroom there are seven separate modules: Library, Develop, Map, Book, Slideshow, Print, and Web. The modular approach means Lightroom can expand the range of things you can do in the program but without adding unnecessary complexity to the other existing modules. Lightroom is designed so that all individual modules are able to tap into the two core components of the application. This is what gives the program its speed and adaptability.

Figure 1.1 shows a summary of the Lightroom system workflow. You can begin by explicitly importing stills or video files into Lightroom. For example, you can import files from a camera's flash memory card, directly from a (supported) tethered camera, from files on a hard drive, or via an import from another catalog. The master files are then stored wherever you choose to place them. Once the files are imported, Lightroom is able to process and manage them without you actually editing the files themselves. Everything you do in Lightroom in the various modules is saved automatically to the master catalog file, which is used to store all the Lightroom edit information independently of the master images. As shown in Figure 1.1, you can

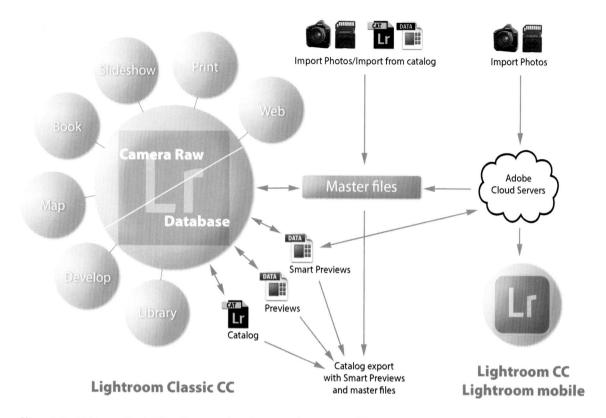

Figure 1.1 Lightroom Classic CC is a file storage-based program that uses a modular architecture system. At its heart are the Camera Raw image processor and catalog database engines. Lightroom CC/Lightroom mobile is a cloud-storage-based suite of program and apps.

export data from the Lightroom catalog as a complete catalog with copies of the master images, plus Smart Previews. You can also synchronize photos via Lightroom CC/Lightroom mobile, using the Adobe cloud servers (the Lightroom mobile workflow is explained in more detail in Chapter 11). The Library module is used to manage the catalog, the Develop module to carry out the image processing and the remaining modules are for creating different types of outputs from Lightroom: i.e., published books, slideshow presentations, prints, or web galleries.

You will notice Lightroom has a locked interface, where all you can do is edit the visibility of the modules and module panels—you can't actually rearrange the panels or make them float. I see this as a positive thing because you always know where you are when you are working with Lightroom. With other programs, like Adobe Photoshop CC, people tend to personalize the program in the way they arrange the panels and their appearance. I find that if I am asked to take control of someone else's computer, it can take a while to work out where everything is in their version of Photoshop. With Lightroom, the interface is always the same, and it's never a problem trying to locate a particular panel or tool.

NOTE

The Figure 1.1 diagram assumes you wish to continue working with Lightroom Classic CC as the main hub in a local storage workflow. As this book is primarily about how to work with Lightroom Classic CC, this is the workflow you should adopt in order to make the most of Lightroom Classic CC working in conjunction with Lightroom CC/mobile. However, you do now have the option to migrate the entire Lightroom Classic CC catalog to Lightroom CC (see Chapter 11). In this scenario the cloud can become the main hub, although it is possible to combine the two.

NOTE

Metadata refers to things such as the flags, star ratings, and color labels, as well as keywords that you can apply to photos in Lightroom. This also includes geotagging, where you can add GPS metadata to add location data to a photo.

Lightroom performance

One of the key aims with Lightroom Classic CC has been to improve Lightroom performance. With larger catalogs the launch time is faster, plus there have been many other speed improvements, especially with regards to the preview management. For example, Lightroom now applies what is known as predictive caching to speed up the preview loading in the Develop module. It does this by loading the Camera Raw cache for two photos on each side of the current selected image before then loading the final high-quality image into RAM memory. In this respect, the more available RAM memory you have the better. You can also expect faster image-loading times while navigating images sequentially in the Develop module. Steps have also been taken to speed up the Library module performance. The way this works is as follows. The Camera Raw cache always stores preview-quality negatives, and whenever Lightroom renders thumbnails or smaller standard previews for use in the Library module, these preview-quality negatives are requested and loaded first. As a result, when you're working in the Library module Grid or Loupe view, the thumbnail/preview rendering is now faster. Exporting is also faster, and this should be particularly noticeable when making bulk exports. File moving performance has been improved, as is backup performance to network-attached servers. To improve Lightroom's responsiveness, Lightroom's thread priority queuing system gives high-priority rendering tasks, such as Develop module editing, priority over such background tasks like exporting images, converting photos to DNG, and building Smart Previews.

Choosing to build Smart Previews as photos are imported enables you to continue working in Lightroom when the master files are off-line. For example, all the masters might be stored on a remote hard drive that is disconnected from the computer. Where Smart Previews are available, you can also manage the photos via the Library module and geotag photos using the Map module. Although you can create on-screen slideshows using Smart Previews, you cannot export slideshows. Similarly, you can use Smart Previews in the Book module to create or edit a book layout (but not to generate a book). Also, you can't export Smart Previews to Photoshop. Working with Smart Previews can help you achieve faster Lightroom performance, because Lightroom can work more quickly when using Smart Preview (compact, lower-resolution) versions of the master files. To help you take advantage of this, the Performance preferences now include the option to use Smart Previews in place of the originals when editing in the Develop module.

Of course, as camera files get bigger and photographers tend to shoot more and more pictures, it remains an ongoing and uphill battle for the computer hardware, operating systems, and software to keep up with the demand for speedier processing. The minimum requirements listed on page 8 are fine for processing regular capture files, but you will definitely want to use a modern, dual-core processor computer with as much RAM as possible to achieve the best performance. With a well-configured computer, you'll be able to quickly navigate

a collection of images, apply image adjustments, and synchronize settings across a folder or collection of photos. Image catalog searches should be fast, and you'll find it quick and easy to add and edit the metadata.

Adobe Camera Raw processing

If you are accustomed to using Camera Raw for Photoshop, you will already be familiar with the Develop module controls in Lightroom. This is because Lightroom shares the same Adobe Camera Raw processing engine as Photoshop, which has evolved to become one of the best raw processing tools on the market. It supports over 500 proprietary raw file formats, including most medium format cameras, digital SLRs, and the latest mirrorless cameras.

Color controls

Lightroom is primarily a raw processing program, but Develop module image adjustments also can be applied to TIFF, PSD, PNG, or JPEG images that are in RGB, Grayscale, CMYK, or Lab mode (but note that Lightroom image adjustments always are carried out in RGB). The Basic and Tone Curve panels provide intuitive controls with which you can easily adjust the tone and color in any photograph. The B&W panel offers an adaptable approach to black-and-white conversions whereby you can adjust the balance of color information that is used to create a monochrome version of a color original. The split-tone controls work nicely on color images as well as black-and-white converted pictures, and with a little experimentation you can easily produce quite dramatic cross-processed-type effects. The Develop module provides further tools to optimize your photographs. You can easily manipulate the brightness and color characteristics of global or targeted colors, for instance, and there are the tools for spotting and applying localized adjustments, not to mention tools for optical and geometric corrections.

It is worth pointing out that all Develop adjustments in Lightroom are non-destructive and recorded as edit instructions that are stored in the central catalog (and can also be stored as metadata with the image itself). This means that a single raw master file can be edited in many ways and output or printed at different sizes without you having to create different pixel image versions from the original. Any image edits and ratings you make in Lightroom can be recognized in current versions of Adobe Bridge and Photoshop. The same thing applies to ratings and other metadata. If you edit the metadata in Lightroom and save the changes made to the file, these can be read in Bridge. The reverse is also true. For example, if you add keywords and assign a colored label to an image in Bridge, these metadata edits can be read by Lightroom and updated to the Lightroom catalog—although this does raise the question of which settings are correct when a single image has been modified in two separate programs. In this situation, Lightroom informs you of any conflicts and lets you decide which settings should override the others.

NOTE

PNG files can be imported into Lightroom, but when you choose the "Edit in" command, a PNG will open up in Photoshop as a TIFF or PSD. Any transparency contained in the PNG original will be supported, and will appear white in Lightroom. However, there is no PNG option available when exporting from Lightroom (other than to export a PNG image using the original file format).

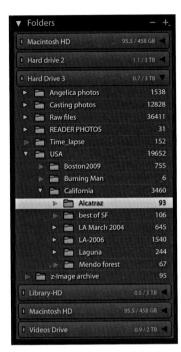

Figure 1.2 The Library module Folders panel showing an expanded list tree view of the folder structure, mirroring the contents of the system list tree folder view.

Lightroom provides high-pixel-density display support for Macintosh computers with Retina displays as well as Microsoft Windows high-density displays. Users working with such devices will see high-detail image previews and smoother text and icons in the Lightroom interface.

Managing the image library

Lightroom has been designed to provide a flexible workflow that meets the requirements of all types of photographers. When you work with Lightroom, you begin by explicitly choosing the photos you would like to add to the catalog. From this point on, the way Lightroom manages those images is actually not that much different from working with any other type of browser program. Most browser programs are like glorified versions of the Mac Finder or Windows Explorer, which are mainly useful for inspecting the contents on a computer and allowing you to see everything that is on a drive or in a specific folder. The main difference with Lightroom is that you control which images and videos are imported into the program, which are then cataloged by the program's central database. Files can be imported from a camera card, directly from the camera (via the Tethered Capture panel), or by copying them from an existing folder. Or, you can tell Lightroom to "add" photos to the catalog by importing them from the current folder location. After the files have been imported to the catalog, anything you do in Lightroom (such as changing a folder name or filename, deleting a file, or moving a file) is mirrored at the system level. When deleting, you have the option to remove a file from the catalog only or move it to the trash for deletion. Working with the Folders panel in Lightroom (Figure 1.2) is, therefore, not dissimilar from working with a hierarchical folder tree list view in a browser program. But in Lightroom, the tree list in the Folders panel shows only those files that you have requested to be in the catalog and nothing else.

Of course, a hierarchical folder management is fine if you know in which folders your images are stored. But as you start working with many thousands of photographs, you'll soon find this is no longer such a practical solution. Yes, Lightroom can store all your images in a neat hierarchy of folders, but its real power as an image asset manager comes into play when you use the Filter bar to search for images in the catalog. Once you get into the habit of entering descriptive keyword information each time you import new photos, you will be able to search your archive more easily and more quickly when browsing for specific photographs.

Where does Photoshop fit in?

For many years now, Photoshop has pretty much dominated the pixel image-editing market and has constantly adapted to meet the varying demands of lots of different types of Photoshop customers, from graphic designers to illustrators to special effects artists working in the motion picture industry. Although Photoshop is a powerful image-editing program with a wide range of tools to suit everyone's requirements, it also has become increasingly complex. When the two

Knoll brothers, Thomas and John, first created Photoshop, they could hardly have predicted how their program would develop or what Photoshop users in the future would be doing with it, much less predict the technological demands that digital capture would make. Photoshop started out as a program for editing single images in real time (as opposed to a deferred image-processing route), and the legacy of Photoshop's architecture led to various compromises being made as more and more features were added.

Lightroom has been built from scratch, which means the engineers were able to design a program that not only addressed current demands but also anticipated future needs. For example, whenever you apply consecutive image adjustments in Photoshop, you are progressively degrading the image. Lightroom, on the other hand, allows you to make as many adjustments and changes as you like; it applies them as a single adjustment only when you choose to edit in Photoshop or export the photo as a fixed-pixel image. You can also revisit the edits you make and create improved versions as the Lightroom editing tools are improved (**Figure 1.3**).

Adobe Camera Raw, which is used by both Bridge and Photoshop, does provide the same level of flexibility, but only up until the point when you render a raw file as a pixel image to be edited in Photoshop. In Lightroom, the photos in the catalog are like your digital negatives. Whether they are raw files, PSDs, TIFFs, or JPEGs, they are always preserved in their original state throughout the entire Lightroom workflow. You can create slideshows, generate web galleries, or make print outputs without ever physically altering the original files.

Integrating Lightroom with Photoshop

People often ask if Lightroom can ever become a complete replacement for Photoshop. I used to think not, but now when you consider the many kinds of things you can do to your images in Lightroom, the gap is certainly narrowing. The majority of photographs I work on are processed exclusively in Lightroom. Overall, I would say Lightroom is an ideal front-end application for importing new images and building a searchable database of your master photographs. Once your photos are in Lightroom, you have all the controls you need to carry out image-edit selections, group and rename photos, and make basic and advanced Develop adjustments. When you're ready to take your photos into Photoshop, you can use the Photo ⇒ Edit in Adobe Photoshop command or use the File ⇒ Export command to create exported versions of your master images. From there, you can make use of the tools in Photoshop to make photo composites or perform essential production tasks such as CMYK color conversions.

Once you start bringing images into Lightroom, you won't necessarily find yourself locked into working exclusively in Lightroom the way you are with some other programs. Lightroom is flexible enough to allow you to work simultaneously with Bridge or other image browser programs.

Figure 1.3 The photograph at top was shot and processed in Version 1 using just the Basic panel adjustments available in Camera Raw 2.0. The version below was reprocessed using the latest (Version 4) Basic panel sliders in Lightroom.

TIP

To see if the raw files from your camera are supported in Lightroom, go to the Adobe Photoshop website at: helpx.adobe.com/photoshop/camera-raw.html.

Cameras capable of capturing raw images using the Digital Negative (DNG) format are also supported in Lightroom. The DNG format offers many benefits: It is a self-contained raw format that can incorporate externally edited XMP metadata (no need for .xmp sidecar files), and, because it is an open standard format, it offers better long-term support.

If your Lightroom subscription should come to an end

Now Lightroom Classic CC is available via the Adobe Creative Cloud only. People are naturally worried about how they will be able to access their catalogs after their subscriptions come to an end. The good news is that when this happens, Lightroom will continue to launch and give you access to your files. The Develop and Map modules will be disabled, however, and integration with Lightroom mobile will no longer function.

What you need

Lightroom can process JPEGs, TIFFs, raw images, and video files. If your camera is capable of capturing raw images, I strongly advise you to shoot in raw mode whenever possible.

You will require a computer that meets the minimal specifications listed below. Although it is possible to run Lightroom with a minimum of RAM, Lightroom will certainly benefit from having as much memory as possible. Therefore, it is recommended that you install 4 GB or more of RAM. A computer with a fast processor will help, of course. You don't need much hard disk space to install Lightroom, but you will need to give serious consideration to how you will store all the images in the catalog. Here are the minimum requirements for Mac and PC systems.

Mac

Multicore Intel processor with 64-bit support

Mac OS X 10.11 or later

4 GB of RAM minimum (ideally, 8 GB or more)

2 GB of available hard disk space

Computer display with 1024 x 768 resolution or greater

Internet connection (for initial activation and Internet-based services)

Windows

Intel Pentium 4 or AMD Athion 64 processor

Windows 7 with Service Pack 1 or Windows 8 (64-bit) or Windows 10

4 GB of RAM minimum (ideally, 8 GB or more)

2 GB of hard disk space

Computer display with 1024 x 768 resolution or greater

Internet connection (for initial activation and Internet-based services)

Installing Lightroom

The Lightroom installation process should be fairly easy. All you need to do is download the program and run the installer. **Figure 1.4** shows the Adobe Creative Cloud installation dialog. To install Lightroom Classic CC, you will be required to enter your Adobe ID information and accept the Adobe Software License agreement. If the computer you install on is not connected to the Internet, you have one week to connect online and register the install. Beyond that, Lightroom will go into expiry mode, where the Develop and Map modules will be unavailable, until you have a chance to connect to the Internet again. If you have an earlier, perpetual license version of Lightroom on your computer, the Lightroom installer will install a separate, new version. However, if you are upgrading an existing Lightroom

Figure 1.4 The Lightroom installation dialog.

catalog, you will be asked at this stage if you would like Lightroom to run a verification process to test the integrity of the current catalog (see "Upgrading from an older Lightroom catalog" on page 11). The install process will also need to update the previous catalog file.

The Adobe Photoshop Lightroom Creative Cloud agreement permits you to install Lightroom on a main computer and a secondary computer such as a laptop. This is because Adobe recognizes that a lot of its customers regularly work on more than one computer. Another useful thing to know is that you can use a single Lightroom subscription to run a Mac and/or Windows version of the program. All Adobe applications use the same install process, which requires you to have an Adobe ID when installing the software. Your Adobe ID can help Adobe when handling customer support issues or if you move Lightroom to a new computer. The other benefit is that Adobe can improve the product by analyzing workflows in greater detail and can ultimately present tailored content and help based on your unique workflow. However, you do have the ability to opt out of data gathering: Choose Help ⇒ Lightroom Classic CC Online, click on your account ID in the top-right corner, choose Manage Account, and go to the Security and Privacy section.

Although Lightroom will require you to sign in to install, it is still possible to register computers that are normally kept permanently offline (such as those used in secure environments). Follow the regular install procedure until you get a message that says "having trouble connecting to the Internet." At this point, click the link and follow the instructions on how to generate a response code using a separate Internet-enabled device. This code will be valid for 72 hours.

The first time you launch using Lightroom, you will be shown a dialog asking you to select the country/region where you currently live. This is now required due to Google Maps usage in the Map module; the Google Maps usage terms prohibits its use in certain countries.

Sleep protection

Lightroom Classic CC is designed to prevent your computer from going to sleep while certain processes are taking place, such as building previews, generating slideshows, publishing, importing, or exporting. It also prevents the computer from going to sleep when carrying out a Lightroom Classic CC to Lightroom CC/Lightroom mobile synchronization (provided the "Prevent system sleep during sync" option is checked in the Lightroom mobile preferences [see page 18]). None of the above will prevent the display from going to sleep (depending on how your system preferences are configured).

Upgrading from an older Lightroom catalog

If you are upgrading Lightroom from a previous version of the program, you can let the installer create an upgrade catalog for you, and it will leave the old version and old catalog intact on the computer system.

If you are updating Lightroom with a dot release update, the process is simple. A dot release update will simply overwrite the current version of Lightroom in the Application/Programs folder.

Lightroom allows you to create Smart Collections that can sort files according to the bit depth and/or number of color channels in an image. As a consequence of this, you may notice it takes a little longer than expected to update the catalog while Lightroom reads in these additional searchable fields in the existing catalog.

To carry out a super-clean upgrade, you can first make an export copy of your current Lightroom catalog, launch Lightroom Classic CC to create a brand-new empty catalog, and then use File ⇒ Import from Catalog to import the previous catalog and at the same time carry out a catalog upgrade. If you choose to upgrade your Lightroom catalog using this upgrade method, there is the downside that you will lose any Publish Services data. This is because such data is not stored as part of the Lightroom catalog. So, if you have previously made extensive use of Publish Services in Lightroom, you will want to avoid using this method.

Using Lightroom for the first time

During the initial install, Lightroom will ask you where you wish to store the catalog and what you want to call it. It is important to understand here that the Lightroom catalog is something that is stored separately from the photos themselves. You may want to keep the catalog in your Pictures/My Pictures folder on the main system hard disk, but you can store it anywhere you like. Just bear in mind that a large catalog can easily grow to 100 GB or more. Above all, it is important to be aware that when you import files into Lightroom, it *references* the photos and videos you import and keeps an updated record of where those files are kept and how they are named. Lightroom doesn't actually store copies of your files in an internal archive. So, whatever you do, don't delete the files after you have imported them. Sadly, there have been instances where people have imported photos into Lightroom, thinking they were then "in Lightroom," deleted the originals, and found out too late that they had just erased the master files.

Lightroom preferences

On Mac OS, the Lightroom Preferences are located in the Lightroom menu (or you can use the ﷺ shortcut). On a PC, they are located in the Edit menu (or you can use the Ctrl shortcut). You can access Catalog Settings via the Lightroom menu (Mac) or Edit menu (PC). There is also a Go to Catalog Settings link in the

Ш

You can reset the application preferences at launch time by holding down the Alt 公 Shift keys as the program launches. Resetting preferences at launch in this way clears the user preferences only and not the startup preferences. The Lightroom team has moved a few critical preferences out of the main preference file. so deleting Lightroom's preferences doesn't make it forget essential things like which catalog you were using or which catalogs you've already successfully upgraded, Mac users running OS 10.10 or later will need to take extra steps to completely delete all cached preferences. Go to username/Library/Preferences and delete any files with Lightroom or LR in their name. Next, launch Terminal and enter defaults delete com.adobe.LightroomX, and then relaunch Lightroom. As always, make sure you have data backed up first.

Lightroom Performance Preferences. Or, you can use the **Mat**, (Mac) or Ctrl, (PC) keyboard shortcut to open the Catalog Settings dialog.

The default Library location for your Lightroom catalog is the *username*/Pictures folder (Mac), or the *username*/My Documents/My Pictures folder (PC). If you want to create a new catalog in a different location, you can do so by restarting Lightroom with the Alt key (Mac) or the Ctrl key (PC) held down during startup. This displays the Select Catalog dialog shown in **Figure 1.5**, where you can click the Create a New Catalog button to select the location to store a new Lightroom catalog. After you have successfully launched the program, go to the Lightroom menu (Mac) or the Edit menu (PC) and choose Preferences. This opens the General Preferences dialog shown in **Figure 1.6**, followed by the other preference sections shown in **Figure 1.7** onwards. Chapter 12 details more about the preference settings, so I'll just highlight the key settings for now.

Figure 1.5 Holding down the Alt key (Mac) or the Ctrl key (PC) during startup allows you to select which catalog to use or lets you create a new catalog.

Figure 1.6 In the General Preferences, the Default Catalog section also lets you choose which catalog to use when launching Lightroom. The default setting uses "Load most recent catalog," or you can choose "Prompt me when starting Lightroom." If you have already created other catalogs, you can select one of these from the menu. If you want the Lightroom Import Photos dialog to appear automatically each time you insert a camera card ready for download, I recommend checking "Show Import dialog when a memory card is detected." There is also a language selection menu at the top of the General Preferences section. This enables you to switch between different language versions of the program.

Figure 1.7 In the Presets preferences, the Default Develop Settings section refers to establishing Develop settings defaults for individual cameras settings and/or ISO settings. Until you are fully aware how this works, I suggest you leave the "Make defaults" options unchecked. If you check the "Store presets with this catalog" option, it allows you to store custom preset settings as part of the catalog. This is fine if you are working with one catalog. A downside of this approach is that presets are from then on saved specifically to the Lightroom Settings folder that's stored with the catalog. They are no longer saved simultaneously to the globally accessible Lightroom folder. If you later create a new catalog, you won't be able to access and share the settings you had created previously, whereas you can if this option is left unchecked.

Figure 1.8 In the Lightroom External Editing preferences, you can customize the pixel image-editing settings for Photoshop plus an additional external editor. These are the File Format, Color Space, and Bit Depth settings that are used whenever you ask Lightroom to create an Edit copy of a catalog image that is to be opened in an external pixelediting program. The File Format options include Photoshop's native PSD file format or TIFF. For Color Space, you can set ProPhoto RGB (which is fairly close to the chromaticities of the native Lightroom workspace), Adobe RGB (which many photographers like to use when working in Photoshop), Display P3 (a new, widegamut display space), or sRGB (which is ideal for web-based output only). The Bit Depth choices are 16 bits, which preserves the most Levels information but doubles the output file size; or 8 bits, which is a more standard bit depth but won't necessarily preserve all the Levels information that can be obtained from your master library images.

Figure 1.9 In the File Handling preferences, the Import DNG Creation section lets you customize the DNG settings for when you choose to import and convert to DNG directly. These DNG options, as well as the others that appear here, are discussed more fully in Chapter 12.

in a second		Prefere	ences			
General Presets	External Editing	File Handling	Interface	Performance	Lightroom CC	Network
Import DNG Creation						
,	ile Extension:	dng		0		
	Compatibility:	Camera Raw 7.1	and later	0		
	PEG Preview:	Medium Size		0		
		Embed Fast L Embed Origin				
Reading Metadata						
Treat " as a keyword separator	During impo	rt or when reading r I slash, and backslas	netadata Ligh	troom can reco	gnize word	
Treat "/ as a keyword separator	hierarchies	instead of flat keywo	ords. The vert	ical bar is autor	natically	
File Name Generation						
Treat the following characters as ill	egal: /:		٥			
Replace illegal file name characters	with: Dashes	: (-)	0			
When a file name has a sp	pace: Leave	As-Is	0			

Figure 1.10 In the Lightroom Interface preferences, you can customize various items, such as the appearance of the interface when using the Lights Out and Lights Dim modes, and customize the background appearance of the main window and secondary display window when viewing a photo in Loupe view or the Develop module.

Figure 1.11 In this example, the main window Fill Color was set to Light Gray. You can right-click anywhere in the background to access the context menu, which will allow you to change the default color of the background.

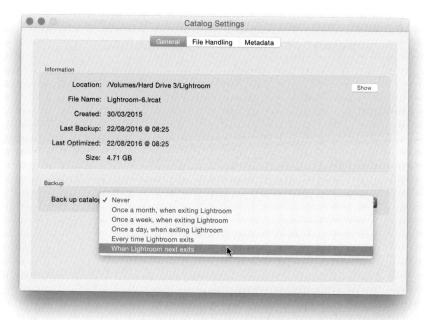

Figure 1.12 If you choose Lightroom

⇒ Catalog Settings or click the Go to
Catalog Settings button at the bottom
of the Performance preferences in
Figure 1.13, the Catalog Settings dialog
opens. Here, you can set the catalog
backup policy, the catalog previews
sizes, and metadata handling settings.
You can read more about configuring the
catalog settings in Chapters 3 and 10.

NOTE

Currently, the GPU acceleration described here applies only to processing carried out on the main display. Users with multiple displays should be aware that performance on secondary displays will be unchanged regardless of whether Use Graphics Processor is checked.

Performance preferences

Lightroom performance can be improved by checking the Use Graphics Processor option in the Performance preferences (Figure 1.13). When checked, this allows Lightroom to use the Graphics Processing Unit (GPU) to speed up its interactive image editing when working in the Develop module. How much of a benefit you'll see depends on the video card and the display. The main impetus for this has been to accommodate Lightroom customers using 4K or 5K displays where the screen pixel density is four times that of a regular display. For example, both the panning and zooming are much faster with GPU support, and the slider response should be virtually instantaneous. If you open a large image and choose a 1:1 zoom view, check out how quickly you can scroll from one corner of the image to another. Without GPU support, the Lightroom Develop module performance tends to be slow and jerky. But when Use Graphics Processor is enabled, the scrolling should be much smoother. If you look at what is happening more closely, you will notice how the on-screen image initially loads a standard-resolution preview image before rendering a full-resolution preview. Also, when you have an image in the Develop module at a 1:1 view, Lightroom preemptively loads and renders parts of the image that are just outside the current visible area. By doing so, Lightroom is able to provide a smoother scrolling experience. When adjusting the Develop sliders, the preview response will appear to be a lot less jerkier when Use Graphics Processor is enabled, although you'll see more of a performance boost with some types of Lightroom Develop module edits than others.

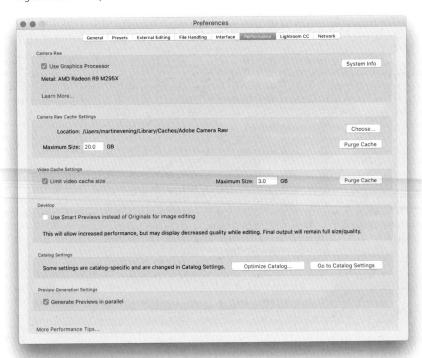

Figure 1.13 The Lightroom Performance preferences.

Graphics card compatibility

When you launch Lightroom, it will test your video card to make sure it is compatible and there are no errors. For example, an error may mean the card driver needs updating. If there is a problem, GPU support will be disabled and Adobe does disable some cards by default due to known compatibility issues. If the card you are using is compatible, the video card name will be shown in the Performance section of the Lightroom Preferences dialog. If it is not, Lightroom will show an error message. You will also need to make sure your video drivers are up to date. On the Mac system, video drivers are updated whenever you carry out an operating system update, but on Windows the operating system is not always as accurate and may tell you that the outdated drivers you have installed are just fine. So in these instances, PC users experiencing problems may need to go to the manufacturer's website to download a dedicated video driver update utility.

Lightroom can currently use only a single GPU, so if your computer has more than one video card, this won't offer any improvement (although the performance boost from using just one should be significant). For best results, the main requirement is that you have a compatible graphics card. You don't necessarily have to have the fastest card to get optimum performance; a solid, midrange card can be just as effective as a high-end one. Also, if your system has a recentgeneration Intel chip, this can make working in the Develop module faster. If you check out the Lightroom system info (Help \Rightarrow System Info), look for an item called "Camera Raw SIMD optimization." If your computer lists AVX2, then you should see an additional small improvement over AVX in terms of Develop module processing. Basically, the GPU is used for both the display preview management and the rendering (but only when Use Graphics Processor is enabled, of course), where different portions of the rendering can occur on the GPU and Central Processor Unit (CPU) simultaneously. The GPU processing is very fast, but the CPU work may take a little longer, which is why you may sometimes see a slight time lag in the on-screen rendering. But if you have AVX2, you will see a small extra speed boost to the CPU aspect of the processing.

Smart previews option

You can use the "Use Smart Previews instead of Originals for image editing" option to help speed up the time it takes to edit images in the Develop module. Providing Smart Previews have been built, you can instruct Lightroom to load Smart Preview proxy versions instead of reading in the original file data for a Fill or Fit to Screen view. Where you have large-size originals this can speed up the time it takes to load each image, and the workflow is the same as when working in Lightroom mobile where image-edit adjustments are applied to proxy versions, rather than the originals. The downside is the preview quality won't be as good as working from the original image data. You may see banding occur in blue skies or dark areas. However, this won't compromise the quality of the final edits (when the adjustments are applied to the master images).

It is important to realize that the GPU performance boost will only be available for certain types of video cards (OpenGL 3.3 and higher) and only if you are using a 64-bit operating system—either Mac OS 10.10 and higher or Windows 7 and higher. Enabling the graphics processor can in some cases lead to slower performance on large displays because of the time it takes to load a full-resolution image. So, depending on the size of the images you are working on and the size of your display you may want to turn the Use Graphics Processor option on or off.

Lightroom CC (mobile) preferences

The Lightroom CC/Lightroom mobile preferences are shown in **Figure 1.14**. You can use these preferences to manage your Adobe Creative Cloud account. If you are not already signed in, you can do so here. Click on More Account Info Online to access your full Adobe account settings and options. Clicking the Delete All Data button will take you first to an Adobe web page. Here, you will be asked to confirm you wish to delete the sync catalog data stored on the Adobe cloud servers. Doing so may cause you to lose any master files that are on the cloud only and have yet to download to Lightroom Classic CC. Because the sync processing can often take a long time, there is a "Prevent system sleep during sync" option to prevent the computer going to sleep and halting a background sync process. This preference will not affect the display sleep settings you might have configured.

The default location to download Lightroom mobile synced photos to is the Pictures/My Pictures folder. In the Location section you can specify an alternative location. Because many people prefer to use low-capacity SSD drives for their boot drives, I suggest the download location should ideally be on a large-capacity internal or external hard drive. Below that is an option to organize the imported subfolders by capture date and on the right is a menu of date format options you can select from. The Pending Sync Activity section provides an update of which files are currently being synced and tells you what is being uploaded/downloaded and from

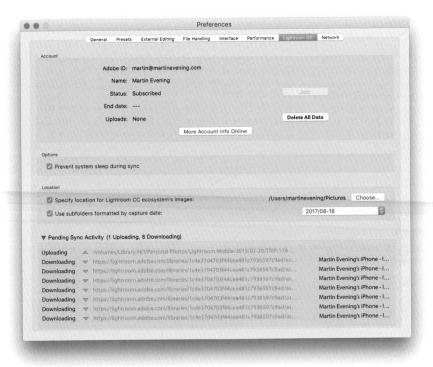

Figure 1.14 The Lightroom CC Preferences.

which source device they are being downloaded. You can click on these links to be taken to the source files. If the syncing is only partially complete, you won't be able to see the files of course, but you can at least check the source images filenames.

Once you start syncing files to Lightroom mobile, an All Synced Photographs collection item will then appear listed in the Catalog panel (**Figure 1.15**). This lets you view, at a glance, all photographs that have been synced with Lightroom CC/Lightroom mobile.

In the Collections panel, you will see a status icon appear next to collections that have been synced with Lightroom CC/Lightroom mobile. In **Figure 1.16**, the status icons show there are synced Collections. You can click a status icon to pop the dialog shown in **Figure 1.17**, where you can choose to stop syncing photos in that collection.

Figure 1.17 The Sync status dialog. If you stop syncing a particular collection, this will delete all Lightroom mobile data associated with it.

History panel

Lastly, if you check the History panel in the Develop module, you can see recorded the status of any image, which will also indicate where a photo has had its settings changed via Lightroom CC/Lightroom mobile (**Figure 1.18**).

Figure 1.18 The History panel showing changed status from Lightroom CC/Lightroom mobile.

Figure 1.15 The Catalog panel showing All Synced Photographs.

Figure 1.16 The Collections panel showing the current sync status for the synchronized collections.

Figure 1.19 The pop-up Activity Center, which is available via the Lightroom mobile identity plate. This can be used to sync or unsync with Lightroom mobile, as well as manage and monitor address lookup and face detection background tasks.

Customizing the identity plate and interface

There are several ways to customize the appearance of the Lightroom program. The top panel in the Lightroom interface contains the Lightroom identity plate and module selectors. If you go to the Lightroom menu (Mac) or Edit menu (PC) and select Identity Plate Setup, you will see the Identity Plate Editor dialog, which are shown below. (You can also right-click to reveal the context menu where you can choose Edit Identity Plate.) The "Lightroom mobile" option displays a smaller Lightroom logo with your Adobe ID below. This option enables you to click the small arrow or anywhere in the identity plate area to reveal the Activity Center (Figure 1.19), while the Lightroom option displays the Lightroom logo. Or, you can select the Personalized Identity Plate option, which lets you replace the standard Lightroom logos with a custom design of your own. The following steps explain how. Note that identity plates are saved with the catalog and are therefore catalog-specific. Consequently, if you work with multiple catalogs, you'll have to repeat these steps for each catalog that's in use.

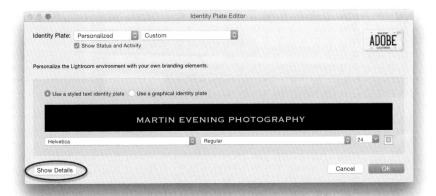

1. This shows the Identity Plate Editor after I selected the Personalized option. I then selected the "Use a styled text identity plate" option, so I could enter custom text, set the font type and font size, and use any font that was available on the computer. In the example shown here, I edited the text to show the full name for my business and set the font to Copperplate.

2. After I had configured a custom identity plate, I went to the Identity Plate Custom pull-down menu and chose Save As to save the settings as a new custom template design.

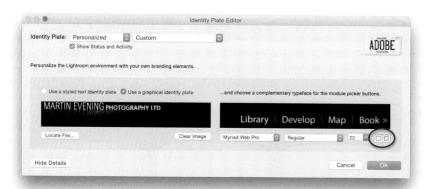

add an image logo by copying and pasting or dragging a PDF, JPEG, GIF, PNG, TIFF, or PSD image into the identity plate area (PSD files can be added via the Identity Plate Editor using the Mac OS version of Lightroom). The logo image you place here should not be more than 57 pixels tall and can contain transparent pixels. Graphical identity plates can also be used in Slideshow and Web module templates, but be warned that a 57-pixel-tall logo will be far too small for use in a print layout. For print work, you will probably want to create identity plate graphics that exceed the suggested 57-pixel limit and that are therefore big enough to print with. By clicking the Show Details button (circled in Step 1), you can also customize the appearance of the module selector by choosing an alternative font, which can be in any size you like. Lastly, if you click either of the little color swatch icons (circled), the system color picker opens, allowing you to edit the font colors for the active and nonactive modules that appear in the top panel.

4. These examples show how the top panel looked after I customized the identity plate with the styled text (top) and graphical (bottom) identity plates options.

Figure 1.20 The Help menu is common to all Lightroom modules. This figure shows the Library module Help menu; the other modules look similar except that they show help items and help shortcuts relevant to that particular module. The Lightroom module tips (Figure 1.21) can help you quickly find your way around the different modules.

Figure 1.21 The Module tips are turned on by default each time you first visit a new module. These are designed to help you discover the main features in each module. They can be hidden or enabled via the Help menu.

Getting help

Figure 1.20 shows the Help menu for the Library module. Choose Lightroom Help to access the Lightroom Help page (**Figure 1.22**). The Lightroom Support Center page is shown in **Figure 1.23**, where you can find Lightroom tutorials to help you get started.

Figure 1.22 The Lightroom Help page.

Figure 1.23 The Lightroom Support page.

The Lightroom interface

The following section provides a quick overview of the Lightroom interface (**Figure 1.24**), which you'll find has a consistent layout design from one module to the next.

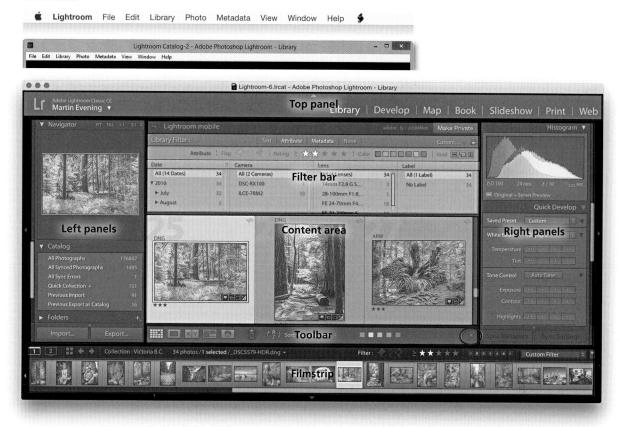

Figure 1.24 The Lightroom menu bars and Lightroom program interface.

As with any application, the main menu commands are located in the Lightroom menu bar at the top of the screen (Mac) or at the top of the application window (PC). If you are in absolute full-screen mode, the menu bar will be hidden, but you can reveal it by simply hovering over the top of the screen.

The top panel section contains the identity plate, which normally shows the Lightroom logo. But, as was shown on the previous pages, you can customize this via the Lightroom ⇒ Identity Plate Setup menu. For example, you can replace this with your own name or add a company logo graphic. On the right, you have the module picker menu for selecting the Lightroom modules: Library, Develop, Map, Book, Slideshow, Print, or Web. You can use the F5 key to toggle showing and hiding the top panel (**Figure 1.25**).

Figure 1.25 Right-click to access the module picker menu. You can use this to hide specific modules if you wish.

The content area is the central section of the interface where you view whatever you are working on. In the Library module Grid view, you see the images displayed as thumbnails in a grid cell layout. In the Library module Loupe view and Develop module, the files are displayed at a Fit view or 1:1 scale size. In the Map module, the content area displays a Map view. In the other modules—Book, Slideshow, Print, and Web—you'll see previews of how print or screen layouts will look.

Whenever you are in the Library module Grid view, the Filter bar can be expanded from the top of the content area. This allows you to carry out searches using a Text search, or search by rating or flag status using the Attribute section. Or, you can use the customizable panels in the Metadata filter section using various search criteria, such as a specific date, camera type, or lens type. You can use the Shiff key to display more than one Filter bar section at a time and use the key to toggle showing and hiding the Filter bar.

The Toolbar at the bottom is available in all of the Lightroom modules. The Toolbar options will vary according to which module you are in and can be customized when you are in the Library, Develop, or Map modules via the Toolbar options menu (circled). You can use the T key to toggle showing and hiding the Toolbar.

In the Library module, the left panel is mainly used for selecting the source files via the Catalog, Folders, Collections, or Publish Services panels. In the Develop module, it is used to display the Presets, Snapshots, and History panels; and in the remaining modules, it is mainly used for accessing collections and preset settings. For example, if you are working in the Print module, you can save custom print settings as presets, which can then be applied to other images. The individual panels can be expanded or collapsed by clicking the panel bar header. Alt -clicking a panel bar toggles expanding to show the contents of that panel only or expanding to show all panels. You can use the Tab key to toggle showing and hiding both the left and right panels. You can also right-click the arrows for the left or right panels to access the context menu options. These allow you to determine the hide/show behavior when clicking to reveal the side panels.

The right panel section contains mostly panels that provide information about an image, the controls for adjusting an image, or the layout control settings. In the Library module, you can manage the metadata settings for the currently selected photos, and in the Develop module, you can apply image adjustments. In the Book, Slideshow, Print, and Web modules, the right panel controls govern the layout and output. As with the left panel, individual panels can be expanded or collapsed by clicking the panel bar header. (Alt)-clicking a panel bar toggles expanding to show the contents of that panel only or expanding to show all panels. You can also use the (Mac) or (Ctrl) key (PC) in combination with a keypad number (①, ①, ②, ③, etc.) to toggle opening and closing individual panels in the order they are listed from the top down.

The Filmstrip is located at the bottom of the Lightroom window. It displays thumbnails of all the images currently viewable in the Library, highlighting those that are currently selected. The Filmstrip thumbnails are accessible in all the other modules and therefore allows you access to individual images or sub-selections of images without having to switch back to the Library module.

Working through the book

I will explain each aspect of the program in greater depth throughout the book, and you will notice that I have structured the book to match a typical workflow, starting with the various ways you can import your photos into Lightroom. Much of the Lightroom program is fairly self-explanatory. If you need further help, go to the Help menu, where you will see a Shortcuts item for whichever module you happen to be using (**Figure 1.26** shows the shortcuts for the Library module). In keeping with the spirit of Lightroom, I have tried as much as possible to avoid discussing the technical workings of the program and focused on discussing what Lightroom does best: managing, editing, and outputting photographs. If you really want to know more about how Lightroom works, consult Chapter 12, where I elaborate on various technical features. You will also find more detailed technical background information at thelightroombook.com.

Library Shortcuts View Shortcuts Target Collection Shortcuts Return to previous view Add to Target Collection Enter Loupe or 1:1 view ow Target Collection Enter Grid mode Enter Loupe view Photo Shortcuts Enter Compare mode Command + Shift + Import photos and videos Enter People mode Command + Shift + E Command + Return Command + [Rotate left **Full Screen Preview** Shift + F Command + E **Edit in Photoshop** Command + Option + F Return to Normal Screen Mode Save Metadata to File Cycle through Lights Out modes Command + Zoom out Command + J Grid View Options Zoom in Zoom to 100% Hide/Show the Filter Ba Stack photos Command + Shift + G Unstack photos **Rating Shortcuts** Command + R Reveal in Finder Delete Remove from Library Set ratings Shift + 1-5 Set ratings and move to next photo Rename File Set color labels Command + Shift + C Copy Develop Settings 6-9 Shift + 6-9 Command + Shift + V Paste Develop Settings photo Command + Left Arrow Reset ratings to none Command + Right Arrow Next selected photo Decrease the rating Enable/Disable Library Filters Command + Shift + M Mail selected photo: Flagging Shortcuts **Panel Shortcuts** Toggle Flagged Status Hide/Show the side panels Command + Up Arrow Shift + Tab Increase Flag Status Hide/Show all the panels Decrease Flag Status Hide/Show the toolb Set Reject Flag Activate the search field Command + K Activate the keyword entry field nd + Option + Up Arrow

Figure 1.26 It is always worth selecting the Shortcuts item in the Help menu— \mathfrak{A} (Mac) or $\lceil \mathsf{Ctt} \rceil \rceil$ (PC)—to find out more about the shortcuts for each module.

Downloadable Content: thelightroombook.com

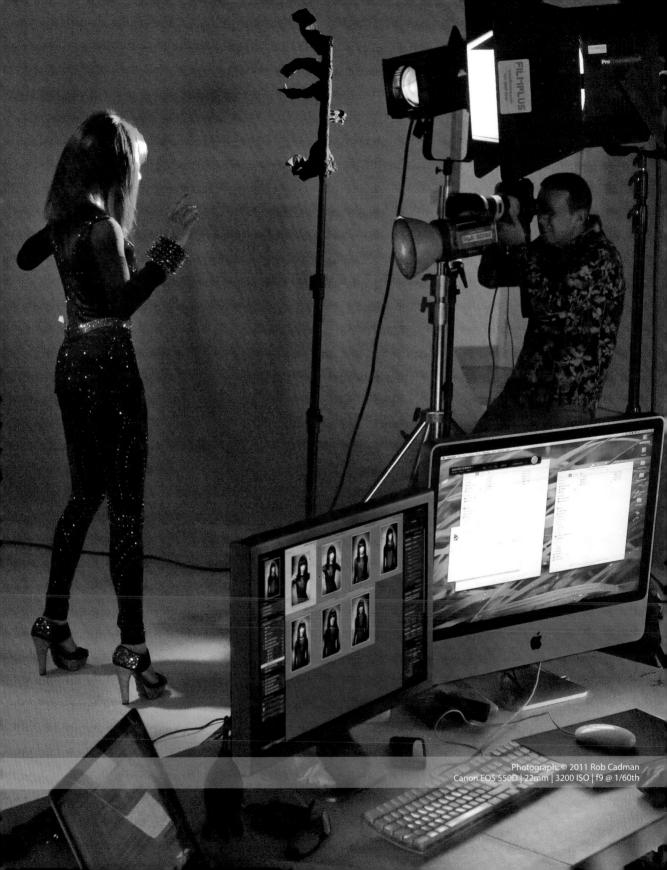

2

Importing photos

A guide to the various ways you can bring your photos into Lightroom

Lightroom is essentially a catalog management program and raw image processor combined into one. It is important, though, to appreciate how Lightroom differs from browser programs such as Bridge, which you simply point at a folder to inspect the contents. The browser method is best suited for those times when you need the freedom to search everything that's on your computer. The downside of this approach is that you first have to know where to look in order to find what you are searching for. Plus, you will be shown all the files that are contained in each folder. If there are also lots of non-image files to sort through, this can make image browsing quite tricky.

Lightroom is different. This is because you must import your photos first and, in doing so, make a conscious decision as to which photos you want to have added to the catalog. As you will come to learn in this chapter, the Lightroom import procedure provides an adaptable import workflow, one that can be streamlined through the use of Import presets, as well as offers the ability to import files directly from the camera using a tethered shooting setup.

The main Import dialog

To import photos into Lightroom, you need to click the Import button in the Library module. The first time you choose to import photos into Lightroom, it will do so via the expanded Import dialog shown in **Figure 2.1**. As you can see, there are lots of options here, so let me take you through them one by one and in the order you should use them.

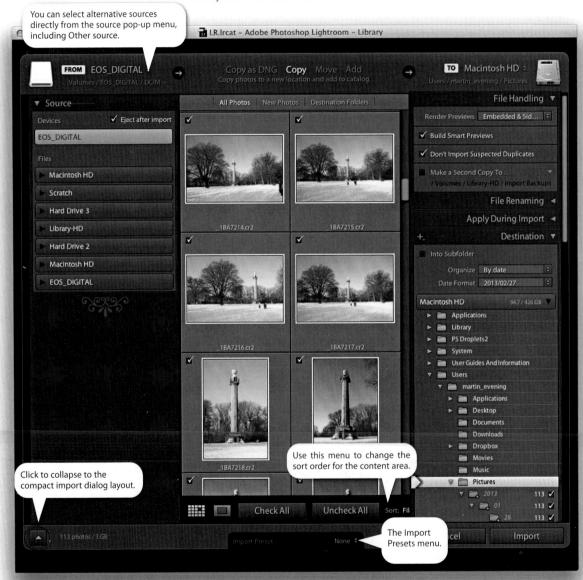

Figure 2.1 The layout of the expanded Import dialog showing all the main panels.

At the top is the import workflow bar. This displays a summary of the current configured import workflow, showing from left to right the import source, the import method, and the destination folder. You mainly use this to select the import method: Copy as DNG, Copy, Move, or Add. Below the workflow bar, you will see, on the left, the Source panel, which is used to select the source device (or folder) to import from. In the center is the content area. This displays thumbnails of the images that are to be imported and offers options to segment the thumbnail display into different groupings. For example, you can choose to display photos by showing all photos, show new photos only, or segment by destination folders (how the photos will finally be imported, according to the Destination panel settings). You can use this central section to select all or select individual photos, as well as see Loupe view previews of the files you are about to import.

The panels on the right are used to manage the photos as they are imported. In the File Handling panel at the top you decide how to render the initial previews, whether to import suspected duplicates, and where (if at all) to create secondary backups. Remember, there can be only one physical copy of each image in any particular folder location. It is possible to import more than one copy of a file to the catalog by disabling the Don't Import Suspected Duplicates option, but it is not recommended that you do so. The File Renaming panel can be used to apply a file-renaming scheme. The Apply During Import panel can be used to apply a Develop preset and/or a metadata template setting to the files as they are imported; plus, you can enter keywords to apply on import here. Then there is the Destination panel, which lets you choose the folder the files should be imported to and how they should be organized within that destination folder. At the bottom, notice the Import Presets menu. Here you can save Import dialog settings as custom presets. This can make it easy for you to select favorite import settings without having to reconfigure everything in the Import dialog each time you want to import files into Lightroom.

If you click the button circled at the bottom of Figure 2.1, you can switch to the compact view shown in **Figure 2.2**. This provides an abbreviated summary of the import settings. This simpler interface is ideal if you have already saved a number of import presets. When working in this mode, all you need to do is to select an appropriate import preset.

NOTE

In the expanded mode, the Import dialog behaves more like a file browser. The browsing experience is slightly more refined, though, as Lightroom knows to wait for a folder to be selected in the Source panel before populating the content area with the images that are available to import.

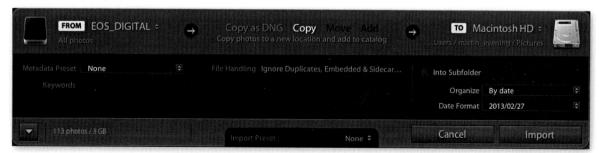

Figure 2.2 The layout of the compact Import dialog mode.

Copy as DNG, Copy, Move, or Add?

Let's look more carefully at the ways in which images can be imported, starting with those that are relevant to camera card imports only. The Copy as DNG option copies the files from the card and at the same time converts them to the DNG file format. This option offers peace of mind, because the DNG file format is an Adobedevised format for archiving raw capture files and widely regarded as a more versatile and, therefore, more appropriate file format for the long-term archival storage of raw camera files. The DNG conversion process also conveniently flags any files that happen to be corrupted as they are imported. When you choose Copy as DNG, the Lightroom DNG converter should report a problem if it is unable to convert a supported raw file. However, this does not guarantee that all file corruptions will be reported. Only those problems that the Lightroom/Adobe Camera Raw processor is able to detect will be highlighted. So the Convert to DNG on import is therefore a useful data verification process. The DNG conversion now takes place as a background task after the photos have been imported, making this a more attractive option. Copy as DNG is mainly useful if the folder of images you are copying from contains unconverted raw images. You can convert non-raw images such as JPEGs to DNG (though this does not actually convert them into raw files).

The Copy option makes a straightforward copy of all the images that are on the memory card and stores them in the designated destination folder or subfolder. The Copy option can be used to make copies of the files to the chosen destination folder location and add them to the catalog. But remember, you don't want to end up creating more duplicate versions of master images than you need to, so "copying" files is mainly used whenever you need to copy files from a camera card or a DVD.

If your intention is to import photographs from existing folders on your computer and add them to the Lightroom catalog, the two options you want to focus on are Move and Add. The Move option copies files from the selected source folder, copies them to the destination folder, and then deletes the folder and files from the original location. This is a neat solution for importing photos into Lightroom, placing them in the exact folder location you want them to be in, but not end up with yet more duplicate images. The downsides are that copying files still takes time and potentially is risky should Lightroom crash mid-move. The Add option is the one I suggest you use mostly. With an Add import, you are telling Lightroom to "reference" the files where they are currently located on the computer. When you add files at the import stage, it takes a minimal amount of time to complete the import process.

You also have to bear in mind that Lightroom does not place any real restrictions as to how or where the images are stored—they can be kept anywhere you like. Also, Windows users can import iPhone Live photos where both the image and the video are imported. To summarize, I mainly suggest you use Copy or Copy as DNG for all card imports and use Add or Move for importing files that are already on the computer system.

DNG benefits

A benefit of converting to DNG is that for raw files conversion typically results in smaller files. This is because the lossless compression is optimized on a per-image basis. Also, when loading DNG images in the Develop module, the compressed image data is stored as tiled information that can be read/decompressed in parallel on multi-core machines. Although some cameras support the DNG format, such as Leica, Pentax, and now iPhones, converting DNG capture files to DNG in Lightroom can still be worthwhile sometimes, specifically to take advantage of the way Lightroom converts to DNG. Incidentally, the raw file data in proprietary raw images is converted to DNG format behind the scenes as it is opened in Camera Raw or Lightroom.

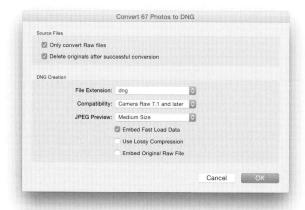

Figure 2.3 The Convert Photos to DNG dialog, where there are options to embed fast load data and apply lossy compression when converting photos to DNG.

Converting to DNG after import

You can choose to convert the imported photos to DNG after importing, as well. You can do this by going to the Library menu and choosing Convert Photos to DNG. The Convert Photos to DNG dialog is shown in **Figure 2.3**. In the Source Files section, you can choose to convert raw files only. Normally, you want to convert only raw images to DNG, but it is possible to convert JPEGs to lossy DNG without increasing the file size. You can also choose to delete the original raw files after successfully converting them to DNG, which can help you avoid ending up with duplicate raw versions of your images.

So should you keep the original raws? It all depends on whether you feel comfortable discarding the originals and keeping just the DNGs. Some proprietary software, such as Canon DPP, is able to recognize and process dust spots from the sensor using a method that relies on reading private XMP metadata information that is stored in the proprietary raw file. If you delete the original .CR2 files, you won't be able to process the DNG versions in DPP unless you chose to embed the original raw file data (because this will allow you to extract the raw originals).

NOTE

When files are converted to DNG, the conversion process aims to preserve all the proprietary MakerNote information that is contained in the raw original. If the data is there, external, DNG-compatible software should have no problem reading it. However, there are known instances of manufacturers placing MakerNote data in odd places, such as alongside the embedded JPEG preview (which is discarded during the conversion process). Basically, the DNG format is designed to allow full compatibility between different products, but this, in turn, is dependent on proper implementation by third parties.

NOTE

Lightroom can't completely convert dual pixel raw files (such as those captured with the Canon 5D Mk IV) to DNG, but it does preserve both parts of the dual pixel raw data within a single DNG. At this point Lightroom only processes one part of the dual pixel raw data.

Personally, I have no trouble converting everything I shoot to DNG and never bother to embed the original raw data. I do, however, sometimes keep backup copies of the original raw files as an extra insurance policy, but in practice I've never had cause to use these—or at least not yet!

The options in the DNG Creation section are the same as those in the Lightroom File Handling DNG Import preferences (see pages 694 to 697 for advice on which options to select here). If you apply lossy compression when converting to DNG, you can preserve the full pixel resolution but at a reduced file size. Lossy DNGs are almost like normal DNGs, except the raw data is 8 bit and permanently demosaiced, but kept in a linear form (see page 698). You can choose whether to embed the original raw file in the DNG image or not. This does give you the flexibility of reverting to the original raw file format state, but the downside is that you will end up with DNG files that are at least twice the size of the original. Mostly, I would say it is safe to leave this option unchecked: Convert everything to DNG and delete the raw originals as you do so.

Import and Library module previews

You may wonder why the Import Photos previews and Library Grid view previews don't match. This is because the Import Photos dialog can only read the camera vendors' embedded previews. Once the files have been imported, previews can be rendered based on the default Develop module settings Lightroom applies, hence the change in preview appearance. If you would prefer the Lightroom previews to match the camera profile settings (what might be called the camera JPEG look), you can do so by selecting the Camera Standard profile (if available) in the Camera Calibration panel. I discuss this later in Chapter 4, the Develop module chapter.

Import options preferences

Before you import any photos, go to the Lightroom menu (Mac) or Edit menu (PC) and choose Preferences. In the General preferences Import Options section (Figure 2.4), make sure the "Show Import dialog when a memory card is detected" option is checked. Lightroom should automatically launch the Import Photos dialog every time a memory card or device is detected. The "Select the 'Current/Previous Import' collection during import" option is checked by default in order to maintain earlier Lightroom behavior. This ensures Lightroom takes you to the Current/Previous Import items in the Catalog panel as the files start to import. If you choose to uncheck this item, the import process will instead happen in the background. This will allow you to continue working in Lightroom and preserve your current image selection. Check the "Ignore camera-generated folder names when naming folders" option if you wish to import everything directly from a camera card into a single Lightroom folder. If you shoot with the camera set to the raw + JPEG mode, leave "Treat JPEG files next to raw files as separate photos" unchecked, and Lightroom will treat the raw and JPEG photos as a combined import.

		Prefer	ences				
General Presets	External Editing	File Handling	Interface	Performance	Lightroom CC	Network	
Language:	English		0				
Settings:	Show splash screen during startup						
	Automatica	ly check for u	pdates				
Default Catalog							
When starting up use this catalog:	Load most re	cent catalog					\$
Import Options							
Show import dialog when a memory	card is detect	ed					
Select the "Current/Previous Impor	t" collection du	ing import					
Ignore camera-generated folder na	mes when nami	ng folders					
Treat JPEG files next to raw files as	separate photo	s					
Replace embedded previews with s	tandard preview	vs during idle	time				
Completion Sounds							
When finished importing photos play:	No Sound						\$
When tether transfer finishes play:	No Sound						0
When finished exporting photos play:	No Sound						٥
Prompts							
		Reset all war	ning dialog	s			

Figure 2.4 The General Preferences dialog showing the Import Options section.

Importing files from a card

EOS_DIGITAL

1. To start importing photos, insert a memory card into the computer so that it mounts on the Desktop. If the "Show Import dialog when a memory card is detected" option is unchecked, you will have to import the photos manually using one of the following manual methods: Choose File

Import Photos and Video, click the Import button in the Library module, or use the

Ctrl 公Shift (PC) keyboard shortcut.

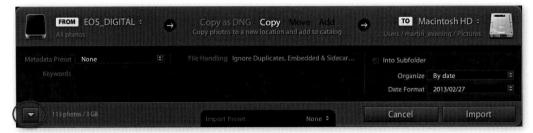

2. If the Lightroom Preferences are configured as shown in Figure 2.4, Lightroom will automatically open the Import Photos dialog. How the Import Photos dialog is displayed when opened will depend on whether you last used the compact interface (shown above) or had checked the expand dialog button (circled) to reveal the full range of options in the expanded mode view (I used the compact interface here). In this example, the EOS_DIGITAL camera card appeared in the From section. In the workflow section, you can choose Copy as DNG, Copy, Move, or Add. For card imports, the choice boils down to Copy as DNG or Copy.

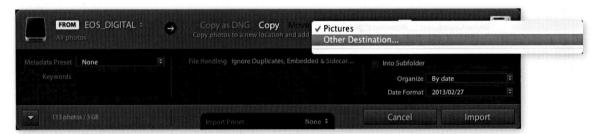

3. The To section initially points to the computer user's Pictures folder. This is a sensible default, but if you wish, you can select an alternative destination folder.

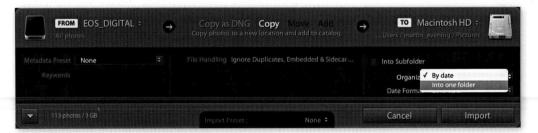

4. For camera card imports, you need to choose whether to import your images into separate, dated folders with the "By date" option or all into the same folder with the "Into one folder" option. There is a lot to be said for the "By date" option: All your files are imported and placed in dated folders, and this provides a neatly ordered way to manage your camera card imports. However, to make this work effectively, you'll need to tag the imported photos with keywords; otherwise, you'll experience difficulties later when tracking down specific photos. Importing photos into one folder (and naming the folder appropriately) will allow you to search for photos by the Folders panel name as well as by keywords. The keywording can be done at the import stage or after, working in the Library module.

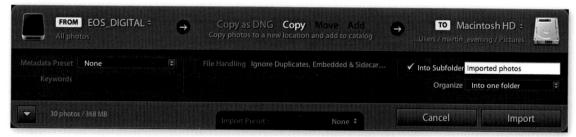

5. If you select the "Into one folder"option, then you will most likely want to check the Into Subfolder box (as shown here) and type in a name for the subfolder you wish to create in the destination location. To keep things easy (and repeatable), I suggest that every time you import photos from a card, you do so to a standard import folder. I usually name this "Imported photos."

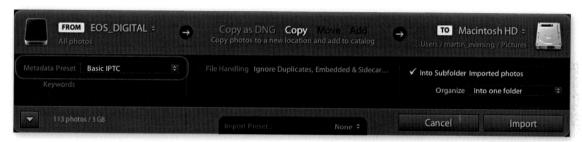

6. If you already have a prepared IPTC metadata template, it is a good idea to select this from the Metadata Preset menu list (circled).

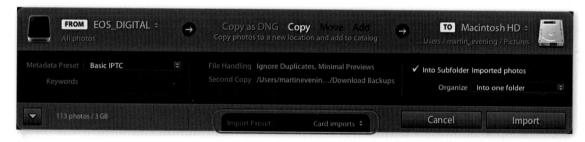

7. After you configure all these settings, you can go to the Import Preset menu and save the import settings as a new preset for future use. When you are done, just click the Import button to commence the camera card import. Lightroom then imports the files from the card to the Lightroom catalog. As the images are imported, the thumbnails start to appear one by one in the Library module view. Meanwhile, the status indicator in the top-left corner shows the import progress. Often, there may be two or more processes taking place at once, and the progress bars give you a visual indication of how the import process is progressing. If more than one operation is taking place at a time, you will see the grouped status indicator (seen on the right). If you click the identity plate area, you can view the Activity Center, which is described in the following section.

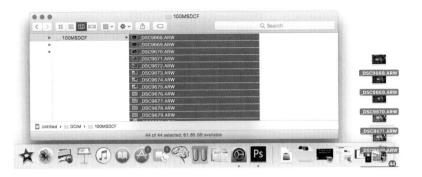

Normally, you shouldn't encounter any problems when importing files from a camera card. But if you choose the Copy Photos as DNG option, you will be alerted to any corruptions in the files as they are imported. After you have successfully imported all the images to the computer, you can safely eject the camera card and prepare it for reuse. However, at this stage, I usually prefer to completely delete all the files on the card before removing it from the computer. This way, when you reinsert the card in the camera, you won't be distracted by the fact that there are still images left on it. For example, when I carry out a studio shoot, I find it helps to establish a routine in which the files are deleted immediately via the computer before ejecting. I find that on a busy session, it helps to avoid confusion if you clear the cards as soon as the files have been imported. Otherwise, you may pick up a card, put it back in the camera, and not be sure if you have imported its files already or not. I would also advise you to reformat the card using the camera formatting option before capturing more images. This good housekeeping practice can help reduce the risk of file corruption as new capture files are written to the card.

Activity Center

Regardless of which identity plate you have selected, clicking anywhere in the identity plate area opens the Activity Center shown in **Figure 2.5**, **Figure 2.6**, and **Figure 2.7**. As you hover over the items in the Activity Center, you'll see help dialogs that explain the functions more fully. For example, in Figure 2.5, you can click "Sync with Lightroom mobile" to turn synchronization on or off. In Figure 2.6, clicking Address Lookup disables or enables Lightroom looking up GPS coordinates to provide IPTC location suggestions. The Face Detection highlighted in Figure 2.7 turns on or off the background process that indexes faces, which is used when carrying out a People search. This search is quite an intensive process, so some users may wish to pause either to free up processor resources, conserve disk space, or simply because they have no desire to make use of this feature.

Figure 2.5 The Activity Center Sync control.

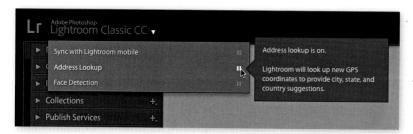

Figure 2.6 The Activity Center Address Lookup control.

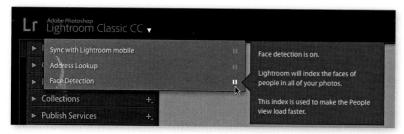

Figure 2.7 The Activity Center Face Detection control.

MOTE

The default option is for the catalog sync to be on, although you can sync to only one catalog at a time. Also, you need to understand that enabling syncing applies just to collections that you select to sync with Lightroom CC/Lightroom mobile. If the catalog is being upgraded for the first time from Lightroom 6/CC or earlier, sync will be on by default. When the sync is enabled, you can choose to pause or resume syncing via the Activity Center. In the paused state, you can still have syncing enabled for collections, but these will all be paused until you choose to resume syncing.

The Activity Center also lists various background operations, such as copying and importing photos (**Figure 2.8**). By default, the only background task that now shows up in the identity plate area is the Sync progress. The other background tasks will be shown in the Activity Center. If you look closely, you'll see a dark gray progress bar for each individual activity. In **Figure 2.9**, Lightroom has finished importing photos, but now lists the additional processes in progress, such as fetching initial previews, building a local index of the current import, and (in this example) converting the imported files to DNG. The Activity Center also shows the current progress for other activities such as generating a Photo Merge. You can cancel any of these activities by clicking the X button (circled in Figure 2.9).

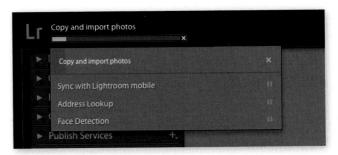

Figure 2.8 A Copy import in progress, and the Copy and Import Photos status is mirrored in the Activity Center.

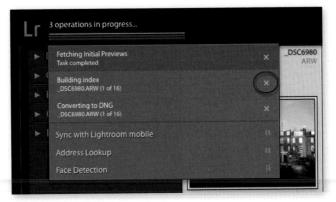

Figure 2.9 Here the Activity Center shows that Lightroom has just finished fetching the initial previews (listed as Task Completed), while it is still building a face detection index of the current import and also converting the imported files to DNG.

Source panel

You use the Source panel to navigate and find the photos you wish to import. The Source panel view displays any found devices at the top under Devices, including camera cards, tethered cameras (where there are files on the camera card), as well as smartphones. So, when you insert a camera card or connect a camera, it should appear listed in the Devices section and selected as the source (**Figure 2.10**). Normally, Lightroom lets you import from only one card device at a time. However, if your computer is able to see memory cards as separate drive volumes and they appear listed under Files rather than Devices, you can import files from several camera cards at once. You can check the "Eject after import" option if you want the card to be ejected after all the photos have been imported—this saves you having to do so manually at the system level.

For all other types of image imports from a hard drive into the Lightroom catalog (using Copy as DNG, Copy, Move, or Add), you can select a folder listed in the Files section. Lightroom will list all connected and available directory volumes here regardless of whether they contain image or video files or not.

The volume headers in the Source panel can be expanded for you to locate the folders you wish to import from, just as you would in a regular file browser program (Figure 2.11). It is also possible to select multiple folders from the Source panel. Use the ①Shift key to select a contiguous list of folders, or 第-click (Mac) or ②TI-click (PC) to make a discontiguous selection. When selecting folders to import from in the Source panel, they don't all have to be on the same drive. You can import from multiple folders that are on different drives. The procedure here is to click the volume header you want to import from to expand it and view the root-level folders. From there, you can click the arrows to the left of each folder to expand the folder hierarchy and reveal the subfolder contents (Figure 2.11).

When you have folders nested several folders deep inside other folders, you may find it helps if you double-click on a selected folder to reveal a more compact hierarchy, such as the one shown in **Figure 2.12**. If you compare this with Figure 2.11, you'll notice how the same folder is selected, but in the Figure 2.12 example, only the folders belonging to that specific folder hierarchy are displayed and all the other folders are hidden. Basically, if you double-click a folder, the Source panel folder hierarchy changes to reveal just those folders that belong to that parent folder's directory. This is known as a docked folder view. Double-click the parent folder to return to the fuller hierarchy view of parent folders. The docked method can at first seem confusing and the folders appear to dance around unexpectedly. Once you spend a little time familiarizing yourself with the double-click method of navigation, the shuffling you see won't be so distracting.

When you click to select a folder listed in the Source panel, the files contained in that folder will appear in the main content area and, depending on whether the Include Subfolders option is checked, all subfolders will be included as well.

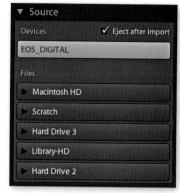

Figure 2.10 The Source panel in card import mode showing a card ready to import under found Devices.

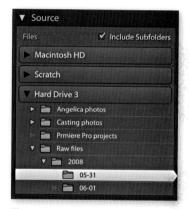

Figure 2.11 The Source panel with no card or other device found, showing the file folders to be selected for import.

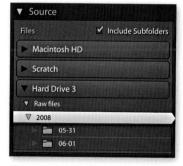

Figure 2.12 Double-clicking the date folder listed in Figure 2.10 changes the folder list view to show a more compact hierarchy.

Content area

As you navigate using the Source panel, the files to be imported are displayed in a Grid view in the content area, and you can use the Thumbnails slider in the Toolbar (**Figure 2.13**) to adjust the size of the grid cells. As with the Library module Grid view, you can double-click a grid cell or use the **E** key to switch to the Loupe view of a selected file. The Loupe view mode allows you to see bigger previews before you import the images into Lightroom. This may be useful if you are importing photos from a folder and need to ensure you have the right ones selected before you carry out an import and to check for things like sharpness. The Loupe view Toolbar options (**Figure 2.14**) can be used to adjust the Loupe view zoom setting; you can also use the Spacebar to toggle the preview between a zoom-to-fit and a close-up zoom view (and use **a**) to return to a Grid view).

Figure 2.13 The Import dialog Toolbar with the Content area in Grid view mode.

Figure 2.14 The Import dialog Toolbar with the Content area in Loupe view mode (there is also an Include in Import check box in the Loupe view mode Toolbar).

In the Grid view, each cell has a check box next to it. You can use the Check All and Uncheck All buttons in the Toolbar (Figure 2.13) to select or deselect all the photos in the current Grid view that you wish to import. With all the cells deselected, you can make a custom cell selection. Use a Shift-click to make contiguous selections of photos, or use a \(\mathbb{H}\)-click (Mac) or \(\textstyle{Ctrl}\)-click (PC) to make a discontiguous selection, and then click any one of the check boxes to select or deselect all the photos that are in that selection. Furthermore, in both the Grid and Loupe views, you can use the "pick" keyboard shortcut (P) to add a photo to an import selection and use the "unpick" keyboard shortcut (either U or X) to remove a photo and use `to toggle between selecting and unselecting. If you hold down the **Ashift** key as you apply these key shortcuts, you can auto advance to the next photo. Lastly, you can use the Spacebar to toggle adding or removing a photo from an import selection. You will notice a Sort menu in the Grid view Toolbar (Figure 2.13). This lets you sort files by Capture Time, Checked State, or File Name, and can play a useful role in helping you determine which files you wish to select when making an import. You can now also sort by File Type, which allows you to quickly select specific file types and remove certain types of files at the import stage.

The Lightroom Import dialog can only show supported image and video files. If no files can be imported, you'll see a "No photos found" message. If you select a folder to import from in the Source panel and Include Subfolders happens to be unchecked, you may see an Include Subfolders button in the middle of the content area (**Figure 2.15**). Clicking this displays the subfolder contents.

Figure 2.15 The "No photos found" message plus Include Subfolders button.

Content area segmenting options

How the photos are segmented in the content area depends on which option you have selected in the bar at the top of the content area (**Figure 2.16**). As you might expect, the All Photos option shows all files without any segmenting. The New Photos option is useful, as it hides any duplicate photos. The Destination Folders option works in conjunction with whichever Organize option you have selected in the Destination panel (see page 52) to determine how the photos appear segmented. If the "Into one folder" option is selected, there will be no segmenting of the files. If the "By original folders" option is selected, the files in the content area will appear segmented in subfolder groupings, matching the selected source folder. If the "By date" option is selected, the files in the content area will appear segmented by the date the files were captured. To illustrate this, Figure 2.16 shows photos ready to import with the Destination Folders option. Here, the Destination panel has Organize set to "By original folders" (circled in blue) and the photos are separated into Source folder named segments in the content area.

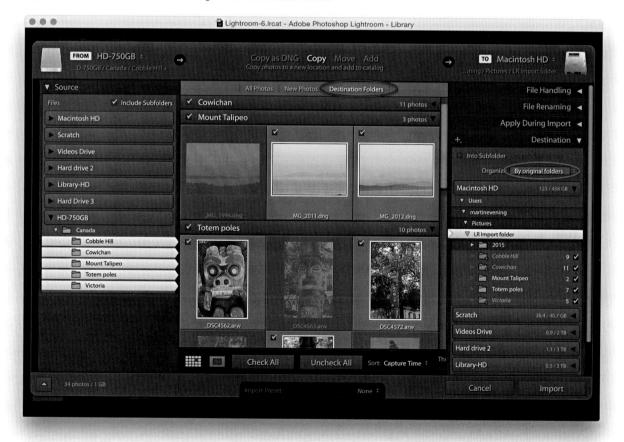

Figure 2.16 These photos are ready to import by Destination Folders and the Destination panel is set to organize "By original folders."

The Grid view cells provide some visual clues regarding import status. You will notice that some of the thumbnails are grayed out. This is because the Don't Import Suspected Duplicates option in the File Handling section was checked and these are duplicate photos that won't be imported. Files that are unselected are displayed with a dark vignette, meaning they won't be included in the import.

In the **Figure 2.17** example, the photos are ready to import by Destination Folders. Because the Destination panel has Organize set to "By date" (circled in blue), the photos are separated into dated segments in the content area. You will notice the date destination folders appear in italics in the Destination panel. Basically, this tells you that these folders have not been created yet and also tells you how many files will be placed in these new folders. If the card contains multiple folders, there will be an option to import photos "By original folders." This option is useful when your camera is set to limit the number of files in any given folder (e.g., 100 photos per folder).

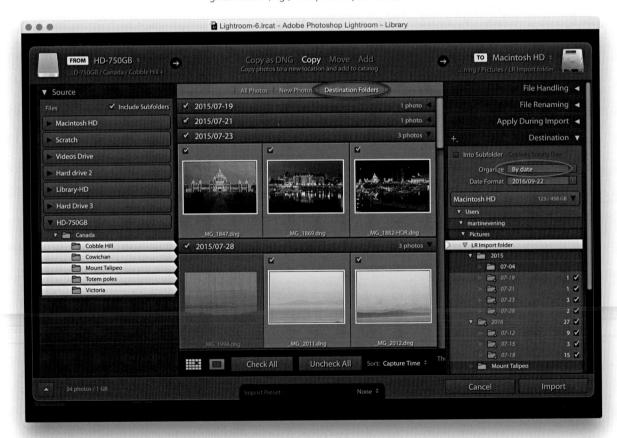

Figure 2.17 Here again, photos ready to import by Destination Folders, but the Destination panel is set to organize "By date."

File Handling panel

The File Handling panel (Figure 2.18) is where you decide how the imported photos should be managed. The Build Previews menu lets you determine how the previews should be rendered during the import process. The default setting here is Minimal, which imports the photos and discards the embedded previews. To make the culling experience better, Adobe improved the Loupe image-to-image walking performance, in case you like to import with Minimal Preview. The Embedded & Sidecar option makes use of any previews that are embedded in the original images or sidecar files, although such previews may offer only a rough guide as to the images' appearance. You can also choose to build Standard previews (at the size determined in the Catalog Settings) or choose 1:1, which will build full-size previews. Fortunately, Lightroom always prioritizes importing the photos first before it proceeds to render the finer-quality previews. Of the four options, Embedded & Sidecar makes the most sense, because although the previews may not be as accurate, this is still the fastest way to get some kind of preview to appear as the files are imported. This in turn enables faster performance when importing and browsing raw images. Basically, the embedded previews are now retained until you edit them or choose to generate new previews. Therefore, after import you'll only see embedded previews, which are identified by a double-arrow badge in the top-left corner (Figure 2.19). There is a preference in the General Preferences (Figure 2.4) to replace embedded previews with Standard previews during idle time, but this is disabled by default (see also the following section on Embedded previews after import).

Build Smart Previews

The Build Smart Previews item creates small proxy versions as you import and archive these to a Smart Previews data file that's stored in the catalog. As you do so, you will see a separate progress indicator for the Smart Preview generation, which you can cancel without canceling the entire import. These are generated more quickly in Lightroom Classic CC on computers systems with Quad Core or higher CPUs. For more about working with Smart Previews, see page 147.

Suspect duplicates

When the Don't Import Suspected Duplicates option is selected, Lightroom carries out a file check to determine whether a file is a suspected duplicate. First, it checks the filename for a match, then it checks the file size and EXIF metadata to see if the original capture date/time and file length match.

Add to collection

When the Add to Collection box is checked, you can simultaneously add imported files to a specific collection. For example, this allows you to import photos to collections that are synced with Lightroom CC/Lightroom mobile.

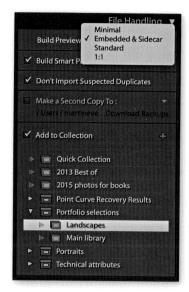

Figure 2.18 A full view of the File Handling panel showing the Render Preview and Add to Collection options.

Figure 2.19 A Grid thumbnail with an embedded preview badge (circled).

Embedded Previews after import

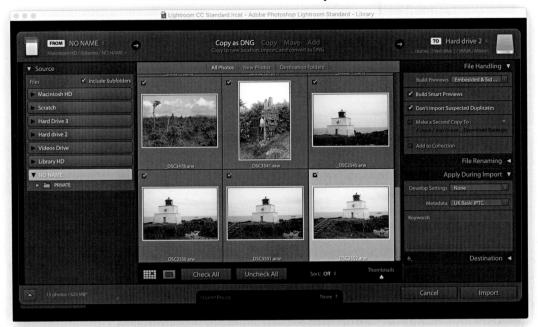

Here, I selected new photos to import from a card using Embedded & Sidecar.

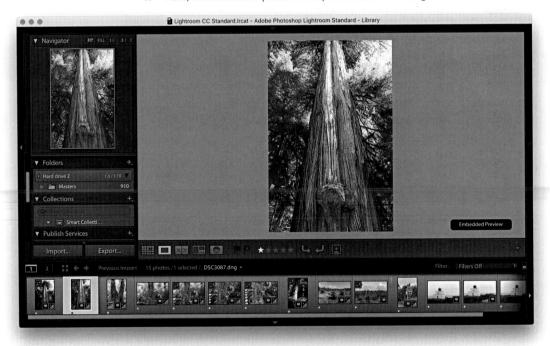

Once imported, the Loupe previews retain the embedded previews and do not update, thereby making the import process faster.

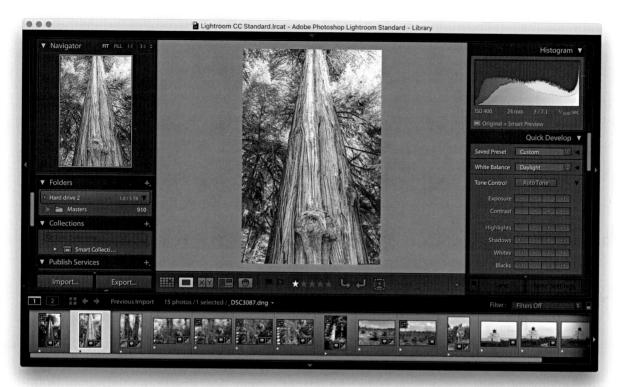

3. After you select an image or apply any image adjustments to the photo, the embedded preview is replaced by a Lightroom-generated preview. If "Replace embedded previews with Standard previews during idle time" is selected in the General Preferences, all the previews will eventually become updated without your having to select each photo in turn.

File format compatibility

Lightroom is able to import all the supported raw file formats plus DNG. Non-raw images can be in 8-bit or 16-bit mode; in the RGB, Lab, CMYK, or grayscale color space; and saved using the TIFF, JPEG, PSD, or PNG file formats. CMYK, grayscale, and Lab mode images can be edited in the Develop module, but when you do so, the edit calculations are carried out in RGB and exported as RGB only. It is therefore best to just use the Library module to manage your CMYK images and not attempt to edit them in the Develop module.

To ensure your layered Photoshop format (PSD) files are recognized in Lightroom, the PSD files must be saved from Photoshop with the Maximize PSD and PSB File Compatibility option enabled in the Photoshop File Handling preferences (**Figure 2.20**) before you save layered PSD files via Photoshop. If you ever find you are unable to import PSD files into Lightroom, try switching on this option in Photoshop and resave the PSDs overwriting the originals. If there are no compatibility problems, everything should import successfully, but if there are files Lightroom cannot process, you'll encounter a feedback dialog like the one shown in **Figure 2.21**.

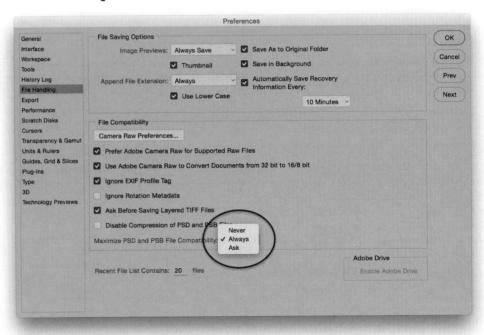

Figure 2.20 The Photoshop CC File Handling Preferences dialog.

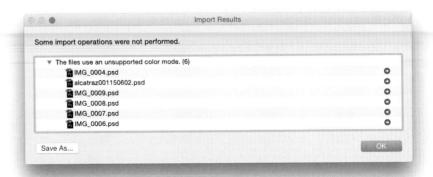

Figure 2.21 If there are files that can't be imported into Lightroom, you'll see the warning dialog shown here, which lists the files that couldn't be imported and the reasons why.

Importing video files

If your camera is able to capture video in the QuickTime movie or AVCHD formats, you can import the video files along with your regular still images (**Figure 2.36**). Once these have been imported into Lightroom they are easily distinguished from regular image files by the time-clip duration badge that appears in the bottom-left corner of the Grid/Filmstrip thumbnails (**Figure 2.35**). To filter for video files, you can use an Attributes search (I'll be discussing that aspect of Lightroom toward the end of the book). Lightroom does, however, support direct video playback and limited video editing. This means you can double-click video files in the Library grid and play them directly in the Library module Loupe view. You can also edit the timeline start/finish times, as well as apply certain types of Quick Develop adjustments. For more information about video-clip editing in Lightroom, see page 221.

Figure 2.35 A video file grid cell view.

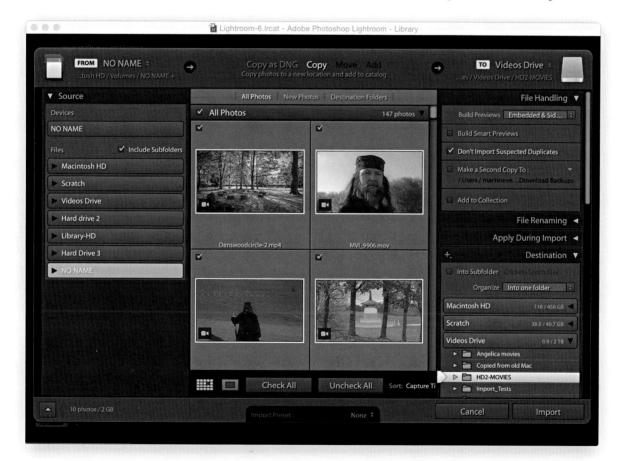

Figure 2.36 An example of a card import that includes video files.

Adding photos to the catalog

Importing photos using the Add method is the quickest and most efficient way to build up a Lightroom catalog from scratch and add photos from existing folders. If you are setting up Lightroom for the first time and have all your images neatly structured in, say, your My Pictures folder, all you have to do is choose Add, select the topmost folder (the root directory), and click Import. This lets you import all the photos in one go, and the folder directory on your computer will appear mirrored in the Lightroom Folders panel. In the Figure 2.37 example below, I selected a folder from the Source panel and chose the Add option from the Workflow bar. You'll notice how when the Add option is selected only the File Handling and Apply During Import panels are displayed in the right panel section. If the folder you are importing from contains subfolders, you'll need to check the Include Subfolders option in the Source panel because you will want the subfolder contents to be included in the import. In the File Handling panel, I chose Embedded & Sidecar previews and to not import suspected duplicates. In the Apply During Import panel, I deliberately chose to leave everything here set to None, because I did not wish to overwrite or add to any of the existing Develop settings or informational metadata contained in the files I was about to import.

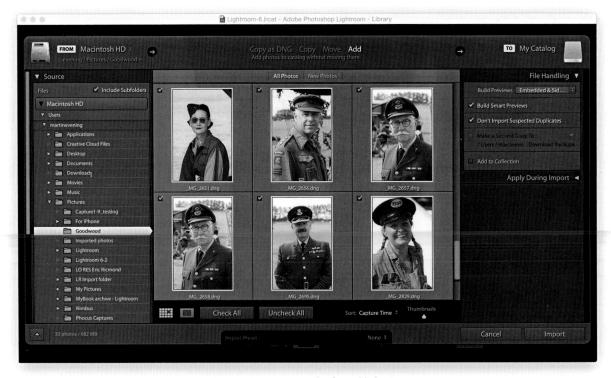

Figure 2.37 An example of an Add photos import.

Importing photos via drag and drop

Another way to import photos into Lightroom is to simply drag and drop files from a camera card or a folder of images from the Finder/Explorer or Bridge to the Library module content area. This method triggers opening the Import dialog with the dragged folder selected as the source and allows you to decide how the new images should be imported. Even when the Import dialog is already open, you can use the drag-and-drop method to make the dragged folder the source.

In **Figure 2.38** below, I located the images I wanted to import and dragged them across to the content area in the Library module. This drag-and-drop action established the dragged folder as the source. From here on, the steps I used were exactly the same as for any other import. All I had to do was decide how I wanted them to be imported, whether to import by copy or to add to the catalog.

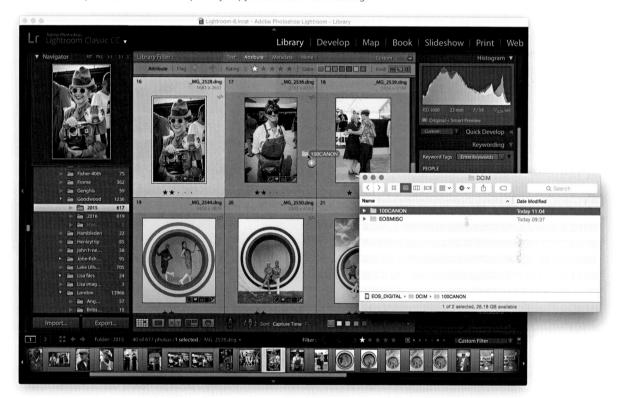

Figure 2.38 An example of a drag-and-drop import.

Importing photos from another application

It is possible to easily migrate libraries from the Aperture or iPhoto programs over to the Lightroom catalog using the Aperture Importer or iPhoto Importer plug-ins. These can be used to migrate files and preserve custom metadata information, but won't be able to preserve and re-create Develop settings that have been created in Aperture or iPhoto.

1. I started in the Aperture library with an image selected that had been rated with two stars and an orange label.

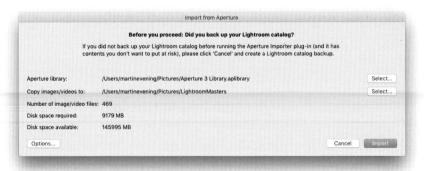

2. I quit the Aperture catalog, and in Lightroom I chose File ⇒ Plug-in Extras ⇒ Import from Aperture Library. This opened the Import from Aperture dialog (if importing from iPhoto, you would select Import from iPhoto Library). I clicked the Select button to select the Aperture library referred to in Step 1 and clicked the Select button below that to choose a folder to copy the images and videos to. I then clicked the Import button.

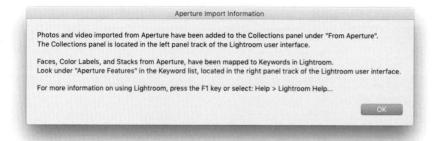

3. Once the import process had completed, the above dialog summarized the import process. If there were any errors, these would have been reported.

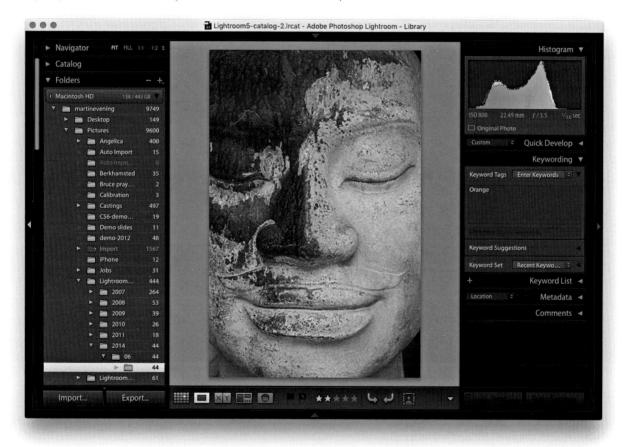

4. In Lightroom, a From Aperture collection was added to the Collections panel (as shown above). The actual files themselves were copied to the folder location specified in Step 2. As you can see here, the Export/Import process preserved the two-star rating and assigned the Orange label as a keyword, which is visible in the Keywording panel. This process also preserved Aperture Faces and Stacks as keywords when imported into Lightroom.

TIP

The Auto Import dialog can also be used to establish a tethered import workflow for those cases when you are reliant on using third-party software programs to download the photos from the camera. For more information about this, please refer to the PDF on the Lightroom book website.

Downloadable Content: thelightroombook.com

Auto Imports

If you go to the File menu and choose Auto Import \Rightarrow Auto Import Settings, Lightroom opens the Auto Import Settings dialog shown in **Figure 2.39**. In the Watched Folder section, you can choose a folder to drag and drop the photos you wish to auto-import, and in the Destination section, choose where you wish to import the photos to. The remaining sections can be used to determine how the files will be named as they are imported and also whether to apply any specific Develop settings, IPTC metadata, or keywords metadata on import. Lastly, you can select an option for generating the initial previews.

The Auto Import feature is incredibly useful. After you have configured the Auto Setup settings once and checked the Enable Auto Import box, you are all set to add files to the catalog by simply dragging and dropping them to the designated watched folder. This offers you a way to quickly import files that bypasses the Import Photos dialog completely. Once files have been imported, you will see them appear in the Destination folder in Lightroom. You can then, if you like, choose to move them to a new folder location.

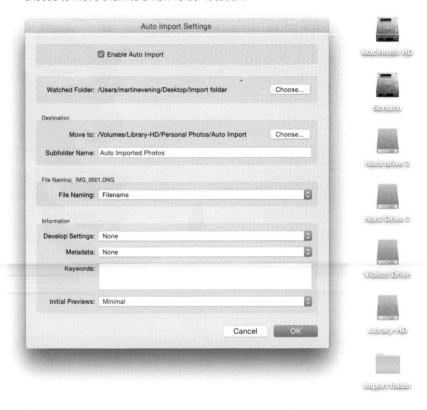

Figure 2.39 The Auto Import Settings dialog. The Import folder referenced here was located on the Desktop. I could then drag and drop files to this folder that I wished to auto-add to the catalog.

Importing photos directly from the camera

It is possible to set up Lightroom to work in a tethered shooting mode, which means photographs shot on the camera can be imported directly into Lightroom (**Figure 2.40**). For instance, tethered shooting allows clients to see the images appear as previews in the Library grid as you shoot. I also find tethered shooting can be useful on model castings because it allows me to individually update the keywords or captions right after a photo has been shot.

Figure 2.40 This is the computer setup that I normally use when shooting in tethered mode in the studio.

Tethered shooting connections

To shoot in tethered mode, you obviously need to be able to connect your camera to the computer. Ideally, you want the fastest connection possible. Most current professional digital SLRs offer a USB 2.0 or USB 3.0 connection. These should provide a fast enough interface to allow you to import the capture files at around the same speed as you can with a standard-speed camera memory card. The only downside is that you must have your camera connected to the computer via a cable, and this can restrict the amount of freedom you have to move about without pulling the cable out or, worse still, pulling a laptop computer off the table! Another option is to shoot wirelessly. Wireless units are available for some digital SLR cameras; these let you transmit images directly from the camera to a base station that is linked to the computer. Wireless shooting offers you the freedom, up to a certain distance, to shoot in a tethered style, but it is really restricted to the transmission of suitably compressed JPEGs. The current data transmission speeds for some camera systems are a lot slower than those you can expect from a USB 2/USB 3 connection. Rapid shooting via a wireless connection can certainly work well if you are shooting in JPEG mode, but not if you intend on shooting raw. Of course, this may all change in the future.

With some Nikon cameras, you can shoot wirelessly via PTP/IP or FTP. It appears so far that PTP/IP is better and should rival USB, because PTP/IP is able to transfer files much faster due to the compression that is built into the transmission.

TIP

To get your camera to tether successfully with the computer, you may need to install the necessary drivers or driver updates for the camera you are using. In most cases, the drivers are already part of the system and you shouldn't experience any problems.

Figure 2.41 When shooting in tethered mode, Lightroom will display warnings like the ones shown here if the camera battery is running low or the memory card is almost full.

Lightroom-tethered shooting

The main reason for choosing to shoot tethered is to make the import process smoother and faster. But a number of factors can affect the overall tethered shoot import speed. First, you have to consider whether you are going to shoot raw or JPEG and the likely size of the capture files. Then there is the camera interface. Professional digital SLR cameras should boast a faster buffer capacity and data transfer rate compared to budget digital SLRs. The Lightroom tethered capture feature does not appear to create any bottleneck problems and can match or exceed other tethered solutions in terms of download speed, but the actual download speed may still be compromised by the speed of the operating system FireWire/USB drivers and how well the software is able to optimize the interface connection. In my experience, the biggest limitation is the interface connection. It doesn't matter how fast your computer is or whether you are using fast hard drives—the camera interface connection is nearly always the weakest link.

The tethered connection process is mostly one-way. Lightroom enables camera capture files to be imported into Lightroom and can read the camera settings data, but unfortunately you can't use the Tethered Shoot control panel to interact with the camera, other than to use the shutter-release button to fire the camera shutter remotely. Having said that, Lightroom does provide feedback from the camera to warn when the battery is running low or the card is full (**Figure 2.41**). What you have to bear in mind is that providing reverse communication for each unique camera interface is a lot harder than simply enabling tethered download communication with the currently supported cameras. Tethered shooting via Lightroom is available for a select number of Canon and Nikon digital SLR cameras, as well as for the Leica S2 and Leica M (go to tinyurl.com/2fow89q for more help and advice on tethering cameras to Lightroom). Adobe has taken steps to make the tethered shooting process more reliable; for example, Lightroom now self-checks the tethered connection more frequently.

Although only the above camera makes are supported, most digital SLR and medium-format cameras come with their own software solutions for tethered shooting. One of the advantages of using dedicated tethered capture software is it does allow you to control the camera settings remotely via a computer interface. This can be particularly useful where it would otherwise prove awkward to reach the camera. If this sounds like a more appealing solution, then you might want to explore using such software in conjunction with Lightroom. If you go to the book website, you can download a PDF with instructions on how to import photos via a tethered connection with the Canon EOS Utility program in conjunction with the Canon EOS 1Ds Mark III camera. In this PDF, I show how Lightroom is able to appropriate the tethered shooting component of the camera communication software, and from there, directly take over the image processing and image management via the Auto Import dialog. Although these instructions relate to Canon software, you should be able to easily translate them to working with other cameras and camera software setups.

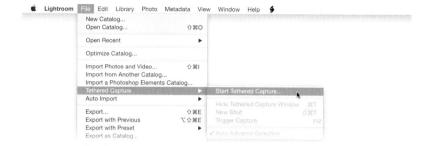

1. To initiate a tethered shoot session in Lightroom, I went to the File menu and selected Tethered Capture ⇒ Start Tethered Capture (the Tethered Capture menu is only accessible via the Library module).

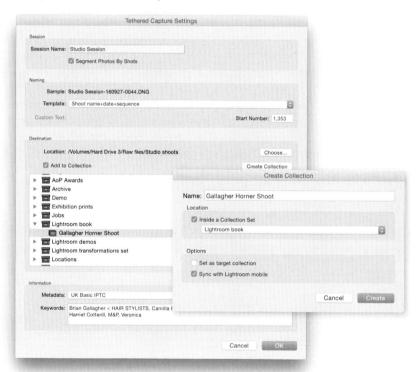

2. This opened the Tethered Capture Settings dialog, where I was able to configure the desired tethered import settings. I retained the default *Studio Session* text for the Session Name and selected Segment Photos By Shots. In the Naming section, I chose a suitable file-naming template. In the Destination section, I set the destination folder location to *Studio shoots*, and in the Information section, I selected a metadata preset to add on import, along with relevant keywords for the shoot. I then clicked OK to confirm these settings. You can choose to add photos to a specific collection or create a new collection (as shown here). You also have the option to sync such collections with Lightroom mobile.

3. Because I had chosen Segment Photos By Shots, the Initial Shot Name dialog appeared next. I called this shoot *Shot 1*, and clicked OK.

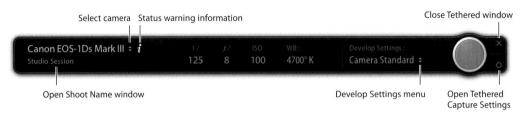

4. This opened the Tethered Shoot control panel. The camera was switched on and the camera name appeared in the top-left section. If more than one camera is connected to the computer, you can click the pop-up menu to choose which to import from. The camera data displayed here is informational only, and the settings have to be adjusted on the camera itself. You can use the big round shutter button to capture photographs remotely, or use the F12 Trigger shortcut.

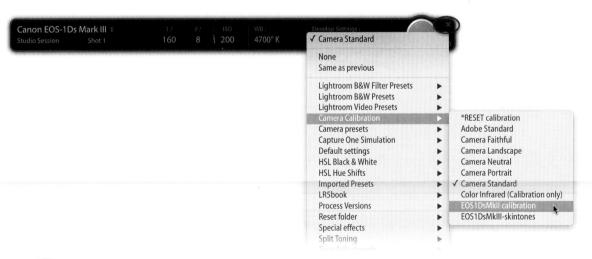

Figure 2.42 You can collapse the tether toolbar down by Alt-clicking the close button (circled in Step 5).

5. If you click the Develop Settings pop-up menu, you can select an appropriate Develop setting. As long as the Tethered Shoot control panel remained active, I could shoot pictures with the selected camera and these would be automatically imported into Lightroom. You can hide the panel using **ST** (Mac) or **Ctrl T** (PC) or quit by clicking the Close button (circled). To collapse the tether Toolbar, **Alt**-click the Close button (**Figure 2.42**).

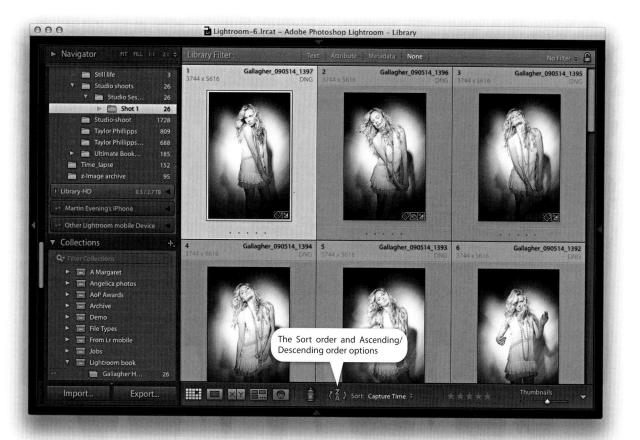

As I started shooting, the capture images began to appear in the Lightroom catalog. There is a menu in the Lightroom General preferences that allows you to select a sound to play when a tethered-shoot import process has completed. You will see I adjusted the sort order so the most recently shot images were shown first (see sidebar tip). If the Auto Advance Selection option is enabled via the File

□ Tethered Capture menu, this ensures that the most recently shot capture image is automatically selected. You will also notice that the photos appeared in the following folder directory: Studio Shoots/Studio Session/Shot 1. To understand the hierarchy employed here, you will need to refer back to the sections I highlighted in Steps 2 and 3. Studio Shoots was the selected master destination folder for the tethered shoot images. Studio Session was the default name used in the Shoot section, and Shot 1 was the name given to this first series of shots. Notice also how the files were added as a collection (see highlighted collection). At this point, I could prepare for a second shoot by opening the Initial Shot Name dialog via the Tethered Shoot control panel (see Step 4) and enter a name for the next set of shots (or use the #GShift Tab [Mac] or Ctrl GShift Tab [PC] shortcut). If you are shooting with a Canon camera, you will need to remember to switch cards as they become full or reformat the card once the photos have successfully imported.

When you shoot using the tethered mode, it is useful to see new images appear at the top of the content area as they are imported. To enable this feature, choose View □ Sort □ Descending. You may want to switch the sort order back to Ascending for normal editing. If the Ascending/ Descending toggle action appears to be broken, it may be because you have a Custom sort order selected. Also, make sure the Sort option is set to Import Order or Capture Time.

3

The Library module

Introducing Lightroom catalogs and the Library module features

In this chapter, we are going to take a first look at how the Lightroom catalog works and how to use the Library module controls to navigate and manage your photos.

The Lightroom catalog is a key component of the program. Lightroom's underlying architecture and central database are designed to provide speed and flexibility when managing and viewing your photos. This can be seen by the way Lightroom allows you to view and update your files more quickly, provides a well-thought-out interface for managing your images, and ties in smoothly with the Book, Slideshow, Print, and Web modules.

To begin with, we will look at what is inside the Lightroom catalog folder and how to keep your catalog data backed up and protected.

Figure 3.1 The Lightroom program folder contents.

About Lightroom catalogs

To understand Lightroom, you need to understand the role of the catalog and how it is central to the way files are managed. The Lightroom catalog references the files you import into Lightroom, creating links from the catalog to the original files, wherever they are stored on the computer. Previews are stored with the catalog that let you navigate the catalog contents, while Smart Previews can be used as proxies to make the catalog portable and independent of the original photos. A browser program like Bridge can also be used to manage image collections, but the disadvantage of this approach is Bridge displays all types of files and the photos you are looking for must be present on the system, which makes the Bridge workflow more rigidly desk-bound.

Lightroom actively encourages you to manage your photos better. As an image collection grows in size, you have to be especially careful as to how you organize everything so you know where all your files are when you want them. Suppose you were to fall ill and a co-worker needed to locate a specific image? How easy would it be for her to find it on your computer? In situations like this, what you require is a cataloging system that can manage your images and keep track of where everything is stored. The Lightroom catalog is written using the SQLite3 database format, which stores all the catalog data in a single file along with previews and Smart Previews data files that are easily transferable for cross-platform use. As you import your photos into Lightroom, the catalog keeps track of where the files are kept, as well as all the information associated with those files, such as the metadata and Develop settings. There is no known limit as to how many photos the catalog file can reference.

When you first installed Lightroom, a new Lightroom catalog folder was created in the username/Pictures folder (Mac) or the My Documents/My Pictures folder (PC). This folder contains a catalogname.Ircat catalog file (the master catalog file that contains all the catalog database metadata) and a catalogname Previews.Irdata file that contains the previews data (Figure 3.1). These two files store all the critical data that relates to the current Lightroom catalog. You may also see a catalogname Smart Previews.Irdata file. This will be dependent on whether you chose to build Smart Previews for any of your library images (see page 147). If you want, you can rename the catalog file. To do this, make sure you close down Lightroom first. Go to the Lightroom folder and rename the .Ircat, Previews.Irdata, and Smart Previews.Irdata files. Just make sure the suffixes remain unaltered and that you change only the first part of the names (the prefix).

While Lightroom is running, you will also see three other files inside the Lightroom folder. The *catalogname.lrcat-shm* and *catalogname.lrcat-wal* files are important, temporary internal work files that have not been written to the catalog database file yet. If Lightroom should suffer a crash, it may temporarily remain in the folder until Lightroom has been relaunched and had a chance to recover all the data. Whatever happens, do *not* delete these files because they may contain important

data that can help Lightroom recover recently modified data information. The other temporary file is a *catalogname.lock* file, which is there to prevent other Lightroom users from accessing the same catalog file over a computer network. Should you suffer a computer crash while working in Lightroom and experience problems when relaunching the program, it could be because a .lock file is still present in the Lightroom catalog folder. If this is the case, try manually deleting the .lock file via the system Finder/Explorer. Lightroom should then relaunch as normal.

You may also see a *Lightroom Settings* folder. This only shows up if the "Store presets with catalog" option is checked in the Lightroom Presets preferences (see page 13). When checked, a *Lightroom Settings* folder is added inside the Lightroom catalog folder. This allows you to store newly created Lightroom settings locally within the Lightroom catalog. It may be useful if you want to keep certain catalog settings restricted to specific catalogs (such as FTP settings you might wish to keep private). The downside is if you later decide to uncheck this option, Lightroom will revert to referencing the main user Lightroom folder. As a consequence of this, some presets may appear to be missing because the catalog stored Lightroom Settings folder will not be synchronized with the one stored in the user Lightroom folder.

If you go to the Lightroom menu (Mac) or Edit menu (PC) and choose Catalog Settings, this opens the dialog shown in **Figure 3.2**. Here you can click the Show button (circled) to reveal the current location of the catalog in the Finder/Explorer. The Lightroom catalog folder does not have to be in the *Pictures/My Pictures* folder. You can move it to any drive location you like. Having said that, you cannot store the catalog on a network attached server (NAS) drive, on optical media, or within a locked (read-only) folder.

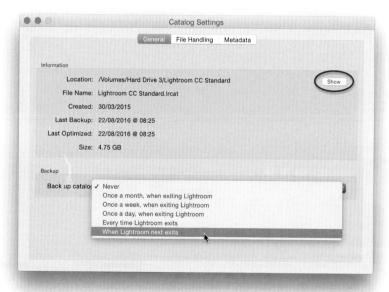

Figure 3.2 The Catalog Settings dialog.

NOTE

The user Lightroom folder is not the same thing as the Lightroom catalog folder. The user Lightroom folder contains various Lightroom settings, as well as custom user preset settings. It can be found in the following locations: username/Library/Application Support/Adobe/Lightroom folder (Mac) or username/App Data/Roaming/Adobe/Lightroom folder (PC).

NOTE

Your Lightroom catalog will most likely consist of tens of thousands of metadata and preview files. It can therefore take a long time for some backup software or virus-checking programs to process such a huge number of individual files, even though the files may be quite small. It is worth checking to see if your virus checker allows you to exclude certain applications/files/locations from the scan process.

Backing up the catalog file

The most important component is the *catalogname.lrcat catalog* file, which is why you need to safeguard it as you would a financial accounts file or other important data document and remember to carry out regular backups. They say there are only two types of computer users: those who have experienced a loss of essential data and those who are about to. In the General section of the Catalog Settings, you can choose how often Lightroom creates a backup copy of the Lightroom catalog database file. This includes options to schedule the backup procedure to take place after you have quit Lightroom. I strongly advise you select one of these options because it provides an extra level of built-in backup security that may well prevent you from losing all your catalog data information. When Lightroom is due for a catalog backup, the Back Up Catalog dialog will appear at the designated time (**Figure 3.3**). This gives you the option to skip the backup for now or proceed.

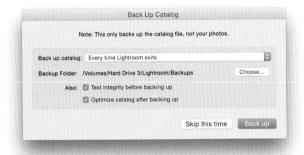

Figure 3.3 The Back Up Catalog dialog.

When you click the "Back up" button in the Back Up Catalog dialog, Lightroom creates a duplicate backup version of the main catalog file and saves it to the designated *Backups* folder, such as the one shown in Figure 3.1. Each time you back up the Lightroom catalog, Lightroom creates a new backup copy of the *.lrcat* catalog file and stores it in a new, dated folder within the *Backups* folder. If the catalog is bigger than 4 GB, you'll see the dialog shown in **Figure 3.4**, which points out the backup catalog will be saved as a compressed ZIP file. If at any stage you notice there is a problem with the catalog not opening, you'll have an

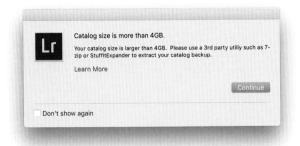

Figure 3.4 The catalog compression warning dialog.

opportunity to replace the current (corrupt) database with a previously backed-up copy of the catalog, placing the decompressed backup catalog in the root-level Lightroom folder. When you relaunch Lightroom, it will launch using the last backed-up version of the catalog. Over time, you may accumulate a lot of backup catalogs in the *Backups* folder, and it makes sense to cull the older ones as they become too out-of-date to be of any practical use.

The Back Up Catalog dialog contains an identical pop-up menu to the one in the Catalog Settings dialog that allows you to set the backup frequency. Click the Choose button to select the location where the backup catalog file should be stored. By default, the *Backups* folder is stored with the main Lightroom catalog folder, but you can store this folder anywhere you like on your system. After all, you might prefer the security of having the backup catalog stored on a separate drive to the master catalog. Next is an option to test the integrity of the catalog before backing up. Depending on the size of your catalog, an integrity check (**Figure 3.5**) should only take a few minutes to complete and can offer you peace of mind that your catalog file is in good shape.

All metadata edits, such as image adjustments and keywords, are written to the catalog file. This happens on a continuous basis and can, over time, lead to data fragmentation. So, if you find Lightroom is running more slowly than expected, you may want to optimize the catalog. You can do this by checking the "Optimize catalog after backing up" option in the Back Up Catalog dialog. You can also optimize the catalog at any time choosing File \Rightarrow Optimize Catalog. This displays the dialog shown in **Figure 3.6**, where you should click the Optimize button. It may take a few minutes to complete, but you should afterwards see an improvement in Lightroom's performance. This process also highlights any potential problems within the catalog file and initiates a repair if necessary.

Backup strategies

A mirrored RAID system can be useful in a mission-critical environment to ensure continuity of data access, but this does not amount to the same thing as having a fail-safe backup strategy. For that, you need to perform scheduled backups to a secondary set of drives, which should be stored in a safe location such as in a fireproof safe or somewhere off-site. In a simple office setup, you could have one drive on the computer that's used to hold the main Lightroom image catalog and a duplicate external drive of similar capacity to make regular, scheduled backups to. With this kind of setup, it is important the backups are scheduled manually. If a problem were to occur on the master disk, such as an accidental file deletion or a directory corruption, you would have the opportunity to rectify the problem by copying data over from the backup drive. And because you are keeping the data on a separate drive, it can be stored in a separate location away from the main computer. For added security, I suggest using two external backup drives and swapping over the backup disk that is connected to the computer and the one

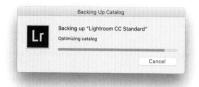

Figure 3.5 An Integrity check in progress during the backup catalog procedure.

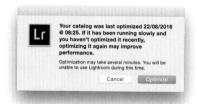

Figure 3.6 If you choose File ⇒ Optimize Catalog, you will see the dialog shown here, which informs you of the last time the catalog was optimized and gives you the option to proceed or cancel.

that is kept off-site. As long as the files are stored on read/write disk media, they may still be vulnerable to accidental erasure or a virus attack that could infiltrate the backup drives. To further reduce the risk, you could make DVD or Blu-ray disc copies of your image files and keep them in an appropriate storage location. It would be a pain to have to reload all the data from DVD/Blu-ray discs, but would at least ensure that the data is free from virus attack or human error. For more about disc setups, see Chapter 12.

Backup software

You can use various programs to carry out data backups. On the Mac platform, I can recommend both ChronoSync from Econ Technologies (econtechnologies.com) and Carbon Copy Cloner by Mike Bombich (bombich.com). I make regular backups of all the drives on my system. Whenever I want to back up any data, I simply switch on a backup drive and run the backup process. I have the settings configured so that Carbon Copy Cloner first compares all the data on the source disk (the drive I want to back up) with the target disk (the drive I want to store the backup data on) and copies all the newly added files. Setting up the backup drives and copying all the data does take a long time the first time around, but after that, if you carry out regular backups, like once a day or each week, the backup procedure can be carried out quite quickly. If you are in the habit of leaving your computer and drives turned on overnight, you can always schedule the backups to take place in the early hours of the morning.

Time Machine and the Lightroom catalog

One of the key features of Mac OS X is Time Machine, which creates automatic backups of your data while you work and allows you to retrieve any lost or overwritten data. To prevent Time Machine from corrupting the Lightroom catalog, Lightroom marks an open catalog file as "being in use" and excluded from a Time Machine backup whenever Lightroom is running. This prevents Time Machine from backing up the catalog while it may be in an incomplete state or in the process of being modified. When Lightroom quits, it takes the catalog off the exclusion list. This means Time Machine can still create backups of the Lightroom catalog, but only while Lightroom is not in use. If you want to restore the Lightroom catalog from a Time Machine backup, you must make sure that Lightroom is not running before allowing Time Machine to run.

Catalog corruption

Catalog corruption is rare, but distressing nonetheless should it happen to you. It can occur for a number of reasons, such as the computer shutting down suddenly during a power cut or drives being improperly disconnected. To avoid the nasty effects of a power cut affecting the stability of your computer system, you should consider getting an uninterruptible power supply unit. The main computer and

display in my office are both connected to the main electricity via an APC ES 700 UPS backup unit. This is capable of providing enough power protection to keep the computer and display running for many minutes after a power cut.

Here's what to do to avoid the worst consequences. First, remember to make regular backups of the Lightroom catalog and to be on the safe side, choose a different drive to save the backup catalog to. The latest solid-state drives offer faster read/write speeds, but when they fail, they fail completely. So you need to anticipate what you would do if you were to lose all the data on the disk. This need not be a problem if you are in the habit of making scheduled backups of all your data to separate disks, where ideally, you keep one set of disks stored off-site (as well as backing up the catalog).

If the catalog does become corrupted, as you launch Lightroom you will see the dialog shown in **Figure 3.7**. It will always be worth trying to repair the affected catalog first. But if you choose to do this, it is best to quit Lightroom and make a backup copy of the catalog before repairing, just in case your attempts at a repair end up causing further damage to an already sick catalog file. If the catalog is too damaged to repair, you will be asked to choose a different catalog to launch with.

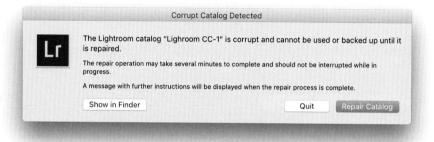

Figure 3.7 If Lightroom detects on launch that the catalog database file has become corrupted, there is a Repair Catalog option.

Sync catalog disaster recovery

Should you happen to lose your main Sync catalog, it is possible to download the cloud sync data back to your computer, rather than have to delete all data from the cloud and re-upload all over again. To do this, create a new catalog and then start syncing the Lightroom mobile data to the new empty catalog. From there you will have to carry out a careful catalog merge to sync the recovered data with your most recent catalog.

The main lesson here is to maintain backups of the catalog file, both locally as well as on separate backup hard drives. If you haven't yet backed up your catalog, I suggest you do so now, just as I would also advise you to make scheduled backups of all your computer data.

Creating and opening catalogs

When you first install Lightroom, it will by default create an empty new catalog. One catalog should be all you need. Personally, I find it more convenient to keep everything in one place, and it really does not bother me if personal and client photos are stored in the same place—the search functions in Lightroom make it easy to filter and search the photos I am looking for. The notion you should keep separate catalogs for different activities or shoots stems from a Bridge-style "file browser" mentality, where the cataloging power of Lightroom is perhaps not fully appreciated. It has sometimes been suggested you should consider having one catalog for personal photographs, another for studio work, another for weddings, and so on. While this approach may seem to make sense because different catalogs can be used to segregate your photos into neat groups, it is much simpler (and easier) to segregate your images when everything is contained in the one catalog. However, let's say two or more family members share the same computer. In this situation, each computer user might want to maintain a separate Lightroom catalog. It is certainly the case that a professional photographer may want to run Lightroom on more than one computer and have separate catalogs on each. In such cases, it is important to make sure there is always one master catalog that is regarded as the "primary" database. Things can get really complicated if your workflow involves maintaining separate catalogs. There should always be one catalog that is regarded as the parent catalog and all the other catalogs are subordinate to it.

Creating a new catalog

To create a new catalog, choose File ⇒ New Catalog. This opens the Create Folder with New Catalog dialog shown in **Figure 3.8**. Choose a disk location and type in the name you wish to give the catalog. This creates a new catalog folder containing an .*Ircat* and a *Previews.Irdata* file.

Figure 3.8 When you create a new catalog, you will be asked to name and create a new folder to contain the new catalog.

Opening an existing catalog

To open an existing, or alternative catalog, choose File ⇒ Open Catalog (or you can double-click the *catalog.lrcat* file itself). This opens the system Finder dialog where you can navigate to locate the correct Lightroom catalog folder. Here, you will need to select the *catalogname.lrcat* file and click the Open button to open it. You can also choose File ⇒ Open Recent to select a recently opened catalog. Whenever you create a new catalog or load an existing catalog, Lightroom always needs a restart because you can have only a single catalog open at a time. Alternatively, hold down the Alt key (Mac) or Ctrl key (PC) as you start up Lightroom. This opens the Select Catalog dialog shown in **Figure 3.9**.

Figure 3.9 The Select Catalog dialog.

Now let's look at the options in this dialog. If you check "Always load this catalog on startup," you can choose to make the selected catalog the default catalog that will open from now on each time you launch Lightroom. The "Test integrity of this catalog" option does the same thing as the option in the Back Up Catalog dialog—it lets you check to see if the catalog is in good shape before you launch it. Although it is a good thing to validate the catalog every now and then, I suspect most people would rather just get on with things and open the catalog straight away. If you don't see the Lightroom catalog you are looking for listed, you can always click the Choose a Different Catalog button and navigate to locate the correct Lightroom catalogname.Ircat file. Or, you can click the Create a New Catalog button to create a brand-new Lightroom catalog in a new folder location. This, of course, is the same as choosing File ⇒ New Catalog.

MP.

You can use the Key (Mac) or Ctrl key (PC) in combination with a keypad number (1, 2, 3, etc.) to toggle showing and hiding individual panels. For example, Quick Develop = 1, Keywording = 2, Keyword List = 3, etc. You can also right-click to access the context menu options for the panels and use this to hide/reveal individual panels in any of the Lightroom modules. Alt -double-clicking in a grid cell takes you directly to the Develop module, and Alt -double-clicking on a photo in the Develop module takes you directly back to the Library Grid view.

The Library Module panels

When the Library module is selected (Figure 3.10), the contents of the catalog can be displayed in a Grid view, which provides a multiple-image view using a grid cell layout; Loupe view, which shows a magnified, single-image view; Compare view, which lets you compare two photos side by side; or Survey view, where all the photos in a current selection are displayed in the content area. The Library module controls are split between the left and right panels. The Catalog panel lets you view the contents of the entire catalog, All Synced Photographs, a Quick Collection of images, or the Previous Import of images. Additional items may appear listed in the Catalog panel such as Missing Photos—these are temporary collections that can easily be removed via the context menu (see page 78). The Folders panel lists all the folders in the catalog by volume and alphabetical order and displays only the folders of those photos that have been explicitly imported into Lightroom. You can use the Folders panel to select specific image folders, but as you will discover in this chapter, there are also other ways you can search and locate the photos in the catalog. The Collections panel can be used to select a group of photos from the catalog and save them as a named collection. However, unlike folders, an individual image can exist in any number of collections. Lightroom also has the ability to create Smart Collections, which are collections created automatically based on custom rule settings (see page 140). You can use the B key to add favorite images to what is known as the target collection. By default this will be the Quick Collection in the Catalog panel, but you can actually make any collection the target collection.

Using the Publish Services panel, you can publish collections of photos to sites such as Flickr. You can then use Lightroom to manage photos that have been published online and view any feedback comments via the Comments panel.

The Filter bar, located at the top of the Content area, provides a one-stop location for making refined photo selections based on text searches, ratings, and/ or metadata. For example, you can filter the catalog based on a keyword search combined with a ratings filter, followed by a metadata filter based on which camera the photograph was taken with. The Quick Develop panel lets you make basic Develop adjustments without having to switch over to the Develop module. The Keywording panel is where you go to enter or edit new keyword metadata; plus, you can select keyword sets, including a Suggested Keywords set, which offers adaptable keyword suggestions based on your current photo selection. Keywords can be applied to images by dragging and dropping keywords onto selections in the content area, by dragging photos onto keywords, or by making a selection and adding keywords via the Keywording panel on the right. Other metadata information, such as the camera's EXIF data, can be viewed via the Metadata panel, which offers several view mode options. You can also use this panel to add custom IPTC metadata such as the title, caption, and copyright information.

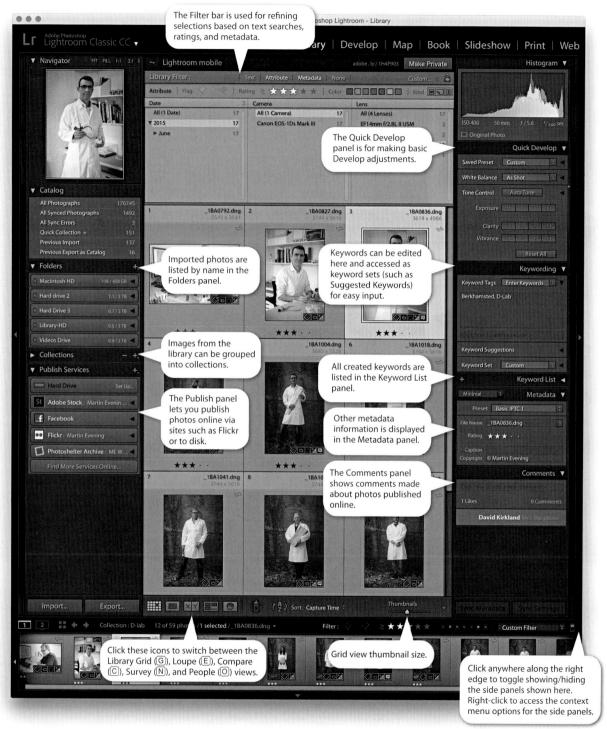

Figure 3.10 The Library module, shown here in Grid view with all panels visible.

Figure 3.11 The Navigator panel.

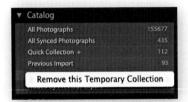

Figure 3.12 The Catalog panel.

Making the interface more compact

If you are working on a computer with a small display, you will be pleased to know that you can collapse both the Navigator and the Histogram displays. This lets you view and work more easily with the panels below. At the same time, the other panels slide beneath as you scroll down the panel list. This, too, can be helpful for those who have limited screen real estate.

The Navigator panel

The Navigator panel (**Figure 3.11**) displays a preview of the currently selected image and provides a number of controls for zooming and scrolling photos (see page 103). The Navigator panel will also update as you hover over the Folders panel or Collections panel lists. When you do this, it previews the first photo that appears in the folder, thus providing a visual reference, making it easier to locate the folder or collection of photos you are looking for.

The Catalog panel

The Catalog panel (**Figure 3.12**) offers several choices for displaying files. All Photographs displays all the files (showing the total number of photos in the catalog). All Synced Photographs displays files synced to Lightroom CC. Quick Collection displays all files in the current Quick Collection, and Previous Import lets you view the most recently imported files. It is important to remember to select All Photographs if you want a filter search to include everything that is in the catalog. I know this may seem obvious, but it is so easy to forget and then wonder why a search has turned up no results! As you work with Lightroom, other items will appear listed in the Catalog panel, such as Missing Photos. These are classed as temporary collections and can easily be removed. Just right-click to access the context menu and select Remove this Temporary Collection.

The Library module Toolbar

The default Library module Toolbar contains the Grid, Loupe, Compare, and Survey view mode buttons, as well as the Painter, Sort control, and Thumbnails slider (**Figure 3.13**). You can customize the Toolbar by clicking the Toolbar options to add Rating, Flagging, Color labels, Rotate, Navigate, and Slideshow playback controls. The Library module Toolbar can be customized individually for both Grid and Loupe views, and you can use the T keyboard shortcut to toggle showing/hiding the Toolbar (you can also just hold down the T key to temporarily access the Toolbar). Each time you do this you will see a message reminding you to use the same shortcut to reveal the Toolbar again. This applies to the Toolbar in all Lightroom modules. Also, the items you see listed here will vary depending on whether you are in the Grid view or Loupe view mode.

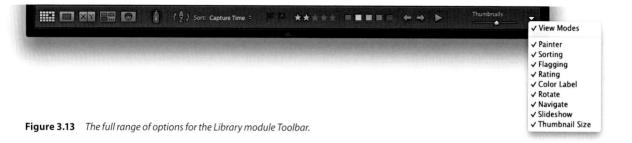

The Folders panel

As photos are imported into Lightroom, the folder locations appear in the Folders panel, listed in alphabetical order and segregated by the different hard-drive volume headers (**Figure 3.14**). Each of these volume header bars can be collapsed by clicking it. The green light in the volume header indicates that a disk drive is connected and has ample free storage space. As the drive nears its full capacity, the light will turn yellow, then orange, and finally red (indicating the hard drive is full). If a disk drive is currently offline, you will notice the volume header name appears in black, and if a folder name within it appears dimmed, this means there are broken links to one or more of the images contained within that folder. The numbers displayed in the volume header bar indicate the number of free gigabytes of data that are left on that drive alongside the total gigabyte capacity. You can right-click the volume header bar to access the context menu shown in Figure 3.14, where you can change the display to show instead the photo count, the online/offline status, or none of these.

Parent folders and subfolders

The Folders panel can be used to manage the folders that make up the Lightroom catalog—they can then be grouped into folders any way you like (as long as the individual folders are stored on the same volume). Folder names that are longer than about 30 characters will appear visibly truncated in the Folders panel, so it is best to keep names short. In some ways, the Folders panel looks like the list tree folder view you would find in a file browser program; the folder structure that is displayed in the Folders panel does, in fact, have a direct relationship with the system folders. But there is one key difference: the apparent absence of parent folders. When you first import photos, Lightroom, by default, lists the folders in as compact a hierarchy as possible. To expand the list view to show a complete hierarchy of folders, you will need to All-click the top-level folder. In Figure 3.15, I imported a folder of images called Jobs that was contained in a system parent folder called Lightroom images. But you can see that the top-level Lightroom images folder was not included here. A browser program would methodically list every folder in the folder tree hierarchy, but in Lightroom the aim is to provide

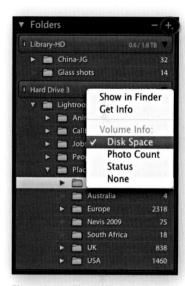

Figure 3.14 The Folders panel.

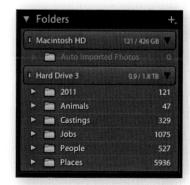

Figure 3.15 The Folders panel without parent folders.

Figure 3.16 The Folders panel with parent folders made visible.

the user with a tidy view of the imported folders. Keeping the folder hierarchy compact makes the Folders panel navigation easier since you don't always have to expand the panel's width to view folders nested several levels deep. Should you wish to reveal the top-level folders, you can do this on a folder-by-folder basis. Right-click the top-level folder (not a subfolder) to reveal the context menu and select Show Parent Folder. This will change the Folders panel view to include showing the parent folders (**Figure 3.16**). If you want to reverse this process, you can do so by again going to the context menu (**Figure 3.17**) and selecting the Hide This Parent option, which reverts to the Folders panel view seen in Figure 3.15. If any loose files happen to be in the parent folder, files that aren't located in any of the subfolders, a warning dialog opens (**Figure 3.18**). Clicking Promote Subfolders will remove those loose files from the catalog, but not actually delete them from the computer. So it is best to proceed with caution here when choosing to hide parent folders.

Figure 3.17 The Folders panel context menu showing the Hide This Parent option selected. You can change the name of a folder by choosing Rename.

Figure 3.18 The Promote Subfolders dialog.

If you click the Folders panel menu button (circled in Figure 3.14), this reveals the pop-up menu options shown in **Figure 3.19**. Here, you will see further options for how the root folders are displayed. You can keep to the default option, Folder Name Only, or you can select the Path From Volume option to identify the folders or the Folder And Path option (both are shown in **Figure 3.20**). These particular folder views can be used for instances where you wish to hide the parent folders but still need to see a full folder path or partial folder path view within the folder header.

Figure 3.20 Folders displayed using the Path From Volume view (left) and folders displayed using the Folder And Path view (right).

Show Photos in Subfolders

Also listed in the Folders panel menu (Figure 3.19) is the Show Photos in Subfolders option. This is always on by default and allows you to see everything that's contained in each folder, including all subfolders. However, when this option is disabled, you only get to see the files selected in each root-level folder (you can also switch this option on or off via the Library module Library menu). And if the folder you select contains no images and just subfolders of images you'll see a "No photos selected"message in the content area. Lightroom explains this more clearly by saying "No photos in selected folder, subfolders not shown."

Incidentally, when Show Photos in Subfolders is selected, you won't be able to apply a custom sort order or stack photos across multiple folders. You can only apply a custom sort order when viewing a folder that contains no subfolders.

As you will have gathered by now, Lightroom offers a lot of options, and this is a good example of where, if your workflow requires special attention to the identification of folders, Lightroom lets you do so. I think most people will be happy to stick with the default setup, although understanding how to manage the Show Parent Folder/Promote Subfolders commands is certainly useful.

Figure 3.19 The Folders panel pop-up menu.

Locating a folder at the system level

Here is an example of how you can locate the system folder via the computer's Finder/Explorer.

1. Here is a view of the Folders panel in Lightroom and the associated system folder. To reveal the system folder from within Lightroom, I selected a photo that resided in the *Moab-Arches* folder, right-clicked to reveal the context menu, and chose Show in Finder (Show in Explorer on a PC).

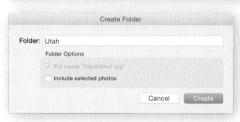

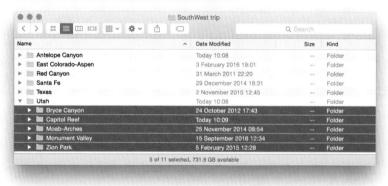

2. In Lightroom, I created a new folder called *Utah*, as a child of the *USA/SouthWest trip* folder. I then moved the *Bryce Canyon, Capitol Reef, Moab-Arches, Monument Valley*, and *Zion Park* folders inside the new *Utah* folder. As you can see, this placed the five folders inside the new *Utah* subfolder. This folder move step was also mirrored at the system level.

The Folders panel/system folders relationship

As was shown in the preceding steps, any changes you make to the folder structure within Lightroom, such as moving or renaming a folder, is reflected at the system level and the system folders will correspond with the folders listed in the Lightroom Folders panel. In addition to rearranging the hierarchy of folders, you can freely move files from one folder to another by selecting the files you want to move and dragging them across. This will prompt the dialog shown in **Figure 3.21**, which gives you a further warning if there is not enough room on the destination drive. You'll sometimes find it helps after you initiate a move if you then deselect the folder view in Lightroom, as this frees Lightroom from displaying an update of the previews in the content area. There is also a potential issue of what might happen if there were to be a computer crash while moving files. Lightroom effectively copies and deletes files during a move process, and there is the risk you may lose some data. An alternative option is to copy the files at the system level and then relink using the Synchronize Folder command described on page 86.

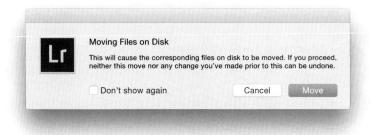

Figure 3.21 The Moving Files on Disk alert dialog.

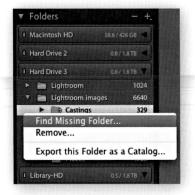

Figure 3.22 A Folders panel view with a broken folder link.

Maintaining folder links

If you happen to move folders containing Lightroom catalog-referenced files at the system level or rename them, then things start to get a little more complicated. If a folder is moved or the folder name is changed at the system level, the Lightroom Folders panel alerts you by showing a question mark over the relevant folder icon (see **Figure 3.22**). If the folder link is broken, then all the imported files within that folder will have broken links, too. The easiest way to restore a folder link is to right-click that particular folder to access the context menu, select Find Missing Folder, and navigate to find the correct folder (wherever it has now been moved to or however it has been renamed).

If the folder link is okay and it is only the files within that folder that have broken links, Lightroom displays an exclamation point icon in the grid cell (**Figure 3.23**). To restore a broken file link, click the exclamation point icon to open the missing link dialog shown in **Figure 3.24**. You can then Click the Locate button to relocate the original source photo on the computer. Once this has been done for one photo, all the other missing files in that folder should automatically update as well.

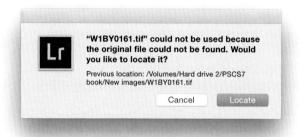

Figure 3.24 If you click the grid cell exclamation point button shown in Figure 3.23, the warning dialog shown here displays.

57 W18Y0161.tif 5569 x 3712

Figure 3.23 The exclamation point in the top-right corner of the grid cell indicates that the individual photo link is broken.

Maintaining volume links

If the entire volume is missing, either because you renamed it or because the drive is not switched on, the volume header will appear dimmed and you will see question marks over the folders (**Figure 3.25**). Once the drive has been correctly named or you have switched the drive back on, the volume header will indicate that the drive is live again, and the folder links should be restored.

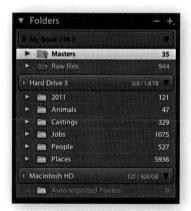

Figure 3.25 A Folders panel view with a broken volume link.

Synchronizing folders

Unfortunately, Lightroom cannot automatically detect if new images have been added to a folder at the system level. For example, let's say you import a folder at the start of a project and as you switch between working Lightroom and Bridge (or the Finder/Explorer), some files may get deleted or new files get added. This can lead to a situation where the Folder view in Lightroom is no longer an accurate representation of what is in the actual system folders.

So, if you need to reconcile changes that have been made to the folder contents at the system level, you can go to the Library module Library menu and choose "Synchronize folder." When you do this the Synchronize Folder dialog appears (**Figure 3.26**) and starts scanning the system folder to see if the folder contents match those shown in the corresponding Lightroom catalog folder. This provides some initial information about what differences there are between the two, such as whether there are any new photos to import, whether any photos in the Lightroom catalog are missing their master images, and whether any metadata changes have been made externally where the Lightroom catalog will need to be updated.

If you check the "Import new photos" option, you can choose to import any new files that have been found and add them to the catalog. By default, the Synchronize Folder dialog automatically imports files to the same folder in which they currently reside. It does this without showing the Import dialog and without modifying the filename, Develop settings, metadata, or keywords. However, you can choose "Show Import dialog before importing," which will open the Import Photos dialog shown in **Figure 3.27** and defaults to selecting the New Photos segmenting option. The main reason for choosing to show the Import Photos dialog when synchronizing a folder is so you can adjust any of the settings as you carry out the import and update the Lightroom catalog. If you happen to have removed any photos from the folder at the system level, you can check the "Remove missing photos from the catalog" option to also remove the files from the catalog. Basically, these options allow you to keep the Lightroom catalog updated with new additions, as well as remove photos that are no longer located in the original system folder.

The "Scan for metadata updates" option works exactly the same as the "Read metadata from files" option in the Library module Metadata menu (see page 626). For example, if you have edited the metadata in any of the catalog images using an external program such as Bridge, where the metadata edits you make are saved back to the file's XMP header space (or saved to an XMP sidecar file), you can use the Synchronize Folder dialog to synchronize such metadata changes with the Lightroom catalog.

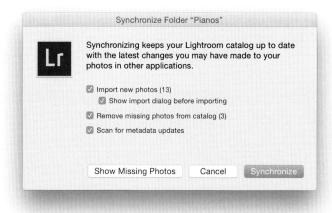

Figure 3.26 The Synchronize Folder dialog.

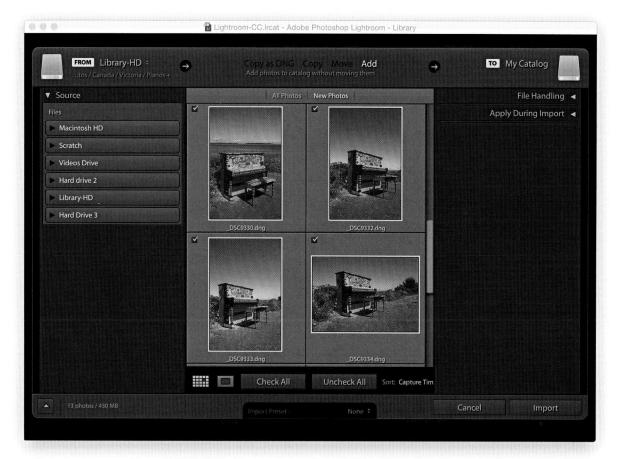

Figure 3.27 The Import Photos dialog, shown here ready to add new photos to the current catalog and sync update the selected folder.

Finding the link from the catalog to a folder

With Lightroom, you are free to organize and sort your photos in ways that are not directly dependent on your knowing the underlying photo structure.

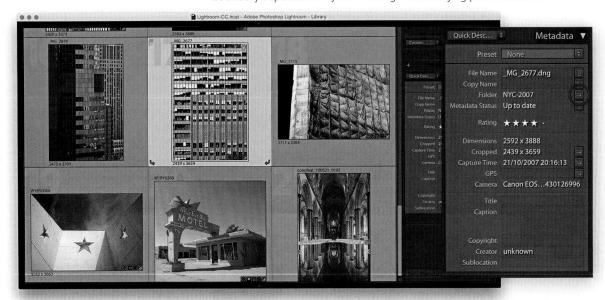

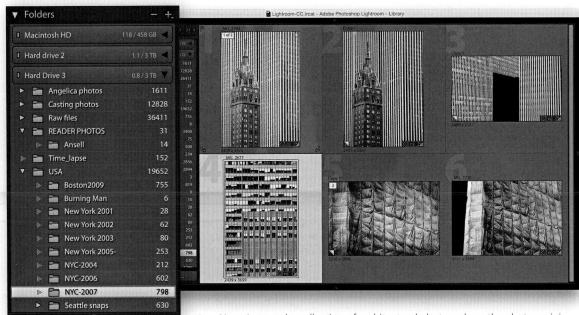

1. Here, I opened a collection of architectural photos where the photos originated from different folders. I selected an image and clicked the Folder Action button in the Metadata panel (circled), which then took me to a Folder view for that particular photo (the folder is highlighted here in blue).

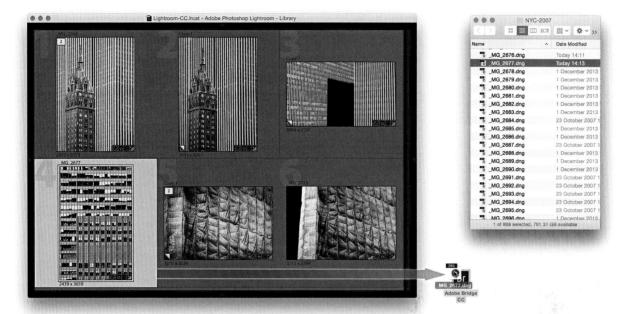

2. If I wanted to see where the photo actually resided at the system level, I could choose Photo \Rightarrow Show in Finder (Mac) or Show in Explorer (PC), or I could use \Re (Mac) or $\operatorname{Ctrl} \Re$ (PC) to reveal the image in a new Finder/Explorer window. I chose a third method: I simply dragged and dropped a photo from the content area to a Bridge alias/shortcut.

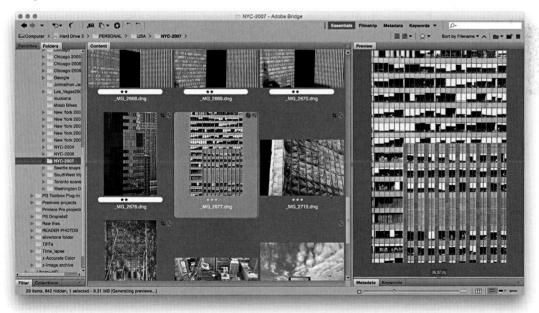

3. Dragging the file to the Bridge shortcut displayed the photo's folder in a new Bridge window with the photo selected.

Figure 3.28 Scalability can be important when you end up needing to store data across multiple hard drives.

How to organize your folders

People often ask how using a Lightroom catalog is different from using the Finder or a browser program to locate images. With a system folder/browser setup, you need to know exactly where everything is kept in order to access the files. Therefore, to retrieve photos, you need to have personal knowledge of how the photos are stored: which folders are on which drives, as well as how the subfolders are arranged. If you are well organized, you might have your files sorted by date, alphabetical order, or a combination of both. Of course, if you have already added metadata to your images in the form of IPTC metadata or keywords, you can use the search command in a program like Bridge to help find the photos you are looking for. However, such searches are made easier if you use a dedicated cataloging program like Lightroom. This is because Lightroom shows you only the image and video files that have been imported and allows you to manage everything by referencing the metadata stored in the catalog.

Since the early days of personal computing, most of us have grown accustomed to relying on folder hierarchies to organize our computer documents. In fact, for a lot of people, the folder name may be the only meaningful method of identification they have for the files stored on their computers. Still, today, it seems a logical way to sort one's files. On my computer, I have an *Office documents* folder inside a general *Documents* folder and within that a series of subfolders for things like letters, accounts files, and job quotes. But when it comes to organizing images, folder management has some distinct limitations. When you import a new set of images, how should you categorize them? Should you put them into folders arranged by date, by subject, or by job reference? When it comes to organizing photographs, it isn't always so straightforward.

Even so, while Lightroom and other cataloging programs are not folder dependent in the way browser programs like Bridge are, the Folders panel in Lightroom remains an important navigational tool for most Lightroom users. Therefore, when working with a large catalog of images, it is important to consider early on how you are best going to organize your image files. When I first started shooting digitally, Lightroom didn't exist and I thought I would sort all my work into A-Z folders, which, because of the limitations of drive space, ended up spanning a lot of hard drives (Figure 3.28). Needless to say, it was not an ideal solution, and the biggest problem was that of scalability. I had to hope there would be enough room on each drive to accommodate a growing image library. Things got really difficult one year when the A–C drive started to run out of space (because I shot a lot for my A-C clients). With the arrival of Lightroom, I soon realized that the folder location where the files were kept no longer mattered so much. From there on, as I added new images, I found that the file organization did not need to be rigidly determined by which drives the files and folders were stored on. Basically, when you make use of metadata information to manage your files, the folder storage method you use is less relevant.

So, how should you organize your files and folders for Lightroom? I have seen a number of strategies suggested. The main thing you need to consider, as I said, is the scalability of the system you are going to use. As your collection of photographs grows, how well will your folder organization keep pace with this? I find it helps to split my catalog photos into different categories. For example, I have one drive for raw files shot on assignment, another to store the derivative versions that have been edited in Photoshop, and another to store all my personal work. This leaves me with quite a bit of breathing space on each drive, where each is currently running at around 60% to 80% capacity. Not too long from now I will probably migrate all my files to even bigger drives. This is a process I see being repeated every few years or so.

Attempting to organize folders by name can prove tricky because you have to decide whether to primarily sort by location or job reference or some other criteria. But despite such drawbacks, it is a system that many people feel comfortable with. From my own point of view, I also find myself dependent on having a folder structure that integrates well when browsing in Bridge (because I need to demo Bridge workflows in my other books). I therefore find it necessary still to use a job-name or location-name hierarchy when cataloging my photos. This is what works for me because of my particular requirements. If you are mostly going to rely on Lightroom to catalog your photos, you could use a date-import folder structure. Importing everything into dated folders keeps everything simple. This is because the folder structure you use is agnostic as to the types of images you are importing (i.e., whether the photos are work or personal). It also allows you to be consistent and makes it easier to manage the catalog as more drives are required.

Lastly, you can use folders as a tool for segregating images in an image-processing workflow. In Chapter 2, I suggested importing your photos to a standard import folder. Here, you can think of using folders as part of a workflow pipeline in which the first thing you do is simply get the photos from the camera card onto the computer without having to immediately think about where the imported photos will eventually end up. In Figure 3.29, I have adapted a folder workflow suggested by Peter Krogh, in which all photos are imported to an Import folder. From there, the next stage would be to move them to a *Photos to keyword* folder. This would be another holding folder, which would be like a reminder that the photos in there needed to be keyworded before they are promoted into one of the main catalog folders. At this point, you could then choose to categorize these main folders using descriptions, dates, or whatever works best for your setup. This kind of workflow offers simplicity and enforces good working practice where files are added to the main catalog only after they have been properly keyworded and you are ready to decide where they should go. If you use keywords to tag your images, it should not matter how the folders are structured. In fact, when you think about it, the way a computer actually segregates files into folders is done by applying a folder metadata tag to the files—the folder designation is simply another type of metadata. It takes just as much time to select all the

Figure 3.29 This diagram suggests a workflow approach for importing photos into Lightroom.

photos from an imported shoot and assign a keyword tag as it does to name a folder. Hence, a workflow folder pipeline approach forces you to first think about assigning keywords to your images before you eventually place them into their final folders. I do not think it is necessary to be too prescriptive here as to how you should go about this.

The main thing to think about is how well will your method of archiving cope as your image library collection expands? There is the bucket system, which Peter Krogh advocates in *The DAM Book: Digital Asset Management for Photographers*, 2nd Edition (O'Reilly). This is where the catalog files are divided into a dated hierarchy of folders of equal size and where the folder capacity matches that of DVD or Blu-ray recordable media. The idea here is that there should be a DVD or Blu-ray disc that matches each folder in the catalog. In the event of file corruption or data loss (where the error may have been copied across to a backup drive), there will always be an optical, read-once media disc available to restore the files from. A system like this can provide the ultimate security for your data. In practice, I think most people will be fine as long as they carry out regular, scheduled backups to one or more backup drives.

The Filter bar

The Filter bar (**Figure 3.30**) consists of a Text search section for searching by filename, caption, keywords, and so forth. The Attribute section duplicates the filter controls at the bottom of the Filmstrip, while the Metadata section lets you filter by various metadata criteria. The metadata search options reduce as you narrow the search criteria at each stage. A downside to using the Filter bar is that it does take up quite a bit of space in the content area, but you can use the \(\sigma\) keyboard shortcut to toggle showing/hiding the Filter bar.

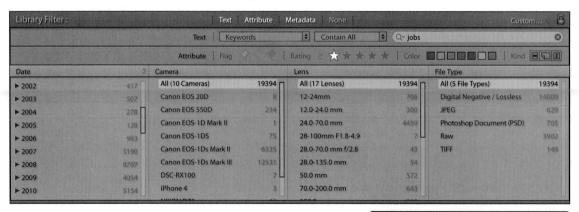

Press \ to show the filter bar again

Figure 3.30 The Library module Filter bar.

Exploring the Library module

The Library module's two main views, Grid and Loupe, offer plenty of options to help you tailor them to your workflow and see the details you need most.

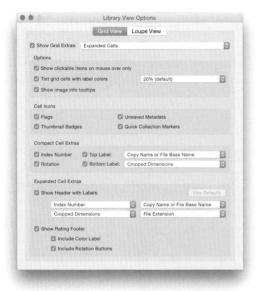

Figure 3.31 The Library View Options dialog.

Grid view options

As new photos are imported, low-resolution previews will appear in the Grid view. If you selected the Standard-Sized Previews option at the import stage, the initial rendering may take a little longer but will force-build better-quality screen previews. If the camera used to capture the images has the camera orientation information embedded in the metadata, the thumbnail previews should correctly rotate to portrait or landscape mode accordingly. Otherwise, you can use the rotate buttons to rotate the images manually or use In to rotate left and In to rotate right (Mac), or use Ctri I and Ctri I (PC).

To open the Library View Options, choose View Diew Options (or press ***J [Mac] or Ctrl J [PC]) and click the Grid View button (Figure 3.31). There are essentially two modes for the Library Grid View: Compact Cells (Figure 3.32), which shows the thumbnail only, and Expanded Cells (Figure 3.33), which displays additional options in each cell. The "Show clickable items on mouse over only" option refers to the Quick Collection markers and rotation buttons. When this is checked, such clickable items are only revealed as you hover over a cell. When the "Tint grid cells with label colors" option is checked, this shades the entire cell border when a color label is applied to a photo and you can adjust the intensity of the tint color. "Show image info tooltips" lets you see additional info messages when rolling over the cell badge icons.

This is a "flagged pick" image.

Image rating status

Figure 3.32 A Library grid cell in Compact Cells mode.

Rotate thumbnail counterclockwise

Rotate thumbnail clockwise

Figure 3.33 A Library grid cell in the Expanded Cells view with "Tint grid cells with label colors" unchecked and Include Color Label checked in the Show Rating Footer options.

93

√ Copy Name or File Base Name File Name File Rase Name File Extension Copy Name Folder Copy Name or File Name Copy Name and File Name File Name and Copy Name File Base Name and Copy Name Copy Name and File Base Name Common Attributes Rating Label Rating and Label Capture Date/Time Cropped Dimensions Megapixels Caption Copyright Title Sublocation Creator Common Photo Settings Exposure and ISO Exposure Lens Setting ISO Speed Rating Focal Length Exposure Time F-Stop Exposure Bias Exposure Program Metering Mode Camera Camera Model Camera Serial Number Camera + Lens Camera + Lens Setting

Figure 3.34 The label options available from the Compact or Expanded Cell Extras in the Library View Options menu.

If you want the image's flag status to appear in the cell border, check the Flags option in the Cell Icons section. The Flag icons indicate if an image has been identified as a pick () or as a reject () (see page 124 for more about working with flags). The Thumbnail Badges are the small icons you see in the bottom-right corner. Five types of badges can be displayed here, depending on what attributes have been applied to each image. If you double-click the Keywords badge (20), this automatically takes you to the Keywording panel in the Library module, where you can start adding or editing keywords linked to this particular image. If you doubleclick the Crop badge (III), this takes you to the Develop module and activates the Crop overlay. If you double-click the Develop settings badge (2), this also takes you directly to the Develop module, and if you click the Collections badge (a), a pop-up menu appears allowing you to select from one or more collections the photo belongs to. Lastly, there is a Map badge to indicate if a photo has GPS data (). Clicking on this takes you to the photo's map location in the Map module, while Alt -clicking takes you directly to a Google Maps view in your web browser. Check the Unsaved Metadata option if you wish to see an alert in the top-right corner if a photo's metadata is out of sync with the main catalog (this is discussed in Chapter 10). If a photo has been added to a Quick Collection, it will be identified in the Grid view with a filled circle Quick Selection Marker in the top-right corner. You can also click inside this circle to toggle adding or removing an image from a Quick Collection.

Figure 3.32 shows an example of a Compact Cell view (which is the default view when you first launch Lightroom). This particular cell view has the grid cell Index Number (the large dimmed number in the cell background) displayed in the Top Label section, along with the Copy Name or File Base Name (selected from the **Figure 3.34** list). The Bottom Label section has room for the Rotation buttons, plus one other custom item from the Figure 3.34 list. When Rating is selected, the image rating is displayed, with five stars as the highest rated and no stars as the lowest. Although it is possible to assign star ratings by clicking the dots in the grid cell area, a more common way to assign ratings is to enter numbers (1–5) or use the square bracket keys ([],]) on the keyboard.

Figure 3.33 shows an example of an Expanded Cells view. You can use the Show Header with Labels check box in the Expanded Cell Extras section to turn the header display options on or off. With the Expanded Cells view, there is room for two rows of information in the header, and you can use the pull-down menu list shown in Figure 3.34 to customize the information displayed here. You can also check the Show Rating Footer option to enable adding the Include Color Label and Include Rotation Buttons options. That concludes all the customizable options for the Grid cells, but note you can use the J keyboard shortcut to cycle through the three different Grid cell views: "Compact view with no badges," "Compact view with badges showing," and "Expanded view with badges showing."

Library Grid navigation

The main way to browse photos in the catalog is to use the Library module in the Grid view mode (**Figure 3.35**). You can navigate the Grid view by clicking on individual cells or use the arrow keys on the keyboard to move from one cell to the next. The Home and End keys on the computer keyboard can be used to move the Grid view to the first or last image, and you can also scroll the grid contents using the Page Up and Page Down keys next to these two keys. To make the thumbnail sizes bigger or smaller, you can drag the Thumbnails slider in the Toolbar, or use

MOTE

Lightroom Classic CC uses new APIs, which means Windows users should see faster rendering in the Grid, Filmstrip, and Loupe views.

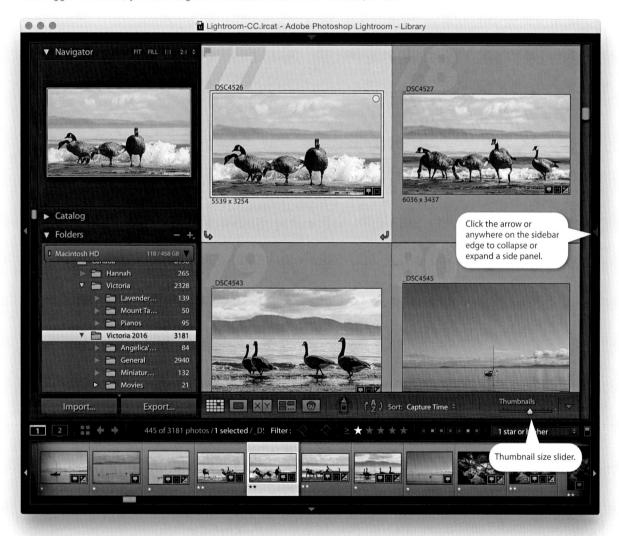

Figure 3.35 The catalog contents displayed in the Library module Grid view. All the images in the selected folder are shown in the main content area and duplicated in the Filmstrip below.

NOTE

Here are some keyboard shortcuts for navigating between the Grid and Loupe views. The G key always takes you to the Library Grid view from whichever module you are currently in, and the E key always takes you to the Library module Loupe view. The H (Mac) or Ctrl (PC) key combination takes you from Grid to Loupe standard view, and the H (Mac) or Ctrl (PC) key combination takes you from the standard Loupe view back to Grid view. More Loupe view shortcuts are listed on page 103.

the keyboard + and – keys to increase or decrease the number of cells per row. The Library grid cells are displayed in the main content area, and the side panels can be hidden by clicking the left or right sidebar edges—this collapses the panels to the edge of the Lightroom window. The panels can then be revealed by rolling the pointer toward either sidebar edge or kept locked in place by clicking the sidebar edges. An even easier way to manage the Library Grid view is to use the Tab key. This toggles displaying the content area with the side panels in view or with both hidden, enlarging the content area to fill the complete width of the window. And, you can use Shift be to toggle showing hiding the side plus top and bottom panels.

The selected thumbnails are shown in both the Grid and Filmstrip with a light-gray surround. Within a photo selection of two or more photos, there will always be a primary or "most selected" image (which will also be displayed in the Navigator). You can tell which this is because in the Grid or Filmstrip, the primary selected image is the one shaded a slightly lighter gray than all the other selected thumbnail cells. When a selection of photos is active, you can click to make another image in the photo selection the most active. Or, you can use the \Re key (Mac) or $\boxed{\text{Ctrl}}$ key (PC) combined with the left/right arrows to select another photo as the "most selected" image within the current photo selection. Some Mac OS users may experience problems navigating using the keyboard arrows. If you do, go to the System Preferences and select Keyboard \Rightarrow Keyboard Shortcuts. At the very bottom, you will see "Full Keyboard Access: In windows and dialogs, press Tab to move the keyboard focus between." Make sure the "Text boxes and Lists only" radio button is selected here.

You can reorder the way the photos appear by dragging the thumbnails within the Grid or Filmstrip. As you move a photo from one location to another, you will see a thick black line appear between the cells. Release to drop the photo (or photos) in this new location. But it is important to stress here that you can only do this when working with a single folder or single collection view. Otherwise, you will find custom ordering is disabled. For example, if you have multiple folders selected or you have selected a folder that contains one or more subfolders, you will not be able to drag and drop images. Similarly, if you create a collection set that contains other collections or if you are viewing a temporary collection in the Catalog panel, custom ordering will be disabled.

Working in Loupe view

Lightroom offers two Loupe viewing modes: standard and close-up. The standard Loupe view either fits the whole image within the content area or fills the entire width of the content area—these are described as Fit and Fill (Fit is shown in **Figure 3.36**). The close-up Loupe view can be set to a 1:1 magnification or an alternative zoomed-in custom view setting, such as 2:1 or higher. The simplest way to switch to the Loupe view is to double-click an image in the Grid or Filmstrip. If you have more than one photo currently selected, the photo you double-click is the one that will fill the screen. The photo selection will still be preserved in the Filmstrip, and you can use the left and right arrow keys to navigate through these photos. If you double-click the Loupe view image, you will return to the Grid view once more.

Figure 3.36 Here is a photo displayed in the Loupe view. An active selection is visible in the Filmstrip below. You can use the left/right arrow keys to navigate the selected photos.

TIP.

The View menu contains an item called Enable Mirror Image Mode. If this is selected, it flips horizontally all the images in the catalog. To turn it off, just select it from the View menu again. This option is intended to let people view portrait photos of themselves the way they see their own reflection when looking in a mirror. However, when you check this option, it flips all the photos in the catalog and not just those in the current Library selection. So, you will need to remember to deselect it after you are finished!

Loupe view options

The Loupe view options in the Library View Options dialog (#J [Mac] or Ctrl J [PC]) can be used to customize the Loupe view (Figure 3.37). When the Show Info Overlay option is checked, this displays an info overlay in the top-left corner, which can use the Loupe Info settings Info 1 or Info 2, as configured below. If the Show Info Overlay option is unchecked, you then have the option to check the "Show briefly when photo changes" option for when a new image is displayed in the Loupe view. This means the info overlay will fade after a few seconds when you select a new image in the Loupe view. You can also control the Loupe view options by using the #I (Mac) or Ctrl (PC) shortcut to toggle switching the Loupe view information on or off. Or, the I key can also be used to cycle between showing Info 1 and Info 2, and switching the Info display off. Figure 3.38 shows a Library module Loupe view captured with a Loupe Info 1 overlay.

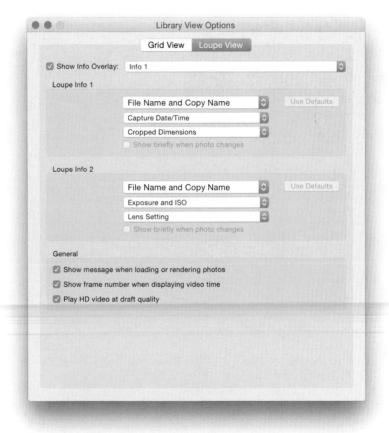

Figure 3.37 The Library View Options dialog showing the Loupe View settings.

Figure 3.38 A Loupe view with the Loupe Info 1 overlay enabled.

When the "Show message when loading or rendering photos" option is checked, you will see status messages appear in the content area, such as when a selected image is loading an updated preview or you have just assigned a new flag or star rating to a photo. The other two options relate to displaying video files. You can choose to display the frame number when displaying the video time. This shows finer time increments in the video timeline display. Enabling the Play HD video at draft quality option can improve playback performance in the Library module Loupe view, but at the expense of lower video image quality.

Draw face region overlay

When the Draw Face Region tool is selected, it enables the face recognition feature. This will display a rectangular face region around any faces found in an image and will have text that either shows the person's name or says "Unnamed." When the Draw Face Region tool is selected, you can click and drag inside the Loupe view to manually define face regions.

Working with photos in both Grid and Loupe views

1. In the Grid view mode, you can make a selection of photos, and the selection will be mirrored in the Filmstrip below.

2. If you use Quick Develop to make Develop adjustments, these are applied to all photos in the grid and Filmstrip selection (the Quick Develop panel is ideal for such adjustments). Here, I decreased the Exposure for all the selected images.

3. However, if you go to the Loupe view mode and apply a Quick Develop adjustment (such as convert to Black & White), this is applied only to the current photo, even though the photo selection remains active in the Filmstrip.

4. Back in the Grid view, you can deselect a photo selection by clicking anywhere in the cell border area to deselect all but the selected photo.

NOTE

In the Lightroom Interface preferences, the "Zoom clicked point to center" option lets you alter the zooming behavior. When this option is unchecked, zooming in close fills the screen to best fit the content area. When this option is checked, where you click is always centered on the screen. I find zooming is more natural when the option is left unchecked. This is because after zooming in, the pointer remains positioned over the point where you originally clicked.

Loupe view navigation

From the standard Loupe view, you can magnify the image preview in a number of ways. A further click will normally zoom in to a 1:1 magnification, centered on where you click (see Note). Another click will take you back to the previous Loupe view (Figure 3.39 shows a close-up Loupe view). Zooming is made faster by the fact that Lightroom renders only the portion of the image you have selected to view in close-up instead of rendering the whole image first. The close-up Loupe view is handy for comparing image details. You can navigate from one image to the next in a selection, using the keyboard arrow keys, and inspect the same area of each image in close-up view. In the View menu is an item called Lock Zoom Position (Shift = [Mac] or Ctrl Shift = [PC]). When checked, it locks the zoom position when switching between images. When the Lock Zoom Position is unchecked, the zoom position is remembered for each individual image. Be aware that if the Draw Face Region tool is enabled (see Figure 3.38), you will be in the Define face region mode, where you can click and drag to define a new face region. To exit this mode, you will need to click in the Toolbar to disable the Draw Face Region tool. You can then click and zoom again to navigate the image.

Figure 3.39 In Loupe view, you can scroll the image by dragging the rectangle in the Navigator, which indicates the area currently being magnified. You can also use the Zoom slider to quickly adjust the zoom level. If you cannot see the Zoom slider, go to the Toolbar options (circled) and select Zoom from the list.

You can scroll by click-dragging the photo. Alternatively, you can drag the white rectangle in the Navigator panel (**Figure 3.40**) to quickly scroll the image with a minimum amount of movement. In the full-screen Loupe view shown in Figure 3.38, the rectangle in the Navigator represented the area that was currently visible in the content area (relative to the whole image). Lastly, you have the Zoom view slider in the Toolbar. This lets you magnify the image from a Fit view, right up to an 11:1 magnification.

Loupe zoom views

There are actually four different Loupe views, and the Navigator panel displays a highlighted zoom view readout in the top-right corner of whichever one is currently in use. They are in order of magnification: Fit view, which displays a standard Loupe view, filling the available content area both horizontally and vertically; Fill view, which magnifies the standard Loupe view to fill the width of the available content area onscreen, cropping the top and bottom of the picture as necessary; close-up Loupe view, which offers a standard 1:1 view; and a fourth close-up view that offers customized magnification levels. You can extend the close-up Loupe view range for this view mode by selecting a new zoom view from the Navigator fly-out menu (Figure 3.40). It is important to understand that the Loupe zoom essentially offers two zoom modes: a standard view and a close-up view. You can use the Navigator panel to set the standard view to either Fit or Fill, and the close-up view to either 1:1 or one of the custom magnified views. The zoom view modes you select via the Navigator panel also establish how Lightroom behaves when you use either a single-click or press the Spacebar to toggle between the two zoom views.

Loupe view shortcuts

By now, you will have come to realize that there are umpteen ways to zoom in and out of an image between the Grid view and Loupe view modes. It is not easy to remember all the zoom shortcuts, so I suggest you play with the various methods described here and just get used to working with whatever method suits you best. For example, you can use the ## keys (Mac) or Ctrl + keys (PC) to zoom in progressively from the Grid view to the standard Loupe view to the magnified Loupe view. And you can use the **%** - keys (Mac) or Ctrl - keys (PC) to progressively zoom out again. You can use the **MAIT** keys (Mac) or Ctrl (Alt) keys (PC) with the + and - buttons to zoom in and out in gradual increments from the Grid view to an 11:1 Loupe view. You can also use the Z key to toggle directly between the grid and close-up Loupe view. When you are in the close-up Loupe view, you can use the Spacebar to toggle between the close-up and standard Loupe views. If you press the Z key again after this, you can toggle between the standard and closeup Loupe views. I sometimes find it useful to use the Return key to cycle between the Grid view and the two different Loupe views. Press once to go from the Grid view to the standard Loupe view, press again to go to the close-up Loupe view, and press once more to return to the Grid view.

Figure 3.40 Here is a view of the Navigator panel, showing all the available custom zoom view options. They can range from 1:16 (6.25%) to 8:1 (800%) or even 11:1. But as in the movie This Is Spinal Tap, I suspect the real zoom value is in fact closer to 10:1.

MOT

Zoom to Fit and Zoom to Fill for the Loupe view can magnify the image beyond 1:1. This allows the Loupe view to render a larger image where the image is heavily cropped, or you are working with a (size-limited) Smart Preview using a high-resolution display.

Loupe Overlay view

The Loupe Overlay menu, (shown in **Figure 3.41**) can be accessed via the View menu in both the Library and Develop modules (or use the ****AltO** [Mac] or Ctrl AltO [PC] keyboard shortcut). This lets you add one or more types of overlay to a photo. You can choose to add a grid, movable crosshair guides, a layout image, or a combination of all three. Basically, you need to go to the Loupe Overlay menu, select an item you wish to enable and return to the same menu and select again to disable, or select another item.

Figure 3.41 The Loupe Overlay menu, which can be accessed via the View menu in either the Library or Develop modules.

Grid and Guides

The Grid view is useful for checking the perspective correction in an image. When the Grid view is enabled, it overlays the image with a grid (see **Figure 3.42**). If you hold down the ****** key (Mac) or Ctrl key (PC), this reveals the Grid Size and Opacity options at the top of the content area view (but this will be disabled if a Develop tool is currently selected). You can then click and hold on either the Size or Opacity values to reveal a scrubby slider and drag right or left to increase or decrease these values.

Enabling Guides overlays the image with movable crosshair guides (**Figure 3.43**). By default, these appear centered on the image view. If you hold down the ***** key (Mac) or Cttl key (PC), you can click where the guides intersect and drag to reposition them and double-click the crosshair intersection to reset to the center again. This feature might be useful for still-life photographers, as you can check if something is correctly positioned or aligned in an image. It might also be useful when preparing images to go in a slideshow presentation. For example, if you were preparing a slideshow of landscape images, you could use the guides to ensure that the horizon level was aligned identically in a photo sequence. Or, you could use it to help align image elements so they appeared to fade smoothly from one image to another.

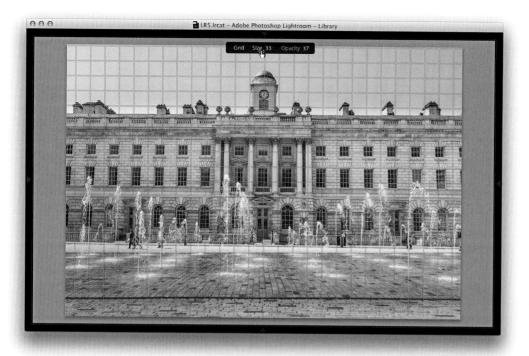

Figure 3.42 The Loupe Overlay Grid view.

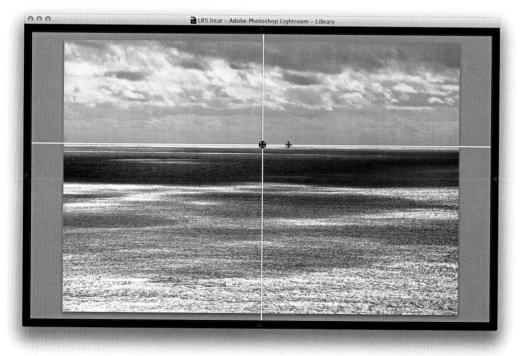

Figure 3.43 The Loupe Overlay Guides view.

Layout Image

This feature is useful if you wish to overlay images with a layout so you can see which images work well within a particular layout design and is particularly useful when shooting tethered in the studio. It can also be helpful if you need to use an art director's layout as a guide to how things should be arranged in a shot. And finally, it might be a good way to compare and align a photograph you are shooting with an existing photograph. For example, if shooting tethered, you could use an existing photo as a reference and use a Layout Image Loupe Overlay view to help align what you are shooting to get it to match the overlay photo. It is all too easy to delete an overlay layout image by accident, or lose track of a previously used overlay layout image when you switch to use a different image. With this in mind, I suggest you create a dedicated subfolder within the Lightroom presets folder in which to store overlay layout images.

The main thing to note here is that the overlay image must be saved as a PNG file. The PNG file format supports transparency. So, if you were editing a scanned layout in Photoshop, you would want to create a semitransparent layer and then save it as a PNG, ready to load as a layout overlay in Lightroom.

If you hold down the \mathbb{H} key (Mac) or \mathbb{C} trl key (PC), this reveals the Opacity and Matte opacity options at the bottom of the content area view. You can then click and hold on either the Opacity or Matte values to reveal a scrubby slider and drag right or left to increase or decrease the values. With the \mathbb{H} key (Mac)/ \mathbb{C} trl key (PC) still held down, you can adjust the size of the overlay image relative to the image view and double-click inside the overlay to reset the bounds of the image. You can see an example of the layout overlay being resized in **Figure 3.44**.

The Layout Overlay feature in use

To create the layout overlay shown in use in Figure 3.44, I opened the cover page layout design in InDesign. This included the page-layout lettering and graphics and semitransparent overlay areas, top and bottom. I saved the layout page as a PDF. I then opened the PDF via Photoshop and saved it using the PNG file format. I then chose View ⇒ Layout Overlay ⇒ Choose Image to load this as a layout overlay and chose View ⇒ Layout Overlay ⇒ Show Layout Overlay so that this overlapped the images displayed in the Fit/Fill Loupe views. With this overlay active, I could navigate through some of the images I was considering using as a cover image for this book.

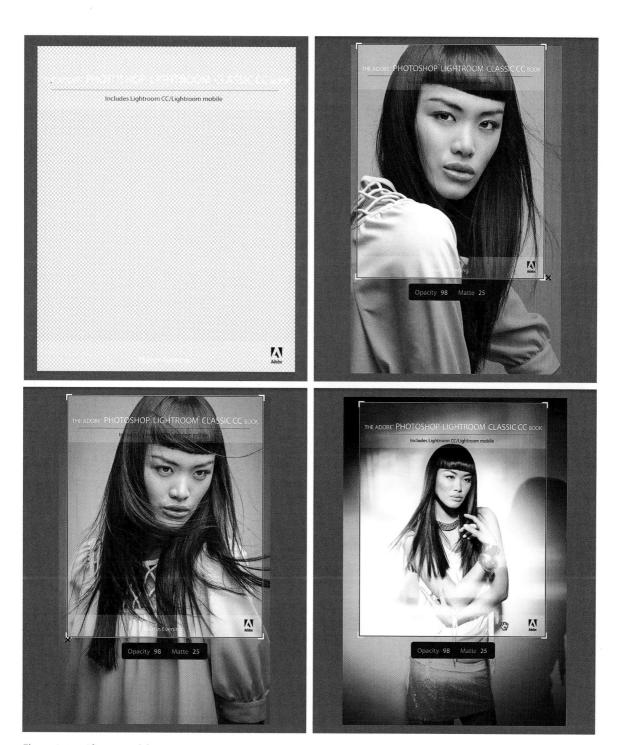

Figure 3.44 I first created the transparent PNG template file (top left) in InDesign and then loaded it as a Loupe view overlay in Lightroom to test images for the book's cover.

Figure 3.45 The File Handling panel in the Import Photos dialog offers four Initial Preview options.

Figure 3.46 The thumbnail previews will start off looking pixelated and possibly appear flat in color. As the Lightroom settings kick in, the previews will change as the Lightroomagnerated previews are rendered.

Previews and preview appearance

There are various preview options available in Lightroom. Which you should choose depends on what you wish to prioritize: speed or accuracy.

Initial Import Photos dialog preview-building options

The File Handling panel in the Import Photos dialog offers a choice of options for building the initial previews (**Figure 3.45**). The Minimal option is quickest as it makes use of the thumbnail previews present in the incoming files. Lightroom assumes everything to be in the sRGB space, and the previews are only updated once all the images have been imported. Such previews are usually fine as a rough visual of how the image looks, but they will not offer much in the way of detail, because these are just the thumbnail JPEG previews that were embedded in the file at the time of capture.

If Embedded & Sidecar is selected, Lightroom uses whatever larger previews are available as it imports the images, utilizing either the embedded JPEG previews or sidecar file previews to guickly build the thumbnails. Depending on the camera default settings you are using, these will most likely look different once Lightroom has had a chance to build proper previews from the image data. As explained in the previous chapter, this now only happens after photos are selected (or you can configure the preferences to build previews when idle). In Figure 3.46, you can see a typical example of the change in appearance from a low-res, camera-embedded JPEG thumbnail to a Lightroom-generated preview using the Adobe Standard profile (see: "Camera-embedded previews vs. Lightroom previews"). If you are importing photographs that have already been edited in Lightroom (or some other program), this option makes full use of the larger previews that are already present. This is a particularly useful choice when importing DNG files, as there is a good chance that the previews will already be based on previously applied Camera Raw/ Lightroom Develop settings. In such circumstances, the previews will most likely not appear to change after being imported.

When Standard is selected, Lightroom avoids using the embedded previews altogether and renders the standard previews directly. It reads the full image data and builds the thumbnails and initial previews to a standard size only, based on the default Lightroom Develop settings. The standard-sized previews will let you see a greater level of detail when displaying large grid cell thumbnails in the content area or when viewing at a standard-sized Loupe view.

If the 1:1 option is selected, Lightroom reads the full image data, builds thumbnails, and creates standard and full-sized 1:1 previews. The advantage of the Standard or 1:1 option is that you won't always get confused by seeing low-resolution previews that show one color interpretation (the embedded preview version), only for them to be replaced shortly by a new color interpretation (the Lightroom-processed standard-sized preview version). When you render standard-sized or 1:1 previews, the Camera Raw cache also gets updated. Lightroom Classic CC now generates

standard and 1:1 previews faster, and you should notice better walk-through performance, especially at 1:1.

Smart Previews play a role, too, in allowing access to proxy versions of your image assets when these are offline and speeding up the standard view Develop module editing, but this does not affect the previews, as viewed in the Library module.

How Lightroom previews are generated

Whenever you launch Lightroom, it initially loads all the low-resolution thumbnails and, within 30 seconds or so, starts running checks on the current catalog contents, checking the thumbnails in order of quality. Lightroom looks to see if any of the standard-resolution thumbnails need to be rebuilt first before going on to build new previews for the images (Figure 3.47). At the same time, it checks existing thumbnail previews against their modification dates. If any file has been modified since the last time a preview was built, Lightroom rebuilds a new set of previews, starting with a standard preview, followed by high-quality previews (on demand). Lightroom does this in the background as and when it can. Once again, with Embedded previews, an embedded preview is displayed unless you choose to select a photo, or the preference option to rebuild previews when idle is enabled. The normal preview rebuilding process usually takes a while to complete, so not every image will have a preview that is available for use right away—it really depends on the size of your files and how many are waiting to be processed. Lightroom tries to let you start working on an image as soon as you select it, but doing so will divert Lightroom to process this image first, before it resumes processing the remaining files in the background.

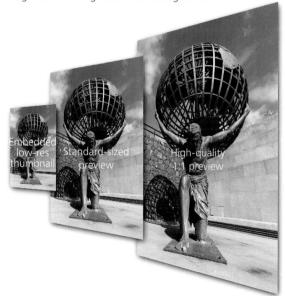

Figure 3.47 Lightroom builds progressive quality thumbnails and previews after the files are imported.

When the Embedded & Sidecar option is selected, Lightroom will make use of the best preview available. Therefore, if you shoot using the raw + JPEG mode and the JPEGs are full size, Lightroom will take advantage of these to use as an embedded preview.

TIP

If you choose to render standard or 1:1 previews and only one image is selected, Lightroom will ask if you wish to build previews for that one photo only or build all (the same applies when choosing to discard previews).

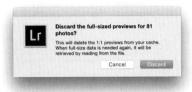

Figure 3.48 The "Discard the full-sized previews" warning dialog.

The 1:1 previews are generated only whenever you choose to zoom in on an image and inspect it close up. But you can force Lightroom to build 1:1 previews in advance. You can do this via the Import Photos dialog File Handling panel, or you can do it after everything has been imported by going to the Library module Library \Rightarrow Previews menu and choosing Render 1:1 Previews. This forces Lightroom to generate 1:1 previews for all the selected photos. These will, at the same time, regenerate the standard-sized previews. 1:1 previews are useful because they can speed up the time it takes to review images at a 1:1 zoom view or higher. There is also an option in the Catalog Settings File Handling section (see page 111) that lets you automatically discard 1:1 previews after a designated period of time. If you are unconcerned about the *Previews.Irdata* file getting too big, you can choose to never discard the 1:1 previews. After all, unless you are using a solid-state drive, hard-disk space is quite cheap these days. If you go to the Library \Rightarrow Previews submenu, you can also choose the Discard 1:1 Previews option. This opens the warning dialog shown in **Figure 3.48**.

Camera-embedded previews vs. Lightroom previews

Some people prefer the look of the camera-generated previews, and in some cases the camera-embedded preview may indeed look better than the default Lightroom-rendered version. But it can be argued that this, like the original embedded preview, is just another initial interpretation of the image and simply a starting point before making further Develop adjustments. Or, you could say it is because users have yet to establish appropriate camera default settings to apply on import (see page 352). For example, the camera default settings could include a suitable camera profile as a starting point for the preview generation. If you go to the Camera Calibration panel in the Develop module and select the Camera Standard profile, you can get the Lightroom preview to more closely match the look of a camera JPEG, providing, that is, all the other settings are applied using the default Develop settings (**Figure 3.49**).

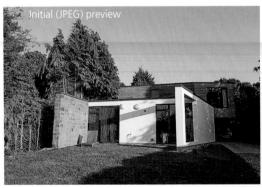

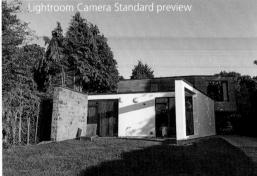

Figure 3.49 Compare a JPEG version (left) and a Lightroom-generated preview using the Camera Standard profile (right).

Missing previews

You may come across grid cells that have missing previews, like the example shown in **Figure 3.50**. This could be for a number of reasons. It could be that the preview cache has become corrupted or the file itself is corrupt. If you see an exclamation point icon in the top-right corner, it could also mean that the image is currently offline, or the link has become broken (see page 84).

Preview size and quality

The size of the individual preview cache files is dependent on how you set the Preview Cache settings in the Catalog Settings (Figure 3.51). Here you can select the pixel size for the standard-sized previews. My advice is to select a pixel size that's suited to your display size. If you are working with Lightroom on a small laptop computer, you probably will not need the standard-sized previews to be any bigger than 1024 pixels in either dimension. There is no point in making the standard previews unnecessarily large as this will simply consume more hard-drive space than is needed. The Auto option works out the optimum size for you based on the screen resolution. For example, with a HiDPI display the native resolution will typically be twice the screen resolution, which can be very large on a 5K display. The preview quality also determines how much compression is applied to the preview files. If the Low Preview Quality option is selected, the preview cache files will be more compact (at the expense of image quality). The High setting applies the least amount of compression and the best image preview quality (but the preview file sizes will be almost double). The Medium setting is probably the most suitable setting to choose for optimum preview image quality, but without consuming too much disk space. Whichever you choose, all previews are rendered using the Adobe RGB space.

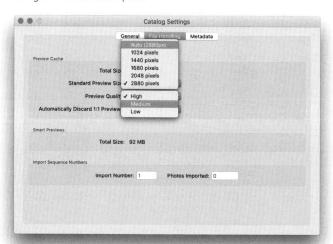

Figure 3.50 A Grid cell view with a missing preview.

NOTE

If Standard Preview Size is set to Auto, the maximum image dimension in the Camera Raw cache now adapts to the resolution of the display (instead of being capped at 2000 pixels). As a result, Library display performance is improved for high-resolution images working with Quick Develop and improves the speed of Grid thumbnail updates when copying and pasting or syncing settings.

Figure 3.51 The Catalog Settings showing the File Handling section. In this instance, the Auto setting for the Retina MacBook Pro is 2880 pixels.

NOTE

Although it is possible to drag and drop photos in a Survey view to change the order in which they appear, you may sometimes find this is easier said than done. This is because you often find yourself fighting with the Survey view mechanism that is designed to optimize the size and placement of photos on the screen.

Working in Survey view

If you have multiple image selections active, you can view all the selected photos at once by clicking the Survey view button in the Library module Toolbar, or switch views by pressing the N key (this keyboard shortcut works from any of the Lightroom modules). Whenever you are in Survey view, the content area is used to display the selected images as big as possible. The relationship between the Survey and Loupe views is the same as that between the Grid and Loupe views. So, if you double-click an image in the Survey view, you are taken to the standard Loupe view, and double-clicking the photo takes you back to the Survey view again.

Figure 3.52 shows a Survey view of the photos currently selected in the Filmstrip. (I will discuss the Filmstrip a little later in this chapter.) The arrangement and size of the individual Survey view previews adjust dynamically according to the number of photos you have selected and the amount of screen real estate that is available in the content area. So, depending on the number of photos you have selected, the orientation of those photos, and the physical size of the content area, Lightroom adjusts the Survey view to display all the selected photos as big as possible. However, if you make a really large selection of photos and choose to view them in the Survey view, there is a cut-off point. Lightroom will show only the first 100 or so photos and will display the number of remaining photos in the bottom-right corner to tell you how many photos in the current selection are not included in the visible Survey view.

The primary, or most selected, image is displayed with a white border, and you can navigate the photos displayed in a Survey view by click-selecting individual images or using the left and right arrow keys to navigate between them. You can remove photos from a Survey view selection by clicking the X icon in the bottom-right corner, or by \Re -clicking (Mac) or $\operatorname{Ctrll-clicking}$ (PC) the photos you wish to deselect (clicking either in the Survey view content area or in the Filmstrip). The Survey view images will then automatically resize to make full use of the screen space that is now available in the content area. Note that removing a photo from a Survey view simply removes it from the selection and does not remove it from the catalog.

Personally, I find the Survey view mode to be a useful tool for editing selections of photos, more so, in fact, than the Compare view that is described on page 114. I find it particularly helpful when I am working with clients and have arrived at a shortlist of favorite shots. By using the Survey view mode, the client and I can see all the final candidate images on the screen at once, much in the same way you would sort through a final selection of photographs on a light box. When editing personal work, I love the simplicity of the Survey view and how it provides you with a quick overview of a final selection of pictures and helps you gauge how well they work alongside each other.

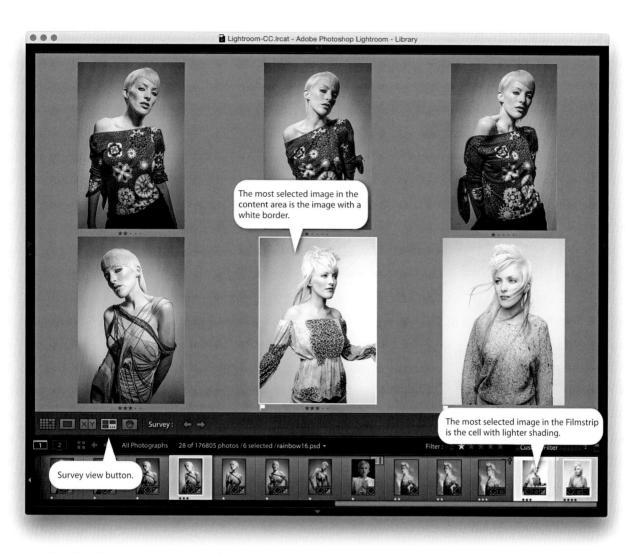

Figure 3.52 The Library module Survey view is based on an image selection made in the Filmstrip below. To navigate through the selected images, you can use the left and right arrow keys, highlighted here on the keyboard.

NOTE

If only one image is selected in the grid when you switch to the Compare view, whichever photo you had selected immediately prior to this becomes the initial candidate image. If you then highlight the candidate image, Lightroom lets you cycle through all the images in the current folder/collection as you navigate using the arrow keys.

Working in Compare view

If you make an image selection and click the Compare view button in the Toolbar (or use the © key shortcut), Lightroom displays the current, "most selected" image as a select image and the one immediately to the right in the Filmstrip selection as a candidate image. In this setup, the select image stays locked and you can use the keyboard arrow keys to navigate through the remaining photos in the selection to change the candidate image view and thereby compare different candidate photos with the current select (**Figure 3.53**). When you find a candidate image that you would like to make the new select, you can click the "Make current candidate image the new select" button to promote this as the new select image (or use the up arrow on the keyboard). A white border in the Compare view indicates which image is active, and you can use the Zoom view slider to adjust the zoom setting. When the zoom lock is switched on, you can lock the level of magnification and synchronize the zoom and scrolling across both image views.

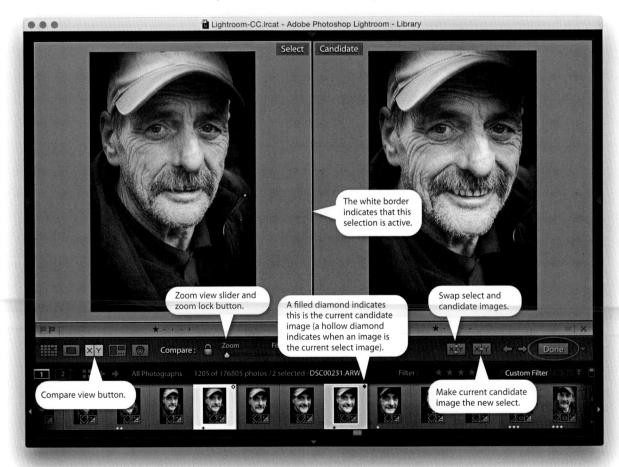

Figure 3.53 In Compare view, you can compare a select image with various candidates and use the left and right arrow keys to select different candidates from the current selection.

If the Navigator panel is open, you can use it to navigate the Compare view display (**Figure 3.54**). Use a single click in the Navigator preview to zoom in to whatever the close-up view zoom level is, and then click and drag the zoomed-in rectangle to analyze different areas of the two images as they are viewed side by side. Of course, you still have the zoom lock button in the Toolbar to unlock the zoom and scrolling for the two images in order to navigate each separately. To return to the normal zoomed-out view, just double-click anywhere inside the Navigator preview. When you have decided which image is the favorite select, click the Done button (circled in Figure 3.53)-to display the current select image in a standard Loupe view.

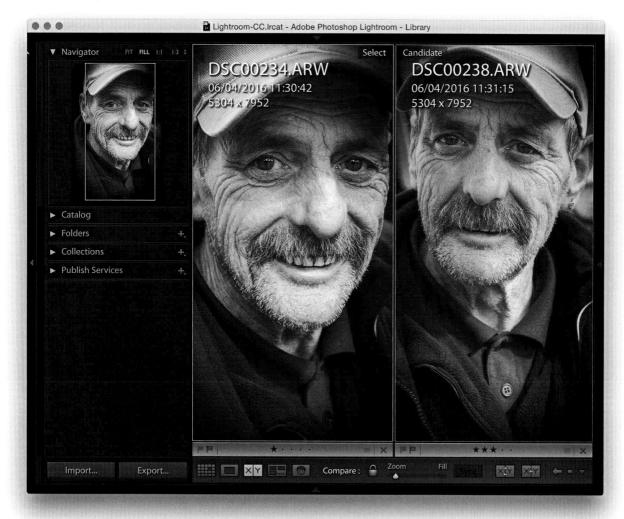

Figure 3.54 The Compare view with the Navigator panel and Loupe Info visible.

Compare view mode in action

The following steps show an example of the Compare view being used to edit a selection of photos made via the Filmstrip.

1. In the Filmstrip, you can tell which photo is the select and which is the candidate by the icon in the top-right corner. The select photo (orange border) is indicated with a hollow diamond, and the current candidate photo (blue border) is indicated by a filled diamond.

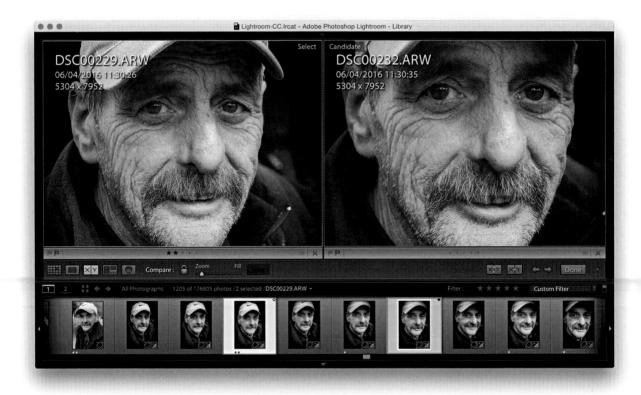

2. In this step, I had the photo highlighted with the orange border as the current select and the photo highlighted with the blue border as the current candidate.

3. I proceeded to use the right keyboard arrow key to move forward through the Filmstrip selection and compared other photos with the original select.

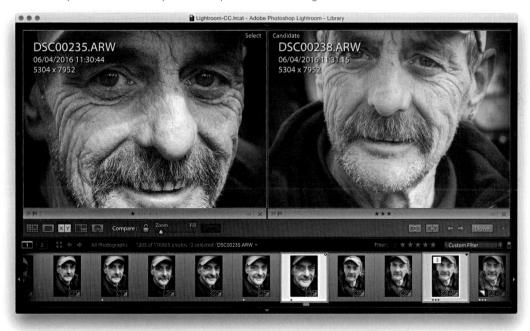

4. When I had found a new photo that I liked more, I used the up keyboard arrow key to promote this candidate photo to become the new select and continued searching for alternative candidates.

Figure 3.55 In the Lightroom Interface preferences section is a Filmstrip section where you can choose whether to display ratings and picks, badges, and stack counts in the Filmstrip thumbnails.

Navigating photos via the Filmstrip

The Filmstrip is located at the bottom of the Lightroom window. You don't get to see the same amount of information in the Filmstrip as you can see in the Library grid cells, although the Lightroom Interface preferences does have an option to "Show ratings and picks" in the Filmstrip, which allows these two additional items to appear at the bottom of the thumbnail cells in the Filmstrip (**Figure 3.55**). Plus, you can choose to show badges as well as stack counts for any stacked photos (see page 130).

The Filmstrip is always accessible as you move between modules in Lightroom and provides a secondary view of the catalog contents (**Figure 3.57**). Therefore, when working in the other Lightroom modules, the Filmstrip provides an overview of the currently filtered photos in the catalog (**Figure 3.56**). As with the Library module Grid view, the Filmstrip lets you make selections of photos. Drag-and-drop editing is possible via the Filmstrip, and any sort order changes you make will be reflected in the Library module Grid view (although drag and drop won't always be possible; see page 96 for the reasons why). Where custom sort order edits are possible, these are remembered when you save a selection of photos as a collection.

The Filmstrip allows you to navigate through your photos just as you can in the Library Grid view. For example, you can press the left or right arrow key to progress through the folder thumbnails one at a time, or hold down an arrow key to quickly navigate through the thumbnails and see the Loupe preview update as you do so. Or, you can drag the Filmstrip's slider bar, or click and hold down on the side arrows to scroll even more quickly through the Filmstrip view.

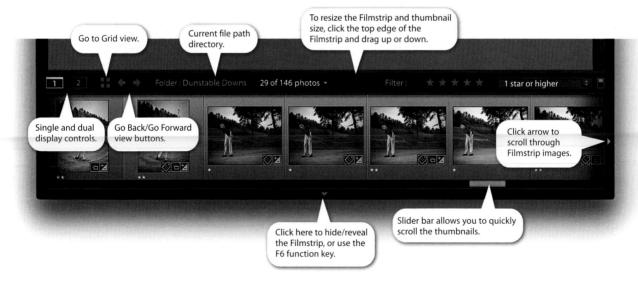

Figure 3.56 The Filmstrip sits at the bottom of the Lightroom interface and is present in all the Lightroom modules. The Go Back/Go Forward buttons let you navigate between the current and recent Lightroom folder/collection views.

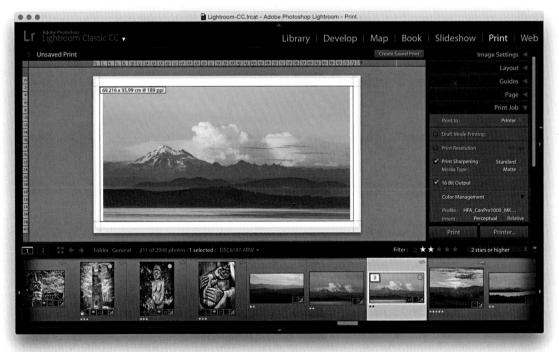

Figure 3.57 The Filmstrip lets you view and work with the currently filtered photos in the catalog and remains accessible as you switch from one module to another.

✓ Show	₩F11
✓ Full Screen	企器F11
Show Second Monitor Preview	℃分器F11
✓ Grid	₽Ġ
Loupe - Normal	ΦE
Loupe - Live	
Loupe - Locked	企業←
Compare	ûC
Survey	ΦN
Slideshow	℃公第←
✓ Show Filter View	∆ \
Zoom In	☆ ₩=
Zoom Out	☆ 第 -
Increase Thumbnail Size	
Decrease Thumbnail Size	

Figure 3.58 The Window ⇒ Secondary Display submenu.

TIP

If the ∰F11 shortcut isn't working on a Mac, go to System Preferences ⇒ Keyboard. Click the Keyboard tab and check the "Use all F1, F2, etc. as standard function keys" button.

Working with a dual-display setup

Lightroom can take advantage of a dual-display setup by opening a second Lightroom window on the other display. Assuming you have two displays, there are several ways you can do this. You can go to the Window \Rightarrow Secondary Display submenu shown in **Figure 3.58** and select Show or access this menu by right-clicking the second display button (circled in **Figure 3.59**). You can also use the **FII** (Mac) or Oth F11 (PC) keyboard shortcut to toggle the second display on or off, or to open a secondary display window, while the **Chrift** (Mac) or Oth Shift (PC) shortcut can be used to toggle the second display to appear in full-screen or window mode. However, if you are using a single-display setup, the second display can only open as a new window.

Let's now look at how you might use a dual-display setup. Figure 3.59 shows a secondary display Loupe view (公Shift) toggles showing/hiding a secondary Loupe view window), where there are three options in the top-right corner. The Normal mode displays the current image and updates it whenever you make a new image active. The Live view updates as you hover over the photos in the main Grid view or the Filmstrip, which is handy if you want to inspect other photos in close-up without losing the current image selection. It also means that if you have the second display set to a 1:1 view, you can run the pointer over the photos in a Grid view and use the 1:1 Loupe view as a quick focus checker. You should try this out—it's like running a large magnifying glass over a set of contact sheets. The Locked view option locks the Loupe view in place and does not update until

Figure 3.59 On the left is the main window with the secondary display button circled, while a second Loupe view window is on the right.

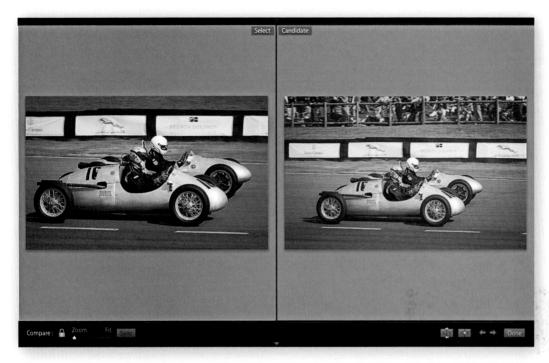

Figure 3.60 The secondary display Compare view window.

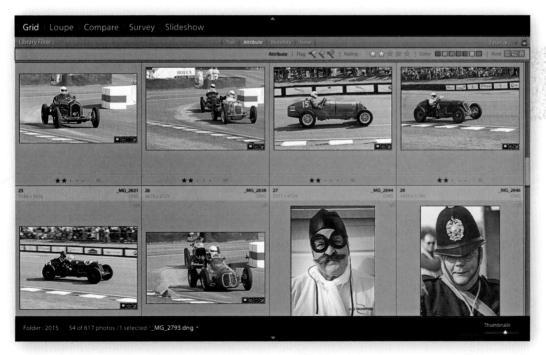

Figure 3.61 The secondary display Grid view window.

TIP

You have the same zoom controls in the secondary Loupe view window as you do in the Navigator panel, but you can set the Loupe zoom to different magnification settings. This means you can preview a photo in a "Fit to screen" Loupe view on one screen while using, say, a 1:1 view on the other.

you unlock from this view mode. This offers an alternative way for you to compare photos side by side, which leads me to the secondary Compare view mode shown in **Figure 3.60** (AShift) toggles showing/hiding the secondary Compare window). The secondary Compare view shown here works just like the main Compare view. **Figure 3.61** shows the secondary display Grid view (AShift) toggles showing/hiding the secondary Loupe window). You have here the same controls as are found in the normal Grid view, including a menu list of recently visited folders/collections, a thumbnails slider to adjust the size of the Grid display, and AShift keyboard shortcut to show/hide the Filter bar. Basically, the keyboard shortcuts for the secondary display are just the same as those used for the normal display, except you add a AShift key to the shortcut.

How to get the most out of working with two displays

Now let's look at a few examples of how a second display view can be useful when working in Lightroom. On the facing page, I have suggested three ways that a second display view can ease your workflow. Figure 3.63 shows how you can have a selection of photos in Survey view mode on the main display and use a Compare view on the second display. In the **Figure 3.64** example, the Loupe view is used on the main display with a Grid view on the second display. With this kind of setup, you can have full access to the Grid and Loupe views at once, instead of having to rely on the Filmstrip. The one thing you cannot have is two Grid views active at the same time. If you are in Grid view mode in the main window and select the Grid view for the secondary display, the main window automatically switches to a Loupe view mode. And lastly, you can combine any module view on the main screen with a Grid, Loupe, Compare, Survey, or Slideshow view on the second display. In the Figure 3.65 example, I used the main display to work on a photo in the Develop module, where I was able to use the Develop tools to edit the image. Meanwhile, I had the current selection of photos displayed in the Survey view mode on the secondary display. With this kind of setup, you can use the second display to select photos from the Survey view and edit them directly in Develop, thereby bridging the gap when working in these two separate modules. However, the second display must be in full-screen mode for you to access the Slideshow option; otherwise, it will be hidden.

It is possible that you may want to use this feature to control a separate display that is set up for clients to view picture selections. If the secondary window is active and in full-screen mode, you can go to the Window \Rightarrow Second Display menu and choose Show Second Monitor Preview (**Alt: \bigcirc Shift] F11 [Mac] or Ctrl Alt: \bigcirc Shift] F11 [PC]). This opens the control preview shown in Figure 3.62. This might be useful where you want to control a display that was set up in a different location and you were using it to preview photos to clients. This kind of setup could be useful for wedding and portrait photographers when presenting photographs on a separate display.

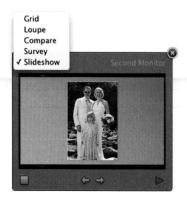

Figure 3.62 The Second Monitor Preview window allows you to preview and remotely control the content of the second display.

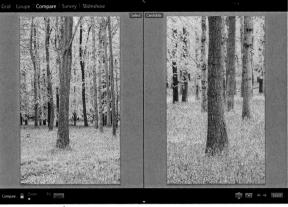

Figure 3.63 The Survey view combined with a secondary Compare view.

Figure 3.64 The Loupe view combined with a secondary Grid view.

Figure 3.65 A Develop module view combined with a secondary Survey view.

Rating images using flags

The next step in managing your images is to determine which photos you like best by assigning ratings to them. In the days of film, you would use a pen or pencil to mark the shots worth keeping with a cross and the ones you liked best with two crosses. These same editing principles can be applied when using the numbered rating system to edit photos from a shoot, where you can progressively mark the pictures you like best. The flag controls in the Toolbar provide an even simpler method for marking favorite and rejected photographs (Figure 3.66). This simple approach lets you mark the pictures you like with a flag by clicking the Pick Flag button in the Toolbar () (or use the (P) keyboard shortcut). Click the Reject Flag button in the Toolbar to mark an image as a reject () (or use the X keyboard shortcut). This also dims the thumbnail in the Grid view. And. you can use the U keyboard shortcut as a kind of undo command to mark a photo as being unflagged. You can therefore use the U key to remove the pick or reject flag status from any image. Meanwhile, the \times key can be used to toggle between a pick and unflagged status. Another approach to working with flags is to use ***** (Mac) or Ctrl (PC) to increase the flag status and use ***** (Mac) or Ctrl (PC) to decrease flag status. Lastly, you can use *Alt A (Mac) or Ctrl Alt A (PC) to select the flagged photos only.

Figure 3.66 Here is a close-up view of the Filmstrip filters where both the flagged and unflagged photos were filtered.

Having marked photos with flag ratings, you can then use the filter controls in the Filmstrip to display your flagged selections. These flag filter buttons are cumulative, which means you can click each to show or hide the flagged, unflagged, or rejected photos. In the **Figure 3.67** example, the Flagged and Unflagged buttons were checked. This meant all the picked and unpicked photos were displayed, but not the reject photos.

One more important thing to point out here is that flag ratings cannot be saved to the XMP space. Therefore, flag ratings can't be viewed in other programs. Star ratings, on the other hand, are universal and can be written to the XMP data.

Refine Photos command

From the Library menu, you can choose the Refine Photos command. This opens the dialog shown in **Figure 3.68**. This informs you that if you proceed with this command, Lightroom will automatically mark the unflagged photos as rejects and mark the previously picked photos as being unflagged. The intention here is to let you make successive passes at the image-selection editing stage and use flagging (in a rather brutal way) to narrow down your final picture choices. This is not an approach I would personally recommend.

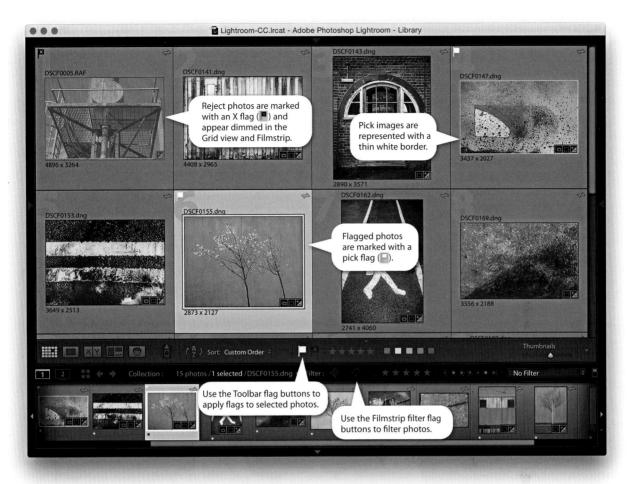

Figure 3.67 You can use the Pick Flag button in the Toolbar (or press ℙ or ℩) to mark your favorite images and use the Reject Flag button (or press ℕ) to mark photos as rejects.

Figure 3.68 The Refine Photos dialog.

NOTE

When you are in Grid view, you can click the empty dots just below the thumbnail to apply a star rating. You can also adjust the star rating by clicking one of these stars and dragging. Also, clicking a star resets the photo's rating to zero. However, these methods are quite fiddly, especially when using a large computer display with a fine screen resolution. All in all, the keyboard shortcuts provide the quickest solution for rating photos.

Rating images using numbered star ratings

The most effective way to rate your images is to use the keyboard numbers ① through ⑤ to assign a specific numbered star rating (these have a toggle action). Or, you can use the right square bracket key ① to increase the rating or the left square bracket key ① to decrease the rating for a file (**Figure 3.69**). You can use the ⑥ shift key plus a number to apply a rating and move to the next photo. Or, do so with the <code>Caps Lock</code> key enabled.

You can assign star ratings to reflect a photo's importance. For example, you can use a one-star rating to make a first pass selection of your favorite images and afterwards use a one star or higher filter to view the one-star photos only. In **Figure 3.70**, you can see how I used the filter controls in the Filmstrip to display only those images that had a one-star rating or higher. Then, you can make a further ratings edit in which you assign higher star ratings to those you consider to be the very best photos. Where you have second thoughts about the photos you previously rated as one star, you can give these a zero rating to remove them from

Figure 3.69 The most convenient way to rate images is to use the \bigcirc - \bigcirc keys to apply number ratings.

Figure 3.70 After applying initial ratings, you can use the number rating filter controls in the Filmstrip to narrow down a selection and display the rated photos only.

the filtered view. You can save a ratings filter as a filter preset. In **Figure 3.71**, a three star or higher filter was active. I went to the Custom Filter menu and chose Save Current Settings as New Preset and saved this as a *3 stars or higher* filter.

I suggest you use the higher ratings sparingly. I use a zero rating for images that have yet to be rated or are unsuitable for further consideration and a one-star rating for pictures that are possible contenders. During a second-pass picture edit, I use a two-star rating to mark my favorite images, and later I may use three stars to mark the final-choice images. I prefer not to assign the higher star ratings too freely. This leaves me some headroom to assign higher ratings later. I want to be careful as to how I allocate my four- or five-star ratings. These should be reserved for the very best shots only.

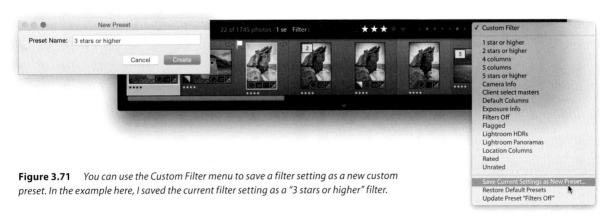

Rating images using color labels

Flags can be used as a simple way to mark photos as rejects or keepers and star ratings can be used to assign levels of importance. Color labels, on the other hand, can be used in conjunction with the above rating systems to segregate catalog photos into different groupings.

Figure 3.72 You can assign a color label by clicking on a label color in the Toolbar.

You can assign color labels via the Photo \Rightarrow Set Color Label menu and choosing a label color. Color labels can also be assigned by clicking a color label button on the Toolbar (**Figure 3.72**), or you can use keyboard numbers to assign labels as follows: red (ⓐ), yellow (⑦), green (⑧), blue (⑨) (there is no keyboard shortcut available for purple). These number shortcuts have a toggle action, so you can press ⑥ to apply a red label and press ⑥ again to remove it. If you hold down the ③Shift key as you press a keyboard number (from ⑥ to ⑨), you can apply a color label and automatically select the photo to the right. Lastly, you can add a color label by typing in the name in the Color Label field of the Metadata panel. The Library grid and Filmstrip cells normally appear tinted when you apply a color label. You can customize the Library View Options (**Figure 3.73**) by adjusting the intensity of the tint color from the default 20% setting. Or, you can deselect the "Tint cells with label colors" option and, instead, check the Include Color Label item in the Show Rating Footer section.

Figure 3.73 You can customize the Library grid cell view by deselecting "Tint cells with label colors" and checking the Include Color Label item in the Show Rating Footer section.

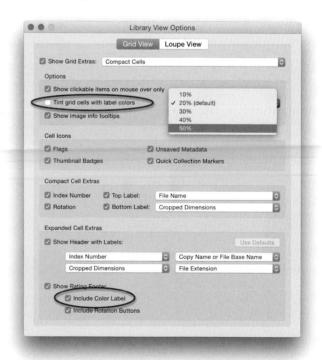

Color label sets

If you go to the Metadata ⇒ Color Label Set menu, you can replace the default color set (which uses color names to describe the color labels) with something different. The options available here include: Bridge Default, Lightroom Default, and Review Status. Choose Edit to open the Edit Color Label Set dialog, shown in Figure 3.74, where you can apply custom descriptions to the color labels. It is important to note that color labels are specific to the color label set that is currently in use. Whenever you apply a color label filter, it filters only those files that were labeled using the current color label set. So, here is the problem: If you select a new color label set, label your photos using this new set, and apply, say, a purple color label filter, you will be able to filter the purple-labeled photos that were edited using that specific color label set only. You will not be able to filter any of the purplelabeled photos that were labeled using another color label set. Furthermore, those photos labeled using a different color label set will be displayed using a white label. The reason for this is because when you filter by color label, the label color and label text description must both match. So, if color label filters are not working as expected, you should check that you have the correct color label set active. Because color labeling can so easily fall apart when different color labels sets are used, I recommend you decide on one color label set to work with and stick with it.

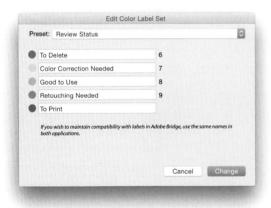

Figure 3.74 If you go to the Metadata menu and choose Color Label Set \Rightarrow Edit, you can create and save your own custom descriptions of what the label colors mean or refer to.

Other ways you can use color labels

While ratings can be used to indicate how much you like an image, color labels provide an overlapping means for classifying images into categories that have nothing to do with how much you rate an individual photo. For example, on a wedding shoot, you could use red labels to classify photos of the bride and groom, yellow labels for all the family group shots, and green labels for the informal photographs. For what it's worth, I mostly tend to use color labels in an arbitrary fashion that will change from job to job. On a model casting, I might use color labels to arrange prospective models into different groups.

NOTE

If you use color labels in Bridge to classify your photos, the color label settings are preserved when you import them into Lightroom or you modify a Lightroom imported image via Bridge. However, this does assume that the Bridge color label set matches the one currently used in Lightroom. The problem here is that it is possible for Lightroom and Bridge to use entirely different text descriptions for their color labels. So although the color label colors may match, the text descriptions will not and this can lead to metadata confusion where neither program is able to read the other program's files properly. For more about color label sorting and how to deal with white labels and color label metadata conflicts, see page 605 and page 635.

Group into Stack	₩G
Unstack	☆₩€
Remove from Stack	
Split Stack	
Collapse Stack	S
Collapse All Stacks	
Expand All Stacks	
Move to Top of Stack	ûS
Move Up in Stack	☆[
Move Down in Stack	쇼]

Figure 3.75 The Photo ⇒ Stacking submenu, which can also be accessed via the context menu (right-click anywhere in the content area and navigate to Stacking in the menu list).

Grouping photos into stacks

Just as photographers would group slides into piles on a light box. Lightroom lets you group photos into stacks. You can do this manually by selecting a group of Stack or by using the \(\mathbb{R} \) (Mac) or \(\mathbb{Ctrl} \) (PC) keyboard shortcut. From there, you can press (S) to collapse the stack so all the stacked images are represented by a single thumbnail and press (S) again to expand the stack. The number of images in a stack is indicated in the upper-left corner of the cell and also in the Filmstrip, providing you have this option turned on in the Interface preferences. If you need to unstack the stacked images, choose Photo ⇒ Stacking ⇒ Unstack or press 黑合Shift) G (Mac) or Ctrl 合Shift) G (PC). To remove files from a stack, select the individual image or images you wish to remove and choose Photo ⇒ Stacking

Remove from Stack. This lets you remove files from a stack group. while preserving the rest of the stack contents. If you single-click the stack badge in the Filmstrip or use the S key to expand a stack, it does so with the first photo in the stack selected. If you double-click or (Shift)-click the thumbnail stack button in the Grid view or Filmstrip, the stack expands with all the photos in the stack selected.

The easiest way to access the Stacking submenu is to right-click in the Grid view or Filmstrip. This lets you quickly access the Stacking submenu options from the main context menu (**Figure 3.75**). If you want to remove an image or selection of images from a stack, select the image or images first, and then use the context menu to choose Remove from Stack. Similarly, you can use this same menu to choose Collapse All Stacks or Expand All Stacks.

If you create a stack to group a series of related photos, it may be that the first image in the sequence does not best represent all the other photos in the stacked group. To switch photos, expand the stack and select the photograph you like most in the series and use \(\Omega \Shift \) to move that image up or use \(\Omega \Shift \) to move an image down the stacking order. Or, to make things simpler, just select the photo you want to have represent all the images in the stack and use the Move to Top of Stack command (\(\Omega \Shift \S) \).

Whenever you choose Photo \Rightarrow Create Virtual Copy, the virtual copy (proxy) image is automatically grouped in the stack along with the master image. Also, when you choose Photo \Rightarrow Edit in Photoshop, there is also a preference for stacking the edited copy photos with the originals.

Automatic stacking

The Auto-Stack by Capture Time feature lets you automatically group a whole folder of images into stacks based on the embedded capture date and time metadata. The following steps demonstrate how to use the Auto-Stack feature to automatically group a series of image captures into stacks.

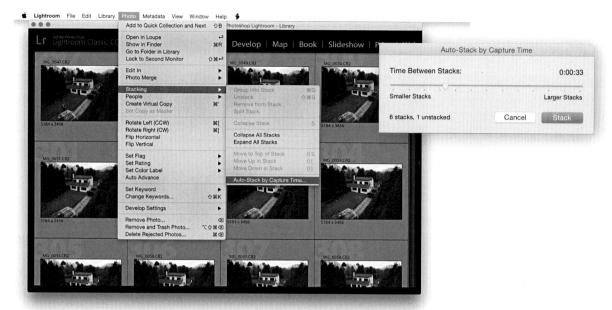

1. Here is a Library view of a folder containing over 900 photos from a timelapse sequence. I wanted to auto-stack the folder contents, so I went to the Photo □ Stacking menu and chose Auto-Stack by Capture Time. I adjusted the Time Between Stacks slider to be between 33 seconds of each other.

2. The photos in the content area were now stacked, but the stacks remained expanded. To collapse the stacks, I clicked the badge icon in the top-left corner. (Clicking again expands the stacks.) I could have also right-clicked to access the context menu and chosen Collapse All Stacks.

Making image selections

A photo selection is a temporary collection of images (**Figure 3.76**), and selections can be used in a number of different ways. For example, you might want to make a selection and apply the same rating to all the selected images. Or, you might want to select a group of images in order to synchronize the Develop settings with whichever is the most selected image in the Grid or Filmstrip. When making image selections via the Library Grid or Filmstrip, you can use the **Shift** key to make a contiguous selection of images (that is, a continuous selection from point A to point E). Alternatively, you can use the **k**ey (Mac) or **c**trl key (PC) to make a noncontiguous (nonconsecutive) selection of images, such as: A, C, and E. You can also use the forward-slash key (**/**) as a shortcut to deselect the most active photo in a Grid or Filmstrip selection. By using the **/** key, you deselect the most selected image in a photo selection, which removes it from the selection and makes the photo immediately to the right in the selection the most active.

Figure 3.76 A Library module Grid and Filmstrip view with an active photo selection.

132

Quick Collections

A selection provides only a temporary way of linking images together in a group. As soon as you deselect a selection or select a different folder in the catalog, the selection vanishes. Of course, you can still choose Edit \Rightarrow Undo or use the keyboard shortcut $\Re \mathbb{Z}$ (Mac) or \mathbb{C} trl \mathbb{Z} (PC) to recover a selection, but the main point is that selections provide only a temporary means of grouping images together. If you want to make a picture selection more lasting, you can convert a selection to a Quick Collection by choosing Photo \Rightarrow Add to Quick Collection or by pressing the \mathbb{B} key. Any images that have been added to a Quick Collection will be marked with a filled circle in the top-right corner in both the Library Grid and Filmstrip views. You can keep adding more images to the Quick Collection, but there can be only one Quick Collection. However, it is possible to make other collections the "target collection" instead of the Quick Selection (see page 139).

You can view the photos in the Quick Collection by clicking Quick Collection in the Catalog panel (**Figure 3.77**), choosing File ⇒ Show Quick Collection, or using the **(Mac)** or **(Ctr) (B)** (PC) shortcut. You can then choose File ⇒ Return to Previous Content (or press #B or Ctrl B again) to return to the previous Library module view. With Quick Collections, you can make selections of photos from separate sources and group them in what is effectively a temporary collection. Quick Collections remain "sticky" for however long you find it useful to keep the images grouped this way. A Quick Collection is always remembered even after you quit Lightroom—no saving or naming is necessary—and the images remain grouped this way until you decide to remove them from the collection. If you want to save a Quick Collection as a permanent collection, you can do so by using **XAIT** (Mac) or Ctrl AIT (B) (PC). This shortcut opens the Save Quick Collection dialog (Figure 3.78), which lets you save the current Quick Collection as a normal catalog collection. Once you have done this, it is good housekeeping practice to clear the Quick Collection, which you can do by choosing File

□ Clear Quick Collection or using 黑公shift B (Mac) or Ctrl 公shift B (PC). Figure 3.79 shows an example of how a Quick Collection can be made up of photos from more than one source folder.

Figure 3.78 Use **MAIL** B (Mac) or Ctrl Alt B (PC) to save a Quick Collection as a permanent collection and add it to the Collections panel.

NOTE

There is no way to embed collections information within the file metadata. Collections that have been created in Lightroom are specific to the Lightroom catalog and the computer on which you created them. The only way to preserve collections when transferring images is to export as a catalog and then use the Import from Catalog feature to import and add the catalog contents to another Lightroom catalog. A workaround is to assign keywords to collections (and make these all children of a Collections keyword). You can then re-create collections using the saved keyword metadata.

Figure 3.77 To view a Quick Collection, click the Quick Collection item in the Catalog panel.

You can group images from different source locations (i.e., different folders) and then select Quick Collection to view all the selected images at once. In the example shown here, I highlighted the source folder locations in the Folders panel for the photos that made up this current Quick Collection. Note the Collection badge that's highlighted here. If you click it, this takes you to the parent collection.

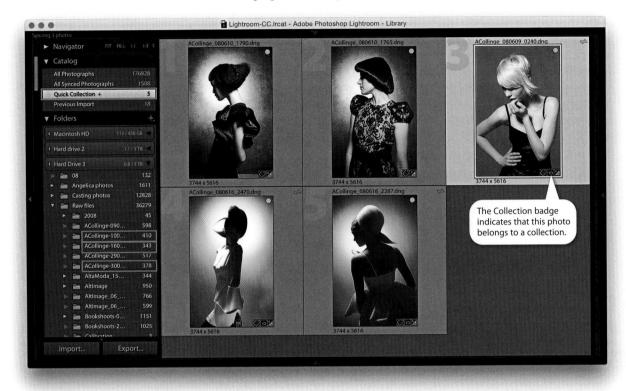

Figure 3.79 An active Quick Collection with the source folders highlighted.

Collections

As I just explained, a Quick Collection can be converted into a collection. You can also convert any selection of photos made in the Library Grid view or Filmstrip into a collection directly via the Collections panel. Although catalog images can exist in single folders only, you can use collections to create multiple references of the master photos. Collections are therefore useful for grouping images together from different folders in ways that are meaningful or useful. When working within the Library or Develop module, you can save selections as standard collections (IIII). Such collections can then be accessed by clicking a collection in the Collections panel within any module in Lightroom. Standard collections are simply saved collections of photos that can be accessed anywhere in Lightroom and have no other special attributes.

To create a new collection from within the Library module, click the + button in the Collections panel (Figure 3.80) or use the **N (Mac) or Ctrl N (PC) shortcut. This opens the Create Collection dialog shown in Figure 3.81. Here, you have the option to save a new collection to the top-level hierarchy within the Collections folder or save within a collection set (see page 140). You will normally want to keep "Include selected photos" checked. You can also check the "Make new virtual copies" option if you wish to create virtual copies only from the master photos when creating a new collection. This might be useful if you want to create a new collection for the purpose of creating black-and-white versions of the selected master photo images. "Set as target collection" will make this collection the target for quick collection additions in place of the Quick Collection in the Catalog panel (you'll see a plus sign appear next to the collection). "Sync with Lightroom mobile" is normally checked by default, allowing you to sync a collection. Figure 3.82 shows a filter being applied in the Collections panel. In this instance I typed "ashridge," which shortlisted the two collections shown here.

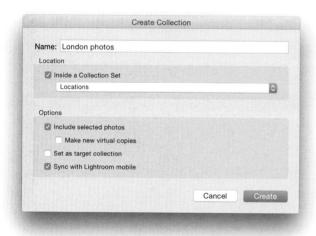

Figure 3.81 The Create Collection dialog.

Module collections

Module-specific collections can be used to store settings that have been applied in the Web, Slideshow, Print, or Book "create" modules. So, when working with a selection of images in any of these modules, you can save the combination of the image selection and module settings as a module collection. Figure 3.80 contains examples of the different collection types, which are distinguished by the collection icon appearance: Book (), Slideshow (), Print (), and Web (). These can perhaps be thought of as project containers or saved documents of a work in progress. For example, when working on a book layout in the Book module, you will want to be able to save the selection of photos to be included in the book layout along with all the Book module work associated with that collection of images.

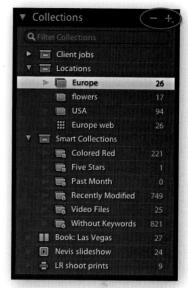

Figure 3.80 The Collections panel, common to all the Lightroom modules.

Figure 3.82 A filter being applied to the Collections panel.

Whenever you make a selection of photos and enter the Book, Slideshow, Print, or Web modules, you normally have the freedom to play around with the settings without saving anything. After all, you won't necessarily need to create a new collection each time you visit, say, the Print module. But when you do want to permanently save the work you've done, you have the option to do so.

In **Figure 3.83**, you can see examples of the Create bars for the four "create" modules. These are made visible by default, but you can use the backslash key (\) to toggle showing/hiding them. The Create bar is displayed prominently in order to prompt you to save what you are doing as a module collection and not lose any work. This is particularly important when working in the Book module, because this can include information about the way the pages have been laid out, as well as any text that might have been added. To create a module collection, just click the Create button to open the Create dialog (**Figure 3.84**). You can then enter a name, select a Set to contain the collection, choose to include selected photos, or make new virtual copies.

Figure 3.83 The Create bars for the Slideshow, Print, Web, and Book modules.

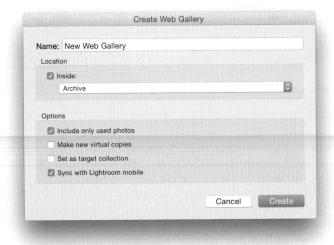

Figure 3.84 The Create dialog.

Clicking the Collections panel + button also opens a menu from which you can launch the Create dialog to create a module-specific collection for the particular module you are working in (**Figure 3.85**).

Figure 3.85 The Collections panel menu can also be used to create a module collection.

Let's say you want to create a new module collection, such as a new Web collection. This will add a new module collection to the Collections panel, which you will be prompted to name via the Create dialog (Figure 3.84), and the Web collection will have a special icon () to distinguish it from other types of collections in that panel. The current Filmstrip contents are used as the source and preserve everything that is in that Filmstrip selection, such as a custom sort order.

Module collections can be created from any collection of photos except for Smart Collections, but photos that have been added to a module collection can be shared across other module collections. Therefore, a single photo can be used in multiple Book collections, as well as in other Slideshow, Print, and Web collections.

To duplicate an existing collection, (Alt)-drag a collection within the Collections panel. This can be useful where you need to, say, duplicate a current book collection to create variations of the current book layout.

Figure 3.86 A Grid cell with a list of the associated collections.

Collection badge icons

When a photo is in a collection, you will see a badge icon ((a)in the Library module Grid view cells. If you click this badge, you will see a list of all the collections the photo belongs to and can navigate to these directly (Figure 3.86). And, if you are in the Library Grid view and hover over a collection name, you will see thin white borders around all the photos that belong to that collection. Whenever you work in the Book module, the Filmstrip indicates whether photos that are part of a Book collection are actually included in the layout or not. For example, in Figure 3.87, the numbers at the top of the Filmstrip cells indicated how many times a photo had been used in a specific book project. If there is no number, it means a photo has not been included in the book layout yet.

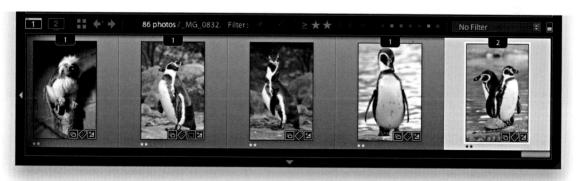

Figure 3.87 When a Book collection is selected in the Book module, you will see the number counts shown here in the Filmstrip.

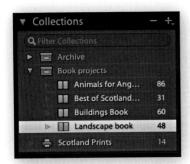

Figure 3.88 A Collections panel list of Book module collections.

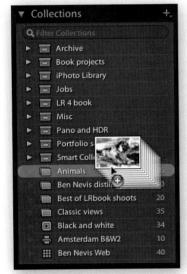

Figure 3.89 You can add more photos to a collection by dragging them to a collection in the Collections panel.

The module collections in use

Now let's look at working with different types of collections. When you are in the Library, Develop, or Map module, clicking a collection of any kind selects the photos in that collection and filters the current Library Grid view and/or Filmstrip. However, if you double-click a module collection, it selects the photos in that collection and takes you to the create module associated with it.

However, when you are in one of the create modules—Book, Slideshow, Print, or Web—you can select any collection that is specific to that module to switch working between different collections of that module type. So, if you are in the Book module, you can click other book collections to switch between different book projects. If you then single-click another type of module collection, this will select the photos in that collection and take you to the associated module. For example, if I were to click on the Landscape book collection highlighted in Figure 3.88, this would filter the catalog to select the 48 photos in that collection. If I were in the Library, Develop, or Map module, I would have to double-click the collection to select the photos and take me to the Book module. But if I were in the Slideshow. Print, or Web module, this would also take me straight to the Book module. Once in the Book module, I would see the book collection with the book layout in the same state as the last time I worked on it. If I were to then select one of the other Book module collections listed in Figure 3.88, this would let me switch between different book projects. If I then clicked on the Scotland Prints Print module collection, this would select the photos contained in that collection and take me to the Print module using the print settings that were applied at the time the Print collection was last saved. Remember also, when you work on a saved module collection, any edits you make to the module settings are saved automatically.

Editing collections

The photos in a collection can easily be edited. You can add photos to a collection by dragging and dropping them onto a collection name (**Figure 3.89**). Photos can be removed from a Quick Collection or a collection by selecting the photo or photos in the Library Grid view or Filmstrip and pressing the Delete key. When you do this, you are removing the photos from the collection selection only and not actually removing them from the catalog or deleting them from the hard disk. Similarly, once you remove a photo from the catalog, it can no longer be in a collection. So, if you happen to delete or remove a photo from the catalog that is part of a Book collection, it will also be removed from the book (assuming it is currently included in a book layout design). What if the photo belongs to a collection synced with Lightroom CC/Lightroom mobile? Then you will see the dialog shown in **Figure 3.90**. Clicking No removes the photo from this collection and All Synced Photographs, but not if the photo is also in another Lightroom mobile synced collection. Clicking Yes keeps it in All Synced Photographs.

Figure 3.90 The sync photos warning dialog.

Deleting collections is faster in Lightroom Classic CC, although this depends on the catalog size as well as the number of collections and images in a collection. Lastly, if you wish to rename a collection, you can do so via the Collections panel context menu, shown in **Figure 3.91**.

Target collection

By default, the Quick Collection is always the target collection, but you can assign any other collection to be the target collection instead. To do this, select a collection and choose Set as Target Collection from the context menu shown circled in Figure 3.91. When a collection has been promoted in this way, you will see a + appear after the name, (but note you cannot set a Smart Collection as the target collection). You can then select photos in the Library Grid or Filmstrip and press the B key to toggle adding/removing them to the target collection (you will see a message flash up on the screen to remind you which collection the photo is being added to). You can also use the Painter tool to select photos and add them to the current target collection (see page 590 for more about working with the Painter tool); plus, there is a "Set as target collection" option included in the Create Collection dialog (Figure 3.92). To reset the Quick Collection as the target collection, use the *Alt Ashift* (Mac) or Ctrl Alt Shift* (PC) shortcut.

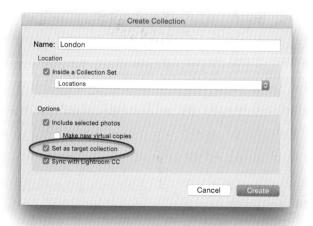

Figure 3.92 The "Set as target collection" option in the Create Collection dialog.

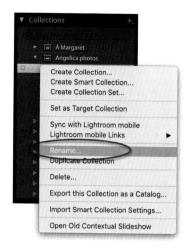

Figure 3.91 To rename a collection, right-click to access the context menu and choose Rename. This opens the Rename dialog.

NOTE

Collection loading speed in Lightroom Classic CC is better, especially for Smart Collection sets that have complex rules. You should find it quicker to switch between multiple collection views. Collection deletion speed is also improved.

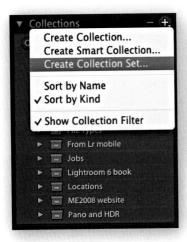

Collection sets

To help organize and manage your collections, you can create collection sets.

To add a new collection set, click the + button in the Collections panel header

(Figure 3.93), or right-click anywhere in the Collections panel to access the

context menu. Choose Create Collection Set, name it and click Create. This adds
a new collection set (
). These can be used to contain individual collections and

Smart Collections. You cannot place photos directly inside a collection set, but you
can have collection sets nested inside collection sets.

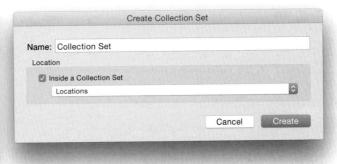

Figure 3.93 Click the + button in the Collections panel to choose Create Collection Set and create a new collection set in the Collections panel.

Smart Collections

Smart Collections can be used to set rules for which photos should be in a collection. Photos that match these criteria are then automatically added. To do this, click the + button, or use the context menu and select Create Smart Collection (a). This opens the dialog shown in Figure 3.94, where you can set up a series of rules (also known as Boolean operators) to determine which files will be filtered by a particular Smart Collection. In the example shown here, I used a Keywords filter to select photos with the keyword Jobs, a File Type filter to select TIFF file type photos, and an Edit Date filter to select images that were captured throughout the year 2009. In the Match section, I selected "all." This meant that files would have to match all the combined rules before being added. Choose "any" when you want to select photos that match multiple terms, but not exclusively so. There are also Smart Collection options for things like megapixel size, Smart Preview status, number of color channels, bit-depth mode, and color profile. New to Lightroom Classic CC are Filter by Lens Correction, as well as "Is Empty" and "Isn't empty" filters for the Title field.

After you create a Smart Collection, you can double-click to edit the Smart Collection settings. **Figure 3.95** shows the Edit Smart Collection dialog, where I was able to change the File Type from TIFF to Raw. So instead of selecting all the TIFF master retouch files from that year, I could edit the Smart Collection to filter all the raw files associated with client jobs for that year into a Smart Collection.

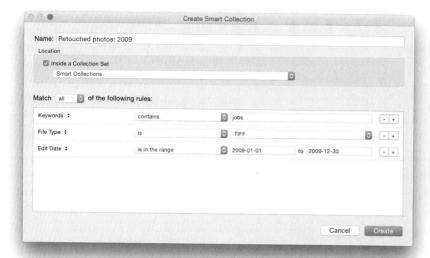

Collections Locations Mulberry Tree Stockholm trip Smart Collections Camera flash photography Colored Red Five Stars Past Month Recently Modified Without Keywords Retouched photos: 2009 194 vianettes IIII Angelica IIII Angelica-Web

Figure 3.94 The Create Smart Collection dialog and, to the right, how the Smart Collection appeared in the Collections panel.

Smart Collection: Reto	uched photos: 2009					
Match all of the	following rules:					
Keywords ‡	contains	٥	jobs			[-]
Edit Date ‡	is in the range	٥	2009-01-01	to 2009-12-30		-
File Type ‡	is	٥	Raw		Ø	-

Figure 3.95 The Edit Smart Collection dialog.

Smart Collections can filter based on static criteria such as the number of star ratings assigned to images or the keywords added. You can create Smart Collections to filter photos that have missing copyright notices or that have not been keyworded yet, or to search by metadata status. You can even create a Smart Collection based on whether the camera flash fired or not. Other Smart Collections can be more dynamic, such as "photos that have been shot in the last month." Using the Collections panel context menu, you can export Smart Collections settings for selected Smart Collections. This allows you to share your Smart Collections settings with other users (**Figure 3.96**). Alternatively, simply export a catalog with, say, a single photo in it. This will let you achieve the same thing when you import from catalog, but preserves your Smart Collection hierarchy.

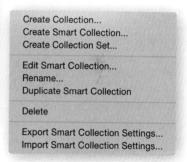

LR5_Smart_Collections.Irsmcol

Figure 3.96 The context menu for Smart Collections (top), where you can choose to export Smart Collection settings or import from a Smart Collection settings file (shown below the menu).

Removing and deleting photos

What should you do with your reject images? I personally prefer not to delete anything since you never know when a reject photo might still be useful. For instance, there have been occasions where I have taken a photograph and not thought too much of it, only to discover later that the photo had a greater significance than I had realized at the time. However, if you happen to have marked photos as rejects using the reject flag or \boxtimes keyboard shortcut, you can go to the Photo menu and choose Delete Rejected Photos or use the \bigcirc Delete (Mac) or \bigcirc Delete (PC) shortcut. This sends all your rejected photos directly to the trash, ready to be deleted.

If you select an image and press the Delete key, you will see the dialog shown in Figure 3.97. Clicking Remove simply removes a photo from the Lightroom catalog and the original remains on the computer hard disk. To avoid seeing this dialog, you can instead use Alt Delete. If the photo is part of a published collection, such as Flickr, you will see a warning dialog asking if you wish to remove or leave the photos on the published service still. The other option is Delete from Disk. This removes the photos from the catalog and sends them to the system Trash/Recycle bin. A warning message reminds you this process cannot be undone, although the files will not be completely deleted until you choose to empty the Trash/Recycle bin. Alternatively, you can use **器Alt 心Shift** Delete (Mac) or Ctrl Alt Shift Delete (PC) to remove a photo and send it to the Trash/ Recycle bin, where again, you will still be able to recover the files before they are permanently deleted—you can always rescue the deleted images from the trash and import them back into the Lightroom catalog again. The fact that the Delete command does not irrevocably remove files from your system provides a margin of safety. However, see "Editing collections" on page 138 for a reminder about how photos in synced collections are managed should you choose to remove any.

Whenever you work with photos that are offline and are therefore working with Smart Previews only, the Delete option is deliberately made unavailable available. This is a deliberate policy to prevent users from deleting photos that are currently offline.

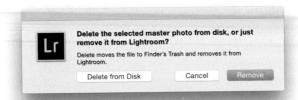

Figure 3.97 This dialog will appear whenever you use the Delete command in Lightroom.

Exporting catalogs

To export a catalog, select All Photographs from the Catalog panel or select a specific folder, and choose File \Rightarrow Export as Catalog. This opens the dialog shown in **Figure 3.98**, where you can choose the location to save the catalog to and add a tag if you wish. If you have first created an active selection, you can check or uncheck the "Export selected photos only" option to decide whether to export the entire catalog or just the selected photos. Or, you can select a collection or collection set and use a right-click to select Export this Collection as a Catalog. Just bear in mind you can use the Export as Catalog feature to create new, separate catalogs only and can't simultaneously export and add to an existing catalog.

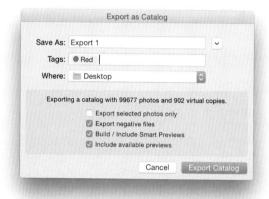

Figure 3.98 The Export as Catalog dialog.

Exporting with negatives

A catalog export will, at a minimum, export all the metadata information, including snapshots and virtual copies. If you want a catalog export to include all the master photos (i.e., the raw files, JPEGs, TIFFs, and PSD image files), then check "Export negative files." Just to be clear, the Export as Catalog dialog refers to the master files as the *negative files*.

You can use this command to create an exact duplicate of your catalog with all the photos in the original catalog copied to a new catalog folder, preserving the hierarchy of all the folders that make up the current catalog. Or, you might want to use it to export a subsection of the catalog. For example, when I am on location working on a laptop computer, I will return with files that have been imported into the laptop Lightroom catalog that I then wish to add to the main Lightroom desktop catalog. I could simply choose to save all the metadata and copy the files (with their updated metadata) across to the main catalog. But, if I choose to export as a catalog, I can create a copy of not just the files but also the preview data that has already been generated plus any virtual copies that I might have made. You can then use the Import from Catalog feature (see page 145) to add the exported Lightroom catalog information and files to the main catalog on

NOTE

A catalog export is different from a normal file export. This is because a catalog export exports everything that is associated with the files in the catalog, such as the snapshots and virtual copy versions of the masters (although it does not include Publish Services data). When you include the negative files in an export, the master files are exported in their original, unflattened state. This means any files you edited in Photoshop will be exported with the layers preserved.

Figure 3.99 A catalog export in progress.

a separate computer running Lightroom. Of course, when you choose to export the master negatives with a catalog export, this can considerably slow down the export process and you will see the progress bar indicator in the top panel of the Library window (**Figure 3.99**). Furthermore, when creating a new exported catalog, you'll need to have at least 200 MB of free disk space on your computer, which Lightroom uses as a temporary file storage directory.

So, if you check the "Export negative files," Build Smart Previews, and "Include available previews" options, you can end up with an exported catalog that looks like the one shown in **Figure 3.100**, where the catalog folder has an .*Ircat* catalog file, a *Smart Previews.Irdata* file that contains Smart Preview versions (where generated), and a *Previews.Irdata* file that contains the thumbnails and preview image data, along with a subfolder containing the master negatives.

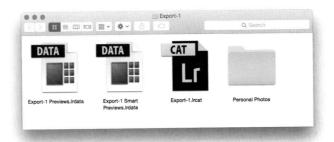

Figure 3.100 A folder view of an exported catalog along with the previews and Smart Previews files and a folder containing the actual images.

Exporting without negatives

If you deselect the "Export negative files" option, you can export a complete catalog that does not use up so much disk space and is lightweight enough to run from a laptop computer with limited free disk space. The advantage of this approach is that you can export a large catalog relatively quickly. But the usability of such a catalog will depend on having the Build Smart Previews and "Include available previews" options checked so you can preview the catalog contents.

Including Smart Previews

If the Build Smart Previews option is checked, this adds a *Smart Previews.Irdata* file. This lets you create an export catalog that looks and feels almost like a normal catalog with master images. If you don't include Smart Previews, there will be limitations as to what you can do in Lightroom when working with a catalog that is missing the master negatives. You'll be able to add things like ratings and keywords, but you will not be able to make adjustments in the Develop module or via the Library module Quick Develop panel. For more about Smart Previews, see "Working with Smart Previews" on page 147.

Including available previews

If you check the "Include available previews" option, this adds a *Previews*. *Irdata* file to the export folder, which, as you might expect, contains all available previews that have been rendered in Lightroom. This includes the Library Grid thumbnails, standard-resolution Loupe views (in whatever form they have been rendered), and 1:1 rendered views (if available) as part of the export.

Lightroom goes through several stages of preview rendering. At a minimum, Lightroom should have stored thumbnail and standard-sized previews of each photo in the catalog. You should at least see good-quality thumbnails, but if Lightroom has not had a chance to render proper standard-sized previews (at the pixel size you set in the Preferences dialog), then the standard-sized/full-screen Loupe view previews may look pixelated (because they'll be nothing more than enlarged thumbnails). However, if you export a catalog that contains Smart Previews, it will be possible for the catalog to subsequently render standard-sized previews from the available Smart Previews.

The "Include available previews" option is therefore more critical when exporting a catalog that does not include Smart Previews or master negatives. If a catalog is exported without either of these, there will be no way to re-render them. In which case, you may want to consider choosing Library \Rightarrow Previews \Rightarrow Render Standard-Sized Previews before you export the catalog. If you think you'll need to include full-resolution previews, you may also want to choose the Render 1:1 Previews option. By at least selecting the Render Standard-Sized Previews option, you'll have decent screen previews when working on the exported catalog.

Most of the time you will want to include previews as part of an export. But there are also some good reasons why you might not always want to include them. For example, if you need to export a catalog that contains just the most recent metadata edits (so that you can sync these up with a master catalog), then deselecting "Include available previews" saves having to carry out this extra step and makes the export process much faster. Basically, you can use an export with no negatives and no previews as a means to simply export the most recent metadata edits from one catalog to another.

Opening and importing catalogs

To open an exported catalog as a separate new catalog, choose File \Rightarrow Open Catalog. This opens the Open Catalog dialog shown in **Figure 3.101**, which asks if you wish to relaunch Lightroom. This is because Lightroom must always relaunch when loading a new catalog. If, instead, you want to import an exported catalog and merge the contents into your current Lightroom catalog, you'll want to select File \Rightarrow Import from Another Catalog, locate the recently exported .*Ircat* file, and import it. This process has now been made faster in Lightroom

Figure 3.101 The Open Catalog relaunch dialog.

NOTE

When importing from a catalog, Lightroom allows you to import changes into the main catalog even if the original file is currently offline in both catalogs. Classic CC. If the catalog you are about to import excludes negative files, it will import directly. Otherwise, you'll see the Import from Catalog dialog shown in **Figure 3.102**, where you can choose to import the images by referencing them in their present location or by copying to a new location and adding them to a current Lightroom catalog.

New photos section

If the files you are about to import already exist in the current catalog, you have the option to decide what will be preserved and what will get replaced during the import process. For example, in Figure 3.102, some photos already existed in the catalog. The New Photos section let me decide how to handle importing these new images and the Changed Existing Photos section allowed me to decide how to handle the duplicates.

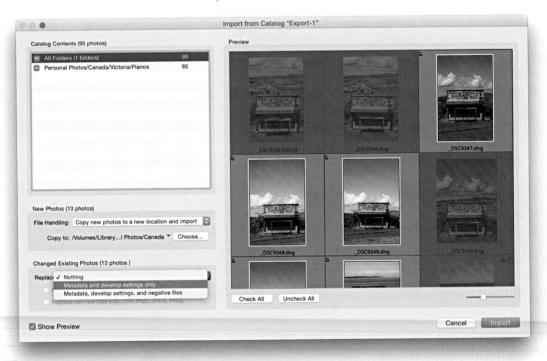

Figure 3.102 The Import from Catalog dialog shows that of the 95 photos I was about to import, just 13 were new photos.

Changed Existing Photos section

The Changed Existing Photos section in the Import from Catalog dialog covers all eventualities. From the Replace menu, you can choose to replace the metadata and develop settings only or to replace the settings plus negative files. For example, in Figure 3.102, I selected the "Metadata and develop settings only" option from the Replace menu so that the import updated the metadata only for these files.

If you are worried about overwriting the current Develop settings, you can choose "Preserve old settings as a virtual copy" (especially if you also choose to replace "Metadata, develop settings, and negative files"). If you want to avoid overwriting any of the raw masters, you can select the "Replace non-raw files only" option, which can save time, because the raw files will not be overwritten and only the metadata edit settings will be imported to the catalog. As an extra security option, any photos that are exactly the same (i.e., they share the same creation date) will not be imported or overwrite the originals.

Limitations when excluding negatives

Where the master files have been excluded from an export, the Folders panel displays such catalog folders with the folder names dimmed because the links to the master folders are considered offline (Figure 3.103). If Smart Previews are available, you can edit photos using Quick Develop and the Develop module. But if no Smart Previews are available, the Develop module (and Quick Develop) will be accessible but inoperative: You will be able to see which Develop settings have been used but that is all. You will be able to use the Slideshow module to run slideshows (providing the pre-rendered previews are good enough) and use the Web module to generate web galleries. However, the Web module may remind you that the "best-available previews" are being used in place of the original masters (although to be honest, this is not always likely to be a problem). The Print and Book modules need to reference the original files, so you will not be able to output work from a catalog that is missing the master negatives.

Export and import summary

You use the File ⇒ Open Catalog command to load individual catalogs, but Lightroom can run only one catalog at a time. There is nothing to stop you from working with multiple catalogs, but a single catalog is probably all you need, even if you have a very large collection of photographs to manage. You can use File ⇒ Export as Catalog to create a new catalog, but you can't export a catalog and add to an existing catalog in one go. If that is your goal, you will have to export a catalog first and then use File ⇒ Import from Another Catalog to merge the catalog data. Depending on the catalog you are importing from, you can either import the complete catalog contents (images and metadata) or update the metadata information only (without importing any photos).

Working with Smart Previews

Smart Previews are lightweight versions of the master images (resized to 2560 pixels along the long edge) that can be used in place of the original raw files throughout the application, including the Develop module. They are stored as lossy DNG file versions of the original masters in a *Smart Previews.Irdata* file within the catalog folder.

Figure 3.103 If the imported catalog excludes the master negatives, the folder names will appear dimmed in the Folders panel.

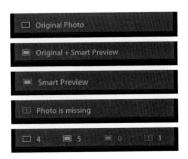

Figure 3.104 The four states for a selected photo (just below the Histogram): Original Photo, Original Photo + Smart Preview, Smart Preview, and "Photo is missing" (or offline). Below that, if multiple images are selected, you will see a count against each state.

Figure 3.105 The circled Grid cell badge indicates that the original photo cannot be located and references a Smart Preview.

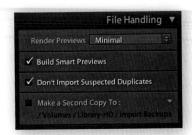

Figure 3.106 The File Handling panel in the Import Photos dialog includes a Build Smart Previews option.

Choosing to generate Smart Previews as you import new photos can prove useful in a number of ways. When working in the Develop module at a standard Fit or Fill screen view, a Smart Preview can load more quickly, allowing you to start work sooner on a small (proxy) version rather than waiting for the entire master image to load. This might help when editing large capture files. There is also an item in the Performance preferences for Lightroom to fully use Smart Previews in place of originals for image editing. The Smart Preview status is indicated in the Histogram panel in the Library and Develop modules. This is shown in **Figure 3.104**, along with a brief description of the four indicated states. **Figure 3.105** shows the Grid cell badge for an image where only the Smart Preview is available. An identical badge is also displayed in the Filmstrip.

Another benefit is that Smart Previews are easily portable with the catalog, letting you work offline more effectively. As I mentioned previously, a catalog without negatives has certain restrictions, but if you generate Smart Previews for some or all of your catalog images, you will be able to work offline more effectively. You can use the Develop module and Quick Develop to edit original images offline, and once the catalog is reunited with the originals, the edits applied offline are updated automatically. Note that original files are prioritized over Smart Previews and these will always be used when available—a Smart Preview is used only in the absence of an original file. There are some limitations, though. Because Smart Previews are reduced-size versions, when editing a Smart Preview, you won't be able to evaluate an image properly to adjust the Detail panel settings or other adjustments that require working at a proper 1:1 view mode (when zooming to 1:1, this zooms to the maximum Smart Preview resolution rather than a true 1:1). Smart Previews can be built from photos only and not video files. Smart Previews can be exported as JPEGs and used with Publish Services. You can lay out a book in the Book module using Smart Previews, but not actually create a print book (for that, the originals will need to be online).

How to create Smart Previews

Whenever you import photos into Lightroom, you have the option to generate Smart Previews of photos as they are imported (**Figure 3.106**) or when you import from another catalog. As for images that are already in your catalog, you can generate Smart Previews for these by going to the Library module and choosing Library \Rightarrow Previews \Rightarrow Build Smart Previews (use Delete Smart Previews to discard). If the original files are not available when you choose to build Smart Previews, you will see an error message. There is also a Build Smart Previews check box in the Export as Catalog dialog (Figure 3.98). If you intend to build a large number of Smart Previews at once, be warned this process may take hours to complete. Finally, to see which photos have Smart Previews and which do not, the easiest thing to do is to create a Smart Collection, such as the one shown in **Figure 3.107**, where I filtered the photos that had no Smart Preview (but were also not video files).

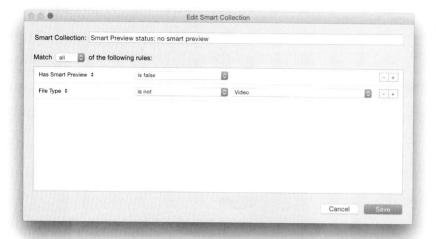

Figure 3.107 Here, I created a Smart Collection that could be used to filter photos that had no Smart Preview.

Making the catalog portable

Up until recently, there has been no easy answer to the problem of how to share a catalog between two or more computers. You can use the Export as Catalog command to export the catalog settings to an external hard drive and use the Import from Another Catalog command to import and update the exported settings to update a catalog on another computer. This is a fairly cumbersome process, but if you are interested, there is an example of how this procedure works that you can download as a PDF from the book's website.

However, thanks to Smart Previews, there is another way. If you place the entire catalog on an external drive and choose to generate Smart Previews for all the photos in the catalog, it can be made portable between different computers, so long as both are able to run Lightroom. This way you can transfer from working on one computer to another in a matter of a few minutes. You can have all the master assets stored on one computer system and be able to edit the files whether working online or offline, plus preserve the Publish Services settings. If this sounds appealing, it makes sense to use an external drive that is easy to carry around and that does not require an external power source; ideally, a solid-state drive (SSD) that provides fast read/write access and has enough disk capacity to hold the catalog file plus previews and Smart Previews data. These days, a 512 GB SSD would not be unreasonably expensive, and it would be just about big enough for most Lightroom users' needs. I have tried this approach, and it works very well. You can edit offline remotely, and as soon as the catalog is reunited with the master images on the main computer, Lightroom updates them automatically. Having said that, there are some pitfalls to be aware of. SSDs are still considered new technology. I recommend regular catalog updates to a backup folder on the host computer, as well as regular scheduled backups of the drive holding the catalog to include

NOTE

Bear in mind that if you choose to generate Smart Previews for all the photos in your catalog, the resulting Smart Previews file may end up being quite large. In fact, the Smart Previews.Irdata file could easily grow to be just as big as your Previews.Irdata file if you were to build Smart Previews for all your photos. With this in mind, you need to plan carefully where the Lightroom catalog folder is stored and if there is enough room on the drive to allow for expansion.

Downloadable Content: thelightroombook.com

There is also the option of placing the catalog file on Dropbox.com and having it synced to two computers. However, you need to make sure the catalog is accessed in this way by using only one computer at a time and is fully synced to avoid creating what might best be described as a DAM mess.

the previews and Smart Previews files. Also be aware of the consequences if the external drive holding the catalog were to lose its connection. This happened to me while using a drive that proved to be unreliable. No lasting damage was done, but the incident highlighted a major weakness in this way of working. Weigh these considerations carefully before doing the same. The following steps explain in more detail how this can be done.

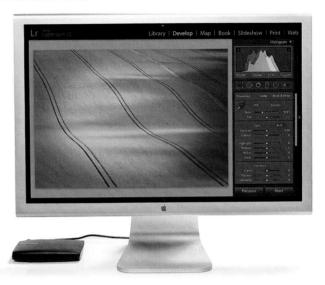

1. Let's say you have all the master catalog asset files stored on a main computer and wish to continue working with the catalog remotely. With the setup shown here, the catalog files, including the Smart Previews, were stored on an external drive

2. I closed Lightroom on the main computer, disconnected the external drive, and reconnected it to a laptop computer. I opened Lightroom on the laptop, launching the same catalog stored on the external drive.

3. I was then able to edit the catalog on the laptop. This could include making Develop module edits (providing Smart Previews were available for those images).

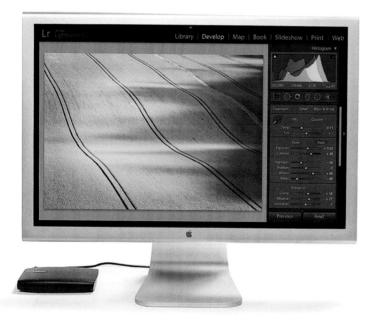

4. I quit Lightroom on the laptop, disconnected the drive, and reconnected it to the main computer. I then launched Lightroom again, opening the same catalog. The Develop edits made while working on the laptop were automatically synchronized to the main computer.

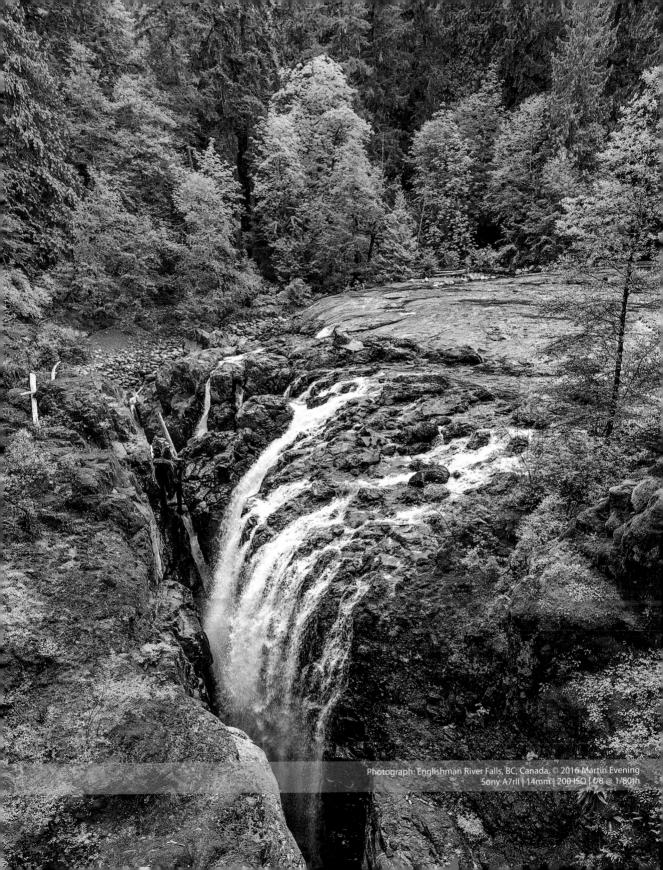

4.

Develop module image editing

A definitive guide to working with the imageprocessing controls in the Develop module

One of the most powerful features in Lightroom is the image-processing engine, especially the way the image-adjustment processing is deferred until the time you choose to edit in Photoshop or export an image. This method of image processing actually originated in the early days of computer imaging, when deferred processing was adopted by programs such as Live Picture and xRes as a means to speed up the image editing. Computers were a lot slower back then, but it was possible to manipulate large image files in real time on relatively slow computers (with as little as 24 MB of RAM) and defer the image-rendering process to the end of a photo edit session.

Of course, these days, you can edit large images in no time at all in Photoshop. But one of the key advantages of Lightroom is that you can apply a crop, spot the image, make localized adjustments, tweak the color, do some more retouching, readjust the crop again, and so on, without ever touching the pixels in the original photograph. In a conventional pixel-editing workflow, the pixels are always modified in a consecutive sequence of steps. When you work in Lightroom, no restrictions are placed on the order in which you do things, and the edit changes you make in the Develop module are applied only when you output a photo as a rendered file, such as a PSD, TIFF, or JPEG.

Smarter image processing

The Lightroom image-processing engine is notable for a number of reasons. First, the Adobe engineers have made Lightroom simple to use—there are no color management settings, color space issues, or profile warnings to worry about. But just because the image processing is simpler does not mean it is inferior, as these changes have been made without compromising on quality. The Lightroom image-processing engine ultimately reduces all of its pixel calculations into a single calculation, in which any image degradation is minimized. Another advantage of the Lightroom image-processing engine is that you have full access to all of the image controls when working with JPEG, PNG, TIFF, and PSD images, just as you have when working with raw camera files. You can use any of the image controls available in the Lightroom Develop module.

Lightroom uses a single RGB workspace to carry out all its image calculations, which is similar to the ProPhoto RGB space that was originally specified by Kodak. It uses the same coordinates as ProPhoto RGB but has a gamma of 1.0 instead of 1.8. By using a 1.0 gamma, the Lightroom RGB workspace is able to match the native 1.0 gamma of raw camera files, and its wide gamut can therefore contain all the colors that any of today's digital cameras are capable of capturing. For these reasons, the Lightroom RGB workspace is ideally tailored to the task of processing the color data contained in the raw camera files. Concerns about banding in wide-gamut color spaces have perhaps been a little overrated, because it is really quite difficult to pull apart an image in ProPhoto RGB to the point where you see gaps appearing between the levels. Suffice it to say, the Lightroom RGB space uses a native bit depth of 16 bits per channel, which means that Lightroom is able to process up to 32,768 levels of tonal information per color channel. Because a typical digital camera will only be capable of capturing up to 4096 levels per color channel, it is probably true to say that the Lightroom RGB workspace can safely handle all of the tone and color information captured by any digital camera.

The Develop controls in Lightroom can be accessed as soon as a low-resolution preview has had a chance to load, instead of waiting for a full preview. For example, if a Smart Preview is available, Lightroom loads this first, before loading the full-sized image. When going to the Develop module, individual panels are not loaded into memory unless they are already open. This helps improve the initial first launch speed of the Develop module. In Lightroom Classic CC, there is now faster switching from the Library to Develop modules. Furthermore, if you have 16 GB RAM or more, sequential navigation (using the keyboard arrows to move from one photo to the next) in Develop is faster in Lightroom Classic CC. This is because Lightroom now pre-caches upcoming photos, both before or after the direction you are navigating in. While you spend a few seconds on an image, Lightroom pre-loads the next two or three images to enable faster scrolling through these.

Steps for getting accurate color

The color management system in Lightroom requires no configuration, because Lightroom automatically manages the colors without your having to worry about profile mismatches, which color space the image is in, or what the default workspace is. There may be problems with missing profiles, but this applies only to imported files where a conscious decision has already been made not to color-manage an image. Apart from these rare instances, you can rely on Lightroom to manage the colors perfectly from import through to export and print. However, you do need to give special consideration to the computer display and ensure that it is properly calibrated and profiled before you can rely on it to judge the colors of your images. This is because you want the display to show as accurately as possible what you are likely to see in print. Calibrating and profiling the display is essential, and it does not have to be complicated or expensive. So if you want to get the colors right and avoid disappointments, you should regard the following pages as essential reading.

Choosing a display

The choice of display essentially boils down to which type of liquid crystal display (LCD) you should buy. As with all things in life, you get what you pay for. Because the display is what you will spend all your time looking at when making critical image adjustments, it is pointless to cut corners, just as it is pointless to scrimp on buying anything but the best-quality lenses for your camera. There are different classes of LCDs, starting with the budget-priced screens (such as those used on laptop computers) to large professional LCD displays that offer a high degree of color accuracy and wide color gamut, such as the Eizo ColorEdge and the NEC SpectraView. Both these displays are easy to calibrate and profile, and the large screen size means they are comfortable to work with.

Calibrating and profiling the display

The only truly effective way to calibrate and profile a display is to use a colorimeter or spectrophotometer. It is possible to buy a good device along with the necessary software package for under \$250. You can spend up to \$1000 on a good-quality display plus calibration package or spend even more on a professional calibration kit that also allows you to measure and build custom print profiles. But if all you want to do is calibrate and profile the display, these more expensive devices do not offer any significant advantages over what a basic colorimeter device can do. Having said that, some software packages can help you build better profiles using the same basic hardware-profiling kit.

NOTE

You do not need to be concerned with RGB workspaces or profiles when working in Lightroom. As for raw files, Lightroom automatically applies profiles for all the currently supported cameras.

In the case of pixel images that have been imported into Lightroom, the profile recognition is handled automatically. Image files in Lightroom can be in any color space and colormanaged accordingly (provided the image has an embedded profile). Whenever Lightroom encounters a file with a missing profile, it assumes the image to be sRGB.

Figure 4.1 I normally use the X-Rite Eye-One Photo to calibrate the displays I use at work.

There are two stages to a profiling process. The first step is to calibrate the display to optimize the screen brightness and contrast, and to set the desired white point and gamma (**Figure 4.1**). The second step involves measuring various color patches on the screen, where the measurements made from these patches provide the source data to build a profile. On some of the advanced displays, there may be controls that allow you to adjust the brightness and contrast of the display, as well as possibly some color controls for setting different white points and fine-tuning the color output. These settings can be adjusted during the calibration process to optimize the performance and neutralize the display before making the profile measurements. Most LCDs have only a brightness control that adjusts the luminance of the backlight on the screen. So when running through the preliminary calibration steps, there is often nothing you can adjust other than the brightness, and you simply skip the steps where you are unable to make any adjustments to the display.

White point and gamma

Apart from asking you to adjust the hardware settings, the calibration software will ask you to choose appropriate white point and gamma settings before you proceed to build the profile. On an LCD, it will not be possible to manually adjust the white point the way you could with a cathode ray tube (CRT) display. You can set a specific white point for an LCD, such as 6500 K, whereas some people may prefer to select the native white point for the LCD they are calibrating.

Matching white balances

People often assume that the goal should be to match the white balance between different displays and viewing light sources. For a side-by-side comparison using a light viewing box, this will be important. But the fact is, human vision is adaptive and our eyes always evaluate colors relative to what is perceived to be the whitest white. In reality, our eyes are constantly compensating and can accommodate changes in white balance from one light source to another. You can edit an image on a display using a white point of 6500 K and check the results with a viewing box that has a white balance of 5500 K, as long as the two are a distance apart.

Whether you are using a Mac or a PC, the gamma should ideally be set to 2.2, since the 1.8-gamma Mac option is really only there for quaint historical reasons. In fact, the Mac 1.8 gamma dates back to the early days of Macintosh computers, long before color displays and ICC color management. Back then, it was found that the best way to get an image viewed on a Macintosh screen to match the output of an Apple black-and-white laser printer was to adjust the gamma of the monitor to 1.8. These days, Adobe programs like Photoshop and Lightroom always compensate for whatever monitor gamma is used by the system to ensure that the images are displayed at the correct brightness regardless of the gamma that was selected when calibrating the display. Setting the gamma to 1.8 instead

of 2.2 will have absolutely no impact on the lightness of the images that are displayed in Lightroom. These will be perceived as being displayed at the same brightness regardless of the monitor gamma. However, if you are mainly using your computer for image-editing work, it is best to use a gamma setting of 2.2, as the image tones will be more evenly distributed when previewed on the display. When using the basICColor software described below, you can also select the L* option. The technical reason why this is recommended is because L* uses the luminance tone axis as prescribed in the Lab color space—it's better because it more closely matches human perception and provides a more linear gray axis.

Steps to successful calibration and profiling

The performance of your display will fluctuate, so it is advisable to update the display profile from time to time. LCDs vary in performance a lot less than CRT displays used to, so you will probably need to re-profile once every month or so only.

For accurate calibration, you first need to decide whether you want to buy a basic device for calibrating the display only or a more advanced device that allows you to create your own custom print profiles. The following steps show how the basICColor software can be used to calibrate and profile a display using a display calibration device such as the X-Rite i1 Photo. Other calibrating software will look different of course, but the underlying principles of calibration and profiling will be the same. Prior to doing a calibration, you should make sure the calibrator head is clean and also ensure that the screen surface is clean and free of dust before making any measurements.

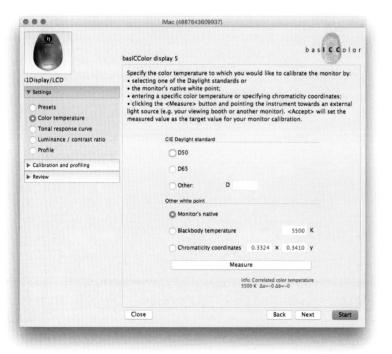

MOTE

The profile measurement process usually takes a few minutes to complete, so you will need to make sure that your screensaver does not kick in while the calibration is underway. For example, the energy conservation settings on an LCD laptop in battery-power mode may automatically dim the display halfway through the profiling process, and this can adversely affect the results of the profile measurement. It is also recommended that the display be switched on at least 30 minutes before starting the calibration process.

1. To start with, I set the color temperature. Because you cannot physically adjust the white point of an LCD, it is usually best to select the Native White Point option. But with a good-quality LCD you can set this to a standard setting, such as D65.

2. Next, I went to the Tonal Response Curve section and selected the recommended L* option. When using other calibration software packages, I recommend selecting Gamma 2.2.

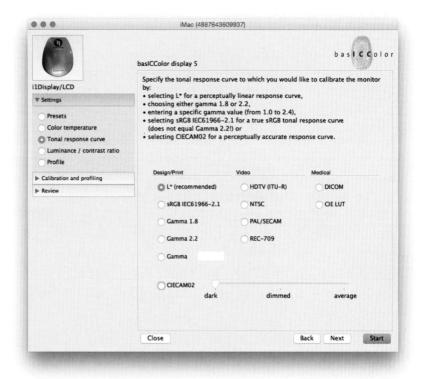

3. I then set the Luminance/ contrast ratio. A maximum luminance of 110-140 candelas m² is ideal when calibrating and building profiles for a desktop LCD, but this is not an absolute figure and is dependent on the brightness of the ambient light where the display is located. You cannot always adjust the contrast on an LCD, but you can sometimes adjust the computer operating system brightness controls to adjust the luminance brightness of the display so that the measured brightness matches the desired target setting. I was ready to place the calibrator on the screen and start the calibration process.

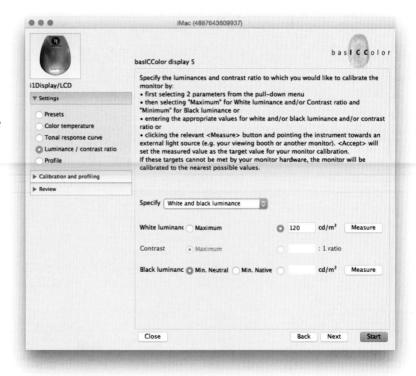

Process versions

Since Lightroom was first released, there have been several updates to the core Camera Raw processing that have been distinguished as new process versions. Previously referred to as Process 2003, Process 2010, and Process 2012, these are now known as Version 1, Version 2, Version 3, with the most current being Version 4. The Version 3 and 4 processing is actually more or less identical. The only real difference with Version 4 is the ability to apply Range Masking, along with new, improved Auto masking. All new imported images now use Version 4 and whenever you adjust any Version 3 image it will silently update to Version 4. except where Auto Mask has previously been applied. In such instances (and to avoid confusion), the image remains as Version 3. Essentially, the new Version 4 update makes a distinction between the use of Auto mask and Range Masking to edit localized adjustments. And, it is the lack of compatibility with existing Version 3 images that has necessitated this new version update. For example, if you add a localized adjustment to a Version 4 image, apply a Luminance or Color Range Mask and then convert back to Version 3, you'll see a change in the image's appearance as the "Version 4 only" Range Mask will be ignored.

The biggest changes will be seen when converting a Version 1 or 2 image to Version 3 or 4, whereby the Exposure slider in Version 3/Version 4 is both a midtone brightness and highlight clipping control and is essentially a hybrid of the old Exposure and Brightness sliders. The Contrast control is placed just below Exposure and is used to adjust the tonal compression. The Highlights and Shadows sliders are symmetrical in their behavior. They can be used to lighten or darken the highlights or shadows independently, but they don't affect the midtones guite so much—the midtones should mainly be controlled using the Exposure slider. The Blacks and Whites sliders allow you to fine-tune the blacks and whites at the extreme ends of the tonal range. Another benefit of using Version 3/Version 4 is that all images now have the same default settings. With Version 3/Version 4, raw and non-raw files both have 0 defaults. This makes it possible to share and synchronize settings between raw and non-raw images more effectively. The tone controls are good at handling contrasty images of high-dynamic-range scenes and can be processed more effectively. As camera manufacturers focus on better ways to capture high-dynamic-range scenes, it is important that the raw imageprocessing tools offer the flexibility to keep up with such developments.

In case you are interested, you can download a PDF from the book's website that describes in full how to use the older Version 1/Version 2 controls.

Downloadable Content: the lightroom book.com

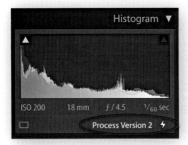

Figure 4.2 Highlighted here is the process version warning icon in the Develop module Histogram panel.

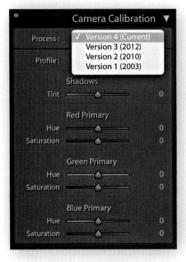

Figure 4.3 The Camera Calibration panel showing the process version menu options.

Upgrading to Version 4

I will be going into more detail about working with the Version 4 controls shortly, but for now, let's look at the version update process. Whenever you are editing a photo in the Develop module that has previously been edited in an earlier Version 1, 2, or 3 of Lightroom, a thunderbolt icon will appear in the bottom-right corner of the Histogram panel (**Figure 4.2**). This indicates that it is an older process version image, and clicking the icon updates the image to Version 4. A warning dialog will appear asking you to confirm the update (you can Alt)-click the thunderbolt icon to bypass this dialog). Once updated, you can edit using Version 4. Alternatively, you can go to the Settings menu and choose Update to Current Process. This lets you update single or multiple photos to Version 4. Or, you can go to the Settings \Rightarrow Process submenu and select the process version you want to work with. Finally, if you go to the Camera Calibration panel (**Figure 4.3**), you can select the desired process version from there. This menu also can be used to revert to a previous Version mode, should you wish to do so.

Whenever you choose to update to the latest process version, Lightroom will try to achieve as close a match as possible, although it won't always do so successfully. For example, with images where the Blacks slider has been run up the scale using Version 1 or Version 2, these will most likely appear somewhat different after a conversion, as the Version 3 and 4 Blacks sliders tend to back off quite a bit. You will also see the dialog shown in **Figure 4.4**. This warns you about the consequences of updating and allows you to select a Before/After view if desired. I think you will be fine choosing the "Don't show again" option and clicking Update. If you go to the Library module Library menu, you can choose Find Previous Process Photos to create a temporary collection of Version 1, 2, and 3 photos in the Catalog panel.

I do not advise you to upgrade all your images to Version 4 in one go. For example, I only upgrade my older, legacy images to Version 4 on an image-by-image basis. The way I see it, I was probably happy with the results I achieved previously using Version 1, 2, or 3, so why be in a hurry to update? If I am going to upgrade to Version 4, I would rather do so gradually. And, of course, all newly imported images use Version 4 by default.

Figure 4.4 The Update Process Version warning dialog.

Process version mismatches

If you are synchronizing photos and there is a process version mismatch, the Quick Develop panel will look like the example shown in **Figure 4.5**, where the Tone control buttons appear dimmed.

Camera Raw compatibility

While the Lightroom Develop adjustments are compatible with Camera Raw, it is possible to maintain absolute compatibility between the Lightroom and Camera Raw and Bridge only if you are using the latest versions of both programs. As new cameras are released, or new features are added to Lightroom, Adobe provides updates for Lightroom and Camera Raw. You can usually count on an update being released roughly every three or four months. If you had previously purchased Lightroom 6, you would have been entitled to upgrades up until Lightroom 6.12 and no more. Only Lightroom Classic CC subscribers will have access to updates that appear after this. At the same time, Photoshop customers subscribed to Photoshop CC have had access to Camera Raw updates from 9.1 to 9.12, and they will continue to get updates. When Lightroom Classic CC comes out with new features, only those subscribers will get to see these features. Lightroom 6 perpetual license customers will soon be left with no further upgrade path.

Maintaining compatibility between Lightroom and Photoshop used to be quite tricky, but now that Lightroom is available as a Creative Cloud subscription only, all you need to do is make sure you update your Photoshop CC Camera Raw subscription at the same time you upgrade Lightroom Classic CC. Therefore, when you choose the Edit in Photoshop command (WE [Mac] or Ctrl [PC]), the Photoshop Camera Raw engine will render a pixel image that opens in Photoshop CC as an unsaved Photoshop file. The only time this won't work is if you have yet to upgrade Camera Raw to match your most recent Lightroom Classic CC update. However, when choosing the Edit in External Editor command (WAITE [Mac] or Ctrl AITE [PC]), Lightroom Classic CC always uses its own internal Camera Raw processing engine to render a TIFF, PSD, or JPEG image, so in this respect Camera Raw compatibility won't be an issue.

Editing CMYK images in Develop

Lightroom does allow you to import CMYK images and edit them in the Develop module, although understand that these edit adjustments are taking place in RGB, and any export you make from Lightroom (except for export original) will result in an RGB output. It is not really ideal to use a program like Lightroom to edit your CMYK files in this way. The best route would be to go back to the raw or RGB original, make your adjustments there, and create a new CMYK output from that. You can do this in Lightroom by using the Export dialog to create, say, a TIFF output and incorporate a CMYK conversion Photoshop droplet action as part of the Export process routine (see page 442).

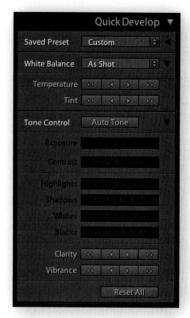

Figure 4.5 The Quick Develop panel dims the Tone Control buttons if there is a process version conflict

NOTE

You can learn about Lightroom shortcuts by going to the module help options via the Help menu (or using 幾?). The following shortcuts enable you to switch between individual modules. (These are Mac shortcuts. PC users should use Ctri Alt plus the number).

Alt 1 to select Library
Alt 2 to select Develop
Alt 3 to select Map
Alt 4 to select Book
Alt 5 to select Slideshow
Alt 6 to select Print
Alt 7 to select Web
Alt 7 to go back to the

previous module

Also, ③ selects the Library module in Grid mode, Ē selects the Library module in Loupe mode, ℝ selects the Crop Overlay mode, ⊚ selects the Spot Removal tool, M selects the Graduated Filter, Shift M selects the Radial filter, ₭ selects the Adjustment Brush, and D selects the main Develop module again.

The Develop module interface

The Develop module has everything photographers need to make adjustments and corrections to their images (Figure 4.6). The main controls are located in the right panel section. The panels in the right section of the Develop module can be expanded by clicking the panel headers. If you (Alt)-click an individual panel header, you put the panels into "solo" mode, which means that as you click to select and expand a panel, this action simultaneously closes all the other panels. You can reset the individual Develop settings at any time by double-clicking the slider names. At the top are the Histogram panel and Develop Tools panel, and below that the Basic panel, which is where you make all the main tone and color adjustments. This is followed by a Tone Curve panel, which provides you with a more advanced level of control over the image tones, letting you further fine-tune the tone settings after they have been adjusted in the Basic panel. The Tone Curve features a Target Adjustment tool, which when you click to activate it, allows you to click and drag on an area in the image itself to lighten or darken, instead of dragging the sliders. Similar Target mode controls are available when making HSL and B&W panel adjustments. The Tone Curve panel also features a point curve editing mode and the ability to edit individual RGB channels.

Below that is the HSL / Color / B&W panel. The HSL tab section provides similar controls to the Hue/Saturation adjustment in Photoshop, where you can separately adjust the hue, saturation, and luminance components of an image. The Color tab section is similar to HSL but with simpler controls (and no Target mode option). Clicking the B&W tab section (or using the \boxed{V} shortcut) converts an image to black and white and lets you make custom monochrome conversions, creatively blending the RGB color channels to produce different types of black-and-white outputs.

The Split Toning controls can be used to colorize the shadows and highlights separately (the Split Toning controls work quite nicely on color images, as well as on black-and-white photos). The Detail panel lets you add sharpness to imported images and has controls for suppressing the color and luminance noise.

The Lens Corrections panel allows you to correct for global lens vignetting, as well as the chromatic aberrations responsible for color fringing. It also offers auto lens corrections, plus automatic perspective and manual transforms. The Effects panel includes post-crop vignette sliders for applying vignette effects to cropped images, Grain sliders for adding film grain effects, plus a Dehaze slider.

The Camera Calibration panel lets you apply custom camera profile or camera calibration settings that can compensate for variations in the color response of individual camera sensors. Develop settings can be saved as custom presets. The left panel contains a selection of default presets to get you started, but it is easy to create your own presets using all, or partial combinations, of the Develop module settings. As you roll over the list in the Presets panel, you will see an instant preview in the Navigator panel, without having to click to apply the effect to an image.

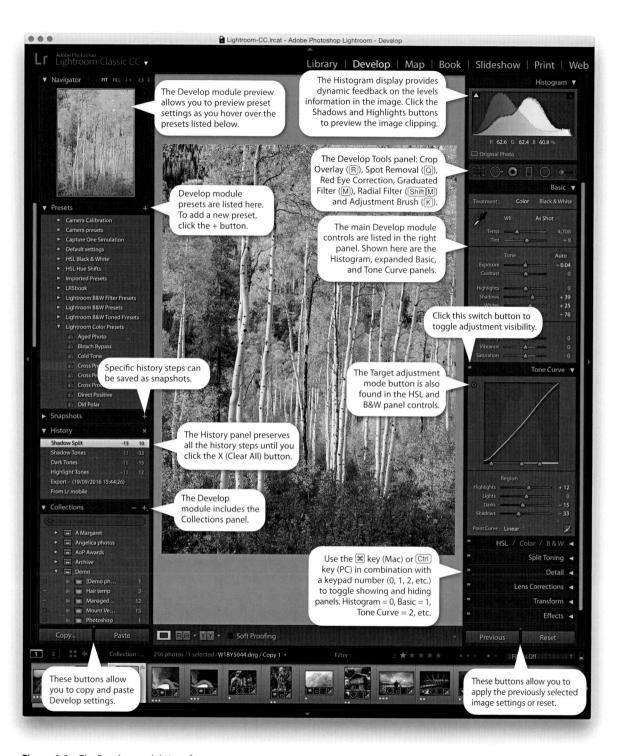

Figure 4.6 The Develop module interface.

Figure 4.7 The Develop View Options dialog. The options here are the same as in the Loupe View settings in the Library View Options dialog (see page 98).

View options in Develop

If you go to the view menu and choose View Options (**J [Mac] or Cttl J [PC]), you can access the dialog shown in **Figure 4.7**. This includes a "Show message when loading or rendering photos" option at the bottom; check it if you want a message to appear whenever the Develop module is processing a photo.

Develop module cropping

From any of the modules in Lightroom, you can use the R keyboard shortcut to switch directly to the Crop Overlay mode in the Develop module. Or, if you are already in the Develop module, you can also click the Crop Overlay mode button in the Tools panel. **Figure 4.8** shows a close-up view of the Crop Overlay tool panel controls. Once you are in the Crop Overlay mode, a crop bounding box appears, initially selecting all of the image. As you drag the crop handles, the image and crop edges move relative to the center of the crop and the areas outside the crop bounding box appear shaded. In the **Figure 4.9** example, as I dragged the top-right handle inward, the image shifted out of the way to accommodate the change made to the crop area, and the center crop handles (aligned to the green line) always remained in the center of the content area.

Dragging inside the crop bounding box lets you easily reposition the photograph relative to the crop bounding box. If you hold down the Att key, you can resize the crop bounding box relative to the crop box center. You can also click the Crop Frame tool in the Tools panel (Figure 4.8) to activate it: Place the Crop Frame tool over the photograph, and then click and drag to make a free-form crop (as you would using the Crop tool in Photoshop). When you have finished defining a crop, the Crop Overlay tool returns to its docked position in the Tools panel. Click the Close button to apply a crop and exit the Tools panel (or just press R). To reset the Crop Overlay, click the Reset button or use RATE (Mac) or Cett Att R (PC). Whenever you drag one of the crop handles to make a non-rotational crop, you will see a dividing-thirds grid overlay the image (as can be seen in Figure 4.9). The dividing-thirds overlay lines can be useful as an aid to composition, though you can also choose from other custom overlay options. In the Toolbar, you can choose for the Tool overlay to always be on, off, or in Auto mode, when it will be visible only when you drag one of the crop handles.

Rotating a crop

To rotate and crop an image at the same time, move outside the crop bounding box, click, and drag. Alternatively, you can use the Angle slider in the Tools panel, or the Straighten tool, to straighten a photograph. In either case, the image rotates relative to the crop bounding box (which always remains level).

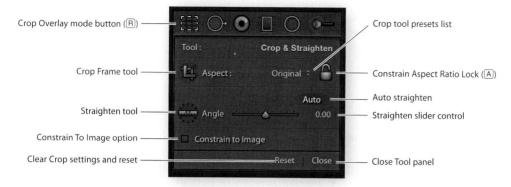

Figure 4.8 A close-up view of the Crop Overlay tool panel controls.

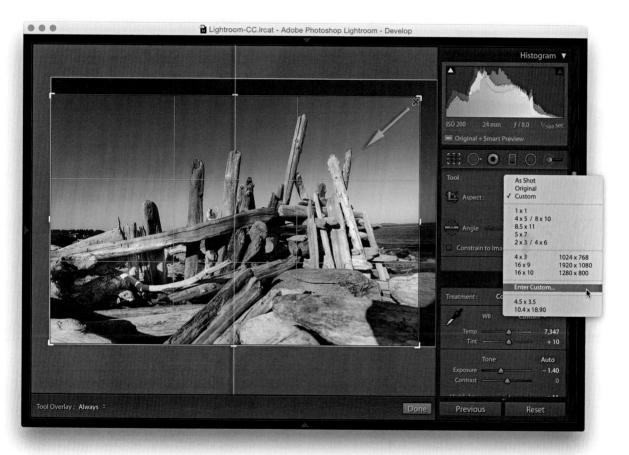

Figure 4.9 An example of a crop overlay being applied to an image.

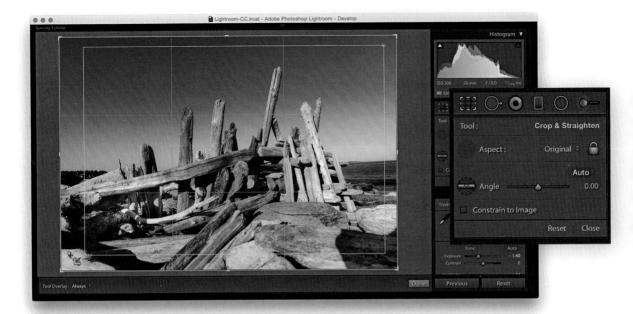

1. I clicked to select the Crop Overlay tool, then simply dragged to apply a free-form crop to the photograph. When I released the click, the Crop Overlay tool returned to its usual location in the Tools panel.

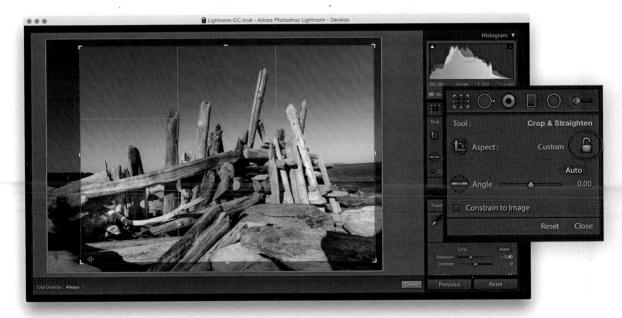

2. First, I clicked the Constrain Aspect Ratio Lock button (circled) to unlock. This allowed me to then click a corner or side handle of the crop bounding box and drag to reposition the crop without restriction.

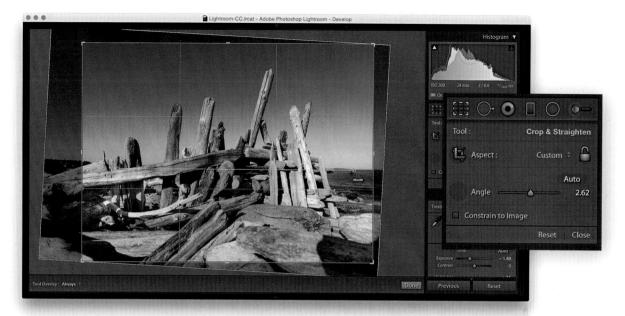

3. I then clicked to select the Straighten tool and dragged it across the image to define a straighten angle (you can also adjust the straighten angle by using the Angle slider in the Tools panel).

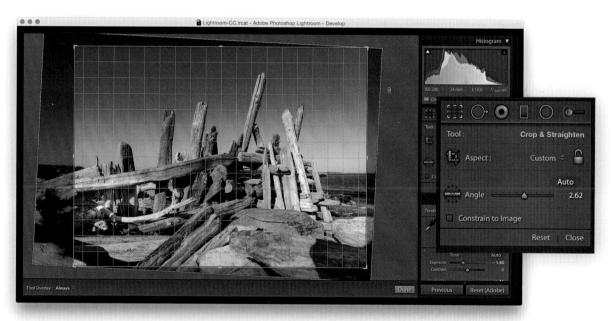

4. You can also straighten a photograph by clicking anywhere outside the crop bounding box and dragging. As you can see here, when I did so, a fine grid appeared. You can use the grid lines to help align the rotation to elements within the photograph.

Constrain to image cropping

Because Lightroom can apply lens profile corrections and transform adjustments, profile-corrected or transformed images can end up being distorted to some degree. For example, when you apply a lens profile correction, the crop is normally constrained to the warped image bounds. However, extreme Upright adjustments or manual transforms can result in white padded areas showing around the outer bounds of the image. Checking the Constrain to Image option ensures the crop bounds never exceed the image bounds (Figure 4.10).

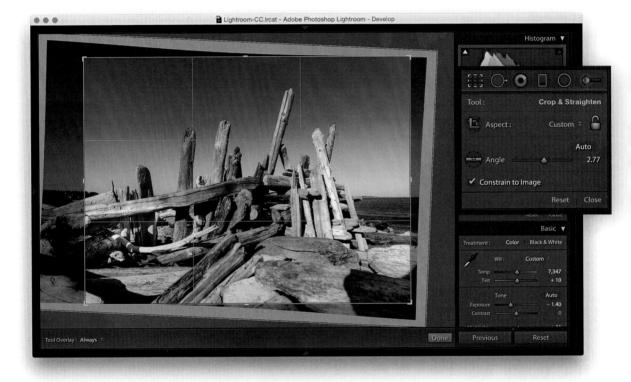

Figure 4.10 Checking the Constrain to Image box in the Crop Overlay and Lens Corrections panel settings automatically constrains the warp to the image bounds.

Auto straightening

The Crop Overlay tool features an Auto button. This essentially provides the same function as a Level Upright adjustment applied via the Transform panel (which is discussed later in this chapter). The following steps demonstrate applying the Auto option being applied.

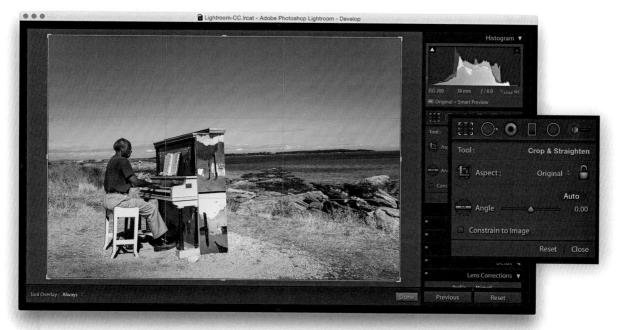

1. I began by selecting the Crop Overlay tool.

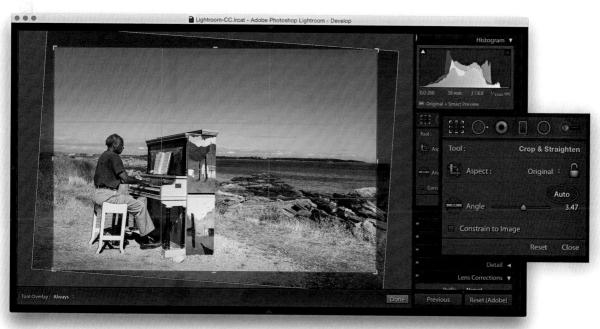

2. I then clicked the Auto button (circled) to auto straighten the photograph. This applied the same type of adjustment as a Level Upright adjustment in the Lens Corrections panel.

NOTE

Whenever you enter large numbers for a custom crop aspect ratio (anything greater than 20), you will notice that as these are entered, the decimal place will shift over to the left. So, for example, if you type in a screen display ratio of, say, 1675 x 1150, this will actually set a ratio of 16.75 x 11.5. When you enter crop ratio units, Lightroom always tries to reduce these to the simplest ratio expression possible.

Crop aspect ratios

When the Constrain Aspect Ratio Lock is on (A) toggles the lock closed/on and open/off), the current crop aspect ratio will be preserved as you apply a crop (Figure 4.11). If no crop has been applied yet, the aspect ratio will be locked to the current image proportions. So, if you click the crop bounding box and drag any of the handles, such as a corner handle, the crop area will match the exact proportions of the current image. In Crop Overlay mode, you can use the X key to rotate the aspect ratio (i.e., you can change a current landscape aspect ratio crop to a portrait crop). Also, when the Crop Aspect Ratio Lock is on, you can quite easily flip the aspect ratio from landscape to portrait (or vice versa) by dragging the corner handle in such a way as to force the aspect ratio to switch. You can select any of the aspect ratio presets from the Aspect Ratio list or choose Enter Custom, which opens the dialog shown in Figure 4.12. Here, you can enter settings for a new custom aspect ratio setting and click OK to add this setting to the Crop presets list. Hold down the Alt key when changing the aspect ratio to have the Crop Overlay fill the current image bounds.

Repositioning a crop

The Crop tool in Lightroom always restricts the cropping to within the boundary of the document. Unlike Photoshop, you cannot drag the Crop tool outside the image

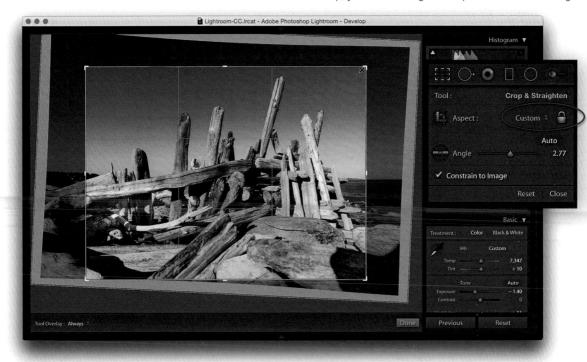

Figure 4.11 The Constrain Aspect Ratio Lock is closed (circled), which means the crop bounding box is locked to the current aspect ratio.

Figure 4.12 The Enter Custom Aspect Ratio dialog.

document area to increase the canvas area. You can crop an image only within the confines of the photograph (plus padded areas). So, however you drag or rotate the crop, you will always be applying the crop to the inside of the picture. When you click inside the crop bounding box, the pointer changes to show the Hand tool, which allows you to scroll the image relative to the crop. As you drag, the crop box remains static and the image moves behind the crop.

Crop guide overlays

In the Tools \Rightarrow Crop Guide Overlay menu, there are seven crop guide overlays you can choose from. These range from the simple grid crop guide overlay shown earlier, to other more exotic overlay designs, such as a Diagonal crop and an Aspect Ratios crop guide overlay. The Thirds overlay provides a standard reference that you may already be used to seeing in say, a camera viewfinder screen, while the Golden Ratio and Golden Spiral crop overlays offer new ways to preview a photo as you compose a crop. With regards to the Aspect Ratios overlay, you can go to the Tools \Rightarrow Crop Guide Overlay menu and select Choose Aspect Ratios to open the dialog shown in **Figure 4.13**. This lets you select which aspect ratio options you want made visible. Regardless of which crop guide overlay you choose, the Grid overlay design shown in Step 4 on page 167 always appears whenever you rotate a crop by dragging outside the crop bounding box. The Grid overlay is useful in these instances because it can help you align the horizontal or vertical lines when straightening an image.

When working in Crop Overlay mode, you can use the ② keyboard shortcut to cycle through the crop guide overlays and the �Shift)③ shortcut to cycle through the crop guide orientation for the individual Triangle and Golden Spiral crop overlay modes. Triangle includes two modes and Golden Spiral has eight. The cycled overlay options can be accessed via the Tools ⇒ Crop Guide Overlay menu (**Figure 4.14**). You can use this to choose which options are available as you cycle through them using the ② keyboard shortcut.

So, why should you want to use these different crop overlays? Cropping is partly about trimming away parts of the picture that are distracting and aligning straight edges, but it is also about creating a nice-looking, well-balanced visual composition of the picture content. These alternative crop overlays can, therefore, help you compose better when applying a crop.

Figure 4.13 The Choose Aspect Ratios dialog.

Figure 4.14 This shows the Tools ⇒ Crop Guide Overlay ⇒ Cycled Overlays options.

Figure 4.15 The Tool Overlay menu options.

Canceling a crop

You can use the Esc key to revert to a previously applied setting made during a crop session. Let's say you have a photo that has been cropped and rotated slightly. If you were to alter the crop by adjusting the crop ratio or crop angle and then press the Esc key, you would be taken back to the original crop setting. If, on the other hand, you adjusted the crop, exited the crop mode for this photo, started editing photos in another folder, and returned later to this picture, the new crop setting would be the one Lightroom reverts back to if you readjusted the crop and pressed the Esc key. Essentially, canceling a crop is not the same as resetting the Crop Overlay. Canceling takes you back to how the image was before you edited it, which might include a previously applied crop adjustment.

Tool Overlay menu

The Tool Overlay options can be accessed via the Toolbar at the bottom of the content area or the Tools menu (**Figure 4.15**). The Tool Overlay menu can be used to control the behavior of on-screen overlays. Different options appear when the Spot Removal, Red Eye, Graduated Filter, Radial Filter, or Adjustment Brush are made active. I will be covering these in more detail toward the end of the chapter. But for now let's just look at the Tool Overlay menu options in the context of the Crop Overlay tool.

The Tool Overlay options

The Tool Overlay options in Crop Overlay mode determine the visibility of the crop overlays. If you select the Always Show menu option, the crop overlay remains visible at all times. If you want to hide the crop overlays, select Never Show. The Auto Show mode makes the tool overlays visible only when you hover over the content area. In other words, the Crop Overlay guides will disappear from view whenever you roll the pointer outside the image area, such as to the top panel menu.

Another way to work with the tool overlay show/hide feature is to use the <code>\mathbb{H}\subset Shift(H)</code> (Mac) or <code>Ctrl(Shift(H))</code> (PC) keyboard shortcut, which acts as a toggle for switching between the Always Show and Never Show options. An easier-to-remember (and more flexible) shortcut is to simply use the <code>H</code> key. This toggles between the Auto Show and Never Show modes. Or, it toggles between the Always Show and Never Show modes (depending on whether you had Auto Show or Always Show selected first).

Quick Develop cropping

The Crop Ratio menu options in the Library module Quick Develop panel (**Figure 4.16**) can be used to apply a preset crop ratio that trims the photo evenly on either side. Cropping is something you usually want to apply manually to each photo individually, but having a quick way to change the aspect ratio for a bunch of photos in one go might be quite useful for someone like a school portrait photographer who wants to quickly prepare a set of portraits using a fixed-aspect ratio setting. As with the Develop module Crop Overlay options, you can click the Enter Custom item in the Crop Ratio pop-up menu to create your own Custom Aspect Ratio crop settings for use in the Quick Develop panel (Figure 4.9). In the **Figure 4.17** example below, I selected an 8.5 x 11 proportional crop and applied this to the selected photograph. The custom crop settings are also shared between the Develop module and the Quick Develop panel in the Library module.

Figure 4.16 The Quick Develop Crop Ratio menu contains a list of presets.

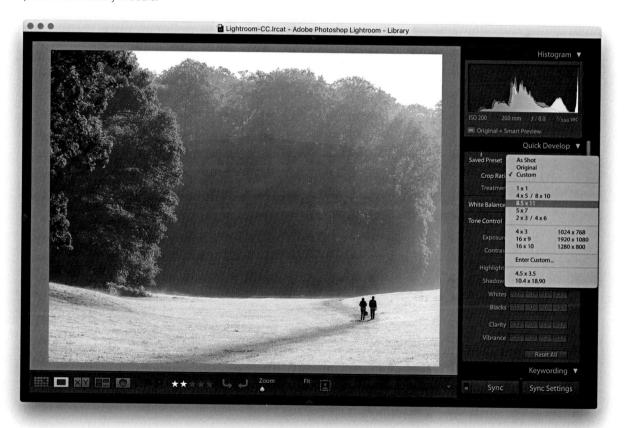

Figure 4.17 I applied an 8.5×11 proportional crop to this landscape image, which originally had a 2×3 aspect ratio.

TIP

When setting the white balance, as you zoom out, the magnified pixel view shows more and more of the image (this is good for averaging large areas for high-ISO images). As you zoom in, the magnified pixel view shows less and less of the image (which is good for picking out small, specific areas). In other words, the white balance sample area is zoomlevel dependent.

Figure 4.19 The White Balance tool undocked from the Basic panel.

The Basic panel

When working with the Basic panel tools, remember that you can click the inside panel edge and drag to adjust the width of the side panels. **Figure 4.18** shows the Basic panel in normal and expanded form. A wider panel offers you more precision when dragging the sliders. If you also hold down the Alt key as you drag, you can drag the panel as wide as you like. (Incidentally, this width resizing is possible with all side panels.)

Figure 4.18 Lightroom panels can be expanded by dragging on the side edge.

White Balance tool

The Temp and Tint sliders in the White Balance (WB) section can be used to precisely adjust the white balance of a photograph. With these, you can color-correct most images or apply alternative white balances to your photos. There is also a White Balance tool. You can activate this by clicking it or by using the W shortcut. This unlocks the tool from its docked location and lets you click anywhere in the image to set a new white balance (Figure 4.19). The floating loupe magnifier provides an extreme close-up of the pixels you are measuring, which can really help you select the correct pixel reading. As you hover over an image, you will also see the RGB readout values for the point immediately beneath the pointer (Figure 4.20), as well as at the bottom of the Histogram panel. These RGB readings are shown as percentage values and can help you locate and check the color readings (if the RGB values are all close enough to the same value, the color can be regarded as neutral). You can also use the ISShift (Mac) or Ciri Shift (PC) keyboard shortcut to apply Auto White Balance. If the Auto Dismiss option is disabled in the Toolbar (see Step 1), all you have to do is click W to activate the White Balance tool and continue clicking with the tool until you find the right setting. You can then use the Esc key or the W key again to cancel working with the White Balance tool and return it to its normal docked position in the Basic panel.

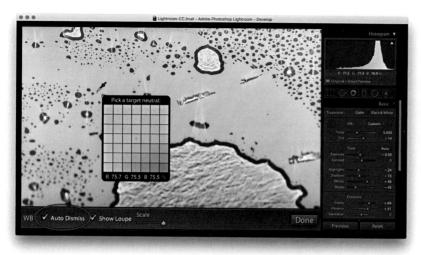

1. To make a white balance adjustment, I selected an area of the picture that was neutral in color (but not a bright white area). If the Auto Dismiss box (circled) in the Toolbar is checked, the White Balance tool automatically returns to its docked position in the Basic panel after a single click. If the Auto Dismiss box is unchecked, you can click and keep clicking with the White Balance tool until you are satisfied with the white balance adjustment that you have made.

2. The Show Loupe check box allows you to toggle displaying the loupe that appears below the White Balance tool. You can adjust the loupe scale setting by dragging the slider next to the Show Loupe item in the Toolbar. This slider adjusts the sample grid pixel size, and dragging the slider to the right increases the number of pixels used when sampling a white balance point measurement. Increasing the pixel sample size can be beneficial if you want to aggregate the pixel readings more, such as when you are sampling a really noisy image and you do not want the white balance measurement to be unduly affected by the pixels that contain color noise or other artifacts.

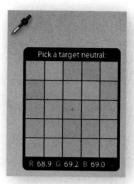

Figure 4.20 A close-up view of the Loupe magnifier and RGB percentage readouts below.

NOTE

Do we still need the 0 to 255 scale in the readout section? I know some people say that they would like to see this as an option, but there are no real valid reasons for doing so. The 0 to 255 scale came into existence only because of the way the number of levels are calculated for pixel-rendered 8-bit images. The percentage scale (in my view) makes it easier to interpret what the Eyedropper readout numbers mean. Having said that, when you view a photo with Soft Proofing turned on. the RGB numbers in the Histogram display use the 0 to 255 scale (see pages 483 to 485).

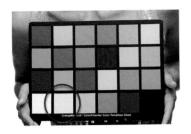

Figure 4.21 The X-Rite/Gretag Macbeth ColorChecker chart. To take a white balance reading in Lightroom, click the light gray patch next to the white patch.

White Balance corrections

In most shooting environments, once you have found the right white balance, all the other colors will tend to fit into place. You can help get the white balance right in-camera by choosing a fixed or Auto setting. Or, you can use a white balance or color checker chart (like the X-Rite/Gretag Macbeth ColorChecker chart shown in **Figure 4.21**) as a preparatory step that will help you make a more accurate, measured reading later in Lightroom. A camera Auto White Balance setting may do a good job, but it really depends on the camera you are using, because even the best cameras will not know how to handle every lighting situation. **Figure 4.22** shows a scene with mixed lighting conditions. This photograph could be processed for either the exterior daylight or the tungsten lighting indoors, and each could be said to be correct. In situations like this, you cannot always rely on the sames of Auto White Balance setting; you have to decide for yourself which

be processed for either the exterior daylight or the tungsten lighting indoors, and each could be said to be correct. In situations like this, you cannot always rely on the camera's Auto White Balance setting; you have to decide for yourself which setting works best. This is where the White Balance tool () can come in handy. The trick is to analyze the picture and look for an area in the scene that should be a neutral, nonspecular, textural highlight. Aim to select something that should be a neutral light gray. If you click on an area that is too bright, there may be some clipping in one or more of the color channels, which can result in a false white balance measurement and consequently make an inaccurate adjustment.

Figure 4.22 This image shows two possible white balances: one measured for the indoor lighting (left) and one measured for the outside daylight (right).

Creative white balance adjustments

Who is to say if a correct white balance is any better than an incorrect one? Before digital capture and the ability to set accurate white balances, photographers could only choose between shooting with daylight-balanced or tungsten-balanced film emulsions. Most would simply accept whatever colors the film produced. With digital cameras, it is easy to set the white balance precisely. There may be times, such as when shooting catalog work, when it is critical to get the color exactly right from camera to screen to print. But you do not always have to obsess over the color temperature at the capture stage on every type of image. You have the freedom to interpret a master raw file any way you like, and can change the mood in a photograph completely by setting the white balance to an alternative, incorrect setting (**Figure 4.23**). The key point to emphasize here is that the White Balance controls are used to assign the white point as opposed to creating a white balance. Dragging the Temp slider to the right makes an image warmer and dragging to the left makes it cooler.

TIP

Warning! If you shoot using a studio flash system (not with the built-in flash) and have the camera set to Auto White Balance, the white balance reading will be influenced by the ambient light, such as the tungsten modeling lights instead of the strobe flash.

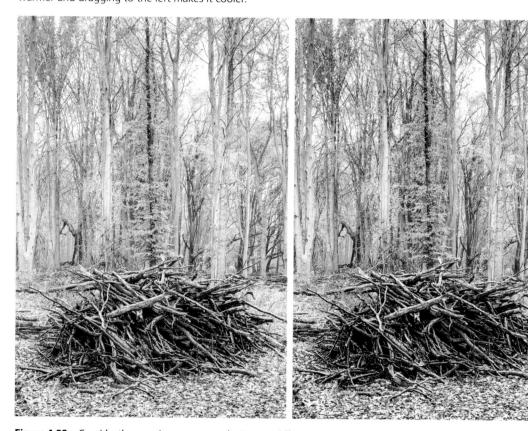

Figure 4.23 Consider the same image processed using two different white balance settings. It is often largely a matter of personal judgment when deciding which version you prefer, because neither example has what could be described as a "correct" white balance.

White balance and localized adjustments

The Basic panel White Balance tool takes into account locally applied white balance adjustments. For example, if you use the Graduated Filter tool to apply a cooling white balance, when you then click with the White Balance tool, it ignores localized Temp or Tint adjustments to ensure the pixels where you click are neutralized.

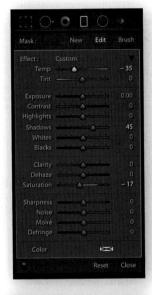

1 I applied a cooling Temp adjusted Graduated Filter to the sky in this image.

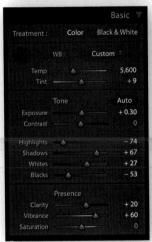

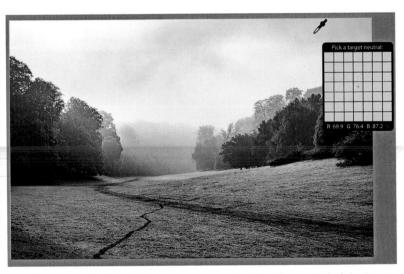

2 When I selected the White Balance tool and clicked the top half of the image, the new, calculated white balance adjustment ignored the locally applied Temp adjustment and applied a cooler white balance as if there were no filter effect.

Independent auto white balance adjustments

As well as selecting Auto from the White Balance menu, you can use the **Ashift** key plus a double-click on the Temp and Tint sliders to set these independently.

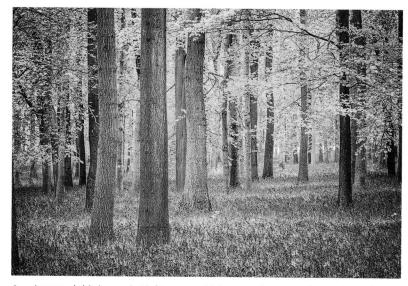

1 I opened this image in Lightroom, which currently shows the As Shot white balance.

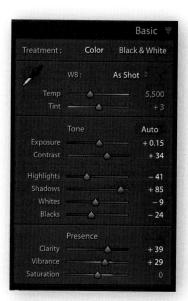

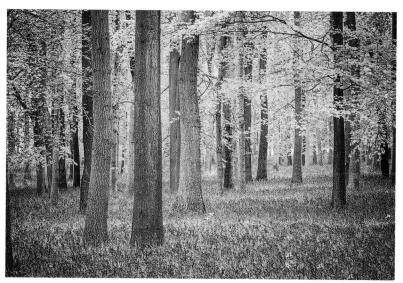

2 I held down the <u>♠Shift</u> key and double-clicked the Tint slider. This auto-set the Tint slider only to apply an auto-calculated "Tint only" White Balance setting.

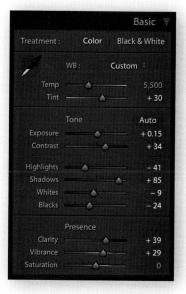

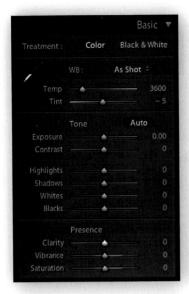

Figure 4.24 The Basic panel controls using Version 4.

The Basic panel tone-editing controls

The tone adjustment controls are designed to be applied in the order they appear listed in the Basic panel (**Figure 4.24**), although there is no reason why you can't adjust them out of order, should you prefer. In the following section, I refer to the Version 4 slider controls (although these are exactly the same as Version 3). Here, then, is a summary of what the Basic Panel sliders do.

Exposure

The Exposure slider is both a midtone brightness and highlight clipping adjustment. This means that when evaluating an image, you use the Exposure slider to adjust the image to make it the right brightness. You drag to the left to darken. However, if you set the Exposure too dark, you will not be exploiting the full tonal range of the highlight areas. As you drag to the right to lighten, the image becomes progressively lighter. As you approach the point where the highlights might potentially become clipped, the brightening adjustment smoothly ramps off toward the highlight end, which helps preserve detail in the highlight areas. As you push the Exposure slider further, only then will you start to clip the brightest highlights. Mainly, you want to use the Exposure to get the image brightness looking right. From there on, no matter what you do with the other tone sliders, the midpoint brightness value will not shift too much until you further adjust the Exposure slider.

The Exposure slider's response correlates quite well to the way film behaves, but is also dependent on the image content. With Version 4, as you increase Exposure, there is more of a "soft clipping" of the highlights as the highlight clipping threshold point is reached. Additional increases in Exposure will see the highlights roll off smoothly instead of being clipped. As you further increase Exposure, you will, of course, see more and more pixels mapping to pure white, but overall, lightening Exposure adjustments should result in smoother highlights and reduced color shifts. You should also find that it provides you with about an extra stop of exposure latitude compared to editing with the Version 1/Version 2 Exposure slider.

If you hold down the Alt key as you drag the Exposure slider, you will see a threshold mode view, which indicates the highlight clipping. This may be seen as a useful guide to where clipping may be taking place, but I do not recommend you get too hung up about the highlight clipping when adjusting the Exposure. When using the Version 4 Exposure slider, you just need to judge the image brightness visually and reserve using the Alt key threshold view for when you adjust the Whites slider.

Contrast

The Contrast slider can be used to control the global contrast. As you drag the slider to the right, an increased contrast adjustment will make the shadows darker and the highlights lighter. Dragging the slider to the left reduces the contrast adjustment, making the shadows lighter and the highlights darker. The Contrast slider does adapt slightly according to each image and allows you to better differentiate the tone information in the tone areas that predominate. For low-key images, the midpoint is offset slightly toward the shadows, and with high-key images, the midpoint is offset toward the highlights. **Figure 4.25** shows how the contrast adjustment range adapts for a low key and a high key image, where the midpoint will sometimes be offset, depending on the image content. Note that increasing the contrast in Lightroom does not produce the same kind of unusual color shifts that you sometimes see in Photoshop when you use Curves. This is because the Lightroom/Camera Raw processing manages to prevent such hue shifts as you increase the contrast.

Essentially, you want to first use the Exposure slider to set the Exposure brightness, and then adjust the Contrast slider according to how much the tones in the image you are adjusting need compressing or expanding. The remaining sliders can then be used to make further tweaks after these two initial image adjustments have been made.

One of the things that tends to confuse some people is the fact that, in addition to there being a Contrast slider in the Basic panel, there is a separate Tone Curve panel that can be used to adjust the contrast. The adjustments you make using the Contrast slider in the Basic panel are a basic, preliminary kind of tone curve adjustment. The thing to appreciate here is that when you go to the Tone Curve panel (where the default curve is a linear curve shape), the adjustments you apply here are applied relative to the contrast adjustment that has already been applied in the Basic panel. The Tone Curve provides a secondary fine-tuning control.

Highlights and Shadows

The Highlights and Shadows sliders are symmetrical in the way they behave, allowing you to lighten or darken the highlight or shadow areas. For example, you can use a negative Highlights adjustment to restore more highlight detail, or a positive adjustment to deliberately blow out the highlights. These sliders only affect the tone regions on either side of the midtone point. To be precise, the range of these sliders does extend beyond the midtone value, but the greatest effect is concentrated in the highlight tones for the Highlights slider and the shadow tones for the Shadows slider. Adjustments in the +/- 50% range will have a normal type effect when lightening or darkening, but as you apply adjustments that are greater than this, the lightening or darkening adjustments are applied via a halo mask (this is similar to the method used in HDR tone mapping). The thing to watch out for here is that as you apply a strong effect, the underlying halos

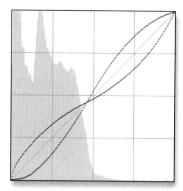

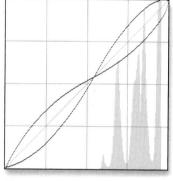

Figure 4.25 Compare the effective Contrast curve range for the Contrast slider with a low key image (top) and high key image (below).

can become noticeable. The goal has been to make the halo mask as unobtrusive as possible. For the most part, it is quite well disguised, but when pushed to extremes, it can be possible to detect halos.

Typically, after setting the Exposure and Contrast, you will then use the Highlights and Shadows sliders to enhance the highlight and shadow areas as necessary. Here again, it is possible to hold down the Alt key to reveal a threshold view as you adjust the Highlights and Shadows sliders. There may be some potential value in doing so at this stage, but I would urge you to mainly judge the appearance of the preview image for the nuances that can be achieved in the shadow and highlight regions rather than what a threshold analysis is telling you. The Highlights and Shadows controls also inform the whites and blacks how much tonal compression or expansion has been applied and the Whites and Blacks controls will adjust their ranges automatically taking this into account.

Whites and Blacks

In many cases, the Exposure, Contrast, Highlights, and Shadows adjustments may be all that are needed to make a good tone correction. Meanwhile, the Whites and Blacks sliders should be regarded as fine-tuning adjustments that are usually adjusted last. Here, it can definitely be useful to hold down the Alt key to reveal a threshold view, as this will allow you to set the white and black clipping points more precisely. To darken the blacks, drag the Blacks slider to the left and drag to the right when you wish to lighten. Blacks adjustments are auto-calculated based on the contrast range of each individual image. The Blacks range is adaptive and auto-calculated based on the image content. Where you have a low-contrast image, the Blacks adjustment will become increasingly aggressive as you drag the Blacks slider toward a –100 value. This means that you end up with more range, but at the expense of some precision as you attempt to crush the darkest tones.

Auto Whites and Blacks adjustments

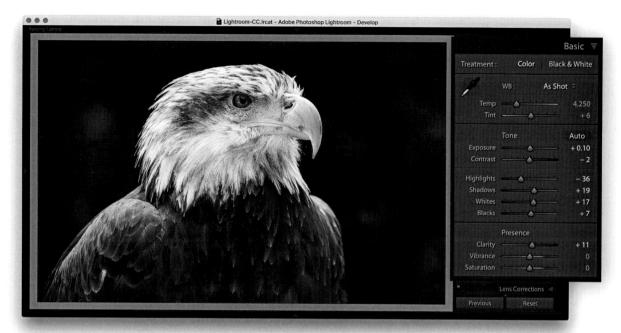

1 I started with a full-frame view of a photograph and then **☆Shift** + double-clicked the Whites and Blacks sliders to auto-set the Whites and Blacks sliders.

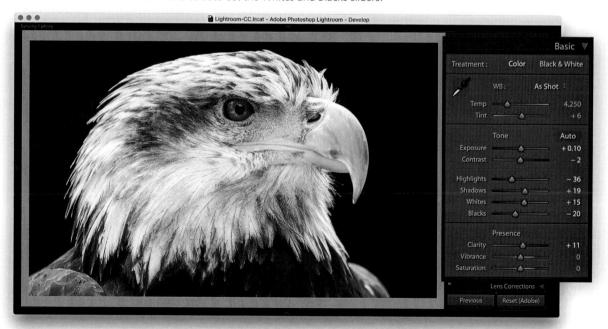

2 I then cropped the image to focus more on the eagle's head. When I ⚠Shift + double-clicked the Whites and Blacks sliders again, different values were computed based on the tighter image crop.

Figure 4.26 The Auto Tone button (circled) can be used to apply an instant auto correction.

General Auto Tone adjustments

The Auto Tone setting (��U [Mac] or Ctrl U [PC]) can work well on a great many images as a quick-fix tone adjustment (circled in **Figure 4.26**). It automatically sets the Exposure, Contrast, Highlights, Shadows, Whites, and Blacks. And, as just mentioned, you can also use Shift plus a double-click to auto-set these sliders independently. From there, you can adjust any of the Basic panel sliders to manually fine-tune an auto adjustment. An Auto Tone adjustment can be undone by double-clicking the Tone button next to Auto, or you can use the ��Shift (Mac) or Ctrl Shift (PC) shortcut to reset everything. In addition, the Auto Exposure preset has been improved over a number of versions of Lightroom. The results you see should be more consistent from image to image, as well as more consistent across different image output sizes (as set in the Workflow options). For the most part, you should find that the Auto Exposure results appear to produce more or less the same results as in earlier versions of Lightroom. However, with over-bright images, the auto-setting results will now be noticeably tamer.

An Auto Tone adjustment can sometimes make an instant improvement. Or it may not do much at all because the tone adjustments were close to being correct anyway. It is unfair to expect an automatic function such as this to perform flaw-lessly every time, but for the most part, I do find the Auto Tone can still be a bit hit or miss. Auto Tone can sometimes produce decent automatic adjustments and provide an okay starting point for newly imported photos. However, you may often see less-than-perfect results. Photographs of general subjects—such as landscapes, portraits, and most photos shot using the camera auto-exposure settings—may be improved by using Auto Tone. However, subjects shot under controlled lighting conditions, such as studio shots, can often look worse. A lot of the time it really depends on the type of photography that you do as to whether an Auto Tone adjustment can help or not. Even if Auto Tone does not always produce perfect results, what it does produce can often be a useful starting point for making further edit adjustments.

Auto Tone can also be included as part of a Develop preset, allowing you to import images with Auto Tone applied right from the start.

Basic panel adjustments workflow

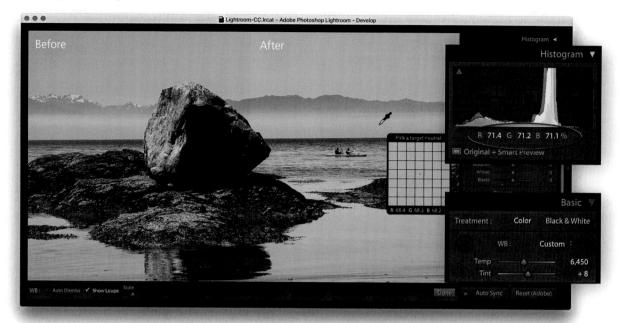

1. To start with, I selected the White Balance tool (W) and clicked a nonreflective neutral color to set the white balance. The RGB percentage readouts where I clicked with the White Balance tool now show a more neutral color balance.

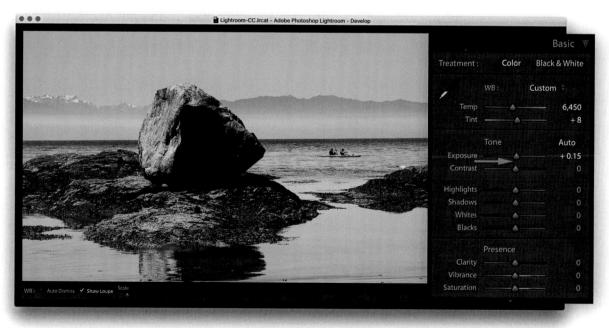

2. I dragged the Exposure slider to the right to lighten the image slightly.

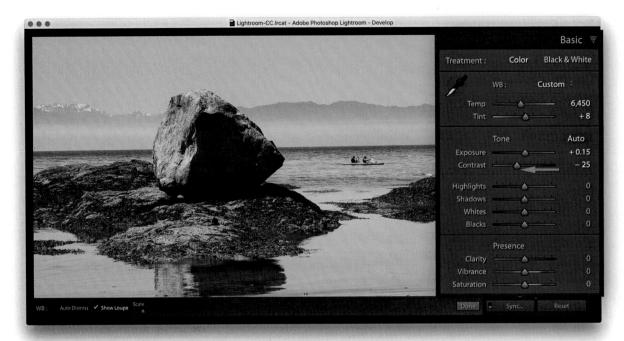

3. I then dragged the Contrast slider to the left to decrease the tone contrast.

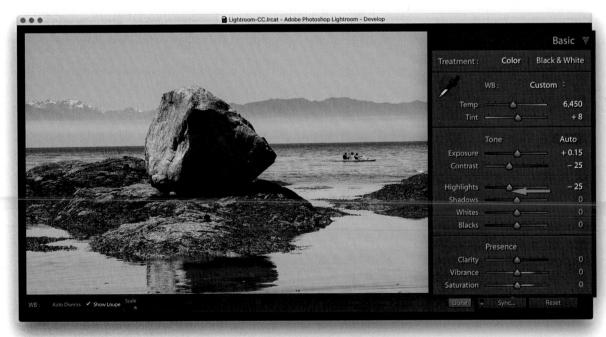

4. Once the Exposure and Contrast had been set, I dragged the Highlights slider to the left to bring out more detail in the midtone to highlight regions of the photo.

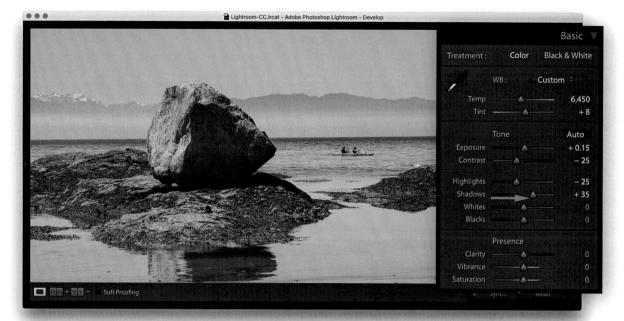

5. Here, I dragged the Shadows slider to the right to lighten the shadow tones.

6. I now needed to fine-tune the highlight and shadow clipping points. To do this, I adjusted the Whites and Blacks sliders as shown. At this stage, it can be useful to hold down the Alt key to see a threshold clipping preview for the whites and blacks. It is usually best to allow the shadows to just start to clip. In this example, you can see the threshold preview as I adjusted the Blacks slider.

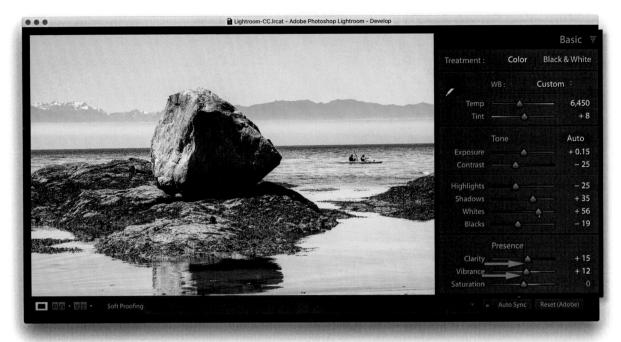

7. In this final version, you can see the result of the Whites and Blacks adjustment. I also added +15 Clarity to boost the midtone contrast and added +12 Vibrance.

Histogram panel

When you are in the Develop module, the Histogram panel is displayed in the top-right corner. (The Library Module also contains a Histogram panel, but the histogram in the Develop module has more direct relevance when you're making Develop adjustments.) Basically, the Histogram panel provides you with information about the distribution of the levels in an image and the means to turn the clipping previews for the shadows and highlights on or off. These previews indicate where there might be any shadow or highlight clipping in the image. You can either roll over or click the buttons circled in **Figure 4.27** or press J to toggle displaying the clipping preview. A solid blue color overlay in the preview image indicates where there is shadow clipping, such as the on the chimneys in Figure 4.27, and the solid red overlay color indicates any highlight clipping, such as on the lighthouse and building fronts in the example. The clipping warning triangles themselves also indicate which colors in the red, green, or blue channels (or combination of channels) are initially being clipped most; the triangle colors eventually change to white as all three channels become clipped. If you want to hide the Histogram panel, you can use the \(\mathbb{H} \) (Mac) or \(\text{Ctrl} \) (PC) shortcut to toggle collapsing and expanding this panel. In the case of the Figure 4.27 image, the clipping preview showed blue channel clipping in the shadows and yellow (red and green color channel) clipping in the highlight regions.

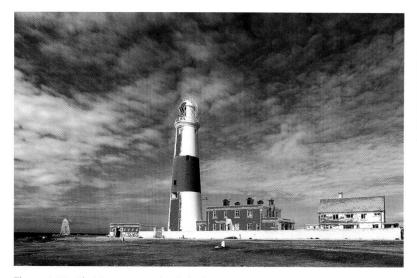

Figure 4.27 The Histogram panel with the clipping warning triangles highlighted.

If you are editing an imported JPEG, PNG, PSD, or TIFF image, the Lightroom histogram represents the tone range based on the file's native color space. If, however, you are editing a raw capture, there are no gamut constraints until you export the image as a JPEG, TIFF, or PSD file, at which point the gamut space limit is determined by the choice of RGB output space. The sRGB space has a small gamut, and some of the colors may be clipped when you export. Display P3 matches the color gamut of the latest Mac screens and is a little bigger than sRGB. Adobe RGB is a popular, commonly used color space. ProPhoto RGB has the widest gamut of all. Incidentally, Lightroom uses a wide-gamut RGB space similar to ProPhoto RGB to do all the image calculations, and the histogram and RGB percentage readouts are based on this native Lightroom RGB space. To find out more about the Lightroom RGB space, please refer to the book's website.

As you roll the pointer over an image, the Histogram display changes from displaying the camera data information to showing the RGB values (**Figure 4.28**). The Histogram information is useful, though only if you know how to interpret it correctly. For example, if you shoot using raw mode, the histogram display on a digital camera is misleading because it is based on what a JPEG capture would record, and the dynamic range of a JPEG capture will always be less than that available from a raw file. If you are shooting raw, the only way to tell if there is any clipping is to inspect the raw image in Lightroom or via Camera Raw in Photoshop. In other words, do not let the camera histogram unduly sway your judgment if you have good reason to believe the camera exposure you are shooting with is correct.

Figure 4.28 A Histogram panel view showing the RGB values.

Figure 4.29 In the Histogram panel view on the left, the highlights needed to be expanded to fill the width of the histogram. In the example on the right, I adjusted the Exposure slider to make the image brighter.

The Histogram panel and image adjustments

As you adjust an image, you can observe how this affects the image levels in the Histogram panel. In **Figure 4.29**, notice how as the Exposure was increased, the levels expanded to the right. Also, as it was increased, the highlights did not clip any further and the midtones were brightened. But, if you push the Exposure adjustment to extremes, the highlights will eventually be forced to clip. You may also find it useful to reference the Histogram panel when adjusting images that appear to be overexposed. As you decrease the Exposure slider, more information should appear in the highlights, and this will be reflected in the histogram display (**Figure 4.30**). However, the ability to recover highlight detail in this way mostly only applies when processing raw images.

Figure 4.30 The Histogram panel view on the left shows the histogram of an overexposed image with shadow and highlight clipping. The example on the right shows how the histogram looked after applying negative Exposure and Highlights adjustments.

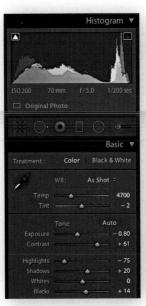

Lightroom also provides optional Lab color readouts. To enable this, right-click in the Histogram panel to access the context menu shown in **Figure 4.31** and select the Show Lab Color Values option. As you hover over the image, you will now see Lab values in place of an RGB readout. With this enabled, you might, for example, want to aim for even a* and b* values when evaluating skintones. However, when soft proofing is switched on, the readout display will always default to RGB values.

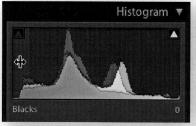

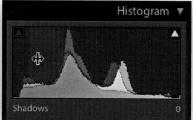

Figure 4.31 The Histogram context menu with the Show Lab Color Values menu option.

Figure 4.32 You can click different sections of the histogram and drag right or left to increase or decrease the setting represented by that particular section of the histogram.

The histogram is more than just an information display. You can also use it to actively adjust the following Basic panel tone slider controls: Exposure, Highlights, Shadows, Whites, and Blacks. As you roll the pointer over the histogram, you will see each of these sections highlighted (**Figure 4.32**). And if you click and drag left or right inside the Histogram panel, you can use this as an alternative way to adjust the Basic panel sliders. You can also double-click these areas of the histogram to reset the values.

Navigating the Basic panel via the keyboard

You can use the < and > keys (or you could refer to these as the , and . keys) to cycle backward or forward through the Basic panel settings, making each active in turn. When a setting is selected, you can use the + and - keys to increase or decrease the unit settings. Holding down the Ashift key when tapping the +/- keys uses larger increments, while holding down the Alt key uses smaller increments. As you do this, you will also see an overlay appear in the content area indicating the adjustments being made (Figure 4.33).

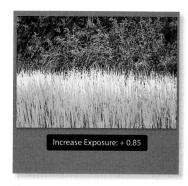

Figure 4.33 A Basic panel settings overlay.

Figure 4.34 Compare an extreme highlight recovery in Version 2 (top) and Version 4 (bottom).

Correcting overexposed images

Lightroom has the ability to reveal highlight detail that might otherwise be hidden. You can often recover seemingly lost highlight information by combining a negative Exposure adjustment with a negative Highlights slider adjustment. Although Lightroom can recover the highlight detail on most images, it has a limited effect on pixel-based images such as JPEGs, PNGs, or TIFFs. This technique produces the best results on raw images, because Lightroom is able to use all of the luminosity information contained in a raw file that is simply waiting for you to access it. In the accompanying example, I was able to recover just over one stop of overexposure, but in some instances it may be possible to recover as much as two stops.

How this works is that Lightroom features an internal technology called *highlight recovery*, which is designed to help recover luminance and color data in the highlight regions whenever the highlight pixels are partially clipped—in other words, when one or more of the red, green, and blue channels are partially clipped, but not all three channels are affected. The highlight recovery process initially looks for luminance detail in the non-missing channel or channels and uses this to build luminance detail in the clipped channel or channels. After that, Lightroom applies a darkening curve to the highlight region only and, in doing so, brings out more detail in the highlight areas with good highlight color rendering that preserves the partial color relationships, as well as the luminance texture in the highlights. There is also less tendency for color detail to quickly fade to neutral gray. This technology is designed to work best with raw files, although JPEG images can sometimes benefit too (but not so much).

The ability to recover overexposed highlight detail is also dependent on the capture abilities of the sensor. Not all sensors are the same, and with some cameras you do have to be very careful not to overexpose. If the highlights are completely blown out in the original image, you will never be able to recover all the detail completely, but using Version 4 (or Version 3), I think you will be pleasantly surprised at the difference when reprocessing some of your older Version 1/Version 2 shots. **Figure 4.34** shows a direct comparison between working in Version 2 and working in Version 4 on an image where the highlights were burned out (and you cannot get much more burned out than shooting directly into the sun).

It is often better to optimize the camera exposure to capture as much of the shadow detail as possible, but without overexposing to the point where you are unable to process important highlight information. I will often ignore the camera or light-meter readings and deliberately overexpose at the time of capture in order to record the maximum amount of levels information and use the combination of negative Exposure and Highlights adjustments when processing the image in Lightroom.

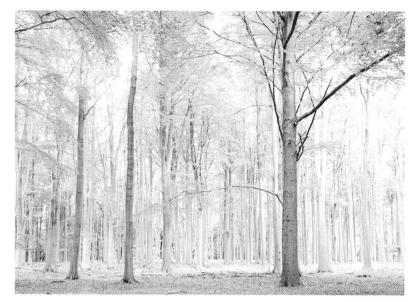

1. This overexposed photograph was initially processed using the default Basic panel settings in the Develop module. The histogram showed severe clipping in the highlights, and you can see here how there is not much detail in the lightest areas. A histogram like this can appear disconcerting until you realize that there is more information contained in the image than appears at first sight.

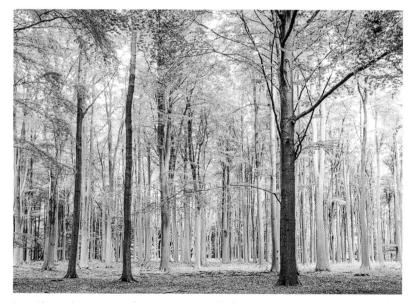

2. The main treatment for an overexposed photo is to apply a combination of negative Exposure and Highlights adjustments, though I mainly used the Exposure slider to achieve the desired darkening.

Correcting underexposed images

Underexposed images present a bigger problem because there will be fewer levels available for you to manipulate, particularly in the shadows. However, the Basic panel controls in Lightroom can be used to brighten an image and lift out the shadow detail. The way you need to approach this is to start by dragging the Exposure slider to the right until the image appears to have about the right brightness. As you do so, do not worry too much about the shadows, because the next step will be to adjust the Shadows slider by dragging this to the right to bring out more detail in the shadow regions of the image. Beyond that, it is all about fine-tuning the remaining sliders. In the example shown here, I needed to reduce the Highlights to preserve tonal detail in the highlight areas, and I also needed to adjust the Blacks slider to compensate for the Shadows adjustment and maintain the right amount of contrast in the darker areas. You will also want to watch out for deteriorating shadow detail, as brightening up a dark photo can reveal problems in the shadows such as tone banding and noise. See Chapter 6 for advice on how best to handle such situations.

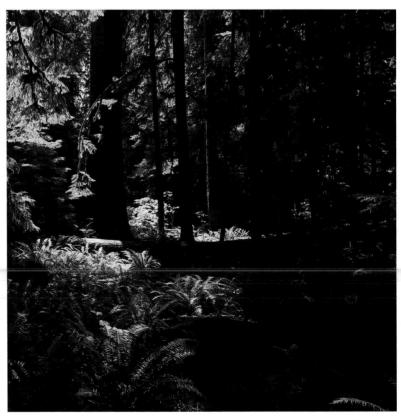

1. To begin with, this image was underexposed and the Basic panel settings remained at the default 0 settings.

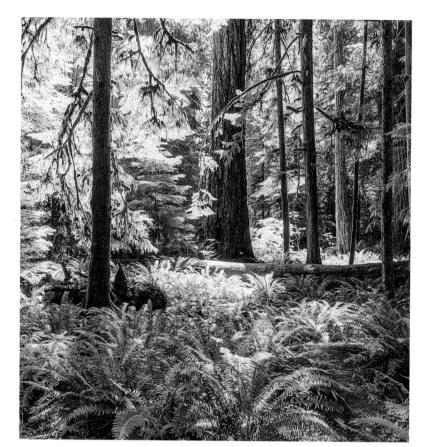

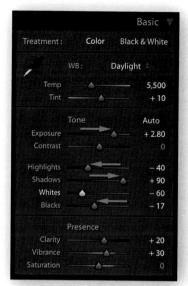

2. I dragged the Exposure slider to the right, which lightened the image considerably. But because I was lightening for the midpoint, this adjustment also over-brightened the highlight areas. To compensate for this, I applied a negative Highlights adjustment. I also added a positive Shadows adjustment to lighten the dark areas of the photo. Finally, I applied a small negative Blacks adjustment to ensure the shadows were clipped correctly. The end result is a photo that is perfectly usable (considering how dark it was before). However, lightening such a dark original will also amplify the noise, which may be especially noticeable in the deep shadow areas.

TIP

The Match Total Exposures command is also available as an option in the Library module Photo □ Develop Settings menu.

Match Total Exposures

You can use the Match Total Exposures command to match the exposure brightness across a series of images that have been selected via the Filmstrip. Match Total Exposures calculates a match value by analyzing and combining the shutter speed, the lens aperture, the ISO, and any camera-set exposure compensation. It then factors in all these camera-set values, combines them with the desired exposure value (as set in the most selected image), and calculates new Lightroom exposure values for all the other selected images. I find this technique can often be used to help average out the exposure brightness in a series of photos where the light levels have gone up and down during a shoot, or where there is a variance in the strobe flash output. The former chief Lightroom architect Mark Hamburg also liked to describe this as a "de-bracketing" command. Basically, if you highlight an individual image in a series and select Match Total Exposures, the other images in that selection will automatically be balanced to match the exposure of the target image.

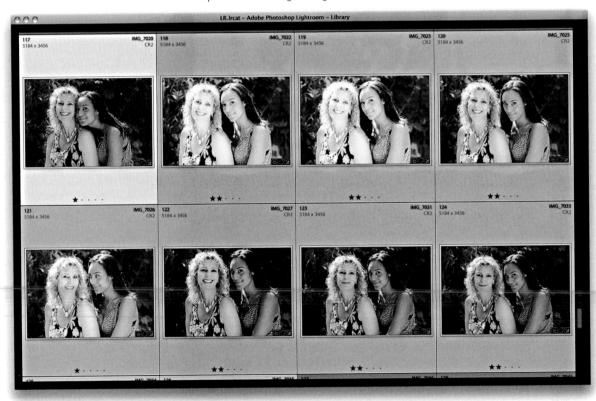

1. To begin, I made a selection of photographs in the Library module Grid view. As you can see, the light levels varied quite a bit when I shot this photo sequence.

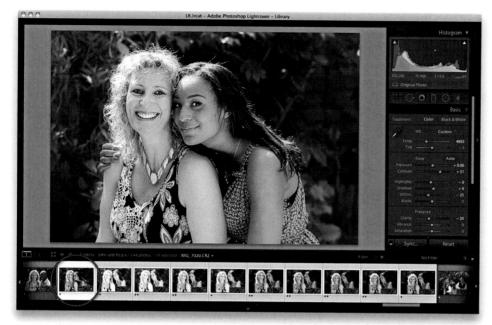

2. I selected the photo with the most correct-looking exposure and made this the most selected, target image. I went to the Develop module and chose Match Total Exposures from the Settings menu (***Alt Shift M** [Mac] or Ctri Alt Shift M** [PC]).

3. In the Library Grid view, you can see the exposure appearance of the selected photos is now more evenly balanced compared to the Library Grid view in Step 1.

Figure 4.35 The top image mostly has reflective highlights that do not contain any detail. In the lower image, the lightest areas are the building and carriages. These contain nonreflective highlights that should not get clipped.

Highlight clipping and Exposure settings

The main objective when optimizing an image is to ensure that the fullest tonal range can be reproduced in print. With this in mind, it is vitally important you set the highlights correctly. If the highlights are clipped, you risk losing important highlight detail in the finished print. And if you don't clip them enough, you will end up with flat-looking prints that lack sparkle.

When setting the Exposure and Whites sliders, you need to be aware of the difference between reflective and nonreflective highlights and how the highlight clipping you apply affects the way the image will eventually print. The two examples shown in **Figure 4.35** help explain these differences. A *reflective highlight* (also referred to as a specular highlight) is a shiny highlight, such as the light reflecting off a glass or metal surface, and contains no highlight detail. It is therefore advisable to clip these highlights so that they are the brightest part of the picture and are printed using the maximum paper white value. In Figure 4.35, the metal sculpture has plenty of reflective highlights, and you would want to make sure these were clipped when making an Exposure adjustment. Nonreflective highlights (also known as nonspecular highlights) need to be treated more carefully. These mostly contain important detail that needs to be preserved. Each print process varies, but in general, whether you are printing to a CMYK press or printing via a desktop inkjet printer, if the nonreflective highlights are set too close to the point where the highlights start to clip, there is a risk that any important detail in these highlights may print as paper white.

It is not too difficult learning how to set the Exposure and Whites sliders correctly. Basically, you just need to be aware of the difference between a reflective and nonreflective highlight, and the clipping issues involved. Most photos will contain at least a few reflective highlights. In practice, I use the highlight clipping preview when adjusting the Whites slider (discussed on page 187) to analyze where the highlight clipping is taking place and toggle between the clipping preview and the Normal image preview to determine if these highlights contain important detail. Alternatively, you can use the clipping warning in the Histogram panel as a guide as to when the highlights are about to become clipped. I usually adjust the Whites slider so that the reflective highlights are slightly clipped, but at the same time, I carefully check the nonreflective highlights to make sure these are protected. To do this, I will either reduce the Highlights slider to protect the highlights or (more likely) adjust the Whites slider so that the reflective highlights are a little less bright than the brightest white.

Clipping the blacks

Setting the blacks is not nearly as critical as adjusting the highlight clipping. It all boils down to a simple question of how much you want to clip the shadows. Do you want to clip them a little, or do you want to clip them a lot?

There is no need to set the shadow point to a specific black value that is lighter than a 0 black unless you are working toward a specific, known print output. Even then, this should not really be necessary, because both Lightroom and Photoshop are able to automatically compensate the shadow point every time you send a file to a desktop printer, or each time you convert an image to CMYK. Just remember this: Lightroom's internal color management system always ensures that the blackest blacks you set in the Basic panel faithfully print as black and preserve all the shadow detail. When you convert an image to CMYK in Photoshop, the color management system in Photoshop similarly makes sure the blackest blacks are translated to a black value that will print successfully on the press.

On page 187, I showed an example of how to use a clipping preview to analyze the shadows and determine where to set the clipping point with the Blacks slider. In this example, the objective was to clip the blacks just a little so as to maximize the tonal range between the shadows and the highlights. It is rarely a good idea to clip the highlights unnecessarily, but clipping the shadows can be done to enhance the contrast. **Figure 4.36** shows an example of deliberately clipping the shadows in an image to go to black. A great many photographers have built their style of photography around the use of deep blacks in their photographs. For example, photographer Greg Gorman regularly processes his black-and-white portraits so that the photographs he shoots against black are printed with a solid black backdrop. Some photographs, such as **Figure 4.37**, may contain important information in the shadows. In this example, a lot of information in the shadow region needs to be preserved. The last thing I would want to do here would be to clip the blacks too aggressively, as this might result in important shadow detail becoming lost.

Figure 4.37 Here is an example of a photograph with predominantly dark tones. When adjusting this photo, it would be important to make sure the blacks were not clipped any more than necessary to produce good, strong blacks in the picture.

Figure 4.36 In this photo, the Blacks slider was dragged to the left to deliberately clip the shadows to black.

TIP

You can search for Photo Merge HDR images by creating a smart collection that filters photos that are both DNG files and have the -HDR suffix.

Figure 4.38 The Metadata panel in DNG mode showing DNG information for a Photo Merge HDR DNG file.

Creating HDR photos using Photo Merge

The Photo Merge feature can be used to process raw or non-raw images to generate either high dynamic range (HDR) or panorama images, which are saved as master DNG files. Let's start though by looking at how Photo Merge can be used to create HDR DNGs.

The principles here are the same as when using the Merge to HDR Pro method in Photoshop. You need to select two or more photos of a subject that has been photographed using different exposure settings and shot using the same format—either raw or JPEG. You can even use the Photo Merge feature when only Smart Previews are available. The photographs need to be shot from the same position, ideally, with the camera firmly mounted on a tripod. When making the exposures, the lens aperture must remain fixed, and you adjust the exposure only by varying the time duration. You can shoot a bracketed sequence of two, three, five, or seven images, where the exposures can be bracketed in two-stop increments (or even wider). According to the engineers, a DNG Photo Merge can be really effective when processing just two image exposures; for example, you might have a landscape subject and one capture is exposed for the ground and the other for the sky.

Creating an HDR Photo Merge from raw file originals can produce a merged DNG master image that extends the dynamic range and preserves the image data in a raw state. It can be argued that many raw images do already have a high dynamic range. Consequently, there should not necessarily be a huge difference when editing Photo Merge HDR photos compared to regular raw photos. The results you get using HDR Photo Merge in Lightroom will be slightly different from using Merge to HDR Pro in Photoshop. This is to be expected because the processing technique is not exactly the same. Therefore, you will find the results you get in Lightroom may be better, or they can sometimes be worse.

To create an HDR Photo Merge, select two or more photos to merge; both must be in Version 4. If not, make sure you update them to the latest process version. Having done that, choose Photo ➡ Photo Merge ➡ HDR, or use the Ctrl ℍ short-cut. To open in "headless" mode, use Ctrl Shift ℍ. In "headless" mode, Lightroom processes the photos automatically without showing the HDR Merge Preview dialog (and processes the images based on the last used settings). Otherwise, you will see the dialog shown in Step 2 (see page 202), where you have the option to edit the HDR Photo Merge settings. If the photos were shot handheld, you will need to select the Auto Align option (the auto alignment has been improved in this latest version of Lightroom).

If Auto Tone is unchecked, default Develop settings will be applied and these will be based on the most selected photo. When Auto Tone is checked, Lightroom applies a suitable Auto Tone adjustment during the Photo Merge HDR DNG creation process. If settings have already been applied to the source images, some of

these will be copied to the resulting HDR DNG, but not all. In the case of an HDR Photo Merge, existing Basic panel tone adjustments, Tone Curve adjustments, localized corrections, plus Upright and Crop adjustments will not be copied, but other settings will be.

The resulting DNGs from an HDR Photo Merge will be saved as 16-bit floating point files (**Figure 4.38**), where the merged data will be raw linear RGB data. If the source images used in a Photo Merge come from multiple folders, the resulting DNG file will be created in the same folder as the first image in the selected set. The HDR DNG files can be quite large in size. You could argue these are not truly raw files, but DNGs produced this way are still mostly unprocessed and allow you to make creative color and tone decisions via the Lightroom Develop module. You also retain the flexibility to reprocess the resulting HDR DNG files any time you like and apply later process versions. Essentially, you can merge raw files to create an unprocessed master where you can then fine-tune the settings at the post-Photo Merge stage, adjusting things like the white balance and endpoint clipping.

Deghost Amount options

It is crucial to avoid anything in the scene moving between exposures. Some cloud movement can be okay, providing the clouds haven't moved too much. Where subject movement is likely to be a problem, such as with moving water and trees, the Lightroom Photo Merge deghosting algorithm can help reduce ghosting artifacts.

When creating a Photo Merge HDR, you can click on one of the four buttons ranging from None to High (**Figure 4.39**) to apply the desired level of deghosting. In this particular example, I merged three bracketed exposures where there was movement in some of the trees and water between each exposure. I selected the Low Deghost Amount option and checked the Show Deghost Overlay option. This highlighted in red the areas where the deghosting would be applied. (On the Mac, use ① to turn the overlay on or off and use ①Shift) to cycle through the available overlay colors.)

It is recommended that you enable deghosting only when it is necessary to do so. The Lightroom Photo Merge method may utilize more than one image to deghost the resulting HDR. When it works, it is great, but when it doesn't, this can sometimes lead to unwanted artifacts in the final image, so it is best to leave it at the default None setting if you don't need it.

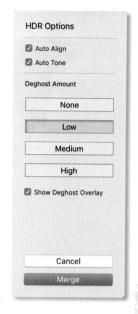

Figure 4.39 This shows a close-up of the Deghost Amount options plus examples of the Photo Merge HDR dialog preview without and with the Show Deghost Overlay options checked.

1. I went to the Library module and selected the two photos shown here. There was a four stops exposure difference between each of these captures. In the Library module, I chose Photo □ Photo Merge □ HDR.

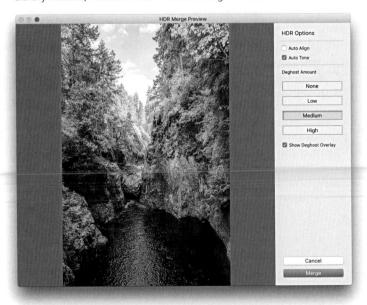

2. In the HDR Merge Preview dialog, I checked Auto Tone to apply an auto adjustment. Because this scene featured fast flowing water, I selected a Medium Deghost setting with Show Deghost Overlay checked.

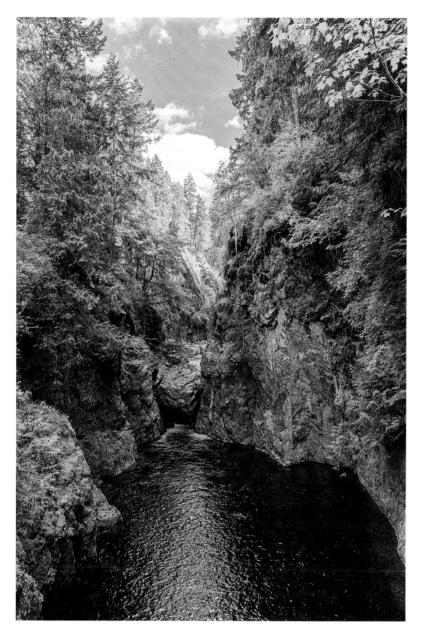

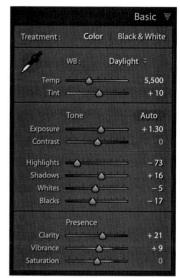

3. I clicked the Merge button in the Photo Merge – HDR dialog to create a DNG HDR master, which was automatically added to the catalog. The DNG I created was named based on the most selected image in the photo selection, with an –HDR suffix to distinguish it from the source images. In this example, an Auto Tone Develop adjustment was applied. You may want to fine-tune these settings though. For example, with this image I also adjusted the HSL panel settings and applied a lens correction to the image.

Figure 4.40 The Metadata panel in DNG mode with a Photo Merge Panorama DNG file selected.

Creating panorama photos using Photo Merge

You can also use the Photo Merge feature to create DNG panoramas from raw as well as non-raw files. The resulting files are 16-bit integer DNGs. Like the HDR DNGs, these are demosaiced DNGs saved as raw linear RGB data (**Figure 4.40**). What distinguishes these from regular DNG files is the fact they don't have mosaic data, but do have transparency data. Although the images are partially processed, you still retain the ability to apply Develop module edits and update to later process versions as they become available.

One of the things I have noticed with a conventional Photoshop Photomerge workflow is how the Photomerge processing can often cause the highlight values to clip. You may carefully set the highlight end points at the pre-Photomerge stage, only to find they become clipped in the resulting Photomerge composite. Therefore, being able to preserve the raw data when using the panorama Photo Merge in Lightroom allows you to avoid this problem completely, maintaining full control over the tones, and avoid undesired clipping. Because you have the ability to use Photo Merge in Lightroom to create HDR DNGs, you can also produce panoramas that are made up of HDR DNG files. However, the file sizes can end up being really huge if you adopt this approach, and it may take longer to carry out all the processing. For optimum alignment, it is best to carry out the HDR Photo Merge first, and then apply the panorama Photo Merge after.

To create a regular Photo Merge panorama, you first need to select a series of photographs that together make up a panoramic view. Then, go to the Photo menu and choose Photo Merge ⇒ Panorama (Ctrl)M). You can use Ctrl) Shift M to open Photo Merge in "headless" mode, without showing the Panorama Merge Preview dialog (and process the images based on the last used settings). Otherwise, you will see the dialog shown in Step 2 (see page 206), where you have the option to adjust the projection method and other settings.

When photographing a panorama sequence, it helps for you to have a decent overlap between each capture. There should be at least 25% overlap, or more if shooting with a wide-angle lens. It helps if you have the camera mounted on a tripod when you capture these; better yet, use a special tripod head that allows you to align the nodal point of the lens to the rotation axis. But you can certainly get good-enough results shooting handheld. Ideally, the exposure setting should be consistent, but even if the photos are captured with a variance of exposure, the Photo Merge process can even these out to a certain extent. Lens warp, vignette, and chromatic aberration are automatically applied to the images behind the scenes before stitching, so such settings in the source images are ignored and not copied to the resulting panorama DNG. Other adjustments, such as Basic panel, Tone Curve panel, Lens Corrections panel defringe adjustments, and color adjustments, are copied, but Upright and Crop adjustments aren't included.

Panorama projection options

The Panorama Merge Preview projection options are shown in **Figure 4.41**. In most cases, Photo Merge auto-selects the best method and will give the best results. It may also better preserve image content in individual photos such as birds flying in the sky. But the auto-selected projection method won't always be the best one, so it is often good to check the alternatives. Perspective mode can produce good results when processing images that were shot using a moderate wide-angle lens or longer, although wider-angle lens captures can produce distorted-looking results. Perspective is the best option to choose for architectural subjects, which can then be successfully corrected using the Transform panel controls. Cylindrical mode ensures that photos are correctly aligned to the horizontal axis. This mode is particularly appropriate when merging single rows of photographs that make up a super-wide panorama. Spherical mode transforms the photos both horizontally and vertically. This mode is more adaptable when it comes to aligning tricky panoramic sequences. So, for example, when you shoot a sequence of images that consists of two or more rows, the Spherical projection mode may produce better results than the Cylindrical method.

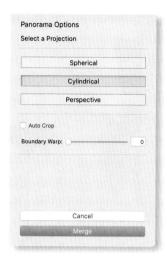

Figure 4.41 The Projection options in the Panorama Merge Preview dialog.

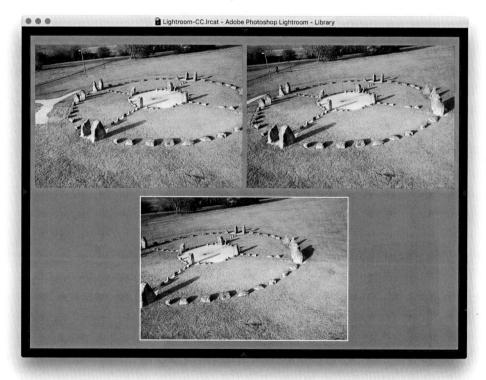

1. To demonstrate the Panorama Merge Preview function, I selected the three photographs that are shown here in the Library module Survey view mode. I then went to the Photo menu and selected Photo Merge ⇒ Panorama.

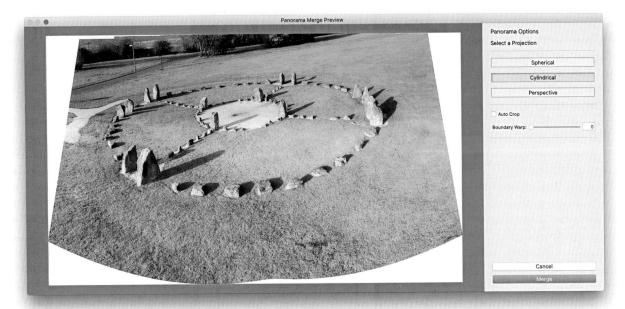

2. This opened the Panorama Merge Preview dialog, where I could select the desired projection and preview the results before committing to creating a full Photo Merge. In this instance, Photo Merge auto-selected the Cylindrical option.

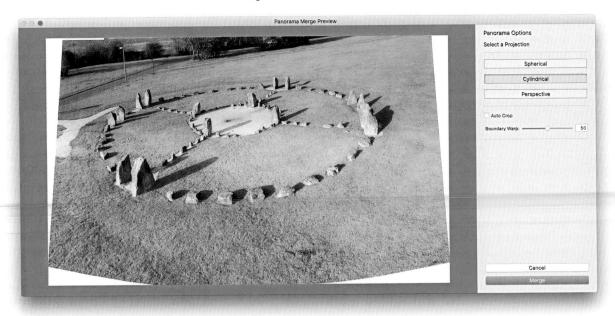

3. I set the Boundary Warp slider to 50% to warp the image to make the boundary fit the surrounding rectangular frame (Boundary Warp is discussed in the following section). I then clicked the Merge button.

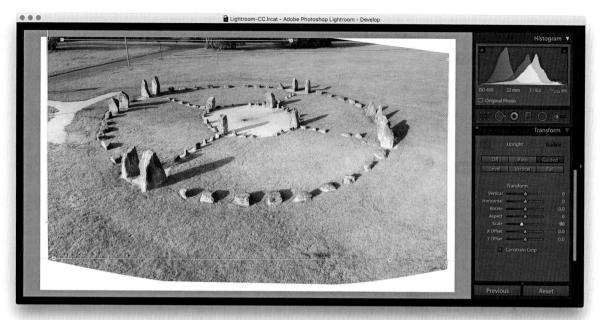

4. Lightroom created a full Photo Merge Panorama DNG, renamed based on the most selected image in the photo selection, adding a *Pano* suffix. The Develop settings applied here were based on whatever was the most selected photo in Step 1. I also added Guided Upright adjustments to correct the perspective.

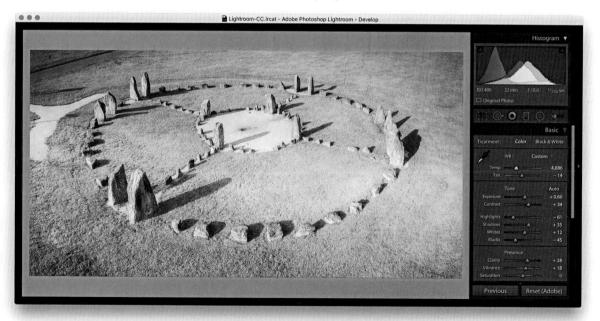

5. Finally, I went to the Basic panel in the Develop module and adjusted the Tone and Color settings to produce the finished version shown here.

Panorama Photo Merge performance

Panorama Photo Merges have been optimized to run up to twice as fast compared with the previous version of Lightroom, plus you can now create panorama Photo Merges when only Smart Previews are available. Multiple merge operations are added to a queue for better management. However, queued jobs are only initiated when the CPU usage is below a tolerable limit. Panorama Photo Merges also respect localized adjustments, such as spot removal work that has been applied before merging. For example, if you have a dirty sensor, you can use the Spot removal tool and sync the edits across all the frames before you merge them. This might save you time carrying out repeat spotting work on the final merged image.

Boundary Warp slider

You can adjust the Boundary Warp slider to preserve image content near the boundary that might otherwise be lost due to cropping. Higher amounts cause the boundary of the panorama to fit more closely to the surrounding rectangular frame. This can be beneficial when processing landscape panoramas, although it may cause some noticeable distortion if applied to architectural subjects. However, Lightroom-generated panoramas contain the necessary metadata to allow them to be perspective-corrected using the Adaptive Wide Angle filter in Photoshop CC.

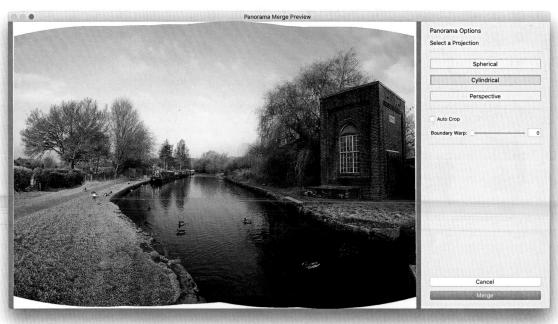

1. In this example, I selected six photographs in Lightroom and chose Photo

Photo Merge

Panorama. This opened the Panorama Merge Preview dialog and auto-selected the Cylindrical projection option.

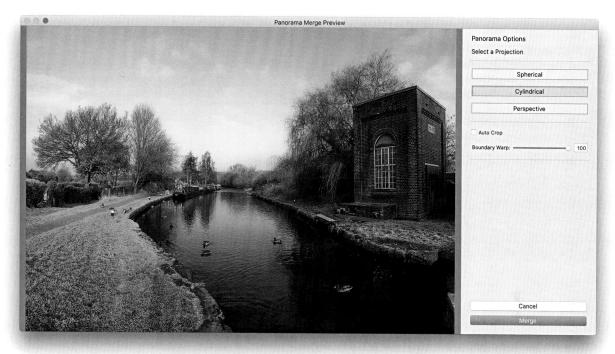

2. I adjusted the Boundary Warp slider to 100 to get the boundary to fit the surrounding rectangular frame, and clicked Merge.

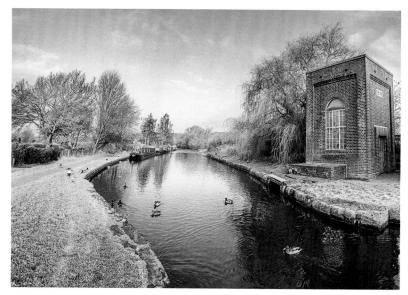

3. For the final panorama, I edited the image using the Transform panel, adding a couple of Graduated Filters plus Basic panel tone and color adjustments.

		Basic W
Treatment:	Color	Black & White
1	WB:	Daylight ÷
Temp		5,500
Tint		+ 10
	Tone	Auto
Exposure		+ 1.35
Contrast	0	+ 19
Highlights	O	- 100
Shadows		- △ + 78
Whites		+ 17
Blacks		- 20
	Presence	
Clarity		+ 25
Vibrance		+ 31
Saturation		0

You can also add Clarity to an image using the localized adjustment tools.

Later you will see a few examples of how you can apply Clarity adjustments with the Adjustment Brush.

Clarity slider

The Presence section in the Basic panel includes the Clarity slider, which is essentially a local area contrast adjustment control. The Clarity effect is achieved by creating variable amounts of contrast by adding soft halos to the edges in a photograph. This builds up the contrast in the midtone areas based on the edge detail in the image. The halos are generated with the same underlying tone mask algorithm that is utilized for the Highlights and Shadows sliders, which makes the halos less noticeable. The net effect is that a positive Clarity adjustment boosts the apparent contrast in the midtones but does so without affecting the overall global contrast. Normally, you would want to start with a Clarity setting of around 10 so as not to overdo the effect too much. But as you increase the Amount, this strengthens the midtone contrast, which in turn makes the midtone areas appear more crisp.

1. This Fit view magnification shows a photograph of an old tractor with the Clarity slider at the default 0 setting.

2. For comparison, I set the Clarity slider to +100. The reason I took the slider all the way to the maximum setting was to create the most dramatic difference between this and the previous screen shot. You can see much more midtone contrast in the texture of the rust and lichen.

Images that benefit from adding Clarity

All image adjustments are destructive. So, one way or another, you will end up either expanding the tones in an image, which stretches the levels farther apart, or compressing the tones by squeezing the levels closer together. Where tone areas become compressed and portions of the tone curve become flattened, you consequently lose some of the tonal separation that was in the original. A positive Clarity adjustment can, therefore, be used to expand areas of flat tone and enhance detail that was in the original capture image. The kinds of photos that benefit most from adding Clarity are those that have soft midtone contrast where you want to make the image look more contrasty, but without causing the shadows or highlights to clip. For example, when I use the Soft Proofing feature and preview photos that are to be printed on a matte paper, I find it helps to increase the Clarity to counter the lack of contrast seen in the preview image.

Negative Clarity adjustments

A negative Clarity adjustment does the exact opposite of a positive Clarity adjustment. It softens the midtones and does so in a way that produces an effect not too dissimilar to a traditional darkroom diffusion printing technique (see steps below). The net result is that you can create some quite beautiful diffuse soft-focus image effects, and negative clarity is particularly suited to black-and-white photography.

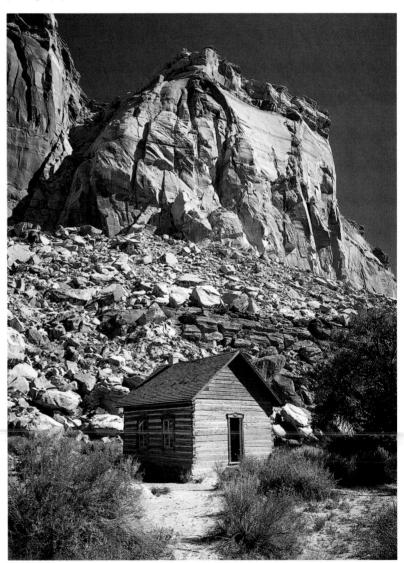

1. With the Clarity set to 0, this is a nice picture with lots of sharp detail, but it is also a good example to show the pseudo-diffusion printing technique.

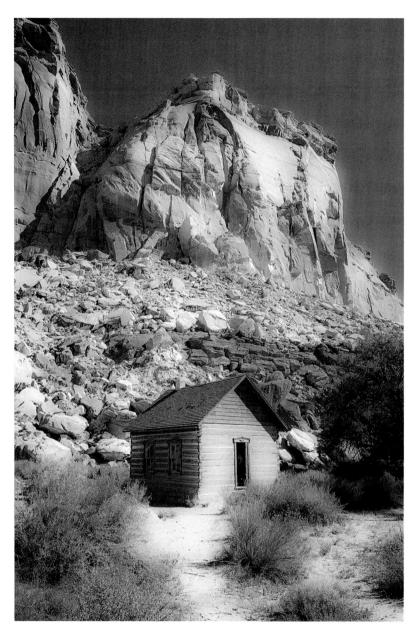

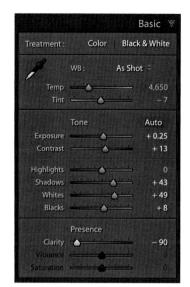

2. In this step, I applied a –90 Clarity adjustment. As you can see, the negative Clarity adjustment created a kind of diffuse printing effect.

Figure 4.42 The Basic panel with the Vibrance and Saturation sliders located at the bottom.

Vibrance and Saturation

The Vibrance and Saturation sliders are located at the bottom of the Basic panel in the Presence section (**Figure 4.42**). Both can be used to adjust the saturation in an image. The main difference between the two is that the Saturation slider applies a linear adjustment to the color saturation, whereas a Vibrance adjustment uses a nonlinear approach. In plain English, this means that when you increase the Vibrance, the less saturated colors get more of a Saturation boost than those colors that are already saturated. This can be of a real practical benefit when you are applying a Saturation adjustment to a picture and you want to make the softer colors look richer, but you do not want to boost the color saturation at the expense of losing important detail in the already bright colors. The other benefit of working with Vibrance is that it has a built-in Caucasian skin color protector that filters out colors that fall within the skin color range. This can be useful if you are editing a portrait and you want to boost the color of someone's clothing, but at the same time, you do not want to oversaturate the skin tones.

With most photographs, Vibrance is the only saturation control you will want to use. However, the Saturation slider still remains useful, because a Saturation adjustment can be used to make big shifts to the saturation, such as when you want to dramatically boost the colors in a photograph or remove colors completely. **Figure 4.43** shows some examples of Saturation and Vibrance adjustments.

The main thing to understand is that a positive Saturation adjustment will boost all colors equally. In the example shown in Figure 4.43, it made all the colors equally more saturated and as a consequence, there was some color clipping in the red nose of the mandrill monkey. In the version next to it, I increased the Vibrance to +100. This resulted in an image where the reds in the nose did not receive such a big color boost, but the other colors, which were less saturated to begin with, did receive a major boost in saturation. However, they were not oversaturated to the point where any of the color channels were clipped. This shows how the Vibrance adjustment can be effective in preserving more tonal detail as you boost the color saturation. Dragging the sliders the other way, a full negative Saturation adjustment will desaturate all the colors completely, whereas a negative Vibrance can be used to gently desaturate a photo. As you can see, a negative Vibrance of -100 produced a subtle, desaturated look. Ultimately, many images can benefit from a small Vibrance boost, although in this example, because I really wanted to emphasize the colors in the mandrill's face, I felt the optimum adjustment would be +50 Vibrance. This is much more Vibrance than I would apply generally, but it seemed an appropriate setting to use for this particular photograph.

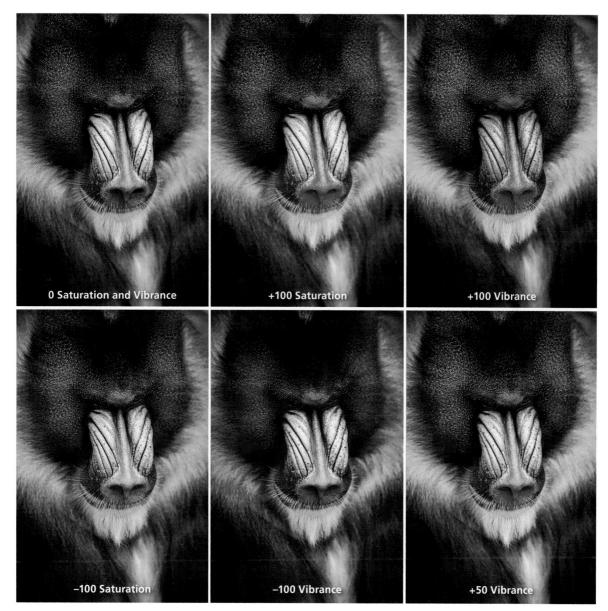

Figure 4.43 A comparison of Vibrance and Staturation slider adjustments.

Figure 4.44 The Quick Develop panel.

Quick Develop panel tone adjustments

All the Develop controls discussed so far are also accessible via the Quick Develop panel in the Library module (**Figure 4.44**). To see all the controls shown here, you need to click the expansion arrows on the right. To restore an adjustment to its default setting, click the name of the adjustment. Using the Quick Develop panel, you can apply Basic panel tone and color adjustments without having to leave the Library module. Quick Develop adjustments can be applied to multiple selected images in a Grid view or in the Filmstrip. But the main difference with Quick Develop is that Quick Develop adjustments are always applied *relative* to the current Develop settings. For example, if you select a number of images that have already had different Exposure settings applied to them, you can use the Exposure buttons in Quick Develop to make those photos relatively lighter or darker (as opposed to synchronizing all of the photos with the same Exposure value).

Using Quick Develop is the same as working in the Develop module, except you don't have the same fine degree of control. It is therefore ideal for making firstpass edits, where you still need to do most of your work in the Library module (such as rating images and adding metadata) without having to switch back and forth between Library and Develop to apply image adjustments. However, it is important to bear in mind that the Library module previews will not be as accurate as those displayed in the Develop module. The Library module previews are Adobe RGB rendered, whereas when you edit a photo in the Develop module, the image preview you see is generated on the fly via the Lightroom Camera Raw engine and edited using the wider-gamut Lightroom RGB space. Therefore, the previews you see in Develop are always going to be the most accurate. Also, when you edit a photo using the Quick Develop controls in the Library module, the quality of the Loupe view preview will be dependent on whatever settings you have selected in the Catalog Settings File Handling section. You have to bear in mind here that the Library preview mechanism is primarily designed to generate decent-quality previews that enable fast Library module browsing; it is not so ideal for assessing Develop settings adjustments. You may also notice that unlike the Histogram panel in the Develop module, the Histogram panel in the Library module features an animated transition when adjusting the values in the Quick Develop panel.

To apply Quick Develop adjustments, go to the Library module and select a photo, or make a selection of several photos. Next, you can click to access the Saved Preset list shown in **Figure 4.45** and choose a default setting or a previously saved preset as your starting point (the Develop settings are arranged here in a hierarchical list). Or, you can click the arrow buttons in the Quick Develop panel to increases or decreases any of the Quick Develop adjustments. The single-arrow buttons increase or decrease a setting by small amounts, and the double-arrow

buttons by larger amounts. Any adjustments you make here simultaneously update the settings in the Basic panel of the Develop module.

The Treatment menu section lets you decide whether to process an image in Color or Black & White. To be honest, I think it is better to memorize the \boxed{V} shortcut as a means for toggling between the Color and Black & White modes and rely on the Treatment menu as more an indicator of which mode a photo is in.

Next, we come to the White Balance options, which include the Temperature and Tint button controls. If you are shooting with a camera set to Auto White Balance mode, or you used a white balance that was correct for the lighting conditions at the time of shooting, you will probably want to leave this set to As Shot.

Otherwise, you can click the White Balance menu (Figure 4.45) and choose one of the preset settings listed there, or select the Auto setting and Lightroom will calculate an optimized White Balance setting for you (or use the <code>\mathbb{H}\subset\shift\(\mathbb{U}\) [Mac] or <code>\mathbb{Ctrl\Shift\(\mathbb{U}\)</sup> [PC] shortcut)</code>. With the Temperature buttons, if you click the left-arrow buttons, the image becomes incrementally cooler, and if you click the right-arrow buttons, the image becomes warmer. The Tint buttons can be used to apply a green/magenta bias. Clicking the left-arrow buttons makes a photo more green, and clicking the right-arrow buttons makes it more magenta. The single-arrow buttons produce small shifts in color, and the double-arrow buttons produce more pronounced color shifts.</code>

Clicking the Auto Tone button applies an Auto Tone adjustment (黑U [Mac] or Ctrl [PC]). This automatically adjusts the Exposure, Contrast, Highlights, Shadows, Whites, and Blacks settings.

Process version conflicts

If there is a process version conflict when two or more photos are selected, the Quick Develop buttons will appear dimmed (see page 161).

The other tone controls

With the remaining tone and color controls, I advise you to start by adjusting the Exposure amount first, because the Exposure is critical for determining the overall brightness. A Shift-click on the Exposure single-arrow button is equivalent to a 0.17-unit shift in the Develop module, a single click equivalent to a 0.33-unit shift, and a click on the double-arrow button equivalent to a 1.0-unit shift.

After you set the Exposure, you may want to adjust all the other tone control buttons. Here, a Shift-click on the single-arrow button is equivalent to a 3.0-unit shift in the Develop module, a single click on the single-arrow button equivalent to a 5.0-unit shift, and a double-arrow click equivalent to a 20.0-unit shift.

Figure 4.45 The Quick Develop panel showing the Preset and White Balance menu lists.

Figure 4.46 The Quick Develop panel view with the Alt key held down.

If you hold down the Alt key, the Clarity buttons in the Quick Develop panel switch to Sharpening buttons (**Figure 4.46**). In this Alt key mode, the Sharpening controls in Quick Develop are equivalent to Sharpening Amount slider adjustments in the Develop module Detail panel. Although you do not have access to the other three sharpening sliders, you can still make an initial sharpening adjustment before you get around to fine-tuning the other settings later. As you hold down the Alt key, the Vibrance buttons switch to become Saturation buttons. With both the Sharpening and Saturation controls, a single-arrow click is equivalent to a 5-unit shift in the Develop module, and a double-arrow click is equivalent to a 20-unit shift.

The Reset All button at the bottom resets all the Develop settings that have been applied to a photo (and not just those that have been applied via Quick Develop) to their default import settings. You can also use the <code>\mathbb{H}Shift(R)</code> (Mac) or <code>Ctrl(Shift(R)</code> (PC) shortcut. However, this action resets all the Develop settings to a zeroed or default state, so use this button with caution.

A typical Quick Develop workflow

The following steps show how you might want to use the Quick Develop panel while working in the Library module.

1. These photographs were shot in raw mode and imported using the Default Develop settings and As Shot White Balance (circled above). In this first step, I made a selection of the photos I wanted to edit.

2. I wanted to warm the colors in the selected photos, so I clicked the double-arrow button (circled above) to make the selected photos appear warmer.

3. I then wanted to apply some tonal edits. I clicked the Auto Tone button followed by the Exposure, Contrast, Highlights, and Shadows buttons (circled above). This improved the brightness and contrast.

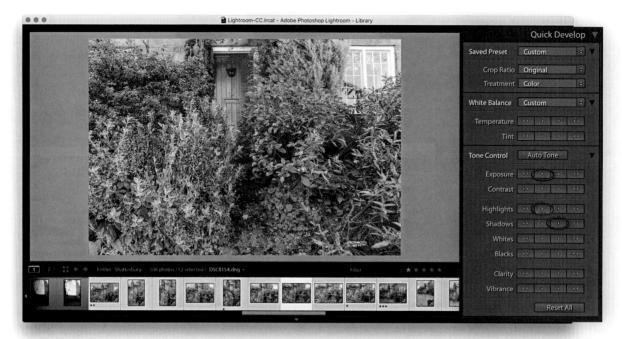

4. Alternatively, you can work on the images one at a time in Quick Develop. I double-clicked one of the photos to work in the Loupe view, then I reduced the Exposure, darkened the Highlights, and lightened the Shadows.

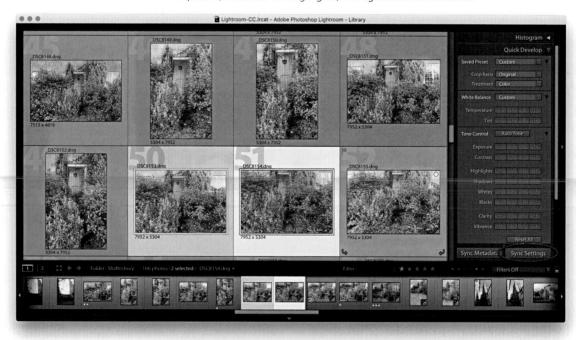

5. I selected this recently edited image and the photo next to it and clicked the Sync Settings button at the bottom (circled above).

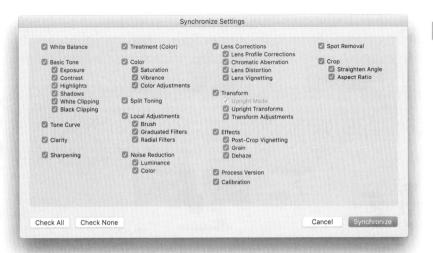

NOTE

The Sync Settings button can be used to synchronize all Develop module settings, not just those applied via the Quick Develop panel.

6. This opened the Synchronize Settings dialog, where I clicked the Check All button to select all settings. I then clicked the Synchronize button to synchronize the settings across the two photos selected in Step 5.

Editing video files in Quick Develop

As well as being able to play video files directly in the Library module Loupe view, some limited video editing is possible using the Quick Develop panel. Lightroom does not yet offer full video-editing features—for that, you will want to use dedicated video-editing software. But it is nonetheless an achievement to at least be able to view and edit video clips in Lightroom. So, let me run through some of the key features. **Figure 4.47** shows how video files are displayed in the Library module Grid view. In the Library Loupe view, you can navigate a clip to play it and edit the start and end times; you also have access to some of the Quick Develop image-adjustment options that will let you adjust the White Balance, Exposure, Contrast, Whites, Blacks, and Vibrance.

Loupe view video-editing options

There are a few selectable items in the options menu (which are shown in the following steps). Capture Frame can be used to extract a frame and automatically add this to the folder and to the catalog as a separate JPEG image. The Set Poster Frame option allows you to select a frame other than the start frame and then use it as the thumbnail preview in Lightroom (Slideshow will then also use the poster frame). Lastly, there is the Display Trim Time as SMTPE option. This is an absolute time code that is used when you want to synchronize different devices (providing they are compatible). It is something that is really of more interest to those who are carrying out professional video editing. Personally, although I find Lightroom useful for importing video clips at the shoot stage, I do all the main editing and grading using Adobe Premiere.

Figure 4.47 An example of a video thumbnail in the Library module Grid view. The video badge shows the track length time.

MOTE

There is a Video mode for the Metadata panel, although most cameras record very little metadata.

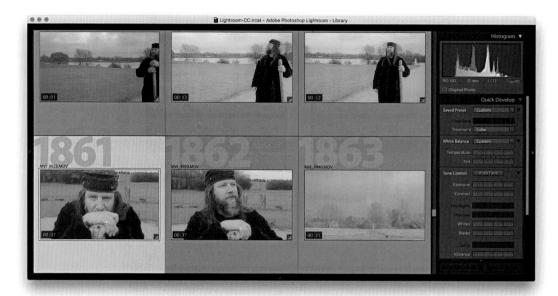

1. When you inspect a video file in the Lightroom Library module Grid view, you can quickly track all the frames in a sequence by hovering over the thumbnail and moving from left to right.

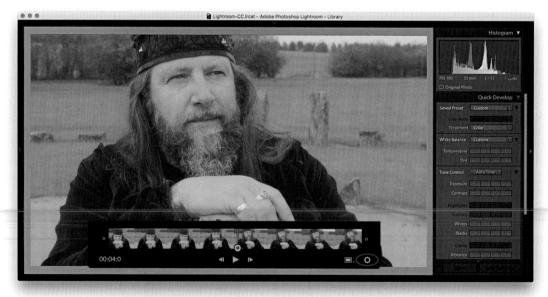

2. I double-clicked the thumbnail in the Grid to go to the Loupe view. Here, I could click the Play arrow button or tap the Spacebar to play the selected movie clip (click again to pause). I could quickly navigate a video clip by dragging the frame-selection button and click the gear button (circled) to reveal the key frames. If "Show frame number when displaying video time" is selected in the Loupe View Options, the frame number is displayed after the minutes/seconds timeline display.

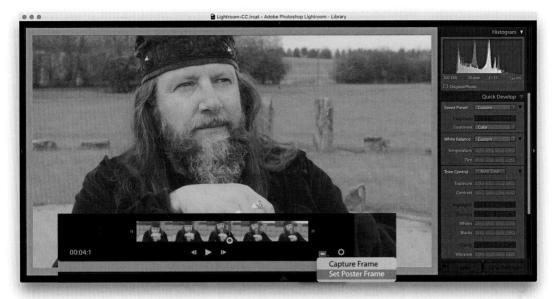

3. I dragged the start and end points to trim the movie sequence (You can also use Shift I to set the input point and Shift O to set the output point for a clip). I then selected a midway point in the video clip and selected Set Poster Frame from the Settings menu. This updated the thumbnail preview in the Grid view with a more relevant frame from the movie sequence.

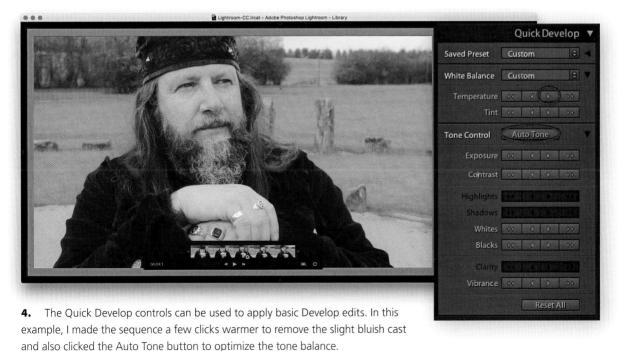

223

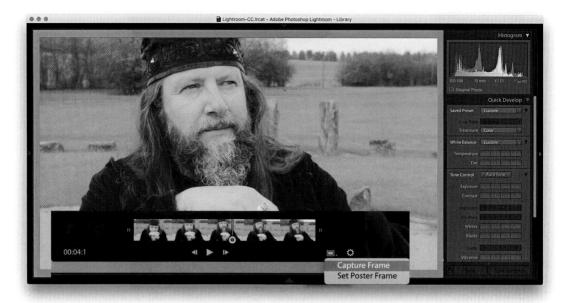

5. Although you cannot edit videos extensively in the Quick Develop panel or Develop module, you can make use of saved presets to apply some types of Develop adjustments. To do this, I clicked the Settings menu and selected Capture Frame. This created a JPEG photo from the selected frame stacked with the original.

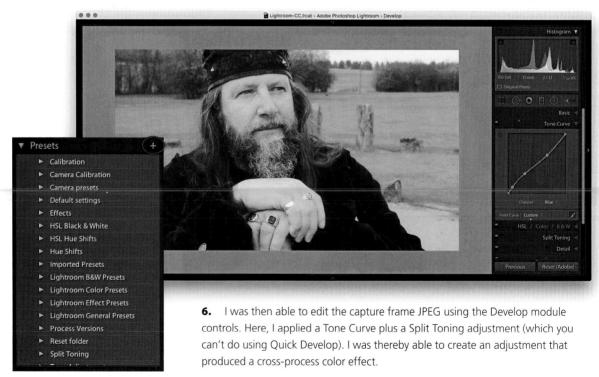

7. I then clicked the + button in the Develop module Presets panel and saved the edited setting as a new preset. Although you can save any Develop setting as a preset, there is still a limited range of options when saving a preset to be applied to a video clip. Not all your current Develop presets can be applied to video files; therefore, these will appear grayed out.

8. Finally, I returned to the video-clip file in the Library module and selected the preset I had just created from the Saved Preset menu in the Quick Develop panel.

Figure 4.48 The Histogram and Tone Curve panels.

The Tone Curve panel

The Tone Curve controls offer a different approach to tone curve mapping, where the tone curve is modified through slider control (parametric) adjustments. The Tone Curve controls are presented in this way to encourage people to make Tone Curve adjustments based on descriptive criteria (Figure 4.48). If you are used to working with the point-edit Curves dialog in Photoshop, the Lightroom method may appear restrictive at first, but the Tone Curve slider controls in Lightroom can often inspire you to create tone curve shapes that are guite unlike any curve shape you might have applied when using the traditional point curve method. The parametric Tone Curve sliders now make curves adjustments accessible to everyone. but the good news is, you can still manipulate the curve graph directly by clicking a point on the curve and dragging up or down to modify that particular section of the curve. Best of all, you can edit the curve by targeting an area of interest in the image directly. You can also use the keyboard arrow keys: The up and down arrows can be used to increase or decrease the tone values (the left and right arrow keys are reserved for navigating images in the Filmstrip). Holding down the 公Shift) key as you adjust the values applies larger incremental adjustments. If you enable the Target Adjustment tool button (#(Alt Shift) (Mac) or Ctrl (Alt Shift) (T) (PC), you can then click any part of the image and drag up or down to make the tones there lighter or darker. When you start using the Target Adjustment tool editing method to refine the tones in an image, you will not necessarily even need to look at the Tone Curve panel. You can turn off the Target Adjustment tool by clicking the Target Adjustment tool button again, pressing [Esc], or by using the #Alt Shift N (Mac) or Ctrl Alt Shift N (PC) shortcut.

The four main sliders for controlling the tone curve are Highlights, Lights, Darks, and Shadows. These controls also provide a shaded preview of the range of the shapes an individual Tone Curve slider adjustment can make. In Figure 4.48, I was in the process of adjusting the Shadows slider, and you will notice how the histogram in the Histogram panel is mirrored in the curve graph and both are updated as you edit the Tone Curve controls. The gray-shaded area represents the limits of all possible tone curve shapes I could create with this particular slider in conjunction with the other current slider settings. For those who understand curves, this provides a useful visual reference of how the curve can look.

As mentioned earlier, the Basic panel is used to apply the main tone adjustments. It is important to understand that these are all applied upstream of any Tone Curve adjustments, so the Tone Curve slider is an image-adjustment control that you always want to apply *after* you have made the initial Basic panel adjustments.

The layout of the Tone Curve panel is influenced to some degree by the legacy constraints of the Adobe Camera Raw plug-in. It has been necessary to ensure that the settings applied to an image via Camera Raw in Photoshop are also recognized (and made accessible) when the same image is opened via the Develop

module in Lightroom. I mention all this as an explanation for the presence of the Point Curve menu at the bottom of the Tone Curve panel (Figure 4.49). In the early days of Camera Raw, some purists argued that the tone curve for processing raw files should always default to a linear mode, and if you wanted to add contrast, it was up to you to edit the curve how you wanted. Meanwhile, almost every other raw converter program was applying a moderate amount of contrast to the curve by default. The reason for this was because most photographers tend to like their pictures with a more contrasty and film-like look as a standard setting. For example, Capture One applies adaptive tone adjustments to newly imported photos that in most instances produce a more contrasty default look compared to Lightroom. Consequently, the Adobe Camera Raw plug-in has evolved to offer three choices of curve contrast: Linear, Medium Contrast, and Strong Contrast. So, the Point Curve menu in the Tone Curve panel (not to be confused with the point curve editing mode discussed on page 228) is mainly there to allow you to match up raw files that have been imported with legacy Camera Raw settings. With Version 1/Version 2, the default setting for raw files was Medium Contrast. With Version 4, the default point curve now says Linear and, as you would expect, presents a straight line curve. But this is, in fact, applying the same underlying curve setting as the previous default Process Version 1/Version 2 Medium Contrast tone curve. Basically, the current Linear curve does exactly the same thing as the older Version 1/Version 2 curve: It applies more of a kick to the shadows to make them slightly darker and lightens the highlights slightly. This also brings the benefit of tone curve setting compatibility between non-raw and raw images. Non-raw images have always defaulted to a linear tone curve shape. This remains the case in Version 4. Consequently, the starting point for both raw and non-raw images is now the same: a linear tone curve representation. The Point Curve options are, therefore, nothing more than a curve shape setting, and these can be used as a starting point when making further edits to the tone curve.

If you convert a Version 1/Version 2 tone curve to Version 4, the tone curve shape will appear adjusted (even though the parameter values will actually remain the same). Therefore, Tone Curve settings are now process-version-specific. This means whenever you save a Develop preset that includes a Tone Curve setting, you are obliged to include saving the Process Version setting along with the Tone Curve setting.

The tone range split points at the bottom of the tone curve let you restrict or broaden the range of tones that are affected by the four Tone Curve sliders (**Figure 4.50**). Adjusting each of the three tone range split points enables you to further fine-tune the shape of the curve. For example, moving the dark tone range split point to the right offsets the midpoint between the Shadows and Darks adjustments. These adjustment sliders are particularly useful for those instances where you are unable to achieve the exact tone localized contrast adjustment you are after when using the Tone Curve sliders on their own (see also page 238).

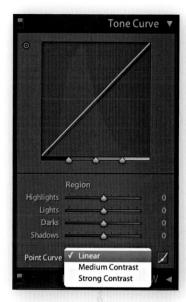

Figure 4.49 The Point Curve menu offers a choice of three curve settings.

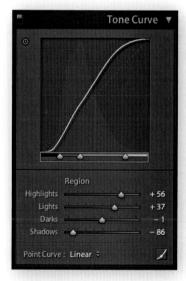

Figure 4.50 The tone range split point controls.

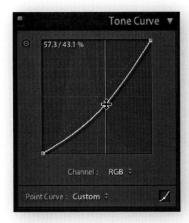

Figure 4.51 The Tone Curve in Point Curve editing mode.

Point Curve editing mode

To switch to the Point Curve editing mode (**Figure 4.51**), click the button circled in Step 1 below. In this mode, you can click on the curve to add new control points and drag these up or down to modify the curve shape. The before/after value of the control point that is being moved is shown in the top-left corner of the editor view as a percentage value. When selecting an existing control point to move, you do have to click within a few pixels of the control point on the curve. It can help here to hold down the Alt key as you adjust individual control points. This reduces the sensitivity of tracking movements by a factor of ten. You can also click to select the Target Adjustment tool: **Alt Shift (PC). As with the parametric editing mode, you can use up or down movements to make the selected region of the curve lighter or darker.

Unlike the Adjustment panel in Photoshop or the Point Curve mode for the Tone Curve panel in Camera Raw, Lightroom does not provide modal, keyboard focus when editing the tone curve control points, so you can't nudge using the keyboard arrow keys. To delete a selected point, right-click to open the context menu and select Delete Control Point, or double-click a control point. You can save the entire tone curve as a preset, including the Point Curve adjustments, but not separately as a preset. However, you can save custom Point Curve settings via the Point Curve menu (see Step 3).

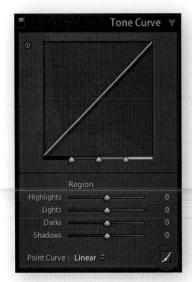

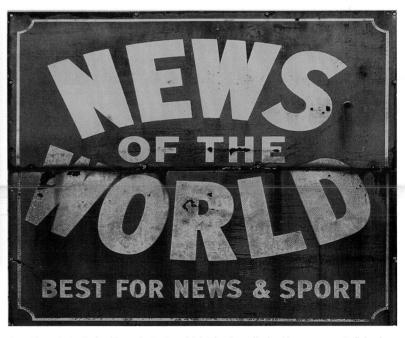

1. Here, I started with a photo to which I had applied a Linear curve. I clicked the Point Curve button (circled) to switch to the Point Curve editing mode.

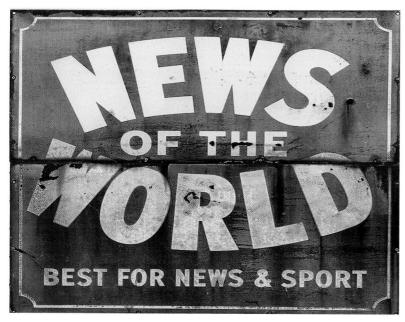

2. I selected the Target Adjustment tool from the top-left corner (circled), clicked in the preview area to add new control points to the tone curve, and dragged up or down to modify the curve shape. The context menu could be used to delete selected control points or flatten the curve.

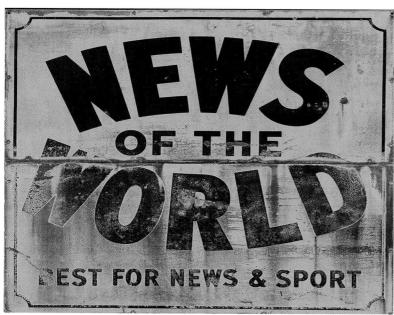

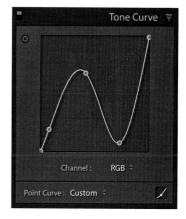

3. You can use the Point Curve editing mode to either invert the tones in an image or apply a solarized-type look to a photo and use the Point Curve menu at the bottom to save a custom curve setting.

Figure 4.52 The Tone Curve in Point Curve editing mode in the default RGB curve mode.

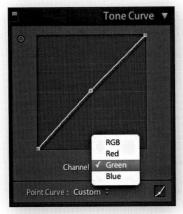

Figure 4.53 The Tone Curve in Point Curve editing mode with the Green channel selected.

RGB curves

You also have the option to separately edit the red, green, and blue channel curves, just as you can in Photoshop. To do this, you need to go to the Tone Curve panel in Point Curve mode, where you will see the Channel menu (**Figure 4.52**). This defaults to the RGB curve editing mode. If you click to open the pop-up menu, you will see the channel curve options shown in **Figure 4.53**.

Having RGB curves in Lightroom gives you extra tools to work with when adjusting color, and allows you to achieve some unique color effects using just channel curve adjustments. You can use them to correct photos shot under mixed lighting conditions or to produce split-toning effects that are distinctly different from those that can be achieved using the Split Toning panel. Or, as shown here, you can use channel adjustments to apply strong color overlays. Just be aware there is a fair amount of overlap here with the functionality of the White Balance controls (which I would still advise you to use first when correcting color), as well as other controls, such as the Split Toning panel (see page 368).

1. In this example, I prepared an image in which the colors were neutralized and I had only applied a few Basic panel adjustments.

2. I then went to the Tone Curve panel in Point Curve editing mode and adjusted the individual red, green, and blue channels to achieve the saturated green color effect shown here.

3. I next edited all three channels to produce a warm autumn coloring effect.

TIP

The Target Adjustment tool can also be activated by going to the View \Rightarrow Target Adjustment submenu, or by using the following shortcuts: <code>MAIT Shift T (Mac)</code> or <code>Ctrl Alt Shift N (Mac)</code> or <code>Ctrl Alt Shift N (Mac)</code> or <code>Ctrl Alt Shift N (PC)</code> to active;

The Tone Curve regions

The Tone Curve Zones are evenly divided between the four quadrants of the tone curve. In the following step-by-step example, I show a series of Tone Curve adjustments in which each of these regions gets adjusted. Here, I have highlighted the active quadrants with a green overlay to accentuate these zone regions and show which areas of the curve are being altered. If you want to reset the Tone Curve settings, you can do so by double-clicking the slider names in the Tone Curve panel; you can also reset the Tone Curve adjustments by double-clicking the adjusted region within the tone curve itself.

lighten the highlights. However, in this instance, I clicked the Target Adjustment

tool button (circled) to make it active, moved the pointer over the image, and hovered over a highlight area in the clouds. I then clicked and dragged upward to

lighten the tones in this selected portion of the curve.

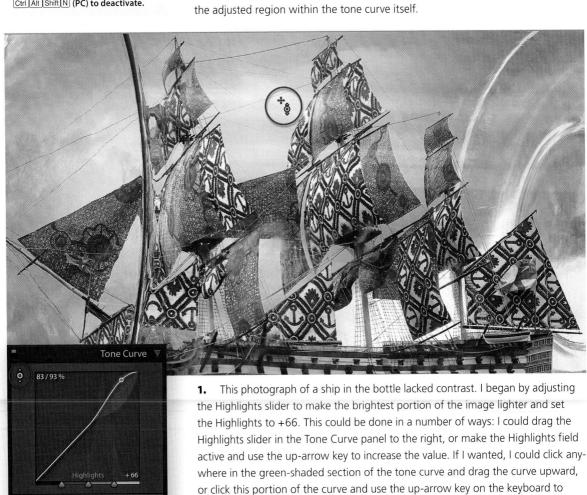

Highlights

Point Curve: Linear

Reset Region

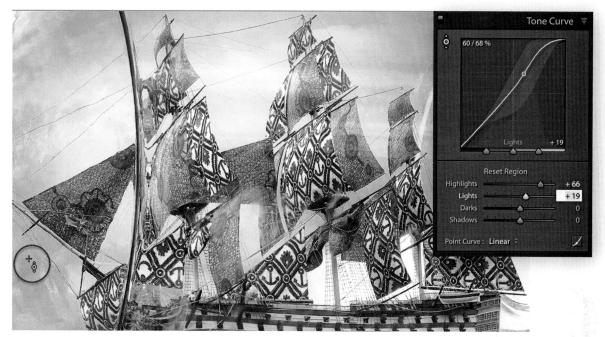

2. Next, I wanted to concentrate on lightening the tones within the Lights zone of the curve. I placed the pointer over a darker area of the sky and dragged upward.

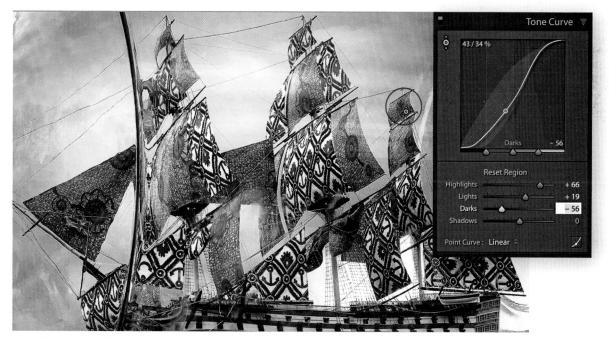

3. I then moved the pointer over one of the sails and dragged downward to darken the Darks zone.

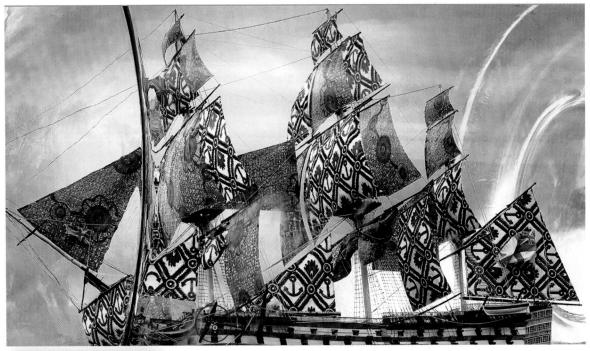

4. Lastly, I adjusted the Shadows by placing the pointer over the shadow area circled above and dragging downward to darken. If you compare the finished step here with where I started, you can see that the combined Tone Curve adjustments managed to increase the image contrast, but in a more controlled way compared to using the Basic panel Contrast slider on its own.

Combining Basic and Tone Curve adjustments

So far, I have shown how Tone Curve adjustments can be applied in isolation. But you would more typically work using a combination of both Basic and Tone Curve adjustments. Over the next few pages, I have provided a step-by-step example in which the Basic panel adjustments were applied first to correct the white balance and improve the overall tone contrast in the photograph. This was then followed by a Tone Curve adjustment to fine-tune the tonal balance and bring out more detail in the highlights and shadows. You can do a lot to improve the appearance of a photograph by making just a few Basic and Tone Curve adjustments. Through careful use of these adjustment controls, it is possible to edit the tones in a picture so that you will not always have to apply localized adjustments to achieve a good-looking image.

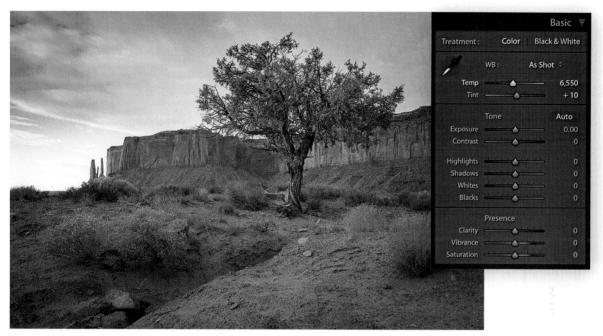

1. Here is a raw image in which the default Lightroom Develop settings had been applied. I first corrected the As Shot white balance by selecting the White Balance tool and rolling the pointer over an area that I wanted to make neutral.

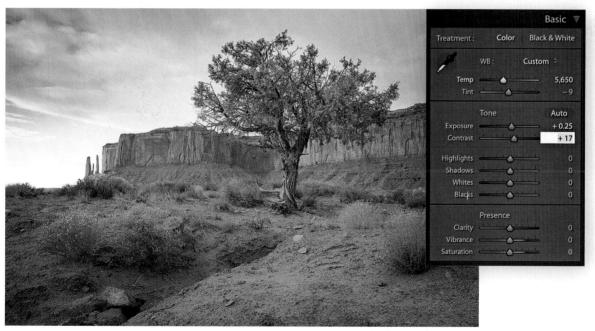

2. I clicked with the White Balance tool to achieve a slightly cooler color with less of a magenta tint and then proceeded to add more Exposure and Contrast.

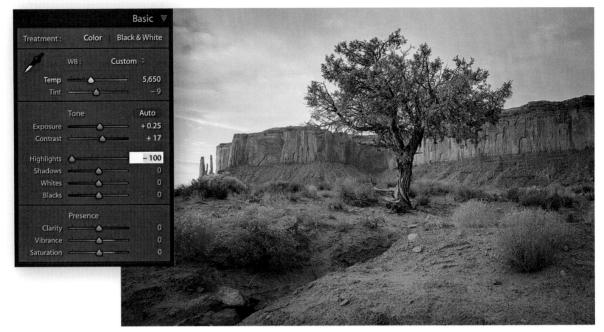

3. Next, I adjusted the Highlights slider to bring out more detail in the clouds. Here, I applied a –100 adjustment.

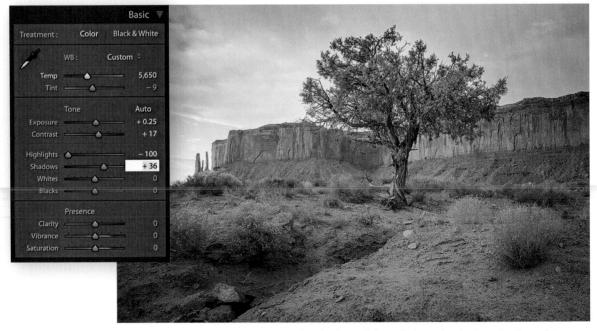

4. I then adjusted the Shadows slider to lighten the shadow detail, applying a +36 adjustment.

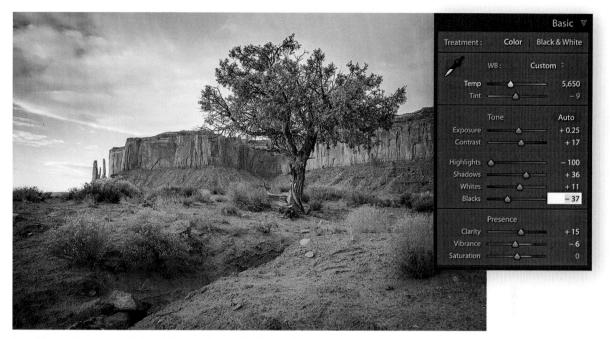

5. This next step was all about fine-tuning the Basic panel settings. I adjusted the Whites slider to set the white clipping and the Blacks slider to set the black clipping. I also adjusted the Clarity and Vibrance.

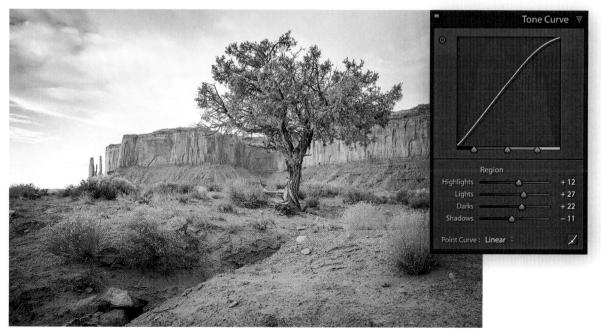

6. Finally, I went to the Tone Curve panel and adjusted the parametric sliders to further improve the tone contrast.

TIP

Double-click the tone range split points if you need to reset them to their default settings.

Region Highlights + 30 Lights + 30 Darks - 30 Shadows - 30

Tone range split point adjustments

The tone range split points are at the bottom of the Tone Curve panel. In **Figure 4.54**, The Tone Curve panel on the left shows an S-shaped tone curve with the tone range split points in their normal positions with equal spacing for the Shadows, Darks, Lights, and Highlights zones. The middle example shows the Shadows zone set to its widest extent, compressing the other three zones. The example on the right shows the Highlights zone set to the widest point. **Figure 4.55** shows how moving the two outer tone range split points in closer, increases the midtone contrast and moving them farther apart reduces the midtone contrast.

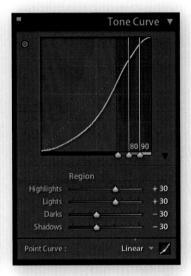

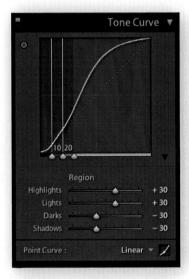

Figure 4.54 Adjusting the split points can affect the tone curve shape.

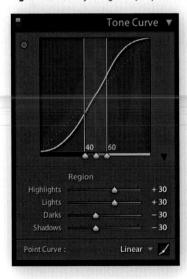

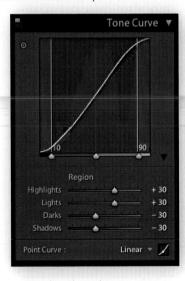

Figure 4.55 Adjusting the split points can increase or reduce the midtone contrast.

Refining the tone curve contrast

The following example shows how the Tone Curve Zones can be adjusted to fine-tune the tone curve contrast. I find it also helps sometimes to drag the Shadows zone slider to the extreme left position and the Highlights zone slider to the extreme right to concentrate a contrast boost to add a contrast kick to the shadows and highlights and leave the midtone contrast relatively flat.

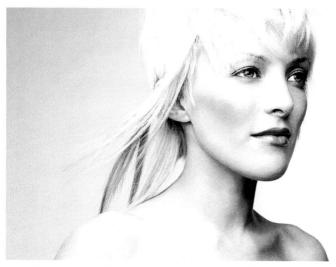

1. Here, a contrast-increasing tone curve was applied to the image. The tone range split points were in their default positions and, as you can see, the Tone Curve Zones were evenly divided.

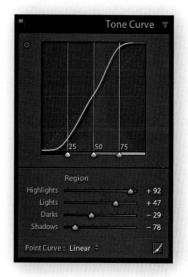

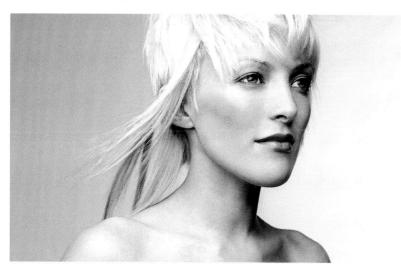

2. In this step, I moved the middle and outer right sliders to the right. This compressed the width of the Lights zone and thereby increased the contrast in the Lights zone area. This revealed more tone detail in the face.

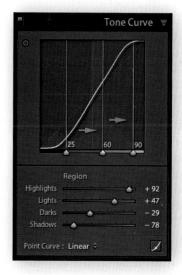

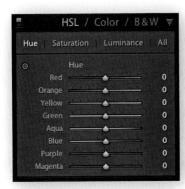

Figure 4.56 The HSL / Color / B&W panel with the HSL mode selected.

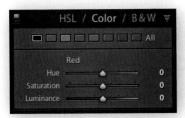

Figure 4.57 The HSL / Color / B&W panel with the Color mode selected.

HSL / Color / B&W panel

The HSL / Color / B&W panel is an all-in-one panel for making fine-tuned color adjustments and black-and-white conversions. The HSL component (Figure 4.56) is kind of equivalent to the Hue/Saturation dialog found in Photoshop, except in Lightroom you can apply these types of adjustments to raw photos as well as rendered pixel images, such as JPEGs and TIFFs. It is a color adjustment tool to use when you need to target specific colors. The HSL panel has three color adjustment sections that allow you to control the Hue, Saturation, and Luminance over eight color-band ranges. These provide a more practical range of color hues to work with and more usefully match the colors people most often want to adjust. The Color section of this panel (Figure 4.57) provides a more simplified version of the HSL controls, with button selectors at the top for choosing the desired color band to edit, with Hue, Saturation, and Luminance sliders below. The B&W section can be used to carry out black-and-white conversions (which I discuss in the following chapter).

The sliders in the Hue section control the hue color balance, and these can be used to make hue color shifts in each of the eight color-band ranges. For example, dragging the Green Hue slider to the right makes the greens more cyan, while dragging to the left makes them more yellow. The sliders in the Saturation section control the color saturation. Dragging a slider to the right increases the saturation, while dragging to the left decreases the saturation. If all the Saturation sliders were dragged to the left, you could convert the whole image to black and white. The Saturation slider controls apply a nonlinear saturation-type adjustment (similar to what the Vibrance slider does). This means that as you increase the saturation, lower saturated pixel values are increased relative to the already higher saturated pixel values in an image. The sliders in the Luminance section can be used to darken or lighten colors in the selected color ranges, and in a way that manages to preserve the hue and saturation. If you click the All button, the panel expands to let you see all the sliders at once. Also, clicking the Hue, Saturation, or Luminance tabs toggles showing just the controls for those parameters or showing All sliders.

As with the Tone Curve panel, the HSL controls can be applied using a Target Adjustment mode. Select the Hue, Saturation, or Luminance tab and click the Target Adjustment tool button to activate it. You can then click an image and drag up or down to adjust the colors targeted by the pointer. You can use the following shortcuts to enable the various HSL Target Adjustment modes: Hue,
#AIT Shift (Mac) or Ctrl AIT Shift (PC); Saturation, *AIT Shift S (Mac) or Ctrl AIT Shift (PC); and Luminance, *AIT Shift (Mac) or Ctrl AIT Shift (PC). You can turn off the Target Adjustment tool by clicking the Target Adjustment button again, pressing Esc, or using the *AIT Shift N (Mac) or Ctrl AIT Shift N (PC) shortcut. The Target Adjustment tool is then deactivated whenever you switch to working in a new panel.

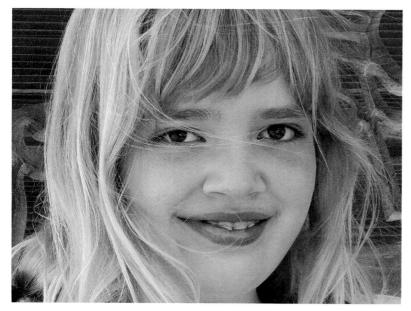

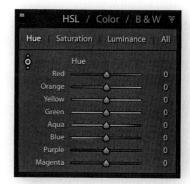

1. To better handle skin tones, you might consider creating a custom camera calibration profile (see "Camera profiles" on page 274). But if you shoot a mixture of subjects with the same camera profile, you can also use the HSL panel Hue section to compensate for reddish skin tone colors.

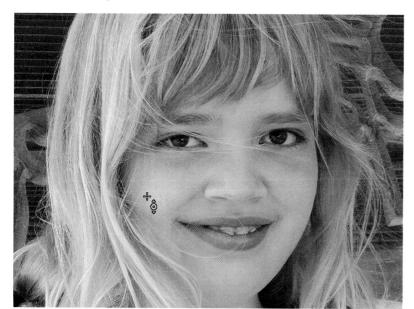

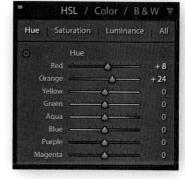

2. In this example, I went to the Hue section and activated the Target Adjustment tool. I then clicked on a skin tone area in the picture and dragged upward to make the skin tones less red and more yellow.

Selective color darkening

At first glance, the HSL controls in Lightroom appear to work the same as those used in Photoshop's Hue/Saturation dialog, but if you experiment a little further, you will notice some distinct differences. For example, the Lightroom Hue slider adjustments are somewhat tamer than their Photoshop cousins. The Saturation sliders respond more or less the same as they do in Photoshop, but the most marked differences are revealed when working with the Luminance controls. You may have noticed that when you adjust the Lightness slider in the Photoshop Hue/Saturation dialog, the adjusted colors tend to lose their saturation. To selectively darken a color in Photoshop, you generally have to search for a particular combination of Saturation and Lightness to achieve the desired result. However, the Lightroom sliders really do respond the way you would expect them to and provide you with complete control over the luminance of any color range, as shown in the following steps.

The challenge here was to simulate the effect of a polarizing lens filter and darken the blue sky without affecting the tonal balance of the other colors.

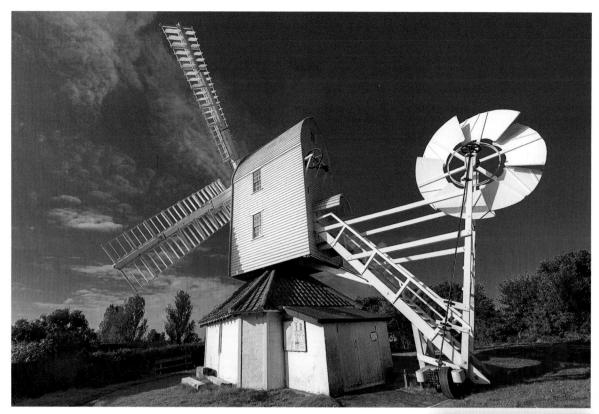

2. To darken the blue sky colors in Lightroom, I enabled the Target Adjustment mode in the Luminance section of the HSL panel, clicked an area of blue sky, and dragged downward. As you can see, this mainly reduced the Blue slider luminance and successfully added more contrast between the sky and the white windmill.

When darkening a blue sky, as in the example shown here, you sometimes end up seeing banding or mottling in the blue sky areas. One solution is to go to the Detail panel and increase the Color and Smoothness settings in the Noise Reduction section.

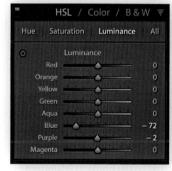

False color hue adjustments

There is still some room to go crazy and do things like turn blue skies purple, but the Hue adjustments in Lightroom are definitely more constrained. To create more extreme hue shifts, you will want to shift more than one Hue slider at a time. For example, you could create a series of Develop settings in which all the Hue sliders are shifted by equal amounts. To give you an example, I created a series of hue-shifted Develop preset settings. In one setting, all the Hue sliders are shifted +30; in another, they are shifted to +60; and so on. I suggest this as one way to create creative hue-shift coloring effects (**Figure 4.58**).

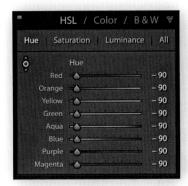

Figure 4.58 This shows a before and after example of an even –90 Hue color shift applied across all the hue values.

Using the HSL controls to reduce gamut clipping

The camera you are shooting with is almost certainly capable of capturing a greater range of colors than can be shown on your computer display or in print. But just because you cannot see these colors does not mean they are not there.

The following steps show a photograph taken of a rock formation in Arches National Park in Utah. This was shot at sunset when the rocks appeared at their reddest. At first glance, there did not appear to be much detail in the rocks, but this was only because the computer display was unable to show all the color information that was actually contained in the image. By using the HSL panel Luminance controls to darken the red and orange colors, I was able to bring these colors more into the gamut of the computer display so that they no longer appear clipped.

If you are using a standard LCD display, there is a good chance the more saturated colors will appear clipped, which can make it hard to predict how some colors will appear in print if you can't actually see them. If the display you are using has a wide color gamut, it should be a better indicator as to which colors will and will not print. This is especially true when using soft proofing to visualize what the final print should look like (see Chapter 8). The display I work with has a gamut that matches 98% of the Adobe RGB color space, and this certainly helps when making evaluative adjustments such as in the example shown here. Even so, I find with certain color images I need to constrain the color saturation and luminance to achieve more printable result.

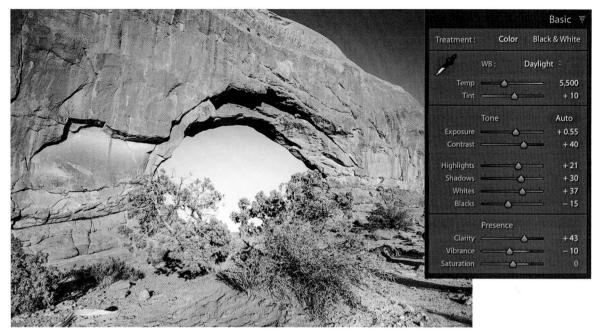

1. Shot late in the day as the sun was setting, this photograph captured a lovely warm glow on the red rocks. Shown here are the Basic panel settings I used.

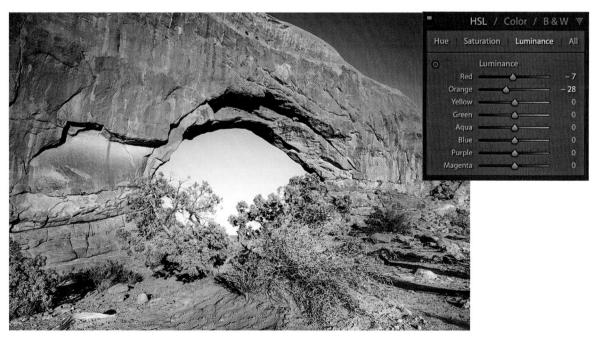

2. From the HSL panel, I selected the Luminance tab and adjusted the Red and Orange sliders to darken the luminance of the red rocks.

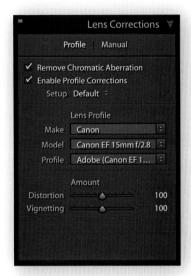

Figure 4.59 The Lens Corrections panel with the Profile section selected.

Lens Corrections panel Profile mode

The Lens Corrections panel can be used to cure various kinds of lens problems and has two sections: Profile and Manual (**Figure 4.59**). I will start by looking at the Profile controls

Lens profile corrections

Checking the Enable Profile Corrections box applies an auto lens profile correction adjustment. This can be done for any image, providing it contains the lens information in the EXIF data and there is a matching lens profile in the Lightroom lens profile database. Also, some lens corrections profiles now also take into account when a teleconverter is combined with a lens. Images that are missing their EXIF metadata cannot be processed using the Enable Profile Corrections feature. However, by saving Lens Profile Corrections settings as Develop presets, it is possible to apply such adjustments where the EXIF metadata is missing.

If the lens you are using is not included in the camera lens profile database, you can use a custom lens profile. (I will cover custom lens profiles shortly.) Assuming Lightroom offers lens profiles for the lenses you are shooting with, it is a simple matter of clicking the Enable Profile Corrections box to apply an auto lens correction to any selected photo. When you do this, you should see in the boxes below the make of the lens manufacturer, the specific lens model, and the lens profile (which will most likely be the installed Adobe profile). If these appear empty, then you may need to first select the lens manufacturer from the Make menu, the lens model from the Model menu, and the preferred lens profile from the Profile menu. It is important to appreciate that some camera systems capture a full-frame image (therefore making full use of the usable lens coverage area for many lenses), whereas compact SLR range cameras tend to have smaller sensors that capture the image using a smaller portion of the lens's total coverage area. The Adobe lens profiles have mostly been built using cameras that have full-frame sensors. This means that from a single lens profile it is possible to automatically calculate the appropriate lens correction adjustments to make for all other types of cameras where the sensor size is smaller. Lightroom and Camera Raw should use lens profiles generated from raw capture files. This is because the vignette estimation and removal has to be measured directly from the raw linear sensor data rather than from a gamma-corrected JPEG or TIFF image.

Lens profile corrections consist of two components: a Distortion correction to correct for the barrel or pincushion geometric distortion, along with a Vignetting correction. The Amount sliders allow you to fine-tune a profiled lens correction. So, for example, if you wanted to allow an automatic lens correction to automatically correct for the lens vignetting, but not correct for, say, a fisheye lens distortion, you could set the Distortion slider to 0 (dragging it all the way to the

left). On the other hand, if you believe an auto lens correction to be too strong or not strong enough, you can easily apply a compensation to the correction amount by dragging either of these sliders left or right.

The default option for the Setup menu is Default. This instructs Lightroom to automatically work out what is the correct lens profile to use based on the available EXIF metadata contained in the image file, or use whatever might be assigned as a default Lens Correction with this particular lens. The Custom option appears only if you choose to override the auto-selected default setting, or you have to manually apply the appropriate lens profile. As you work with the automatic lens corrections feature on specific images, you also have the option to customize the Lens Corrections settings and use the Setup menu to select the Save New Defaults option. This lets you set new Lens Corrections settings as the default to use when an image with identical camera EXIF lens data settings is selected (such as when you adjust the Distortion and Vignetting sliders to under- or overcompensate for a lens profile correction). The Setup menu will, in these instances, show Default as the selected option in the Setup menu.

Accessing and creating custom camera lens profiles

If you do not see any lens profiles listed for a particular lens, you have two choices: You can either locate a custom profile that someone else has made or make one yourself using the Adobe Lens Profile Creator program, which is available for free from labs.adobe.com. The Adobe Lens Profile Creator page provides full documentation that explains how to go about photographing an Adobe Lens Calibration chart and build custom lens profiles for your own lenses. This is not too difficult to do once you have mastered the basic principles.

Incidentally, the Photoshop Lens Correction filter includes an Auto Correction tab where one of the submenus allows you to access shared custom lens profiles that have been created by other Photoshop customers (using the Adobe Lens Profile Creator program). Unfortunately, the Lens Corrections panel in Lightroom does not provide a shared-user lens profile option, so whether you are creating lens profiles for yourself or wish to install a custom lens profile, you will need to reference the directory path lists shown in the Note opposite. After you add a new lens profile to the Lens Profiles folder, you need to guit Lightroom and restart before a newly added lens profile appears listed in the Lens Corrections panel Lens Profile list.

Profile lens corrections in use

The following steps show I was able to use a lens profile correction to correct the geometric distortion in a fisheye-lens photograph.

NOTE

Custom lens profiles created via Adobe Lens Profile Creator 1.0 should be saved to the following shared locations.

Mac OS X: Library/Application Support/Adobe/CameraRaw/Lens Profiles/1.0 Windows: Program Data\Adobe\

Camera Raw\Lens Profiles\1.0

247

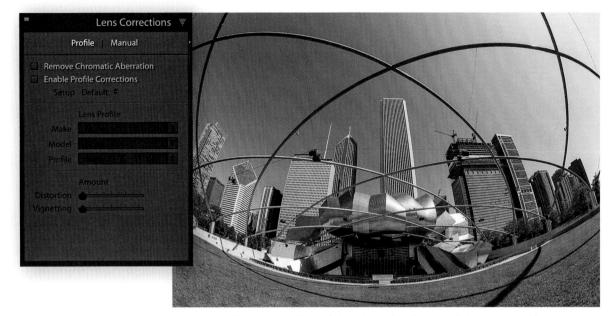

1. Shot using a 15mm fisheye lens, this photograph has a noticeable curvature in the image.

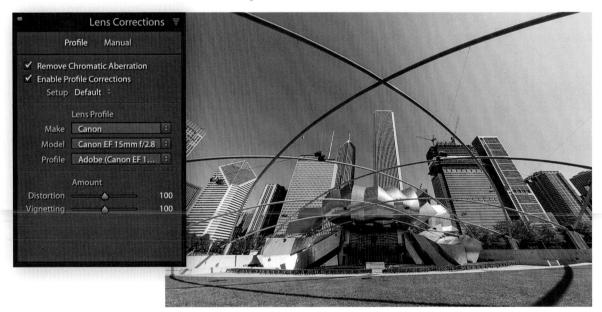

2. In the Lens Corrections panel, I checked the Enable Profile Corrections box to apply an auto lens correction to the photograph. Here, I left the Distortion and Vignetting sliders at their default 100 settings.

3. Next, I went to the Transform panel and applied a Vertical Upright correction. In the Transform section below, I adjusted the Vertical slider to partially restore some of the keystone distortion. I adjusted the Aspect Ratio slider to stretch the image vertically and adjusted the Scale slider to zoom out slightly and reveal more of the image content.

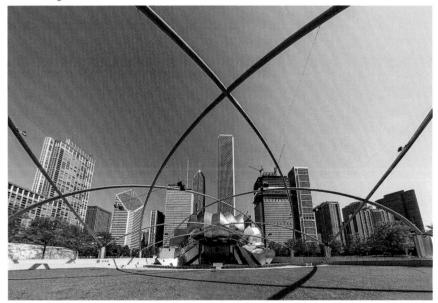

4. Finally, I opened the photo in Photoshop and used the Content-Aware Fill feature to fill in the white space at the bottom. (There is a video on the book website that shows how this was done.)

Downloadable Content: thelightroombook.com

Figure 4.60 If lens corrections have already been embedded "in-camera," you will see the "Built-in Lens Profile applied" message.

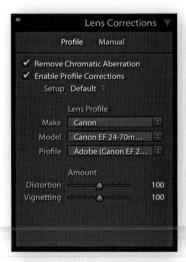

Figure 4.61 You can enable Remove Chromatic Aberration via the Profile tab.

In-camera lens corrections

Some digital cameras, such as the Panasonic DMC-LX3 and Sony RX100, are capable of storing lens-corrected linear raw data that can be read and used to optically correct for things like geometric distortion. Lightroom is able to read this data and use what are referred to in the DNG specification as "opcodes." These allow the lens correction processing to be applied at the raw processing stage rather than in-camera. In fact, the camera manufacturers have not been willing to allow Adobe to provide Camera Raw support for their cameras unless Adobe respects this data and applies the lens corrections in Camera Raw. In instances where a built-in profile has already been applied, the Lens Corrections panel now indicates this with an alert message stating that a built-in lens profile has already been applied automatically. Clicking the "i" button opens a dialog with a more detailed description of the lens profile correction that has been applied (Figure 4.60).

Removing chromatic aberration

Chromatic aberration is caused by an inability to focus the red, green, and blue light wavelengths at the same position toward the edges of the frame, which is more correctly known as lateral or latitudinal chromatic aberration. The sensors in the latest digital SLRs and medium-format camera backs are able to resolve a much finer level of detail than was possible with film. As a consequence, any deficiencies in the lens optics can be made even more apparent. Therefore, where some color wavelengths are focused at different points, you may see color fringes around the high-contrast edges of a picture. This can be particularly noticeable when shooting with wide-angle lenses (especially when they are being used at wider apertures), and here you may well see signs of color fringing toward the edges of the frame. This is easy enough to fix by checking the Remove Chromatic Aberration option in the Profile tab section of the Lens Corrections panel (Figure 4.61). When checked, Lightroom carries out an automatic chromatic aberration correction regardless of whether you have a lens profile correction enabled or whether a suitable lens profile is available or not. This option can also automatically correct for chromatic aberrations when using decentered lenses, such as tilt/shift lenses.

The following steps show how the Remove Chromatic Aberration option can help improve the appearance of an image that has obvious signs of color fringing.

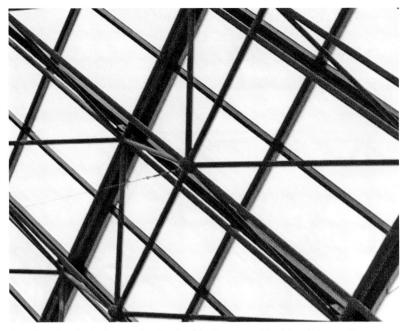

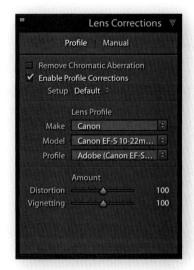

1. Here is a typical example of color fringing caused by lateral chromatic aberration toward the edges of the frame of a wide-angle zoom lens. This is the uncorrected version with the Remove Chromatic Aberration box unchecked.

2. I checked the Remove Chromatic Aberration option in the Lens Corrections panel Profile tab section to remove the color fringing completely.

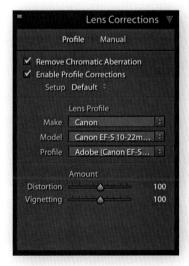

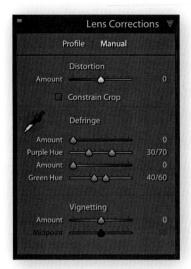

Figure 4.62 The Lens Corrections panel showing the Defringe sliders in the Manual tab section.

Lens Corrections panel Manual mode

Sometimes an image needs a little more fine-tuning than the automatic corrections can provide. That's where Manual mode comes in handy.

Defringe adjustments

The Defringe controls are designed to fix axial (longitudinal) chromatic aberration. This can be caused due to ghosting, lens flare, charge leakage (which affects some CCD sensors), as well as changes in focus.

Unlike lateral chromatic aberration, which occurs toward the edges of the frame, this type of aberration can appear anywhere in an image. It particularly affects fast, wide-aperture lenses and is typically most noticeable when shooting at the widest lens apertures, where fringes will usually be at their most visible just in front of and just behind the plane of focus. These will typically appear purple/magenta when they are in front of the plane of focus and appear green when they are behind the plane of focus. But even at the exact point of focus, you may sometimes see purple fringes (especially along high-contrast or backlit edges), which can be caused by flare. As you stop down the lens aperture, these types of aberrations are usually less noticeable.

The Defringe section consists of four sliders (**Figure 4.62**). The Purple Amount and Green Amount sliders control the degree of correction, and below each of these are the Purple Hue and Green Hue sliders, which have split slider controls.

Looking at the two Purple sliders, the Amount slider has a range of 0 to 20 and is used to determine the strength of the purple fringing removal. The Purple Hue slider can then be used to fine-tune the range of purple colors that are to be affected. What you need to be aware of here is that a higher Purple Amount setting applies a stronger correction, but the downside is that at higher settings this may cause purple colors in the image that are not the result of fringing to also become affected by the Purple Amount adjustment. To moderate this undesired effect, you can tweak the Purple Hue slider split points to narrow or realign the purple range of colors to be targeted. You can drag either of the knobs one at a time, or you can drag the central bar to align the Hue selection to a different portion of the purple color spectrum. If you need to reset these sliders, just double-click each individual knob. Likewise, double-click the central bar to reset it to its default position. The minimum distance that may be set between the two sliders is 10 units.

The Green Amount and Green Hue sliders work in exactly the same fashion as the Purple sliders, except they allow you to control the green fringes. However, the default range for the Green Hue slider has a narrower range of 40 to 60 (instead of 30 to 70 for Purple). The reason for this is to help protect common green and yellow colors such as those found in foliage.

The Defringe controls in use

The recommended approach is to carry out all your major tone and color edits first and make sure that you have turned on the profile-based lens corrections to correct for geometric distortion and vignetting. Once these steps have been taken, go to the Profile tab of the Lens Corrections panel and check the Remove Chromatic Aberration check box. Then go to the Manual tab and use the Defringe sliders to remove any remaining signs of fringing. As with the Detail panel controls, the Lens Correction Defringe controls are best used when viewing an image at a 100% view or higher. If a global adjustment is having an adverse effect on the rest of the image, you can always turn down the Purple/Green Amount sliders and use a localized adjustment with the Defringe slider set to a positive value to apply a stronger, localized adjustment.

You can also use the Att key as a visualization aid. This can greatly help you see an emphasized overlay that gives a clearer indication of what effect the sliders are having and making the most suitable slider adjustments. Hold the Att key and drag the Purple Amount slider to visualize purple fringe removal. This will cause the preview to reveal only the affected areas of the image. All other areas will be shown as white. This lets you concentrate on the affected areas and help verify that the purple fringe color is being removed. Hold the Alt key and drag either of the Purple Hue slider knobs to visualize the range of hues that are to be defringed. As you do this, the preview will show the affected hue range as being blacked out. As you drag a slider, you need to pay close attention to the borders of the blacked-out area to check if there are any residual purple colors showing. The same principles apply when adjusting the Green Amount and Green Hue sliders with the Alt key held down.

Eyedropper tool

When working with the Defringe sliders you can activate the Eyedropper tool and use this to select a target fringe color, analyze the pixels in the local area around where you clicked, and auto-calculate the required fringe amount and hue adjustment for the purple and/or green color fringes. To use this tool, it helps to be zoomed in extra close, such as at a 200% or even a 400% view, as this will make the color picking more accurate. If the Eyedropper tool detects a purple fringe color as you move it over the image, the Eyedropper will appear filled with a purple color, indicating this is an okay area to click to sample a representative purple fringe color. Likewise, if the Eyedropper tool detects a green fringe color, you will see a green Eyedropper (Figure 4.63). However, if the area below the tool is too neutral, or the color falls outside the supported color range, the Eyedropper tool will be filled gray. If you click, an error message will appear saying, "Cannot set the purple or green fringe color. Please sample a representative fringe color again."

Figure 4.63 As you roll the Eyedropper over the image, the tool indicates whether the selected area is too neutral (left), contains purple fringe colors (center), or contains green fringe colors (right).

Applying a global Defringe adjustment

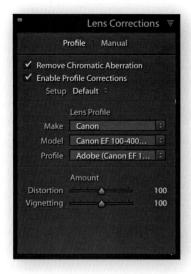

1. The first step was to apply all the main color and tone adjustments and enable the lens profile corrections in the Lens Corrections Profile tab section.

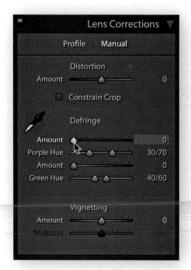

2. I clicked the Manual tab to view the Defringe controls. I then held down the Alt key and clicked and held on the Purple Amount slider to get a visualization of the extent of the purple fringed area, with everything else displayed with a white overlay.

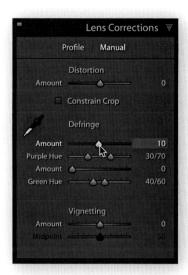

3. With the Alt key held down, I dragged the Purple Amount slider until all of the purple fringing appeared to have been removed. (It helps to use a 200% close-up view or higher when judging the effectiveness of such an adjustment.)

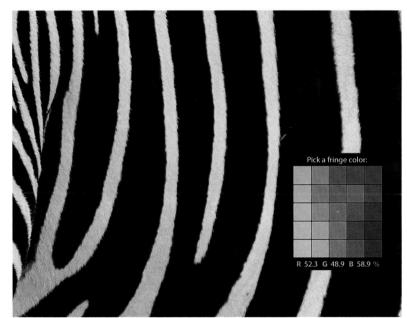

4. I reset the Purple Amount slider and decided instead to carry out an auto-calculated adjustment. I selected the Eyedropper and rolled the tool over the image to locate a magnified view of the purple fringe pixels.

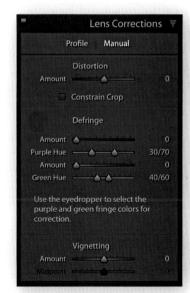

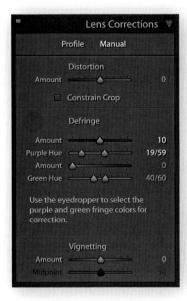

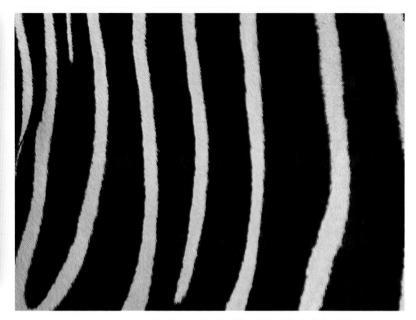

5. Here, you can see what the image looked like after I had clicked the purple fringe area that I had located using the Eyedropper. This auto-calculated the required adjustment and set the Purple Amount and Purple Hue sliders accordingly.

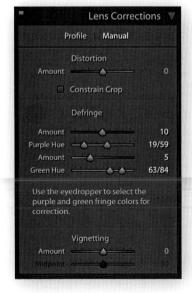

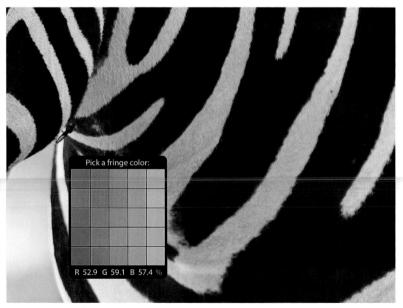

6. Lastly, I used the Alt key to locate the green areas and used the Eyedropper to select a green fringe area to auto-calculate the settings for the Green Amount and Green Hue sliders.

Applying a localized Defringe adjustment

The global Defringe controls should be all that you need in order to remove troublesome fringing. However, there may be instances where it will not be possible to remove all visible fringing using the global Defringe sliders on their own. Or, it may be the case that when applying a strong global correction, the adjustment you apply has an adverse effect on other areas. In situations like this, it can be useful to apply a global adjustment combined with a localized defringe correction using either the Adjustment Brush or the Graduated Filter. With some images, a localized defringe adjustment might be all you need to apply. It is worth pointing out here that localized Defringe adjustments will remove fringes for all colors (not just purple and green), and therefore work independently from the global Purple Hue and Green Hue settings set in the Lens Corrections panel.

To apply a localized a Defringe adjustment, the image you are processing must be updated to Version 3 or 4. The Defringe slider range goes from –100 to +100. A positive Defringe adjustment can be used to apply extra defringing where required, such as when working on specific problem areas in a picture. A negative Defringe adjustment can be used to say "don't apply a defringe and protect this area." When might you want to use this? Imagine a picture in which, say, a strong purple defringe was applied globally and resulted in the edges of the purple areas becoming desaturated. In a situation like this, you can paint over the affected areas with the Defringe slider set to –100, which will allow you to restore the original color to these areas.

Localized defringe adjustments are not as powerful as the global defringe corrections and therefore cannot be as effective on their own when correcting an image. This is why it is often best to use the global controls first and then use a localized adjustment to fine-tune as necessary. Just be aware that, unlike other localized adjustments, there is no benefit to be gained in applying multiple localized defringe adjustments to improve upon what can be achieved with a single localized adjustment step. The steps on the following page show an example of a localized Defringe adjustment.

Vignetting sliders

The Vignetting sliders at the bottom of the Lens Correction panel provide manual controls to correct for lens vignetting. These can be regarded as legacy sliders that have been present in Lightroom since before the introduction of profiled lens corrections. These sliders provide backward compatibility for images that were edited in older versions of Lightroom. They are not really so necessary now, although having said that, you can use them in conjunction with the Effects panel Post-Crop Vignetting sliders to apply vignetting effects. This is discussed in a later section of this chapter.

1. As you can see in this close-up, this image has some obvious signs of color fringing.

RAMEMI

2. Here, I selected the Adjustment Brush, set the Defringe slider to +100, and painted over the affected areas to reduce the color fringing. I was able to get rid of nearly all the visible fringing and target the Defringe adjustment precisely where it was needed most.

Transform panel

The Transform panel (**Figure 4.64**) can be used to apply Upright (automated perspective corrections) and manual transform adjustments. These provide you with control over the perspective and scaling of an image. However, if you want to flip a photograph you'll need to choose Photo \Rightarrow Flip Horizontal or Flip Vertical.

Upright adjustments

When applying an Upright adjustment, Lightroom first analyzes the image for straight-line edges and, from this, is able to estimate a perspective transform adjustment. To get the best results, it is recommended you apply a lens profile correction first. Several Upright options are offered here, because no single type of adjustment will work perfectly for every image, so it is always worth checking out each option to see which adjustment works best for an individual photo. To help, each button has a tooltip that explains its function.

Clicking the Auto button applies a balanced correction to the image, that is it applies a balanced combination of the options listed below plus an Aspect Ratio correction. Essentially, Auto aims to level the image and, at the same time, fix converging vertical and horizontal lines in an image. The ultimate goal is to apply a suitable transform adjustment that avoids applying too strong a perspective correction. The Auto setting mostly crops the image to hide the outside areas. However, if the auto adjustment ends up being quite strong, some outside areas may remain visible. With the Guided option, you manually add guides to correct the horizontal and vertical lines. The Level correction applies a leveling adjustment only—this is like an auto-straighten tool. The Vertical perspective correction applies a level and a converging vertical lines adjustment. And lastly, the Full correction applies a full level and a converging vertical and horizontal perspective adjustment, and in doing so will allow strong perspective corrections to occur. To cycle through the Upright modes, use Ctrl Tab (this shortcut is the same for both Mac and PC).

The Off setting can be used to turn off an Upright correction, while preserving the initial, precomputed analysis of the image. As you click any of the above options (except Off), this automatically resets the Horizontal, Vertical, and Rotate sliders. Upright adjustments preserve any crop that is active, but will reset a crop rotate angle. If an Upright adjustment is unable to do anything, you'll see a message at the bottom of the panel saying "No Upright correction found" and the manual transform sliders will remain as they are.

How Upright adjustments work

It is important to understand that the underlying math behind Upright adjustments is doing more than auto-applying Vertical, Horizontal, and Rotate adjustments. Upright adjustments work quite differently than the manual sliders in the Transform section. The vertical and horizontal adjustments involved in the

Figure 4.64 The Transform panel.

Upright process are actually quite sophisticated. Behind the scenes, there are angle of view and center of projection adjustments taking place. This all has to do with the fact that the interaction of one rotation movement can have an impact on another, and such interactions can be quite complex. For example, think about what happens when you adjust the tilt and yaw on a camera tripod head, and you may get some idea of the problem.

Having the choice of four auto Upright methods means at least one of these should work well and, failing that, there is the manually controlled Guided Upright option. What tends to happen, though, is the perspective can often end up looking too perfect. When correcting the perspective for a building to remove a keystone effect, it is generally a good idea to go to the Manual tab afterward and adjust the Vertical slide, adding something like a +10 adjustment so the corrected verticals still converge slightly. You might even consider creating a preset that combines, say, an Auto Upright correction with a Vertical slider tweak. You may also find it helpful here to enable the Grid overlay via the View Loupe Overlay menu (see page 104).

Lightroom supports and preserves image transparency when reading TIFF, PNG, and DNG files. In Lightroom, you will notice how transparent areas (which can appear when applying a Geometric correction, Upright correction, or Manual transform) are represented in Lightroom as white. It is inevitable that extreme adjustments may cause the image to distort so much that you will end up seeing transparent areas. Where this happens, you can check the "Constrain to crop" box to apply an auto-crop adjustment that trims the image accordingly. Or, you can always apply a manual crop to the image afterwards to set the crop boundary. When exporting images as TIFF or PSD to Photoshop, the transparency will be preserved and appear represented with the usual checkerboard pattern. When exporting as JPEG, the transparent areas are represented as white.

Suggested order for Upright adjustments

You'll want to apply an Upright adjustment early on in the image processing, because unlike most other image edits carried out in the Develop module, the order matters. In particular, you will want to ensure you apply an Upright adjustment before you apply a rotate crop or manual transform adjustment. As for lens profile corrections, it is best to apply these before an Upright adjustment, as a geometrically corrected image can help the line detection work better.

Synchronizing Upright settings

When synchronizing Upright settings, you have to think carefully about what you wish to achieve, as this will have a bearing on the options you select in the Copy/Synchronize Settings dialog (see page 337). If Transform panel adjustments have been applied to an image and you wish to synchronize the Transform panel settings with other images, you can choose to synchronize the Upright Mode, Upright Transforms, or Transform Adjustments. Upright mode simply synchronizes the Upright method, i.e., Auto, Level, Vertical, or Full (note that you can't sync a Guided Upright adjustment using the Upright Mode option). This will result in Lightroom synchronizing the Upright mode method, but analyze each image individually as it does so. It may well produce a different outcome on other images, especially if you happen to sync the Auto Upright mode. The Upright Transforms option synchronizes the Upright transform adjustment precisely. For example, if you were to prepare a group of bracketed exposure images to create an HDR master, you would want to use this method to synchronize the Upright settings. The Transform Adjustments option syncs just the manual slider settings in the Transform panel.

How to apply an Upright adjustment

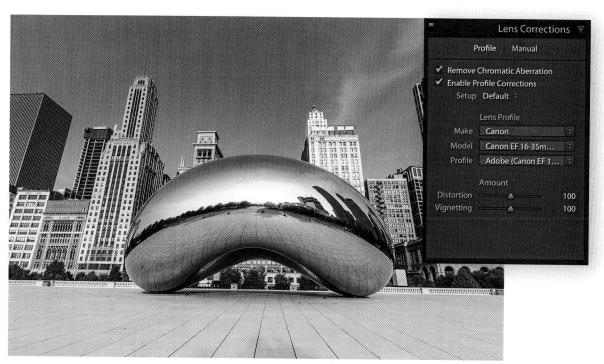

1 I began by checking the Remove Chromatic Aberrations and Enable Profile Corrections boxes in the Lens Corrections panel.

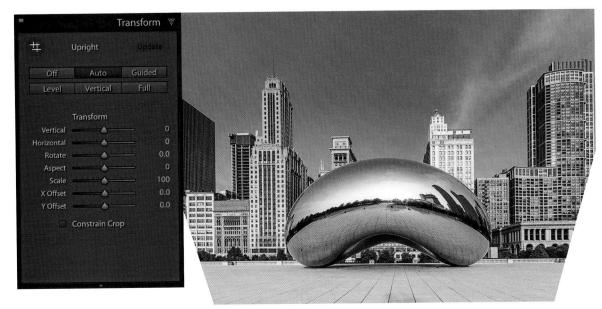

2. In the Transform panel, I clicked the Auto Upright button to apply an auto-correction. This applied an auto-perspective adjustment that combined a leveling and a horizontal and vertical perspective correction and, as you can see, transformed the image in such a way the bottom edge of the image was shortened and revealed white padded areas on either side.

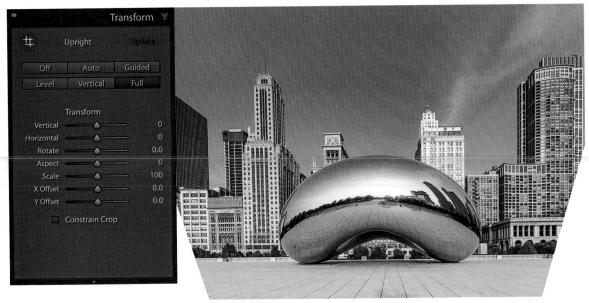

3. I then selected the Full option. This applied a strong perspective correction, similar to the Auto adjustment, which also revealed white padded areas.

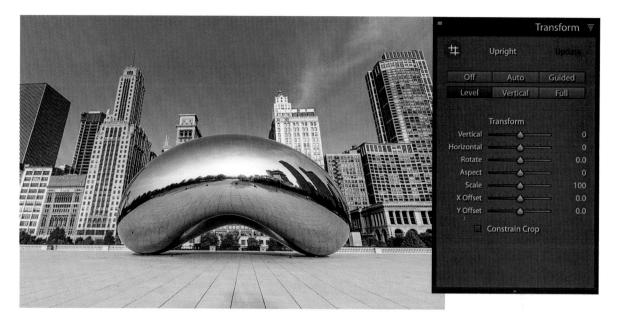

4. I then selected the Level correction. This correction simply applied an auto-level adjustment and did not attempt to fix the keystone perspective.

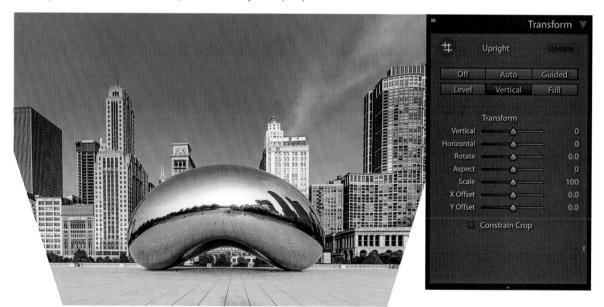

5. Lastly, I selected the Vertical correction. This leveled the image and corrected the keystone effect. Now, with every image you will see different kinds of outcomes when running through these options. Although the Auto, Full, Level, and Vertical corrections looked fairly similar, they were, in fact, subtly different. Of the four methods, I liked Auto best.

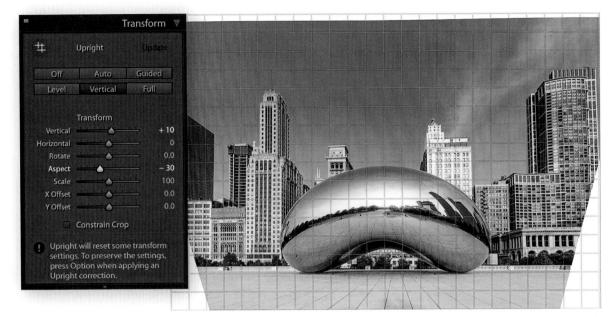

6. In the Transform section, I adjusted the Vertical slider, setting it to +10, which made the vertical lines converge slightly and produced a more natural-looking perspective. The image was a little squashed horizontally, so I also adjusted the Aspect slider to –30 to widen the aspect ratio.

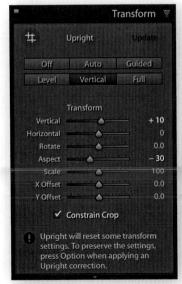

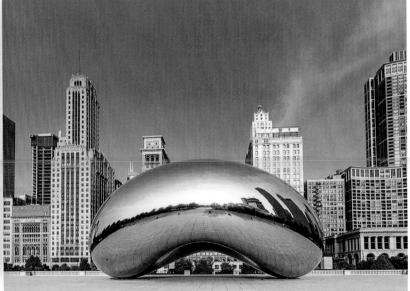

7. Finally, I checked the Constrain Crop box to apply an auto crop that removed the white padded areas and trimmed the image accordingly.

Guided Upright adjustments

When you click the Guided Upright option or click to select the Guided Upright tool (Shift), you can use the Guided Upright tool (Figure 4.65) to add up to four guide lines to define vertical and horizontal lines in an image. It is best to apply a lens profile correction first before you do this, and you will need to first apply a minimum of two guide lines. For example, you can start by adding two guide lines to define the verticals in a photograph followed by one or two more horizontal guides to define the horizontals. Any error and instruction messages will appear at the bottom of the panel. Enabling the Show Loupe option in the Toolbar will reveal a magnifying loupe, which can assist when defining the guide lines.

In practice, I think you will find it still easiest to begin by selecting one of the regular Upright button options to see which works best. If you can't find an optimum result, it is then worth selecting the Guided Upright option so you have complete control and can achieve the desired perspective correction. Another thing about working with the Guided Upright mode is that you don't have to use it just with architectural subjects. It can work on any image and be used as a tool to transform the shape of the image beyond what can be achieved using the Vertical and Horizontal Transform sliders. You don't have to align to straight lines either. You can deliberately offset the lines at an angle to get the image to transform to any angle you like.

Figure 4.65 The Transform panel with the Guided Upright tool selected.

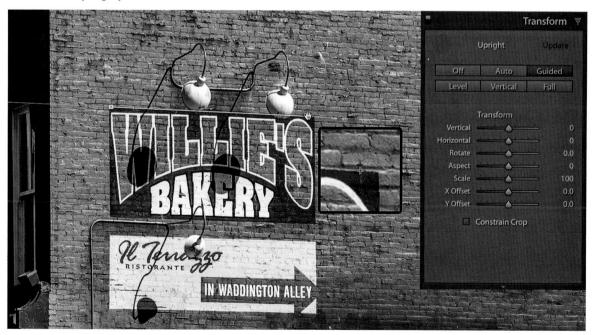

1. In Transform panel, I selected the Guided Upright option, then applied a horizontal guide line to the top of the sign. Nothing will happen yet until a second horizontal guide line is added.

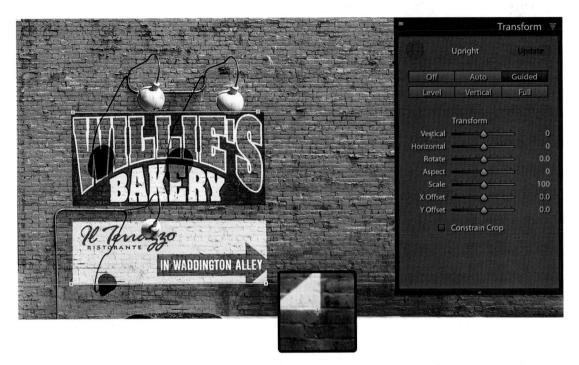

2. I added a second horizontal guide at the bottom of the sign, which then caused the horizontal lines to straighten.

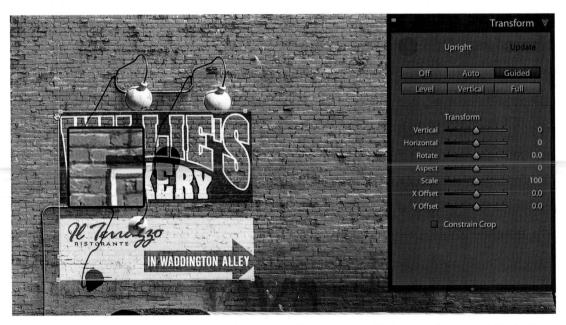

3. After straightening the horizontals, I added a guide line to the left edge to straighten it.

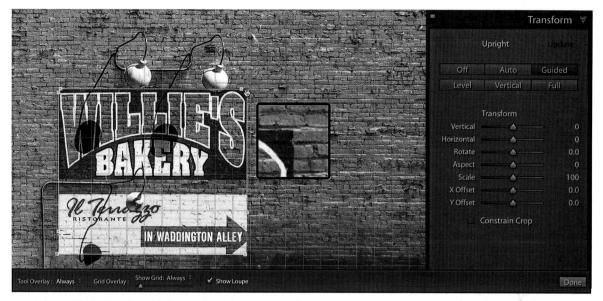

4. I then added a fourth guide line to the right edge. This final version has the Grid Overlay visible in the Toolbar.

The Transform sliders

The Transform sliders in the Transform panel can be used to apply manual transform adjustments (Figure 4.66). With the Vertical slider, you apply a keystone correction to the converging verticals in a photograph, such as those produced when pointing the camera upward to photograph a tall building. The Horizontal slider similarly corrects for horizontal shifts in perspective, which occur when a photo was captured from a viewpoint other than completely "front on" to a subject. The Rotate slider lets you adjust the rotation of the transform adjustment. Although it is possible to use the Rotate slider to straighten a photo, you can also use a Level Upright adjustment or the Straighten tool in Crop Overlay mode to achieve the same kind of result. The Aspect slider is useful for tweaking the results from an Upright adjustment. When correcting the perspective, the resulting image may look vertically or horizontally stretched. Using the Aspect slider, you can control how much the image is stretched vertically and horizontally so the image view looks more natural. The Scale slider lets you adjust the image scale. As you reduce the Scale amount, the outer image area will appear as an undefined white padded area (see the previous step examples). Lightroom does not provide any options for filling in this border (as you have with the Lens Corrections filter in Photoshop), but there are still ways you can do this in Photoshop when retouching a rendered pixel image that has been exported from Lightroom. Lastly, the X and Y Offset sliders can be used to center the image vertically or horizontally. This can be particularly helpful after applying a strong transform adjustment, such as when applying a Guided Upright adjustment.

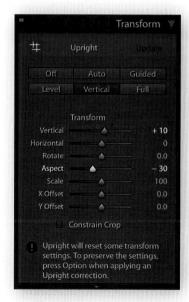

Figure 4.66 The Transform panel showing the Transform sliders.

Figure 4.67 The Effects panel Post-Crop Vignetting controls.

Effects panel

Whether you need to apply a vignette as a finishing touch to your image, add a bit of grain, or compensate for atmospheric haze, the Effects panel can help. The following sections demonstrate how to accomplish each of these tasks and more.

Post-Crop vignettes

The Post-Crop Vignetting controls in the Effects panel can do more or less the same thing as the Lens Corrections panel's Vignetting sliders, except these adjustments are applied relative to the proportions of the cropped photograph. However, whenever you use the Crop Overlay mode to edit a crop setting, you will notice the vignette effect is temporarily disabled. The Amount and Midpoint sliders work the same as those found in the Lens Corrections panel Manual tab Vignetting section, while the Roundness slider lets you adjust the shape of the vignette relative to the proportions of the image. In **Figure 4.67**, you can see that at 0 Roundness, the vignette shape matches the proportions of the cropped image. At +100, the Roundness slider makes the post-crop vignette more circular. With the Feather slider set to 0, this applies a harsh edge to the vignette edge. Meanwhile, the Feather slider allows you to soften or harden the vignette edge. For example, in Figure 4.67, I applied a 0 Feather amount, and this applied a hard edge to the vignette.

The Effects panel has other Post-Crop Vignetting Style options. In **Figure 4.68**, you can see I applied four different Post-Crop Vignetting settings to the same photograph. Also, the ability to apply both an Effects panel Post-Crop vignette and a Lens Corrections panel vignetting effect means that you can experiment using different combinations of these two settings when editing a cropped photograph. For example, in the bottom-right image in Figure 4.68, I combined a maximum +100 Lens Corrections panel Vignetting Amount correction with a maximum +100 Post-Crop Vignetting Amount correction in Paint Overlay mode.

Post-Crop vignette options

I have so far shown just the Paint Overlay effect in use, which was once the only post-crop vignette mode available in Lightroom. The Paint Overlay effect blends either a black or white color into the edges of the frame, depending on which direction you drag the Amount slider. When it was first introduced, some people were quick to point out that this post-crop vignetting was not exactly the same as a Lens Corrections panel vignette effect. You can see for yourself how a Paint Overlay vignette applies a soft-contrast, hazy kind of look. This was not to everyone's taste, though (although sometimes I quite like the look it creates). The two additional post-crop editing modes apply vignetting effects that are close in appearance to lens vignetting corrections applied via the Lens Corrections panel, where the darkening or lightening is produced by varying the exposure at the edges. There is also added scope to refine a vignetting effect whether you are using it to darken or lighten.

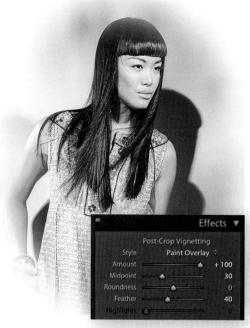

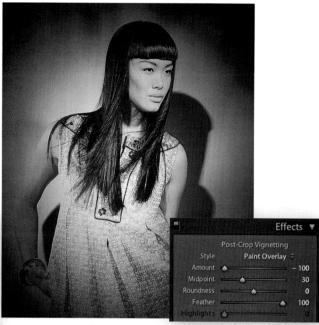

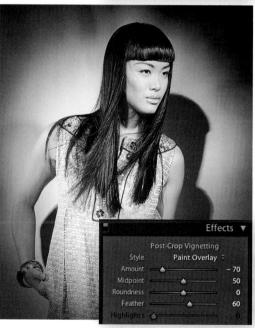

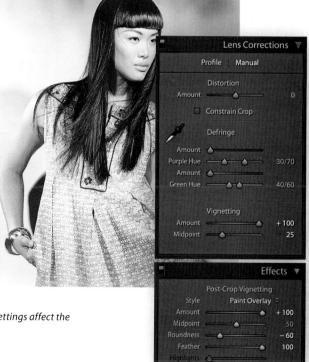

Figure 4.68 Examples of how different Post-Crop Vignetting settings affect the same image.

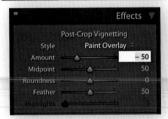

Figure 4.69 An example of a darkening effect using the Paint Overlay Post-Crop Vignetting settings.

In **Figure 4.69**, I initially applied a lens profile correction adjustment to correct for the lens vignetting and cropped the bottom of the photograph. I then applied the Paint Overlay Post-Crop Vignetting settings shown. As you can see, this applied a hazy, darkening effect to the edges of the photo.

In **Figure 4.70**, I used a positive Amount setting to lighten the corners of the photo. I applied Color Priority mode to the image on the left and Highlight Priority mode to the image on the right. Of the two, the Color Priority effect is the more gentle, because it applies the post-crop vignette after the Basic panel Exposure adjustments but before the tone adjustment stage. This minimizes color shifts in the darkened areas, but it is unable to perform any highlight recovery in areas that might be burnt out. Highlight Priority mode, on the other hand, tends to produce more dramatic results. It applies the post-crop vignette prior to the Exposure adjustment and has the benefit of allowing better highlight recovery, but this can sometimes lead to color shifts in the darkened areas.

Figures 4.71 and **4.72** show examples of the Highlight Priority and Color Priority modes applying darkening vignettes. The Highlights slider can further modify this effect, but it is only active when applying a negative Amount setting. As soon as you apply a lightening vignette, the Highlights slider is disabled. Increasing the Highlights setting lets you boost the contrast in the vignetted areas. The effect is really only noticeable in subjects that feature bright highlights, lightening them to take them more back to their original exposure value. Overall, I find the Highlights slider has the greatest impact when editing a post-crop vignette in Color Priority mode.

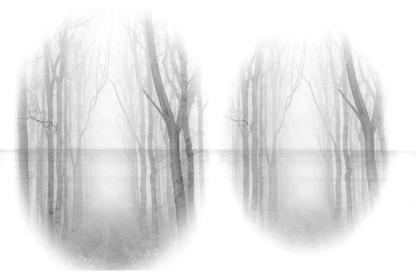

Figure 4.70 Two examples of a maximum lightening post-crop vignette adjustment using Color Priority mode (left) and Highlight Priority mode (right).

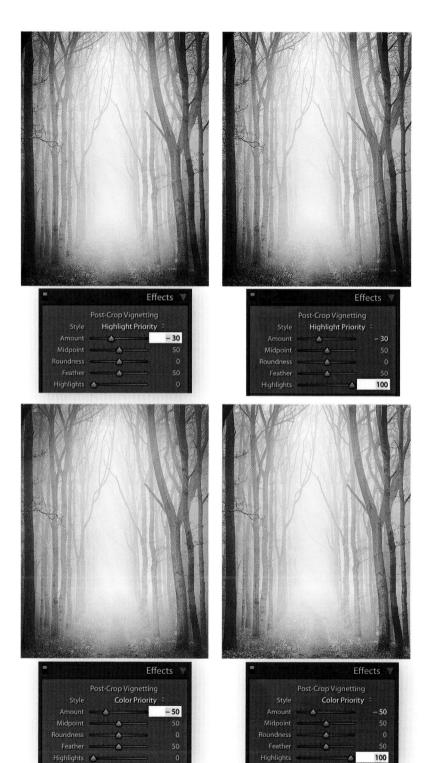

Figure 4.71 A –30 Highlight Priority vignette with the Highlights slider set to 0 (left) and 100 (right).

Figure 4.72 A –50 Color Priority vignette with the Highlights slider set to 0 (left) and 100 (right).

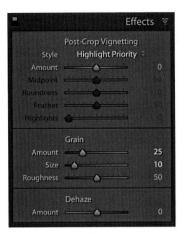

Figure 4.73 The Effects panel showing the Grain sliders.

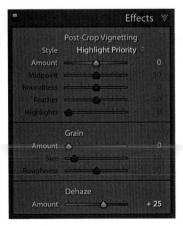

Figure 4.74 The Effects panel showing the Dehaze slider.

Adding Grain

The Effects panel contains Grain sliders, which can be used to give your photos a traditional film-like look (**Figure 4.73**). The Amount slider determines the strength of the grain effect, causing the image to significantly soften when set beyond 25. The Size slider can be used to set the size of the grain pattern and the Roughness slider used to control the smoothness of the grain texture.

You may need to apply quite strong settings if you want a grain effect to be noticeable in print. It has to be said, photographers often have false expectations when it comes to what they see on the screen being an accurate representation of what they will see in print. It is certainly possible to fret needlessly about what you see on screen at a 1:1 or a 200% view when the micro detail you are analyzing will be lost during the print process. The thing is, if you add a grain effect to a typical digital camera capture image and then make an 8" x 10" print, the effect will mostly be lost due to the downsizing of the image data. Similarly, if such images are downsized to appear on the web, I doubt you will notice the grain effect at all. If you have a photo that suffers from noticeable image artifacts, you can use the Grain sliders to add small amounts of grain to help hide these so that a final print can withstand close scrutiny. As my late friend and colleague Bruce Fraser used to say, "In the case of photographers, the optimum viewing distance is limited only by the length of the photographer's nose." It can also be useful to add small amounts of grain when treating heavily noise-reduced images.

Dehaze adjustments

The Dehaze slider in the Effects panel (**Figure 4.74**) can be used to compensate for atmospheric haze in photographs, as well as mist, fog, or anything that contributes to the softening of contrast and detail in a scene. For example, you can use the Dehaze slider to improve the contrast in photographs taken of a starry night sky and reduce the effects of light pollution. Drag the slider to the right to apply a positive value and remove haze from a scene; drag the slider to the left to add haze and make an image look more foggy. Basically, the results you get are in some ways similar to adjustments made using the Clarity slider, but a Dehaze effect is overall a lot stronger than can be achieved using the Clarity slider on its own.

There are a few things to watch out for, though, when working with Dehaze. First, it is recommended you set the white balance first. When you apply a Dehaze adjustment to remove haze this can emphasize the lens vignetting in an image. It is therefore best to make sure you apply a lens profile correction (or a manual vignetting correction) first in order to remove the lens vignetting before you apply a Dehaze slider adjustment. Similarly, a positive Dehaze adjustment will emphasize any sensor spots (although this can easily be dealt with using the Spot Removal tool).

Dehaze as a localized adjustment

Dehaze can be applied as a localized adjustment using the Graduated Filter, Radial Filter, or Adjustment Brush. This makes the effect more useful for treating land-scape images where, very often, the foreground at the bottom of the frame will look fine and it is only the subject matter in the distance from the middle to the top of the frame that needs correcting. You don't really want a Dehaze adjustment to be applied to areas that don't need it, so it is great you can apply Dehaze using the localized adjustment tools.

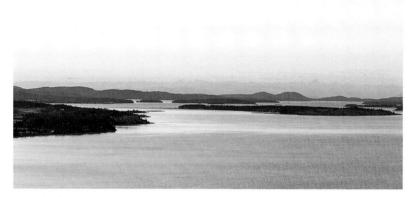

1. This landscape photograph was also shot using a long focal-length lens, then I applied the Basic panel adjustments shown here to optimize the tone contrast.

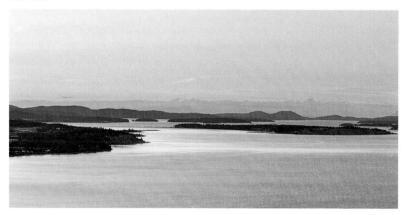

2. I selected the Graduated Filter tool and applied the adjustment settings shown here to the top half of the photograph in order to darken the sky slightly and bring out more detail in the distant hills and clouds. Notice how I also needed to reduce the Saturation to counter the saturation boost that resulted from the +40 Dehaze adjustment.

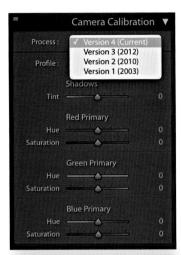

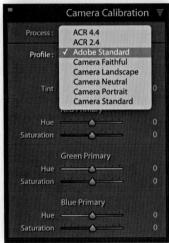

Figure 4.75 The Camera Calibration panel controls showing the Process options (top) and Camera Profile options (bottom).

Camera Calibration panel

The Camera Calibration panel (**Figure 4.75**) can be used to select the most appropriate camera profile to use as a starting point for subsequent Develop module adjustments. To start with, the Process menu allows you to choose which Process Version to apply to an image. Below that is a Profile menu where you can choose a suitable camera profile to use as a starting point for subsequent Develop module adjustments.

Camera profiles

Lightroom ships with calibrated camera profiles for most of the cameras that are supported by the Camera Raw database. These are mainly for Canon, Nikon, Sony, Olympus, and Pentax models. The Lightroom camera profiles are the result of many years of painstaking work. For each camera that is supported by Camera Raw, two sets of profile measurements are used to record the camera sensor's color response under controlled daylight-balanced and tungsten-balanced lighting conditions. Using this data, it is possible to extrapolate what the color response should be for all white balance lighting conditions that fall between these two setups and beyond. More than 500 different cameras are supported by Adobe Camera Raw and Lightroom, and in some instances, several camera samples have been tested to obtain a representative average set of measurements. Other times, only one camera model was actually used. But in all cases, it is clear that the measurements made by the Camera Raw team can only ever be as good as the camera or cameras from which the measurements were made (and how representative these were of other cameras of the same make). At the same time, the sensors in some cameras can vary a lot in color response from camera to camera, and this variance means that although a raw file from your camera may be supported by Lightroom, there is no guarantee it will have exactly the same color response as the cameras the Adobe team evaluated. The Adobe Standard profile (shown selected in Figure 4.75) is the recommended default, as it will be more color accurate than all the older Adobe profiles, such as the ACR 2.4 and ACR 4.4 profiles. These remain accessible simply for legacy compatibility reasons. Alternatively, you can use the Adobe DNG Profile Editor program to create your own custom camera calibrated profiles (see the PDF on the book's website).

All the other profiles are designed to match built-in camera look settings. For example, one of the things that's irritated some Lightroom users is the way the initial raw file previews change appearance as soon as the previews are updated in the program (to the Adobe Standard profile). This is because the embedded preview for a raw file is based on a standard camera JPEG-processed image. In other words, the previews that appear when you first import raw photos from a card show a color rendering determined by the camera JPEG settings. A lot of photographers were inclined to think, "Hey, I like the way those photos are looking," only to find that Lightroom would proceed to redraw the previews using the Adobe Standard profile. If you happen to like the JPEG look and would prefer that Lightroom keep the colors the same on import, you can do so by selecting

the Camera Standard profile from the Profile list that's shown in Figure 4.75. This will allow you to match near enough the default camera JPEG look. All the other profiles you see listed here are designed to match the color response for other specific camera JPEG looks that may be associated with a particular camera. With Nikon cameras, the alternative profile options might include Mode 1, Mode 2, and Mode 3. With my Sony camera files, the options include Camera Deep, Camera Light, and Camera Vivid. Some cameras have Camera Monochrome profiles.

The thing to stress here is there is no right or wrong way to process an image at this stage, because any color interpretation is really just a starting point. But if you want your raw photos to match the "look" of one of the camera JPEG settings, you can select an appropriate profile. **Figure 4.76** has examples of different camera profiles applied to the same image. The top-left image shows the Adobe Standard profile being used, whereas the bottom-right version uses the Camera Standard profile. This would be the one to choose if you wanted to match the appearance of the camera JPEG.

Try using the Develop Presets panel to save "Calibration only" presets for each of the available camera profiles. You can then either hover over each preset to preview its outcome in the Navigator or click through the list to quickly compare the different camera profile renderings.

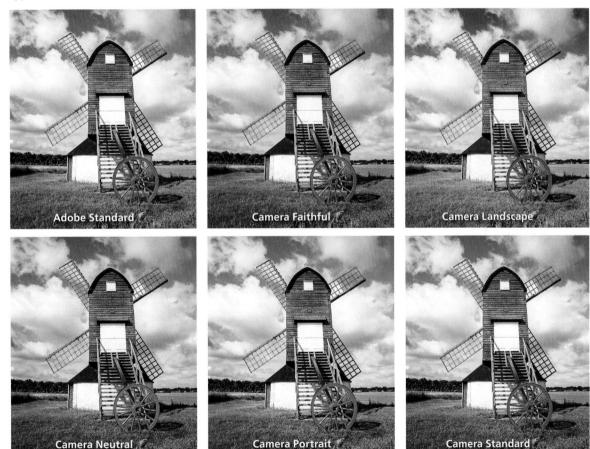

Figure 4.76 Examples of different camera profile renderings.

TIP.

You can switch between the before and after versions in the Develop module by going to the View menu and choosing Before/After □ Before Only. Or, use the backslash key (□) shortcut to quickly toggle between these two viewing modes.

Assessing your images

Lightroom offers several ways to assess and compare your image edits. You can choose to split your preview into either side-by-side or top-and-bottom views of before and after edits, or you can use Reference view mode to compare your working image to a standard reference image.

Comparing before and after versions

While you are working in the Develop module, you can simultaneously compare the before and after versions of any photograph you are working on. This allows you to compare the effect of the Develop settings adjustments, as they are applied to the image. To view the before and after adjustments, click the Before/After view mode button in the Toolbar, and then click the disclosure triangle (circled in **Figure 4.77**) to select one of the four Before/After viewing modes from the menu. These viewing modes display two identical views of the currently selected image. You can choose a Left/Right view to see a horizontal, side-by-side before-and-after preview, or you can choose a Top/Bottom view to see a vertical side-by-side before-and-after preview. Meanwhile, the Split views divide the preview in half, displaying a Before view on the left and an After view on the right (**Figure 4.78**),

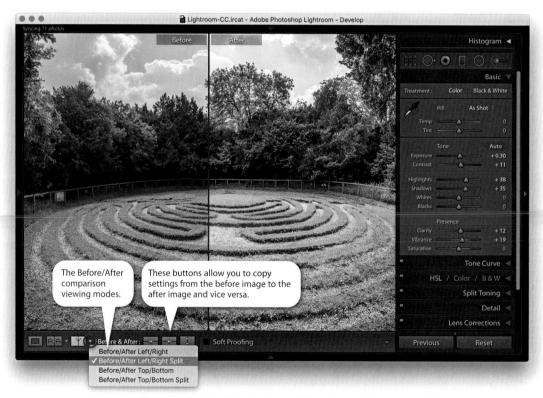

Figure 4.77 The default Before and After view in the Develop module.

or a Before view on top and an After view below (**Figure 4.79**). Alternatively, you can repeat click the Before/After button to cycle through all the available views. You can also use the Y key to toggle the standard Left/Right view mode on or off, press (Alt Y) to toggle the standard Top/Bottom view mode on or off, and use Shift Y to toggle between a split-screen preview or side-by-side previews. Press D to return to the default full-screen preview in the Develop module. While you are in any of the Before/After view modes, you can zoom and scroll the image to compare the adjusted version with the before image.

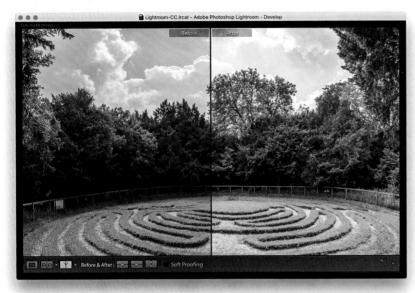

Figure 4.78 The Before/After Left/Right preview mode.

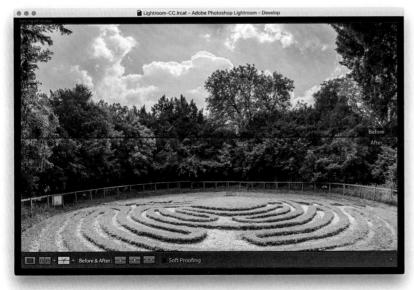

Figure 4.79 The Before/After Top/Bottom Split preview mode.

TP

The Copy After's Settings to Before keyboard shortcut is Alt Shift (Mac) or Ctrl Alt Shift) (PC). The Copy Before's Settings to After keyboard shortcut is Alt Shift) (Mac) or Ctrl Alt Shift) (PC).

You can drag a history step from the History panel and drop it in the Before side of the Before/After to set it as the Before state.

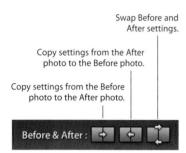

Figure 4.80 The Copy settings buttons appear in the Develop module Toolbar when either the Left/Right or Top/Bottom view modes have been selected.

Managing the Before and After previews

When you edit an image in one of the Before/After viewing modes, you can make umpteen adjustments via the Develop module and at all times be able to compare the revised, After version with the Before version. Just to clarify here, the Before version view uses either the Develop settings that were applied when the photo was first imported into Lightroom or the last assigned Before state. When you click the "Copy settings from the After photo to the Before photo" button, you will assign a new Before state to the Before version view.

Suppose that you want to make the current After version view the new Before. You can do this by clicking the "Copy settings from the After photo to the Before photo" button. This updates the Before image view with the After image settings. What you are effectively doing is making a snapshot of the settings at a certain point in the Develop adjustment process, which then lets you make further new adjustments and compare these with a new Before version. Let's say at this point that you continue making more tweaks to the Develop panel settings, but you decide that these corrections have not actually improved the image and the interim Before version view was better. You can reverse the process by clicking the "Copy settings from the Before photo to the After photo" button. Basically, the Before and After compare mode controls (**Figure 4.80**) let you take a snapshot of an image in mid-correction and compare it with whatever settings you apply subsequently. The following steps illustrate one such workflow.

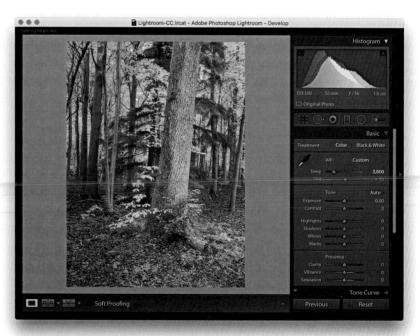

1. I began in the Develop module with the settings that were applied to the image at the import stage.

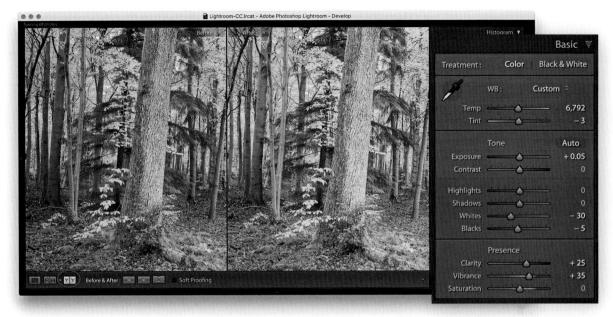

2. I clicked the Before/After view YY button (you can also use the Y keyboard shortcut) and began to adjust the image by altering the white balance. Notice that the modified After version got warmer in color. I also optimized the Tone settings.

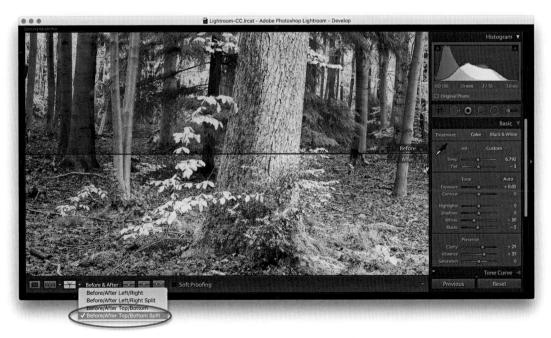

3. I then went to the Before/After viewing mode menu and switched view modes, selecting the Before/After Top/Bottom Split view.

4. I clicked the Develop module full-view button to switch out of the Before/ After view mode so I could work on the photo in a normal full-screen view.

5. While working in the Develop module, you can easily compare the current Develop settings with the before version, using the \(\scale
\) keyboard shortcut. This switches to the Before view, shown here. I then pressed \(\scale
\) again to revert to the After view.

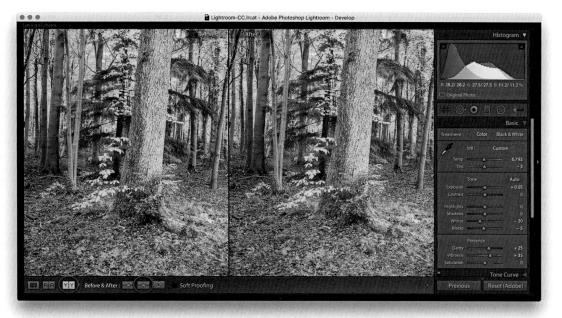

6. I clicked the Before/After view button again (Y) and clicked the "Copy After's settings to Before photo" button (*Alt Shift) [Mac] or Ctrl Alt Shift) [PC]), making the current (After) version the new Before setting.

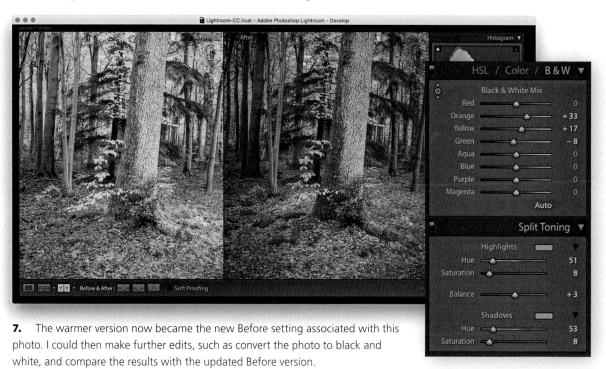

NOTE

The RGB readouts just below the Histogram panel let you compare the RGB values for the active image with that of the Reference image, but only if the crop ratios between the two images match. Otherwise, the RGB readouts will be displayed using (--) for the reference image (as shown in Step 2 opposite).

Reference View

The Reference view mode (Ashift) can be used to compare Develop edits you make in one image with a static "reference" image. This lets you compare the edits you make to a selected image with a previously edited photo. I see this as a useful feature that can help you achieve a consistent look between a collection of photographs. By having one image on screen as a reference, you can see how the image you are currently working on compares with it and maintain the same style or feel throughout a series of pictures. If Auto Sync is enabled, you can sync edit multiple photos at the same time.

When you first use the Reference view both sides will be blank, unless you have an image selected. If an image is selected, it will appear in the right as the Active image. If more than one image is selected, the most selected one will be the active image, the Reference section on the left will be blank. You first need to select your reference image and drag and drop to add it as a reference. This remains sticky until you select another image to replace it, up until the point where you quit Lightroom. You can therefore use the Reference view mode to compare images from different source collections or folders. The lock in the Toolbar can be used to keep the reference image locked if you exit the current Folder/Collection and wish to compare the same reference image with a photo from another source. Otherwise, the Reference image is cleared after each Develop session.

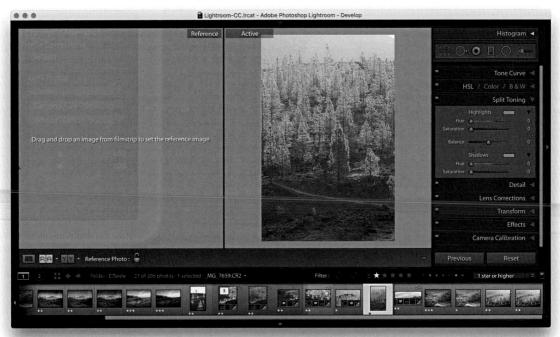

1. I selected an active image I wished to edit and used **Shift** to enter Reference View mode. The Reference section on the left was blank. I therefore needed to select an image to reference by dragging from the Filmstrip.

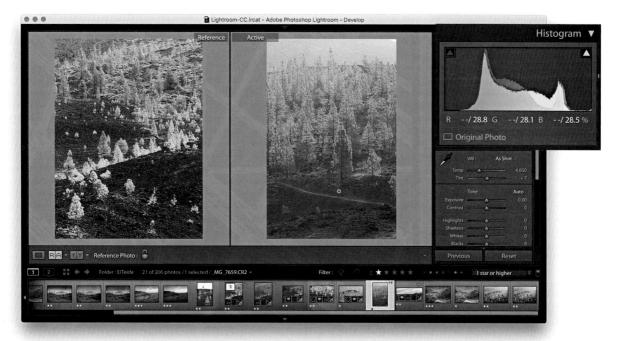

2. Here, I selected an image from the same series. As I rolled the pointer over the Active image, the RGB values were shown as (--) for the reference image and actual values for the Active image. This was because the crop ratios differed.

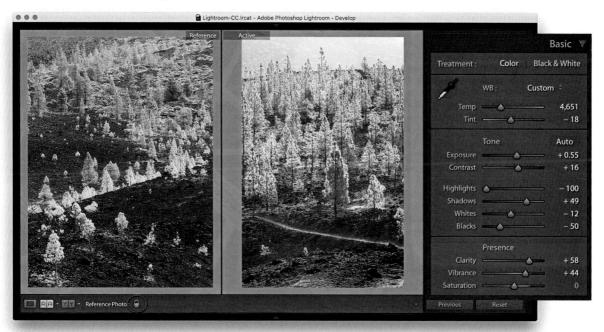

3. I adjusted the Basic panel settings to achieve a close match to the look and feel of the Reference image. I clicked the lock to keep the Reference image sticky.

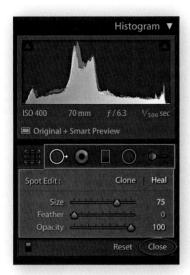

Figure 4.81 The retouching tools. From left to right: Spot Removal, Red Eye Correction, Graduated Filter, Radial Filter, and Adjustment Brush. Shown below are the Spot Removal options.

Image retouching

The retouching tools in the Develop module (**Figure 4.81**) can be used to retouch without actually editing the pixel data. When you work with the Spot Removal, Red Eye Correction, Graduated Filter, Radial Filter, or Adjustment Brush tool, these actions are recorded as sets of instructions and the original pixel image data remains untouched. It is only when you export a file as a TIFF, JPEG, or PSD, or "Edit in an external editor" that the retouching work is permanently applied to the image.

Spot Removal tool

The Spot Removal tool (②) has Clone and Heal modes (use ③Shift ② to toggle between the two). In Clone mode, the Spot Removal tool copies and repairs from a sample area with the surrounding area, but does not blend the result. The Heal mode on the other hand does blend the copied area with the image information that is just outside the area you are trying to repair. The Heal mode is nearly always successful at hiding blemishes because of the way it invisibly blends the healed area with the surrounding pixels. Subtle improvements have been made to the blending in this latest version of Lightroom. In particular, you should see better blending along the edges of an image. But only newly created spots will use the new healing method. You can use the Clone/Heal buttons in the Tool Options panel to switch the Spot Removal mode for any circle spot.

To work with the Spot Removal tool, you can start by adjusting the Size slider in the Spot Removal tool options (Figure 4.81) so the Spot Removal tool matches the size of the areas you intend to repair. You can use the square bracket keys on the keyboard (press or hold down the ① key) to make the Spot Removal circle spot size bigger, or use the ① key to make the size smaller. Or, scroll with your trackpad or mouse. If you then simply click the spot or blemish you wish to remove, this adds a new circle spot and auto-finds a source sample area to clone from. If the tool size is large enough, you will see a small crosshair in the middle of the circle spot, and you can use this to target the blemish you want to remove and center the tool more precisely. A linking arrow also appears to indicate the relationship between the target circle and sample circle areas (**Figure 4.82**). Lightroom then automatically calculates a suitable source area to clone from, and you can use ① to auto-select a new source area and recompute (see auto-find behavior on page 292).

Alternatively, you can hold down the <code>\mathbb{H}</code> key (Mac) or <code>Ctrl</code> key (PC) as you click and drag outward to select the image area to sample from. As you do this, you will notice that the original (target) circle disappears so you can preview the effect of the spot removal action without being distracted by the circle spot. When you have finished applying a spot removal, the target circle spot remains as a thin, white circle on the screen for as long as the Spot Removal tool is active in the Develop module. You can quit working with the tool by clicking the Close button (circled in Figure 4.81) or by pressing the <code>Q</code> key again.

Because Lightroom is recording all these actions as edit instructions, you have the freedom to fine-tune any clone and heal step. For example, you can click inside a circle spot to reactivate it and reposition either the target or the sample circles. If you click the edge of the target circle, a bar with a bidirectional arrow appears and you can click and drag to adjust the size of both the target and sample circles. If you click and drag with the 黑公hift keys (Mac) or Ctrl 公hift keys (PC) held down, this allows you to create a user-defined circle spot scaled from the initial anchor point. And, if you click and drag with the #Alt keys (Mac) or Ctrl Alt keys (PC) held down, the circle spot scales from the center. Basically, you can define a different spot size each time you drag, and the sample circle auto-picks anywhere that surrounds the target circle area. It may seem that the auto-find selection is guite random, but each time Lightroom intelligently seeks an ideal area to sample from (this is similar to the logic used by Photoshop's Spot Healing Brush tool). You can use the On/Off button at the bottom of the Spot Removal tool options (circled in Figure 4.82) to toggle disabling/enabling the spot removal retouching and click the Reset button to cancel and clear all the current Spot Removal tool edits. Use the H key to toggle showing/hiding all the Spot Removal spots.

MOTE

With Use Graphics Processor enabled, you'll see speed improvements to the Spot Removal tool, Local Adjustment Brush, and Radial and Graduated Filters, plus Red Eye Correction.

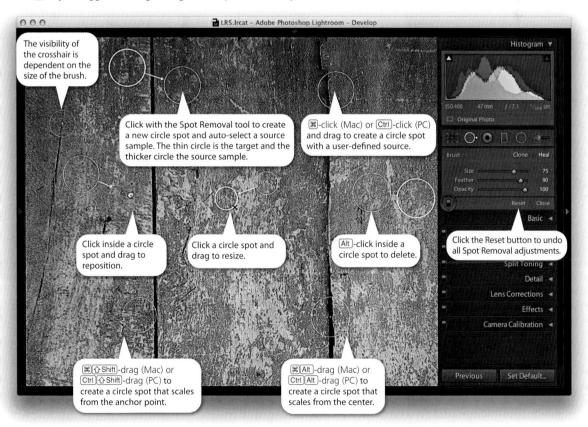

Figure 4.82 A combined series of snapshots taken of the Spot Removal tool in action to illustrate some of the different ways you can work with this tool.

Visualizing spots

In Spot Removal mode, you can use the Visualize Spots feature to detect dust spots and other anomalies. If you go to the Toolbar, you will see a Visualize Spots check box (A) and slider. When you enable it, the image view will switch to a threshold mode preview and you can drag the slider to determine the ideal threshold point to highlight the spots that need to be removed. The slider setting you use remains sticky until you turn on Visualize Spots to treat another image.

1. The effects of the camera's dirty sensor can be seen in the image it captured.

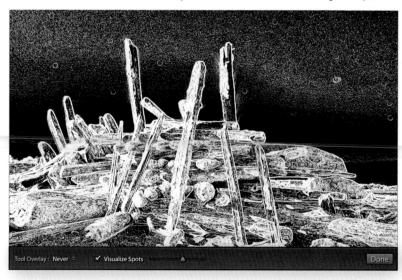

2 I checked the Visualize Spots box at the bottom of the Spot Removal panel options and adjusted the slider to obtain a suitable threshold preview, one that picked out the spots clearly.

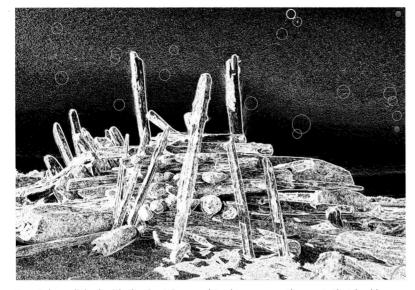

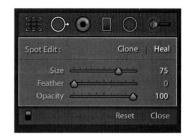

3 I then clicked with the Spot Removal tool to remove the spots that had been identified using this method.

Creating brush spots

So far, I have shown you how to create basic circle spots using the Spot Removal tool. In Lightroom, you can also click and drag to define noncircular areas, known as brush spots, where you basically click and drag to paint over the area you wish to remove. As you do so, you will see the area you are removing covered in a white overlay. When you release the pointer, you will see a brush spot represented like the one shown in **Figure 4.83**. As with circle spots, Lightroom auto-selects the most suitable area to clone from, and you can use the key to auto-select a new source area and recompute. To override the auto-select choice, you can click inside a target or source brush spot and drag to reposition, but you cannot scale brush spots the way you can when editing circle spots. If you drag with the solick and click again with the shift key held down, you can create a "connect the dots" selection. **Figure 4.84** shows an illustrated summary of the brush spots behavior.

Brush spots add really useful functionality to Lightroom, but all this comes at a cost. Heavy use of the Spot Removal tool, especially in brush spot mode, can certainly add to the Develop module processing and slow things down.

Figure 4.83 The appearance of a brush spot adjustment, with the target brush spot on the left and the source on the right.

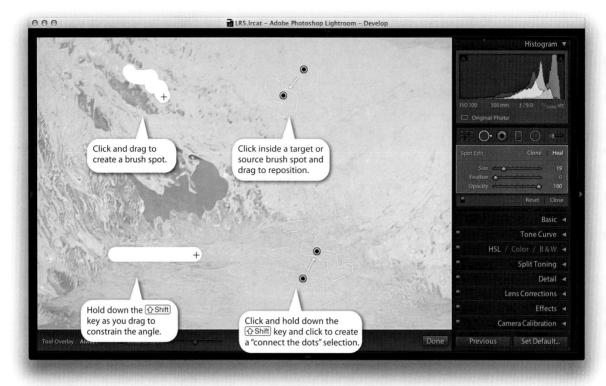

Figure 4.84 Some of the different ways you can apply brush spots.

Retouching example using brush spots

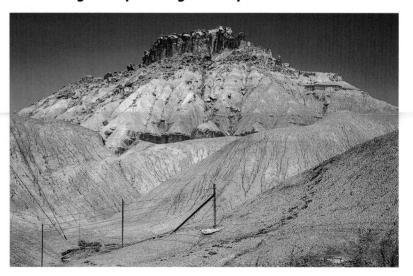

1. The fence and wires spoil the natural look of this shot. I decided to use Spot Removal tool brush spots to retouch the fence from the shot.

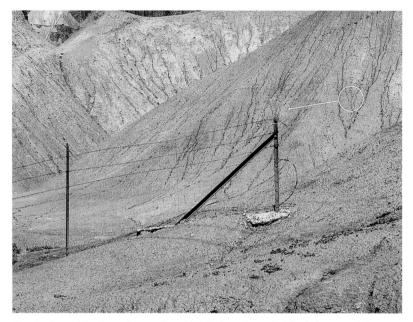

2. I selected the Spot Removal tool in Heal mode and clicked the top of the fence post. This added a regular circle spot and auto-calculated a source area to sample from.

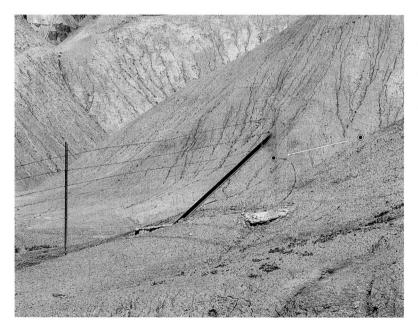

3. I then held down the <u>\text{\Omega} Shift</u> key and clicked near to the bottom of the fence post. The circle spot became a brush spot, constrained to a straight line.

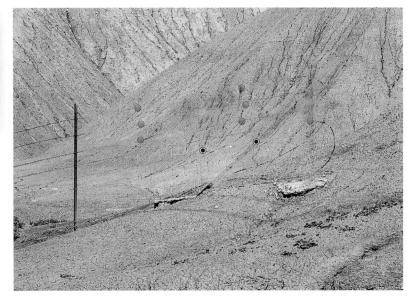

4. I repeated the process to remove the strut supporting the fence post. You can rely on Lightroom to auto-calculate the most suitable area to clone from. You can use the // key to recompute a new source, or you can click and hold inside the brush spot source outline and drag to select a new area to clone from.

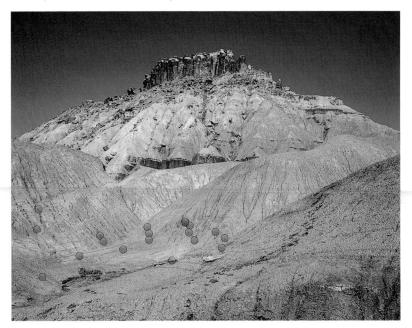

5. After much editing with the Spot Removal tool, I removed nearly all traces of the fence and wires. However, this kind of extensive retouching can easily slow Lightroom down to a crawl.

Editing circle and brush spots

The circle spots always remain editable. You can select an individual circle and use the Spot Removal Size slider to readjust the size. Or, click the edge of a target circle spot and drag to resize. As you drag, the thin circle conveniently disappears, which allows you to see more clearly the effect the circle resizing is having on the photo. If you click inside a target circle or brush spot, the thin circle/outline disappears and changes to show a hand icon. This allows you to drag and reposition the spot so that you can readjust the target position. You can also click on or inside a sample circle/brush spot and drag to reposition the sample area relative to the target so that you can select a new area to sample from. You can use the keyboard arrow keys to nudge a destination circle spot or brush spot. Hold down the ��shift key to magnify the arrow key movements. The nudging becomes more precise the more you are zoomed in.

Tool Overlay options

The Tool Overlay options can be accessed via the Develop module Toolbar (Figure 4.85), as well as via the Tools menu. If you select the Auto option, the circle/brush spots become visible only when you roll over the preview area. If you select the Always option, the circle/brush spots remain visible at all times. When the Selected option is chosen, only the active circle/brush spot is shown and all others are hidden. When the Never menu option is selected, all the Spot Removal overlays remain hidden (even when you roll over the image). But as soon as you start working with the Spot Removal tool, the tool overlay behavior automatically switches to Auto Show mode. The Ashift keyboard shortcut toggles the Tools overlay view between Selected and Never. I think the most convenient way to work here is to operate in Auto mode and use the Auto and Shortcut to toggle between the Auto and Never overlay modes. This toggle action allows you to work on an image without always being distracted by all the circle/brush spot overlays.

Undoing/deleting spots

You can use \(\mathbb{H}\)\(\mathbb{Z}\) (Mac) or \(\mathbb{Ctrl}\)\(\mathbb{Z}\) (PC) to undo the last circle/brush spot. To delete, \(\mathbb{Alt}\)-click inside a circle/brush spot. To delete multiple circle/brush spots, \(\mathbb{Alt}\)-marquee drag to select those you wish to remove. To delete all circle/brush spots, click the Reset button in the Tool Options panel.

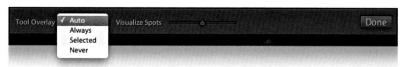

Figure 4.85 The Tool Overlay options in the Develop module Toolbar.

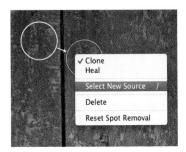

Figure 4.86 The context menu for the Spot Removal tool.

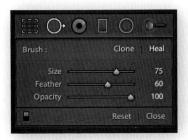

Figure 4.87 The Spot Removal tool panel controls.

Figure 4.88 The Spot Removal tool Feather visualization.

Auto-calculate behavior

As mentioned earlier, you can use the forward slash key () to auto-select a new source area and recompute a Spot Removal tool step, which is also available as a context menu item (**Figure 4.86**). The auto-calculate source feature copes well with textured areas such as rocks, tree bark, and foliage and also takes the applied crop into account. This means that if a crop is active, Lightroom carries out two searches for a most suitable area to clone from: one within the cropped area and one outside it. Preference is then given to the search inside the cropped area when computing the auto-find area. If somewhere outside the cropped area yields a significantly better result, then that is used instead.

Spot Removal tool feathering

The Spot Removal tool in Lightroom has a Feather slider (**Figure 4.87**). This lets you modify the brush hardness when working with the Spot Removal tool in Clone or Heal mode. You can use **Shift** to decrease the feathering amount and **Shift** to increase the feathering, and there is a circle spot feather visualization, which can be seen in **Figure 4.88**.

Although it has always been possible to adjust the brush hardness in Photoshop when working with the Clone Stamp tool, there has never been a similar hardness control option for the Healing Brush. This is because the Photoshop Healing Brush and Spot Healing Brush have always had an internal feathering mechanism built-in, so additional feathering was never needed. However, in Lightroom, the Feather slider works well and is useful for both modes of operation. The Feather slider offers more control over the spot removal blending and can help overcome the edge contamination sometimes evident when using the Spot Removal tool in Heal mode with a fixed feather edge of 0. The feathering is applied to the destination circle spot or brush spot, and the Feather amount is proportional to the size of the spot; bigger spots will use a bigger feather. For brush-type spots, you should think of this in terms of the thickness of the brush stroke (as opposed to the overall length) and the feathering range for brush spots is also slightly greater than for circle spots. The Feather setting remains sticky across Lightroom sessions.

Synchronized spotting

You can synchronize the Spot Removal settings in one image with others from the same sequence. So, if you get the spotting work right for one image, you can synchronize the spot removal work across other selected photos. There are two ways you can do this. One way is to work with the Spot Removal tool on one photo and synchronize the spotting with the other photos later. The other is to Auto Sync a selection of photos and update all the selected images at once as you retouch the most selected photo.

Remember, if you simply click or drag with the Spot Removal tool, Lightroom automatically chooses the best area of the photo to sample from. As long as you don't (A) (Ctrl)-drag to manually set the sample point, or edit the sample point (by manually dragging the sample circle or brush spot to reposition it), the sample points will remain in "auto-select sample point" mode. If you carry out a series of spot removals obeying these rules, you can then synchronize the spot removal adjustments more efficiently, as Lightroom will auto-select the best sample points in each of the individual synchronized photos. This does not guarantee 100% successful spot removal for every image that's synchronized in this way, but you may still find that this saves you time compared to retouching every photo individually one by one.

TP

Syncing spotting settings or using Auto Sync mode when working with the Spot Removal tool can save lots of time when repetitively removing spots from areas such as skies or plain studio backdrops.

Synchronized settings spot removal

1. I first made sure that the photo that had all the spotting work done to it was the most selected in the Filmstrip (the one with the lighter gray border). I then clicked the Sync button.

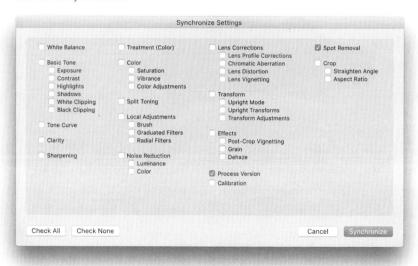

2. This opened the Synchronize Settings dialog, where I made sure the Spot Removal box was checked. When I clicked the Synchronize button, Lightroom synchronized the Spot Removal settings across all the selected photos.

Auto Sync spot removal

1. I made a selection of photos and held down the R key (Mac) or Ctrl key (PC). This changed the Sync button to Auto Sync. I clicked the button to set the photo selection to Auto Sync mode.

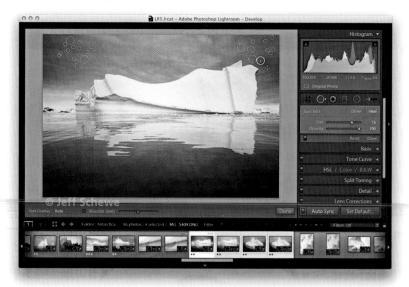

2. I then edited one of the selected photos (I could have chosen any of them), and *all* the Develop settings were automatically synchronized to the target photo. Here, I used the Spot Removal tool in Heal mode to remove dust marks from the photo. As I did so, the Spot Removal settings were automatically applied to all the photos in the selection. When finished, I clicked the Auto Sync button to revert to the standard Sync mode behavior.

Red Eye Correction tool

There are several ways you can prevent red eye from happening. Most compact cameras allow you to set the flash to an anti-red-eye mode with a pre-flash, or you can use a flash gun so the flash source is not so close to the lens axis. But for those times when you cannot prevent it, the Red Eye Correction tool can correct photographs in which the direct camera flash has caused the pupils in someone's eyes to appear bright red.

To use the Red Eye Correction tool, place the tool's crosshair over the middle of the pupil and drag outward to draw a circle that defines the area you wish to correct (**Figure 4.89**). Lightroom automatically detects the red-eye area that needs to be repaired and fixes it. Before applying the Red Eye Correction tool, you can adjust the size of the circle by using the square bracket keys: The left bracket (①) makes it smaller, and the right bracket (①) makes it bigger. To be honest, the circle size does not always make much difference because, once you click with the tool, you can drag to define the area you wish to affect. The circle size is probably more relevant if you are going to be clicking with the Red Eye Correction tool rather than dragging. Also, you do not have to be particularly accurate, and it is interesting to observe how this tool behaves even if you lazily drag to include an area that is a lot bigger than the area you need to correct. Lightroom always knows which area to correct, because the circle shrinks to create an overlay representing the area that has been targeted for the red-eye correction.

After you have applied the tool to a photo, the Red Eye Correction tool options appear (**Figure 4.90**). Here, you can adjust the sliders to fine-tune the Pupil Size area you want to correct and decide how much you want to darken the pupil. You can use the On/Off button at the bottom of the Tool Options (circled in Figure 4.90) to toggle showing and hiding all Red Eye Correction tool edits. You can revise the Red Eye removal settings by clicking a circle to reactivate it, or use the Delete key to remove individual red-eye corrections. If you do not like the results, you can always click the Reset button in the Tool Options panel to delete all the Red Eye Correction retouching and start over again.

This feature raises an interesting question: If you know Lightroom can repair red eye so neatly, do you really need to use the anti-red-eye flash mode? This may sound like a lazy approach to photography, but in my experience, the anti-red-eye flash mode often ruins the opportunity to grab spontaneous snapshots. There is nothing worse than seeing a great expression or something special going on between a group of people in the frame, and then having to wait a few seconds for the camera to get up to speed, firing a few pre-flashes before taking the full-flash exposure. These days I prefer to shoot using the normal flash mode and let Lightroom fix any red-eye problems that might occur.

Figure 4.89 The Red Eye Correction tool design.

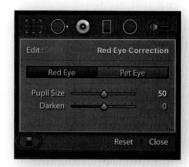

Figure 4.90 The Red Eye Correction tool panel options in Red Eye mode.

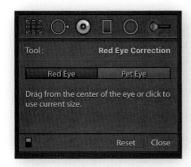

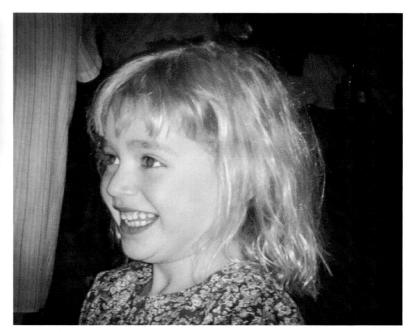

1. I started with close-up view of a photograph that needed red eyes removed.

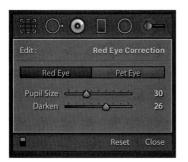

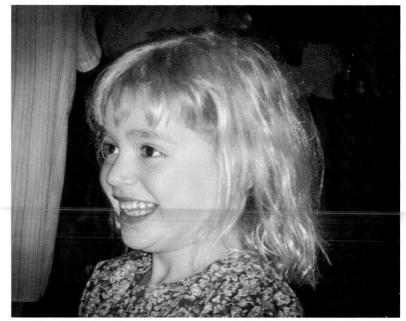

2. I selected the Red Eye Correction tool and clicked both eyes. This automatically got rid of the red-eye effect. I then adjusted the Darken slider so the pupils did not appear too dark.

Pet Eye mode

In animals, the pupil discoloration caused by the camera flash is more likely to be a green or yellow color. To give your favorite dog or cat a more natural look, the Red Eye Correction tool also features a Pet Eye mode. The Pet Eye controls let you adjust each pupil independently by adjusting the Pupil Size slider. You can also check the Add Catchlight box to enable adding a synthetic catchlight highlight, which you can then drag to position over each eye.

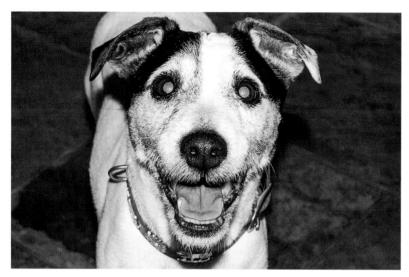

1. As you can see in this close-up view, the flash reflected back off the dog's eyes.

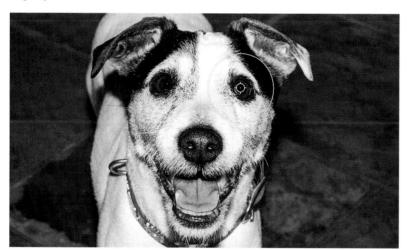

2. I used the Red Eye correction tool in Pet Eye mode to correct both eyes, with the Add Catchlight option enabled.

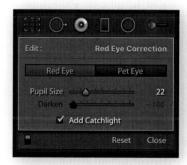

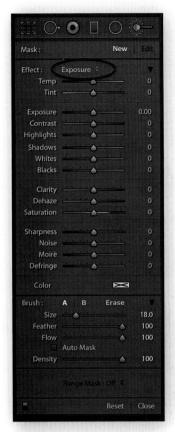

Figure 4.91 The full Adjustment Brush options.

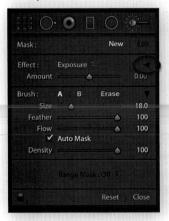

Figure 4.92 The Adjustment Brush options in compact mode.

Localized adjustments

Let's now take a look at the Adjustment Brush, Graduated Filter, and Radial Filter tools. These are more than just tools for dodging and burning, because you have (in the case of the Adjustment Brush) a total of 16 effects to choose from, not to mention dual brush settings and an Auto Mask option. Just like the Spot Removal and Red Eye Correction tools, these tools are completely nondestructive and there is no need for Lightroom to create an edit copy of the master image first. When localized adjustments are applied to an image, the adjustments are saved as instruction edits that are automatically updated as you make further Develop module adjustments, plus you can synchronize localized adjustment work across multiple images using the Sync Settings command.

Initial Adjustment Brush options

When you first start working with the Adjustment Brush (K), the panel may display all its options (**Figure 4.91**) or be in compact display mode (**Figure 4.92**). To begin with, you will be in the New mode, ready to create a fresh set of brush strokes, but first you need to choose an adjustment effect by adjusting one of the sliders, such as Temp, Tint, Exposure, or Contrast. Although very similar, the sliders aren't all exact copies of the identically named sliders in the Basic panel. For example, the Saturation slider is actually a hybrid of the Saturation and Vibrance adjustments found in the Basic panel.

In Figure 4.91, the Exposure effect was selected, where positive values can be used to lighten, or negative values to darken—these are your basic dodge and burn tool settings. But you can use any combination of sliders here to establish different types of localized adjustment effects and save these as custom settings, which can be accessed via the Effect menu. If you would like a simpler interface to work with, click the disclosure triangle next to the Effect drop-down menu (circled in Figure 4.92) to collapse the slider options. In Figure 4.92, there is just an Amount slider, and whatever combination of effect settings you have selected in the Effect menu are now controlled using this single slider. You can expand the Adjustment Brush options by clicking the disclosure triangle again.

Below this are the Brush settings, where you have three sliders. The Size slider controls the overall size of the brush (**Figure 4.93**). You can use the ① and ① keys to make the brush bigger or smaller. Or, you can scroll with your trackpad, mouse, or tablet to vary the brush size. The inner circle represents the core brush size, while the outer circle represents the outer feather radius. As you adjust the Feather slider, the outer circle expands or contracts to indicate the hardness or softness of the brush. Or, you can use ① Shift① to make the brush edge harder or ② Shift① to make it softer. The Flow slider is kind of like an airbrush control: By selecting a low Flow setting, you can apply a series of brush strokes that successively build to create a stronger effect. You will notice that as you brush back

and forth with the Adjustment Brush, the paint effect gains opacity (if you are using a pressure-sensitive tablet such as a Wacom™, the flow of the brush strokes is automatically linked to the pen pressure). It can often help to set the Flow to a low amount to begin with and use multiple brush strokes to gradually build up a particular effect. The Density slider at the bottom limits the maximum brush opacity. At a Density of 100, the flow of the brush strokes builds to maximum opacity, but if you reduce the Density, this limits the maximum opacity for the brush. In fact, if you reduce the Density and paint, you can erase the paint strokes back to a desired Density setting. When the Density is set to 0, the brush acts like an eraser. The A and B buttons can be used to create two separate brush settings so you can easily switch between two different brushes as you work. To reset the settings to 0 and clear any currently selected color, double-click Effect, or hold down the Alt key, and Effect will change to Reset (circled in Figure 4.94). Or. you can hold down the Alt key and click an Effect slider name to reset everything except that slider setting. If you need to reset everything (as in resetting the image without any Adjustment Brush adjustments), you can select individual brush pins to make them active and press the Delete key. Or, if you click the Reset button at the bottom, this deletes all the pin markers that have been added to an image. To exit the Adjustment Brush tool mode of operation, you can click the Close button, click the Adjustment Brush button at the top, or press K. You can use the On/ Off button at the bottom (circled in Figure 4.95) to toggle showing/hiding all Adjustment Brush edits.

Now let's look at how to work with the Adjustment Brush. Where you first click adds an edit pin to the image. This is just like any other overlay, and you can hide it using the \boxdot key (or use the View \Rightarrow Tool Overlay options to govern the show/hide behavior for these overlays). The pin is a marker for the brush strokes you are about to add and can later be used as a reference marker whenever you need to locate and edit a particular group of brush strokes. The important thing to understand here is that you click once and can keep clicking and dragging to create a single group of brush strokes. When you edit the brush strokes, you can adjust the effect slider settings for the group as a whole. So you can come back later and say "Let's make this series of brush strokes a little stronger," or "Let's add more saturation." Consequently, you only need to create new brush groups when you need to apply a different kind of adjustment to another part of the photo. Lightroom Classic CC has some improvements that should reduce the rough, jagged edges and result in smoother curves. Although not always perfectly smooth, the overall responsiveness has improved.

Localized adjustments have the same full strength as global adjustments and the effects have linear incremental behavior except for the Temp, Tint, Highlights, Shadows, and Clarity adjustments. These have nonlinear incremental behavior, which means they only increase in strength by 50% relative to the previous localized adjustment each time you add a new pin group. Lightroom also allows

Figure 4.93 The Adjustment Brush brush.

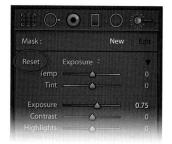

Figure 4.94 When the Alt key is held down, Effect changes to Reset.

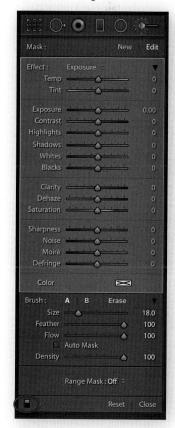

Figure 4.95 The Adjustment Brush panel Edit mode.

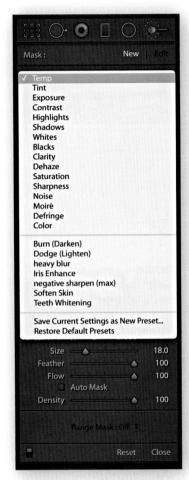

Figure 4.96 The Effect settings menu.

Figure 4.97 The Adjustment Brush context menu.

for "connect the dots" type drawing. (This is similar to the way you can work using the Spot Removal tool.) When painting with the Adjustment Brush, click, hold down the **Shift** key, and click again to create a straight-line brush stroke between those two points.

Editing the Adjustment Brush strokes

To edit a series of brush strokes, click an existing pin marker to select it (a black dot appears in the center of the pin). This takes you into Edit mode (Figure 4.95), where you can start adding more brush strokes or edit the current brush settings. When you are done editing, press —Enter or click the New button to return to the New adjustment mode, where you can click on the image to add a new set of brush strokes. You can erase brush strokes by clicking the Erase button to enter Eraser mode, or simply hold down the Alt key to erase as you paint. You can undo a brush stroke or series of strokes using the Undo command (*2 [Mac] or Ctrl) [PC]).

Saving effect settings

As you discover combinations of effect sliders you would like to use again, you can save these via the Effect menu (**Figure 4.96**). For example, you will find here a preset setting called *Soften Skin* that uses a combination of negative Clarity and positive Sharpness to produce a skin-smoothing effect (see page 304). Also, if you wish to use a combination of the Adjustment Brush and Graduated Filter or Radial Filter tools to apply a particular type of effect, it might be useful to save the settings used for the Adjustment Brush so these can easily be shared when using other local adjustment tools.

Localized adjustment position and editing

When you add a local adjustment—an Adjustment Brush, Radial Filter, or Graduated Filter—there is a context menu for the brush pins (right-click a pin to reveal), which lets you duplicate a selected adjustment or delete it (**Figure 4.97**). Adjustment Brush strokes can be repositioned by selecting and dragging Edit Pins. Earlier versions of Lightroom allowed you to select a pin and drag left or right to decrease or increase the strength of an effect. To do this now, you must hold down the Alt key as you drag on a pin. You can also use the (*Alt)-drag (Mac) or Control Alt)-drag (PC) shortcut to duplicate a localized brush adjustment. This applies when selecting and editing all types of localized adjustments.

Exposure dodging with the Adjustment Brush

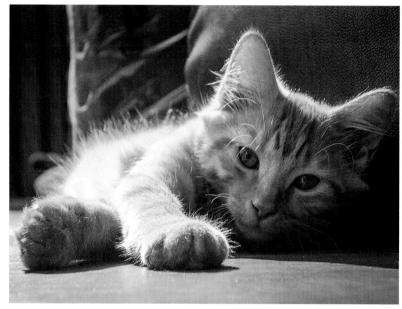

1. I applied some Basic adjustments to this photograph to optimize the brightness and contrast in the image.

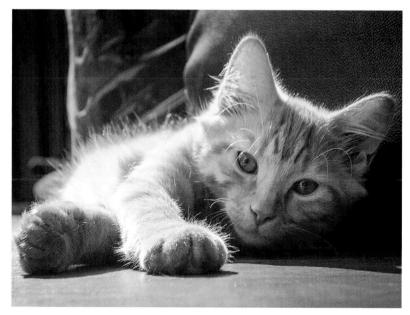

2. I selected the Adjustment Brush and chose a Dodge (Lighten) setting from the Effect menu that I modified by setting the Exposure slider to +0.50. I then clicked on the photo and painted to lighten the kitten's face.

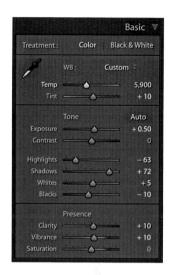

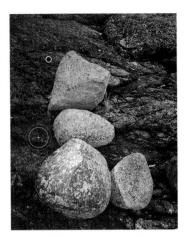

Figure 4.98 The Adjustment Brush in action in Auto Mask mode.

Auto Mask

The Auto Mask option cleverly masks the image as you paint with the Adjustment Brush. It works by analyzing the area where you click with the Adjustment Brush and applies the effect only to those areas that match the same tone and color. For Auto Mask to work, the paint strokes in a pin group do not have to all be based on the same color. As you paint, the Auto Mask resamples continuously when calculating the mask. Figure 4.98 shows an example of the Auto Mask feature in action, and the next series of steps show in detail how I was able to use successive strokes to selectively modify the sky. The Auto Mask feature works remarkably well at auto-selecting areas of a picture based on color, but to fine-tune the edges, you may need to switch back and forth with the Alt key held down to erase those areas where the Adjustment Brush effect spills over the edges (remember, the Auto Mask option can also be used in Erase mode). Here, I was able to carefully select the blue sky and darken it. You can hold down the **38** key (Mac) or Ctrl key (PC) to temporarily switch the Adjustment Brush into Auto Mask mode (or revert back to Normal mode if Auto Mask is already selected). Although the Auto Mask can do a great job at auto-selecting the areas you want to paint, extreme adjustments can lead to ugly artifacts appearing in some parts of the image. It is always a good idea to check such adjustments at a 1:1 view to make sure the automasking hasn't created any speckled edges. However, when editing in Version 4, the Auto Mask edges are now much smoother.

1. With the original photograph open, I began by clicking the Adjustment Brush to reveal the tool options.

2. I set the Exposure slider to -0.50 (to darken) and started painting. Because Auto Mask was checked, the brush darkened only the blue sky areas.

3. After finishing the main brush work, I fine-tuned the settings. In this step, I darkened the Exposure slider more and set the Saturation slider to –45.

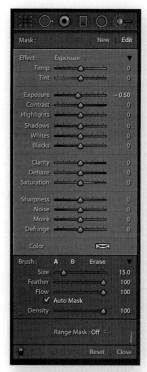

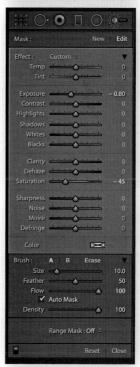

Previewing the brush stroke areas

As you roll the brush over a pin marker, you'll see a temporary overlay view of the painted region (**Figure 4.99**). The colored overlay represents the areas that have been painted. You can also press ① to switch the mask on or off and use ① shift ② to cycle the mask display through the red, green, white, or black overlay colors. Lightroom also has a Show Selected Mask Overlay option in the Toolbar.

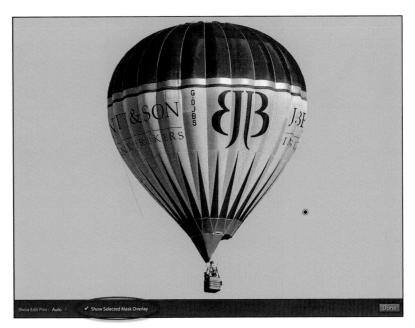

Figure 4.99 An overlay view of the Adjustment Brush strokes and the Show Selected Mask Overlay option in the Toolbar (circled).

Beauty retouching using negative clarity

On page 212, I showed an example of how you could use a negative Clarity adjustment on a black-and-white image to create a diffuse printing type effect. You can also use a negative Clarity effect as an Adjustment Brush effect for softening skin tones. Personally, I have an aversion to the over-retouched look of some fashion beauty portraits, but the Soften Skin setting, which uses Clarity set to –100 and Sharpness to 25, works really well as a skin-smoothing Adjustment Brush. To illustrate how well this works, in the example opposite I used the Adjustment Brush with the Soften Skin Effect setting to retouch the skin tones in a beauty photograph. Here, I painted over the areas of the face that I felt needed softening. After adding the Soften Skin effect, I used the Spot Removal tool to clean up the photograph further.

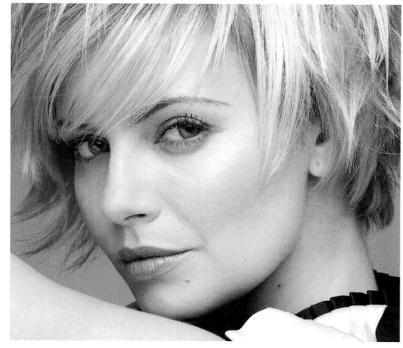

1. I began with a close-up view of a beauty photograph with no localized adjustments applied.

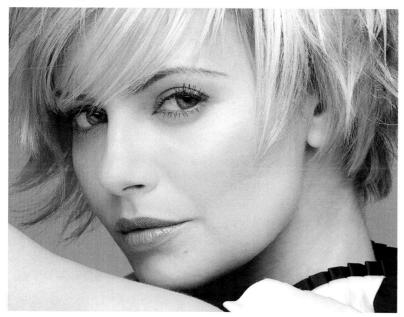

2. I selected the Adjustment Brush with the Soften Skin effect and painted with the brush to soften the skin tones more.

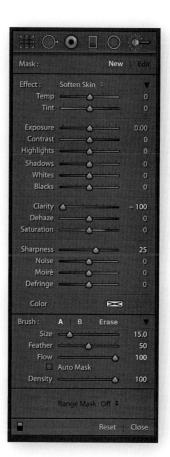

NOTE

When you see an X in the color swatch, this means no color is selected.

Hand-coloring using a Color effect

The Color effect can be used to add a color overlay to your photographs (it is like working with the Brush tool in Photoshop using the Color blending mode). You can use it to change, say, someone's hair or eye color. Or, if dealing with images that require extreme highlight recovery, using a Color effect can help burned-out highlights blend better with their surrounding areas. In the example shown here, I started with an image that had been converted to black and white and added an Adjustment Brush Color effect with Auto Mask selected. Although the image was now in black and white, Lightroom was actually referencing the underlying color data when calculating the Auto Mask. The Auto Mask feature was therefore able to do a good job of detecting the mask edges based on the underlying colors of the flower heads, stems, and leaves. You can use the color picker to sample not just from the color ramp or preview image, but from anywhere on the desktop. Click and hold in the color ramp, and then drag to anywhere you would like to sample a new color from.

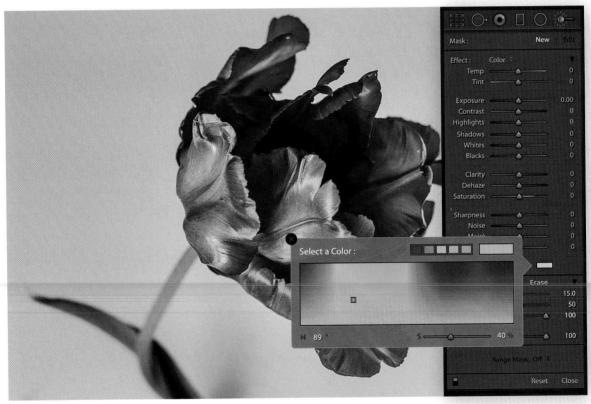

1. Originally in color, this image was converted to black and white in Lightroom. I selected the Adjustment Brush and selected the Color effect from the Effect menu. I then clicked the color swatch to open the color picker shown here, and chose a green color to paint with.

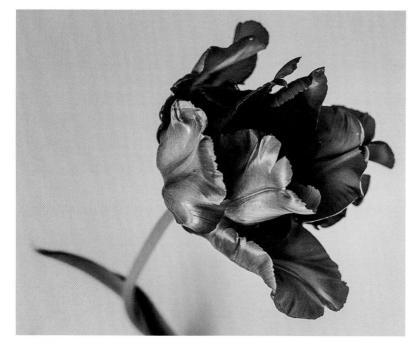

2. With Auto Mask checked, I brushed along the stem and leaf.

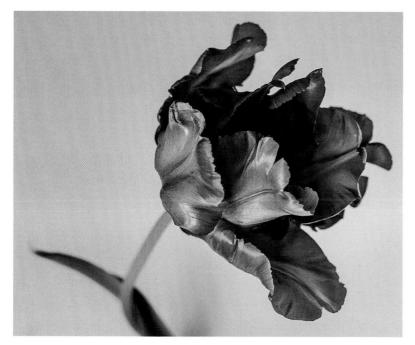

3. I then created a new set of paint strokes. This time I selected a red color and began painting the flower petals, again with the Auto Mask option checked.

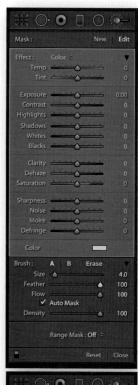

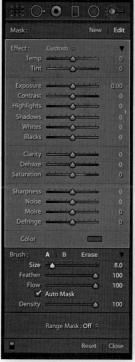

Localized Temperature slider adjustments

Let's now have a look at what you can do using the Temp and Tint slider adjustments. The Temp slider can be used to adjust the white balance locally by dragging to the left to make the white point cooler or dragging to the right to make it warmer. The Tint slider lets you modify the Tint value. The Temp and Tint sliders should therefore be seen as constrained color adjustment controls that allow you to adjust the white point in localized areas. Remember that localized color adjustments, including the use of the Temp and Tint sliders, apply adjustments that are relative to everything else in the image. Therefore, as you continue working in the Develop module, the color adjustments you have made using the localized correction tools will adjust relative to any global color adjustments you might make.

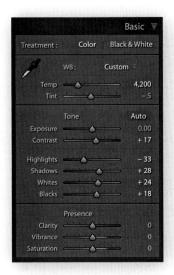

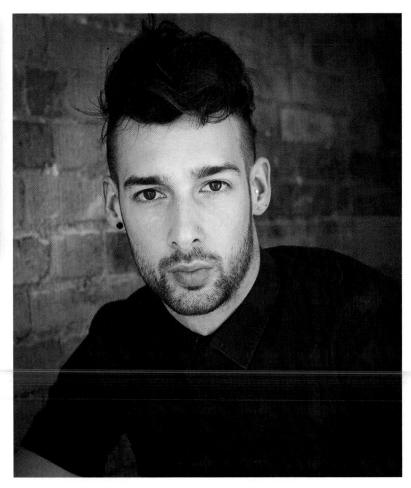

1. For this photograph, I had already carried out most of the desired image corrections. The warm white balance that was set in the Basic panel suited the skin tones in this portrait.

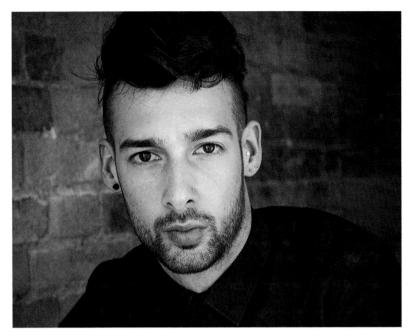

2. Staying in the Basic panel, I adjusted the Temp slides to apply a cooler "baseline" white balance to the image.

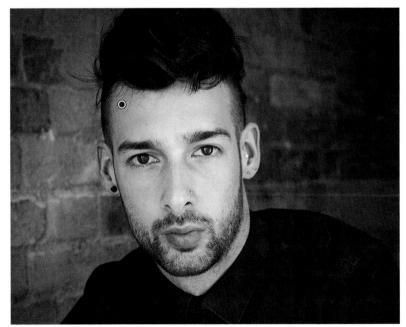

3. I then selected the Adjustment Brush, adjusted the Temp slider to select a warmer white balance, and carefully painted over the face and body to apply a warm color balance that contrasted nicely with the cooler background color.

Localized Shadows adjustments

The Adjustments panel also contains Highlights, Shadows, Whites, and Blacks sliders. As you might expect, these let you manipulate the highlight and shadow areas as a localized adjustment.

In the example shown here, the photograph was shot against a black backdrop, but it was not as deep a black as I would have liked. By applying a negative Shadows adjustment as a localized adjustment, I was able to darken the background, but without darkening the subject. I also applied a second pass adjustment in which I set the Blacks slider to –30. This helped darken everything to black. Incidentally, localized Whites and Blacks adjustments are applied downstream of the global Whites and Blacks adjustments you apply via the Basic panel. These are, therefore, best used to stretch locally the tone range at the top end (using the Whites slider) or bottom end (using the Blacks slider). To perform a highlight or shadow recovery, you should use Highlights or Shadows rather than the Whites and Blacks sliders.

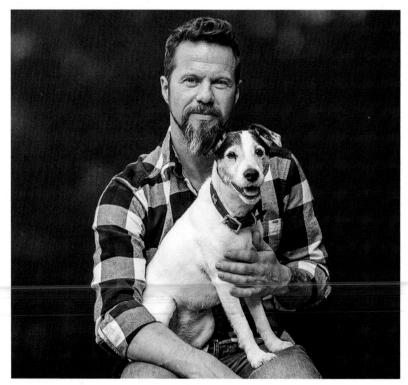

1. In this photograph, I optimized the image as usual. However, in doing so, I could not get the backdrop to go completely black.

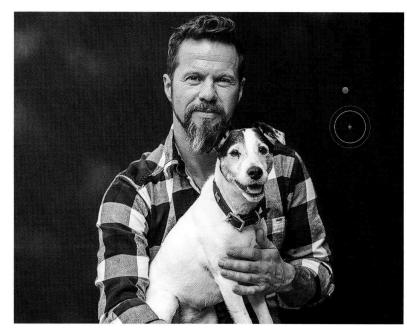

2. Here, I selected the Adjustment Brush, set the Exposure slider to -0.50 and the Shadows slider to -50, and brushed over the backdrop area.

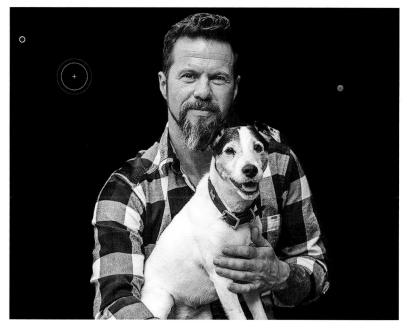

3. To make the backdrop even blacker, I applied a second pass painting with the brush set to -0.50 Exposure, -100 Shadows, and -30 Black. This allowed me to make the backdrop go completely to black.

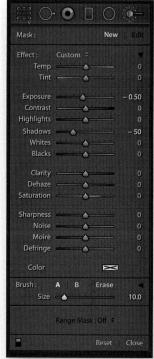

Clarity and Sharpness adjustments

A Clarity setting can be used to selectively paint in more midtone contrast. In the example shown here, I used a Positive Clarity and a positive Sharpness setting to bring out more detail in the surface of the rock. I did not want to add more sharpening or clarity in the sky area, as this would have made any image noise more noticeable. With the Auto Mask option checked, I painted the rock area only, avoiding the sky area.

Whenever you adjust the Sharpness slider in the adjustment tools to add more sharpness, you are essentially adding a greater Amount value of sharpness based on the settings that have already been established in the Detail panel Sharpening section. A negative Sharpness setting in the 0 to –50 range can be used to fade out existing sharpening. Therefore, if you apply –50 sharpness, you can paint to disable any capture sharpening. As you apply a negative Sharpness in the range of –50 to –100, you start to apply anti-sharpening. This can produce a gentle lens blur effect, but you can always strengthen it by applying successive, separate Adjustment Brush groups. I show a further example of localized sharpening in Chapter 6.

A useful tip is to pump up the settings you are working with to produce a stronger effect than what is needed so you can see the results of your retouching more clearly. You can then edit the amounts applied and reduce the slider settings to achieve the desired adjustment strength.

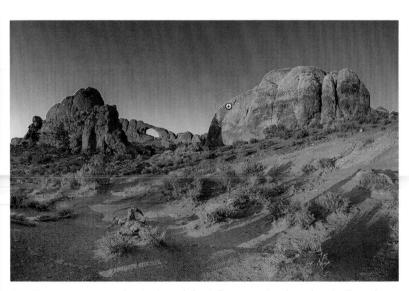

1. Here, you can see that I selected the Adjustment Brush tool and adjusted the Effect settings to add 100 Clarity combined with 30 Sharpness. I then clicked on the rocks and started painting to apply the combined Clarity and Sharpness adjustment effect (with Auto Mask checked).

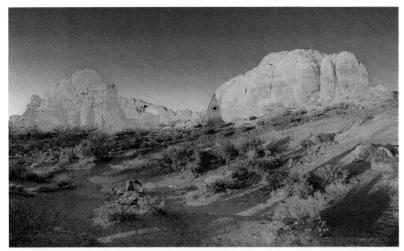

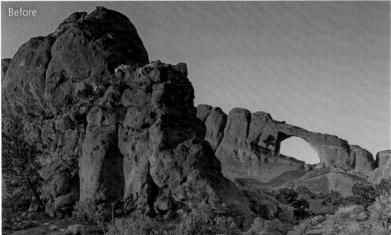

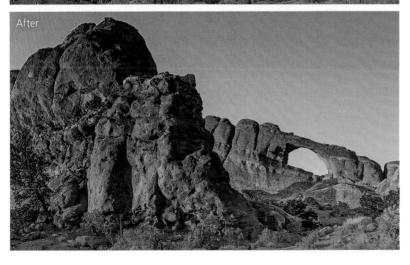

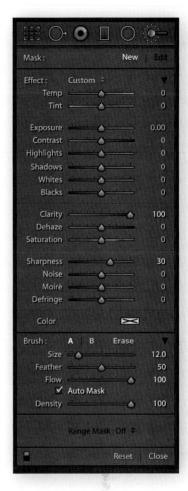

2. I applied this adjustment to the rock areas only, and you can see here an overlay view of the painted area (top) and close-up views that show the Before and After versions.

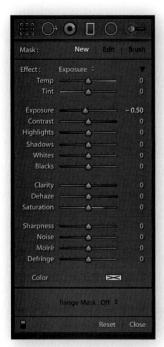

Figure 4.100 The Graduated Filter tool options in expanded mode.

Graduated Filter tool

Everything I have described so far about working with the Adjustment Brush more or less applies to working with the Graduated Filter tool (M) (**Figure 4.100**), which allows you to add linear Graduated Filter fade adjustments. To use the tool, you click on a photo to set the start point for the Graduated Filter (the point with the maximum effect strength), drag to define the spread of the Graduated Filter, and release at the point where you want it to finish (the point of minimum effect strength). This allows you to apply linear graduated adjustments between these two points. There is no midtone control with which you can offset a Graduated Filter effect, and there are no further graduation options. If you hold down the Alt key, Effect will change to Reset. Click this to reset all the sliders to 0 and clear any currently selected color. Or, you can hold down the Alt key and click an Effect slider name to reset everything except that slider setting. You can also double-click slider names to reset them to a 0 setting.

Graduated Filter effects are indicated by a pin marker, and you can move a Graduated Filter once it has been applied by clicking and dragging the pin. The parallel lines indicate the spread of the Graduated Filter, and you can change the width of the filter by dragging the outer lines. If you want to edit the angle of a Graduated Filter effect, you can do so by clicking and dragging the middle line.

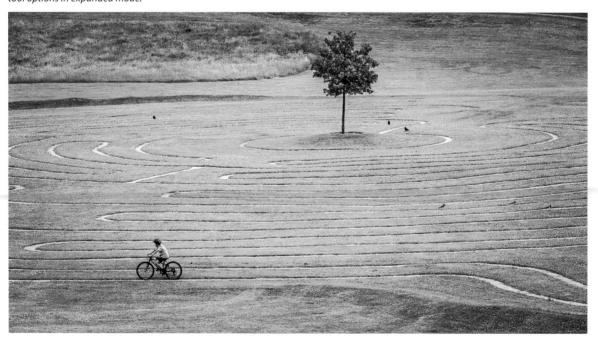

1. To this photograph, I had applied just the main Basic panel adjustments to optimize the highlights, shadows, and contrast.

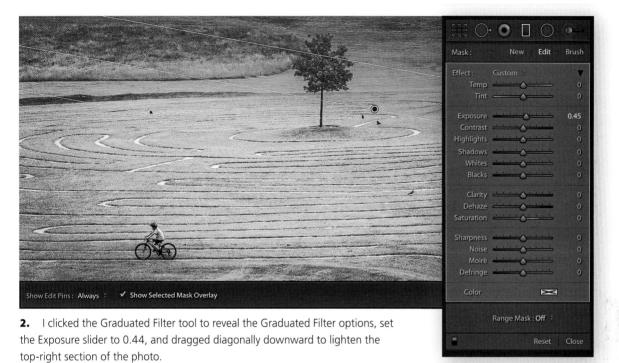

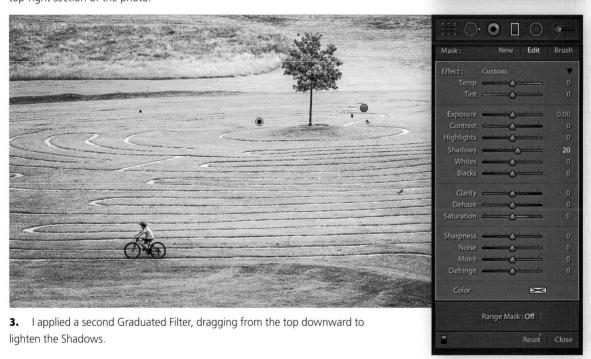

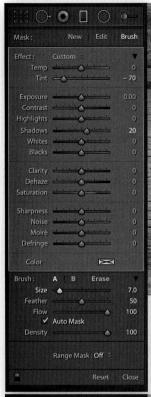

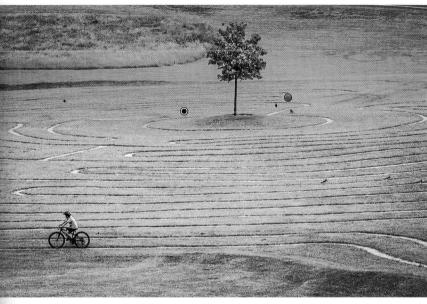

4. I then dragged the Tint slider to the left to make the Graduated Filter effect more green. I also selected the Brush to mask out the tree (there is more on brush editing in the following section).

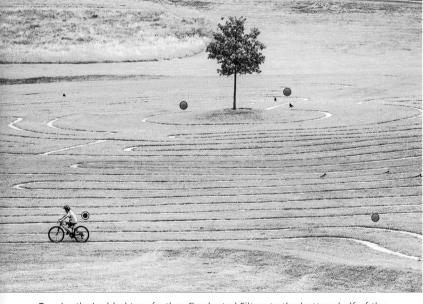

5. Lastly, I added two further Graduated Filters to the bottom half of the picture, where I applied positive Exposure adjustments.

Brush editing a Graduated Filter effect

When the Brush option is selected, you can brush paint to add to or erase from the mask. To edit a Graduated Filter effect in this way, click the Brush button to switch to brush editing mode, or use the ��shift keyboard shortcut to toggle between the brush editing mode and editing the Graduated Filter settings. You can then adjust the Brush parameter settings at the bottom, choosing either an A or B brush, or the Erase mode. Check the Show Selective Mask Overlay option in the Toolbar (①) to help visualize the extent of the Graduated Filter and the manual brush editing.

It is important to understand that two mask controls are in force here. You have a Graduated Filter mask (that you can continue to modify), plus a brush edit mask you can use to mask specific areas of an image. Therefore, you can enter brush editing mode to remove or restore areas to be affected by a Graduated Filter or Radial Filter adjustment and independently adjust the extent of the actual adjustment. The following steps show how to refine a Graduated Filter adjustment, but will also apply to working with Radial Filters as well.

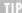

You can use // to toggle between the A and B brushes.

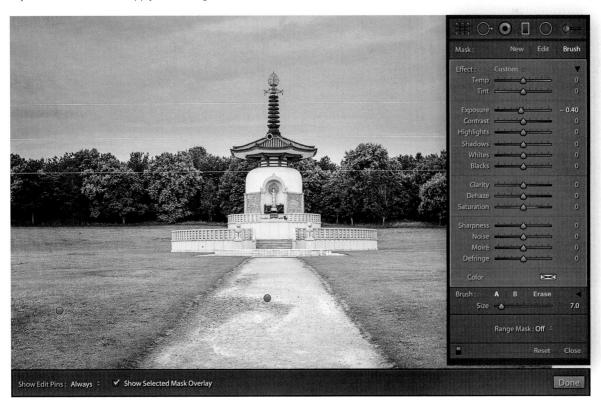

1. I added a number of graduated filter adjustments to the image, including a darkening Exposure adjustment to the sky, which, as you can see here, covered the top section of the pagoda.

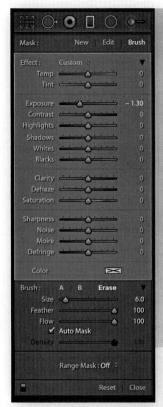

2. I then clicked the Brush button to enter brush editing mode. Using the Erase brush in Auto Mask mode, I erased the mask where it overlapped the top of the pagoda.

3. For the final version, I hid the Graduated Filter mask and pins.

Radial Filter tool

The Radial Filter (Shift)M) can be used to create off-center vignettes and has the same range of options as the Graduated Filter, except you will notice at the bottom of the tool options, there is a Feather slider for softening the boundary edge (Figure 4.101). To apply a Radial Filter adjustment, you simply drag in the preview image to define the area you wish to adjust. This adds an ellipse shape with four corner handles you can drag to refine the shape. You can also drag anywhere on the boundary edge to rotate the ellipse shape; plus, you can click and drag on the central pin to reposition it. If you initially hold down the (Alt) key and drag, this adds a Radial Filter that scales from the anchor point. Holding down the Shift key and dragging adds a Radial Filter scaled around the center point and constrained to a circle. Holding down the (Mac) or (Ctrl) (PC) key and double-clicking anywhere in the preview area adds a new adjustment auto-centered within the current (cropped) image frame area. If you (Mac) or Ctrl (PC) + double-click an existing Radial Filter, this will expand it to fill the current cropped image area. To exit working with the Radial Filter, you can click the Radial Filter button, use the (Shift) M shortcut, or double-click an existing Radial Filter adjustment to apply and dismiss. Use the H shortcut to hide the bounding box.

By default, a new adjustment will have a zero effect at the center and get stronger toward the outer edges of the ellipse and beyond. You can switch this around by checking the Invert box just below the Radial Filter Feather slider, or use the apostrophe key shortcut () to toggle between these two modes. As with all localized adjustments, if you hold down the Alt key and click the pin, you can drag left and right to dynamically modify the current active slider settings, making them increase or decrease in strength. Lastly, you can use **Alt (Mac) or Ctrl Alt (PC) plus a click and drag to duplicate an existing Radial Filter adjustment.

There are lots of potential uses for this localized adjustment. The most obvious example is you can use it to apply more controllable vignette adjustments to darken or lighten the corners. For example, instead of simply lightening or darkening using the Exposure slider, you can use the Highlights or Shadows sliders to achieve more subtle types of adjustments. Or, you might want to adjust the Saturation setting so that either the corners or center of the image appear desaturated or more saturated. I mostly use the Radial Filter in preference to the Adjustment Brush as a tool for applying localized adjustments to specific areas of a photograph.

As with the Graduated Filter, you can add multiple radial filter adjustments to an image. Once added, a Radial Filter adjustment is represented by a pin marker. If you click a pin, this makes it active. You will see the elliptical outline of a Radial Filter adjustment, and can then re-edit the adjustment settings.

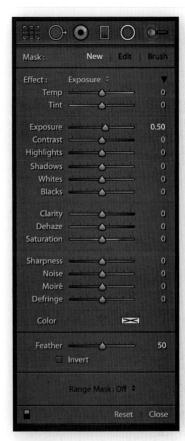

Figure 4.101 The Radial Filter tool options

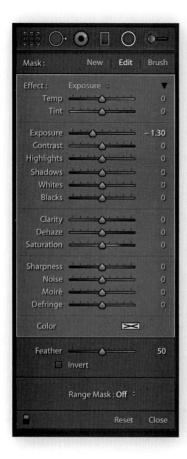

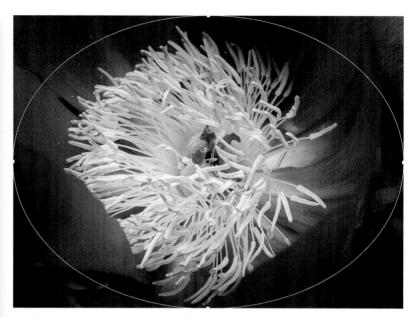

1. I opened an image in Lightroom and selected the Radial Filter tool. I held down the **(Mac)** or **(Ctr.)** (PC) key and double-clicked inside the preview area to add a new adjustment that filled the current frame area from the center pin outward. I set the Exposure slider to –1.29 to darken the outer edges.

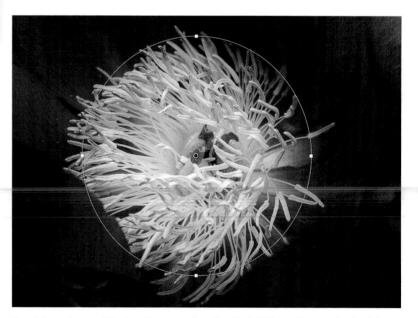

2. I then dragged the handles to realign the Radial Filter effect so the Radial Filter adjustment was centered around the stamen in the middle of the flower.

Correcting edge sharpness with the Radial Filter

Another thing the Radial Filter can be useful for is sharpening the edges of a photo. If you own decent lenses, edge sharpness shouldn't be a problem, but with lesser optics, selectively giving the edges an extra sharpening does help. For example, I sometimes like to photograph using a Sony RX-100 camera, which is a great little compact camera that shoots raw images, but the edge sharpness is not as sharp as what I am used to with my regular digital SLR lenses. To address this, I have found it helps if I use the Radial Filter to apply a Sharpness adjustment that gains strength from the center outward.

Now, it has to be said that the falloff in sharpness toward the edges is more tangential in nature, and a standard/radial sharpening boost is not the optimum way to sharpen the corner edges. For example, DxO Optics Pro features a special edge-sharpness correction that is built into its auto-lens corrections. Even so, the following example shows how you can make some improvements using the Radial Filter.

If you think this technique might be useful, consider creating a "corner sharpening" preset that you can quickly apply to other photos that have been shot with the same lens. In Lightroom, it is also possible to save such a setting as a camera default. It would not make sense to do this for a digital SLR because you could not make it lens-specific, but it could be applied to, say, a compact camera that had a fixed lens.

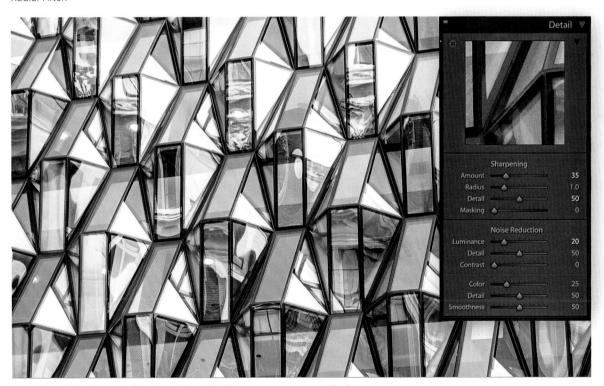

1. I shot this photograph using a Sony RX-100 compact camera. The image quality is very good, though there is a noticeable falloff in sharpness toward the edges of the frame. In this first step, I went to the Detail panel and applied the global sharpening settings shown here.

321

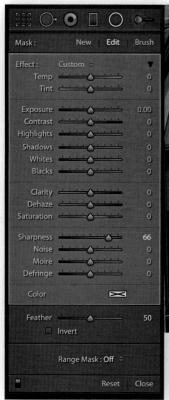

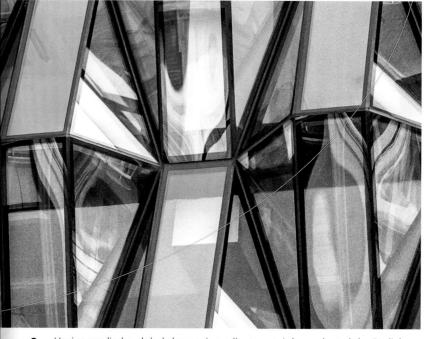

2. Having applied a global sharpening adjustment, I then selected the Radial Filter tool, held down (Mac) or (PC), and double-clicked inside the preview area to auto-center the ellipse shape, so the adjustment effect I was about to apply would extend from the center to the outer edges. I also needed to make sure the Invert Mask box was deselected so that the effect was strongest at the outer edges. I then adjusted the Sharpness slider, setting it to 66.

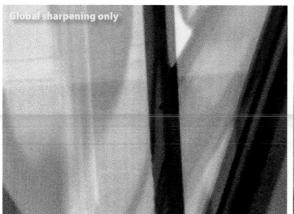

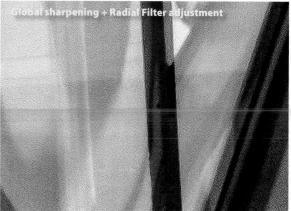

3. Here, you can see a comparison of the bottom-right corner of the image: The version on the left shows how the image looked with the global sharpening only, and on the right, how it looked with additional edge sharpening using the Radial Filter adjustment.

Range Masking

In addition to Auto Mask, Lightroom also offers Range Masking with Color and Luminance Range Masking controls. The Range Mask options are located at the bottom of the Adjustment Brush, Graduated Filter, and Radial Filter panels. For example, if you apply a localized adjustment and the Color Range Mask option is selected (Figure 4.102), you can add a mask to the localized adjustment based on a sampled color. To do this, select the Eyedropper tool (or hold down the 🕱 key [Mac], Ctrl key [PC]). With a single click you can restrict the Color Range Mask area based on a sampled color, such as a blue sky. The Amount slider can then be used to adjust the depth of the Color Range Mask selection. Dragging the slider to the left narrows the range, while dragging to the right widens, but you will notice how the Color Range Mask selection becomes smoother and more diffuse as you do this. For more precise masking, a lower Amount setting is best. To preview a Color Range Mask, you can hold down the Alt key as you drag the Amount slider to see a temporary black-and-white mask preview. To refine a Color Range Mask selection, you can click again to sample a new color or you can marquee drag to make a broader color range selection. To add more sample points, click or drag again with the ①Shift key held down. By doing this, you can sample up to five color points. However, as you exceed that number, the oldest sample points will be removed. To exit the Eyedropper mode, click the Eyedropper tool button again or press the Esc key. Use (0) to toggle the colored overlay.

Alternatively, you can select the Range Mask Luminance mode (**Figure 4.103**). You can then use the Range slider to control the range of luminance tones that are selected within a localized adjustment selection. To do this, drag the shadow (left) and highlight (right) handles on the slider to control the range of luminance tones. The Smoothness slider can be used to modify the smoothness of the selection, which is similar to adjusting the Amount slider in the Color Range mode. As with the Range Mask in Color mode, you can hold down the Alt key to see a black-and-white mask visualization here.

The Color Range and Luminance Range mask controls make it much easier to selectively mask localized adjustments. Previously, only the Auto Mask was available, and the mask edges could sometimes end up being quite blocky, so you would see edge artifacts. By comparison, the Range Mask edges are more diffuse and have much smoother edge blends. In extreme cases, you are still likely to see some edge artifacts, but this can be mitigated by increasing the Color Range Mask Amount slider or increasing the Luminance Range Mask Smoothness slider.

It is also possible to combine a Range Mask with the new, improved Auto Mask, although this does add more complexity. If working with the Adjustment Brush, you should set the Develop settings and paint broadly over the subject with Auto Mask switched off and without aiming for a perfect outline. Next, select Color or Luminance from the Range Mask menu. In the Range Mask Color mode, select the Eyedropper tool and click to sample the colors you want the adjustment to

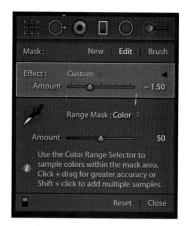

Figure 4.102 The Range Mask Color mask controls.

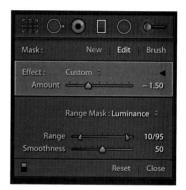

Figure 4.103 The Range Mask Luminance mask controls.

NOTE

To sum up, an Adjustment Brush adjustment can be determined by the defined area (with or without Auto Mask) + Range Mask. A Graduated Filter or Radial Filter adjustment can be determined by the defined area + Range Mask + Brush edit, where Auto Mask can add further refined control.

affect. Having done that, adjust the Color Range Mask Amount slider to fine-tune the adjustment. Or, select the Range Mask Luminance mode and proceed to adjust the Range and Smoothness sliders. Having done that, you can revert to working with the Adjustment brush in Add or Subtract modes with Auto Mask on or off to refine the original adjustment selection.

If editing a Graduated Filter or Radial Filter adjustment, the best approach is to add a Filter effect, adjust the Develop sliders, and select Color or Luminance from the Range Mask menu. Refine the mask as usual by sampling colors/adjusting the luminance range values and then smoothing. Lastly, switch to the Brush edit mode working in the Add or Erase mode. Adding reveals (dependent on the Filter Mask and Range Mask selection), while erasing hides the adjustment completely. You can do this with Auto Mask on or off.

Range Masking and process versions

As I explained at the beginning of this chapter, adding Range Masking to the localized adjustment tools has meant introducing a new process version: Version 4. Version 4 and Version 3 are identical except with regard to how selective edits are masked using either the new Range Masking tools or Auto Mask (because Auto masking has also been updated). For example, if the edited image in Step 3 were to be changed from Version 4 to Version 3, it would look like the Step 2 screen shot.

Color Range Masking

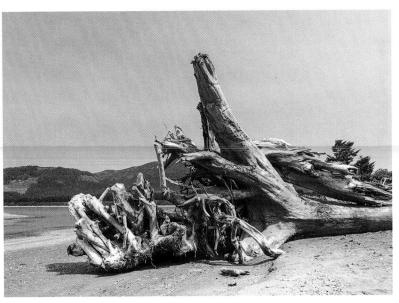

1. With this photograph, I wanted to use the Graduated Filter tool to selectively darken the sky, but without darkening the tree.

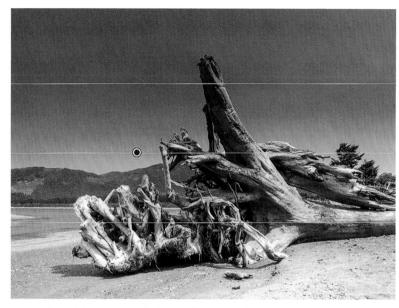

2. I selected the Graduated Filter tool and added a darkening filter adjustment to the sky using a -1.75 Exposure and a +50 Saturation setting.

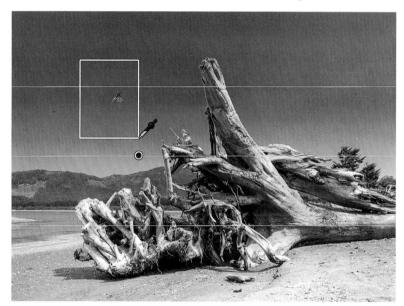

3. I went to the Range Mask menu and selected Color. I then selected the Eyedropper tool and clicked and dragged on the blue sky areas I wished to define as being part of the adjustment. This automatically added a mask, based on the sampled colors, that masked the tree from the Graduated Filter adjustment.

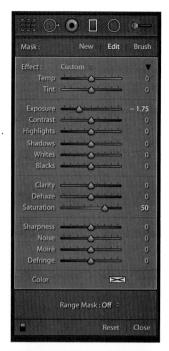

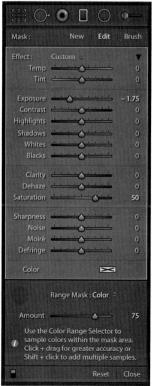

Luminance Range Masking

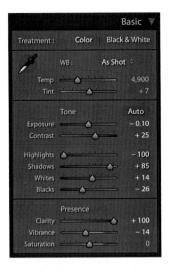

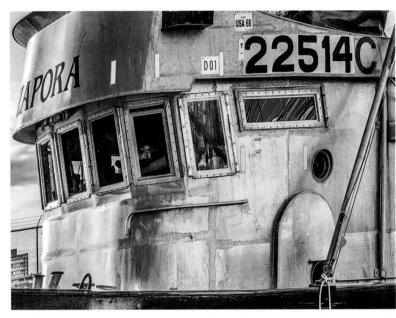

1. I first optimized the Basic panel settings and set Clarity to +100.

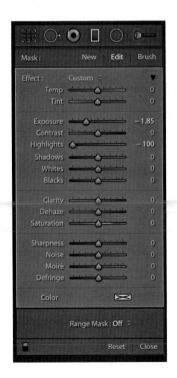

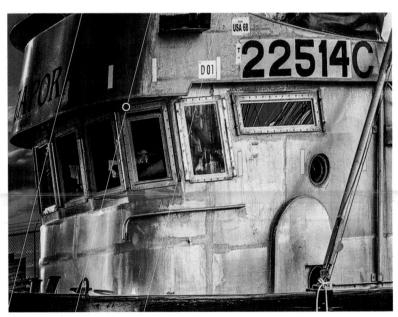

2. I added a darkening Graduated Filter to the left side, setting the Exposure slider to -1.85 and the Highlights slider to -100.

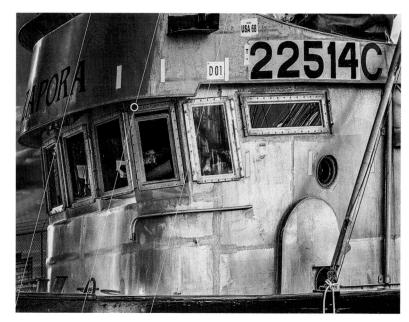

3. In the Range Mask options, I selected Luminance from the Range mask menu and dragged the Range slider shadow handle inward to the 50 setting. This refinement to the Graduated Filter masked the deep shadow areas.

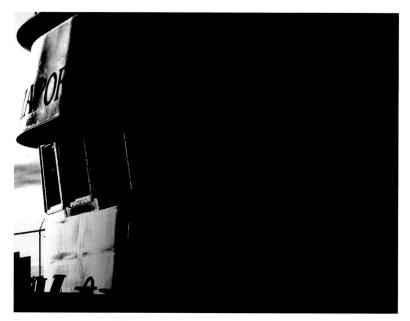

4. I held down the Alt key to see a mask preview as I continued to drag the Range slider shadow handle to 85, which protected more of the shadows.

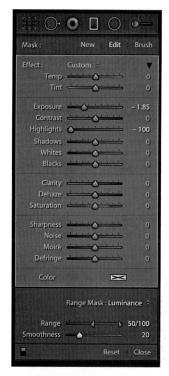

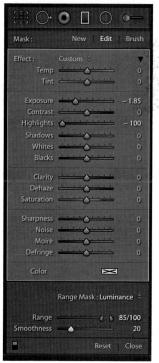

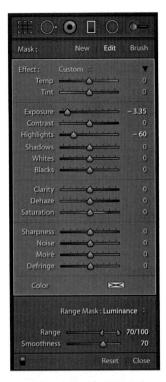

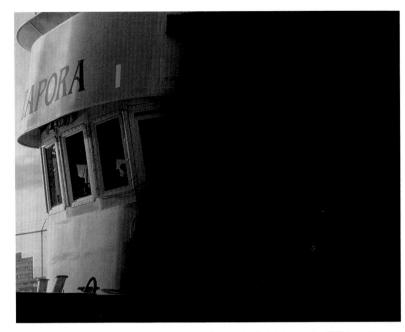

5. I dragged the Smoothness slider, while I again held down the Alt key. The mask preview here shows the Range Mask with a Smoothness setting of 70.

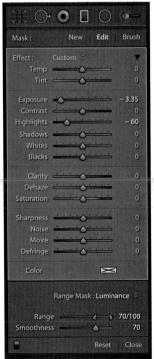

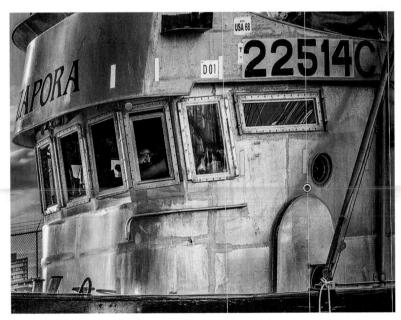

6. Here's the final image. Besides the settings applied in Step 5, I also added a second Luminance Range Masked Graduated Filter to the right side of the photograph.

History panel

Every step you apply in the Develop module is recorded as a separate history state in the History panel (Figure 4.104), which is located just below Presets and Snapshots panels (Figure 4.105). The History feature in Lightroom has a unique advantage over Photoshop in that the history steps are always saved after you guit Lightroom. The History panel is therefore useful because it allows you to revert to any previous Develop module setting and access an unlimited number of history states without incurring the efficiency overhead that is normally associated with Photoshop image editing and History. However, keeping multiple history states can lead to the catalog ballooning in size. There are several ways you can navigate through a file's history. You can go to the History panel and click to select a history step. This will let you jump quickly to a specific state. Or, you can roll the pointer over the list of history states in the History panel to preview them in the Navigator panel and use this to help select the one you are after. Figure 4.104 shows how the History panel looked after I had made a series of Develop adjustments to the image. Here, the original history state is date stamped at the time of import and subsequent history states listed in ascending order. You will also notice that the numbers in the middle column show the number of units up or down that the settings were shifted, and the right column lists the new settings values.

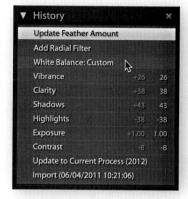

Figure 4.104 A close-up view of the History panel.

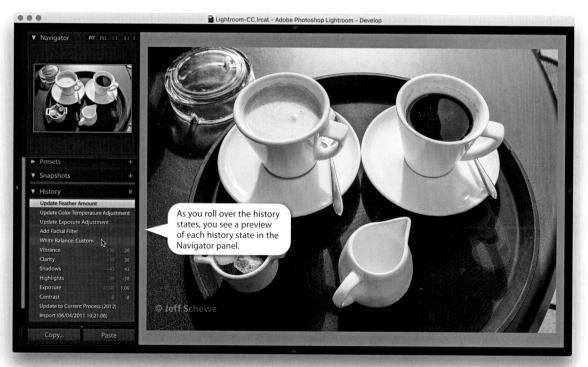

Figure 4.105 The steps applied to the image are recorded to the History panel in the order in which they were applied.

NOTE

In Lightroom Classic CC, the Develop History and Metadata values are compressed, which should result in improved responsiveness.

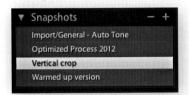

Figure 4.106 The Snapshots panel with a saved snapshot selected.

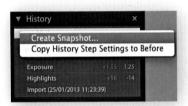

Figure 4.107 The History panel context menu.

Figure 4.108 The New Snapshot dialog.

Figure 4.109 You can use the context menu to choose Update with Current Settings.

You can also choose Edit ⇒ Undo or use ℜZ (Mac) or Ctrl Z (PC) to undo the last step. As you repeatedly apply an undo, the history steps are removed from the top of the list one by one, but you can restore these steps by choosing Edit ⇒ Redo or using the ℜAshift Z (Mac) or (Ctrl Ashift Z (PC) shortcut. However, if you carry out a series of undos in this way and then quit Lightroom, you will not be able to recover those history steps later. Also, if you click to select a specific history step and then adjust any of the Lightroom Develop settings, this, too, will erase all the previously recorded history steps from that point onward in history. Lastly, if you click the Clear button in the History panel, you can delete all the history steps currently associated with a photo or a selection of photos made in the Filmstrip. Clearing the history can be useful if the number of history steps is getting out of control and you need to manage the history list better.

Snapshots panel

Another way to manage your history states is to use the Snapshots panel. Snapshots can be used to store specific history states as a saved image setting (**Figure 4.106**). It is often more efficient to use the Snapshots panel to save specific history states, as this can make it easier for you to retrieve history states that are of particular importance or usefulness, instead of having to wade through a long list of previously recorded history states from the History panel.

To use the Snapshots feature, use the current image state, or select a history state you want to record as a snapshot, and click the + button in the Snapshots panel. You can also use the context menu shown in Figure 4.107 to create a snapshot from a selected history state. This then opens the New Snapshot dialog (Figure 4.108) and lets you create a new snapshot. You can use the provided date/time stamp as the name for the new snapshot or rename the snapshot using a descriptive term, and then click Create. Snapshots are always arranged alphabetically in the Snapshots panel, and the Navigator panel preview will update as you hover over snapshots in the list. To load a snapshot, simply click a snapshot to select it. If you want to update the settings for a particular snapshot, you can do so via the context menu: Right-click a snapshot and select Update with Current Settings (see Figure 4.109) to update a snapshot with the current history state. You can therefore use the Snapshots panel to save multiple variations of a master photo, such as a color-enhanced or a black-and-white version of the original. Also, unlike history steps, Snapshots can be saved to the XMP metadata and therefore made readable in Camera Raw, or vice versa. To delete a snapshot, just click the minus button.

The Sync Snapshots command in the Develop module Settings menu (see page 333) is particularly useful for updating existing snapshots with new settings. For example, if you have just spent some time removing blemishes or cropping an image, it can be handy to use the Sync Snapshots command to update the Spot Removal and Crop settings across all the previously created snapshots.

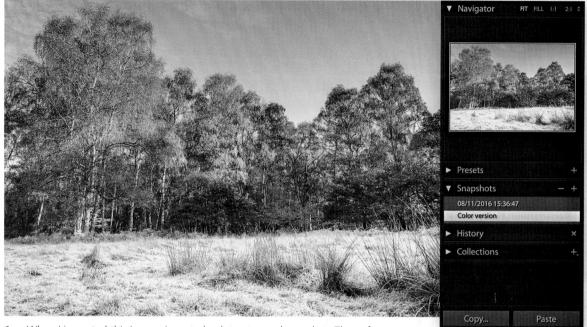

1. When I imported this image, I created a date-stamped snapshot. Then after editing the photograph, I created a new snapshot and named it "Color version."

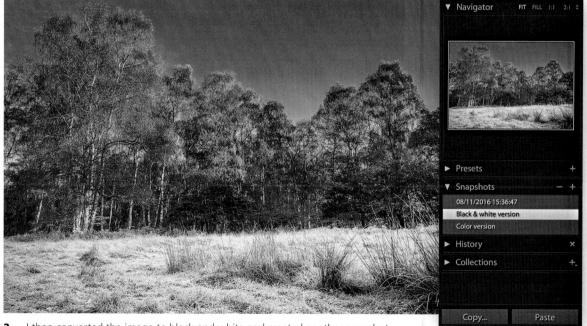

2. I then converted the image to black and white and created another snapshot, naming it "Black & white version."

How to synchronize snapshots

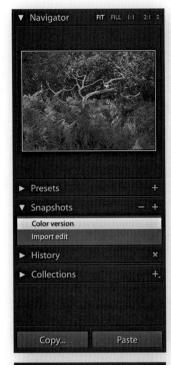

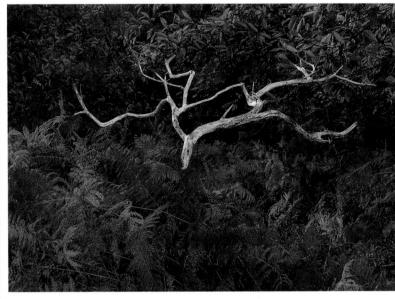

1. In this example, the current Develop settings were saved as a new snapshot, which I named "Color version."

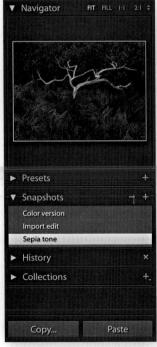

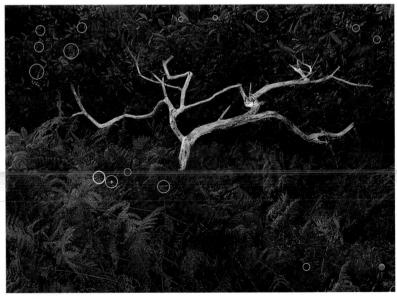

2. I continued editing the photo and saved a new black-and-white snapshot. However, this snapshot now included a lot of spotting work that I carried out since saving the previous snapshot.

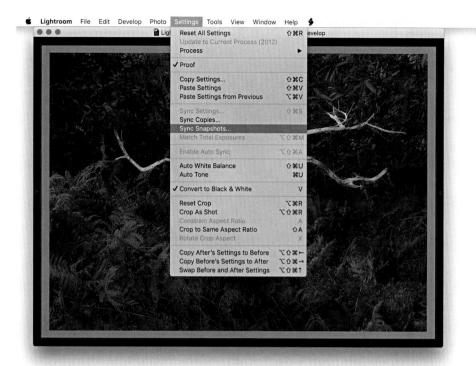

3. To update the other snapshots, I went to the Settings menu and chose Sync Snapshots.

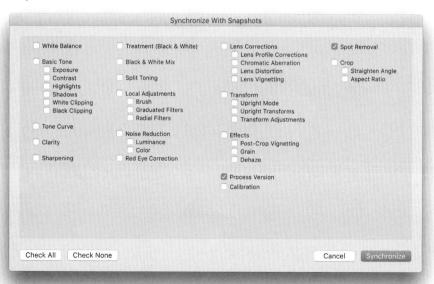

4. This opened the Synchronize With Snapshots dialog. I made sure only the Spot Removal option was checked and clicked Synchronize to update all the other snapshots in the Snapshots panel with the most recent Spot Removal settings.

Figure 4.110 A Virtual copy image.

Easing the workflow

Virtual copies and synchronizing your develop settings across a sequence of images can all give you more creative flexibility, as can the use of Presets in Lightroom.

Making virtual copies

In addition to making snapshot versions, you can create virtual copies of your master photos by going to the Library module and choosing Photo \Rightarrow Create Virtual Copy (\Re) [Mac] or Ctrl [PC]). This makes a virtual copy of the master image (**Figure 4.110**) that is automatically grouped in a stack with the master photo. When viewing the Library Grid view or Filmstrip, you can tell which images are virtual copies by the turned-page badge in the bottom-left corner. As the name suggests, you are making a proxy version of the master. It may look and behave like a separate photo, but it is, in fact, a virtual representation of the original master that you can continue to edit in Lightroom as if it were the original image.

So, what is the difference between a virtual copy and a snapshot? Well, a snapshot is a saved history state that is a variation of the master. You have the advantage of being able to synchronize specific edit adjustments across all the snapshot versions but lack the potential to create multiple versions as distinct entities that behave as if they were actual copies of the original. A virtual copy is therefore like an independent snapshot image, because when you create a virtual copy, you have more freedom to apply different types of edits and preview these edits as separate image versions. You could, for example, create various black-and-white renderings and experiment with alternative crops on each virtual copy version. The example on the page opposite shows how you might use the Compare view mode to compare a virtual copy version of a photo alongside the master version (or you could use the Survey view to compare multiple versions at once). Virtual copies also make it possible for you to create collections that have different settings. For example, you can use the Create Virtual Copy command to create black-and-white versions as well as colorized versions from a master image, and then segregate these virtual copies into separate collections.

You also have the freedom to modify the metadata in individual virtual copy images. For example, you may want to modify and remove certain metadata from a virtual copy version so that when you create an export from the virtual copy, you can control which metadata items are visible in the exported file. For instance, when submitting photos to clients, you may wish to exclude certain metadata that cannot normally be removed automatically at the export stage.

Making a virtual copy the new master

Once you create one or more virtual copies, you can then choose the Photo \Rightarrow Set Copy as Master command to make any virtual copy version of an image become the new master version (and make the old master version become a virtual copy).

1. As you make new virtual copies of a master file, these are automatically stacked with the original master image.

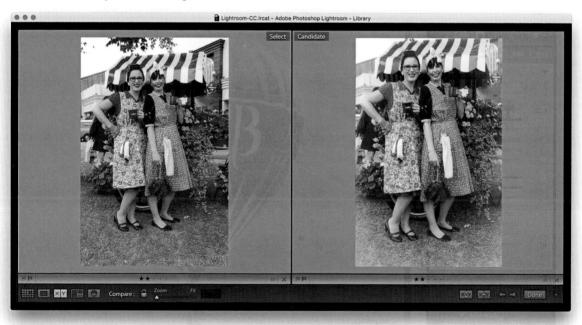

2. One of the advantages of having virtual copy versions of a master file is that you can explore applying different Develop settings and compare these against the original master.

Figure 4.111 The Sync... and Reset buttons.

Figure 4.112 Holding down the Alt key bypasses the Synchronize Settings dialoa.

MATE

Whenever you choose to synchronize the Develop settings, Lightroom checks the process version status of the most selected image when deciding what to do. If the Process Version box is checked, it applies the process version of the most selected photo to all the other photos (if the selected photos already share the same process version as the most selected photo, no conversion needs to take place). If the Process Version box is not checked, things can become more unpredictable. In this situation, the process version will not be referenced when making a synchronization. Therefore, if you attempt to synchronize Version 1 settings to Version 4 images, such settings as Recovery or Fill Light will not be translated. Similarly, if you try to synchronize a Version 4 image to Version 1 or 2, adjustments such as Highlights and Shadows will not be recognized.

Figure 4.113 Hold down the 🗷 key (Mac) or Ctrl key (PC) to switch to the Auto Sync mode.

Synchronizing Develop settings

Let's look at ways the Develop settings can be applied to multiple images. Whenever you have a selection of images selected in the Develop module, the Previous button changes to Sync (Figure 4.111). Clicking the Sync button lets you synchronize the Develop settings across two or more photos, based on the settings in the target photo, and opens the Synchronize Settings dialog (or you can use the <code>\colongle \cdot \shift(\sigma) [Mac] or \(\text{Ctrl} \cdot \shift(\sigma) \shift(\sigma) [PC] \) keyboard shortcut). If you hold down the lat key, the Sync button loses the ellipsis (Figure 4.112), and clicking the button will bypass the Synchronize Settings dialog and apply a synchronization based on the last used Synchronize settings. In this mode you will see a Set Default button. This lets you set the current Develop settings as the new default settings for files shot with this particular camera plus this specific serial number and ISO setting. What gets set here all depends on how the preferences have been configured (see page 353).</code>

If you click Check All in the Synchronize Settings dialog, every item will be checked. If you click Check None, you can then choose any subset of synchronization settings. Whether you choose to save everything or just a subset of settings, this will have important consequences for how the photos are synchronized. If you choose Check All, everything in the selected image will be synchronized. In some cases, this might well be the easiest and most practical option. But you will not necessarily always want to synchronize everything across all the selected photos. Sometimes you'll need to think carefully about which specific settings you should synchronize. If not, you may end up overwriting settings that should have been left as they were (although you can always recover a previous image version via the History panel on an image-by-image basis). For example, if your imported photos have the camera default settings applied for Sharpening, Noise Reduction, and Calibration, you will want to be careful not to overwrite these settings. The sync behavior can also be critically affected by the process version of the most selected and other photos (see Note).

Auto Sync mode

If you \(\mathbb{H}\)-click (Mac) or \(\text{Ctrl}\)-click (PC) the Sync button, it switches to Auto Sync mode (see \(\mathbb{Figure 4.113}\)) and stays as such until you click the Auto Sync button to revert back to Sync mode again. In Auto Sync mode, you first make a selection of photos, and as you adjust the Develop settings for the most selected image, you will see these adjustments propagated across all the images in the selection. You will notice that there is a switch next to the left of the Sync/Auto Sync buttons. Clicking this toggles between the Sync and Auto Sync modes, or you can use the \(\mathbb{H}\)\(\text{Shift}\)Alt (A) (Mac) or \(\text{Ctrl}\)\(\text{Shift}\)Alt (A) (PC) keyboard shortcut. Lastly, there is the Reset button, which can be used to reset photos back to their Lightroom default settings.

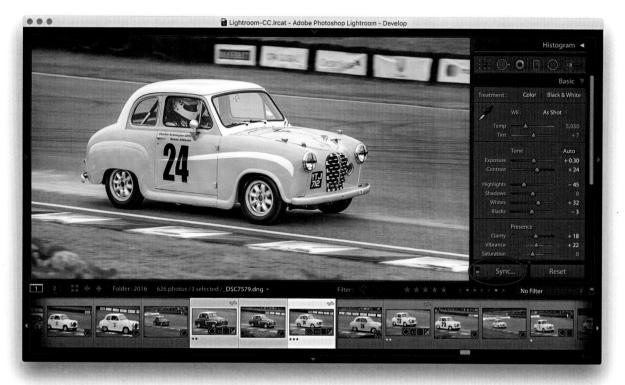

1. The Develop settings in the most selected photo can be synchronized with other photos in a selection by clicking the Sync button (circled) or using the <code>\(\mathbb{H}\)\Constrain Shift\(\mathbb{S}\) (Mac) or \(\mathbb{Ctrl}\)\Constrain Shift\(\mathbb{S}\) (PC) keyboard shortcut.</code>

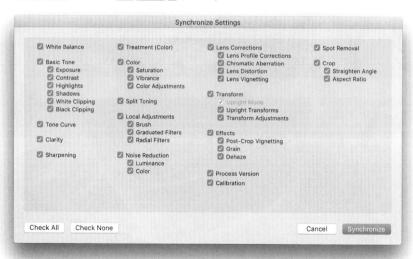

2. In the Synchronize Settings dialog, I selected the Check All settings option. This should be used with caution, because synchronizing everything may overwrite important Develop settings in the selected photos.

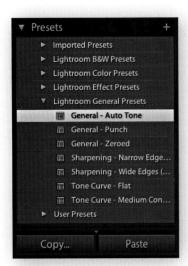

Figure 4.114 The Copy and Paste buttons in the bottom-left section of the Develop module.

NOTE

Whenever you copy the Develop settings, Lightroom utilizes the Basic panel settings associated with the process version of the selected image, and Lightroom will automatically want to include the process version of the image in the copy settings. You can override this by disabling the Process Version box, but see the Note on page 336 for information about how Lightroom handles process version conflicts that might arise when the process version of the image you are pasting to does not match that of the image you copied the settings from. Applying any of the default Lightroom presets will automatically update a photo to Version 4.

Copying and pasting Develop settings

Another way to synchronize images is to copy and paste the Develop settings from one photo to another using the Copy and Paste buttons in the Develop module (**Figure 4.114**). You can also do this by selecting a photo from the Library Grid or Filmstrip and use **\(\frac{\pmathbb{C}}{\pmathbb{D}}\) iff (Mac) or *\(\text{Ctri}\subseteq \text{Shift}\) (PC) to copy the settings. Either method opens the Copy Settings dialog shown in **Figure 4.115**. Here, you can specify the settings you want to copy. If you *\(\text{Alt}\)-click the Copy button, you can bypass this Copy Settings dialog completely. So, if you had previously clicked the Check All button to apply all the settings in the Copy Settings dialog, *\(\text{Alt}\)-clicking the Copy button copies all settings without showing the dialog. After you have copied the Develop settings, you can select a photo or selection of photos via the Library module Grid view or Filmstrip and click the Paste button to apply the current copied settings (or use the *\(\frac{\pmathbb{C}}{\pmathbb{S}}\) iff \(\text{V}\) [Mac] or \(\text{Ctri}\subset \text{Shift}\) V [PC] shortcut). Incidentally, Library Grid copying and pasting performance has been improved in this latest version of Lightroom and now is slightly faster than Bridge.

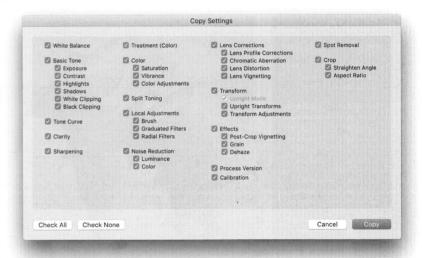

Figure 4.115 The Copy Settings dialog.

Applying a previous Develop setting

As you navigate the Filmstrip, Lightroom temporarily stores the Develop settings for each photo you click on and thereby allows you to apply a previous Develop setting to any photo. When you apply a previous Develop setting, the Copy Settings dialog does not open because clicking the Previous button simply applies all the Develop settings from the previously selected photo. You can also use the **FAIT** (Mac) or Ctrl Alt (PC) shortcut to apply a Previous setting. If more than one photo is selected in the Filmstrip, the Previous button will say Sync instead. If you still wish to apply a Previous setting, hold down the Shift key and the Sync button will change to Previous. Click it and Lightroom will apply a copy of the previous image settings to the most selected photo in the Filmstrip.

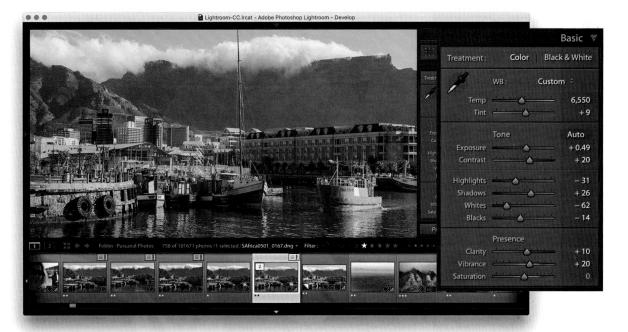

1. Whenever you select a photo in the Filmstrip, Lightroom automatically stores the Develop settings as a Copy All setting.

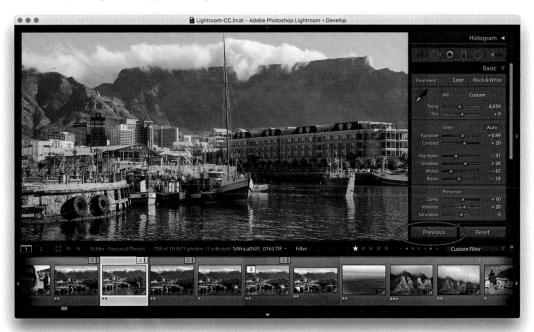

2. If you then select another photo in the Filmstrip and click the Previous button, this pastes *all* the Develop settings from the previously selected photo.

Lightroom and Camera Raw compatibility

Lightroom and Camera Raw share the same Camera Raw processing engine. This means any development adjustments that are applied in one program can be recognized and read by the other. However, you need to bear in mind that new features are added with each new Camera Raw release, making Camera Raw version-specific. If you are subscribed to a Creative Cloud plan, you will have immediate access to the latest updates for Lightroom and Photoshop and can therefore maintain full compatibility. You can open files processed in earlier versions of Camera Raw or Lightroom and edit them. But problems can arise when you share files that have been edited in the latest version of Lightroom or Camera Raw with someone using an older version. This is because Lightroom and Camera Raw cannot be expected to provide full backward compatibility for older versions. For example, if you are using the most current version of Lightroom, you can add Guided Upright corrections and apply Dehaze adjustments. If you edit an image using these controls and share the raw files, only another user using the same version of Camera Raw or Lightroom will be able to read the files and edit the Guided Upright and Dehaze settings. If you share the files with someone using an older (incompatible) version of Camera Raw or Lightroom, the person will be able to open the file and see the later verison edit changes applied in the preview but not have the controls to edit these adjustments. Therefore, you need to take version compatibility into account when sharing catalogs or exported raw files with other Lightroom users.

Making Camera Raw edits accessible in Lightroom

For Camera Raw edits to be visible in Lightroom, you need to make sure that image adjustments applied in Camera Raw are also saved to the file's XMP space. To do this, launch Photoshop and choose Photoshop ⇒ Preferences ⇒ Camera Raw to open the Camera Raw Preferences dialog (**Figure 4.116**). In the dialog, go to the "Save image settings in" menu and select "Sidecar '.xmp' files."

Figure 4.116 To keep the Camera Raw edits in sync with Lightroom, you need to make sure that the Camera Raw settings are always saved to the sidecar .xmp files.

Making Lightroom edits accessible in Camera Raw

To allow Camera Raw to read Develop module adjustments that have been applied in Lightroom, you need to save the edits to the files' XMP space. You can do this by choosing Photo ⇒ Save Metadata to File, or by using the ※S (Mac) or Otro (PC) keyboard shortcut.

Keeping Lightroom edits in sync

If Lightroom detects that a file's metadata has been edited externally, Lightroom displays a metadata status conflict warning badge in the thumbnail cell (providing you have the Unsaved Metadata option checked in the Library View options: Grid View Cell icons section). This may appear as an upward arrow (**Figure 4.117**), indicating the metadata has been edited externally, such as in Camera Raw. Clicking this badge opens the dialog shown in **Figure 4.118**, where you can choose to import the settings to Lightroom or overwrite with the current Lightroom settings. You can instead import external settings by choosing Metadata \Rightarrow Read Metadata from files (in the Library module) or Photo \Rightarrow Read Metadata from file (in the Develop module). If you are unsure about the current metadata conflict status, choose Library \Rightarrow Synchronize Folder (**Figure 4.119**). The Synchronize Folder command will run a quick check to determine if everything is in sync between Lightroom and update the badge icons for any metadata conflicts.

Figure 4.118 The metadata status change warning dialog.

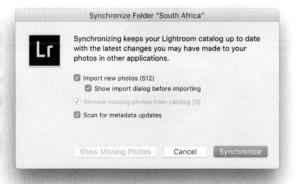

Figure 4.119 The Synchronize Folder command can run a quick scan for metadata updates.

Figure 4.117 A Grid view of an image where the metadata has been edited in an external application.

MOTE

If you have unsaved metadata changes in Lightroom, you will see a downward arrow in the top-right corner. If you have unsaved metadata changes in Lightroom and have also made external metadata changes, you will see an exclamation point badge. In either of these situations, clicking the badge opens a dialog like the one in Figure 4.118 with options to resolve the sync conflict.

Synchronizing Lightroom with Camera Raw

The following steps illustrate how to keep a set of photos in sync when switching between Lightroom and Adobe Camera Raw.

1. Here is a selection of photos in Lightroom with only the default settings applied.

2. I opened the same photo selection in Camera Raw, optimized the settings, and synchronized these settings with all the selected photos.

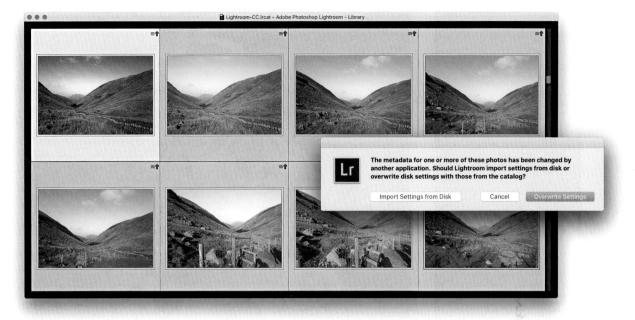

3. In Lightroom, the "out-of-sync" photos displayed a metadata status change warning icon with an upward arrow, indicating the settings had been changed externally. I clicked the badge and then clicked the Import Settings from Disk button to import the Camera Raw adjusted settings (sometimes you won't see the badges straight away and may want to choose Metadata

Read metadata from file).

4. The externally adjusted settings now appeared updated in Lightroom.

Figure 4.120 The Presets panel.

Saving Develop settings as presets

If you have created a setting you are likely to use again, it is a good idea to save it as a preset. For example, it is a tedious process to access the different camera profiles in the Camera Calibration panel Profile menu. Rather than click on each one to see what effect it has, you can create a Develop preset in which only the calibration setting is saved for each preset. Figure 4.120 shows an expanded view of the Develop module Presets panel in which you can see a list of custom preset settings. The Lightroom Presets folder will be installed already and has enough presets to help you get started. To add your own presets, click the + button at the top of the Presets panel (circled). This opens the New Develop Preset dialog shown in Figure 4.121, where you can choose which settings you want to include. The process version of the current selected photo determines which Basic panel adjustments are displayed here. Note also the process version warning. It is important to appreciate how process versions affect the available settings and subsequent preset behavior. When you have decided which to check, give the preset a name, choose a folder location to save the preset to, and click the Create button to add it as a new preset to the list. As you roll over the list of presets, you get to see an instant preview in the Navigator panel, as shown in Figure 4.120. You can update existing settings by right-clicking to reveal a context menu for the presets (which also allows you to select a preset to apply in the Import dialog for the next time you do an import).

Figure 4.121 The New Develop Preset dialog.

By default, new presets are automatically placed in alphabetical order in a folder called *User Presets*. To make them more manageable, you might want to number them. Or, if you prefer, you can organize your presets into different folder groupings. For example, in **Figure 4.122**, I added a number of preset folder groups to the Presets panel. To add a new folder to the Presets list, right-click anywhere inside the Presets folder to open a context menu (Figure 4.122), and choose New Folder to open the New Folder dialog. Give the folder a name, and it will appear added to the Presets list. You can also use the context menu Import option to import presets you may have downloaded.

Auto Tone preset adjustments

The Auto Tone option lets you include an Auto Tone adjustment as part of a preset. In some instances, this might be considered useful, because you can get Lightroom to combine an auto correction with other Develop adjustments. Because it can lead to different tone settings being applied to each image, this might not always produce the results you were after (even though the Auto Tone logic has continually been improved in Lightroom). So, just be aware of this when you include Auto Tone in a saved Develop preset setting; the results you get may sometimes be unpredictable.

The art of creating Develop presets

Lightroom Develop presets have proved incredibly popular. Lots of Lightroom users have gotten into sharing their preset creations. Although it is possible to encapsulate a complete Develop module look in a single preset, it seems to me that the best way to use Develop presets is to break them down into smaller chunks. In my experience, the trick is to save as few settings as possible when creating a preset. You often see Develop presets where the creator checks too many boxes and ends up with a preset that adjusts not just the settings it needs to adjust, but other settings, too. In many cases, it is not always obvious which settings a Develop setting is meant to be altering, and applying the preset may overwrite settings it shouldn't. Or, the creator includes White Balance or Exposure settings that may have been relevant for the pictures the creator used to test the Develop setting with, but are not necessarily suited for other people's photographs (in the following section, I have provided a guick guide on how to create neatly trimmed Develop presets). More importantly, Process Version 4 has had a significant impact on Develop preset compatibility. However, if you apply a legacy preset to a Version 4 image, the absence of a process version tag should mean such settings still translate okay to a Version 4 image (except for those settings that are specific to Version 1 or 2, such as Fill Light). In Figure 4.121, I deliberately left the Process Version box unchecked. Because of this there was a reminder to include the process version when saving a new setting.

Figure 4.122 The Presets panel context menu.

NOTE

If the Process Version box is checked when you save a preset, the process version is included when applying the preset to other images. If the photos to which you apply a preset share the same process version, no conversion will take place, but if they do not share the same process version they will have to be converted.

If the Process Version box is not checked when you create a preset, things become more unpredictable. In this situation, the process version will not be referenced when applying the preset. Therefore, if you apply a Version 1 preset to a Version 4 image, settings such as Recovery or Fill Light will not be translated. Similarly, if you apply a Version 4 preset to a Version 1 or 2 photo, settings such as Highlights and Shadows will not be recognized.

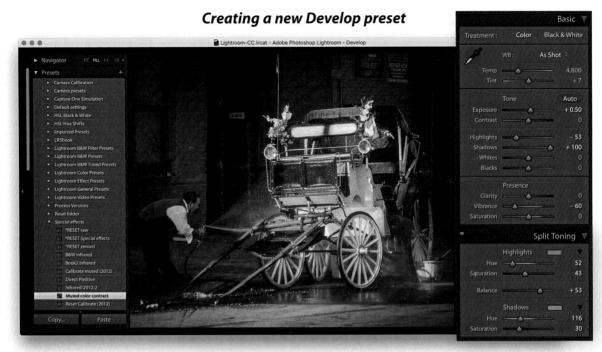

1. After adjusting this photograph in the Develop module, I wanted to save the current Develop settings as a new preset.

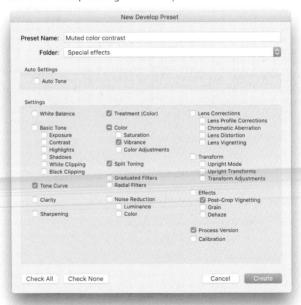

2. I clicked the Presets panel's + icon to open the New Develop Preset dialog and checked only those settings that were relevant for this effect. I named the preset setting *Muted Color Contrast* and saved it to the *Special effects* folder.

Understanding how presets work

Even with a Develop setting like the one described opposite and examined in detail below in **Figure 4.123**, it can get confusing. A Develop preset like this is doing several things at once. It is boosting the contrast, reducing the color vibrance, and adding a split-tone effect. Incorporating all these Develop settings into one preset has disadvantages and can lead to messy situations like that described in **Figure 4.124**.

	Auto Tone	White Balance	Exposure	Contrast	Highlights	Shadows	White Clipping	Black Clipping	Tone Curve	Clarity	Saturation	Vibrance	Color Adjustments	Split Toning	Sharpening	Noise Reduction	Black & White	Lens Corrections	Effects	Process Version	Calibration
Start Settings		V	V	V	V	v	v	V	V			v						v		V	V
Muted Color Contrast									~			V		V					~	~	
Final Settings		V	V	V	V	v	V	V	V			V		V				V	V	V	V

Figure 4.123 The outcome of the Muted color contrast Develop preset adjustment. In the Final Settings row, the green check marks represent the settings that were adjusted in the original image version and that remained unaltered after applying the preset. The black check marks represent those settings that are new and have been changed. This illustrates what can be regarded as a "clean" preset—it adjusts only the settings that need to be adjusted. Note that the process version did not change, as the preset process version matched that of the image.

Infrared Color Effect		~					~													V	
Split-Tone Effect									,	,				~			,			~	
Muted Color Contrast									~			~		~					~	~	
tart Settings		V	V	4	V	V	V	V	V			V								V	V
	Auto Tone	White Balance	Exposure	Contrast	Highlights	Shadows	White Clipping	Black Clipping	Tone Curve	Clarity	Saturation	Vibrance	Color Adjustments	Split Toning	Sharpening	Noise Reduction	Black & White	Lens Corrections	Effects	Process Version	Calibration

Figure 4.124 This chart shows you what can happen when you apply a series of Develop presets. In the Final Settings row, the green check marks represent the settings that were adjusted in the original image and remained unaltered at the end. The black check marks represent the settings that are new or have been changed. However, the red check marks represent the settings that have changed cumulatively during the process of trying out different Develop presets (but that were not meant to be part of the last applied preset). This highlights the fact that when the Infrared Color Effect was applied as a Develop setting, some of the other Develop settings (that were not part of the Infrared Color Effect) had already been altered by the previously applied Develop presets.

TIP

Preset names must be unique. You cannot have two presets sharing the same name, even if they are stored in separate folders.

How to prevent preset contamination

As I explained earlier, when I create presets I like to trim them down so that each preset performs a discrete task, such as a black-and-white conversion or a split-tone coloring effect. That way, I find I have more options to combine different settings and prevent getting into a situation like the one shown in Figure 4.124, where the end result was a contaminated mess. For example, I may apply one preset to modify the contrast and another preset to apply a coloring effect. I then keep these presets stored in separate preset folders so it is easy for me to locate all the presets that can be used to apply, say, different black-and-white conversions or cross-processing effects.

The chart shown in **Figure 4.125** summarizes a series of Develop preset steps that were applied in the step-by-step example that begins on the page opposite. The final setting does include lots of red check marks where the settings have changed cumulatively, but this does not matter as much as in the Figure 4.124 example because the whole point is to build up the settings one step at a time. You will notice that I included a *RESET Special Effects step. This preset is designed to cancel out previous preset settings and therefore acts like a "clear settings" button. To illustrate this, I have used crosses to indicate these items are returned to their default settings). Therefore, when applying, say, different split-tone effects, you can click each of the presets in turn to see a full-screen view of what the end result will look like, without fear of messing up any of the settings that have been applied already. To clear a Split Toning preset adjustment, you can simply select a specially created Split Toning "reset" preset. You can also use \(\mathbb{H}\mathbb{Z}\) (Mac) or \(\mathbb{Ctrl}\mathbb{Z}\) Shift \(\mathbb{R}\) (Mac) or \(\mathbb{Ctrl}\mathbb{Q}\) Shift \(\mathbb{R}\) (PC) shortcut to reset all the Develop settings.

	Auto Tone	White Balance	Exposure	Contrast	Highlights	Shadows	White Clipping	Black Clipping	Tone Curve	Clarity	Saturation	Vibrance	Color Adjustments	Split Toning	Sharpening	Noise Reduction	Black & White	Lens Corrections	Effects	Process Version	Calibration
Start Settings		V	V	V	V	4	V		V	V	V	V	V							V	1
Light Contrast									v											V	
SFX-Cool Tone													~	V						V	
*RESET Special Effects										×	x	×	×	×				×	X	~	×
Black & White Infrared		V					V		V	~							~			~	
Sepia Split Tone														V						~	
Cool Tone														~						~	
Burn Corners																			~	~	
Final Settings		V	V	V	V	V	V		V	V	V	V	1	V			V		V	V	V

Figure 4.125 An example of the effects of cumulative presets applied to an image.

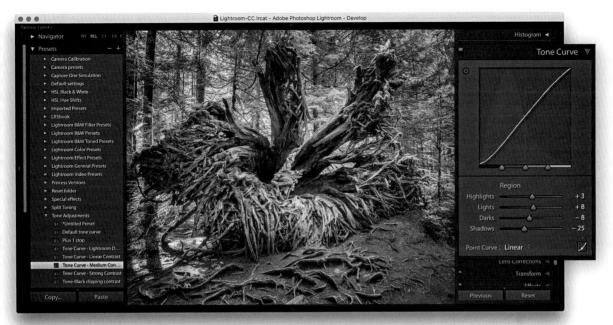

1. Here, I went through a list of tone adjustment presets and selected the *Tone Curve-Medium Contrast* preset to apply a moderate contrast boost to this image.

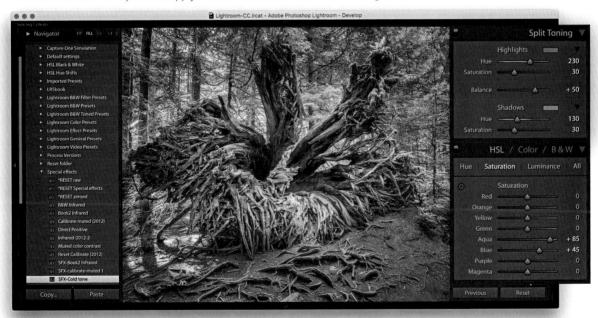

2. I wanted to try some special effect coloring presets, so I selected an *SFX-Cold tone* preset from my *Special Effects* preset folder. In case I wish to reset the preset settings here, I have included a RESET setting in each folder that resets all the relevant sliders to zero.

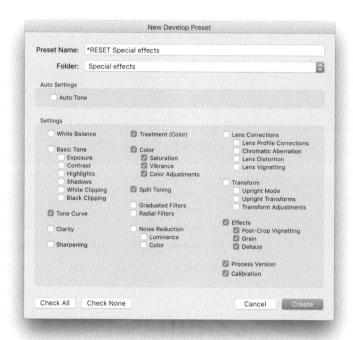

3. I selected a *RESET Special effects preset. Shown here are the settings I saved when creating this preset (I zeroed all the items checked here). I use all caps so the reset presets stand out more. And, I place an asterisk at the beginning of the name so the preset appears listed first in each of the preset folders.

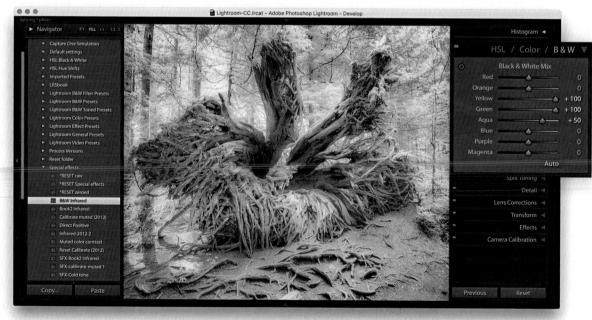

4. I then applied a *B&W Infrared* preset from the *Special Effects* folder.

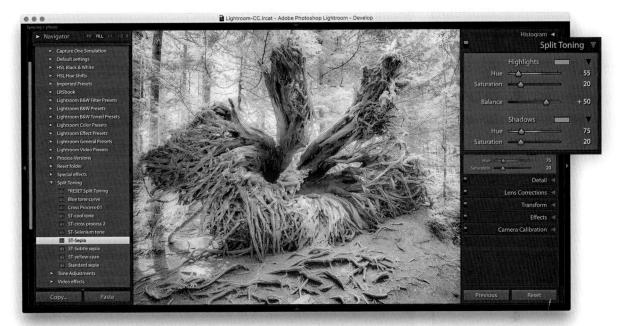

5. Next, I went to the *Split Toning* folder. Here, I selected the *ST-Sepia* splittoning effect.

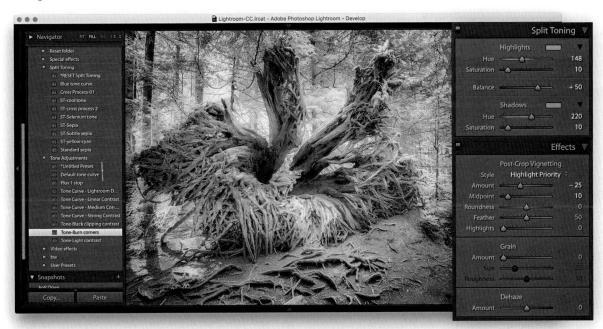

6. Finally, I opted for the *ST-cool tone* split-tone preset and finished off by adding a *Tone-Burn corners* preset from the *Tone Adjustments* folder.

TIP

The default Develop settings shown here work well for the cameras and lenses I shoot with. However, be warned that including Enable Profile Corrections in the Lens Corrections panel may cause incorrect profiles to be applied to some lenses. It's rare, but can happen.

Creating default Develop camera settings

Some Develop settings you may wish to apply as standard at the import stage. For example, you want to always apply a Profile lens correction, you may want to apply a particular camera profile or a modified sharpening setting. To do this, you can go to the Develop module Develop menu and choose Set Default Settings. This opens the New Develop Preset dialog shown in Step 3, where you can click the Update to Current Settings button to update the default settings for the camera model listed in the same dialog. But if at the same time you have "Make defaults specific to camera serial number" and "Make defaults specific to camera ISO setting" checked in the Lightroom Presets preferences, clicking Update to Current Settings will make the default setting specific to the camera serial number and ISO setting. This is useful if you wish to apply specific noise reduction settings based on the camera's ISO metadata. The combination of the Set Default Settings and Default Develop Settings preferences allows you to establish the default settings that are applied to all newly imported photos.

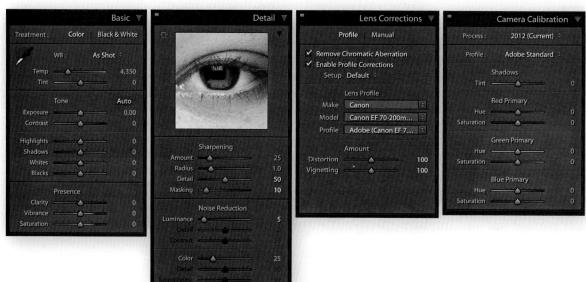

1. To create a default camera preset setting, first select a photo shot with a particular camera that is representative of how the camera performs at a specific ISO setting. Then work on the photo in the Develop module to achieve the optimum sharpness and noise reduction that would make a suitable starting point for future image editing. In the Lens Corrections panel, I recommend checking Enable Profile Corrections and Remove Chromatic Aberrations. In the Camera Calibration panel, I suggest checking to make sure that the process version is set to Version 4 and the Adobe Standard profile is selected (which is the default setting anyway for newly imported photos). In all the other panels, it is essential that the sliders are at their default settings. This is especially important in the Basic panel, where the White Balance setting should be left set to As Shot.

2. Go to the Lightroom Presets preferences (ﷺ, [Mac] or Ctrl, [PC]) and make sure that "Make defaults specific to camera ISO setting" is checked. It is important that you do this before proceeding to the next step. You can also check "Make defaults specific to camera serial number" if you want the settings to be camera-body specific.

3. Now go back to the photo you worked on in Step 1 and choose Develop
Set Default Settings. This opens the dialog shown here, where you need to click
the Update to Current Settings button. Do this and Lightroom will automatically
make this the default setting for all newly imported photos that match the camera
model, serial number, and ISO setting. When camera default settings are applied
to a photo, there will be no badge on the thumbnail to indicate that it contains
edits. This is because Lightroom treats such edits as default values. Although this
may seem obvious, it is easy to forget you have applied camera default settings
and then wonder why the Lightroom-rendered image looks different from what
you expected, yet has no badge to indicate changed settings.

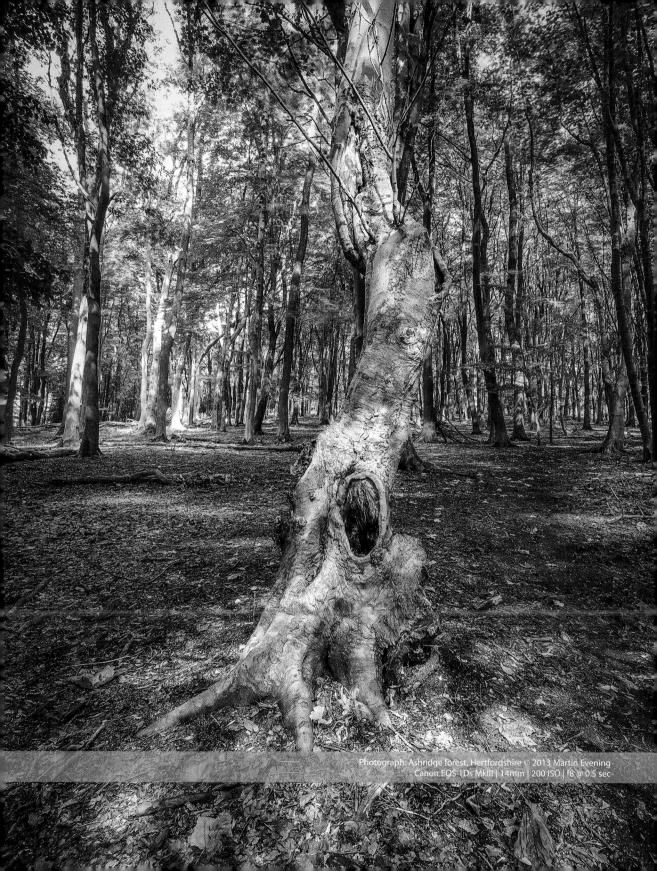

5

The art of black and white

How to achieve full creative control over your black-and-white conversions

I began my photographic career learning how to photograph and print in black and white. Since then, I have retained an enduring passion for black-and-white photography. In this respect, Lightroom does not disappoint because the Develop module tools provide the best environment I can think of to gain the most creative control possible from your color to black-and-white conversions.

The techniques described in this chapter show you the three main ways to convert a photo to black and white. You will find out how to master the B&W sliders in manual, auto, and target adjustment mode; how to work with the White Balance sliders while in black-and-white mode; and how to use the HSL panel controls as an alternative approach to black-and-white conversions. I show you how to achieve particular black-and-white styles such as the black-and-white infrared look, as well as how to work with the Split Toning panel to color-tone your photos.

THE LEARNING CENTRE CITY & ISLINGTON COLEGE 444 CAMDEN ROAD LONDON N7 0SP TEL: 020 7700 8642

Black-and-white conversions

There are various ways you can convert a color image to black and white. You can click the Black & White button in the Basic panel; you can click B&W in the HSL/ Color / B&W panel; or you can use the V keyboard shortcut. Figure 5.1 shows the main panels associated with black-and-white conversions. It is important to understand that when you create a black-and-white image. Lightroom is not permanently converting a color image to black and white. Rather, it is creating a black and white version of the color original. As you adjust the B&W panel controls. Lightroom blends the gravscale information contained in the individual red, green, and blue channels that make up the composite RGB image. If you have ever played with the Channel Mixer controls or the Black & White adjustment in Photoshop, these controls will probably appear familiar. In Lightroom, you have eight color sliders to play with, and these provide you with some nice, subtle control over how the color component channels are blended in the conversion process to create custom black-and-white conversions. To make things a little easier, the B&W panel offers an Auto button that, when you click it, applies an automatic black-and-white conversion that is determined by the White Balance setting in the Basic panel. You can then further vary a black-and-white conversion by adjusting the Temperature and Tint sliders in the Basic panel and re-clicking the Auto button if necessary.

The great thing about the Lightroom B&W panel is how the tonal balance of the image automatically compensates for any adjustments you make. Even so, it may still be necessary to revisit the Basic panel and readjust the tone controls such as the Exposure, Contrast, Highlights, and Shadows sliders after you have applied a B&W panel adjustment.

It is possible to convert an image from color to black and white by dragging the Saturation slider fully to the left. But you then only have the White Balance Temperature and Tint sliders with which to modify the conversion (or Calibration sliders as well if you know how to work with them). In my opinion, this is an unnecessarily convoluted approach when most of the controls you need are all there in the HSL / Color / B&W panel. You can also use the HSL desaturate technique described at the end of this chapter, which does actually provide you with more scope to produce different types of black-and-white conversions.

The Split Toning panel can be used to add a split-tone color effect to a black-and-white image, but it can also be applied to color originals to produce color cross-processing effects. As always, favorite Develop settings can be saved as presets in the Presets panel, and there are already a couple of black-and-white presets there for you to play with. In Figure 5.1, I rolled the pointer over the *Selenium Tone* preset, which updated the Navigator preview accordingly.

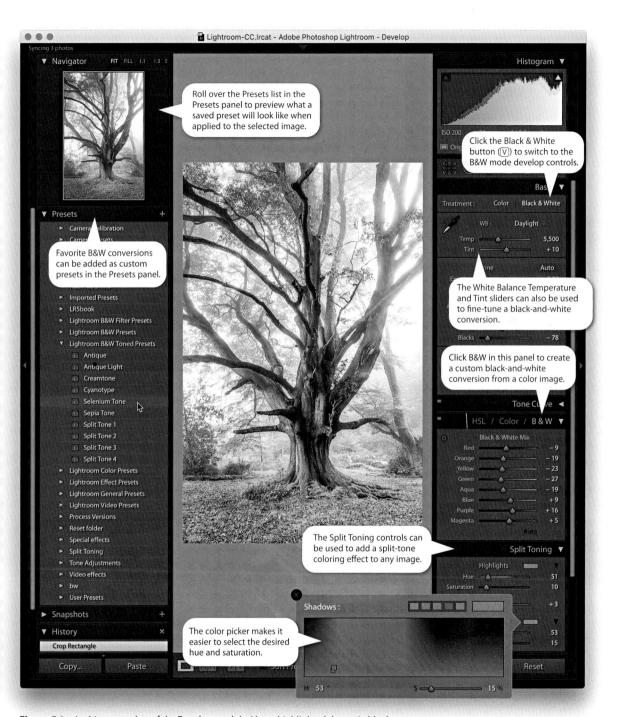

Figure 5.1 In this screen shot of the Develop module, I have highlighted the main black-and-white adjustment controls.

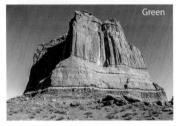

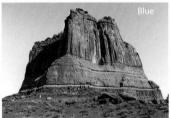

Figure 5.2 An RGB image consists of three grayscale channels that describe the red, green, and blue color information.

Black-and-white conversion options

In the early days of black-and-white photography, film emulsions were fairly limited in their color response. Most were mainly sensitive to blue and green light only, which is why the skies in old photographs often appear very light and why photographers could process their films in the darkroom using a red safe light. As film emulsion technology improved, panchromatic black-and-white films began to emerge, and film photographers were able to creatively exploit their extended color sensitivity. This section shows you how to continue that tradition when working with digital-capture images.

RGB color images, such as raw-processed digital captures, are made up of three grayscale images that record the luminance information of the original scene after it has passed through the red, green, and blue filters that overlay the camera sensor's photosites. The color image you preview on the computer display is therefore a composite made up of three different grayscale recorded captures.

Figure 5.2 shows what the individual red, green, and blue components look like when viewed separately. The B&W controls in Lightroom let you blend the red, green, and blue filtered grayscale capture information in various ways to produce different black-and-white conversion outcomes, such as in the examples in Figure 5.3. You will notice that there are actually eight B&W panel sliders you can use when converting to black and white: Red, Orange, Yellow, Green, Aqua, Blue, Purple, and Magenta. Adjusting these sliders allows you to lighten or darken these respective colors in the color original when making the conversion.

How not to convert

Some photographers limit their black-and-white options unnecessarily, simply because they are unaware of the black-and-white conversion techniques that are available to them in Lightroom and Photoshop. For example, some people may set their cameras to shoot in a black-and-white JPEG mode. This restricts not only the tone adjustment, but also the black-and-white conversion options. The camera's onboard image processor decides on the fly how to blend the color channel information and produces a fixed color to black-and-white conversion. You are consequently left with no room to maneuver, because all the color data has been thrown away during the in-camera JPEG conversion process. Then there is the RGB-to-Lab mode method in which you delete the a and b channels and convert the remaining, monochrome Lightness channel to grayscale or RGB mode. There is nothing to be gained from this approach because, yet again, you are throwing away all the color data rather than making use of it in the conversion.

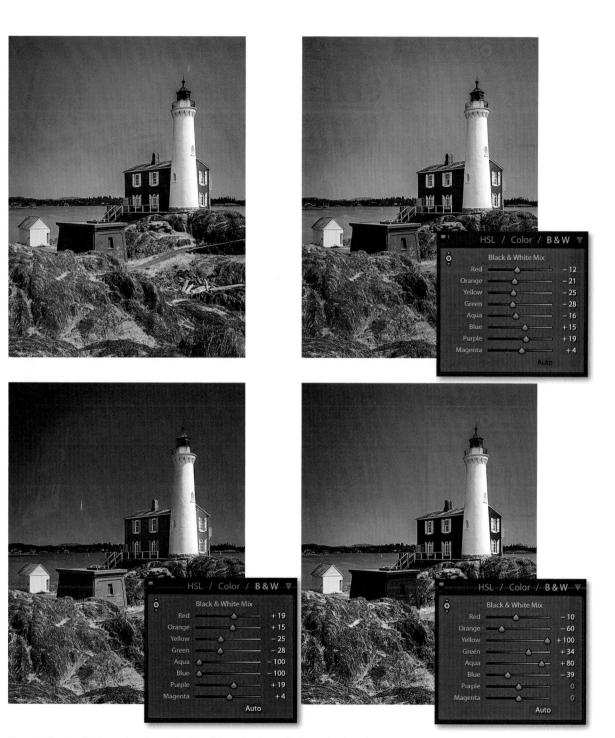

Figure 5.3 The B&W panel can be used to blend the color channel information in various ways to produce different-looking monochrome conversions from a color original.

Temperature slider conversions

Let's now look at some of the different ways in Lightroom to convert a color image to black and white. The standard method is to click the B&W button in the HSL/Color/B&W panel. This applies a default black-and-white conversion in which the Auto slider settings are linked to the White Balance settings. The Step 2 and Step 3 examples opposite show two possible black-and-white outcomes that can be achieved by first adjusting the Temp slider in the Basic panel and then clicking the Auto-Adjust button in the B&W section of the HSL/Color/B&W panel. The Step 2 version shows a white balance with a warm bias. Notice how the red and yellow colors appear lighter when converted this way. When I dragged the Temp slider in the opposite direction, as shown in Step 3, the red and yellow colors ended up darker. You can also vary the black-and-white conversion by adjusting the Tint slider. For example, in Step 3, I set the Tint slider to –100, which had quite an effect on the outcome. There is also an example coming up on page 365 where you will see how a green Tint slider adjustment can be used to simulate an infrared look.

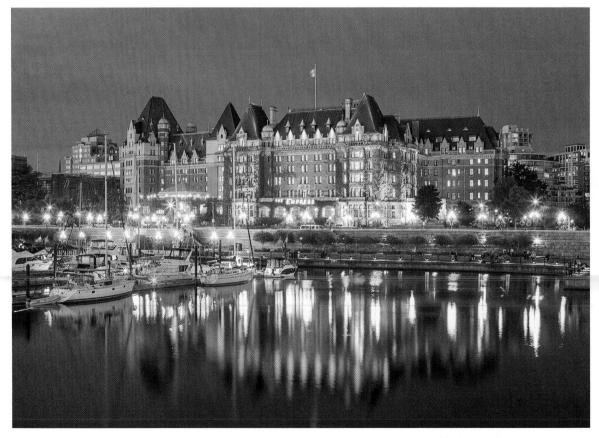

1. I decided to convert this color photograph to black and white.

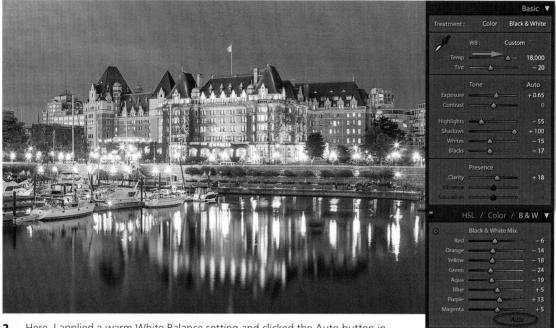

2. Here, I applied a warm White Balance setting and clicked the Auto button in the B&W panel. The B&W sliders adjusted accordingly.

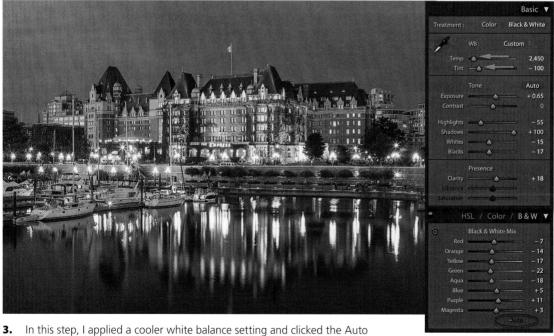

3. In this step, I applied a cooler white balance setting and clicked the Auto button for the B&W sliders to adjust again.

TIP

Fringe artifacts can be avoided by backing off on the more extreme slider adjustments. Extreme black and white slider adjustments can result in ugly fringe artifacts. However, you may find you can improve its quality by adjusting the Color, Detail, and Smoothness color noise reduction sliders in the Detail panel.

Manual black-and-white adjustments

Manually dragging the B&W panel sliders gives you almost unlimited freedom to create any number of different types of black-and-white adjustments. This is where the real fun begins, because you have complete control over how light or dark certain colors will be rendered in a black-and-white conversion. The following steps show how I was able to improve upon the default Auto B&W panel setting and thereby maximize the contrast in the sky. While you can adjust the B&W sliders by dragging them, you may find it easier to select the Target Adjustment tool mentioned in Step 3 to edit the image directly (you can use **Alt Shift (Mac) or Ctrl (Alt Shift) (PC) or Esc to disable it).

Black-and-white adjustments are accessible and easy to work with. However, when you switch to B&W mode in Lightroom, the Vibrance and Saturation controls appear grayed out (if you adjust them the image converts to color). This is a shame, because these sliders can potentially affect the black-and-white conversion, but you can overcome this limitation by using the HSL desaturate technique described at the end of this chapter.

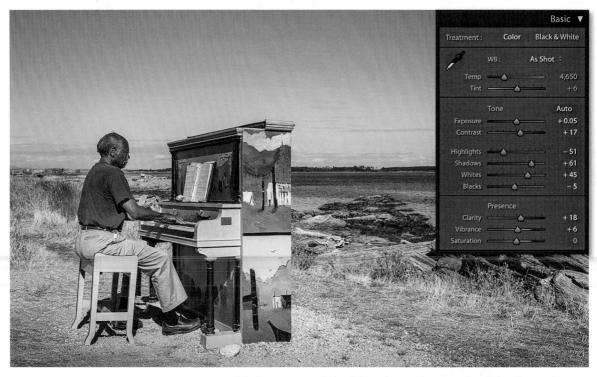

1. In this first step, I optimized the colors and tones using the Basic panel controls only.

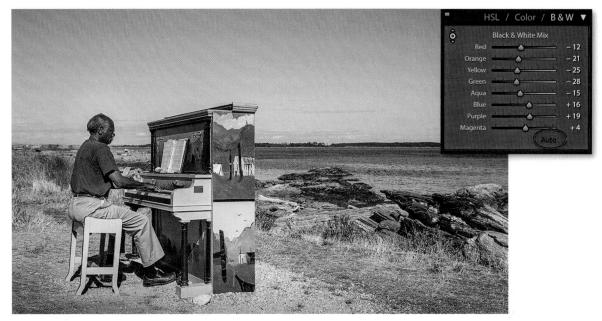

2. I first tried using the Auto B&W setting, which produced this black-and-white version.

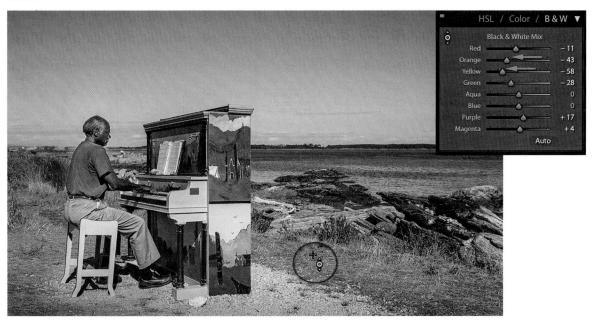

3. The default black-and-white conversion was not as dramatic as I would have liked, so I made some custom edits using the B&W sliders. I clicked to select the Target Adjustment tool button, moved the tool over the grass, and dragged downward to darken the yellow/orange colors.

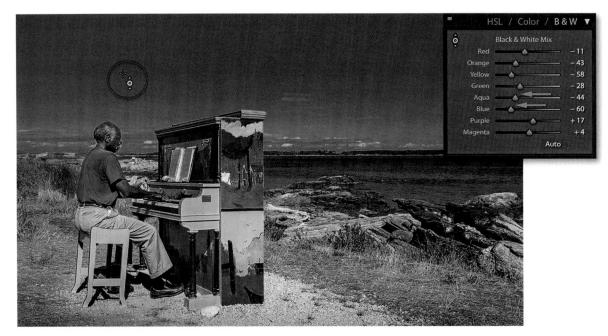

4. I then moved the tool over the sky and dragged downward to darken. This applied a negative Aqua and Blue setting.

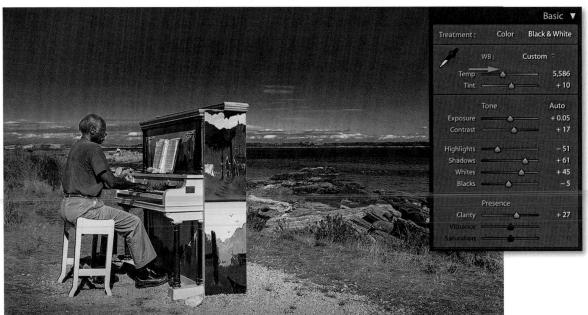

5. I next adjusted the White Balance Temp slider to make the white balance setting warmer. This, in turn, also made the black-and-white adjusted version look slightly more contrasty. Finally, I added a sepia split-toning effect.

Black-and-white infrared effect

Now watch what happens when you take the White Balance settings to extremes. The following black-and-white infrared technique illustrates just one of the ways you can achieve a creative black-and-white conversion using Lightroom.

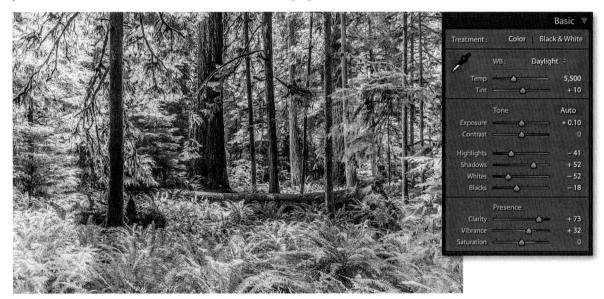

1. Here is the Before version, which is ideal for demonstrating the infrared effect.

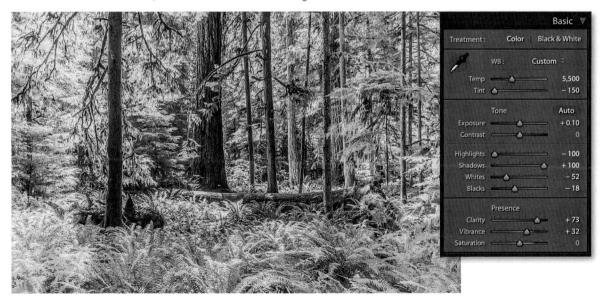

2. To create a fake black-and-white infrared look, I first applied a full negative Tint adjustment to the white balance. This made all the green colors (i.e., the leaf foliage) as bright green as possible.

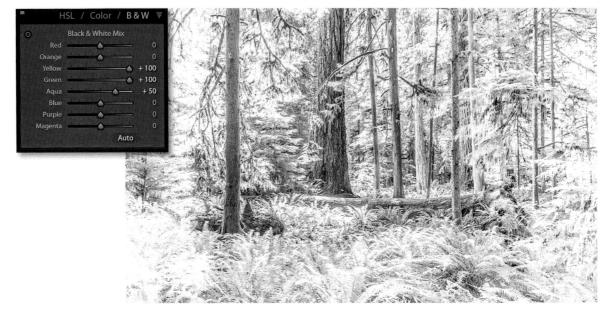

3. I then clicked the B&W button in the HDL / Color / B&W panel to convert the photograph to black and white. To get the full infrared look, I set the Yellow and Green sliders in the B&W panel to +100 and the Aqua slider to +50.

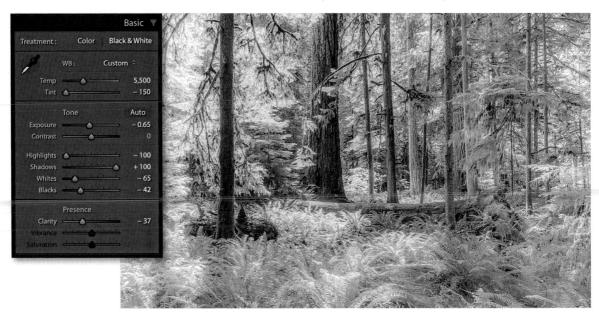

4. I also adjusted some of the Basic panel settings. In particular, I set the Highlights slider to –100, which helped preserve some of the delicate tone information in the leaves. I also set the Clarity slider to –37 to apply a diffused printing effect that added a nice, soft glow to the photograph.

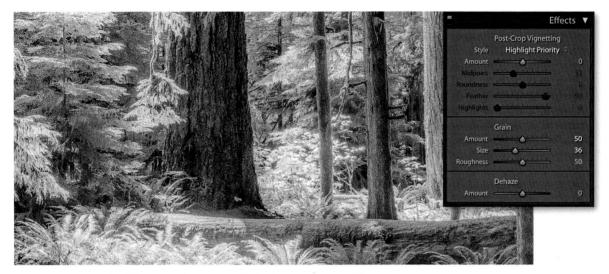

5. I next went to the Effects panel, where I added a large Amount and large Size grain effect.

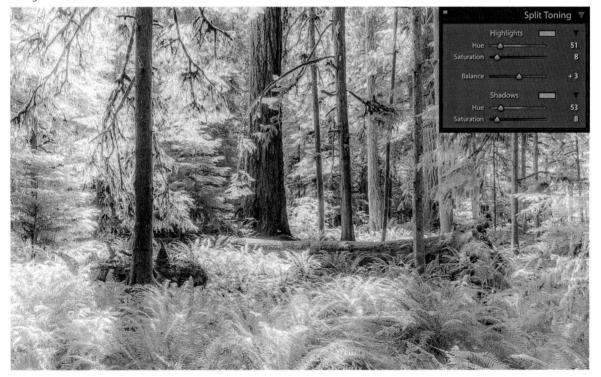

6. Finally, I used the Split Toning panel to add a split-tone coloring effect. The settings shown here worked well for this particular image. If I wanted to apply this black-and-white infrared effect to other photographs, I would need to save these settings as a custom preset.

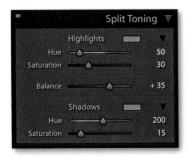

Figure 5.4 The Split Toning panel.

Figure 5.5 The Split Toning panel color picker.

Refining black-and-white conversions

As long as you have a good profile for your printer, it should be easy to obtain a neutral gray print. It does not even matter how well your display is calibrated. If an image is in black and white, you should be able to produce a neutral gray print regardless of how neutral the photo looks on the display. If not, there may be something wrong with your printer profiles. Or, the print heads on your inkjet printer may need cleaning. Many times, I have gone to make a print and the colors have been distinctly off, all because it was several weeks since I had last used that particular printer. Usually a quick nozzle clean is all that is required.

Now that you've practiced making basic black-and-white conversions, let's take a look at how you can customize them even further with the Split Toning and HSL panels.

Split Toning panel

The Split Toning controls (Figure 5.4) let you add color tones to a photo after it has been converted to black and white. The Hue sliders can be used to adjust the hue color in either the highlights or the shadows, and the Saturation sliders to apply varying strengths of color. If you hold down the Alt key as you drag a Hue slider, you will get a saturation-boosted preview that can help you see more clearly which hue color you are selecting without having to adjust the Saturation slider first. Clicking on either of the color swatches opens the color picker shown in **Figure 5.5**. This lets you guickly select the hue and saturation in one step. Click anywhere in the color ramp to select a color. You can even select colors from anywhere on the display, such as an image that's opened in Photoshop. To do this, click the color ramp, and drag outside the color ramp to anywhere you want. You can save a new color swatch as a preset by clicking in any of the preset swatch boxes to the left of the main before/after color swatch box. To do this, click to change the selected preset to the current selected color. You will notice that the color picker displays both the Highlight and Shadows color positions on the color ramp, so you can judge the relative positions of the two color sample points. (The current selected color is the one with the thicker border.) Incidentally, if you click in the Highlights swatch, you can \(\mathbb{H}\)-click (Mac) or \(\mathbb{Ctrl}\)-click (PC) to select a color for the Shadows (and vice versa). And, there is a slider at the bottom you can use to adjust the saturation while keeping the hue value locked.

The Balance slider in the Split Toning panel can be used to offset the balance between the shadow and highlight color toning and provides a nice fine-tuning control for your split-tone effects. Even when the Hue and Saturation settings are identical for both the highlights and shadows, the Balance slider can induce quite subtle variations to a split-toning effect. The following two examples give you an idea of what is possible using the Split Toning panel controls on a black-and-white as well as a color image.

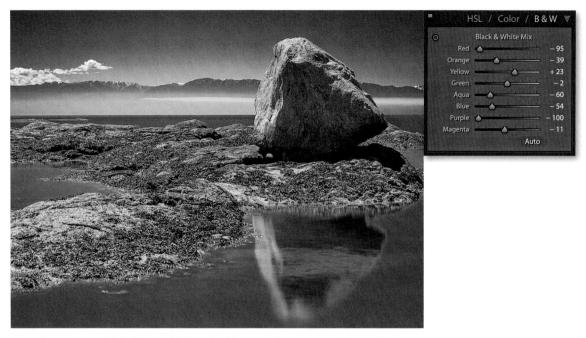

1. I first converted this photo to black and white using the B&W panel controls.

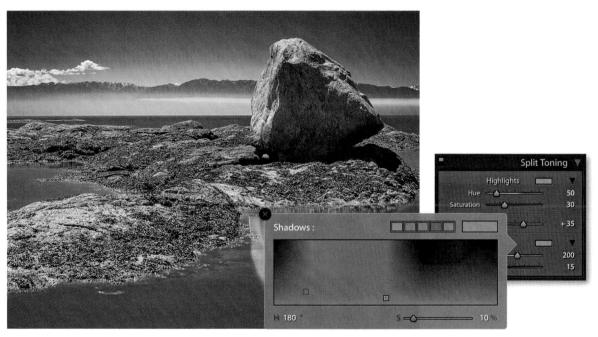

2. I then went to the Split Toning panel and used the color picker to select a warm sepia color for the highlights and a cool color for the shadows. Lastly, I offset the split-tone midpoint by dragging the Balance slider to the right.

Split-toning a color image

The Split Toning controls can also work great on regular color images. If you want to give your photographs a distorted color look, here is how to create a cross-processed effect in Lightroom. It is really easy to vary the effects shown here and save favorite color split-tone effects as presets.

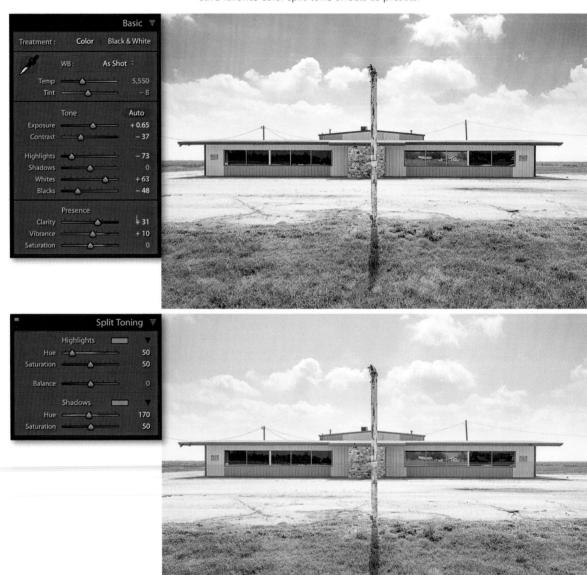

1. Here is a color photograph that I converted to black and white and applied a split-tone effect to warm the highlights and make the shadows green.

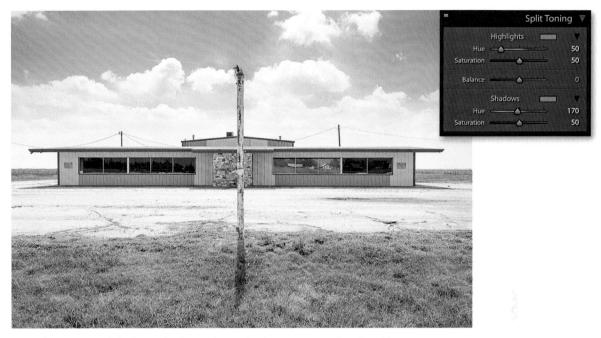

2. I then converted the image back to color again. As you can see, in color, this produced a classic type of cross-processing effect.

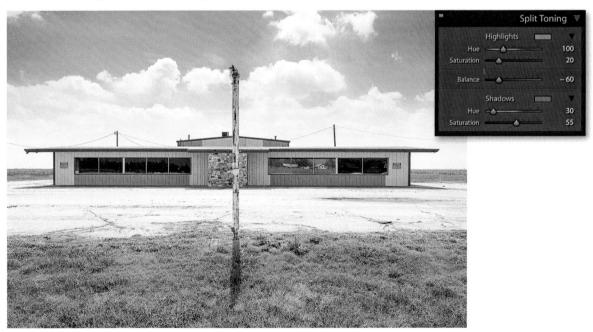

3. In this example, I used a different split-tone effect to achieve a green/brown type of color cross-processing effect.

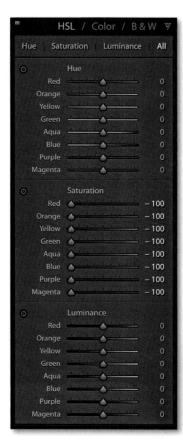

Figure 5.6 The HSL panel showing all controls with the Saturation sliders all set to –100.

HSL panel: Desaturated color adjustments

There is another less obvious way to convert to black and white. If you go to the HSL panel and drag all the Saturation sliders to -100 (Figure 5.6), you can desaturate the color completely to create a black-and-white version of a photo. On the face of it, this would appear to be the same thing as dragging the Basic panel Saturation slider all the way to the left, but the key difference here is that the Saturation slider applies its adjustment upstream of all the other color sliders. thus rendering them inoperable (apart from White Balance, Color Noise, and Calibration). The HSL desaturate method cleverly gives you full access to all the color controls in the Develop module, and this is where it can sometimes score favorably against regular B&W panel adjustments. You see, when you work with the B&W panel, the Vibrance and Saturation sliders are both unavailable and appear grayed out. This is a shame, because when you use the HSL desaturate method, the Vibrance and Saturation sliders offer you a great deal of added control over the outcome of your black-and-white conversions. With the HSL desaturate method, the Saturation slider in the Basic panel can act like an amplifier volume control for the HSL Luminance adjustments. So, increasing the Saturation

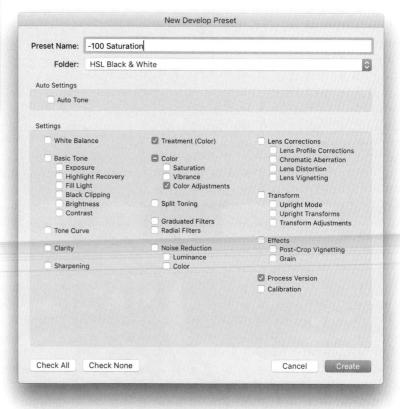

Figure 5.7 Saving the HSL setting in Figure 5.6 as a new Develop preset.

can therefore magnify the effect of the HSL slider settings. The Vibrance slider offers a more subtle, fine-tuning control. But interestingly, a Vibrance adjustment can sometimes appear to have an opposite effect to the Saturation slider, and decreasing the Vibrance can sometimes make certain colors (such as blue) appear darker when converted to black and white.

The HSL black-and-white method in detail

To create an HSL black-and-white conversion, go to the HSL panel and set all the Saturation sliders to -100. Before you do anything else, it is worth saving this adjustment as a preset setting, like the one shown in **Figure 5.7**. At the end of Chapter 4, I suggested that you use folders to organize your Develop presets, so my advice here would be to save a setting like this to a dedicated folder for storing HSL black-and-white presets such as the HSL Black & White folder I previously created and then selected in Figure 5.7. All you need to do is apply the preset saved here and then adjust the HSL panel Luminance sliders. Don't bother editing the Hue sliders as they won't have any effect on the black-and-white conversion. The Luminance sliders can be used to lighten or darken specific colors in the photo, just as you would when adjusting the B&W panel sliders. The Target Adjustment tool can also be used here. Click the tool button to activate it, or use the MAIT Shift L (Mac) or Ctrl Alt Shift L (PC) keyboard shortcut to switch to Target Adjustment mode and #(Alt)(Shift)(N) (Mac) or Ctrl)(Alt)(Shift)(N) (PC) to exit. If you want, you can save individual HSL black-and-white settings as new presets, in which case you would click the + button in the Presets panel, check the Develop settings shown in Figure 5.7, and save as a new custom preset.

Camera Calibration adjustments

You can also use the Camera Calibration panel sliders to apply further fine-tuned adjustments. Here, things do get a little more unpredictable, and it can be a matter of playing with the sliders and seeing what happens. Even so, this method still offers more opportunities for experimentation that are otherwise lacking with a standard Lightroom black-and-white conversion.

Not all black-and-white conversions are likely to require these alternative methods. However, the following steps illustrate a typical example of where an HSL desaturate black-and-white conversion plus the use of Camera Calibration panel adjustments helped me to achieve a strong cloud contrast and seemed less prone to generating fringe artifacts around areas of high tone contrast.

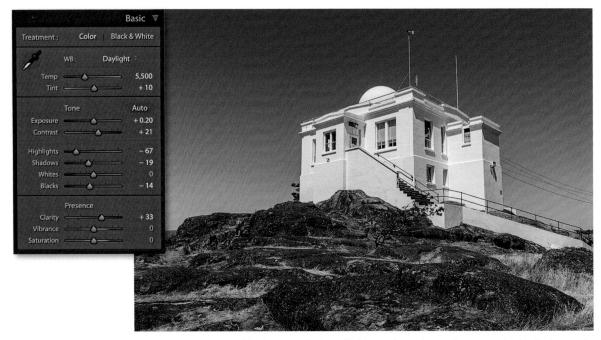

1. In this photograph, I applied just a few minor adjustments in the Basic panel.

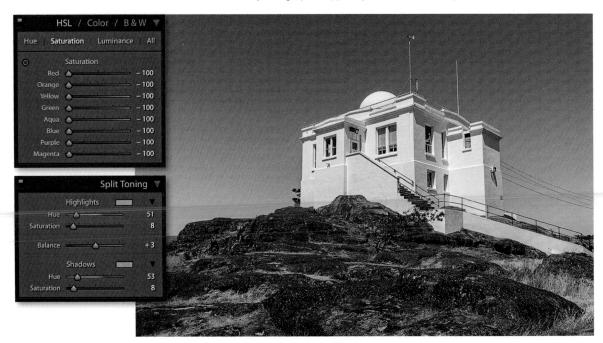

2. This shows how the photograph looked after I had set all the HSL Saturation sliders to –100. I also applied a sepia-color split-toning effect.

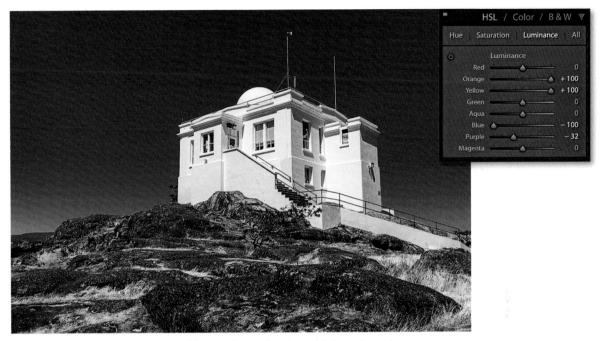

3. Here, I adjusted the Luminance sliders to darken the sky and lighten the rock.

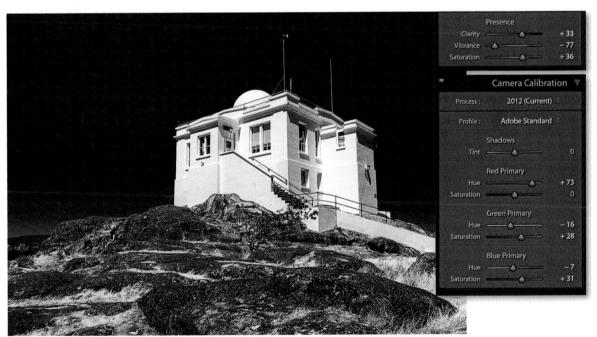

4. Finally, I added a negative amount of Vibrance and a positive Saturation setting. I then went to the Camera Calibration panel and adjusted the Hue and Saturation sliders, which added even more tone contrast to the photograph.

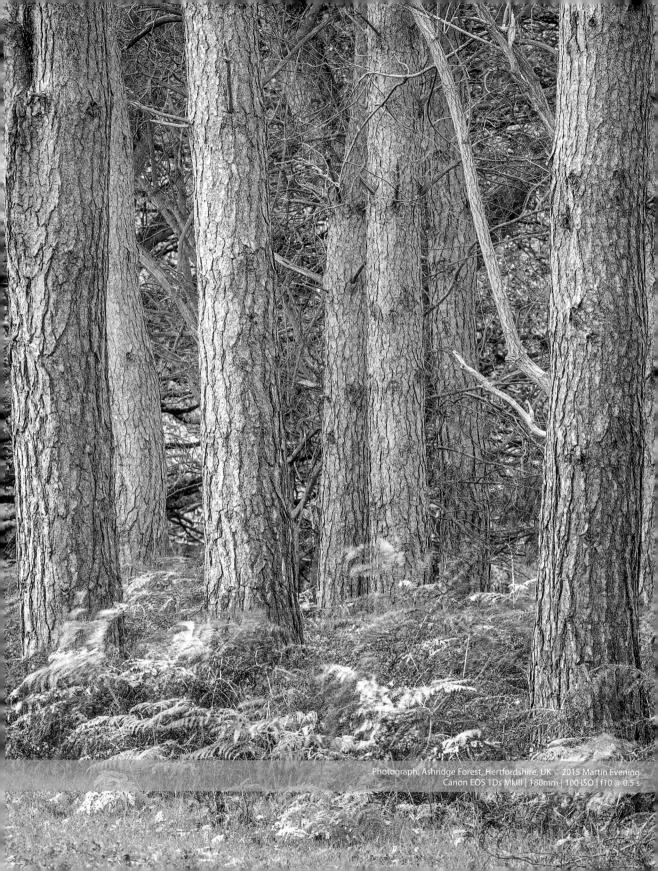

Sharpening and noise reduction

How to make full use of the capture sharpening and noise-reduction controls in the Detail panel

Digital capture undoubtedly offers photographers the potential to capture more detail than was previously possible with film, but it is also important to understand that presharpening has always been an integral part of the digital capture process. There are many reasons why it is necessary to sharpen. The process of converting the light information that hits the photosites on the sensor and subsequent digital data processing will result in an image with softer edge detail than would normally be considered desirable. It could be the lens on your camera is not particularly sharp. Therefore, a little sharpening after the post-capture stage is usually necessary to produce an image that is sharp enough to look good on the display. If a photograph is sharpened too much at this stage, you may end up with artifacts that will only be compounded as additional adjustments are made to the image. Presharpening should therefore be applied in moderation and to raw capture images only. It is all about striking the right balance between compensating for image softness in the raw file while avoiding the problems that can be caused by any oversharpening at the preliminary stage.

This chapter emphasizes the importance of sharpening digital photographs and how to reduce image noise. I explain how the sharpening sliders in the Detail panel work and offer suggestions on which settings to use for sharper and less noisy photos.

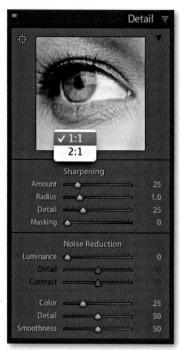

Figure 6.1 The expanded Detail panel includes a preview window that can be set to a 1:1 or 2:1 view via the context menu.

Capture sharpen for a sharp start

Before discussing the sharpening controls in Lightroom, I should briefly explain the principles behind capture sharpening and the difference between this and output sharpening.

For many years, the Unsharp Mask filter in Photoshop was considered the main tool for image sharpening, and it was ideally applied just prior to print. Over the years, our knowledge of sharpening improved and various techniques were devised to use the Unsharp Mask filter to its best advantage. In his lifetime, author and Photoshop guru Bruce Fraser did the industry a great service with his research into Photoshop sharpening. His recipes for optimum sharpening, based on whether you were sharpening for input—that is, capture sharpening—or sharpening for output, did a lot to improve our understanding of how to apply the most appropriate level of sharpening at each step of the image-editing and output process. It is also fair to say that Bruce's research and writing affected the way some of the sharpening controls in Lightroom evolved. But more on this later.

Input/capture sharpening is all about adding sufficient sharpening to a photograph to correct for the inherent lack of sharpness all digital images suffer from. The main goal is to have your photographs look nicely sharpened on the display. At the same time, you don't want to oversharpen, because this can lead to all sorts of problems later at the retouching stage in Photoshop. Photos that have been shot using the JPEG mode will have been presharpened in-camera and therefore shouldn't need further sharpening. But if you shoot using raw mode, your photographs will most definitely need some degree of sharpening.

The Detail panel sharpening controls (**Figure 6.1**) can be used to manually control the capture sharpening process. To evaluate the sharpening correctly, you need to look at the image on the display using a 1:1 or 2:1 view setting. It is possible to view the sharpening effect at lower view ratios, but the sharpening and noise reduction are disabled below a certain zoom setting (this is done to speed up rendering times). The Detail panel controls are therefore designed to let you apply such sharpening in a controlled way so that only the edge detail gets sharpened and the flat-tone areas are preserved as much as possible. You will also read later how the Detail panel Sharpen settings are linked to the Sharpen mode of the Adjustment tools. This means you can use the Adjustment Brush, Graduated Filter, and Radial Filters as creative sharpening tools to dial in more (or less) sharpness. Lastly, there are the noise-reduction controls, which have options for controlling the luminance and color noise in an image.

Improved Lightroom raw image processing

The image examples in **Figure 6.2** show how the underlying demosaic processing and default Detail panel sharpening have improved in recent years. The top image shows a photograph processed using Version 1, and the bottom one

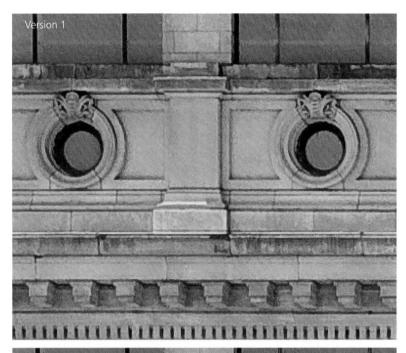

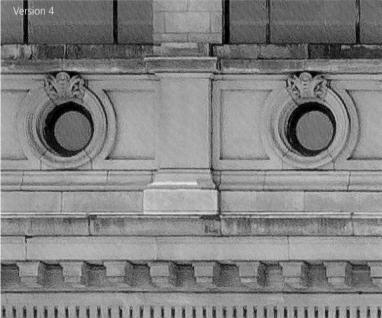

Figure 6.2 Compare the demosaicing capabilities in Version 1 (top) and Version 4 (bottom). This image was shot with a Canon EOS 1Ds MkIII camera using an EF 70–200mm lens (70mm setting), ISO 160, f6.3 at 1/320th second exposure (the full-frame version is shown top right).

NOTE

You can download a layered version of this close-up view from the book website.

Downloadable Content: the lightroom book.com

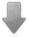

NOTE

Did you know that your sensor may have dead pixels? This is something that is quite common, and you normally will not even be aware of this because the raw processing is good at spotting problem pixels and removing them during the conversion. You may notice them briefly, though, when editing particularly noisy photos. For example, if you edit a photo that was shot at night using a long exposure, you may initially see a few brightly colored pixels always appear in the same spot before the Develop module finishes updating the preview.

shows the same image processed using Version 4 (which is essentially still the same as Version 3). These photos have been enlarged to 400% so that you can see the differences more clearly. The first thing to point out is that the Version 4 demosaic process is more "noise resistant," which means that it does a better job of removing the types of noise that we find unpleasant, such as color artifacts and structured (or pattern) noise. At the same time, the aim is to preserve some of the residual, non-pattern noise that we do find appealing. The underlying principle at work here is that colored blotches or regular patterns tend to be more noticeable and obtrusive, whereas irregular patterns, such as fine, random noise, are more pleasing to the eye. The Version 4 demosaic process does a better job of handling color artifacts and filters the luminance noise to remove pattern noise, yet retains some of the fine, grain-like noise. The net result is that Lightroom is able to do a better job of preserving fine detail and texture.

The next component is the sharpening, which is achieved by adding halos to the edges in an image. Generally speaking, sharpening halos add a light halo on one side and a dark halo on the other side of an edge. To quote Lightroom engineer Eric Chan, "good sharpening consists of halos that everybody sees but nobody notices." To this end, the halo edges in Version 4 are very subtle and balanced such that the darker edges are a little less dark and the brighter edges are brighter. They are there and you notice them in the way they create the illusion of sharpness, but you are less likely to actually "see" them as visible halos in an image. Also, when you select a Sharpen Radius within the 0.5 to 1.0 range, the halos are narrow enough to sharpen fine-detailed subjects such as landscapes or fine textures more effectively.

Output sharpening

Output sharpening is always done at the end, just prior to making a print, using the Print Sharpening options in the Print module Print Job panel. However, the print sharpening process is hidden from view, and the only way to evaluate print output sharpening is to judge the print output. The amount of sharpening that's required at the print stage varies according to many factors, such as the print process, print size, print resolution, and type of paper used. Lightroom uses output sharpening processes based on PixelGenius PhotoKitTM SHARPENER to work this out automatically at the print stage.

Default Detail panel settings

The default behavior is for Lightroom to apply sharpening adjustments to raw images only. Other images, such as JPEG, TIFF, PSD, and PNG, should not require any Detail panel processing either (unless you are working on an unsharpened

scanned image, of course). Basically, if a pixel image has already been sharpened, the last thing you want to do is add more sharpening after it has been imported into Lightroom. This is why the default sharpening is always set to zero for everything except raw images.

As for the amount of sharpening that's applied, the default Amount setting in Lightroom is 25. The exact amount of sharpening does actually vary from camera to camera. Basically, the sharpening amount is adjusted such that all raw images should be equally sharp at a 25 Amount setting. Lightroom's approach is to apply standardised default tone, color, and Detail panel settings, which some may consider to be on the conservative side. Other raw processing programs may use different approaches.

There are those who claim the sharpening from Phase One's Capture One is sharper. This is true, but it is mainly because the Capture One default sharpening settings just happen to be stronger. You can simulate Capture One's default sharpening by setting the Amount sharpening in Lightroom to between 45 and 75, setting the Radius to 0.9 and the Detail slider to 15. This isn't the whole story though. There is some additional Capture One processing that adds what can best be described as a wide-edge Clarity-type enhancement, which makes the highcontrast edges stand out more. This is only apparent on certain types of images. At a zero sharpening setting, there is not much difference between the underlying sharpness in both programs. I am not trying to put down Capture One's capabilities, because it is a fine raw processing program with its own particular strengths. Capture One's approach produces a more optimized look, which you can match near enough in Lightroom by increasing the sharpening Amount setting. It is perhaps more important, therefore, to have an understanding of what the sharpening sliders do and how and when to adjust them to suit the particular image you wish to sharpen, rather than simply use the default settings. The following sections explain how this can be done in Lightroom

Presets Camera Calibration Camera presets Default settings HSL Black & White HSL Hue Shifts Imported Presets Lightroom B&W Filter Presets ▶ Lightroom B&W Presets ► Lightroom B&W Toned Presets ► Lightroom Color Presets Lightroom Effect Presets ▼ Lightroom General Presets Auto Tone Medium Contrast Curve Sharpen - Faces Sharpen - Scenic 亩 Zeroed Lightroom Video Presets Process Versions Reset folder Special effects Split Toning Tone Adjustments User Presets

Figure 6.3 The Develop module Presets panel contains two sharpening presets in the Lightroom General Presets folder.

Sharpen preset settings

The easiest way to get started is to use either of the two Sharpening presets: Sharpen – Faces and Sharpen – Scenic, which are highlighted in the Develop module Presets panel shown in **Figure 6.3**. These presets are also available via the Library module Quick Develop panel. All you have to do is decide which of these two settings is most applicable to the image you are about to sharpen. They can also be a useful starting point when learning how to sharpen in Lightroom. Start off by selecting one of these settings, and then fine-tune the Detail panel sliders based on the knowledge you'll gain from reading the rest of this chapter.

Sharpen - Faces

To start with, let's look at the two preset settings found in the Lightroom General Presets subfolder. **Figure 6.4** shows a close-up portrait, where naturally enough, I chose to apply the *Sharpen – Faces* preset. This combination of sharpening slider settings is the most appropriate to use for portraits where you wish to sharpen the important areas of detail, such as the eyes and lips, but protect the smooth areas (like the skin) from being sharpened. You may wish to strengthen this setting by increasing the Amount setting, and you may also wish to increase the Masking slider if the skintones are looking a little too "crunchy"—a higher Masking setting should help preserve the smooth tone areas.

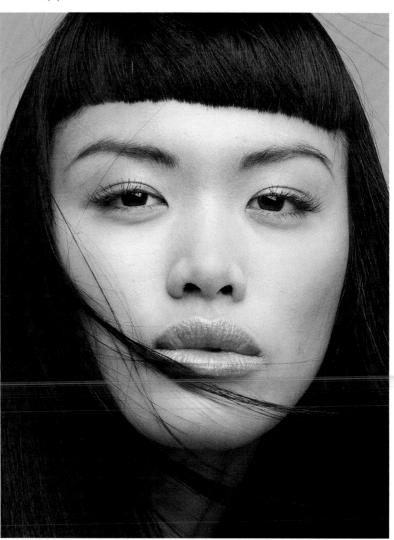

Figure 6.4 Here is an example of the Sharpen – Faces preset in action.

Sharpen - Scenic

The other preset setting you can choose is *Sharpen – Scenic*. This combination of sharpening slider settings is most appropriate for subjects that contain a lot of edge detail. You could include quite a wide range of subject types in this category, and in **Figure 6.5**, I used this preset to sharpen an architectural photograph. Basically, you should use this particular preset when you needed to sharpen photographs that contain a lot of fine edge detail.

The two preset settings described here provide you with a great way to get started and get the most of the sharpening settings without having to understand too much about how the sharpening in Lightroom works or what the individual sliders do.

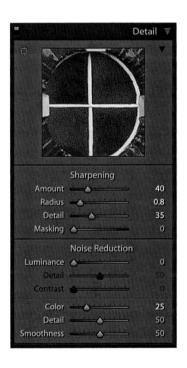

Figure 6.5 Here is an example of the Sharpen – Scenic preset in action.

Sample sharpening image

To help explain in more detail how the individual sliders work, I prepared a test image to show some of the key aspects of Lightroom sharpening. You can download this image by going to the book's website. You can then use it to follow the steps shown here to see how the Lightroom sharpening works.

The **Figure 6.6** image was specially designed to demonstrate several key aspects of sharpening. The eye and surrounding skin texture allow you to see the effects of portrait-style sharpening where the objective is to sharpen detail like the eyelashes (but avoid sharpening the skin texture). Conversely, the patchy texture in the bottom-right corner enables you to test the ability to sharpen smooth texture content, where you do want to emphasize the texture detail. The high-contrast detail content in the left section allows you to test the effects of sharpening on fine-detailed image areas, and the crisscross lines have been added to highlight the effects of the Radius slider adjustments.

Downloadable Content: thelightroombook.com

Figure 6.6 The sample image that is used in this chapter can be accessed via the Lightroom book website.

Evaluate at a 1:1 view

As I mentioned earlier, the only way to properly evaluate the capture sharpening is to use a 1:1 view. You can view the sharpening effect at lower zoom settings, but this won't help you make an accurate assessment of how much sharpening is required. When you go to the Detail panel, a warning sign (circled red in **Figure 6.7**) will appear if the selected photo is displayed at anything less than a 1:1 view. Click this and it will immediately take you to a 1:1 preview, and the warning triangle goes away. You can also click on the disclosure triangle (that is circled blue) to expand the Detail panel to reveal the Preview Target tool and preview window (**Figure 6.8**). If you click to activate the Preview Target tool, you can click on an area of interest in the image to see a close-up view displayed in the preview window. This, in turn, can be set to show a 1:1 or 2:1 view (Figure 6.1). You can then drag inside the preview window to scroll the image.

Luminance targeted sharpening

Lightroom sharpening is applied to the luminance information in the photograph and filters out the color content when sharpening. This is a good thing, because sharpening the color information would enhance any color artifacts. In Photoshop, for example, you can convert an image to Lab mode and sharpen the Luminosity channel separately (although it is easier and less destructive to sharpen in RGB mode and use the Luminosity blend mode to restrict the sharpening to the luminance information only). What Lightroom does is kind of similar to that. It filters out the color content when sharpening. For this reason, it can be useful to inspect the image in Luminance mode when working with the slider controls. To do this, you can hold down the (Alt) key as you drag the Amount slider in the Detail panel to see more clearly the effect the adjustment is having on the luminance sharpening.

The sharpening effect sliders

Let's start by looking at the two main sharpening effect controls: Amount and Radius. These sliders control how much sharpening is applied and how the sharpening is distributed. Don't forget to download the image shown in Figure 6.6 from the book's website and import it into Lightroom to follow the steps described over the next few pages.

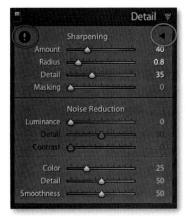

Figure 6.7 The Detail panel with the 1:1 view warning and preview disclosure triangle.

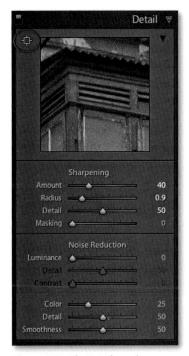

Figure 6.8 The Detail panel expanded to show the preview.

Amount slider

The previews shown here and on the following pages were all captured with the Alt key held down as I dragged the Sharpening sliders. The grayscale preview can help you concentrate on seeing how the sharpening effect is applied to the luminance image information.

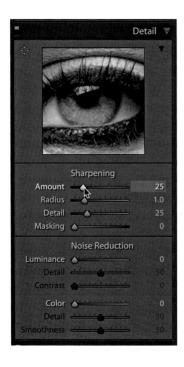

1. The Amount slider is basically like a volume control. The more you apply, the more you sharpen the image, and in this respect it is similar to the Amount slider in the Unsharp Mask filter. The Amount range can go from 0 (which applies no sharpening) to a maximum sharpening setting of 150, where the slider scale goes into the red. The sharpening is somewhat excessive at 150, but you can always use the sharpen suppression controls (that are described later) to dampen the sharpening effect. You probably will not ever need to set the sharpening as high as 150, but the extra headroom is available should you need it. In this example, you can see how the sample image looked using the default 25 Amount sharpening.

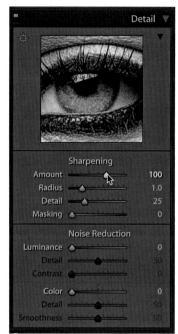

2. As you increase the Amount sharpening to 100, you can see how the detail in the image looks crisper. On its own, the Amount slider is a fairly blunt instrument to work with, but it is the ability to modify the distribution of the sharpening and the ability to mask the edge halos that make Lightroom sharpening so special. The important thing to remember here is not to overdo the sharpening. The intention is to find the right amount of sharpening to correct for the lack of sharpness that is in the original raw image and not let any sharpening artifacts become noticeable at a 1:1 view.

Radius slider

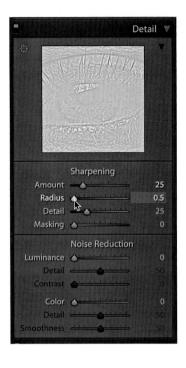

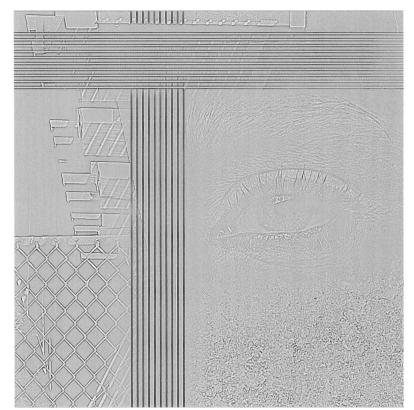

effect that the Radius setting would have on the image. At the minimum Radius setting, you can see how a small Radius has a greater effect on the narrow edge detail, such as the wire fence, but has very little effect on the soft edge detail, such as the eye and eyelashes. Notice also the effect a small Radius setting has here on the crisscross lines. This demonstrates that for high-frequency detailed subjects such as architecture photographs or landscapes, you will often benefit from choosing a Radius setting that is smaller than 1.0. With Version 4, the Radius edges values in the 0.5 to 1.0 range are calculated to produce finer halo edges than was previously the case with Version 1. This results in narrower, razor-sharp edges when sharpening fine-detailed images with a low Radius setting. If you toggle between using Version 1 and Version 4, you should see quite a difference here.

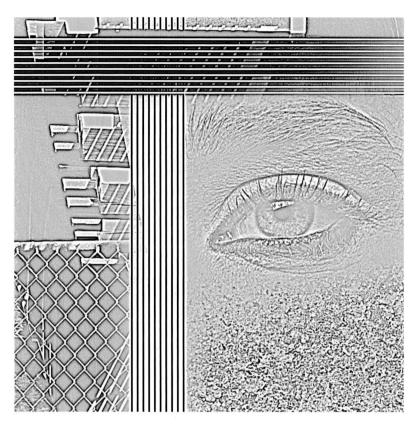

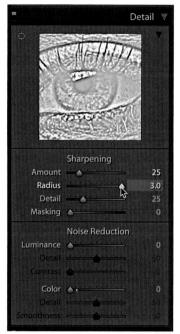

2. As you increase the Radius slider and set it to its maximum setting, you will notice how the halo width increases to the point where the halos have less real sharpening effect on the fine edge detail. The sharpening around the wire fence area looks kind of fuzzy, but at the wider setting, there is now more noticeable sharpening around the eyelashes and the eye pupil. For this reason, you will find it is usually more appropriate to select a Radius higher than 1.0 when sharpening photographs that contain a lot of soft-edged detail, such as portraits. The halo edge calculation in Version 4 is balanced such that the darker edges are a little less dark and the brighter edges are a little brighter. They are there and you notice them in the way they create the illusion of sharpness, but you are less likely to actually "see" them as visible halos in a sharpened image.

TP

When sharpening landscape photographs that have been shot at a low ISO setting, it is often possible to increase the Detail slider, even to as high as 100.

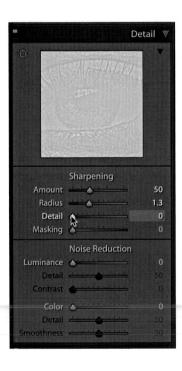

The modifying controls

The next two sharpening sliders act as modifying controls that can moderate or dampen the effect that the Amount and Radius sharpening settings have on an image.

Detail slider

The Detail slider cleverly modifies the halo effect, allowing you to concentrate the sharpening on the edge areas. This, in turn, allows you to apply more sharpening with the Amount slider, adding sharpness to the edges, but without generating noticeable halos around them. The default setting for the Detail slider is 25. As you take the slider below this value, it suppresses the amount of contrast in the halos. As you set the Detail slider above 25, it acts as a "high-frequency concentrator," which is to say it biases the amount of sharpening, applying more to areas of high frequency and less to areas of low frequency.

1. In this step, the Detail slider was set to 0 (I again held down the Alt key to preview in isolation the effect this slider adjustment was having). When the Detail slider is at this lowest setting, nearly all the edge halos are suppressed. The combination of a low Detail setting and a medium-to-high Radius setting allows you to apply a strong sharpening effect to bring out details like the eye and eyelashes while suppressing the halos on the smooth skintones.

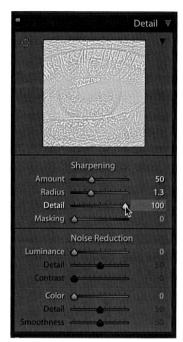

2. When the Detail slider is raised to the maximum setting, all of the sharpening effect is allowed to filter through, and the high-frequency areas will be further enhanced. Higher Detail slider settings tend to do more to exaggerate the highest-possible edge detail in the image. This can result in the Lightroom sharpening emphasizing more those areas with fine-textured detail (including noise). If this is likely to cause problems, you may want to avoid setting the Detail slider too high, or you can increase the amount of Masking that is applied. On the other hand, it is safe to set the Detail slider to a maximum value of 100 if you think this is required, but would only recommend doing so on low-ISO images where the inherent noise in the image you are sharpening is low enough not to cause a problem.

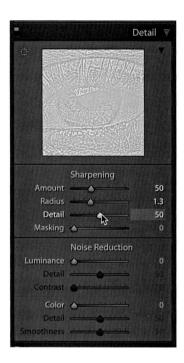

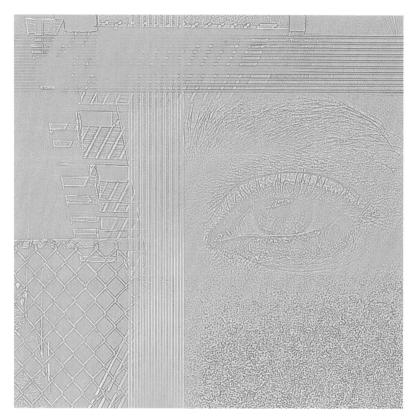

3. When the Detail slider is set to a midpoint value between these two extremes, you'll see how the Detail slider can be used to target the areas that need sharpening most. If you refer back to the Faces sharpen preset used earlier, a lower setting of 15 is suitable for portrait sharpening because it does a good job of suppressing the sharpening over the smooth tone areas. A higher Detail setting will carry out less halo edge suppression and is therefore more suitable for emphasizing fine edge detail.

Interpreting the grayscale sharpening preview

This is a good point for me to explain what the grayscale previews are actually showing us. If you hold down the Att key as you drag the Amount slider, you see an accurate preview of the cumulative effect that all the sharpening sliders are having on the Luminosity information in an image. But when you Att-drag on the Radius and Detail sliders, you are seeing a different kind of preview, because with these you are able to preview the combined sharpening effect in isolation.

What does this mean? Experienced Photoshop users will understand better if I explain that this is a little like the Photoshop sharpening technique where you apply the High Pass filter to a duplicate of the Background layer to pick out the edge detail and set the duplicate blend layer to Overlay mode. The High Pass filter turns most of the image a mid-gray, but when you set the layer to the Overlay blend mode, the mid-gray areas have no effect on the appearance of the photograph, while the lighter and darker areas in the Overlay blend mode layer build up the edge sharpness. The Radius and Detail (Alt) mode previews are essentially showing you the edge enhancement effect as if it were on a separate sharpening layer (which, as I say, is like previewing a duplicate layer of the Background layer after you have just applied the High Pass filter). Basically, these previews are showing you an isolated view of the combined Amount, Radius, and Detail slider settings.

Masking slider

The Masking slider adjustment adds a final level of suppression control and was inspired by the late Bruce Fraser's Photoshop sharpening techniques. If you want to read more about Bruce's techniques for input and output sharpening, plus his creative sharpening techniques, I highly recommend you check out *Real World Image Sharpening with Adobe Photoshop, Camera Raw, and Lightroom,* 2nd Edition. This book was originally written by Bruce Fraser but has since been updated by Jeff Schewe (see Note).

The basic concept behind the masking control is that you can use the Masking slider to create a mask that is based on the image content and protects the areas you do not want to be sharpened. If you take the Masking slider down to 0, no mask is generated and the sharpening effect is applied without any masking. As you increase the Masking setting, more areas are protected. The mask is generated based on the image content; areas of the picture where there are high-contrast edges remain white (the sharpening effect is unmasked) and the flatter areas of the picture where there is smoother tone detail turn black (the sharpening effect is masked).

None

The latest update to Bruce Fraser's book is Real World Image Sharpening with Adobe Photoshop, Camera Raw, and Lightroom, 2nd Edition, by Bruce Fraser and Jeff Schewe (Peachpit).

Masking slider preview mode

The Att mode previews for the Masking slider shows a mask that limits the sharpening adjustment. The best way to interpret this preview is to imagine the preview of the sharpening adjustments as being like a sharpening layer above the image and think of the masking preview as a layer mask that has been applied to that imaginary sharpening layer.

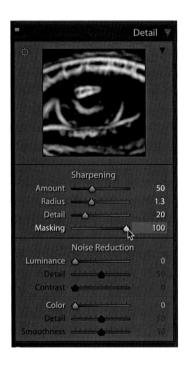

1. In this example, I set the Masking slider to 50 and held down the Alt key to reveal the mask preview. At this midway setting, notice how the flatter areas of the picture are just beginning to get some mask protection, such as the skintone areas around the eye.

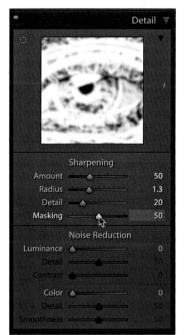

2. As the Masking setting is increased to the maximum setting of 100, you can see how more of the flatter tone areas are now protected while the high-contrast edges are preserved. At this extreme setting, the Lightroom sharpening is only applied to the white mask areas. The black portions of the mask are completely protected, and no sharpening is applied here. Generally, you set the Masking slider high for images that contain fine-detailed areas that you do not want to enhance (such as skin), and you set it low for images where you do wish to enhance the fine-textured areas. However, if you take into account the enhanced fine-detail sharpening that can be obtained using the Detail slider, most subjects can benefit from having at least a small amount of Masking applied to them.

Applying custom sharpening adjustments

Now that I have given you a rundown on what the individual sharpening sliders do, let's look at how you would use them in practice to sharpen an image.

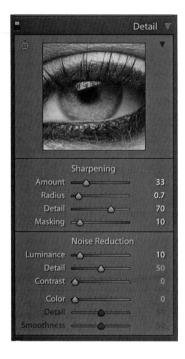

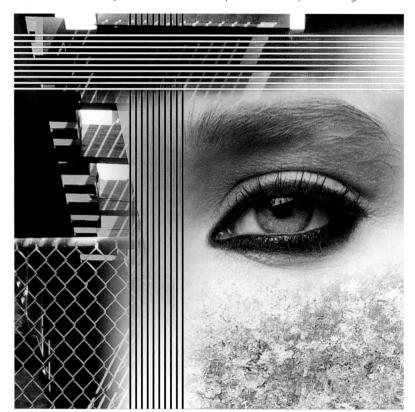

1. For this first step, I adjusted the Sharpening sliders to provide the optimum amount of sharpening for the fine-detail areas. I applied a Radius of 0.7, which added fine halos around the edge details (such as the wire fence) and a Detail of 70, which limited the halo suppression. I applied an Amount of 33 to make the fine edge detail nice and crisp and set the Masking slider to 10, which meant only a small amount of masking was used to mask the sharpening effect. I also adjusted the Luminance slider (setting this to 10) because most images, even those that have been shot using a low ISO setting, may benefit from some Luminance noise reduction (see page 402).

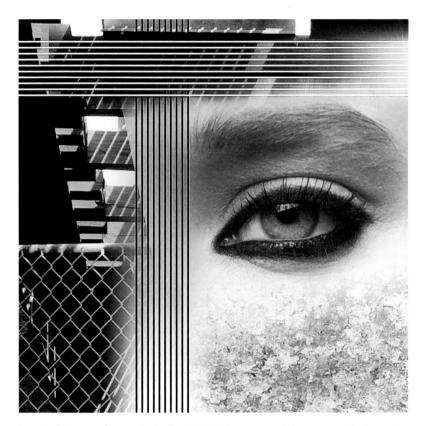

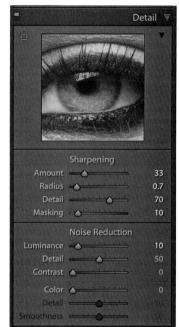

2. In this second example, I adjusted the Sharpening sliders to provide the optimum amount of sharpening for the soft-edged detail around the eye. I applied a Radius of 1.4 to build wider halo edges around the eyelashes, but at the same time, I used a Detail setting of 20 to suppress the edge halos. The Radius setting still had an effect on the sharpening, but the Detail slider was nicely suppressing the halo edge effect to produce a smoother-looking sharpening effect. I took the Masking slider all the way up to 85, so I could target the sharpening on just those areas that needed sharpening most (that is, the details in the eye and eyelashes). You will note that the Amount was set to 45. This is a higher value than the default 25 setting, but the sharpening was being substantially suppressed by the Detail and Masking sliders, so it was necessary to apply a larger Amount setting here.

Creative sharpening with the adjustment tools

The golden rule when sharpening in Lightroom is to sharpen your images just enough so that they look sharp on the display, but not so sharp that you begin to see any sharpening halos. With some images, it can be tricky to find the settings that will work best across the whole picture, so this is where it can be useful to apply localized sharpening. Basically, you can adjust the Sharpness slider in the localized adjustment tools to add or reduce the sharpness, and this adjustment will then vary the sharpness Amount setting based on the other settings that have already been established in the Detail panel Sharpening section.

In the following steps, you will notice in Step 2 I set the Sharpness slider to 100. This is more than you would want to apply normally and, in this instance, was similar to applying 145 Amount sharpening in the Detail panel. On the other hand, I was using the localized adjustment to make the out-of-focus statue look sharper. You will also notice in Step 3 I applied a negative sharpening effect to blur the background. Negative sharpening is discussed in more detail in the following section.

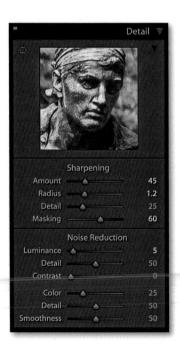

1. In this photograph, I used the Detail panel to apply a global sharpen, but the statue was not quite as sharp as I would have liked.

2. To address this, I selected the Adjustment Brush, set the Sharpness slider to 100, and painted over the statue to add some extra sharpening.

3. In this final version, I added a new brush group using a -70 Sharpness. I then painted over the background to create more contrast between the sharpness of the statue and the background.

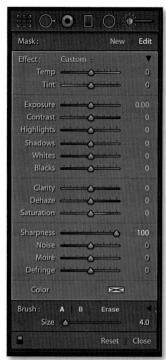

Adding localized blurring

Negative local sharpening in the 0 to -50 range can be used to fade existing sharpening. Therefore, if you apply -50 Sharpness as a localized adjustment, this will disable any capture sharpening. As you apply a negative Sharpness in the -50 to -100 range, you start to apply anti-sharpening, which is kind of like a gentle lens blur effect. But you can, in fact, go beyond the +100/-100 limit by applying multiple passes of negative sharpness. In other words, if you add multiple adjustments with a -100 Sharpness value, you can increase the amount of blur. However, with multiple negative Sharpness adjustments, the effect will eventually max out and the image will not become any more blurred beyond three passes.

There are a number of examples where a negative sharpening effect might come in handy. I sometimes use this technique to help create a shallow focus effect and therefore find it is best to apply a negative Sharpness adjustment via a Graduated Filter. Another popular technique is the use of a shallow focus effect at the post-processing stage to give video footage a miniaturized feel. I have seen a number of successful examples, but one in particular that stood out was "The Sandpit" by Sam O'Hare (vimeo.com/9679622). Now, according to O'Hare, the original raw files were color processed in Lightroom and the after-effect blurring was created using separate software. However, it could also be possible to carry out the blurring in Lightroom and synchronize the settings across all the photos in a time-lapse sequence.

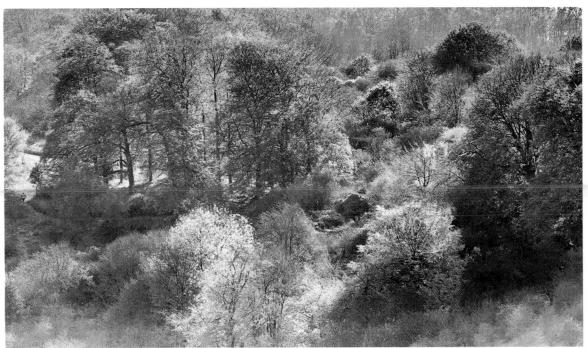

1. This shows an image before I applied a localized blur effect.

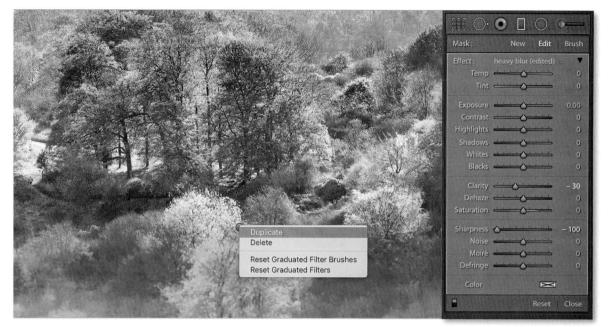

2. I selected the Graduated Filter tool and selected the *heavy blur* preset. I modified this by setting Clarity to –30 and dragged from the bottom to the middle. I right-clicked and selected Duplicate to achieve the cumulative blur seen here.

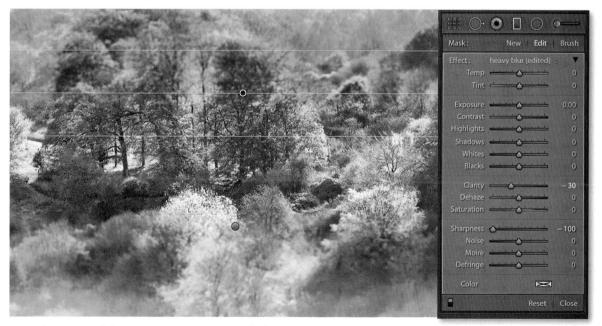

3. I then repeated the same thing for the top half of the picture, where I applied three Graduated Filter blur effects to achieve a maximum blur.

Figure 6.9 The Detail panel, showing the Noise Reduction sliders.

TIE

Some cameras offer in-camera long exposure noise reduction where, using a process known as dark frame subtraction, a second dark frame is captured and blended with the capture image to automatically remove hot pixels. This works for raw as well as JPEG captures. The downside is that when you make a long exposure capture of, say, 15 seconds, you have to wait a further 15 seconds while the camera records the second, dark frame image and blends this with the image capture.

Noise reduction

Noise in digital images is caused by a number of factors. For example, noise can be the result of too few photons reaching the sensor. This is known as shot noise, where the low number of photons result in sensor signal errors. You can see this for yourself when using a camera in live view mode under low light conditions. The screen image will be very noisy. Yet, when you capture an image using a correct exposure value at a low ISO setting, the image can appear noise-free. This is because shooting at the correct exposure (such as with a longer time exposure) allows enough photons to reach the sensor and generate a clean image. The characteristics of the sensor itself is another contributory factor. All digital captures will contain an underlying amount of noise that is generated by the sensor. It is only as the ISO is increased that the noise is amplified and becomes more apparent to the eye. Not all cameras are the same, and some sensors are particularly prone to showing noise, although the latest digital SLRs perform exceptionally well in low light conditions. The ISO speed itself is another important factor. As you increase the ISO setting, shadow noise will become an issue. It is like turning up the volume of an audio tape that was recorded at a low volume and hearing lots of hiss. This is an appropriate comparison because the camera sensor is an analog device and the digital file is created via the camera's analog-to-digital converter. An amplified input signal will inevitably contain a lot of noise after it has been digitized.

Lightroom's demosaic processing does a good job of filtering out the good noise from the bad, but it is not ideal that every trace of noise gets removed from the image at this stage. You might think this would be a good thing, but when viewed closely, the photograph would look rather plastic and over-smooth in appearance. The Camera Raw/Lightroom engineers determined it is better to concentrate on eradicating the noise we generally find obtrusive, such as color and luminance pattern sensor noise (which is always a problem), but leave in place the residual luminance noise that is random in nature. The result of this filtering should be an image that is free of ugly artifacts yet retains the ultra-fine-grain-like structure that photographers might be tempted to describe as being "film-like." Extra help is then needed to further suppress the unwanted image noise that can be characterized as luminance and color noise. This is where the Noise Reduction sliders in the Detail panel come in.

Luminance noise reduction

The Luminance slider in the Detail panel (**Figure 6.9**) can be used to smooth out luminance noise, which is the speckled noise that's always present to some degree but is more noticeable in high-ISO captures. The default Luminance setting is 0. You can try raising this to around 5 to 20, but it should not be necessary to go beyond 50 except in extreme circumstances. Jeff Schewe likes to describe the

Luminance slider as "the fifth sharpening slider" because the sharpening process goes hand in hand with the luminance noise reduction. Because luminance noise reduction inevitably smoothes the image, it is all about finding the right balance between how much you set the Luminance slider to suppress the luminance noise and how much you sharpen to emphasize the edges (but without enhancing the noise). Lightroom does a good job of reducing any white speckles in the shadows to provide the smoothest luminance noise reduction possible.

The Noise Reduction Detail slider acts like a threshold control for the main Luminance slider in determining what is noise. The default setting is 50. As you drag to the right, this reduces the amount of smoothing and preserves more detail but may cause noisy areas of the image to be inappropriately detected as detail and therefore not get smoothed. As you drag to the left, it smoothes the noise more, but be warned that some detail areas may be inappropriately detected as noise, and important image detail may become smoothed.

Luminance noise tends to have a flattening effect at the macro level where the underlying texture of the noise grain also appears to be smoothed out. The Contrast slider therefore allows you to restore more fine-detail contrast, but it does so at the expense of making preserved noise blobs more noticeable. The smoothest results are achieved by leaving the Luminance Contrast slider at the default 0 setting. However, doing so can sometimes leave the noise reduction looking unnatural and plastic-looking and the details may appear to remain too smoothed out. Dragging the slider to the right helps you preserve more of the contrast and texture in the image, but at the same time can lead to increased mottling in some high-ISO images. The Contrast slider has the greatest effect when the Luminance Detail slider is set to a low value. As you increase the Luminance Detail, the Contrast slider will have less impact on the overall luminance poise reduction.

The noise reduction adjustments should ideally be assessed at a 1:1 view or higher. While it is possible to preview the effects of noise-reduction adjustments at lower zoom settings, you can only judge the effect the sliders are having by viewing the image at 1:1.

As with the Sharpening Amount slider, the noise reduction in Lightroom is adaptive to different camera models and their respective ISO settings. The effective amount of noise reduction for the Luminance noise and Color noise amount settings therefore varies when processing files from different cameras, because the noise reduction is based on a noise profile for each individual camera. The end result is that the noise-reduction behavior feels roughly the same each time you adjust the noise-reduction controls, although under the hood the values applied are actually different.

If you use the Shadows slider in the Basic panel or the Tone Curve controls to bring out more shadow information, just be aware that this may emphasize any shadow noise in the image. It is therefore always worth inspecting the shadows close up after making a sharpening adjustment and check to see if any Luminance and Color slider adjustments are needed to hide the noise. Many camera manufacturers are only too painfully aware of the problems of shadow noise and do their best to hide it by deliberately making the shadows darker in JPEG captures to help hide any shadow noise. Some camera manufacturers' raw processor programs also apply a shadow contrast tone curve by default.

Figure 6.10 The Detail panel and Effects panel settings for removing noise and adding grain.

Color noise reduction

Color noise occurs due to the inability of the sensor in low light levels to differentiate color because the luminance is so low. As a result, you see errors in the way color is recorded and, hence, the appearance of color blobs in the demosaiced image. Color noise is usually the most noticeable aspect of image noise, and the Color slider's default setting of 25 does do a fairly good job of suppressing the color noise artifacts while preserving the color edge detail. If necessary, you can take the slider all the way up to 100. However, as you increase the Noise Reduction Color slider, this can result in color bleeding and the fine color details of an image becoming desaturated. This kind of problem is one that you are only likely to see with really noisy images that contain fine color edge details. Most of the time, it is not something you'll need to be concerned with, but where this is a problem, the Color Detail slider can help. As you increase the Color Detail slider beyond the default setting of 50, you will notice how it preserves more detail and prevents the color edges from bleeding or becoming desaturated. Just be aware that as you increase the Color Detail setting, this can lead to color speckles appearing along the preserved edges. To understand the effect this slider is having, you may want to zoom in to see a 400% view as you adjust the slider in order to gauge the effect on the image.

Noise-reduction tips

I suggest you get to know your camera and how the sensor responds to different lighting conditions. Some cameras fare better than others in low-light conditions. There will always be a trade-off between shooting at a medium ISO setting with a wider lens aperture or slow shutter speed and shooting at a high ISO setting with a smaller lens aperture or faster shutter speed. Consider using a tripod or image-stabilizing lenses as an alternative to shooting at the highest ISO setting.

Setting the Luminance slider too high can make the image appear over-smooth, and doing so can compromise the sharpness. Instead of tweaking the Noise Reduction sliders on every image, you may find it worth following the advice on page 352 about saving camera-specific defaults that include ISO-specific defaults. This can help automate the process of applying the appropriate amount of noise reduction for each image and avoid the need for multiple presets.

If after attempting to remove the Luminance and Color noise the image looks over-smooth, it can sometimes help to add a small amount of grain (**Figure 6.10**) to add a little texture back into the image. Adding grain in this way is a bit like extending the range of the Luminance Contrast slider described on the preceding page. Above all, do not be too paranoid about noise. There is no point in trying to remove every bit of noise, as the print process can be very forgiving!

Color noise corrections

1. Here is a 1:1 close-up view of a photograph using a 6400 ISO setting. All the Noise Reduction settings here were set to 0.

2. In this step, I set the Noise Reduction Color slider to 70. This was enough to remove the color speckles, but it also had the undesired effect of causing the colors in the image to bleed.

3. To counteract this, I set the Color Detail slider to 100. As you can see, the color edge detail was restored. I then applied the Luminance adjustments shown here to eradicate most of the luminance noise. On the left, you can see a direct comparison between this and the Step 2 settings.

Color Smoothness slider

The Detail panel also has a Color Smoothness slider in the Noise Reduction section. This can be used to help deal with color mottling artifacts (or large colorful noise blobs). These are usually caused by low-frequency color noise and can be present in low- as well as high-ISO images, especially in the shadow regions. The default setting is 50. Dragging to the right can help make these disappear, although this will, at the same time, cause the image to appear smoother. For the example that's shown opposite, I shot the photograph using a Pentax 645Z camera with the Sony 50-megapixel CMOS sensor, which was set to the maximum ISO 204,800 setting. As you can see, there was quite a big difference between the 0 and 100 settings, although not every image will show such a marked benefit from applying this adjustment. Also, you may notice that boosting the Color Smoothness slider can bring with it a hit in performance speed as you further edit in the Develop module.

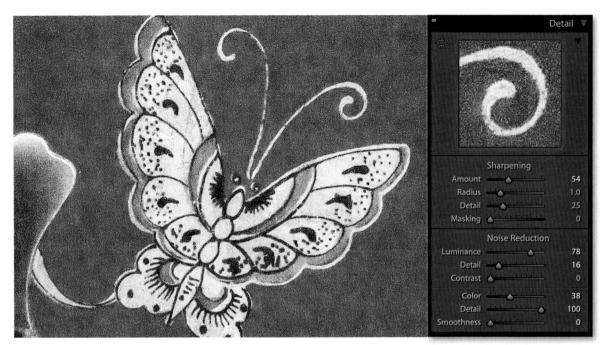

1 In this close-up view (with the Color Smoothness slider set to 0), there are clear signs of color mottling.

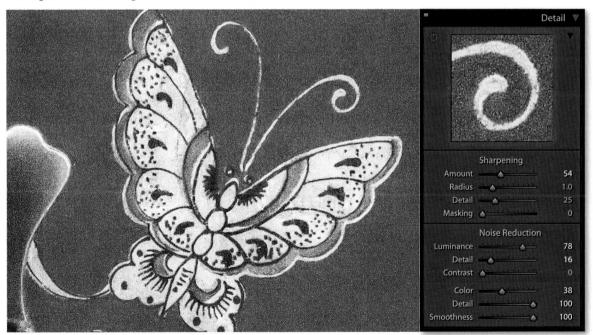

2 In this step, I took the Color Smoothness slider all the way across to 100 to remove the mottling effect.

Selective noise reduction

There is a Noise slider in the Adjustment Brush, Graduated Filter, and Radial Filter settings. When you increase the slider setting, you strengthen the noise reduction that is applied to the selected area. As with the localized sharpening adjustments, this strengthening of the noise reduction effectively increases the settings for the Luminance and Color sliders by a proportional amount. Basically, you can use a Noise slider adjustment to apply additional noise reduction where it is needed most, which will most likely mean where you need help cleaning up the shadow areas. I see this tool being useful where you have used a localized adjustment to deliberately lighten the shadows in a scene. Instead of bumping up the overall noise reduction to compensate for the increased noise presence, it now makes sense to do so locally by editing the Adjustment Brush, Graduated Filter, or Radial Filter settings to apply a positive Noise setting.

It is also possible to apply negative amounts of noise reduction with the Adjustment Brush. At first, this might seem odd, but this essentially allows you to tackle the problem of selective noise reduction in reverse. You can start off by applying a high amount of global noise reduction to tackle noise where large parts of the image need a strong noise-reduction treatment. You can then use the Adjustment Brush with a negative Noise setting to selectively reduce the noise reduction around the areas that do not need such a strong level of noise reduction and where you would like to preserve more detail in the image.

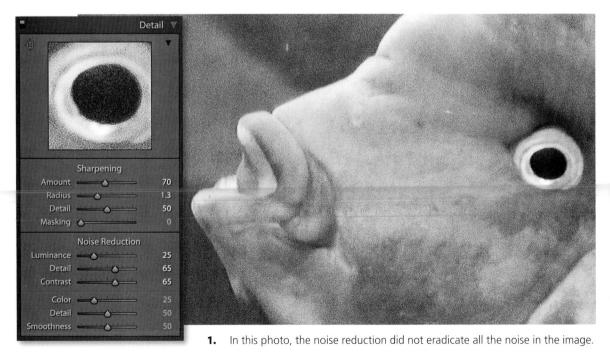

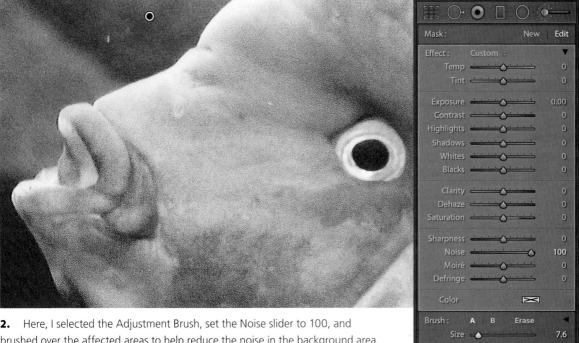

brushed over the affected areas to help reduce the noise in the background area.

Selective moiré reduction

Moiré is a problem that's associated mainly with high-end backs (and digital SLRs, such as the Nikon D800E) where there is no anti-aliasing filter. When photographing areas of fine detail, such as the mesh in a fence, if the detail is more than 1 pixel wide, the sensor will not have any problem resolving this. Where the detail is less than 1 pixel wide, however, you are more likely to see the effects of moiré. It is a problem you will find more often with today's high-resolution, medium-format sensors, but it is not completely unheard of with regular digital SLR cameras. The example shown on the next page is a close-up view of a photograph shot using the Kodak DCS Pro 14N.

To address this issue, Lightroom now features a Moiré slider in the localized editing controls. As with the Noise slider, you will need to drag it to the right to apply a positive value that can help reduce the effects of moiré. The higher the setting, the stronger the effect will be. If necessary, you might want to apply a second-pass adjustment in situations where you are trying to remove really stubborn moiré artifacts. The thing to watch out for is that the stronger the moiré reduction effect, the more likely you are to see examples of color bleeding along the affected edges. As you use the Adjustment brush to apply a moiré reduction, the brush references a broad area of pixels around where you are brushing in order to calculate what the true color should be where you are painting. So, when retouching a photograph such as the Sydney Opera House image shown here, it was important to maintain a hard edge to the brush in order to calculate a true color based on the color of the roof tiles and not allow the brush to sample the adjacent blue sky color (which would otherwise have spilled over here). Selecting the Auto Mask option can certainly help, too. Also, when fixing different sections of an image that are affected by moiré, you might want to consider creating new brush pins and working on these areas separately.

As with the Noise slider, you will note that you also have the ability to apply negative amounts of moiré. This means that you can apply multiple passes of positive moiré reduction in which subsequent applications of negative moiré can be used to reduce the previously applied moiré reduction effect.

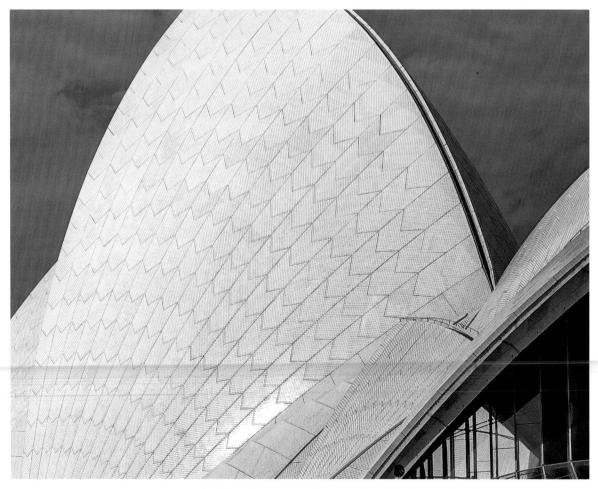

1. This view shows a close-up view of the Sydney Opera House, where you can clearly see a noticeable moiré pattern in the roof area.

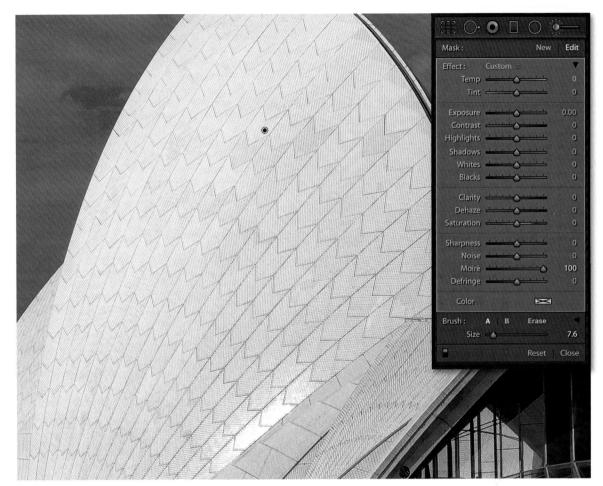

2. I selected the Adjustment Brush and set the Moiré slider to 100. I then used the brush to paint over the affected area, thereby completely removing all traces of the moiré interference pattern.

Moiré removal on non-raw images

Moiré removal is more effective at removing luminance artifacts on raw images than on JPEGs. This is because it can take advantage of the higher-resolution green channel (before color processing) to perform a fix. This is not possible with JPEGs as the green channel has already been fixed. It has already been "color processed" and therefore become "polluted" by the other three channels.

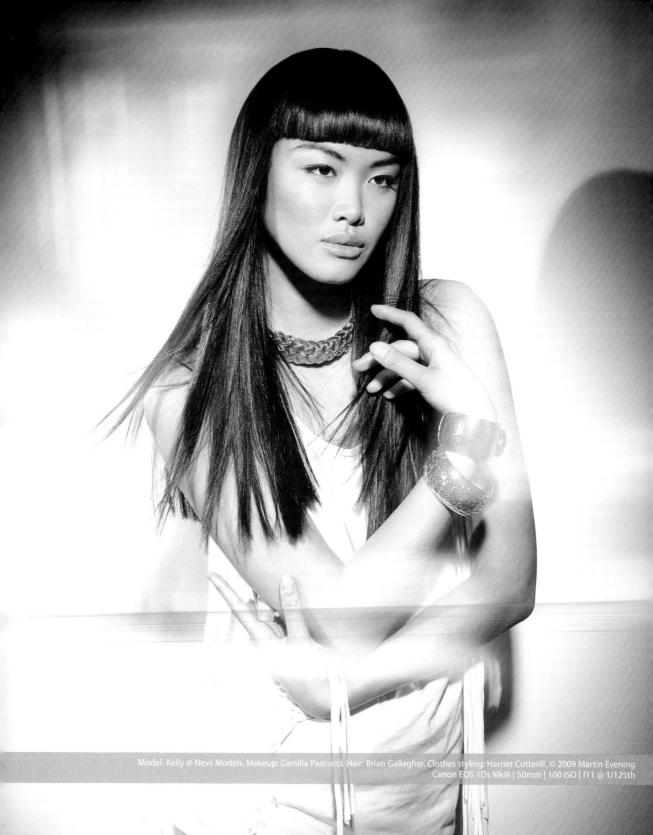

Exporting from Lightroom

How to export files from Lightroom and work in harmony with Photoshop

The best way to understand the Lightroom/Photoshop relationship is to think of Lightroom as a program for managing and processing lots of images, which are filed in the catalog, and regard Photoshop as a program for retouching individual photographs.

Although there is a fair amount of overlap between Photoshop Camera Raw and Lightroom, it is clear that Photoshop will continue to remain the program of choice for serious retouching and layered image editing. The question then is, what is the most efficient way to work between these two programs? In this chapter, I will show you some of the various ways you can take photographs from Lightroom and edit them in Photoshop, as well as how to use the Export module to process single images or batches of photographs. I also show how to use the post-processing section of the Export module to integrate complex Photoshop routines as part of an export.

NOTE

One of the reasons why I prefer managing photos in Lightroom compared to Bridge is because the Lightroom policies are much clearer and the user always remains in full control as to how such photos are opened from Lightroom. For example, if the Photoshop/Bridge Camera Raw preferences are configured with the TIFF or JPEG handling set to "Automatically open all supported TIFFs and JPEGs," then such images will open via Camera Raw rather than directly into Photoshop, which is potentially rather confusing.

Opening images in Photoshop

I have so far covered the image processing that can be done directly in Lightroom using the Develop module controls. Remember, all Lightroom edits are non-destructive. The master photos are managed by the Lightroom catalog, and the master images are always preserved in their original state. If you want to edit an already rendered pixel image outside of Lightroom in an image-editing program such as Photoshop, you can choose to edit the original or edit a new copy version. If you want to edit a raw image in Photoshop, Lightroom must first generate a rendered pixel-image version for you to work with.

The External editing options

Before you do anything else, you will first need to go to the Lightroom preferences via the Lightroom menu (Mac), or Edit menu (PC) and configure the External Editing preferences (**Figure 7.1**). The External Editing settings allow you to establish the file format, color space, bit depth, resolution, and, where applicable, the compression settings that are used when you ask Lightroom to open a

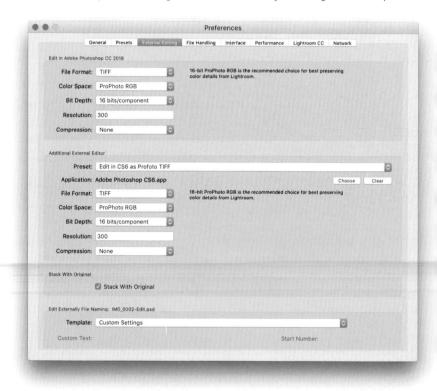

Figure 7.1 The Lightroom External Editing preferences.

catalog image in an external pixel-editing program. There are essentially two ways you can externally edit a Lightroom catalog image: either in Photoshop or in a nominated external photo editor (which can also be Photoshop).

Edit in Adobe Photoshop

In Figure 7.1, ProPhoto RGB was selected as the color space, with a bit depth of 16 bits per channel, saving to the TIFF file format using no compression. An opened image will display the same raw file extension as the master (e.g., NEF, CR2, or DNG), and it is only when you choose File \Rightarrow Save in Photoshop that the file format and other settings configured in the External Editing preferences come into play. The edited image is then saved to the same folder as the original master and added to the catalog. Basically, the Edit in Photoshop command provides you with a means to open raw catalog images in Photoshop without generating new edit copy versions of the master each time you do so. You can open a raw file in Photoshop to make some edits and then decide whether to save it or not. If you prefer, you can choose File \Rightarrow Save As to save the image to an alternative folder location without adding it to the catalog and, if you wish, save using a different file format or different save settings.

If you open a non-raw image such as a TIFF, PSD, JPEG, or PNG in Lightroom using the <code>\mathbb{HE}</code> (Mac) or <code>Ctrl</code> (PC) command, you will see the dialog shown in **Figure 7.2**, where the Edit Original option is selected by default. This is useful for editing layered masters or derivative versions of a master where you wish to carry on editing the source photo, but do not wish to generate a new copy version. You can choose Edit a Copy if you want to create an edit copy of the file in its original state (ignoring any Lightroom adjustments that might have been applied). You can also choose Edit a Copy with Lightroom Adjustments if you want to open a copy of a JPEG, TIFF, or PSD image that has Lightroom adjustments applied to it. So, if you had used the Lightroom Develop adjustments to process a JPEG, PNG, TIFF, or PSD image and wished to apply these adjustments, this would be the option to choose.

Figure 7.2 When opening a non-raw image using the main Edit in Adobe Photoshop command, the Edit Photo options dialog will appear with the default Edit Original option selected.

Edit in additional external editing program

The other alternative is to open images using the additional external editor option, via the Photo \Rightarrow Edit in menu or the \Re Alt E (Mac) or Ctrl Alt E (PC) shortcut. In the Additional External Editor section of the External Editing preferences (Figure 7.1), you can again specify which external editing program to open the images in and the default file settings to use. The external program could be Picasa, Affinity Photo, or you can choose to open in the same version of Photoshop, but with different default file format options. The difference between this and the Edit in Adobe Photoshop command is an edit copy of the master is *always* added to the Lightroom catalog. The Lightroom External Editing preferences let you customize the pixel image-editing settings for any pixel-editing program. For example, you might want to use the settings shown in Figure 7.1 to create new edit versions that are saved using the TIFF file format but with different compression settings. Whichever program you select here, this then becomes available as a menu option when you go to the Photo \Rightarrow Edit in Adobe Photoshop menu, just below the main Edit in Adobe Photoshop command (Figure 7.3).

The main difference when opening a raw image via the "Edit in external editor" option is that it uses the Lightroom raw processing engine to render a pixel image copy of the catalog image. The new copy image is added to the catalog before opening it up in the selected program; you also have the opportunity to override the file format and other settings before the image is opened. So, when you use **AITE* (Mac) or Ctrl AITE* (PC) to open a raw image, instead of the photo opening directly, you will see the dialog shown in **Figure 7.4**. On the face of it, the only available option here is to Edit a Copy with Lightroom Adjustments. If you

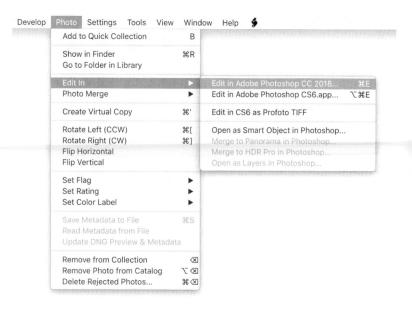

Figure 7.3 The Photo \Rightarrow Edit in menu (via the Develop module).

click the disclosure triangle at the bottom of the dialog, you can expand the Copy File Options and use these to override the file format, RGB space, and bit-depth options set in the External Editing preferences (but if you have selected a program other than Photoshop or Photoshop Elements as the external editor, the PSD file format option will not be available). Photos opened this way are automatically stacked with the original catalog image (see Step 3 on page 421), although you can turn this option on or off via the External Editing preferences (Figure 7.1).

Opening non-raw images in an external editing program

When you open a pixel image such as a TIFF, PSD, JPEG, or PNG, the default option will be Edit Original (**Figure 7.5**). This is almost exactly the same as choosing Edit Original in the main Edit Photo with Adobe Photoshop dialog (Figure 7.2). The only difference here is that the External Editing options allow you to open your catalog photos using a program other than the latest version of Photoshop on your computer (as set in the External Editing preferences). Likewise, if you choose the Edit a Copy with Lightroom Adjustments or the Edit a Copy option, this allows you to edit a copy version in an alternative external editing program.

The Edit a Copy with Lightroom Adjustments option allows you to open a pixel image from the catalog and apply any associated Lightroom adjustments; but when making a copy, this will flatten any layers in the original pixel image. If the image you wish to open contains layers and you want to preserve them, then choose either the Edit Original or Edit a Copy option.

Creating additional external editor presets

In the External Editor preferences, you can save the Additional External Editor settings as presets (**Figure 7.6**). Once saved, these appear as Photo \Rightarrow Edit In submenu options (Figure 7.3).

Figure 7.6 The Additional External Editor presets menu.

Figure 7.4 The Edit photo in External Editor dialog when opening raw photos.

Figure 7.5 The Edit photo in External Editor dialog when opening non-raw photos.

Figure 7.7 The Filename Template Editor.

External editing file-naming options

At the bottom of the External Editing preferences dialog (Figure 7.1) is the Edit Externally File Naming section. Lightroom normally appends –*Edit* to each externally edited image filename, and as you create further edit copies, Lightroom increments the numbering: –*Edit1*, –*Edit2*, and so on. It is possible, though, to customize the file naming. For example, you could create a custom template that always adds a date stamp after the original filename (**Figure 7.7**) and apply this renaming scheme whenever you create an edit copy version from a master file.

The file format and other file settings options

Let's now recap a bit and look at the file format and file settings options in more detail. The file format options in the External Editing preferences let you establish the default file format, RGB space, and bit depth to use when opening an image. There are two edit copy file format options: TIFF and PSD. The TIFF file format is the most versatile of the two, because the TIFF format always stores a flattened composite image and is able to save all Photoshop features, such as layers, paths, and layer effects. The PSD file format is sometimes quicker to save and open. But if you want Lightroom to recognize imported, layered PSD files, you must make sure the "Maximize PSD compatibility" option is switched on first in the Photoshop File Handling Preferences.

The Color Space options are limited to ProPhoto RGB, Adobe RGB, Display P3, and sRGB. ProPhoto RGB is capable of preserving all the color information that was captured in the original raw file after it has been processed in Lightroom. This can prove useful when making high-end print outputs where you need to preserve rich color detail. Adobe RGB is a more commonly used RGB space among photographers and perhaps a safer choice if you are sending RGB images for others to work with. The Display P3 color space matches the display gamut of the latest wide color gamut Retina iMacs and recent MacBook Pros. It is roughly the same size as Adobe RGB, although the color gamut range is different. So, it is not identical, but can certainly contain more colors than sRGB. The sRGB space is a standardized RGB space that is suitable for web work and sending photos via email. It is also a suitable "best-guess" choice if you are unsure whether the recipient is using proper color management or not.

The Bit Depth can be set to "16 bits/component," which preserves the most tonal information (as much as Lightroom is able to). The "8 bits/component" option reduces the number of levels to 256 per color channel and allows you to save smaller-sized files. These settings are crucial for opening raw images, but with non-raw files it is important to realize that the file settings options will be limited by the file properties of the master images. For example, if the source image is, say, an 8-bit, sRGB JPEG and you choose Edit a Copy with Lightroom Adjustments, you will not gain anything by saving it as a 16-bit ProPhoto RGB TIFF.

Camera Raw compatibility

When opening raw images, there is a further issue to take into account when choosing between the main Edit in Adobe Photoshop and "Edit in external editor" commands. The main Edit in Adobe Photoshop command opens raw images directly and relies on Camera Raw in Photoshop to read the Lightroom settings and carry out the raw conversion. What happens next, therefore, depends on which Develop adjustments have been used to edit the photo, whether these are specific to Lightroom or not, and which version of Photoshop and Camera Raw you are using. For example, if you are using Photoshop CS6 with the most recent compatible version (Camera Raw 9.1.1), most Lightroom Develop settings will be readable. But in this instance, Camera Raw 9.1.1 will not provide full Lightroom functionality (for that, you will need Camera Raw 10 or later for Photoshop CC). Therefore, if you are using Photoshop CS6 with Camera Raw 9.1.1, you will see the warning dialog shown in Figure 7.8. Here, you can choose Open Anyway (maybe all the applied Develop settings can be read by the 9.1.1 version of Camera Raw). Or, you can choose "Render using Lightroom," where Lightroom will render an edit copy of the original and automatically add this to the Lightroom catalog. Essentially, you gain the ability to open a Lightroom image in Photoshop CS6, or older versions of Photoshop, but lose the option to open a raw image in Photoshop and choose whether to save or not. Where a raw image has "unknown" Develop settings, you will also see the warning dialog shown in Figure 7.8.

The main thing to understand here when editing a raw image in Photoshop is Lightroom always wants to open the image using the Camera Raw plug-in contained in Photoshop itself. This allows an opened image to remain in an unsaved state until you decide to save it. When there may be compatibility problems (because the version of Camera Raw or the version of Photoshop you are using is unable to interpret the Lightroom settings), you can always choose the Render using Lightroom option to override the default Lightroom behavior. The downsides are that this must always create a rendered copy first and you lose the option to close without saving.

Figure 7.8 The Camera Raw compatibility warning dialog.

How to use the external edit feature

1. Here, I selected a master raw image from the Filmstrip and used the "Edit in external editor" command (黑E [Mac] or Ctrl E [PC]) to create an edit copy that opened in the most current version of Photoshop, but without (yet) automatically adding a saved version to the catalog.

2. With the image opened in Photoshop, I was able to retouch the photo. When I finished, I chose File \Rightarrow Save and closed the image.

3. Back in Lightroom, you can see how the edited version was added to the same folder as the original and appeared highlighted in the Filmstrip. You can see the selected image identified as number 2 of 2 images in the stack. The modifications made in Photoshop were also reflected in the Filmstrip and main preview.

4. If I needed to re-edit the image in Photoshop, I could use either ***E** (Mac)/ Ctrl **E** (PC) or ***Alt E** (Mac)/Ctrl **Alt E** (PC) to open the Edit Photo dialog, where I would choose the default Edit Original option.

Going from Lightroom to Photoshop to Lightroom

There are a number of ways you can use the Develop module controls to produce interesting black-and-white conversions or different types of color-processed looks. The guestion this raises is, when is the best time to apply such adjustments? Let's say you want to convert a photo to black and white, but you also want to carry out a significant amount of retouching work in Photoshop. Should you convert the photo to black-and-white mode in Lightroom first and then choose to edit it in Photoshop? That could work, but once you have converted a photo to black and white in Lightroom and edited it in Photoshop, there is no opportunity to go back to the color original. Suppose later on, a client decides that he does not like the black-and-white look and wants the color version instead? In my view, it is best to prepare your photos in Lightroom to what can be considered an optimized image state, create an edit copy version to work on in Photoshop, and then apply the black-and-white conversion or special coloring effects to the Photoshop-edited image in Lightroom. Of course, the major problem with this approach is that you do not get to see what the image looks like while you are working in Photoshop. However, the following steps suggest one way you can overcome this drawback and make this transition between Lightroom and Photoshop more fluid.

1. I started here with a raw image. Highlighted alongside it is the TIFF edit copy that I had created previously and edited in Photoshop.

2. With the Edit copy version selected, I created a virtual copy using **(Mac)** or **(Ctrl)** (PC). The virtual copy was selected here.

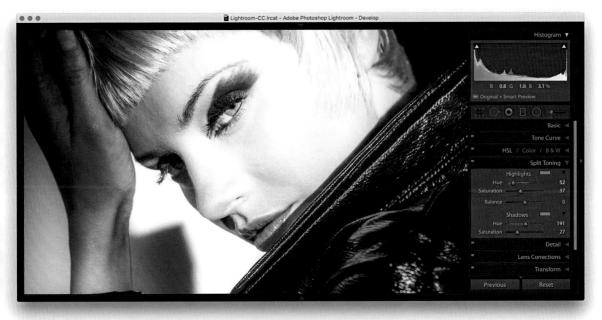

3. I then went to the Develop module and carried out a number of color and tone adjustments. I mainly adjusted the red and blue channels in the Tone Curve point curve editor and combined this with a Split Toning adjustment.

4. Returning to the Library module Grid view, you can see the virtual copy Develop adjusted version next to the TIFF original (which I selected).

5. I chose Photo ⇒ Edit in Adobe Photoshop and continued editing the original image selected in Step 4. As you can see, I was able to carry out the retouching work on the full-color version of the photo without the coloring effect.

6. Meanwhile, back in Lightroom, I could preview a combination of the Photoshop-edited image and the Lightroom-applied adjustments. But I had to remember to keep saving the image in Photoshop in order for the most currently updated version of the photo to appear in the Lightroom window.

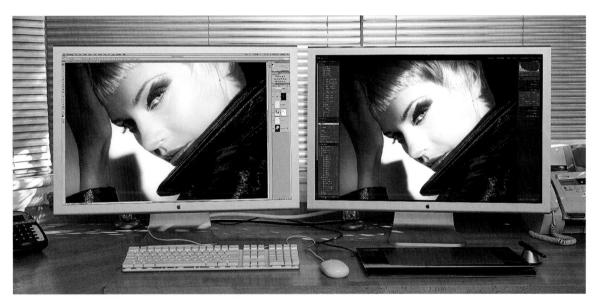

7. At this stage, I could simply toggle between the Photoshop and Lightroom windows to compare the two image previews. Because I had the luxury of a dual-display setup, however, I was able to view the Photoshop image on one display and the Lightroom window on the other.

NOTE

Photoshop Smart Objects are like containers that fully preserve the image contents. As you transform a Smart Object or add filter adjustments, the original image data remains intact. There are two types of Smart Objects: embedded and linked. Both are discussed here.

Extended editing in Photoshop

In addition to being able to edit photos directly in Photoshop, you can make use of Lightroom's extended Photoshop editing features: Merge to Panorama, Merge to HDR, and Open as Layers. These commands use the same settings as the Edit in Adobe Photoshop command and allow you to process images that have been selected in Lightroom, but without adding new photos to the catalog. If you open raw photos from Lightroom as Smart Objects in Photoshop, you can preserve the raw editing capabilities of the original and still be able to use Photoshop to do things like transform the images and add layer masks.

Here are two photographs I wanted to merge together in Photoshop while retaining control over the Lightroom/Camera Raw adjustments.

Photoshop ⇒ Open as Smart Object in Photoshop. This opened the selected photo as a Smart Object (see the (19) icon bottom-right in the layer thumbnail).

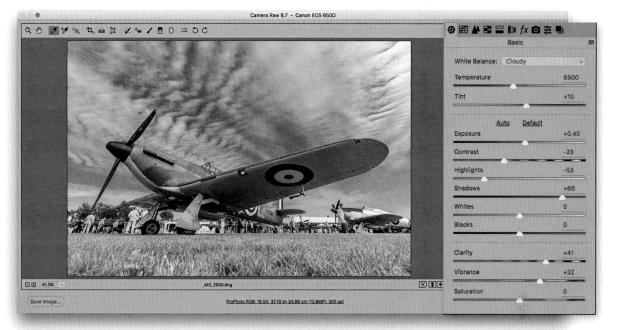

3. I double-clicked the Smart Object layer, which opened it via Camera Raw. This allowed me to edit the Develop settings. Here, I decided to apply a warmer white balance.

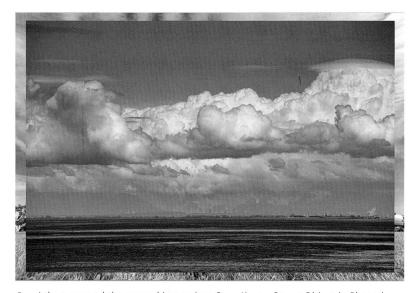

4. I then opened the second image (see Step 1) as a Smart Object in Photoshop and used the Move tool to drag it over to the first document window. This added it as a new layer above the Smart Object layer of the Spitfire.

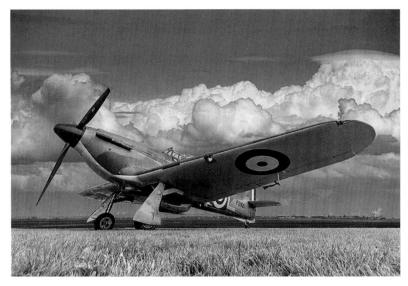

5. In Photoshop, I created a mask of the Spitfire and added this to the sky layer to reveal just the Spitfire and the grass.

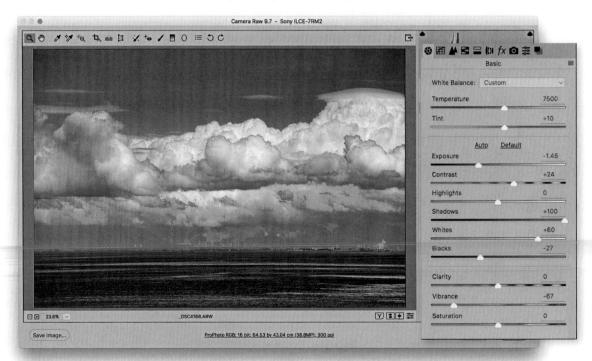

6. I then double-clicked the sky Smart Object layer and revised the Develop settings via Camera Raw. Here, I also applied a warmer white balance to match that of the Spitfire image layer.

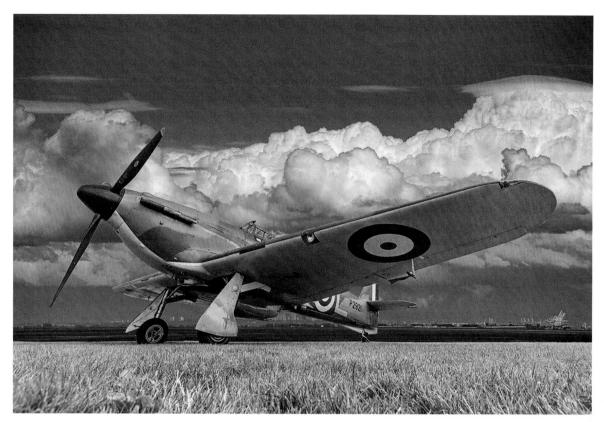

7. Here is the finished composite, where the two Smart Object layers preserved the source files in their raw state and remained fully editable via Camera Raw. With this technique, it remained possible to open the Smart Object layers and continue editing the Camera Raw settings. For example, in this step I added a localized adjustment to remove some of the green tint on the underside of the aircraft wings.

Linking Lightroom photos as Smart Objects

It is possible to synchronize Lightroom Develop edits with files that are being edited in Photoshop. For example, you can create a linked Smart Object in Photoshop that is linked to a photo that happens also to be in the Lightroom catalog. Once the linked Smart Object has been set up, as you make edit changes in Lightroom, these will be reflected in the linked Smart Object when it is opened in Photoshop.

Also, if you Alt drag a raw file from the Lightroom Grid view to a Photoshop document, it will be placed as a linked Smart Object layer. As you update the source raw image in Lightroom and choose Photo ⇒ Save Metadata to File, the edit changes will be updated in the Photoshop Smart Object layer.

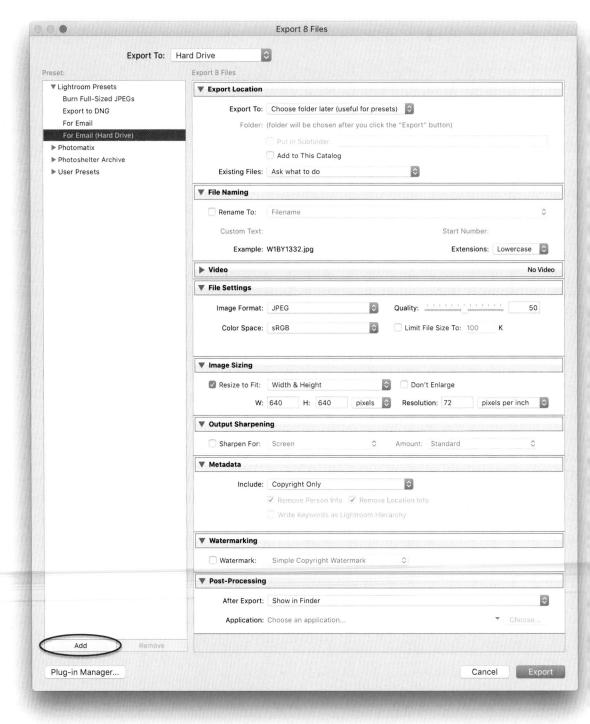

Figure 7.9 The File ⇒ Export dialog is shown here with the For Email (Hard Drive) preset setting selected.

Exporting from Lightroom

The Export function can be used to export single or multiple photos. Master files can be exported as original files, DNGs, flattened TIFFs, flattened PSDs, or JPEGs, and you have full control over the exported file settings, such as where the files get saved to. You can also specify whether to incorporate a post-processing action and save export settings as custom presets, making it easy to create and use different export configurations. To export, make a selection and choose File ⇒ Export or use ★◆Shift (Mac) or Ctrl ◆Shift (PC) to open the Export dialog shown in Figure 7.9. Or, you can use ★Alt ◆Shift (Mac) or Ctrl Alt ◆Shift (PC) to bypass the Export dialog and carry out an export based on the last used settings.

Export presets

The Preset section already contains a few preset export options to get you started. For instance, the *For Email* setting can be used to export JPEG versions of the master catalog images within an email. Plus, you can configure your own custom settings and click the Add button (circled in Figure 7.9) to add these to the User Presets list. The settings listed here can be managed using the context menu, which will let you update user preset settings (**Figure 7.10**).

▼ Lightroom Presets Burn Full-Sized JPEGs Export to DNG For Fmail For Fmail (Hard Drive) ▶ Photomatix ▶ Photoshelter Archive ▼ User Presets 10x8 inkiet output AP-image prep New Folder Rename Show in Finder Delete Export Import... Export CMYK TIFF 300pp Export TIFFs

Figure 7.10 You can right-click to access the context menu and manage the export user presets.

Export Location

In the Export Location section, you can choose to export to the same source folder or to a specific folder. When the latter is selected, the folder location is remembered between exports, so you can regularly send your exports to locations such as the My Pictures folder. In the Figure 7.9 example, I had the For Email (Hard Drive) preset selected; with this preset you are required to choose a folder later, once Lightroom has finished rendering the JPEG exports. You can also check the Add to This Catalog option if you want to automatically reimport the exported photos back into the Lightroom catalog. In the Existing Files menu, you can leave this set to "Ask what to do" when an existing file is encountered as an exported image and is reimported back to the catalog, or choose from one of the following policies. If you select "Choose a new name for the exported file," you get the opportunity to rename the reimported image and create a new master image. You can also choose Overwrite WITHOUT WARNING. As the loud lettering hints, that this is a potentially risky policy to choose, because the images that are likely to be affected are JPEG, TIFF, or PSD masters. Let's say you chose to export as JPEG and resave the exported photos to the same folder location. You could end up overwriting the original JPEG capture masters with low-resolution, heavily compressed versions. Or, you might risk overwriting a layered TIFF or PSD with a flattened version of the original. Finally, you can choose Skip, where Lightroom still exports the existing files but skips reimporting them.

NOTE

Export speed has been improved in this current version of Lightroom, which is slightly faster at bulk exports. This speed gain, however, can be at the expense of performance when carrying out other tasks in Lightroom.

NOTE

The Lightroom Export dialog includes options to add exported images to the catalog and stack them either above or below the original, which I prefer to think of in terms of stacking before or after.

Exporting to the same folder

If you select "Same folder as original photo" from the Export To pull-down menu (**Figure 7.11**), you can export a derivative version of a catalog photo, such as a full-sized TIFF version from a raw original, and export the new photo to the same source folder as the original. The option Add to This Catalog also becomes available and you have the option to stack the exported image either before or after the original. If the Add to Stack option is not available, it is probably because you are trying to export from a Quick Collection. The Export dialog therefore provides you with a simple one-step solution for creating derivative versions of the raw masters and simultaneously adding them to the catalog.

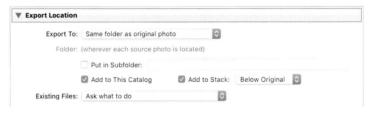

Figure 7.11 Use these Export Location options to create derivative versions of master files and reimport them back into the catalog, stacked with the masters.

1. Here, you can see that I filtered the photos in the catalog to select just the favorite photos from a series shot in Treia, Italy.

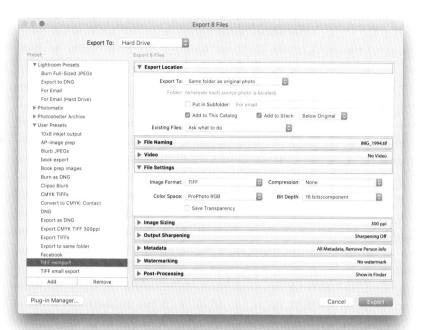

When the panels in the Export dialog are collapsed, the settings are summarized in the panel bars for quick and easy viewing.

2. I used the Export command (黑公Shift) [Mac] or Ctrl公Shift) [PC]) to export these eight photos with a custom *TIFF reimport* preset that used the same Export Location settings as those shown in Figure 7.11.

3. Once the Export process was complete, the exported photos were added to the catalog and stacked *after* the raw masters.

File Naming

If you want to retain the current naming, you can leave the File Naming section (**Figure 7.12**) set to *Filename*. If you want to differentiate the export processed images from the original masters, you can choose a file-naming preset from the Rename To menu.

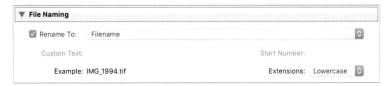

Figure 7.12 The Export dialog File Naming section.

File Settings

In the File Settings section, images can be exported using the JPEG, PSD, TIFF, DNG, or Original format, and the file format options will alter according to the file format you have selected. For example, in Figure 7.9, you can see the File Settings that are available for JPEG exports. If you select the TIFF format, you will see the TIFF options shown in **Figure 7.13**.

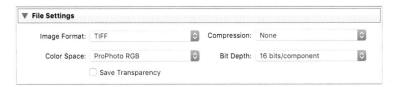

Figure 7.13 The Export dialog File Settings section showing the TIFF options.

When selecting the TIFF format, you can select a compression option. I normally prefer to save uncompressed TIFFs, but you can use ZIP or JPEG compression to make TIFFs smaller to economize on data transfer times. However, it will take longer to save TIFF files that have compression.

All your catalog files will have been edited using the Lightroom internal RGB space, but when you choose to export as a JPEG, TIFF, or PSD, you can select an output color space, which can be sRGB, Display P3, Adobe RGB, or ProPhoto RGB. If you are exporting the photos for photo editing, your choice will boil down to Display P3, Adobe RGB, or ProPhoto RGB. Adobe RGB is a safe general choice, as it is a widely adopted space for general photo-editing work in programs such as Photoshop. Display P3 is a new addition. It is roughly the same size as Adobe RGB and closely matches the gamut of the latest iMac displays (you could select this if exporting images to be viewed in a slideshow on an iMac). ProPhoto RGB is, in many ways, better than Adobe RGB because the ProPhoto RGB color gamut is a lot bigger than Adobe RGB and is more or less identical to the gamut of the native

Lightroom RGB space. With ProPhoto RGB, you can guarantee inclusion of all the colors that were captured in the original raw file, whether your display is able to show them or not. For this reason, ProPhoto RGB is a favorite photo-editing space for high-end print work where you want to preserve the maximum color gamut to achieve the best print results. The downside of using ProPhoto RGB is that you must view the files in a color-managed application in order to see the colors displayed correctly. If you view a ProPhoto RGB image in a program that does not recognize profiles (such as most web browsers) or where the color management is switched off, the colors will look terrible. If you are familiar with the basic concepts of color management and are using Photoshop with the color management switched on, it will be safe for you to export using Display P3. Adobe RGB, or ProPhoto RGB. If any of the preceding information confuses you, then perhaps you should stick to using sRGB. In fact, I would definitely advise choosing sRGB if you are exporting images as JPEGs for web use, for client approval (especially if you are unsure how well the client's systems are color-managed), or when preparing pictures to email friends. For the time being at least, sRGB remains the most suitable lowest common denominator space for web work and general use. The Other menu option lets you choose a custom RGB profile to export to. This option might be useful when you wish to export using a custom print RGB profile. For example, some commercial print labs provide profiles for the printers they use, which you can download. So, if you are able to access these profiles, you might want to export your photos using their profile color space.

You can set Bit Depth to 16 bit or 8 bit. One of the reasons so many professionals advocate working in 16 bit is because you can make full use of all the capture levels in an image when applying your basic tonal edits. If you start out with an 8-bit image and carry out major edits, you will end up needlessly throwing away a lot of data along the way. Keeping your images in 16 bit throughout helps preserve all the levels. In Lightroom (and this is true for any raw processor), you are making all your basic edits in 16 bit regardless of how you export them. So, at this stage, you will already have taken full advantage of all the deep-bit levels data in the original capture. Therefore, choosing 8 bit at this stage is not necessarily such a damaging option, especially if you have carried out all the major edit adjustments to the raw file in Lightroom. If you think 16 bits will help you preserve more levels as you perform subsequent editing work in Photoshop and you feel the extra levels are worth preserving, then the safest option is to choose 16 bit.

You can export images from Lightroom in their original format. For example, when burning a DVD, it will be quicker to export and burn photos to a disc when files are kept in their original format. After all, if your files have already been converted to DNG in Lightroom, there is no point in converting them to DNG all over again. When exporting TIFF or PSD files, you will need to select the original format option if you wish to preserve any layers. Also, because Lightroom supports the managing of CMYK images and video files, you can only really use the Original format option when exporting these types of files from Lightroom.

110113

You can never tell what the future may hold. There was a time when nobody could foresee a real need for deep-bit images. These days, film and video editors regularly rely on 16-bit or higher bit depths for special effects work. And new display technologies are emerging that can show deep-bit images on wide dynamic-range displays. This is why I recommend you export your Lightroom photos as 16-bit files in ProPhoto RGB.

DNG export options

The File Settings DNG options shown in **Figure 7.14** let you choose the desired compatibility and JPEG preview options, as well as whether to embed Fast Load Data (these options are covered in more detail on pages 694–699).

If you check the Use Lossy Compression option, you can also check the Resize to Fit option in the Image Sizing section. This gives you the option to choose either Megapixels or Long Edge from the menu. When you limit by the number of megapixels, the pixel dimensions of the final image will adapt to fit the number of megapixels (the compression amount remains the same). When Long Edge is selected, you can specify the exact number of pixels you want along the longest edge. Whenever you resize a DNG in this way, the image data has to be demosaiced but is still kept in a linear RGB space. This means that while the demosaic processing becomes baked into the image, most of the other Develop controls, such as those for tone and color, remain active and function in the same way as for a normal raw/DNG image. Things like Lens Correction adjustments for vignetting and geometric distortion will be scaled down to the DNG output size. As a safety measure, the Image Sizing for lossy DNG output always resets to "off" each time after you carry out an export.

Just as you can convert any supported proprietary raw file to DNG, you can also save non-raw files as DNGs. One advantage of doing this is that the DNG file format can combine the XMP data with the pixel image information in a single file document. You can also store the Lightroom-edited preview in the DNG version, which can help when viewing DNG-converted JPEGs in other non—Camera Raw aware programs. Having said all this, it is also important to point out that saving a JPEG as a DNG does not convert a JPEG image into a true raw format image. It must be stressed that once you have converted a raw image to a TIFF or JPEG, there is no way of returning it to its raw state again.

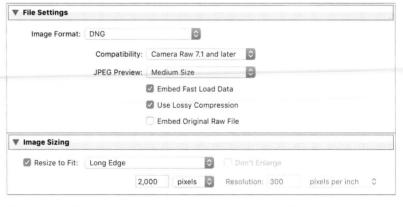

Figure 7.14 The Export dialog File Settings section showing the DNG options plus associated Image Sizing options when Use Lossy Compression is selected.

Exporting files and converting them to DNG is also quicker than converting to DNG internally. This is because the export process makes use of multiple threads. When you select Library Convert Photos to DNG, the process is single-threaded. This is because the expectation is that users will want to keep using Lightroom and, therefore, need the program to remain responsive.

Image Sizing

In the Image Sizing section (**Figure 7.15**), you have the opportunity (where the image format options allow) to resize the exported photos. There are various options here. If you check the Resize to Fit box, you can choose Width & Height to make the photos resize to fit within the values entered in the two boxes. If you select Dimensions, you can force the exported images to fit precisely within set dimensions (which may well change the aspect ratio of the exported images), or you can resize the photos along the long edge, the short edge, by megapixels, or by percentage. If you have a selection of photos where some are landscape and others are portrait, you can specify a long-edge or short-edge dimension limit and all photos will resize to the same long-edge or short-edge dimension constraints. If you choose to export photos as JPEGs, Lightroom allows you to specify a file size limit for the exported JPEGs, where you can let Lightroom auto-calculate the appropriate amount of JPEG compression that is required.

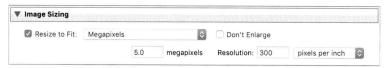

Figure 7.15 The Export dialog Image Sizing section.

The Resize to Fit options can be used to make the exported photos bigger or smaller. If you uncheck the Don't Enlarge check box, you can use the Resize to Fit settings to create output images with bigger pixel dimensions than the original. If the Don't Enlarge check box is selected, this resizes the photos to the desired output dimensions, but if the source photo is smaller than this size, it will output the photo at its native pixel size rather than try to make it bigger. The Resolution box lets you set the number of pixels per inch or pixels per centimeter for the resolution.

When to interpolate

There are no interpolation options in Lightroom. Instead, an adaptive method of interpolation is applied behind the scenes. In Photoshop terms, Lightroom uses an adaptive sampling approach that combines Bicubic and Bicubic Sharper algorithms when downsampling an image and combines the Bicubic and Bicubic Smoother algorithms when upsampling.

70112

Some people still get confused by the Resolution setting. Basically, whatever resolution you set here has no bearing on the actual pixel file size. The Resolution box simply lets you "specify" the resolution for the image in terms of pixels per inch or pixels per centimeter.

MOTE

Photoshop author and digital imaging guru Bruce Fraser worked on the PixelGenius PhotoKit SHARPENER plug-in for Photoshop alongside Mike Skurski and Jeff Schewe. Adobe worked with PixelGenius to bring the PhotoKit SHARPENER technology into Lightroom. This included the inkjet and screen image sharpening that is available in the Print module and in the Export dialog.

Output Sharpening

The Output Sharpening section (**Figure 7.16**) provides the same sharpening controls that are found in the Print module Print Job panel options. These sharpening options are intended for applying sharpening for inkjet print output. This means that, instead of using the sharpening controls in the Print module to sharpen for print, you can use the Export dialog settings to sharpen a file ready for inkjet print output. For example, let's say you wanted to prepare Lightroom photos for printing in Photoshop or via a dedicated raster image processor (RIP). If you apply output sharpening at the Export stage in Lightroom, all of your files will be nicely sharpened and ready to print.

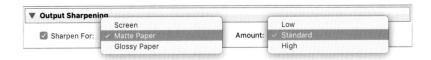

Figure 7.16 The Export dialog Output Sharpening section.

In the Sharpen For menu, you can select Screen (for outputting to a web page or external slideshow presentation) or choose between Matte paper or Glossy Paper for output to inkjet and other types of continuous tone printers. However, there are no sharpening options available specifically for halftone CMYK output. The Amount settings are Low, Standard, and High. The Lightroom output sharpening here is based on routines that were originally devised by Bruce Fraser and were all coded with the Standard setting. The Low and High settings, therefore, allow you to make the sharpening effect weaker or stronger. Whether you need to adjust these or not depends on a number of things. For example, if you are inclined to apply heavy amounts of capture sharpening, you may find the Low setting works better for print output. If you are interpolating an image at the export stage to increase the output size, then you may find a High setting works best. For most situations, I recommend leaving Amount set to Standard.

Metadata

The Metadata section (**Figure 7.17**) lets you decide how much metadata should be included during an export and lets you selectively strip the metadata. Choose Copyright Only or Copyright & Contact Info Only to keep the metadata minimal and exclude keywords. If you want to keep the Camera Raw data hidden, choose All Except Camera Raw Info. Choose the All Except Camera and Camera Raw Info option if you wish to keep the EXIF info hidden as well. To include everything, choose All Metadata. If the Remove Person Info option is checked, this removes Face tagging and People keywords. This might be useful if you need to keep the identity of someone featured in a photograph private. If the Remove Location Info

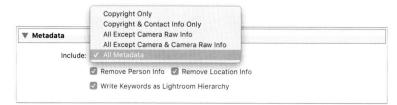

Figure 7.17 *The Export dialog Metadata section.*

option is checked, this removes all IPTC Location info as well as any GPS data. This can be important if the location data is sensitive.

The Write Keywords as Lightroom Hierarchy option is checked by default. This ensures keywords are always written to a file's XMP space so the keyword hierarchy is preserved when the keyword metadata is previewed on another computer running Lightroom, where perhaps the keywords used are unknown or do not share the same hierarchy. It also exports a flat list of keywords at the same time to ensure compatibility with applications that don't support hierarchical keywords.

For example, let's say you have two computers that share the same controlled vocabulary (that is, they both share the same keyword hierarchy structure). If you were to export a photo from one computer and import it into the other, the Write Keywords as Lightroom Hierarchy option would not make any difference because the keyword hierarchy for the individual keywords is recognized anyway. If this option is unchecked and the second computer does *not* share the same information, the keywords will otherwise be output as a flat list without a Lightroom-recognized hierarchy. So, if you happen to adopt a keyword hierarchy that uses *Places* > *USA* > *California*, that hierarchy will be preserved as long as either the computer you are importing the photo to already knows this hierarchy relationship or the Write Keywords as Lightroom Hierarchy option has been checked. If it is not checked, the keywords will only be exported as a flat list: *California*, *Places*, *USA*.

Watermarking

The Watermarking section (**Figure 7.18**) can be used to control how watermarking is applied to your exported images. On the next two pages, you will see two examples of how to add a watermark: one using text and the other using a graphic. In addition to placing a watermark at the time of export, you can do this via the Print module Page panel and Web module Output Settings panel. Watermarks can also be edited by going to the Lightroom menu (Mac) or Edit menu (PC) and choosing Edit Watermarks.

Figure 7.18 *The Export dialog Watermarking section.*

NOTE

There is no industry standard way of writing a keyword hierarchy, nor is there likely to be one. Picture libraries may need to strictly enforce a standard hierarchy for all images that are submitted, but most people will choose to categorize keywords in different ways. Some people may choose to organize geographic locations using a hierarchy such as PLACES > Continent > Asia > India. Other users might use a hierarchy such as LOCATIONS > Asia > India. Both would be valid ways of categorizing images using keywords, but both might trip up when importing a photo supplied by the other person. Both users would tag their India photos using the keyword "India," but the hierarchies used would be different.

NOTE

Watermarks cannot be applied when exporting as a raw original or raw DNG format, because it is not possible to add watermarks to raw images.

Creating new watermark settings

To create or edit a watermark, go to the Lightroom menu (Mac) or Edit menu (PC) and choose Edit Watermarks. Or, if you are already in the Export dialog, go to the Watermarking section and select Edit Watermarks from the Watermark menu. This opens the Watermark Editor (**Figure 7.19**), which shows the Text options. Here, you can type the text to use for the watermark and use the bounding-box handles to adjust the text scale. Over on the right are the text and watermark options for setting the alignment, orientation, opacity, and color; plus, you can also add a drop shadow and adjust the Radius and Angle settings to create a bevel and emboss type of effect. Once you are happy with the watermark settings, click the Save button to save the current settings as a new preset. The saved watermark preset will now be available as a custom option in the Watermarking section of the Export panel (Figure 7.18). Alternatively, you can click the Graphic button, select a PNG or JPEG image, and place this as your logo. The Watermark Editor Graphic options are shown in **Figure 7.20**. There are no active settings here for adjusting a watermark graphic other than to fade the opacity and adjust the size.

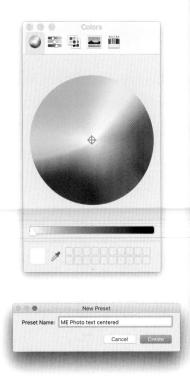

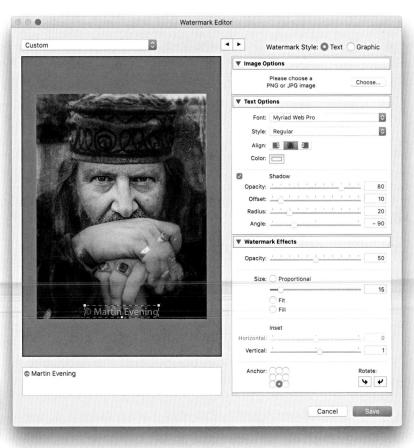

Figure 7.19 The Watermark Editor Text options.

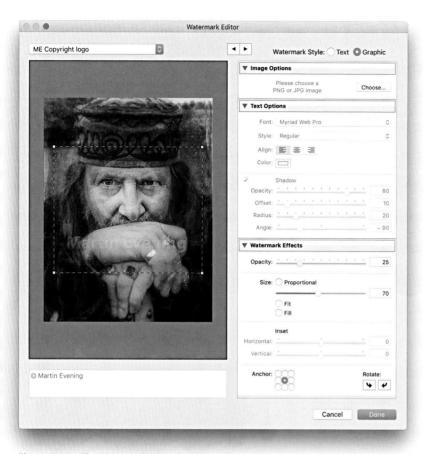

Figure 7.20 The Watermark Editor Graphic options.

Post-Processing

The Post-Processing section (**Figure 7.21**) is a powerful feature. It lets you perform such tasks as showing the images in the Finder at the end of an export and instructing Lightroom to open the photos in Photoshop after exporting. Over the next few pages, you can find out how to create Photoshop droplets (which are self-contained Photoshop action routines) and have these run at the post-processing stage of a Lightroom export.

Figure 7.21 The Export dialog Post-Processing section.

MOTE

The logo shown here was designed using type layers in Photoshop with a rounded bevel edge effect added with the type on a separate layer against a transparent background. The edited logo was then saved as a PNG file ready to be utilized in the Watermark Editor.

Adding export actions in Lightroom

Using the Post-Processing section in the Export dialog you can integrate Photoshop processing routines saved as actions into the export process. All you have to do is run through a sequence of Photoshop processing steps that you would like to see applied at the end of an export and record these as an action. In the following few steps, I show an example of how to create a Photoshop action for converting RGB images to CMYK that includes the necessary presharpening and profile conversion steps. This is just one example of a Photoshop routine that you might like to apply on a regular basis to photos that you export from Lightroom. By following the steps shown here, you can adapt the technique to record almost any type of Photoshop processing sequence.

It is also possible to drag and drop photos from Lightroom to a Photoshop droplet. Be warned, though, that Develop adjustments and other settings will not necessarily be transferred with the file if you drag and drop a file from Lightroom in this way.

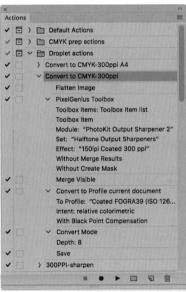

1. I started by opening an image in Photoshop and recorded a series of steps as an action. In this example, I flattened the image, applied an automated sharpening routine, merged the image, and converted it to a specific CMYK profile, before converting it to 8-bits-per-channel mode.

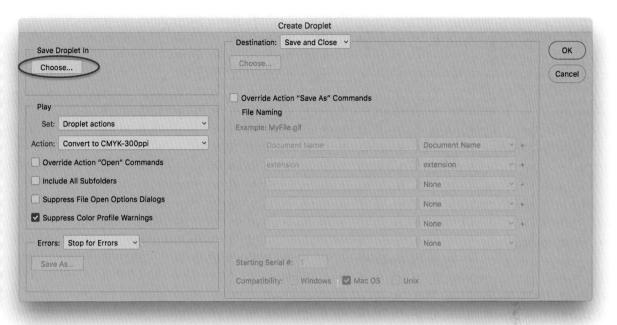

2. Having recorded the action, I was now ready to save it as a droplet. In Photoshop, I went to the File menu, chose Automate ⇒ Create Droplet and applied the settings shown here. There was no need to establish an output folder in the Destination section, because I would be using the Lightroom Export dialog to determine where the exported files would be saved to. I chose Save and Close, then clicked the Choose button (circled).

3. The Photoshop droplet had to be saved to the *Lightroom/Export Actions* folder. On a Mac, go to the *Users/Library/Application Support/Adobe/Lightroom/Export Actions* folder. On a PC, go to the *Users/Username/AppData/Roaming/Adobe/Lightroom/Export Actions* folder.

4. In the Export dialog, I configured the settings to save exported files to a *CMYK TIFFs* folder. In the File Settings section, I selected the TIFF image format with Compression set to None. It did not matter too much which RGB space was selected here because the output files would eventually be converted to CMYK, but I chose ProPhoto RGB as the output color space because this was similar to the native Lightroom RGB space. In the Image Sizing section, I limited the output size to 30 cm along the longest edge at a resolution of 300 ppi. Lastly, in the Post-Processing section, I selected the droplet I had saved previously to the *Export Actions* folder. It was time to save these customized settings as a new preset. For this example, I saved the Export settings as *Export CMYK TIFF 300 ppi*. You can adapt the CMYK conversion action routine shown here for any publication. My recommendation would be to create separate droplet actions for different publications using the correct profile or CMYK setting for each. You can then build up different sets of user presets for each client.

Exporting catalog images to a CD or DVD

You can export images to a CD or DVD via the Export dialog. In **Figure 7.22**, I selected the Burn Full-Sized JPEGs export setting, which uses the CD/DVD Export mode. This setting converts selected photos to JPEG and burns them to a CD or DVD. The photos are first converted to JPEG and automatically placed in a temporary folder. Lightroom then launches the operating system disc-burning

NOTE

Burn to CD/DVD is only available if the computer you are using has an enabled CD/DVD drive.

Figure 7.22 The Export dialog using the CD/DVD Export To mode.

utility (such as the one shown in **Figure 7.23**) and alerts you Lightroom is ready to start copying the files to a blank recordable CD or DVD. If you have more than one CD/DVD burning device available, you can select which unit you want to use to burn the disc. Once you have done this, click Burn, and you will then see the Burn Summary dialog (**Figure 7.24**) where you can enter a name for the archive disc you are about to create. If there is not enough room to burn all the data on a single disc, Lightroom informs you of this and enables a multi-disc burn session. For example, a single recordable DVD disc can hold a maximum of 4.3 GB of data. If your photos consume more space than that, Lightroom automatically divides the library export into batches of equal size (based on the space available on the first disc you inserted to record to) and proceeds to burn the data (and verify) to successive discs, appending each disc burn session with successive numbers. After all the discs have been burned, Lightroom automatically deletes the temporary disc folder.

Figure 7.23 The Mac Burn Disc system dialog.

Figure 7.24 The Burn Summary dialog.

Exporting catalog images as email attachments

The Export To Email option lets you export images directly as email attachments using your preferred email client program. There are several ways to do this. You can choose the *For Email Export To* option from the Lightroom Presets list in the Export dialog; this selects the appropriate settings for creating email attachments. You can also choose File Demail Photo (黑公hith) [Mac] or Ctrl 公hith) [PC]), or use the context menu in the Library module and select Email Photo. The Export dialog gives you control over how the images are exported. You have the means to adjust the JPEG compression settings, apply screen display sharpening, and choose whether to add a watermark.

Next, Lightroom creates an email-ready sRGB JPEG of the original file and opens in its own email client dialog (**Figure 7.25**). Here, you can enter the email address of who to send to, and so on. In the From section, you can select the Lightroom Email Account Manager, enter your regular Internet hosting settings, and use this to send photos directly from Lightroom. There is an Address button in the top-right corner that allows you to save frequent sender emails, and in the bottom-left section, you can choose from different preset sizes (or select the "Create new preset" option to make your own). All of this is kind of fiddly to configure. A simpler solution is to select your existing email client program in the From menu. In Figure 7.25, you can see I selected Apple Mail. With this configuration, there is no need to enter an email address in the To section or enter a Subject. All you have to do is choose to export as an email, and when you see this dialog, ignore everything and just click Send. This then opens a blank new email window (**Figure 7.26**) with the image or images you selected copied to the body of the email.

The Export dialog also offers a *For Email (Hard Drive)* preset for exporting email photos to the hard drive. This creates permanent saved copies to a specified location that you can then use to copy photos to an email. Overall, the standard *For Email* preset is the best to use to send photos in an email and have Lightroom integrate with your regular email program.

	Apple Mail - 3 Photos	
0:		Cc Bcc Address
Subject:	From:	
	Apple Mail	
ttached Files:		
Include caption metadata as a description label		
Small - 300 px long edge, low quality		
Preset: Medium - 500 px long edge, medium quality Large - 800 px long edge, high quality		Cancel Send
Full Size - Original size, very high quality		
For Email		
For Email Custom settings defined in the Export Options dialog		

Figure 7.25 The Lightroom Mail dialog.

Figure 7.26 An email that's ready to send with photos attached to the body of the email.

NOTE

There are several sites offering plug-ins for Lightroom, such as Jeffrey Friedl's site: regex.info/blog/lightroom-goodies. Also check out the Photographer's Toolbox at photographers-toolbox.com. There you will find links to plug-ins such as Mogrify and Enfuse.

Third-party Export plug-ins

The Lightroom Export dialog can work with Export plug-ins from various third-party providers. To install a plug-in, click the Plug-in Manager button (circled) at the bottom of the Export dialog (**Figure 7.27**), which opens the Plug-in Manager shown in **Figure 7.28**. Clicking the Adobe Add-ons button takes you to an Adobe site where you can search for more Lightroom plug-ins.

Figure 7.27 The Plug-in Manager button is shown circled in the Export dialog.

Figure 7.28 The Lightroom Plug-in Manager with a few third-party plug-ins already loaded.

Exporting video files

You can use the Export dialog to export video files. To do so, you must first have the Include Video Files box checked in the Video section (Figure 7.29). You then have three options. If you want to include video files in an export and export them in their unedited state, you should choose Original from the Video Format menu. If, on the other hand, you have edited them in Lightroom using the Quick Develop controls, or have edited the trackline, you can choose to export edited videos using either the H.264 or DPX video formats. Clearly, if you have spent time making use of Lightroom's video-editing features, you will want to make sure your editing work is applied to the video files on export. Of the two available formats, it is more likely that you will want to choose H.264, as this is best known as the codec standard for Blu-ray discs and is also widely used for streaming Internet content. It is also the format you would need to use for videos to go on YouTube, Vimeo, or iTunes. The four quality options allow you to export anything from a high-quality video to a low-quality, small video suitable for fast streaming on mobile devices. Maximum matches as close to the source as possible (1920x1080, 25.000 fps, 22 Mbps). High produces high quality, but with a possible reduction in video bit rate (1920x1080, 25.000 fps, 22 Mbps). Medium is suitable for web sharing and higher-end tablets (1280x720, 25.000 fps, 8 Mbps). Low is suitable for mobile devices (480x270, 25.000 fps, 1 Mbps).

The Digital Picture Exchange (DPX) format is a more specialist, folder-based video format. It is lossless, which means that it produces export folders that are many times bigger in file size than the original video clips. It is really intended as an intermediate format for working interoperatively with professional video applications, such as Adobe After Effects and Adobe Premiere Pro.

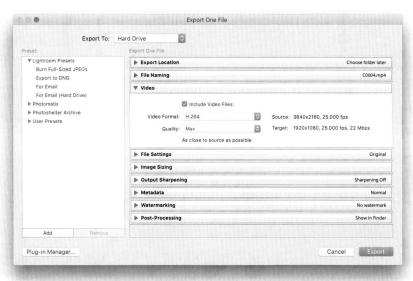

Figure 7.29 The Video Export options.

NOTE

Here are the DPX options:

DPX 24p Full Range: 1920x1080 24p Full Range (max bit depth).

DPX 25p Full Range: 1920x1080 25p Full Range (max bit depth).

DPX 30p Full Range: 1920x1080 30p Full Range (max bit depth).

8 Printing

How to get perfect prints and work efficiently in the Print module

Digital printing has come a long way from the early days of Photoshop, when few photographers were convinced you could produce a digital output from a computer that would rival the quality of a photographic print. Graham Nash and Mac Holbert of Nash Editions were early pioneers of digital printing and the first people to demonstrate how inkjet technology could be used to produce print outputs onto high-quality art paper. In the intervening years, we have seen amazing breakthroughs in technology and pricing. These days, you can buy a photographic-quality printer for just a few hundred dollars. But, alas, many people still get beaten by the complexities of the operating system print dialogs and the inability to make print color management work for them.

Fortunately, the Print module in Lightroom can make your life much easier. Here, you are able to see previews of how the photographs will be laid out on the page. You can set up batches of images in a print queue to produce high-quality prints, or work in draft print mode to quickly generate sets of contact sheets. Plus, the built-in Print module sharpening means you can get nicely sharpened prints without resorting to specialist sharpening routines in Photoshop. Best of all, once you have mastered how to configure your print settings, you can save them as a template setting for more reliable and consistent print results.

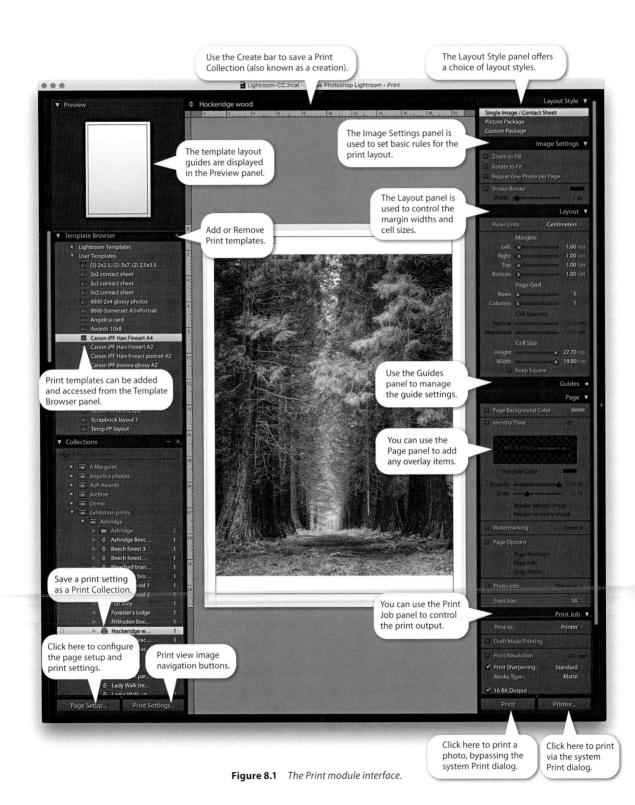

The Print module

The Print module (**Figure 8.1**) provides you with complete control over the print page layout and provides proper-sized previews of the images that have been selected for printing. Starting from top right, the Layout Style panel offers a choice of print layouts: the Single Image/Contact Sheet layout, the Picture Package, or the Custom Package layout. The Image Settings panel can be used to apply basic rules such as how the selected image or images fill the cell areas and whether to rotate the images for the best fit, zoom and crop the photos to fit a cell, or add a stroke border.

The Layout panel can then be used to define the margins, grid layout, and cell size for the images. To help you get started, you can choose from several templates in the Template Browser panel on the left, and you can preview the layout format in the Preview panel as you hover over the items in this list. The Template Browser print templates make it easy to switch print configurations and experiment with different page-layout setups. Once you have settled on a template design, you can easily apply it to other photos and then just click one of the print buttons to make a print.

The Guides panel lets you determine the visibility of various guide items, whereas the Page panel lets you add information to the print. Here, you can place your identity plate as a logo or as custom text and add a watermark plus other items, such as page numbers. You can also include additional file information below the print or individual print cells on a contact sheet and apply a custom page-background color.

The Print Job panel then lets you decide how the page or pages should be printed (there is no need for an Image Resize dialog in the Print module, because the Page Setup options and Print Resolution in the Print Job panel are all you need to size an image correctly for print). The Draft Mode Printing option is great for speedy print jobs, because it makes full use of the large JPEG previews that Lightroom has already rendered. Providing the previews have all been built, the print processing will be virtually instantaneous. When Draft Mode Printing is disabled, Lightroom always processes the image data from the original master file, and you can decide which level of output sharpening to apply. For easy printing, you can use the Managed by Printer setting, or you can select a custom print profile and rendering intent. You can then click the Page Setup button at the bottom to specify the page setup size and paper orientation and click the Print Settings button to specify the print output settings, such as the paper media type and print quality.

This is how things look on a Mac setup, but on Windows systems Lightroom has a single Page Setup button. This is because the Windows print drivers allow you to access the Page Setup and Print Settings options from the one dialog. Both the Page Setup and Print Settings configurations can be saved as part of a print template, which can help reduce the number of opportunities for a print error at

TE

Most of the time, you can ignore the Create bar and just go ahead and print. However, when creating special print jobs that involve configuring specific photo selections and specific Print module settings, it is advisable to go to the Print module and save these settings as a new Print Collection.

Figure 8.2 The Print module Create bar.

Layout Style ▼

Figure 8.3 The Layout Style panel.

Single Image / Contact Sheet

Picture Package Custom Package

Layout Style panel

This panel determines whether you use the Single Image/Contact Sheet, Picture Package, or Custom Package layout styles (**Figure 8.3**). The selection you make here has a bearing on all the other panels displayed in the Print module. For example, if you select the Picture Package or Custom Package layout styles, the remaining panel options will look rather different from those shown in Figure 8.1. Seeing as the Single Image/Contact Sheet layout is the one you are likely to use most often, I will run through these panel options first.

Figure 8.4 The Image Settings panel.

Image Settings panel

The Image Settings panel (**Figure 8.4**) provides some elementary control over how the selected image or images fill the print cell areas. If the Zoom to Fill option is selected, the whole cell area is filled with the selected image so that the narrowest dimension fits within the widest grid cell dimension, and the image is cropped accordingly. Images that have been cropped in this way can be scrolled within the cells in the print layout. The Rotate to Fit option automatically rotates the images to fit the orientation of the print cells. For example, this can be useful when printing a contact sheet with a mixture of landscape and portrait images and you want each image on the contact sheet to print to the same size. The Repeat One Photo per Page option is applicable if the layout you are using contains more than one cell and you want the image repeated many times on the same page.

A stroke border can be added to the outer cell area and used to add a key line border to your photos. However, at lower print resolutions, the width of the stroke border may have to be adjusted to suit the print output. This is because narrow border lines may print unevenly, and you can end up with a line that is thicker on one side of the image than the other. The only way to tell if this will be the case is to make a print and see what it looks like.

Layout panel

The Layout panel can be used to decide how an image (or multiple images) are positioned in a page layout, and scrolling through the Lightroom print templates in the Template Browser panel will give you a quick feel for what you can achieve using the layout controls. Notice how the Layout panel settings in **Figure 8.5** relate to the page layout shown in **Figure 8.6**. Also notice how the Margins settings take precedence over the Cell Spacing and Cell Size settings. After you set the margins, the Cell Spacing and Cell Size adjustments adapt to fit within the margins.

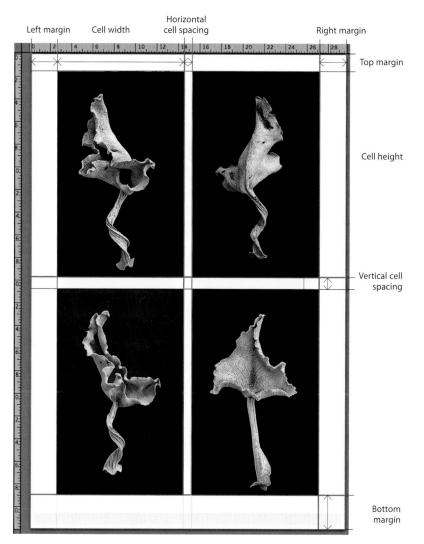

Figure 8.5 The Layout panel.

A quick way to adjust the margins or, indeed, any of these guides is to click the guidelines in the content area and drag them. When you make layout adjustments using this method (or casually adjust the sliders in the Layout panel), the images often auto-adjust in size as you make refinements. If it is essential that the images be a specific size on the page, it is best to use the Layout panel method because this gives you the most precise control over the image placement and layout measurements.

Figure 8.6 The page layout divisions highlighted here can be controlled via the Layout panel.

NOTE

As you adjust the Page Setup settings to select different paper sizes, the Page Bleed area will vary and often appear asymmetrical. This is because some printers require a wider page bleed gap along the trailing edge of the paper. With some applications, centering the print centers the image without allowing for the offset page bleed area; therefore, prints may still print off-center. With Lightroom, turning on the Page Bleed view lets you take into account the page bleed and adjust the margin widths accordingly. This ensures that your prints are always properly centered.

Margins and Page Grid

To place an image precisely on the page, the first step is to set the widths of the margins. If you want to center a photograph, make sure the margins are set evenly and, most important of all, that the image is placed within the widest page bleed edge. Inside of the margins is the Page Grid area, which when set to print a single cell, prints a single image on the page. If you want to print multiple images on each page, you simply adjust the Rows and Columns sliders. The Cell Size sliders determine the size of the print cell area. If the Cell Size sliders are dragged all the way to the right, the cell sizes expand to the maximum size allowed. But by making these smaller, you can restrict the printable area within the cell. However, the cell size adjustment is always centered within the Page Grid area set by the margins, and the margin adjustments take precedence over the Page Grid area. Any readjustments made to the margins will therefore have a secondary effect on the cell size area. The Cell Spacing sliders are active only if the page grid is set to use two or more cells. If you refer back to Figure 8.5, you can see how I applied a 1 cm Vertical and Horizontal spacing to the 2 x 2 image layout.

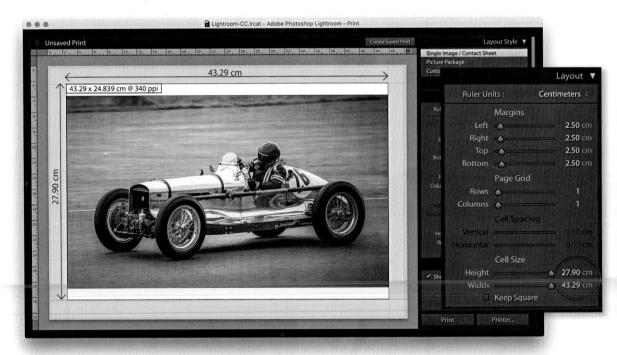

1. With this page layout, the margins (which are shaded blue) constrain the printable area by 2.5 cm left, right, top, and bottom. The cell size is set to the maximum height allowed, which is 27.90 cm. But with the image width constrained to 43.29 cm, the print image fills the width but does not fill the full height of the cell.

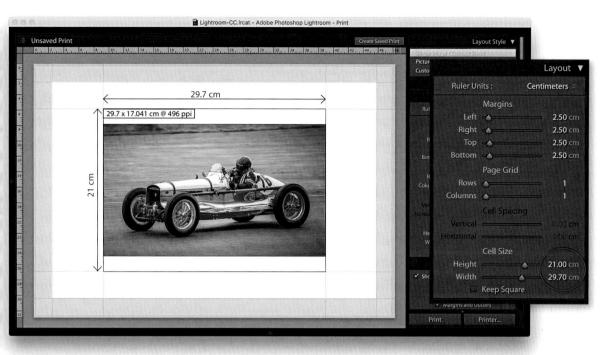

2. In this example, the margins remained the same, but the cell height and width sizes were reduced to an A4 metric size of 21 cm x 29.7 cm. Note the Dimensions box in the top-left corner of the print cell. This indicates the actual print size and resolution (see below).

Guides panel

The Guides panel can help you plan a page layout. The rulers can be made visible by checking Rulers in the Guides panel (or use \(\mathbb{R} \) [Mac] or [Ctrl] [R] [PC] to toggle the ruler visibility). The ruler unit measurements can be altered by clicking the Ruler Units menu in the Layout panel (**Figure 8.7**) or right-clicking the rulers themselves, where you can set these to inches, centimeters, millimeters, points, or picas. The Page Bleed displays a light-gray shading to represent the non-printable areas, whereas the Margins and Gutters and Image Cells check boxes allow you to independently show or hide these items. When the Dimensions box is checked, Lightroom displays the print dimensions in the top-left corner of the cell. This shows the physical unit dimensions, and if Print Resolution is deselected in the Print Job panel, it also shows the pixel resolution the file will print at. It is recommended that you deselect Print Resolution in the Print Job panel and let Lightroom automatically calculate the pixel resolution for you. This is because Lightroom can auto-print-sharpen for any pixel resolution between 180 and 1440 pixels. If the photo's image size exceeds these limits, a plus or minus sign appears, warning you to set an appropriate Print Resolution in the Print Job panel. Lastly, the Show Guides check box lets you show or hide all the Guides panel items.

Figure 8.7 The Layout and Guides panels.

Instead of printing a contact sheet from the Print module, you can always output it as a PDF document via the Print dialog. This can allow you to send a print document such as a contact sheet via email for others to open on their computers or print remotely.

Multiple cell printing

When the Single Image/Contact Sheet layout is set up to print using multiple cells, the Cell Spacing options in the Layout panel become active and these let you set the gap spacing between each cell. In Figure 8.8, I created a custom 3x3 contact sheet template in which the Cell Spacing was set to 0.8 cm for the Vertical spacing and 1.66 cm for the Horizontal spacing. The Cell Size and Cell Spacing settings are interdependent, so if you adjust one setting, the other will compensate. See how in this contact sheet layout, the Keep Square option in the Layout panel was left unchecked. With some contact sheet template designs, it can be useful to have this item checked because it ensures that both landscape and portrait images are printed at the same size on the page and are always printed upright without having to rotate the images for the best fit within the cells. In this case, it was not necessary to do so because all the photos were oriented the same way in portrait mode.

Multiple cell print templates are ideal for generating contact sheet prints from selections of images. When you select more images than can be printed on a single page, Lightroom autoflows the extra images to fill more pages using the same template design and creates as many print pages as are necessary to print the entire job. However, you do need to be aware that the Print Job settings will have a major impact on how long it takes to render multiple pages of images. For fast contact sheet printing, I suggest you always choose the Draft Mode Printing option in the Print Job panel. When this option is selected, Lightroom renders the contact sheet images based on the high-quality preview images that should have already been generated. I say "should have," because this is something you may want to check before you click Print. Whenever a new batch of images is imported, Lightroom automatically generates the thumbnails followed by the Standard previews of all the images. If you have just imported a large number of photographs into Lightroom, it may take a little while for Lightroom to generate all the Standard previews. Until Lightroom has done so, choosing Draft Mode Printing may result in some of the images appearing pixelated when printed because they were rendered from the low-resolution thumbnails only. When you are in the Print module, carry out a quick preview of all the pages that are about to be printed and check if the image previews look like they have all been fully processed. If you see an ellipsis warning indicator in the top-right corner, Lightroom is still busy rendering the preview for that image. Having said this, the Lightroom catalog management is much faster than it was previously, and you are less likely to encounter this problem as the previews can be accessed in the Print module more or less right away. Overall, I find that the Draft Mode Printing option in Lightroom is invaluable in the studio because the print-rendering process can be so quick. The only limiting factor is how long it takes the printer to print all the pages.

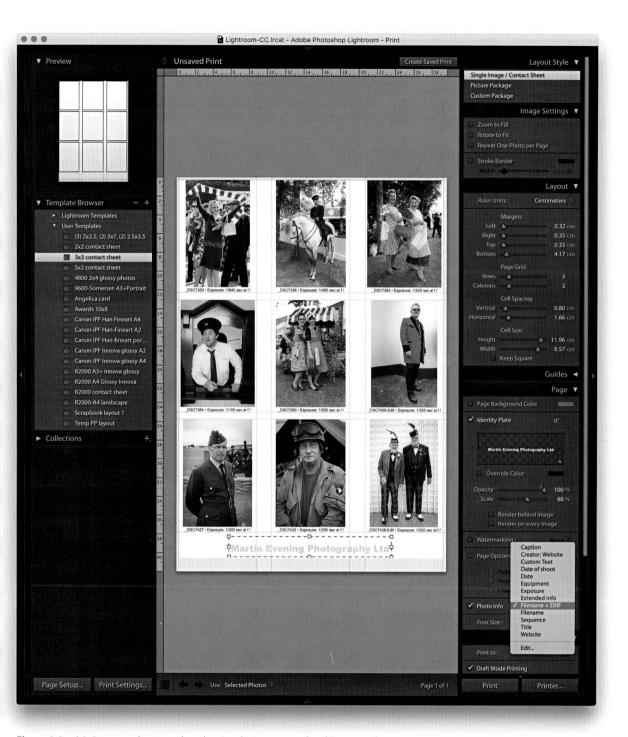

Figure 8.8 A 3x3 contact sheet template showing the Layout panel and Page panel settings.

Figure 8.9 The Page panel showing the Identity Plate menu.

Page panel

The Page panel options (Figure 8.9) determine which extra items are printed. The Page Background Color option lets you choose an alternative backdrop color to print with. For example, you might want to choose black for a contact sheet image layout. When the Identity Plate option is selected, you can click in the Identity Plate preview to reveal the list of identity plate presets and choose Edit to open the Identity Plate Editor dialog. Here, you can choose between adding a styled-text nameplate or a graphical logo. You can then use the Page panel controls to adjust the Opacity and Scale. You can set the scale by adjusting the Scale slider or by clicking and dragging the corner or side handles of the box. You can print an identity plate as big as you like, providing the identity plate image has a sufficient number of pixels to print from. (On page 462, I show how you can use a large graphical identity plate to create a photographic border.) Also, you can rotate the identity plate by going to the Rotate menu circled in Figure 8.9. If you want to repeat your logo in a multiple grid cell layout, choose the "Render on every image" option; there is also a "Render behind image" option for placing large identity plate images in the background. The Watermarking section lets you add a watermark as part of the print image (refer to Chapter 7 for details on how to configure the Watermark Editor).

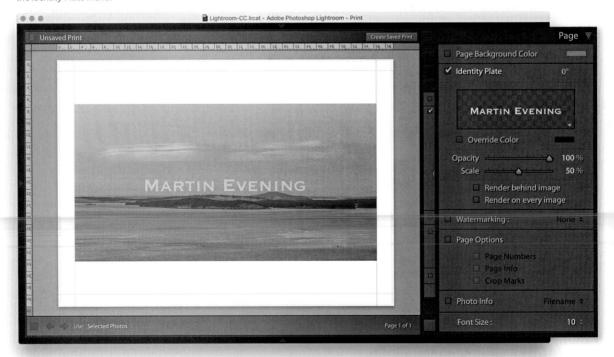

1. When the Identity Plate option is enabled, the current identity plate can be added as an overlay.

2. I wanted to change the identity plate settings, so I clicked the downward triangle in the bottom-right corner of the Identity Plate preview in the Page panel and chose Edit. This opened the Identity Plate Editor dialog, where I chose an alternative font and font size. To change the font color, I clicked the font color swatch (circled) and used the system color picker to choose a new color.

3. Now back to the Print module. I clicked the identity plate bounding box and dragged to move it downward, keeping it centered horizontally, and readjusted the scale to make the identity plate size smaller. The identity plate can also be nudged in small increments by using the arrow keys on the keyboard.

NOTE

You can download this PNG mask border image from the book's website.

Downloadable Content: the lightroombook.com

Adding a photographic border to a print

It is not immediately obvious that you can add an image of any size as a graphical identity plate, because the preview area in the Identity Plate Editor is so small. Graphical identity plates used in the Top panel should normally not exceed 57 pixels in height, and the small preview space helps you judge the correct height to use here (see the warning message in Step 2 below). For print work and other identity plate uses, there is absolutely no reason why you should be limited by this constraint. You can add a graphic such as a scanned signature or company logo at any size you like, as long as it has a suitable number of pixels to reproduce smoothly in print. Thanks to my colleague Sean McCormack, I was shown the following technique for adding a photographic border to Lightroom print images via the Page panel. In the example shown here, I used a scanned photographic border image, but you can easily substitute other types of borders or use the paint tools in Photoshop to create your own.

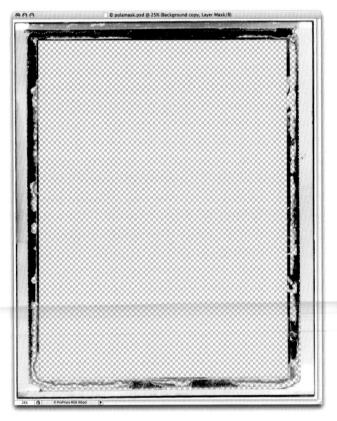

1. I first edited a photograph of a border in Photoshop. This picture is a scan of a Polaroid film border; I created a mask of the center and the semitransparent border edges and hid them with a layer mask. I then saved this image as a flattened PNG file.

2. In the Page panel, I clicked to open the Identity Plate menu and selected Edit. This opened the Identity Plate Editor window where I switched to the "Use a graphical identity plate" option, clicked the Locate File button to choose the recently saved PNG border file, and saved it as a new identity plate.

3. With the new Identity Plate setting selected in the Page panel, I adjusted the scale to make the identity plate fit the edges of the photo.

Page Options

The Page Options let you add useful extras. For example, I find the Crop Marks are handy for when I need to trim prints after output (although the Cut Guides described on page 469 can make this even easier). The Page Info item prints all the information relating to the print output along the bottom of the page, such as the sharpening setting (although it doesn't tell you if the setting used was for Glossy or Matte media), profile used, rendering intent, and printer. This can be useful if you are running tests to evaluate the effectiveness of various profiles and print settings. The Page Numbers option adds a number to the bottom-right corner of the page and is therefore useful if you need to keep the print outputs in a specific page order.

In **Figure 8.10**, I also added a thin black border (via the Image Settings panel) to help frame the picture. You can choose a border-width setting between 1 and 20 points, but if you are using the narrowest border width, make sure the print output resolution is set to at least 300 pixels per inch.

Figure 8.10 The Page panel Page Options.

Figure 8.11 Photo information can be added below each frame.

Photo Info

The Photo Info section lets you add photographic information below each frame (**Figure 8.11**), where you can click on the menu to choose from a list of basic, commonly required items such as Filename or Date. If you choose Edit, this opens the Text Template Editor shown in **Figure 8.12**, where you can select tokens from the pop-up menus to insert and build a new text template. You just click the Insert button to add a selected pop-up menu token to the Photo Info template design; you can add typed text in between the tokens as shown in Figure 8.12. When you are finished, go to the Preset menu at the top and choose Save Current Settings as New Preset; then click the Done button. Once the Photo Info settings have been configured, you can simply select the preset from the Photo Info menu and choose an appropriate font size for the Photo Info text.

This feature has many practical uses, especially as there are many choices of photo information items that can be printed out below each picture. For example, if you are cataloging a collection of images, you may want to print out contact sheets with all the technical data included. Or, if you are sending contact sheets to a client, you may want to include the filename, caption, and copyright information.

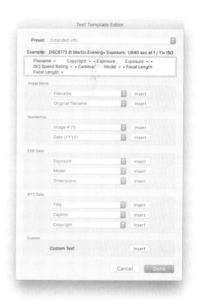

Figure 8.12 The Text Template Editor.

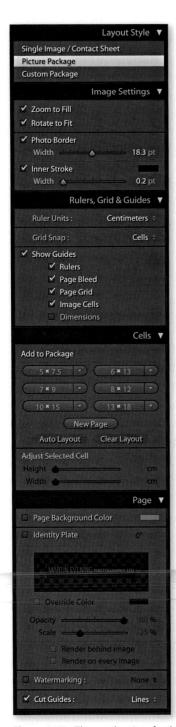

Figure 8.13 The panel options for the Picture Package layout.

Picture Package

So far, we have looked at the Single Image/Contact Sheet options, but there is also a Picture Package engine mode that has its own set of configuration panels (**Figure 8.13**), as well as a few custom templates that can be accessed from the Template Browser panel (**Figure 8.14**). These can be readily identified by the bracketed numbers such as the (3) 2x2.5, (2) 3x7, (2) 2.5x3.5 template that is shown selected in Figure 8.14. The purpose of the Picture Package templates is to allow you to produce multiple-sized photographs on a single-page layout. For example, commercial portrait photographers may use this feature to produce multiple print variations on a single sheet of paper. Rather than be forced to print out two or more different print sheets that use different print sizes, you can produce all the different size prints you need on a single sheet of paper.

Image Settings panel

Here, you have the same Zoom to Fill and Rotate to Fit options as you have in the Single Image/Contact Sheet layout style mode. There is a Photo Border slider for setting the border padding width inside each cell and an Inner Stroke slider that can be used to set the stroke border width.

Rulers, Grid & Guides panel

The Ruler Units options are identical to those discussed earlier. Below this are the Grid Snap options. Basically, you can customize the Picture Package layouts by dragging and dropping individual cells, and the Snap options let you choose to snap to the grid lines or other cells when adjusting the placement of the cells (or turn this option off). The Show Guides options let you turn on or off various items, such as Rulers, Page Bleed, Page Grid, Image Cells, and Dimensions.

Cells panel

To create a new Picture Package layout setting, you need to select Picture Package in the Layout Style panel and click the Clear Layout button in the Cells panel. You can then add new cells to the blank Picture Package layout by clicking the Cell size buttons. These range in size from 2 \times 2.5 inches to 8 \times 10 inches (or 5 \times 7.5 cm to 13 \times 18 cm, if using centimeter units).

You can stick with these default size recommendations, or you can click a cell-size button's arrow and select Edit from the pop-up menu to create and add a new custom cell size (**Figure 8.15**). As you click the cell buttons, new cells are added to the layout, and they are automatically placed to best fit the current Page Setup layout. To arrange the cells better, you can try clicking the Auto Layout button. This rearranges the cells to find what would be the best fit for the page layout. Lightroom does so with a view to what would be the most efficient use of space yet still allow you to trim your photos easily with a paper cutter. As you try to

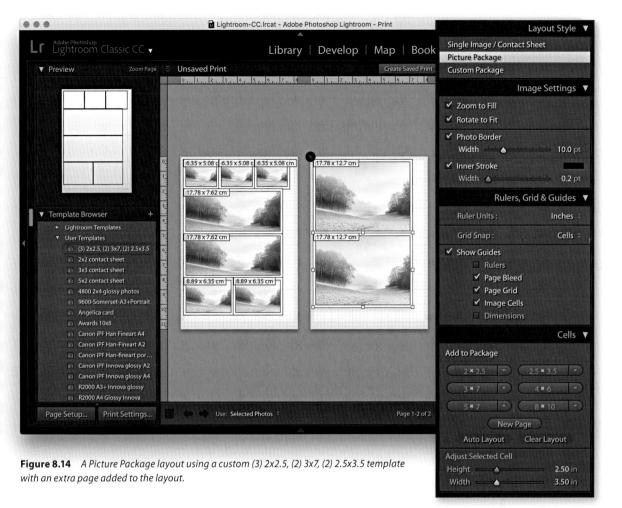

squeeze in more cells, at some point, Lightroom may let you place one more cell, but this will not necessarily allow you to trim the pictures that easily. Even so, the Auto Layout option can otherwise be a useful paper-saving option. The other option is to click a cell and manually drag it to a desired location on the page; this is where the Snap options can come in handy, as they can help you align the cell images. You can use the Zoom to Fill, Rotate to Fit, and Photo Border and Stroke options in the Image Settings panel to refine the layout and determine how the photos will appear within the cell frames.

As you add more cells and there is not enough room on the page, Lightroom adds new pages automatically. You can then adjust the arrangement of the cells' layout across two or more pages. If you want to delete a page, just click the cross in the top-left corner.

Figure 8.15 You can create new cell-size settings by clicking a cell-size arrow and selecting Edit.

Downloadable Content: thelightroombook.com

Custom Package

Custom Package can be regarded as an extension of the Picture Package layout style. The main difference here is that, with Custom Package, you can create and save free-form layouts for placing selected, individual photographs on a page. Figure 8.16 shows a scrapbook-style page layout. To add frames, click the buttons in the Cells panel. Once you have done this, you can resize the cells as desired and drag photos from the Filmstrip into the layout cells. Once they're placed, you can edit the size and proportions of each cell: Click to select it and drag one of the handles to achieve the desired size and shape. Or, you can check the Lock to Photo Aspect Ratio option to have the cells automatically resize to match the proportions of the photos you drag to them. If you click the New Page button in the Cells panel, you can add extra pages to a Custom Package layout. Custom Package layouts are limited to six pages at a time. Having said that, it is possible to exceed the six-page limit to create batches of Custom Package layouts and use the arrow keys in the Toolbar to navigate between them. There is a PDF on the book's website with more detail about this feature.

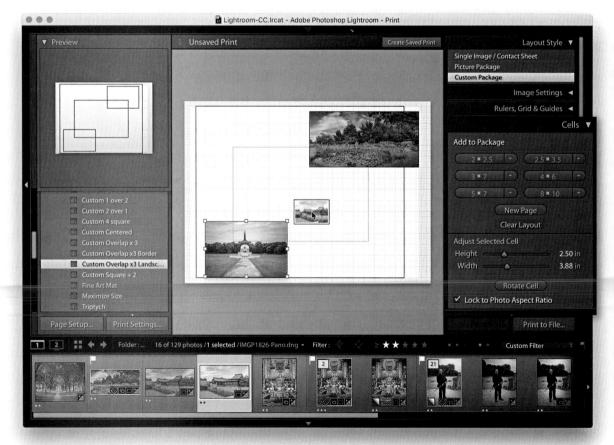

Figure 8.16 The Custom Package Layout Style.

Picture Package/Custom Package Page panel

The Picture Package and Custom Package layout style Page panel is slightly different from that available when using the Single Page/Contact Sheet layout style. You do have the Page Background Color and Identity Plate options, with which you can add a custom identity plate to a Picture Package/Custom Package layout, but there are no Page Options or Photo Info options. One unique thing featured in the Picture Package and Custom Package layout modes is a Cut Guides option. When this is checked, it adds cut guides to the print that can be in the form of crop marks at the edges or crop lines that intersect on the page. Now, although this is a specific package layout feature, it also happens to be useful for single-image print layouts, such as in the **Figure 8.17** example. This can make it easier to trim prints to an exact size in cases where it is not easy to see where the print edge should be, such as photographs that have a white background.

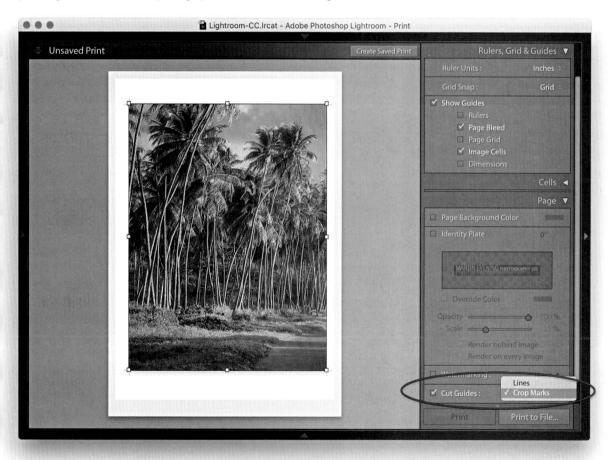

Figure 8.17 The Picture Package/Custom package mode with the Page panel showing.

Page Setup

Before you make an actual print, you first need to click the Page Setup button at the bottom of the left panel section or use the 黑心Shift P (Mac) or Ctrl 公Shift P (PC) shortcut. This takes you to the Page Setup (Mac) (Figure 8.18) or Print Setup (PC) (Figure 8.19) operating system dialog. Here, you need to establish which printer you plan to print with and enter the paper size you are about to print to, followed by the paper orientation: either portrait or landscape. The available Paper Size options will most likely vary depending on which printer model you have selected, as the subsequent options will be restricted to the various known standard paper sizes that are compatible with that particular printer. However, if the size you want to use is not listed, it is usually guite easy to create a new custom page size. The main difference between the PC dialog and the Mac dialog is that the PC Print Setup dialog has a Properties button that takes you directly to the Print Settings section of the system Print dialog (which is why there is only a single Page Setup button in the PC version of Lightroom). The Scale box in the Mac dialog (Figure 8.18) lets you scale the size of the print output, but I advise you to leave the Scale set to 100% and use the Print module Layout panel or Cells panel to adjust the print area size.

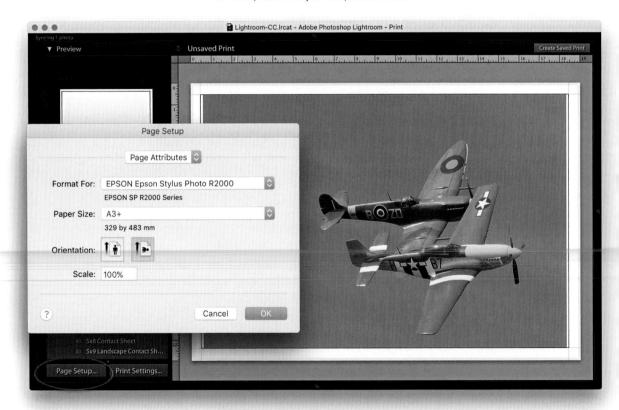

Figure 8.18 The Mac Page Setup dialog.

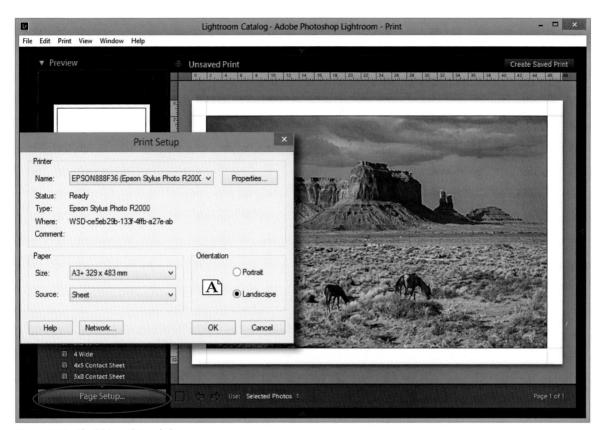

Figure 8.19 The PC Page Setup dialog.

Print resolution

In Lightroom, there is no need to resize an image for printing. After you have configured the Page Setup settings, Lightroom will automatically sample the image up or down in size to produce a print image that has the right number of pixels to match the image dimension size that is a result of the Page Setup, Layout panel, or Cells panel settings and the Print Job panel Print Resolution setting. If you deselect the Print Resolution box in the Print Job panel, Lightroom adjusts the resolution automatically. It is only when the print resolution ends up falling outside the 180 to 1440 ppi range that it might be necessary to override the Print Resolution setting by checking this box and manually entering a value that keeps the print resolution within the above range.

Figure 8.20 The Print Job panel.

Print Job panel

People often ask if Adobe could come up with a better print driver. But this is a problem that neither Adobe nor the printer manufacturers are able to resolve completely. This is because the print driver interfaces are dictated by the rules laid down by the computer operating systems. Lightroom is able to ease the printing headache by allowing you to save print settings within a template, but once you click the Page Setup, Print Settings, or Print button, you are totally in the hands of the operating system's print driver.

Print job color management

The Color Management settings provide you with simple and advanced printing options. For simple printing, leave the Profile set to Managed by Printer (Figure 8.20) and click the Print Settings button (Mac) or Page Setup button (PC) to open the system Print dialogs shown opposite. This method does, however, lock you into using the Perceptual rendering intent, where black point compensation is activated. Basically, you need to choose the appropriate print settings, such as the paper/media type you are going to print with and the print quality. Most important of all, if you are using the Managed by Printer option, ColorSync must be enabled in the Color Management section (Mac) or ICM enabled in the PC Advanced Print Properties panel. These days, ColorSync is usually enabled automatically in the background and you don't have to do anything. After you have configured the relevant print settings, click Save to save these print settings changes.

The Lightroom printing procedure

Regardless of which print method is used, the printing procedure is essentially the same. You must first configure the Page Setup settings to tell Lightroom which printer and the size of the paper you are using. Next, you configure the Print settings to tell the printer how the print data should be interpreted. Then you can click the Printer button (MP [Mac] or Ctrl P [PC]), which takes you to the final Print dialog. Or, use the Print button (\mathbb{R} Alt) (P) [Mac] or (Ctr) (Alt) (P) [PC]) to bypass the system dialog completely. The following steps show the settings I would use for printing to an Epson R2000 printer. The print driver dialogs will vary from printer to printer; some offer different driver interface designs and, in some cases, more options. Unfortunately, there is no easier, universal way to describe the printing steps you should use here. The thing is, the print drivers are designed by the printer manufacturers, which, in turn, have to work within the limits imposed by the different computer operating systems. Not even Microsoft or Apple can agree on a common architecture for the print driver settings. It may be helpful to know, though, that once you have configured the page and print settings, you can permanently save these as a print template. And because you are able to save the page and print settings, you can lock the correct print settings to a template and avoid having to configure the print driver each time you make a print.

Managed by Printer print settings (Mac)

1. I clicked the Print Settings button (黑Alt 公ShiftP) to open the Print dialog, which is shown here with the full list of options for the Epson R2000 printer. You may need to select the printer again to make sure it matches the one selected in the Page Setup dialog.

2. In the Print Settings section, I selected the media type that matched the printing paper and selected the optimum photo color setting and print quality. I then clicked the Save button to return to the Lightroom Print module.

NOTE

As you configure the Page Setup and Print settings, they are saved as part of the current print layout setup. If you proceed to save a print template, the Print settings will be saved along with all the other Layout settings. Later in this chapter, I explain how to update an existing print template with the modified Print settings.

Managed by Printer print settings (PC)

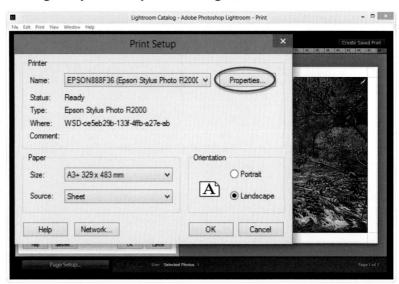

1. Here, I clicked the Page Setup button in the Print module (Ctrl Alt Shift P). The Print Setup dialog is similar to the one in Figure 8.19. I then needed to click the Properties button to go to the Printer Properties dialog.

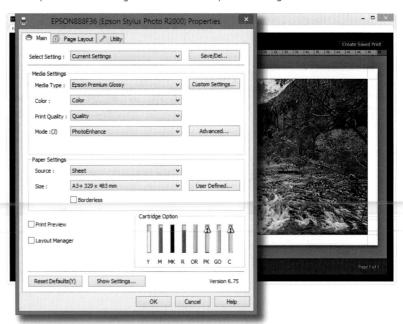

2. In the Printer Properties dialog, I selected the correct print media type, the best photo print quality, and optimum photo print mode. I clicked OK to these settings and clicked OK once more to return to the Lightroom Print module.

The Managed by Printer method, outlined in the steps, work reasonably well for many photographers. Although some of the more advanced drivers provide a greater range of options, the basic print settings shown here are common to most print drivers. I generally use the Managed by Printer method for Draft Mode Printing whenever I need to generate contact sheet prints. With the Managed by Printer method, the most important thing is that ColorSync or ICM color is somehow enabled. If the driver doesn't do this automatically, look for an ColorSync or ICM check box.

There will sometimes be a further choice of Color Settings options. If offered a choice, select whatever looks like the Standard, or optimum photo print output setting. Just make sure you don't have a vivid color or "No color adjustment" setting selected.

Printer profiles

When you buy a printer and install the print driver that comes with it, the installer should install a set of standard profiles for a select range of print media types that are designed for use with your printer. For example, if you purchase an Epson printer, the print driver installs a limited set of profiles for use with a specific range of Epson printing papers. If you want to add to this list, it is worth checking out the printer manufacturer's website and other online resources to see if you can obtain printer profiles that have been built for your printer. The other alternative is to have custom printer profiles made for you by a color management expert.

There was a time when it was necessary to have custom print profiles built for each printer because of fluctuations in the hardware manufacturer process. But these days, you can expect a much greater level of consistency. Hence, a custom profile built for one printer should work well when used with another printer of the same make.

Print Adjustment controls

At the bottom of the Print Job panel are the Print Adjustment options (Figure 8.21). When Print Adjustment is checked, you have the option to modify the Brightness and Contrast of the print output independent of the actual Develop settings. You see, there has been a problem where some people reckon their print outputs from Photoshop and Lightroom are too dark. The reason for this may be that the display has been calibrated too bright or the prints are being viewed under dim lighting conditions. What is offered here is a kind of workaround to tweak the output, making the prints lighter/darker or more contrasty. It is also important to point out that these adjustments do not affect the screen display image. The adjustments are seen only in the print output when you make an actual print or save a JPEG print file.

MI

Do not click the Printer or Print buttons in Lightroom until you have configured the Page Setup and Print settings. Click these buttons only after you have configured the other settings first.

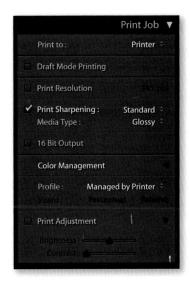

Figure 8.21 The Print Job panel showing the Print Adjustment settings.

TIP

The most effective way to stop the system print preset settings from interfering with the Lightroom Print settings is to click the Print module Print button. This ensures the print output prints using the Print settings established in Lightroom are not affected by any external factors.

Print

After the Page Setup and Print settings have been configured, you just need to send the print data to the printer. If you click the Print button, Lightroom conveniently bypasses the system Print dialog (see Tip). Alternatively, if you do wish to see the system print settings, you can click Printer to open the Print dialog (**Figures 8.22** and **8.23**). The printer model will be the same as whatever was selected previously. On the Mac, the Presets must say Default Settings, and if you select Print Settings from the menu circled below, this should confirm you have the correct preconfigured print settings selected.

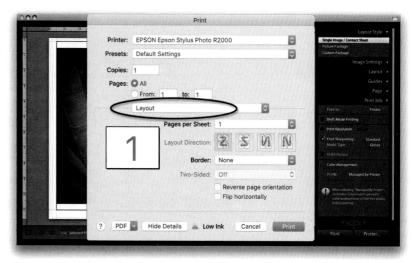

Figure 8.22 Clicking the Printer button on the Mac reopens the system Print dialog, with the pre-established print settings configured. Click Print to make a print.

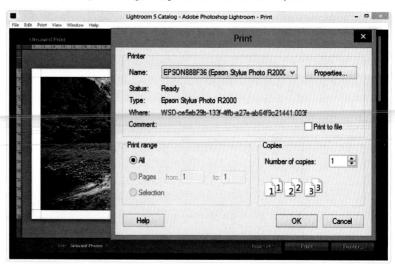

Figure 8.23 Clicking the Printer button on a PC reopens the Print dialog with the settings that were established previously. Just click OK to print the image.

Printing modes

When you make a regular print output, Lightroom reads the image data from the original master file and resizes the image on the fly to match the print size specified in the page layout and ensures you get the highest print quality possible, whatever the print size is. However, if you are processing a large number of images to produce a set of contact sheet prints, it can take a long time for Lightroom to read in all the image data and resize the images. Whenever Draft Mode Printing is checked, Lightroom instead uses the image previews to generate the print files. The advantage of this approach is that the print processing time is pretty much instantaneous, and this can make a huge difference in the time it takes to generate, say, 10 contact sheet pages from a folder of 100 raw images. In Draft Mode, Lightroom uses whatever previews it has to work with. The Standard previews should be sufficient for most Draft Mode print jobs, but it is worth visiting the Library module and choosing Library ⇒ Previews ⇒ Render Standard-Sized Previews before making a set of Draft Mode prints. Draft Mode Printing is perfect for any print job where speed is of the essence. For everything else (especially when you want to produce the highest-quality prints), you will want to deselect this option so you can control the color management via Lightroom and apply the all-important print sharpening (Figure 8.24).

Figure 8.24 The Print Job panel with the Draft Mode Printing option deselected.

Print sharpening

Photographic images will inevitably appear to lose sharpness as a natural part of the printing process. To address this problem, it is always necessary to add some extra sharpening prior to making the print. You can do this by checking the Print Sharpening option in the Print Job panel. You won't be able to preview the sharpening effect, because Lightroom applies this behind the scenes to ensure the picture looks acceptably sharp when printed. So, when you are working in the Lightroom Print module, enabling Print Sharpening is essential if you want your prints to look as sharp as they do in the screen preview. The print sharpening is all thanks to Adobe working closely with PixelGenius to bring PhotoKit SHARPENER routines to Lightroom. All you have to do is enable the Print Sharpening option, indicate whether you are printing to matte or glossy paper, and choose Standard to apply the default sharpening. You can select Low or High if you wish to modify the standard strength setting. But if you find yourself preferring High, check if you remembered to adjust the Detail capture sharpening beforehand.

Lightroom automatically resizes the image data to the print size you set in the Layout panel. Providing the print output image ends up falling within the range of 180 to 1440 ppi, there is no real need to use the Print Resolution option to interpolate the print data. Basically, Lightroom automatically applies the correct amount of sharpening on a sliding scale between 180 and 1440 ppi, and it is best to let Lightroom work out the optimum pixel resolution and sharpening. With some prints though, it may help to manually increase the resolution (see Note).

NOTE

If you are making blow-up prints that contain high-frequency edge detail, it is worth checking the Dimensions info box (see pages 456 to 457). If the output resolution appears to fall significantly below 360 ppi, and especially if making smaller prints, it may be worth using the Print Resolution box in the Print Job panel to manually set the file's resolution to 50% more than whatever the native resolution happens to be. When you do this, Lightroom applies an adaptive upsampling routine that combines the Bicubic and Bicubic Smoother interpolation algorithms prior to applying the print output sharpening.

Figure 8.25 The Print Job panel in Print to JPEG File mode.

16-bit output

Image data is normally sent to the printer in 8-bit mode, but many inkjet printers are now enabled for 16-bit printing. You can take advantage of this providing you are using the correct plug-in for the program you are working with; in the case of Lightroom, you'll need to make sure the 16 Bit Output box is checked (Mac only). Some people say the 16-bit printing option is overkill; others claim they can see a difference. Given that 16-bit printing technology is now commonplace, it does seem sensible to have this option available in the Lightroom Print module. In any case, selecting this option will not slow you down, so there is no harm in checking it if this is applicable. I always leave it switched on by default.

Print to JPEG File

The Print to JPEG File option is available from the top of the Print Job panel, and the JPEG file options are shown in **Figure 8.25**. This option was introduced by popular request because a lot of Lightroom customers wanted to have a way to produce print-ready image files directly from the Print module. As you have seen already in this chapter, it is really easy to set up contact sheet layouts and do things like add signatures or add an identity plate overlay as a custom photo border. With the Print to JPEG File option, you can use the Print module to generate a JPEG image instead of sending the data to the printer.

In Print to JPEG mode, you can use the Draft Mode Printing option to quickly generate sets of contact sheet print files. For example, with a JPEG output file, you can send the file to another computer for printing. This is potentially useful for a number of reasons. You can free up using the main computer while you let another computer manage the printing. Also, you can generate JPEG print files for others to share and print from. Or, you could output contact sheets from a shoot via the Print module and send them as email attachments to a client or colleague so that they could run the prints off remotely. When not in Draft Mode, you have access to the same sharpening controls as were discussed earlier. The JPEG Quality slider lets you control how much JPEG compression is applied, and the File Resolution field can be edited to set a specific resolution for the output. When the Custom File Dimensions box is checked, you can also edit the dimensions of the JPEG print file page size to create a custom-sized document (using the current ruler units). In the Color Management section, you have a choice of the four main RGB output spaces—sRGB, Display P3, Adobe RGB, and ProPhoto RGB—along with any other custom print profiles that you may have loaded (see the next section on custom profile printing). You can then select the most suitable rendering intent option.

Custom profile printing

The Managed by Printer printing method lets you print with the color management carried out by the print driver. If you are printing with a modern inkjet printer, you can expect to get good results using the Managed by Printer option so long as the ColorSync or ICM option is somehow enabled in the print driver settings. However, if you want more control over how your images are printed, you are better off getting Lightroom to handle the printer color management. To do this, deselect the Managed by Printer option and choose Other. This opens the Choose Profiles dialog shown in **Figure 8.27**, where you can click the check boxes to enable the printer profiles that are relevant to your print workflows. Here, you can choose canned profiles or custom profiles that have been specially made for your printer. **Figure 8.26** shows how I was then able to change the Color Management Profile setting so that instead of using Managed by Printer, I could choose from a list of chosen printer profiles. This, in turn, offered me a choice of rendering intents for the print job (see page 482).

If you choose Lightroom to handle the printer color management, you must adjust the print settings accordingly. For example, if you select a standard printer-supplied profile, the Media Type selected in the print settings must match the selected profile. If you are using a custom profile generated from a print test target, always make sure you use the exact same print settings as you used to print the target. Most important, the ColorSync/ICM settings should be set to No Color Management, because you want to avoid double-color-managing the print image data.

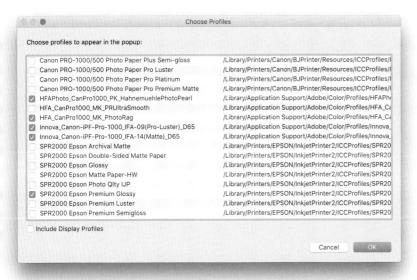

Figure 8.27 The Profile list menu that displays when you click the Other option in the Print Job panel Profile menu.

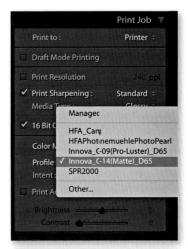

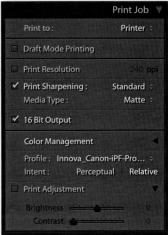

Figure 8.26 When you click the Profile menu in the Print Job panel (top), you can choose a custom profile from the pop-up menu.

Managed by Lightroom print settings (Mac)

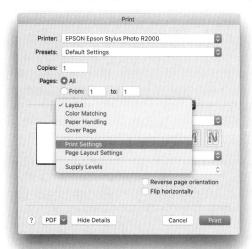

1. The steps outlined here are similar to those for the Managed by Printer procedure. I clicked the Print Settings button to open the Print dialog, which is shown here with the full list of settings options for the Epson R2000 printer.

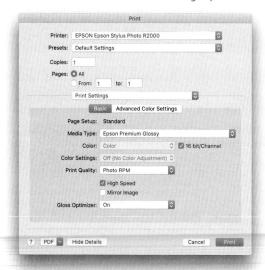

2. Once again, the most critical section is the Print Settings. I had selected the Epson R2000 Premium Glossy profile in the Print Job panel and ensured matching paper was loaded in the printer. Therefore, the selected Media Type also needed to match (because the subsequent Print Quality settings would be governed by the Media Type setting). I selected the desired print quality and speed setting. In the Mac print driver for the Epson R2000, the Color Settings are automatically set to Off. I clicked the Print dialog Save button and was then able to click the Lightroom Print button in the Print module to make a print, bypassing the system Print dialog.

Managed by Lightroom print settings (PC)

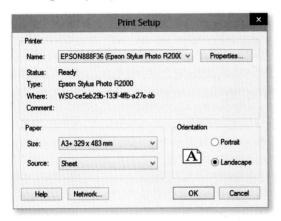

1. When you click Page Setup in the PC Lightroom Print module, the main Print dialog opens. Here, I clicked the Properties button to open the Printer Properties dialog shown in Step 2.

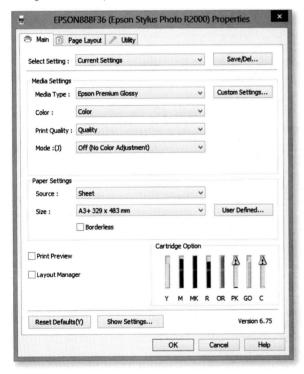

2. Here, I was able to select the correct Media Type and Print Quality. In the Mode section, I selected the Off (No Color Adjustment) option. I clicked OK to return to the Print dialog and clicked OK to save these print settings and return to the Lightroom Print module. I then clicked the main Lightroom Print button to make a print, bypassing the system Print dialog.

NOTE

If you want to have custom profiles made for your printer, your best bet is to contact a color management consultant, who will supply appropriate test targets and direct you on how to print out a target from your printer. However, you cannot use Lightroom to print out such test target images. Target images are always unprofiled, and in the absence of an embedded profile, Lightroom automatically assumes an sRGB profile for the imported images and then converts the data from this assumed space to the native Lightroom RGB space as it is processed through the (non-Draft Mode) Lightroom pipeline.

To make a custom-paper profile for your printer, you will need to use the Adobe Color Printer Utility (tinyurl.com/79sbhmg) and save the settings used to make the print (as described on these pages). When using the custom profile, make sure the exact same settings are applied as you used to generate the test target. All you really need to know is that printer targets must be printed without color managing them and remember to save the print settings so that the saved preset settings can be recalled when establishing the print settings for Lightroom to use.

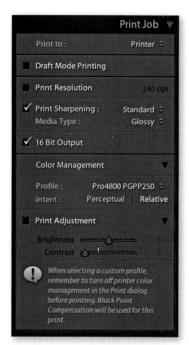

Figure 8.28 In the Print Job panel, you can use the Rendering Intent buttons to choose between Perceptual and Relative for the print output.

Rendering intent

Whenever you deselect the Managed by Printer option and select a custom print profile in Lightroom, you have two choices of rendering intent: Perceptual or Relative (**Figure 8.28**). Hovering above the rendering intent displays a tooltip with a short description of how this will affect the image.

The Relative rendering intent (also referred to as Relative Colorimetric) maps all the colors in the source image to the nearest equivalent in-gamut color in the selected print profile print space, but at the same time clips those colors that fall outside the gamut of the print space. The Perceptual rendering intent maps all the colors in the source image to fit smoothly within the destination print profile space. Therefore, when Perceptual is used, all color differentiations are preserved. The brightest colors in the source image map to the brightest printable colors in the print space, and all the other colors will be evenly mapped within the gamut of the print space. The difference between these two rendering methods is most obvious when comparing an image that contains bright, saturated color detail, such as a photograph of a flower. With Relative rendering, the brighter colors may get clipped, but with Perceptual rendering, you should see better preservation of detail in the bright color areas.

Some people point out that the downside of Perceptual rendering is that it has a tendency to unnecessarily desaturate the colors in an image where there were no out-of-gamut colors in the first place. In these situations, a Relative Colorimetric rendering may produce a better result. Others argue that if the print does not look good when printed using a Perceptual rendering intent, it may be because you have not fully optimized the image in the Develop module. Personally, I find both rendering intents to be useful. If the image is fairly standard, without large areas of bright color detail, I will usually use Relative, especially if I am printing to glossy media with the wide-gamut inks found in the latest inkiet printers. However, some printers have a more limited gamut; this is especially true when printing to matte art papers using photo matte black inks. When using a Relative rendering intent, I may well see some gamut clipping in the shadow areas, so I find if I use the Perceptual rendering intent, I will get smoother tonal renditions in the shadows when printing images that contain a lot of dark colors. I also find this to be true when printing black-and-white images. In these circumstances, the Perceptual rendering intent is usually the best choice.

The simplest solution is to make use of the Soft Proofing feature in the Develop module. Just switch between Perceptual and Relative when evaluating an image to see which rendering intent you prefer best.

Soft proofing for print output

The soft-proofing feature in Lightroom lets you see a preview of how a printed photo is likely to look before making a print. This is something that has to be done in the Develop module rather than the Print module. This is mainly because only the Develop module can provide a truly accurate preview of how an image will look and also because you need to have access to the Develop controls (mainly the Basic, Tone Curve, and HSL panels) to tweak the soft-proofed image and get it looking as close as possible to the master. But before we look at the soft-proof mechanism in Lightroom, let's consider some of the limitations of color management so you can better understand what you can and cannot do when soft proofing.

Why what you see isn't always what you get

Whenever people complain that color management is not working, it often boils down to their having unreasonable expectations as to how a color-managed system should work. The assumption is that when you photograph a scene, you can then expect to see it portrayed accurately on the computer display, as well as in print. Color management can certainly help you achieve this desirable goal, providing you understand the constraints you are working within. To begin with, you need to appreciate that while the contrast range of a daylight scene might be around, say, 10,000:1, the maximum contrast range that can be achieved in a print output is only 300:1. At the same time, the contrast range of a computer display may be just 1000:1. So, in terms of contrast, neither the computer display nor the print output can be expected to match the original scene. More important is the ability of each device in the chain to capture or reproduce accurate colors. When you take a photograph, the tone and color information you capture is determined by the spectral sensitivity of the sensor. In other words, if your sensor cannot "see" particular colors, it cannot capture them. This is crucially dependent on whether an image has been captured in JPEG or raw mode. If captured as a JPEG, the gamut of the capture file is constrained to that of the selected RGB space, as set on the camera. This will typically be sRGB or Adobe RGB, both of which are significantly smaller than the native gamut of the sensor capturing in raw mode.

Probably the biggest limiting factor is the display itself. Most have quite small color gamuts compared to the actual gamut of the image files you are editing. Such displays are also restricted compared to the gamut of most photographic desktop printers. In fact, the gamut of a typical LCD is not far off that of the ubiquitous sRGB space. In practice, a good many photographers are capturing raw images that contain a wide gamut of colors and are using printers that are capable of reproducing quite deep colors. But they are editing their images in Photoshop or Lightroom via a display that constrains those colors to what is (by comparison) quite a small color space. This is why, for serious color editing work, you should use a display that is capable of displaying a wide color gamut. Smart displays such

The white point set for the display calibration does not really affect how cool or warm your images will appear on the display. When evaluating color, your eyes always adapt relative to whatever they perceive to be the whitest part of any scene. Therefore, it does not matter if you view an image with a warm or cool white point: Your eyes compensate automatically. Similarly, as you view a print under different lighting conditions, your eyes will, again, adapt. What is critical, though, is that when making side-by-side comparisons, such as when comparing a print lit by a calibrated color viewer, the white point of the display matches that of the viewer precisely.

Figure 8.29 The top view shows a soft-proof preview captured on an NEC 3090WQXi display (with an Adobe RGB gamut), and the bottom view shows the preview captured on an Apple LCD (which has a gamut similar to sRGB).

Downloadable Content: the lightroombook.com

as those made by Eizo, NEC, and LaCie are capable of displaying nearly the entire Adobe RGB gamut, which gives you the potential to preview the entire color gamut of most CMYK output proofing devices and also allows you to preview most of the colors that a typical desktop photo printer is capable of reproducing. So, the message here is, if you have invested heavily in buying the best cameras and printers, there is no point in limiting their potential through the use of a cheap computer display. Most photographers are perhaps not even aware of this, but this is one of the main reasons why people complain that their prints do not match what they have seen on the screen. The problem is not with the printing necessarily; it is simply the limitations of the display hardware. Figure 8.29 is interesting because it attempts to show in print the difference that might be seen between a standard display and a smart display with a wider color gamut (even when soft proofing had been switched on in the Develop module). In fact, when soft proofing this photo on an NEC display, I was still unable to see an accurate preview of how the image would actually print. This was because the final print output contained deeper blues and cyans than could be shown on the NEC display. You can download variations of this file from the website and see for yourself what happens when they are printed. There is also a PDF you can download.

If we assume that we can get a reasonably accurate preview of a photograph on a display, the way those colors reproduce in print all boils down to the quality of the ICC profile used to make the profile conversion. At best, a profile conversion is a process in which colors from the source image are transformed to the color gamut of the output device. The profile does not know anything about the colors in a photo other than how to mechanically translate them to the nearest equivalent color in the destination space. An ICC profile conversion does not know which particular colors are of most importance to you; hence it is a dumb process, but one that you can adapt to suit the particular needs of each individual image (which I will be coming to shortly).

Lastly, we have to take into account the lighting conditions under which the final print is viewed and, more particularly, how the luminance brightness of the lighting used to view the prints compares with the luminance brightness of the computer display. A frequent complaint aired on the Photoshop and Lightroom forums is "My prints look too dark," implying that there must be something wrong with the color management system to cause this perceived discrepancy. It is important to understand that in order to evaluate a print properly, the luminance brightness of the print viewing area needs to match that of the computer display. What typically happens is that the printer is located next to the computer in a room where the lighting is quite subdued. This may be ideal when working in Lightroom or Photoshop, but not when it comes to assessing prints. In this kind of situation, anything that comes off the printer that is viewed straight away is bound to appear too dark. To judge a print properly, it should be viewed under lighting conditions where the luminance brightness closely matches that of the display. You can do this by using a calibrated print viewer.

For those on a limited budget, an inexpensive option would be to buy something like the GrafiLite from ColorConfidence (tinyurl.com/7rpjwsa) or a GTI desktop viewer (colourmanagement.net/gti.html). Alternatively, you can adjust the Print Adjustment controls in the Print Job panel to compensate for perceived differences. One of the big problems we see these days is that a lot of LCDs are running way too bright for image-editing work. It is probably no coincidence that this is an issue that has only emerged as everyone switched from CRT to LED computer displays. A lot of LCDs, especially the cheaper ones, have the problem of being too bright. More recently, the emphasis has been on glossy-screen LCDs or LEDs that are capable of showing a high-contrast picture tailored for the optimal viewing of movies and computer games. For photo-editing work, the display you are working with should be capable of operating within the 110 to 140 cd/m2 luminance range. You will need to properly calibrate your display of course, but as long as you have the means to get the brightness down to a sensible level, you are well on your way to having a computer setup where you can preview your images correctly relative to how they are going to print. If you want to be really precise, you might want to purchase a desktop color viewer with dimmable lights. With this type of setup, you will have the means to adjust the luminance of the display and that of the desktop viewer, so that when a print and an the image on a computer display are placed side by side, they will appear to have the same brightness.

Figure 8.30 The Develop module Toolbar with Soft Proofing enabled. The Before/After view button is circled here.

Soft proofing in practice

The goal of soft proofing is to simulate the print output appearance on the display. To enable soft proofing, click the Soft Proofing option in the Develop module Toolbar (Figure 8.30) or press shift to toggle it. When you do this, the Histogram panel changes to become the Soft Proofing panel (Figure 8.31), and you will see a number of things happen. The canvas color fades from gray to white, and the image appearance changes to reflect the current selected profile. The fading to white allows your eyes to adjust to the white background color, but you can right-click the background to access the context menu and change the color if you wish. You would not normally want to do this, but there may be instances where, if you are making a print that will be displayed against a color other than white, applying the same color at the soft-proofing stage may help you visualize the colors better. If the Simulate Paper & Ink option is checked, the white background color will be based on the paper-white information in the current selected profile. You can choose different profiles to soft-proof with by selecting a new profile via the Profile menu. Obviously, you will want this to match the profile you will select later in the Print Job panel settings. Below this are the

Figure 8.31 The Histogram panel as it appears initially in Soft Proofing mode.

NO III

Soft Proofing for CMYK images was removed recently from Lightroom. Therefore, you can no longer select CMYK profiles to soft proof with.

two rendering intent buttons: Perceptual and Relative. The clipping previews are highlighted in Figure 8.31. The one circled in blue is a display gamut warning and uses a blue overlay to highlight the colors that fall outside the color gamut of the computer display. The one circled in red is a destination gamut warning ((Shift)) and uses a red overlay to act as a gamut warning for the destination profile (i.e., it highlights the colors that will be clipped when outputting to the destination profile space). As you roll the pointer over the image, you will see RGB values in place of the camera data. These represent the RGB numbers (using a 0 to 255 scale) for the selected profile output space.

If you adjust the image in soft-proofing mode using the Develop controls, this opens the dialog shown in **Figure 8.32**, where you will be asked if you wish to create a proof-copy version (you can also create a new proof copy by clicking the Create Proof Copy button in the Soft Proofing panel [Figure 8.31]). If you have already clicked Create Proof Copy in the Soft Proofing panel, the dialog will not be shown. The Soft Proofing panel then changes to the view shown in **Figure 8.33**, where the Soft Proofing controls appear highlighted and adds the profile name inside the Copy Name field in the Metadata panel (**Figure 8.34**).

Figure 8.32 This dialog appears whenever you are in Soft Proofing mode and make any kind of Develop module adjustment.

Before and Proof preview

If you click the Before and After view button (circled in Figure 8.30), you can see a Before version alongside the Proof preview. The Proof preview will show a flatter preview, one that takes into account the diminished contrast range of the final print (a glossy print may have a contrast range of 300:1 and a matte print even less). The first thing you will want to do is select the most appropriate rendering intent—either Perceptual or Relative—to determine how the out-of-gamut colors are handled during the profile conversion (see page 482). As you do this, you can compare the Before and Proof previews as you apply Develop adjustments and adjust the Proof preview so it more closely resembles the Before version. Regardless of whether you are using a standard or smart display, the Proof preview at least gives you an idea of how an image might print tonally. Here, you can go to the Tone Curve panel and carefully tweak the contrast to help preserve the "contrast look" seen in the master. You might also want to use the Clarity

Figure 8.33 The Soft Proofing panel in Create Proof Copy mode.

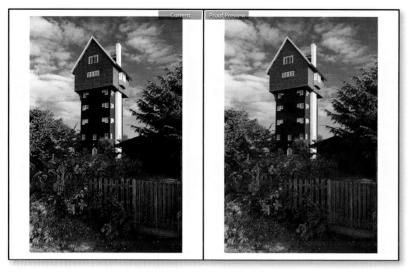

Figure 8.34 Here, you can see a master image with the soft-proofed version alongside it. The proof profile is automatically entered in the Metadata panel Copy Name field.

slider in the Basic panel to boost the midtone contrast. This can be particularly helpful when preparing images to be printed on a matte paper finish. When it comes to trying to match the colors, this is where things get a little more tricky. As I explained earlier, you can make effective color corrections to a proofed image only if you are sure that the display you are working on is capable of previewing the image accurately in the first place. Assuming the display you are working on is able to do this, you can apply fine-tuned tweaks via the HSL panel to adjust the Hue, Saturation, and Luminance of specific colors. This can help you adjust the Proof preview so that it more closely resembles the Before. If there are colors in the original image that cannot be reproduced in print, you can never hope to match these, but you can fine-tune the relationship between the luminance and saturation of the colors in the Proof preview so that you come as close as possible to preserving the relationship seen in the master.

The soft-proofing process gives you the opportunity to overcome the dumbness of a standard profile conversion and finesse the color conversion process in a way that is not possible with a straightforward profile conversion. All you have to do now is make a print using the newly generated virtual copy and make sure that in the Print Job panel you select the same print profile and rendering intent as was selected in the Soft Proofing panel. This is critical, as the print output won't match unless you remember to carry out this final step.

When you make a new snapshot with soft proofing enabled, it defaults to using the profile name (**Figure 8.35**). Therefore, when you adjust an image while soft proofing and choose to create a snapshot, the snapshot will be named appropriately using the current soft-proof profile name.

Figure 8.35 A Snapshot created with soft proofing enabled.

1. To soft-proof this image, I checked the Soft Proofing box in the Develop module Toolbar and selected an output profile from the Profile menu. Checking the Simulate Paper & Ink option adjusted the preview to simulate the contrast range of the media I intended to print to. As soon as I adjusted the Develop settings, this opened the dialog seen here, where I clicked Create Proof Copy.

2. I then clicked the Before and After view button to see side-by-side previews (comparing with the Current State photo) and switched between the Perceptual and Relative rendering intents to see which produced the best-looking preview. In this instance, the Relative rendering intent appeared to work best.

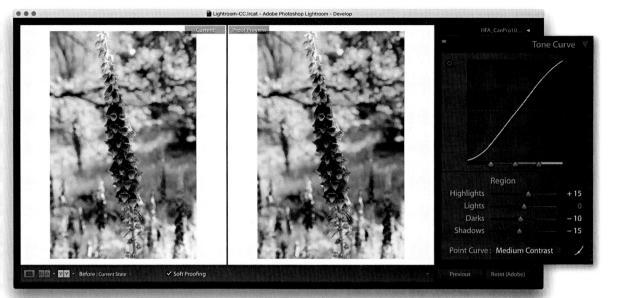

3. Next, I decided to compensate the tone contrast. This can be done by tweaking the Tone Curve sliders. When making matte prints, it may help to also adjust the Clarity slider in the Basic panel, which will boost the midtone contrast.

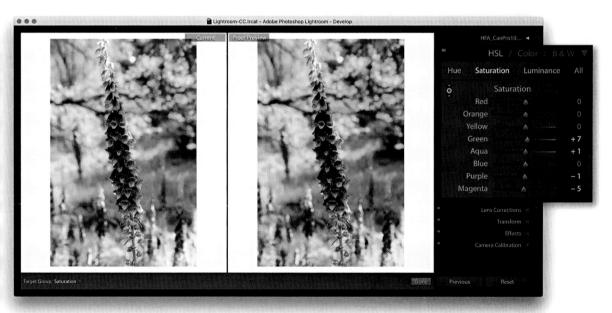

4. In the HSL panel, I tweaked the Saturation, and Luminance sliders to finetune the color relationship. This can help preserve the color relationship and color contrast to achieve a better match with the master version. You can never hope to get an exact match, but soft proofing can get you closer.

Before state options

Let's now look at the Before/After view options. When a master image is selected, the choice will be between the Before State and the Current State. The Before State shows an earlier version of the photo with the Soft Proofing option turned off. It defaults to displaying the import state, but you can update it to any state you want. To do this, disable Soft Proofing and update the Before State with the Current State (**Figure 8.36**) and then enable the Soft Proofing again. However, the Before state is configured this allows you to compare the unproofed image with a proofed version without having to create a virtual copy first. The thing is, you will be editing the master version when you do this, but you should end up with a master image that will print nicely using the selected printer profile. The unproofed master image preview will now look quite different, of course, although you can always reselect the original image state from the History panel. Essentially, the Current State option lets you see how the most recently edited version compares with the proof preview.

If a virtual copy photo is selected, the Before state options will be like those shown in **Figure 8.37**. Here, you still have the Before State and Current State, but also a Master Photo option. This lets you compare the adjustments made to the output-specified, soft-proof virtual copy with the Master Photo version. You may see other virtual copies listed in the Before pop-up menu. This allows you to compare different soft-proof previews (for different output devices) with one another. The names you see listed in the pop-up will have come from the Copy Name metadata field. If you create a virtual copy while the proof preview is enabled, this field is automatically filled in with the name of the selected profile. Otherwise, it will default to Copy 1, and so on.

The above options are there should you require this level of complexity. Personally, I find it sufficient to simply follow the steps outlined on the previous pages and click the Create Proof Copy button to create a virtual copy image that can be edited and stored independently of the master photo.

Figure 8.36 The Before State options when a master image is selected.

Figure 8.37 The Before State options when a virtual copy is selected.

Saving a custom template

After you set up the page-layout design and configure the Page Setup and Print Setup settings, you can save the print setup (including all the print settings) as a custom template. In the Template Browser panel, click the + button at the top of the panel header to add the current print setup as a template and give it a name (**Figure 8.38**). To delete a template, select the template name in the Template Browser and click the – button.

As you update the layout or print settings relating to a particular template, you can easily update the settings by right-clicking the template name to reveal the context menu and choosing Update with Current Settings.

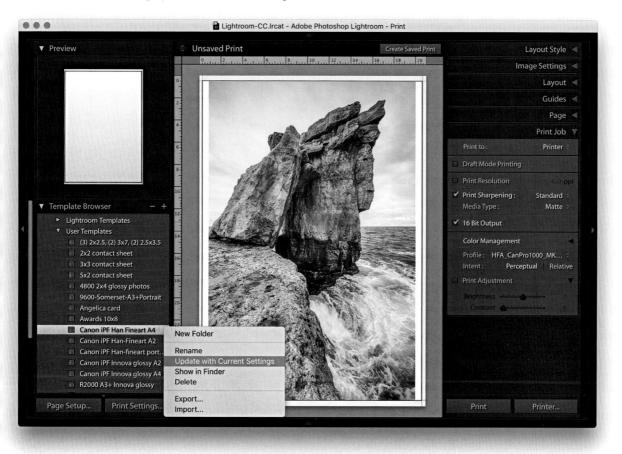

Figure 8.38 The Print module showing the Template Browser panel.

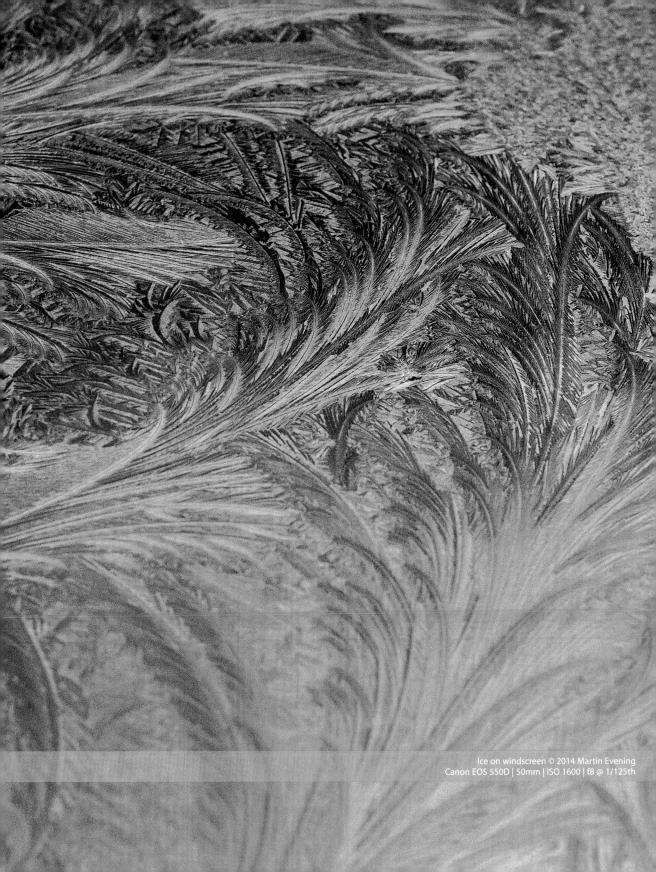

Presenting your work

How to make use of the Book, Slideshow, and Web modules

This chapter is all about how to present your photographs for output in the form of a book, slideshow, or web gallery. The Book module provides all the necessary tools to produce professional-looking books. The Slideshow module can be used to create slideshow presentations for business or personal use. These can be played on the computer directly or exported as self-contained presentations.

Lightroom's Web module lets you create instant websites of your pictures, which can easily be uploaded to the Internet without having to leave Lightroom. In truth, the Web module has largely been superseded by Lightroom CC/mobile and its ability to make images viewable on a personal devices, or share photos via a web page interface and have them update dynamically. Lightroom CC/mobile is discussed in more detail in Chapter 11. However, the Web module does at least offer a choice of web template interfaces, which you can customize.

NOTE

Whenever you work in the Book, Slideshow, Print, or Web modules, you are preparing photos for some kind of output. You can therefore class these modules as being "create" modules (that is to say, modules that are used to create some kind of output). It also implies that when you visit these particular modules, you are effectively doing the same thing as creating a new document and that you might well want to save the work you do in them. As you work through this chapter, it should become apparent why it is often desirable to save your work as a saved module collection (or creation). You can do this when creating a book, slideshow, print layout, or web gallery. Basically, it is a good thing to be prompted to save the work you have been doing as a collection with the module settings stored in it. At no time is this more important than when working in the Book module.

The Book module

The Book module includes a direct connection to Blurb, a photo book vendor that has proven popular with a lot of photographers. I do not know whether there will be plans in the future to extend this functionality to produce books through other book service vendors, although it is possible to produce a PDF output. This may offer a means to produce layouts that can be printed elsewhere, but only if the page formats are exactly the same. So, yes, the Book module is steering you toward using a specific service provider, but it is no more proprietary than the way, say, iPhoto is linked to Apple's own book printing service.

In the Book module (**Figure 9.1**), you can create new book projects based on a current selection of images or a saved collection from the Collections panel on the left. The main content area lets you view a book layout as a multi-page view (Figure 9.1), as double-page spreads, or as a single-page view, including a close-up view. In the multi-page view, you get to see a complete overview of a book project and can adjust the zoom view via the Toolbar Thumbnails slider. Double-click a page or click on the spread or page-view buttons in the Toolbar to view these pages in closer detail. You can drag images to individual pages to change photos, click photos to adjust the zoom setting, or right-click to use the context menu to adjust how a photo fits or fills a photo cell and choose different page-layout options.

The panels on the right are used to manage a book layout. The Book Settings panel is where you initially configure the book format size and cover type and select the paper you want the book to be printed on. You can then click the Auto Layout button in the Auto Layout panel to create an instant book layout. There is also the option here to output a book as a PDF or JPEG files. As you fine-tune a book layout, you can also see a price update of how much a book will cost when printed locally. The Auto Layout panel, as I just mentioned, lets you create instant layouts and clear previous ones so you can start afresh. The Page panel offers more than 180 professionally designed page layouts to choose from, and the Guides panel allows you to show or hide the various book-layout guides. Using the Cell panel, you can control the padding for either the photo or text cells—this provides a nice simple method for controlling the positioning of the text and photos on each page. The Text panel lets you automatically add text using custom, IPTC caption, or IPTC Title metadata.

The book module contains most of the rich text attributes of the Adobe Text Engine. Here, you have all text-styling features that are normally found in other Adobe programs such as InDesign and Photoshop. The default page background color is paper white. Using the Background panel, you can change the background to apply any color you like, such as a black background. You can also choose to use images here, or select one of the background graphics that come supplied with the Book module.

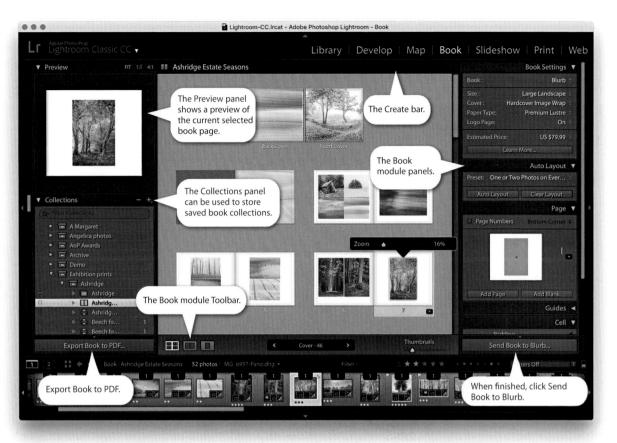

Figure 9.1 The main Book module controls.

Creating a new book

To create a book, you first need to make a selection of images. You can do this by selecting photos in the Library module or Filmstrip, or select a collection from the Collections panel via the Book module. To begin with, you will be in the multipage layout view. The selected photos will appear in the Filmstrip, but the book layout will be empty. The best way to get started is to select a preset from the Auto Layout panel and click the Auto Layout button. This creates an instant book layout based on the preset settings. If you want to try an alternative auto layout, click the Clear Layout button, or click Clear Book in the Create bar (**Figure 9.2**), and click Auto Layout again. It is important to familiarize yourself with this procedure. If you exit the Book module, select another set of images, and revisit the Book module, the previous book layout (and selection of images) will still be active. At this point, you can do one of two things. You can click the Clear Layout

Figure 9.2 The Book module Create bar.

Figure 9.3 The Create Book dialog.

Figure 9.4 The Collections panel with a Book collection selected.

button to clear the previous layout and Filmstrip selection, or click the Create Saved Book button in the Create bar. This opens the Create Book dialog shown in **Figure 9.3** and lets you save the current layout work as a new Book collection. If you have selected a subset of the Filmstrip selection for use in the book, remember to check the "Include only used photos" option. Basically, you use the Clear Layout button each time you wish to start a new layout and the Create Saved Book button to save a new Book collection. If a photo you have included in a book layout is currently offline, you will see a red exclamation point badge in the top-left corner of the photo cell. You will also see a warning message if the combination of the layout preset option and number of images selected means a book will exceed the maximum 240 pages.

Once saved as a Book collection, the settings are updated automatically as you edit the layout. This is both a good thing and a bad thing. It is good because any changes you make are saved automatically. At the same time, if you make drastic edits to a layout, you lose what went before. In **Figure 9.4**, you can see a close-up view of the Collections panel (which is common to all modules). Here, you can see that I had already saved a number of Book collections (III), which were book projects I had created previously. If you do not want to run the risk of overwriting a layout that you have got just right, you can always (Alt)-drag a Book collection to create a duplicate, which you can then edit as a variation of the master version.

Book Settings panel

The Book Settings panel options are shown in **Figure 9.5**. Here, you can choose to create a Blurb book, generate a PDF book layout, or create JPEG files. Next, you have the book format options, where you can select a Square, Portrait, or Landscape format in a small, standard, or large size. Not all combinations are possible as these are dependent on the available Blurb layouts. For example, you can create a landscape book in a standard or large format, but you can create a portrait book in a standard format only. The initial content area preview gives you a rough idea of how your book might look depending on what you choose here. When creating a book, you also have the following cover options: a Hardcover Image Wrap, a Hardcover Dust Jacket, or a Softcover (Softcover is not available for the large books). If creating a PDF or JPEG output, you can choose among Hardcover Image Wrap, Hardcover Dust Jacket, or No Cover options.

There are five paper type options to choose from. Standard is the cheapest. It looks pretty much like the Premium Lustre paper but is lighter weight. Premium Lustre, Premium Matte, and ProLine Uncoated use heavier-weight paper and offer better-quality finishes. ProLine Pearl Photo is the heaviest-weight paper with a glossy finish and also the most expensive. Below this is the Logo Page option. This is on by default and adds a small Blurb logo to the last page of the book. You can disable this, but doing so will add to the cost of the book. You will see a book price update at the bottom of the panel. Bear in mind that the book price reflects

the cost of the book with the current selected paper and cover finish but does not include the cost of delivery, which can add quite a bit more to your final book order. Do bear in mind that discounts should be available when you place an order for ten or more copies of a book. You can click the Estimated Price menu to select the currency price that reflects where you live (which also affects subsequent book delivery costs).

PDF and JPEG book export

If PDF is selected as the output, you will see the Book Settings panel view (bottom of Figure 9.5), which allows you to export a Book project as a PDF document. The following settings are also the same if choosing to output as JPEG files. To start with, you have similar Size and Cover options. You can use the JPEG Quality slider to determine how much compression should be used. Obviously, a lower-quality setting generates a more compact PDF document at the expense of image quality. The Color Profile can be set to sRGB, Display P3, Adobe RGB, or ProPhoto RGB. sRGB is the safest choice to make here if you want the PDF to be compatible with other printers. If you choose the Other option, you can select other RGB profiles, such as custom printer profiles. The Sharpening controls are the same as those used in the Print module, letting you apply a low, standard, or high sharpening for glossy or matte media type. Strictly speaking, these are intended for preparing images for inkjet output rather than halftone reproduction on an Indigo press. Even so, it is better to apply this type of sharpening than no sharpening at all. Incidentally, sharpening is applied by default when you output via the Blurb panel. In these instances, the sharpening always uses the Standard setting. The PDF option can also be used to produce PDF books that will look good when presented on a tablet device such as an iPad. For this type of output, you will probably want to keep the sharpening switched off.

When Blurb is selected as the output in the Book Settings panel, you will see an Export Book as PDF button at the bottom of the left-hand panel section. In these circumstances, the Export Book to PDF button is useful if you want to create a PDF proof of your book before you commit to spending money on having a book published. If you use this option, you can create a PDF proof of your book and use it to view the layout in Adobe Reader or Adobe Acrobat. You could perhaps use this PDF to print the pages on a desktop printer to check them before getting the book printed with Blurb.

Preview panel

The Preview panel (**Figure 9.6**) shows a preview of the page or pages you are currently working on. There are three view options. Fit lets you see a double-page spread view, 1:1 shows a single-page view, and 4:1 shows a magnified view suited for close-up inspection of text. When using the 1:1 or 4:1 views, you can drag the rectangle that appears in the Preview area to scroll the page.

Figure 9.5 The Book module Book Settings panel.

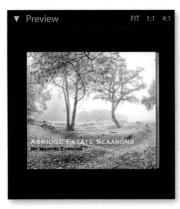

Figure 9.6 The Preview panel.

To go to a multi-page view, use #E

(Mac) or Ctrl E (PC). To go to a spread view, use #R (Mac) or Ctrl R (PC).

To go to a single-page view, use #T (Mac) or Ctrl T (PC). To go to a zoomed page view, use #U (Mac) or Ctrl U (PC). Use #E (Mac) or Ctrl = (PC) to go to the next view mode and #C (Mac) or Ctrl - (PC) to go to the previous view mode. Use the + and - keys on their own to make the multi-page view bigger or smaller.

While in a spread or single-page view, double-clicking toggles going to a zoom page view and back again.

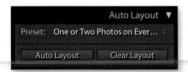

Figure 9.8 The Auto Layout panel.

Toolbar

The Toolbar (**Figure 9.7**) offers some of the same Book view options as the Preview panel, allowing you to switch from a multi-page layout (**11)** to a spread layout view (**11)** or a single-page view (**11)**. In the multi-page view mode, you can use the Thumbnails slider to make the multi-page view bigger or smaller. Note that if you click in the page count display in the center, you can type in a page number to select. If you click there again and type in another page number, you can add that as an extra page to the current page selection. In the spread or single-page view, you can click the page arrow buttons to navigate from one spread (or page) to the next.

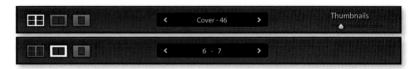

Figure 9.7 The Book module Toolbar in multi-page view (top) and spread view (bottom).

Auto Layout panel

With any new project, you are going to be confronted with the dreaded "blank page" scenario. When designing a book, it can help if you have some elementary design skills, but with so many layout options to choose from, it is easy to get stuck with so much choice. But if you click the Auto Layout button in the Auto Layout panel (**Figure 9.8**) at the beginning of a project, this automatically generates a complete book layout for you based on the current Auto Layout preset setting.

Auto Layout Preset Editor

You first need to select or create an Auto Layout preset. You can do this by going to the panel's Preset menu and selecting Edit Auto Layout Preset. This opens the Auto Layout Preset Editor shown in **Figure 9.9** and **Figure 9.10**. Here, you can select a supplied preset from the Preset menu. Or, you can choose to edit the left and right pages independently, or leave one page blank. If you wish to keep the pages consistent, keep the Left Pages menu set to Same as Right Side so that the Right pages options govern the layout for both sides.

In the Fixed Layout mode (Figure 9.9), you can select a specific page-layout option. First choose the layout type (1 Photo, 2 Photos, etc.) and then choose a specific layout from the scrolling menu. Next, you have the Zoom Photos options. Here, you can choose to let the photos zoom to fit the photo cells or zoom to fill. Below that is a Match Long Edges option. When checked, this can help you standardize the longest edge size for all the photos placed in a book layout. So, regardless of whether they are landscape or portrait, the longest edges match.

When the Add Photo Texts option is checked, captions are automatically added to the text frames (see Tip). These can be aligned to the photos and make use of a pre-created text style preset selected from the pop-up menu at the bottom.

When Random From Favorites is selected (Figure 9.10), this restricts the layout selection to favorite layouts only, i.e., page layouts you have designated as "favorites." In the middle is the Number of Photos option. This lets you decide how many photos you wish to place on each page: one, two, three, or four photos. When you let the auto layout do its thing, it randomly chooses from the favorite page layouts that allow that many photos per page. When you have finished customizing the Auto Layout Preset Editor, save the settings as a new preset.

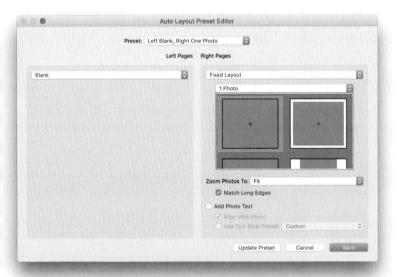

TP

The Text Options in the Book preferences (see Figure 9.27 on page 507) must be set to Fill text boxes with Title metadata or Caption metadata in order for photo captions to be filled automatically.

Figure 9.9 The Auto Layout Preset Editor with an edited Left Blank, Right One Photo preset. This setting will autoflow the layout with blank pages on the left and add one photo on the right using the selected 1 Photo layout.

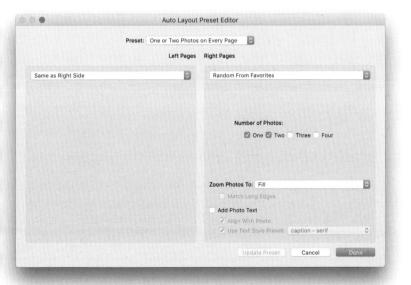

Figure 9.10 This One or Two
Photos on Every Page preset applies
Random From Favorites layouts when
autoflowing the layout. For this to
work effectively, you will need to have
already selected some layouts as
favorites (see Figure 9.18 on page 504).
In this instance, the preset enabled the
One and Two boxes, meaning it would
select only the one and two photos per
page favorite layouts.

Figure 9.11 A close-up view of a Filmstrip cell viewed in the Book module.

Editing the book pages

The auto-layout option can certainly help break the ice and get a book project started, but at some stage, you will almost certainly want to edit the pages and refine the layout. Figure 9.12 shows a multi-page layout view of a book project. As you can see, this gives you the ability to see an overview of a book and make some basic edits. For example, you can select individual pages by clicking them (or clicking just below a page) and drag on the yellow bar to change the page order. If you hold down the **公Shift** key, you can click to add more pages to a selection. Use 黑(A) (Mac) or Ctrl(A) (PC) to select all of the pages in a layout and 黑(Alt) 公Shift(A) (Mac) or Ctrl (Alt 公Shift)(A) (PC) to select all pages including the cover. You can also click photo cells or text cells to edit them. So, for example, you can drag photos from one photo cell to another and swap their positions. If you drag a photo from the Filmstrip to a photo cell, you can remove a photo that is there and replace it with the one you have just dragged. Figure 9.11 shows a close-up view of a Filmstrip cell viewed in the Book module. The count number at the top indicates how many times this photo has been used in a book project (such as once on the cover and once inside the book). If you use the context menu (right-click a cell). you can remove a photo and leave the cell blank. When you click a photo cell, you will see the Zoom slider for reducing or increasing the zoom setting.

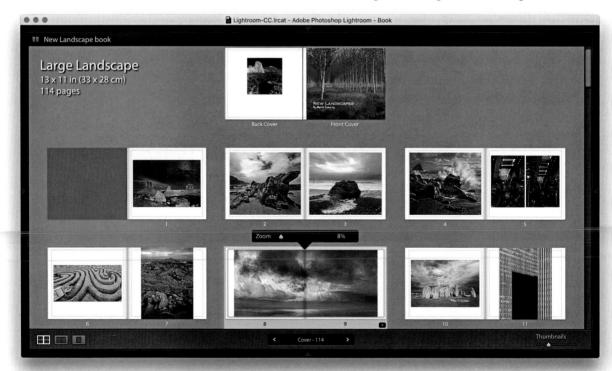

Figure 9.12 The Book module content area in the multi-page layout view.

Clicking the Spread View button (\mathbb{H}\mathbb{R}) [Mac], \mathbb{H}\mathbb{R}) [PC]) takes you to a double-page view like the one shown in **Figure 9.13**. This lets you preview the pages in a book as double-page spreads and get a better feel for the final layout and how the pages will look. In this example, I had a single landscape image running across both pages. Here, I right-clicked to deselect the Zoom Photo to Fill Cell option, and then clicked and dragged the photo to move it to the left of the photo cell. I had to be careful setting the Zoom level so the photo did not reproduce any bigger than the actual pixel resolution would allow. You can also select multiple photo cells and use the zoom slider to zoom all at once, or right-click to apply the fit or fill setting.

In the spread view, you can click the arrow buttons in the Toolbar to navigate from one spread to the next (or use the keyboard arrow keys). If you click the Change Page Layout button (circled), you can open the layout menu, which shows here the Two-Page Spreads layout options. You can access all of the available page layouts from here; they are listed in groups. Some layout options let you choose different combinations of photo cells, as well as text cells, and thereby experiment with all different kinds of layout possibilities. In this instance, there were 11 different options to choose from, including a double-page spread with margins (the one currently selected).

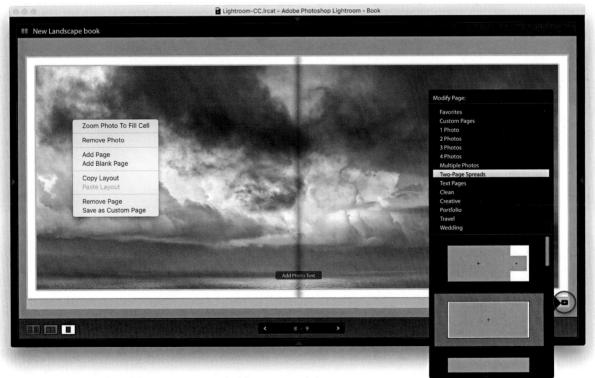

Figure 9.13 The Book module content area in a double-page spread view.

The single-page view is shown in **Figure 9.14** (******T [Mac], ******T [PC]) and can be used to edit individual pages.

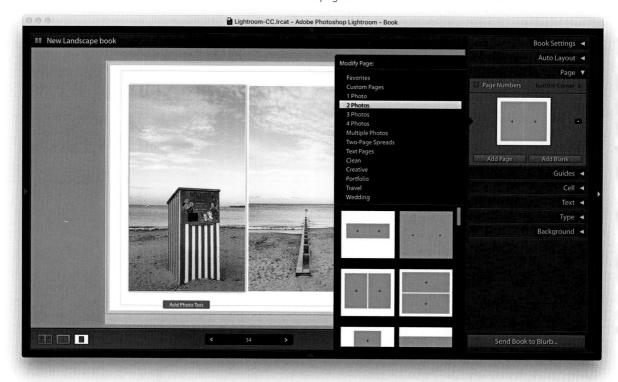

Figure 9.14 The Book module in single-page view, showing the page layout options.

Figure 9.15 Some of the front and back cover template options.

Editing the cover pages

The front and back cover pages are displayed at the top of the multi-page layout view, and have separate template options. Of these, the one highlighted in Figure 9.15 is quite interesting, as it allows you to place multiple images from the book in the cover design. This layout is shown in use in Figure 9.16, which also illustrates how you can drag a selection of photos from the Filmstrip to auto-populate the squares. Once photos have been added to a layout, you can rearrange them by dragging and dropping from one cell to another (Figure 9.17). Other layout options allow you to place full-bleed images on both the front and back cover pages with overlaid text. Lightroom makes use of the first image in the collection as the front cover image and the last image in the collection as the back cover image. To add text to the spine, click in the spine text box and text will be applied rotated 90 degrees. Depending on how you set the size of the type, you may need to adjust the baseline shift so the spine text appears centered across the width of the spine. Discussed later are ways you can set the text in the text cells and, in particular, how you can maintain control over the justification and cell padding, as well as how to precisely place the text on the cover pages.

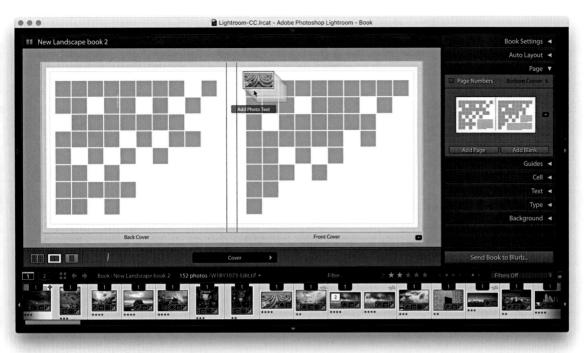

Figure 9.16 A multi-celled front cover template.

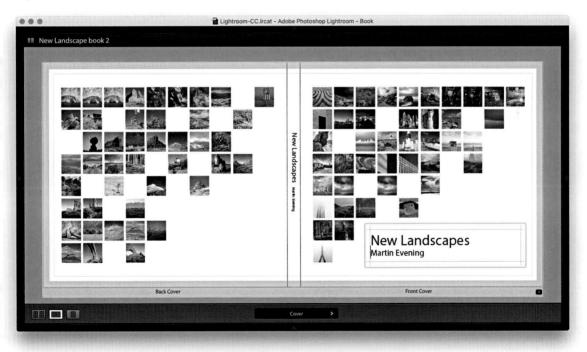

Figure 9.17 A multi-celled front cover template with photos added. Here, I added a title to the front page text cell (using the default Cover style) and added some spine text.

Figure 9.18 The Page panel.

Figure 9.19 The Page panel page layout picker.

Page panel

Figure 9.18 shows the Page panel with a three-photo plus text page layout. You can click the Add Page button to add a new page using whatever page template is currently shown in the Page panel preview. Or, you can click the Add Blank button to add blank pages. If you click anywhere in the middle section, this opens the page layout picker shown in **Figure 9.19**, where you have multiple options to select from different layout groupings, such as 1 Photo, 2 Photos, or custom design layouts, such as Portfolio or Wedding.

You can choose Edit 中 Copy Layout to copy a selected layout (黑公Shift) [Mac] or Ctrl 公Shift) [PC]). This can be a single page or a selection of pages. You can then choose Edit 中 Paste Layout (黑公Shift) [Mac] or Ctrl 公Shift) [PC]) to paste the selected layout. This adds new empty pages at the selected insertion point using the copied layout settings (but does not include the images themselves).

Marking page layouts as favorites

Favorite page layouts are used when generating an auto layout. To mark layouts as favorites, go to the page layout picker (Figure 9.19). As you move the pointer over the layouts, you can click in a layout's hollow circle to add it as a favorite (indicated by a filled circle). Or, you can right-click a layout to mark it as a favorite. To remove a layout from the Favorites list, right-click again or click inside the filled circle.

Adding page numbers to a layout

To add page numbers to all the pages in a current book layout, check the Page Numbers box. On the right is a menu that gives you a choice of five positions where the page numbers should be placed on the page. However you configure the numbering for one page will be mirrored on the other. The default font used here is Myriad Pro in quite a big type size, but it is easy to change. Highlight the page number text on any page, go to the Type panel, select a new font, and adjust. Then, right-click to access the context menu shown in **Figure 9.20** and select Apply Page Number Style Globally to update all the other pages. As you can see, the context menu also includes the options Hide Page Number and Start Page Number (i.e., start the numbering from this page on).

Saving custom page layouts

It is possible to edit the preset page layouts to create a custom page layout setting. For example, if you use the cell padding sliders to adjust the layout of a page preset layout, you can modify an existing layout to create a custom layout of your own. Having done that, right-click the modified page layout in the content area to access the context menu shown in Figure 9.20 and select Save as Custom Page. This then adds the modified page layout as a

new User Page setting (**Figure 9.21**), which will also appear listed in the Page panel Layout menu. Photo text settings are also included when you save custom page layouts.

Guides panel

The Book module has a Guides panel (Figure 9.22). Here, you have the option of showing/hiding various guides (黑公Shift)(G) [Mac] or (Ctrl)公Shift)(G) [PC]). If you intend to publish photographs as full-bleed images, it is critical that you allow enough room for the page bleed. You have to bear in mind that when producing a printed book, it is never going to be possible for the final trimmed product to be aligned exactly the way it appears laid out on the computer. You may not notice this when you pick up a book, but there is a margin of error of around a millimeter or so between all the pages after they have been trimmed. Therefore, it is customary to allow a bleed area of around 3 mm outside the specified page area when placing page elements that are intended to overflow the page edge. You can see these when enabling Page Bleed guides (黑公hift[J] [Mac] or [Ctrl] 公Shift [J] [PC]). Similarly, it is not a good idea to create a page layout in which graphics or text are placed too close to the edge of the page, which is why most books have guite generous margins. In the case of the Book module, the Text Safe Area is defined by the thin vellow lines and can be shown or hidden using 黑公shift(U) (Mac) or Ctrl 公Shift(U) (PC). The golden rule is to keep safely within these margins or, if you want to print full page, make sure the images fill to the page-bleed edges. Next is the Photo Cells option, which allows you to turn their visibility on or off (黑公shift)(K) [Mac] or (Ctrl)公Shift(K) [PC]).

Whenever you create a sample layout, prior to adding actual text it can be helpful to see the empty text frames filled with a sample, filler text. This is usually done by filling with the often-used *Lorem ipsum* Latin text. When the Filler Text option is checked, this temporarily fills the text frames and provides a rough indication of how the page will look when the proper text has been added (the filler text you see in the layout will not actually print). As soon as you click inside a text frame, the filler text vanishes, allowing you to fill the text frame with real text instead. You can also toggle this on or off using ****Ashift**** (Mac) or **Ctrl **Cshift**** (PC).

Figure 9.22 The Guides panel.

Figure 9.20 The context menu options for the page layout view.

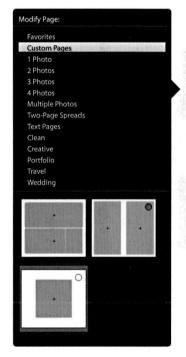

Figure 9.21 The Page panel page layout picker showing available custom page layouts.

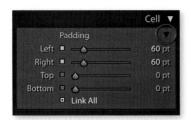

Figure 9.23 The Cell panel (shown here in the expanded view mode).

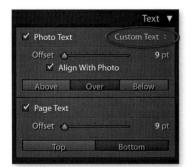

Figure 9.24 The Text panel.

Figure 9.25 The Text panel showing the Photo Text menu options.

Cell panel

The Cell panel can be used to pad the position of a photo within a photo frame or text within a text frame and thereby fine-tune the placement of images and text within a layout. The default mode for the Cell panel is a compact view with a single padding slider. Click the arrow (circled) to access the expanded view shown in **Figure 9.23**. In this view mode, you can individually adjust the sliders to alter the padding within a frame and click the lock buttons to lock one or more sliders. Or, click the Link All button at the bottom to lock all sliders.

Text panel

The Text panel (**Figure 9.24**) can be used to add text to individual photos or page layouts. When you view a new page layout in a single-page or spread view, you will see an Add Page Text box overlay at the bottom of each page. When you click on it, the text box becomes active, the words "Page Text" are highlighted, and the Page Text options are enabled in the Text panel. You can now start typing to overwrite the current text and add a page caption to that particular page. The buttons at the bottom of the panel can be used to choose to anchor the page text to the top or bottom of the page layout. While the page text box is active, you can click the yellow border to manually offset the text box or you can drag the Offset slider in the Text panel.

If you click to select an actual photo, an Add Photo Text overlay appears. As for the Page Text, when you click this overlay, the words "Photo Text" will be highlighted and the Photo Text options enabled in the Text panel. And again, you can manually offset the text by dragging the Photo Text box or dragging the Offset slider. The alignment options allow you to align the text just above, just below, or overlaying the selected photo. When the Align With Photo box is checked, the text box left-aligns to the photo boundary and automatically realigns the caption text as you adjust the zoom setting or padding for the associated photo cell. When the box is unchecked, the text box left-aligns to the left edge of the page layout.

You can also choose an auto-fill text option for the Photo Text using the custom text menu shown circled in Figure 9.24. **Figure 9.25** shows a list of the options that are available. These include items that can be pulled from the file metadata.

Text box layouts

Some page layouts include text boxes for placing text and are there to help you maintain continuity in a layout design when adding text (**Figure 9.26**). These are represented in a page layout by a thin-line, rectangular guide outline. To enter custom text, click inside a box and start typing. If the Filler Text option is checked in the Guides panel (Figure 9.22), you will initially see filler text appear in these text boxes. This disappears as soon as you click in the text box.

Adding auto text

You can auto-add text within the page layout text boxes. To do this, right-click to access the context menu and select one of the options from the Auto Text menu shown in **Figure 9.28**. By default, this is set to Custom (which overrides the auto-text option). Any text that you have already entered will remain in the text box and not be edited. If you select the Title, Caption, or File Name option, this reads and adds the data that may have been entered in either of these metadata fields and auto-fills the text box accordingly. If multiple type styles have been applied to the text in a particular text cell, when Auto Text is applied it utilizes the first character in the box to format the rest of the text. A useful tip is to make sure you fill out the Title and Caption fields via the Library module. You can then use these metadata entries to populate the text cells using the Auto Text feature. You can then easily reformat the page layout or access the Title or Caption data when placing the same image in another book creation.

If the associated metadata fields happen to be empty, the text box will be left blank. After you have done this, if you replace a photo in a photo cell, the text will update automatically as you change images. If you click a text box and delete the current text or start typing, this turns off Auto Text mode, and the text box reverts to the Custom mode again.

If you go to the Book menu, you can select Book Preferences to open the Book Preferences dialog (**Figure 9.27**). Here, you can configure the Autofill options so that when you start a new book, the text cells are autofilled by default. Below this are the Text options where you can choose to fill using Filler Text, Title, Caption, or File Name.

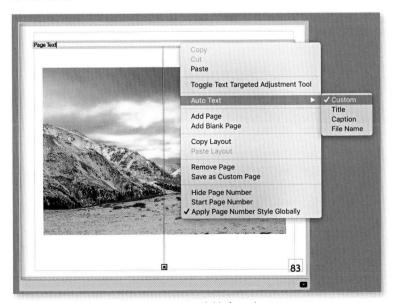

Figure 9.28 The Auto Text options are available from the context menu.

Figure 9.26 An example of a page layout with text placement boxes.

Figure 9.27 The Book Preferences dialoa.

Figure 9.29 The Type panel.

Type panel

In any book design project, it is important to have full control of the text. The Book module has a number of type controls in the Type panel (**Figure 9.29**). These utilize the same Adobe type engine used in other Adobe products. The Book module may not offer all the type features that can be found in Adobe Illustrator or Adobe InDesign, but there is enough here to help you produce decent-looking text in a book. At the top of the panel is the Text Style Preset menu, where you can select text presets. The *title – sans serif* and *caption – sans serif* text style presets use Myriad Pro. This is a modern sans-serif font and offers a nice wide range of styles from Condensed to Black, while the *caption – serif* and *title – serif* styles use the Adobe Garamond Pro serif typeface. As you start editing the character settings in the section below, you can choose Save Current Settings as New Preset. This opens the save dialog shown in **Figure 9.30**, which lets you add the character settings as a new text style.

Figure 9.30 The New Preset dialog.

Type panel Character controls

When setting the type, you will want to have quick access to all the available fonts and associated type options. In the Type panel, click the disclosure triangle (circled in Figure 9.29) to reveal the full list of options. Here, you can set the character color, size, and opacity. It helps to have some understanding of working with fonts. If you are unsure, try making a test print with your desktop printer at 100% to see how the text settings actually look when printed. With the various book projects I have worked on, I have used a font size of between 7 points and 10.7 points for the captions and body text. For example, the body text in this book uses an 8.5-point typeface. You will probably want to experiment with different font sizes, and it is possible to end up with a mixture of font sizes in a final layout. As a rule, designers prefer to use a serif typeface for body text (serif text is characterized by semistructural details at the ends of the font strokes). Examples of this are Times New Roman and Garamond. This is because it is argued that serif text is easier to read. For headings, bolder sans-serif typefaces are commonly used, such as Gill Sans or Arial. But rules are made to be broken. With The Adobe Photoshop Lightroom Classic CC Book, Myriad Pro is used for the headings and Frutiger Light (a sans-serif typeface) is used for the body text.

The Tracking slider narrows or widens the gap between selected characters. This can be used to create deliberately condensed or spaced-out lettering, or it can be used to fine-tune body text where you find that text added to a frame is just starting to overflow (and you wish to condense it slightly), or you wish to deliberately force the text to flow in a way that avoids ugly hyphenation. The Baseline slider can be used to adjust the text relative to the default baseline. You can therefore use this to adjust the type up or down. The Leading slider adjusts the width between the baselines. In most instances, you are best off leaving this set to the 0 or Auto setting, but there are times where you may want to tweak this. For example, when designing a cover, it is quite likely that you will want to experiment with different leading settings. To quickly return to the default Auto setting, select the text and click the Auto Leading button.

Kerning is kind of the same as tracking, but is used to adjust individual characters by placing the type cursor between two characters and then adjusting the width of the gap. The aim with kerning is to balance the gap between individual characters to create an even look. Text is auto-kerned by default, but when it comes to large headings, you can make the typesetting look more professional by spending a little extra time balancing the individual characters. This is something that you only really need to do when setting type for the cover or such elements as chapter headings. The trick is to look at the empty space formed between each of the characters and try to get them all roughly balanced. In Figure 9.31, the top two lines show an imaginary book title in the Copperplate Gothic Light typeface sized at 18 points with Auto Leading enabled. Below that I modified the text by setting the Tracking to +200. I made the book title 24 point and the author name 10 point. The bottom version used the same settings, except I modified the kerning slightly between some of the characters to improve the balance of the type. If you decide you need to reset the kerning, select the text and click the Auto Kerning button. To learn more about type kerning or test your typography skills, check out Kerntype, a kerning game, available at type.method.ac/#.

NEW PERSPECTIVES BY ANOTHER PHOTOGRAPHER

NEW PERSPECTIVES

BY ANOTHER PHOTOGRAPHER

NEW PERSPECTIVES

BY ANOTHER PHOTOGRAPHER

Figure 9.31 *Text set using different tracking and kerning settings.*

TIP

You can use MAITA (Mac) or Ctr/AITA (PC) to select all type boxes. This selects all the type boxes in the current view. Once you have selected multiple text objects, you can edit the text within them using the Type panel settings.

MI:

Figure 9.32 The Type panel Character controls.

Figure 9.33 The Cell panel.

Figure 9.34 The Background panel.

Target Adjustment tool options

The Type panel also features a target adjustment tool (circled), which, when selected, can be used to directly modify type. Drag horizontally over a selection to adjust the size, and drag vertically to adjust the leading. If you hold down the (Mac) (PC) key and drag horizontally, you can adjust the tracking. If you hold down the (Mac) (Ctrl) (PC) key and drag vertically, you can adjust the baseline shift. If you drag horizontally over the cursor insertion point, you adjust the kerning. Also, (Alt) -dragging temporarily deactivates the Target Adjustment tool, which allows you to alter your text selection before releasing the (Alt) key and modifying the type settings again. Finally, you can use the (Esc) key to exit the Target Adjustment mode.

The Columns slider can be used to set one or more columns within a text cell, and the Gutter slider lets you adjust the width between multiple columns.

Type panel Frame controls

The Frame buttons (at the bottom of **Figure 9.32**) can be used to control how text is placed within the text cells. From left to right, you can choose to align text to the left, center, right, or with full justification. The next three buttons allow you to also align the text to the top, middle, or bottom of the cell. You can then use the Cell panel (which is shown again in **Figure 9.33**) to pad the text, adjusting the sliders to pad the left, right, top, and bottom edges. As I mentioned earlier, when you click the boxes next to each of these sliders, you can link the individual padding settings. Or, you can click the Link All button at the bottom to link all the sliders together.

Background panel

Most will want to have their photos printed against a paper-white background. But if you wish, you can use the Background panel (**Figure 9.34**) to edit the background and choose another color instead. For example, I have had a Blurb book printed using black as the background color, which, in my opinion, printed really well. The Apply Globally option is checked by default, so whatever settings you choose to apply here will be applied to all the inside pages. If you deselect this option, you will have the option to apply custom background settings to individual pages. If you click the Graphic option, you can also add a graphic image that fills the entire page bleed areas. To do this, you have to select an image from the Filmstrip and drag this up to the Background graphic preview area. You can then adjust the Opacity slider to set the opacity. If you click the downward arrow (circled), you can access the custom graphic backgrounds shown in **Figure 9.35**. You can also combine the Graphic and Background Color settings to achieve the desired mix of background image and color shade.

Publishing your book

Once your book project is complete, you are all ready to publish, which you can do by clicking the Send Book to Blurb button at the bottom. This opens the first of the two dialogs shown in **Figure 9.36**. First, you need to log in as a new member or enter your existing login information. Next, you will be asked to give the book a title, a subtitle, and an author name. These are not required, but they will help you identify individual book projects when visiting the Blurb store. The remaining dialogs take you through the pricing options, where you can choose to order multiple books to gain a discount or enter promo codes. Although you are shown a price for getting the book printed, this does not include the delivery cost. Delivery times vary depending on which territory you live in and where your nearest Blurb printing center is located.

Figure 9.36 The Purchase Book dialog.

Figure 9.35 Some of the background graphics available from the Background panel.

NOTE

There is HiDPI support for preview images in Slideshow module. But this only affects people who are working with one of the most recent MacBook Pro or iMac computers with Retina displays or other comparable PC hardware.

The Slideshow module

The Slideshow module (**Figure 9.37**) can be used to create onscreen presentations that can be played directly via the Slideshow module. The Options panel can be used to manage the framing and offers the ability to edit the Stroke Border styles and image Cast Shadow options for slideshow images.

The Layout panel in the Slideshow module is similar to the Layout panel in the Print module and can be used to set up the margin widths for the slide frames. The Overlays panel is also similar to the one in the Print module, where you can add elements to a slideshow template design, such as a custom identity plate, custom watermark, or rating stars information. When you enable the Text Overlays option, you can add custom text objects with full text-editing control and optional drop shadows. The Backdrop panel lets you set a backdrop color and color-wash effect. You also have the option to add an image from the Filmstrip as a backdrop. The Titles panel lets you add slides at the beginning and end of a slideshow during playback, with the option to use the Identity Plate Editor to place saved custom text captions or graphics and a Music panel for managing multiple sound tracks. Meanwhile, the Playback panel can be used to control slide length and fades and randomize options, sync the slides to the music, and add pan and zoom effects.

As with most of the other modules, the Slideshow settings can be saved as a custom template setting via the Template Browser. As you hover over the presets listed, the Preview panel generates a quick preview using the current, most selected image in the Filmstrip selection. The playback controls in the Slideshow Toolbar can be used to quickly switch to the Preview mode. This lets you preview how the slideshow will look in the content area before clicking the main Play button. You can also initiate an impromptu slideshow while in the Library, Develop, or Print module by using **Enter* (Mac) or Ctrl Enter* (PC); whenever you do so, the currently selected Slideshow template is used. Any time you want to exit a slideshow, just press Esc.

You can save Slideshow image collections (plus the Slideshow settings used) as Slideshow collections via the Collections panel. This then lets you quickly select Slideshow collections while working in other modules. Slideshows can also be exported as self-contained PDF documents, or as individual JPEG slide images for use in third-party slideshow presentations. You can even export slideshows as movies. Just go to the Slideshow module Slideshow menu and choose one of the Export Slideshow options. Use **U (Mac) or Ctrl U(PC) to export a PDF Slideshow, **Oshift U(Mac) or Ctrl Ashift U(PC) to export JPEG slides, or **EAIT U(Mac) or Ctrl Alt U(PC) to export videos. A built-in sleep override prevents the screen from going to sleep during a slideshow presentation.

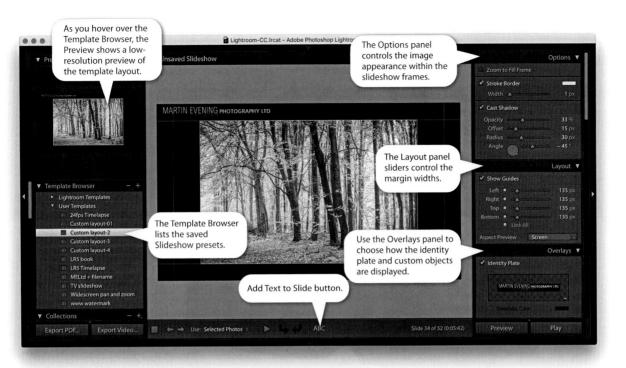

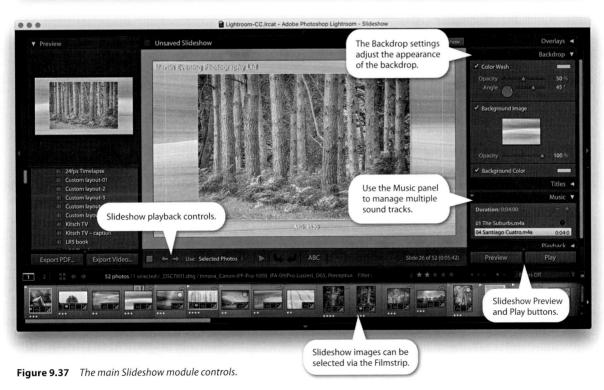

The Slide Editor view

Figure 9.38 shows the slide editor view, which always displays the most selected Filmstrip image. You can change the image view by using the left and right arrow keys to navigate through the selected images in the Filmstrip. As adjustments are made to the Slideshow settings in the panels on the right, these changes are reflected in the Slide Editor view. The Toolbar has preview playback controls and options for choosing which photos are displayed in a slideshow. You can choose from All Filmstrip Photos, Selected Photos, or Flagged Photos. As with other Lightroom modules, you can toggle showing and hiding the Toolbar using the T keyboard shortcut.

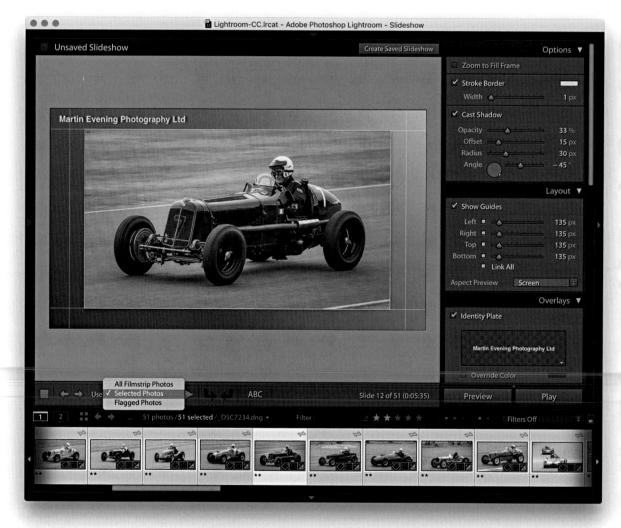

Figure 9.38 The Slideshow module showing a view of the slideshow layout in the content area and the Filmstrip below.

Layout panel

The Layout panel lets you edit the slide layout by specifying the margins for the image display. In Figure 9.39, the layout guides are highlighted in red. You can adjust the margins by dragging the slider controls. Or, you can double-click the panel boxes, enter a pixel value, and fine-tune this setting using the up and down arrow keys. A single arrow click increases or decreases the pixel dimensions by 1 unit, and a A Shift -click increases or decreases the pixel dimensions 10 units at a time. You can also drag on the guides directly within the content area to adjust the margin widths. The unit dimensions have linking check boxes next to them. This means that when two or more boxes are checked, as you adjust one value, the other field values are linked. For example, in Figure 9.39, I checked the boxes for the left and right margins only. This meant that as I adjusted the width for the right margin, the left margin was adjusted by the same amount. You can hide the slide layout guides at any time by unchecking the Show Guides box in the Layout panel or by using the 黑心Shift (Mac) or (Ctrl) 公Shift (H) (PC) shortcut. In the Aspect Preview menu, you can select Screen to make the aspect ratio of the Slideshow match the proportions of the monitor display you are working on, or you can select a fixed ratio of 16:9 or 4:3. This is something you want to consider early on, especially if you plan to export a slideshow to play back on a different screen.

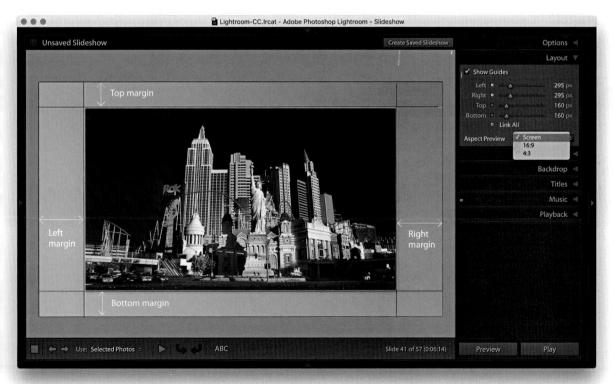

Figure 9.39 The Slideshow Layout panel controls.

Figure 9.40 The Options panel.

Options panel

Now let's look at how the photographs are displayed within the slide frames. At the top of the Options panel (Figure 9.40) is the Zoom to Fill Frame check box. In the Figure 9.42 example, this was deselected, and as you can see in the Slide Editor view, the image was centered within the margins (as specified in the Lavout panel). If the Zoom to Fill Frame option is checked (Figure 9.43), the photo resizes and expands to fill the available space. You should be aware that when you select this option, it automatically centers each image in the slideshow as it applies the necessary cropping to the picture. In Figure 9.43, you will notice that the cropped view is aligned more toward the top of the frame. This is because I clicked on the slide preview image and dragged it downward to preserve more of the top of the photo. This tweaking overrides the automatic cropping and is applied on a per-image basis. In other words, you can pre-edit a selection of pictures that are to be included in a slideshow and customize the cropping for each image. Just be aware that these adjustments are lost as soon as you make a new selection of images. If you end up spending time making custom tweaks to a slideshow presentation, you will definitely want to save these adjustments as a Slideshow collection. In these two examples, I also checked the Stroke Border option to add a light-gray stroke to the slideshow frame images (use the Stroke Border slider to adjust the thickness). If you want to change the stroke color, double-click the color swatch to open the color picker dialog shown in Figure 9.41.

If you select the Cast Shadow option, you can add drop shadows behind the photographs. This applies a black shadow, and by adjusting the Opacity, Offset, Radius, and Angle sliders (or adjusting the angle wheel), you can customize the way the shadow effect looks. As you adjust the angle setting, the shadow preview temporarily hardens to a flat shape, but as you release the adjustment controls, the shadow is re-rendered in the Slide Editor view.

Figure 9.41 The Lightroom color picker dialog.

Figure 9.42 The Options panel with Zoom to Fill Frame unchecked.

Figure 9.43 I checked the Zoom to Fill Frame option and the image expanded to fill the area within the frame margins.

Photo © Eric Richmond

Overlays panel

Having established the layout margins and image placement, you can begin adding content to the slide frames. If you enable the Identity Plate option, you can select a custom preset template by clicking the identity plate preview, and choosing Edit from the drop-down menu to create a new one. The Opacity and Scale properties let you customize the identity plate appearance and decide whether you want the identity plate to be on top or placed behind each slide image. Once enabled, the identity plate can be repositioned by simply clicking and dragging anywhere inside the slide frame area. In this respect, the identity plate is just like any other custom object. The Watermarking option allows you to select a custom watermark setting such as was discussed in Chapter 7 (see pages 439) to 440). The Rating Stars options let you display the current image star rating, as well as adjust the color and scale size. As with all custom objects, you can scale each object by dragging a corner or side handle. The Text Overlays check box toggles displaying all other text objects apart from the identity plate and ratings. For example, in Figure 9.44, this option is checked, which allows you to see a filename text object that I had placed centered below the image. The Shadow check box lets you apply a drop shadow effect to each overlay object and apply independent shadow settings to each.

Figure 9.44 The Slideshow module Overlays panel.

Creating a custom identity plate

I will discuss working with text overlays shortly, but let's take a quick look at the Identity Plate options first (**Figures 9.45** and **9.46**). To open the Identity Plate Editor, click the identity plate preview in the Overlays panel and choose a presaved Identity Plate setting, or select Edit.

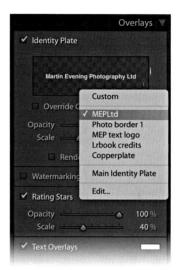

Figure 9.45 The "Use a styled text identity plate" option was selected here. The styled text was then saved as a new identity plate preset and added to the Overlays panel settings.

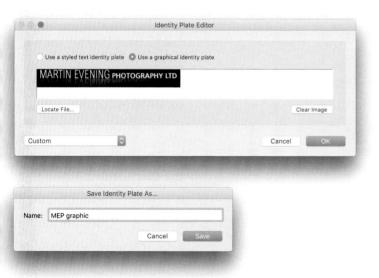

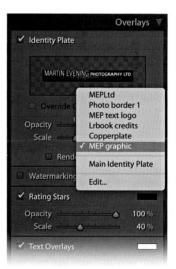

Figure 9.46 The "Use a graphical identity plate" option was selected here. A logo file was selected and added, then saved as a new identity plate preset and added to the Overlays panel settings.

NOTE

In the Overlays panel Text Overlays section, you can edit the individual text overlays, changing the font typeface, style, opacity, and color as desired.

Adding custom text overlays

To add a custom text overlay, click the Add Text to Slide button (Figure 9.47). This opens a text box next to it in the Toolbar, where you can type to add custom text. Click Enter), and the text appears as a new text overlay in the Slide Editor view. You can add as many text overlays as you like and re-edit them. To hide a Custom Text box, click the Add Text to Slide button a second time. You can also use the Rotate buttons on the Toolbar to rotate text overlays by 90 degrees and to remove a text overlay; just click to highlight it and press Delete. If you click to select a text object in the Slide Editor view, you can edit the content by simply typing in new text. Or, you can click to open the Text Overlays menu shown in Figure 9.48 and select an item from the list such as Date or Filename. Choosing Edit opens the Text Template Editor (Figure 9.48). This lets you add various metadata items as tokens. Just click an Insert button to add new tokens to a template design, and combine these with custom text to create your own custom text overlay presets. In Figure 9.49, I show how you could create text overlays using different tokens, such as Date (Month, DD, YYYY).

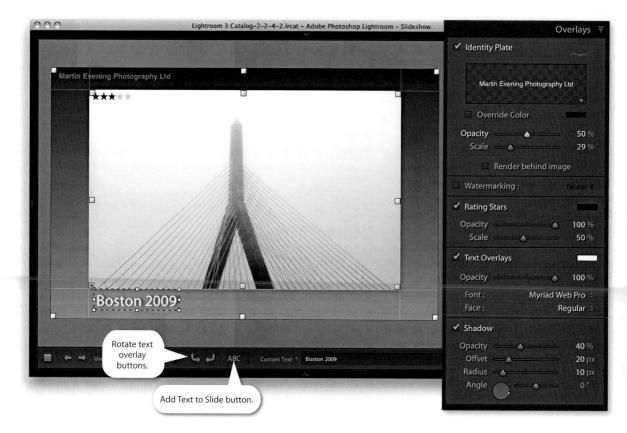

Figure 9.47 A basic custom text object. You can use the various anchor points to help align a text overlay (I have shown all of them here).

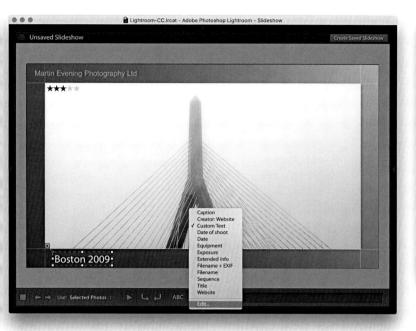

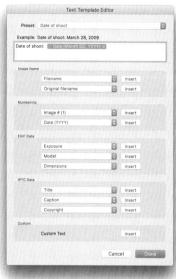

Figure 9.48 To add other types of text overlays, you can click the Text Overlays menu and select a text object preset. Or, click Edit to open the Text Template Editor.

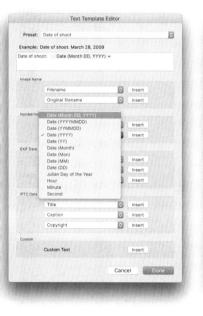

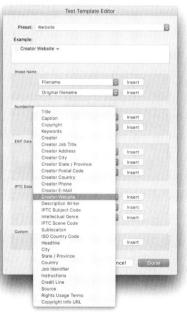

Figure 9.49 Some example views of the Text Template Editor. The Date token options (left) can be used to apply different date and time formats. The token options (middle) include items relating to the camera capture data. The IPTC Data token options (right) include items relating to the IPTC metadata (see Chapter 10).

Backdrop panel

The Slideshow frame appearance can be modified via the Backdrop panel. With the Color Wash controls, you can set up different color scheme combinations using the Color Wash and Background Color swatches and adjust the Opacity and Angle sliders to fine-tune the effect. You can also place an image as a backgrop. The first time you check the Background Image option, you will not see anything happen, because you have to select a photograph from the Filmstrip first and drag it into the backdrop area (or Background image preview) for the background image to register. After that, you can use the check box to toggle the backdrop image on or off. The Color Wash colors can be combined with the applied backdrop image and used to mute the backdrop image contrast. Whenever an image is applied to the backdrop, you still retain full control over the Color Wash Color, Background Color, and Color Wash settings, and you can mix them any way you like to achieve the desired look for the backdrop. Remember also that all the settings, including those in the Backdrop panel, can be saved as a template. So, you can create Backdrop panel designs that use different background images and save them to the Template Browser panel. The following steps show how I went about creating a custom backdrop design for a slideshow.

1. To start, I checked the Background Color option to enable it and clicked the background color swatch to choose a backdrop color.

2. With the Color Wash option checked, I was able to introduce a secondary color to apply a gradient wash across the backdrop.

3. I added an image to the backdrop by dragging a photo from the Filmstrip into the slide Background Image preview area and then adjusted the Background Image opacity.

TP

On PCs you can add multiple lines of text in the identity plate directly.

Ctrl Enter takes the cursor to next line.

Titles panel

The Titles panel can be used to add intro and ending screens to a slideshow presentation. You can add these using the Identity Plate Editor, as shown below. You simply check the Add Identity Plate options to add a screen at the beginning and/or end. The Titles panel also has a few extra controls so you can scale the identity plate and override the text color, as well as set the background color for the intro and ending screens.

1. Because the Identity Plate Editor dialog has limited text-formatting options, I used a text editor program to write the credits. I made the first line bold, added soft returns (using Shift—Return), and centered the text. I copied and pasted this into the Identity Plate Editor dialog and saved as a new styled text identity plate.

2. I then selected a standard identity plate company logo for the Intro screen and selected the credit list for the ending screen. This screen preview shows where the last image in the slideshow sequence faded to the ending screen credits.

Music panel

Music sound tracks can be added to a slideshow via the Music panel shown in **Figure 9.50**, which allows you to select sound track audio files to add to a slideshow presentation. To add these, click the + button. On the computer setup in my office, I maintain a complete MP3 music library and use the system Finder (**Figure 9.51**) to select the music I wish to have played in the background. You can add multiple audio tracks; the track duration appears alongside each sound track name. To remove a sound track from the Music panel, click the – button. If a music track you have selected later appears to be missing, you will see a warning icon in the Music panel that alerts you to relink.

Music sound tracks cannot be saved as part of a PDF Slideshow export, but you can save a music sound track with a video export. If a video is ultimately going to be published to a wider audience, you must ensure you have the rights to use the music. You will not be able to play any music files that are DRM protected.

Figure 9.50 The Music panel.

Figure 9.51 To select a sound track, click the + button in the Music panel (Figure 9.50) and use the Navigator to locate the desired sound track from the music library on your computer.

Figure 9.52 The Playback panel in Automatic mode.

Playback panel

The Playback panel can be used to configure the slideshow playback settings. There are two modes for this panel. **Figure 9.52** shows the Automatic mode, which gives you control over the playback attributes.

If you check the Sync Slides to Music box, Lightroom automatically detects the beats in the music and sets the slide transition speed accordingly. So, if the music track you have selected has a slow beat, the crossfade transitions will be longer, and if it has a fast-paced beat, they will be faster. Checking this option also disables the slide transition controls and Fit to Music button below, and the music will fade to silent with the last photo, thus avoiding an abrupt end to the show. When deselected, you can manually adjust the times for the Slide Length and Crossfades. If you want the slideshow to run at a fast speed, you can try selecting shorter slide and transition duration times, but bear in mind that the ability to play back at a faster speed is governed by the size of the master library image files and whether these have been fully cached yet, not to mention the performance of your computer. If you click the Fit to Music button, this auto-sets the exact slide duration required for all the slides in the slideshow to play at an even pace from start to finish based on the length of the selected sound track (or sound tracks).

Because Lightroom lets you incorporate video files into a slideshow presentation, there may be audio tracks in the video clips. Therefore, there is an Audio Balance slider that allows you to adjust the balance between the volume of the video clips and the music sound track. This is a global slider control and does not allow you to control the mix for individual video-clip components. If you need more control than this, you will probably be better off using a video-editing program instead.

Pan and zoom options

When the Pan and Zoom option is checked, this enables automatic pan and zoom style transitions between slides, applying a Ken Burns—style effect to the slideshow images. For those of you who are unfamiliar with this term, Ken Burns is a documentary film director and producer credited with incorporating pans and zooms of stills images in order to bring more life to static pictures. It is a style that is much used these days for slideshow and movie presentations and most notably featured in Apple video-editing applications. To apply this type of effect to your slideshows, enable the Pan and Zoom option and adjust the Pan and Zoom slider. A Low setting will result in gentle pans and zooms, while a High setting will result in more sweeping movements. After adjusting the Zoom Ratio setting, click the Preview button to check out the result.

Should you be so inclined, you can check the Repeat Slideshow option to have the slideshow run in a loop and check the Random Order option to shuffle the play order.

Manual mode

If you click the Manual button, this switches the Playback panel to Manual mode, as shown in **Figure 9.53**. This disables and hides the music sync, the slide length, crossfade controls, and Fit to Music button, as well as the audio balance and Pan and Zoom options.

Playback screen and quality settings

The Playback screen section displays a representation of connected computer displays. All the Playback panels shown here were captured with Lightroom running on a computer with two displays. The big arrow indicates which display the slideshow will appear on when in Play mode, and in such instances, you can click either display. Check the "Blank other screens" option to blank out the other display during Play mode.

The Quality menu offers a choice of Draft, Standard, or High playback settings, which determine how a slideshow will preview on playback within the application. If you want to see a rough preview, select the Draft option. For higher-quality preview playback, select Standard or High. The thing to be aware of here is that this menu option affects the playback quality of the preview only; exported slideshows always play at best quality.

Play and preview

You will now be ready to play the slideshow. To do this choose Slideshow \Rightarrow Run Slideshow, or click the Play button in the bottom-right corner (circled in **Figure 9.54**). Or, you can press **Enter** to launch a full-screen slideshow using the currently selected slideshow template settings. When you switch to full Play mode, the display fades to black and then fades up to show the slides in sequence. You can pause a slideshow by clicking the Pause button or by pressing the **Spacebar**. To stop a slideshow, just press the **Esc** key. If you just want to see a quick preview of a slideshow, click the Preview button next to the Play button (**Alt Enter**). This allows you to preview a slideshow within the content area using the current quality settings. While you are in Preview mode, you can interact with the slideshow using the navigation keys located on the Toolbar (**Figure 9.55**).

Figure 9.55 The Slideshow Preview mode playback controls, showing the slideshow controls in both Play mode and Pause mode.

Figure 9.53 The Playback panel in Manual mode.

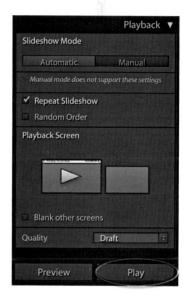

Figure 9.54 Preview and Play buttons.

Navigating slideshow photos

You can manually override a slideshow sequence by using the left and right arrow keys to go backward or forward through the sequence. Use the Spacebar to pause a slideshow, and press the Spacebar again to resume playing.

Impromptu slideshows

If you want to run an impromptu slideshow in any of Lightroom's modules, press [#[Enter] (Mac) or [Ctrl][Enter] (PC). Press [Esc] to then cancel or exit a slideshow.

Slideshows and selections

There are Slideshow module options in the Toolbar (**Figure 9.56**), as well as in the Play ⇒ Content submenu (**Figure 9.57**). These determine which images are accessed from the Filmstrip when playing a slideshow (providing more than one image is selected). If All Filmstrip Photos is selected, the slideshow plays all the photos in the current Filmstrip starting from the most selected image or the target image. If Selected Photos is selected, the Slideshow module plays only the selected images, and if Flagged Photos is selected, only those photos that have been rated as flagged images will be played.

Figure 9.56 The Slideshow module Toolbar showing the content options.

Figure 9.57 The Slideshow module Play menu showing the Content options.

Template Browser panel

After you have gone to all the trouble of designing a slideshow layout with measured margins, identity plate, customized text objects, and backdrop image, it makes sense to save it as a template that can be used again later. To do this, click the + button in the Template Browser panel header and give the template a descriptive name. **Figure 9.58** shows a template that I created on some of the earlier pages of this chapter and saved as *Custom layout-3*. As you roll over the

other template presets in the list, you will see a preview based on whichever is the most selected image in the Slide Editor view. As with the other Lightroom modules, you can remove a template by highlighting it and clicking the – button in the Template Browser panel. You can also update the settings for a particular template by right-clicking and choosing Update with Current Settings. There is no nesting capability built into the Template Browser panel, although to be honest it is not something that you are likely to need because there should be enough room to accommodate all the slideshow templates you might use. You can see how social and wedding photographers might find it useful to take a standard layout design and save variations of this template with alternative music playback settings to suit the music tastes of different clients, and how art photographers might like to create custom slideshows for exhibition displays on a large screen.

When you save a template that includes a specific backdrop image and, for whatever reason, that image is no longer available in the library, you may see an error warning in the preview. However, if you select a template in which the backdrop image is missing from the library, Lightroom will look to substitute the last used backdrop image.

Creating a Slideshow collection

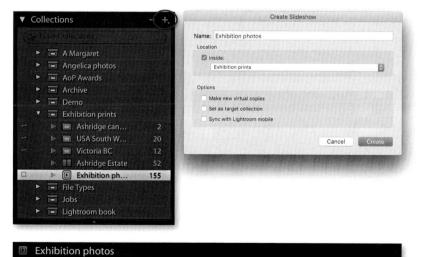

Preview ▼ Template Browser Lightroom Templates ▼ User Templates 24fps Timelapse Custom layout-01 □ Custom layout-2 ■ Custom layout-3 Custom layout-4 Custom layout-5 **Ⅲ** Kitsch TV LR5 book LR5 Timelapse TV slideshow Widescreen pan and zoom m www watermark

Figure 9.58 The Template Browser and template preview in the Preview panel.

Figure 9.59 The Collections panel, Create Slideshow dialog, and Create bar.

NOTE

Adobe Reader is a free PDF player program for Mac or PC. To download the latest version, go to get.adobe.com/reader. Only the latest versions of Adobe Reader are able to play a slideshow with transition dissolves, and even then, they will be of a fixed speed.

Exporting a slideshow

In addition to displaying slideshows, you can also export them. For example, you can export a self-contained slideshow in the Adobe PDF format, which can be played via the freely available Adobe Reader program or any other program capable of reading PDF files (such as Apple Preview). Or, you can export individual JPEG slides that can be placed as pages in presentation programs such as Microsoft Powerpoint or Apple Keynote. The Export buttons are positioned at the bottom left of the screen and are shown in **Figure 9.60**. Normally, you will see two options—Export to PDF and Export to Video—but if you hold down the Alt key, the Export to PDF button will change to Export to JPEG, which completes the three export options available in Lightroom. (You can also access these via the Slideshow menu or use the keyboard shortcuts mentioned in the following sections.)

Figure 9.60 The Export buttons in the bottom-left section of the Slideshow module. If you hold down the Alt key, Export PDF changes to Export JPEG.

Exporting slideshows to PDF

To export a PDF slideshow, choose Slideshow ⇒ Export PDF Slideshow, or use ∰ J (Mac) or Ctrl J (PC). Figure 9.61 shows the Export Slideshow to PDF dialog, where you can name and choose a destination to save the exported PDF to. Below this, you have the PDF export options, such as the Quality slider (to set the amount of compression used) and the Width and Height sections (to determine how large the slideshow document will be). You need to take into account the likely computer display size that the exported slideshow will be played on. For example, most computers will have an LCD display that uses a wide-screen

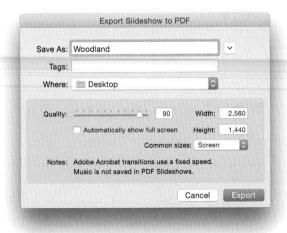

Figure 9.61 The Export Slideshow to PDF dialog.

format ratio—something like 16:9. If you want to scale down the slide size but preserve the full slide area, the size dimensions must match the ratio of the current pixel width and pixel height of your display. However, to make life easier for you, the Common Sizes menu will be set to the current monitor display resolution (actually the format of the slideshow slides will have already been influenced by the computer display you are working with). If you click this menu, you can easily select a common monitor resolution size for other typical computer screens. The "Automatically show full screen" option determines whether the slideshow starts playing in full-screen mode when the person who receives the slideshow opens the exported slideshow PDF document on his or her computer.

When you play back a PDF slideshow in Adobe Acrobat or Adobe Reader using the full-screen mode, the default view fills the entire screen. This is fine if you make the slideshow match the full-screen pixel resolution. However, if you want to play the slideshow at the actual pixel resolution, press **I1 (Mac) or Ctrl | 1 (PC) when viewing in Adobe Acrobat or Adobe Reader.

The compression settings can be adjusted according to how you intend to use a slideshow. If a PDF slideshow is to be distributed by CD or DVD, use a full-screen size and best-quality compression setting. If you intend to send a slideshow by email, you'll want to keep the pixel size and compression settings low enough so you don't send an attachment that is too large.

Exporting slideshows to JPEG

To export a slideshow to JPEG files, choose Slideshow \Rightarrow Export JPEG Slideshow, or use ****Shift** (Mac) or **Ctrl Shift** (PC). This opens the Export Slideshow to JPEGs dialog shown in **Figure 9.62**, where again, you can select the desired compression and screen size settings. This option is mainly useful if you wish to prepare individual JPEG slides that can then be incorporated into, say, a Microsoft PowerPoint or Apple Keynote presentation.

Save As:	Seascapes	
Tags:		
Where:	Desktop	0
Quality: 📥	90 Width:	1,600
	Height:	1,200
	Common sizes: 1600x1	200

Figure 9.62 The Export Slideshow to JPEGs dialog.

Exporting slideshows to video

The Export Video feature can be used to export high-quality movie slideshows (**Figure 9.63**). By utilizing the H.264 movie format, you can generate movie files that can be uploaded to any of the popular video-sharing websites such as YouTube. You can also optimize video files to be played back on mobile media devices such as the iPhone. Lightroom Classic CC has upgraded the framework used for the video rendering, which should result in faster processing times.

To export a video, click the Export Video button, go to the Slideshow menu, and choose Export Slideshow to Video, or use the *Alt J (Mac) or Ctrl Alt J (PC) keyboard shortcut. Here is a summary of the various video-output options, as described in the Information section of the Export Slideshow to Video dialog: 480x270 is suitable for mobile devices such as the iPhone and Android, and 640x480 is suitable for small handheld devices and web use. 720p provides medium-size HD quality, which can be used for online sharing (e.g., YouTube, Facebook, Blip.tv, etc.) and also for home media/entertainment (e.g., AppleTV or Windows Media Center). Lastly, 1080p provides high-bit-rate HD video at 1920x1080 pixels. All of the above are compatible with Adobe Media Player, Apple Quicktime, and Windows Media Player 12 and will export using H.264 video at 30 fps.

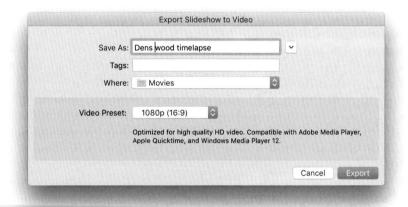

Figure 9.63 The Export Slideshow to Video dialog.

Exporting a timelapse video

Figure 9.64 shows an example of a time-lapse movie that was created directly from Lightroom. This was achieved by making a sequence of photos shot once every 6 seconds and making them into a slideshow. To create this, I used a custom 29.97 fps time-lapse Slideshow template that was created by Sean McCormack. This Slideshow template is available for download via the Lightroom Blog website (tinyurl.com/gedzggy).

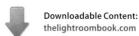

Figure 9.64 This slideshow movie was assembled from a series of time-lapse photos and put together at a frame rate of 29.97 fps.

Licensing audio tracks

If your video export is to include an audio sound track, this does raise the question of whether it is legitimate to do so, because one of the big problems facing the music industry has been the illegal sharing of music downloads. If you produce a slideshow movie that includes original, unlicensed music, you cannot expect to export such a movie and publish it to a wider audience. Even if you purchase an iTunes Plus track, this does not allow you to redistribute it if it is used in a slideshow movie. In any case, websites such as YouTube will notify you of copyright infringements if an uploaded file contains unlicensed music. So, if you plan to create a slideshow movie, make sure you have acquired the rights where necessary to use the sound track material. There are websites where you can purchase music for this type of usage, such as Getty's audio division at pumpaudio.com. Another solution is to check out websites or social networking pages for unsigned music artists and see if you can strike up some kind of reciprocal deal. Sometimes a band might be interested in letting you use their music if you let them use your edited movie. The musician Moby licenses some of his B sides and other unreleased material for free for non-commercial film usage. Check out mobygratis.com to check out the conditions for use and how to sign up.

NOTE

The Web module is built using Google's Chromium Embedded Framework. As a result of this, the rendering performance of web galleries is made more stable. It means Lightroom can recover more easily if the underlying web render process should happen to crash.

The Web module

As I mentioned at the beginning of this chapter, the usefulness of the Web module has been largely superseded by Lightroom CC/mobile. Having said that, the Web module offers another way to publish collections of images on a website. You can use it to show photographs from a shoot you are working on or to integrate galleries with your personal photography website. Or, you can use it to share pictures with friends and family.

The Web module controls are shown in **Figure 9.65**. The main difference between the Web and Slideshow modules is that although you have only a small amount of control over the web gallery designs, there is more emphasis on being able to customize the content information. The Web module uses the catalog previews and builds a website on the fly as you adjust the Web module settings. What you see in the content area is not just a preview but shows the web gallery as it might look when viewed via a web browser. As you adjust the Web module panel settings, the changes you make are constantly updated. As with the Slideshow module, a web gallery can be generated from a selection of images such as a Collection, a filtered catalog selection, or a subselection of images made via the Filmstrip.

In the Layout Style panel, you can choose which type of gallery you wish to implement. The choice here is between legacy (classic HTML) and HTML5 layout styles. The type of layout style you select affects the options that are subsequently made available in the other remaining panels. In the Site Info panel, you can enter custom information such as the site name and your contact details. With the Color Palette panel, you can edit the color scheme for all the web gallery design elements. In the Appearance panel, you can customize the appearance of the layout design for the HTML or HTML5 layout styles and decide things like how many rows and columns are to be used in the thumbnail grid, and set the thumbnail and preview image sizes. The Image Info panel can be used to customize the content that appears beneath (or alongside) the individual gallery images and provides an opportunity to add multiple items of relevant data information. The Output Settings panel is used to control the image quality and output sharpening, and you can also choose to add a watermark to the web gallery images. Quite a few templates are provided in the template Browser panel. With a little patience and practice, you can easily adapt and customize these to create your own web gallery design layouts.

At this stage, you can either click the Export button to save the web gallery to a named output folder or click the Upload button to upload the web gallery to a server; also, the Preview in Browser button lets you preview the web gallery site in the default web browser program. However, before clicking the Upload button, you will need to use the Upload Settings panel to configure the FTP server settings for uploading a gallery to a specific server address. Lastly, custom web gallery configurations can be saved to the Template Browser panel.

Figure 9.65 The Web module panels and controls.

Figure 9.66 The Layout Style panel showing the expanded view (top) and compact view (bottom).

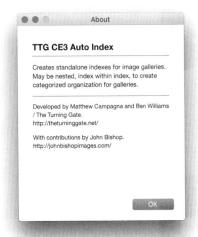

Figure 9.67 The About gallery window.

Layout Style panel

The Layout Style panel is located at the top of the right panel section and offers several choices of gallery styles, which you can select from the list shown in **Figure 9.66**. When the Layout Style panel list is compacted, you will see the name of the selected gallery layout style appear in the Layout Style panel header; from there you can access the available Layout styles via a pop-up menu list. If you go to the Web menu, you can select "About layout gallery" to open a window that provides more information about the individual gallery layout styles (**Figure 9.67**).

The Lightroom HTML and HTML5 galleries

The Classic Gallery style is based on a classic HTML-coded template design that can be used to produce a simple web gallery that has two viewing levels. Thumbnail images are displayed in a grid on the main index page. When you click one of the thumbnail cells, this takes you to a single-image page view where there is room to include title and caption information above and below the photo. From there, you can click the image to return to the index page thumbnail view again. Because the Classic Gallery style uses standard HTML code, it is probably the most compatible gallery layout style you can choose, as any visitor who goes to a gallery created using an HTML gallery style will be able to view these pages. The custom options let you make some basic modifications, such as adjust the size of the large image view, metadata display options, and color scheme, but it is otherwise a fairly rigid gallery style.

HTML5-style galleries can be used to render smooth, animated slide transitions between images and are a great way to present your photographs online. There are three HTML5 Layout Styles to choose from: the Grid Gallery, Square Gallery, and Track Gallery. These HTML5 layout styles are compatible with all modern web browsers, as well as mobile devices. The HTML5 Gallery layout styles also offer a few more options for customizing a gallery layout. For example, when a Grid Gallery layout style is selected, you have a choice of pagination styles, where you can choose to have a single page or multiple pages. With a Square or Track Gallery style, you can choose whether the thumbnail images load "on scroll," meaning the thumbnails will load as you scroll down a page, or load all at once. The main differences between HTML and HTML5 Gallery layout styles can be seen over the next two pages.

It can sometimes take a few seconds or so to see changes update in the content area. For this reason, I recommend that you have only a few images selected while editing the Web module settings. You can choose the Reload command in the Web menu or press #® (Mac) or com® (PC) to force a refresh in the content area. Lightroom gallery pages update the content area all the time anyway, so you should not really need to use this command. But the more complex third-party gallery styles often do need to be refreshed.

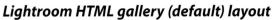

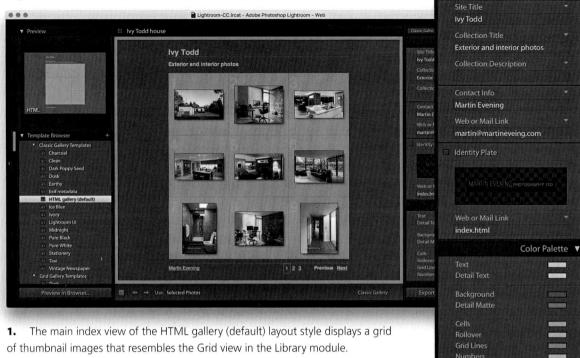

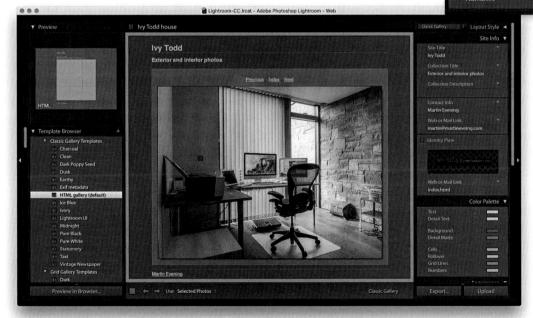

2. You can click a thumbnail to go to the main image view, and then click the image (or the Index link) to return to the index view again.

Site Info ▼

Lightroom Grid (HTML5) Gallery layout

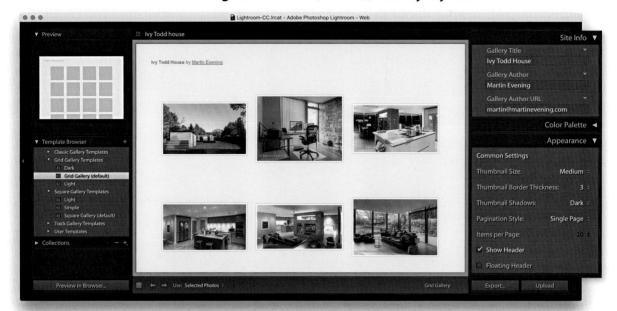

1. When using the Grid Gallery (HTML5) layout style, you have a thumbnail grid like the HTML layout, but with extra options for how these are displayed.

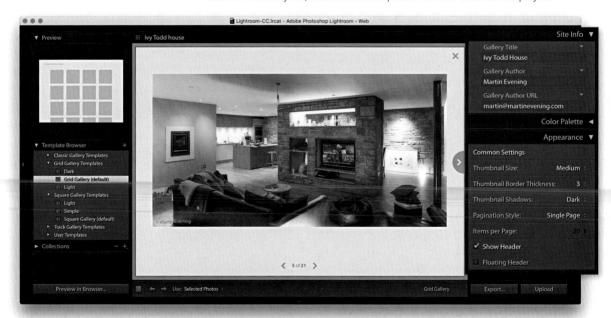

2. This shows what a Lightroom Classic Gallery single-page view can look like, with navigation buttons at the bottom and an X at the top right to go back to the Grid thumbnail view.

Third-party gallery styles

Adobe has made it easy for third-party companies to create their own layout styles. (Well, I guess it is only "easy" if you know how to code such things.) This has led to a number of third-party companies and individuals creating their own brands of gallery layout styles, which when loaded take over the right panels in Lightroom and allow you to customize these layout styles just as you would when adjusting the built-in styles. My favorite web gallery styles are those designed by Matthew Campagna of The Turning Gate, which can be downloaded from theturninggate.net. I highly recommend you check these out, as they offer great additions to the Lightroom Web module. **Figure 9.68** shows a Lightroom Web module preview of the TTG CE4 Gallery style.

Mora

You can click on the Find More
Galleries Online button in the Layout
Style panel to discover other thirdparty galleries.

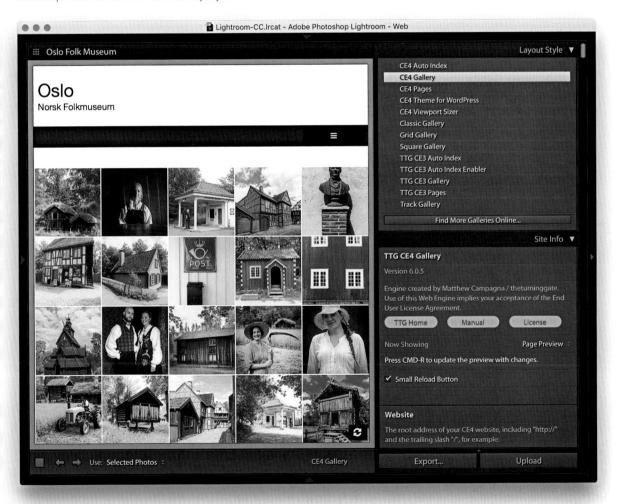

Figure 9.68 The CE4 gallery layout style from theturninggate.net.

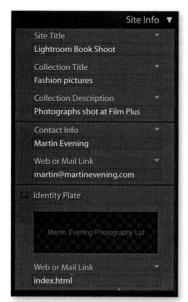

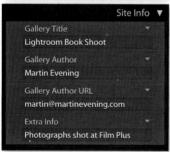

Figure 9.69 The Site Info panel showing the HTML version (top) and the HTML5 version (bottom).

Be aware that entering your email address as a mailto: link on any website exposes your email address to being harvested by web crawler engines.

Don't confuse web gallery layout styles with the web gallery templates that are saved to the Template Browser. To install a web gallery layout style like those supplied by theturninggate.net, place the downloaded layout style in the following location: Username/Library/Application Support/Adobe/Lightroom/Web Galleries (Mac) or Users\Username\AppData\Roaming\Adobe\Lightroom\Web Galleries (PC). Note that on a PC you may need to ensure that hidden files and folders are made visible in order to locate this folder. Remember to quit and restart Lightroom after you have installed a new layout style. Once you have done so, the newly added layout style will appear listed in the Layout Style panel.

Site Info panel

The Lightroom gallery layout styles provide the core web gallery structure, and the gallery style you select affects the range of options made available in the panels that appear below. These additional panels allow you to customize the web gallery content, so let's start by looking at the Site Info panel (**Figure 9.69**). Here, you can complete the various fields that are used to either describe or provide information about the web gallery images. If you click the down-facing triangles, you can access the most recent list of data entries.

The first three Site Info items describe the site and images. The Site Title is used as the main heading in the template design; when an HTML gallery style is chosen, the Site Title also appears in the web browser title bar. The Collection Title is like a subheading to the main title. For example, if you were preparing a web gallery of a wedding, the main title would probably be a general description such as "Jones wedding." You might then prepare several galleries with different collection titles: one gallery might be for the ceremony and another for family groups. The Collection Description can be used for entering longer text. When an HTML gallery style is selected, this information appears just below the Collection Title header.

You can enter your own name into the Contact Info/Gallery Author box and use the Web or Mail Link or Gallery Author URL box to enter a link that you want to have associated with the contact/author info. If you wish to add an email link here, just type in your email address. When you do this, the contact info appears as a text hyperlink at the bottom of the page (HTML) or after the gallery title (HTML5), and when a visitor clicks this link, it automatically launches her email program and prepares a new email that is ready to send with your email address placed in the *To*: header. Alternatively, you can insert a URL that takes visitors to your website. There is no need to type in the *http://* at the beginning of the website address as Lightroom automatically fills that bit in for you.

If you refer back to Creating a Custom Identity Plate on page 519, you can remind yourself of the steps required to design and edit an identity plate and save it as a new setting. When working with the Web module, the only real options you have are to enable or disable an identity plate from appearing at the top of the web gallery interface (in place of the site title).

Color Palette panel

The Color Palette panel can be used to customize the gallery interface. The items in this panel depend on whether the Lightroom HTML gallery or Lightroom HTML5 Gallery is selected. **Figure 9.70** shows a Color Palette panel in HTML gallery mode, with the color scheme used in the Stationery HTML template design. In this particular example, the Text color is set to mid-gray and the Detail Text is set to a slightly lighter gray, offset against a cream color background with various dark shades of blue and cream used for the thumbnail cells, cell frame rollover colors, grid lines, and cell frame numbers. The color you choose for the Detail Matte is used as a matte backdrop for full-image page views, so you will have to inspect the HTML galleries in full-image page-view mode to see the effect this is having on the layout.

Figure 9.71 shows an example of the Color Palette appearance when the Grid Gallery Lightroom HTML5 Gallery style is selected. Here, I have shown the settings used for the Grid Gallery style: Background is a light gray, header Text a mid-gray, the Icons a slightly lighter gray, and the Thumbnail Border is white (there are no Thumbnail Border options for the Square and Track Gallery optons). The header text is the gallery title, and the thumbnail border is the edging that defines both the main image and the thumbnail list sections.

Choosing a color theme

With so many color choices, which should you use? There is a definite art to picking the colors that work well together. The safest thing to do would be to select one of the gallery templates listed in the Template Browser or stick to designing a layout that uses a neutral range of colors. Many photographers prefer to keep the color accent neutral because the presence of colors can be a distraction when displaying color photographs. **Figure 9.72** shows the color picker, which has a HEX edit box, where you can enter hexadecimal values to select web-safe colors. You may also want to check out Adobe Color CC (color.adobe.com), a web-hosted application that allows you to explore and create different color harmonies (**Figure 9.73**).

Figure 9.72 The color picker showing the HEX edit box.

Figure 9.70 The Color Palette panel for a Lightroom HTML gallery.

Figure 9.71 The Color Palette panel for the Grid Gallery HTML5 Gallery style.

Figure 9.73 The Adobe Color CC webpage.

Figure 9.74 The HTML gallery Appearance panel.

Appearance panel

The Appearance panel provides additional controls for the layout appearance of the different gallery layout styles.

Appearance settings for the HTML gallery

The grid layout must have a minimum of three columns and three rows. You can customize the design layout by clicking in the grid to set the grid cell range (**Figure 9.74**). When you create a gallery with more images than can fit the grid layout, these overflow into successive, numbered index pages. If you have a saved collection of photos and are creating a web gallery of the entire collection, it can be useful to check the Show Cell Numbers option; some people find it easier to identify a particular image using a cell index number rather than the filename. The image size for the image pages can be anywhere from 300 to 2071 pixels along the widest dimension. Also included here are check boxes for customizing the look of the HTML grid, such as adding drop shadows and borders. At the bottom, you have the Image Pages options, where you can adjust the image size and color and width of the photo borders. The exclamation point you see in **Figure 9.75** alerts you that these adjustments can be seen only if you click on a grid image to make a single page visible in the content area preview.

Figure 9.75 A Lightroom HTML gallery layout with the Appearance panel set to a 3 x 4 grid.

Appearance panel settings for the HTML5 Gallery

The Appearance panels for two of the available HTML5 Gallery styles are shown in **Figure 9.76**.

Figure 9.76 The Appearance panel settings for the Grid Gallery layout style (top) and Track Gallery layout style (bottom).

Figure 9.77 The Image Info panel.

Figure 9.78 The Image Info panel with the Custom Text item displayed.

Image Info panel

From the Image Info panel, you can customize the look and placement of your gallery's titles and captions.

Adding titles and captions

The Image Info panel has a Title and Caption section where you can add image-related information to the main image views. In an HTML gallery layout, the title appears above the image in the main image view and the caption is placed just below. In an HTML5 Gallery layout, the caption is displayed just beneath the main image view and the title is placed just below the caption.

The simplest way to create a custom setting is to click the pop-up menu to the right of the current setting and select an item from the list. **Figure 9.77** shows all the available Title and Caption menu options. In **Figure 9.78**, I chose Custom Text for the Title and was able to enter the desired text in the box below. For the Caption, I selected Equipment. These are the easy-to-access default options, but if you want to extend these, you can click the Edit item at the bottom of the menu to open the Text Template Editor shown in **Figure 9.79**, where you can create your own custom templates.

Figure 9.79 The Text Template Editor.

Customizing the title and caption information

Figure 9.80 shows a preview for a customized HTML gallery using the Image Info panel settings shown in Figure 9.78. You can see that the custom text that was entered for the Title appears in the matte frame just above the image, while the Equipment appears below and shows the name of the camera and lens used.

As I just mentioned, if you choose Edit from the Image Info panel, this opens the Text Template Editor (Figure 9.79), which is identical to the one shown earlier in the Slideshow module section and allows you to insert metadata tokens from the pop-up menus and combine these with custom text. **Figure 9.81** shows an HTML5 Gallery layout in which I used the Text Template Editor settings shown in Figure 9.79 to create a custom Caption setting, which I then saved as an Extended Info setting.

Figure 9.80 An example of the Title and Caption information displayed in an HTML gallery style using Custom Text for the Title and Equipment for the Caption.

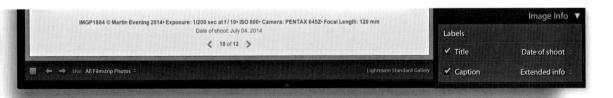

Figure 9.81 An example of the Title and Caption information displayed in an HTML5 Gallery style page view using the Text template setting shown in Figure 9.79.

Creating a custom Text template

Figure 9.82 shows a progression of steps in the Text Template Editor to configure a new Image Info panel Title/Caption preset, the results of which you can see in Figure 9.84. If you select a preexisting preset and choose Edit to make changes to the layout via the Text Template Editor, the preset name is marked as an edited version. If you want to update a current preset's settings, do not forget to choose Update Preset from the Preset menu in the Text Template Editor. I started by clicking one of the Image Name pop-up menus and selected a Filename token. This added a Filename token to the editor window. I typed "● Exposure" and clicked one of the EXIF Data menus to add an Exposure token. I then went to the EXIF Data section again and added an ISO Speed Rating token. Then, from the Preset menu, I chose Save as New Preset. I named the preset Filename + EXIF, and clicked Done. This preset then appeared added to the Image Info panel menus.

Figure 9.83 The "Exif metadata" template.

Figure 9.82 A sequence of steps using the Text Template Editor to create a new Title/Caption preset.

Custom presets cannot be formatted in any particular way, and the information is always displayed as a continuous flow of text in the Title or Caption field. However, if you choose the HTML *Exif metadata* template from the Template Browser panel (**Figure 9.83**), it includes a unique, built-in custom setting where some of the camera EXIF metadata information is presented in a formatted way in the Caption section (see **Figure 9.85**). You cannot actually edit this setting, and the only way to access it is by selecting the Lightroom *Exif metadata* template.

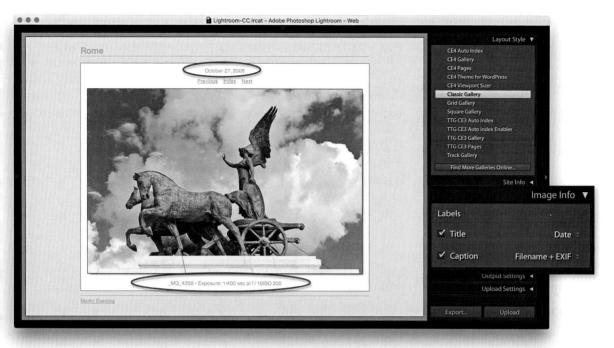

Figure 9.84 Here is how the Caption information appears on an HTML detail page when using the custom Filename + EXIF preset I created in Figure 9.82.

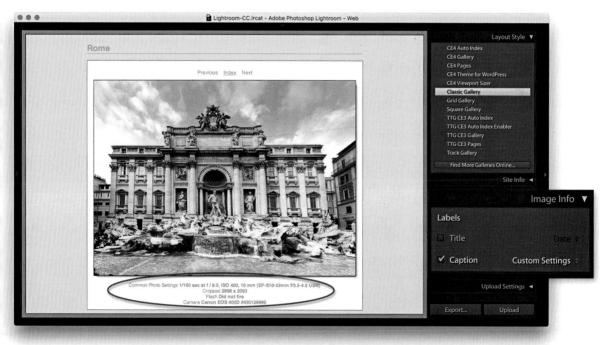

Figure 9.85 The EXIF metadata template and how it appears in the Caption section.

547

Figure 9.86 The Output Settings panel.

Output Settings panel

The Output Settings panel (**Figure 9.86**) can be used to adjust the Quality, Watermarking, and Sharpening settings. The Quality slider is used to set the amount of compression that is applied. The web gallery images that you preview onscreen are all JPEG versions of the master images, and the JPEG file format uses a lossy method of compression to reduce the physical file size so the JPEG images are small enough to download quickly. The choice boils down to a higher quality setting with minimal compression or a lower quality setting with greater compression. As you adjust the Quality slider, you should give Lightroom a chance to refresh the gallery so you can accurately preview the effect the compression setting is having on the appearance of the images in the web gallery.

The Metadata section lets you choose between embedding All Metadata or Copyright Only. Embedding metadata is useful if you want to ensure your photographs are output with all the essential metadata, such as the EXIF information and IPTC captions, and that these are preserved in the file header. The downside of doing this is that the file size of your JPEG web images will be bigger. So, if your main concern is to keep the file size down and have your web gallery sites load quickly, then choose the Copyright Only option. You can also check the Watermarking box to add a copyright watermark to all of the gallery images. This option also makes use of the Watermark Editor that was described on page 440.

The Sharpening section makes use of the Lightroom output sharpening routines. When the Sharpening box is checked, Lightroom automatically calculates the correct amount of sharpening to apply to each image, based on the final output pixel dimensions. The sharpening that is applied here is not the same as that applied for print in the Print module but is instead based on sharpening routines that have been devised specifically for a computer display output. The Standard Sharpening setting applies what is regarded as the optimum auto-sharpness setting, but if you prefer a weaker or stronger sharpening effect, you can choose to use the Low or High setting. However, you will not see any changes take place to the images previewed in the Web module content area until you choose Preview in Browser or Export Web Photo Gallery. It is only at this stage that the photos are fully processed and the sharpening routines are applied. This will certainly increase the time it takes to export the web gallery, but if you test how the gallery images look with and without sharpening, you will find the web output sharpening makes an appreciable difference.

Previewing web galleries

One of the benefits of working with the Web module is that the content area gives you an almost exact preview of how a web gallery will look (apart from the output sharpening), because it is effectively showing you a web browser view. Even so, this might not be exactly how everyone will see your website after it has been uploaded. There are always a number of unknown factors, such as the variability of the displays used to view the images that are on your website. Therefore, in addition to previewing the gallery pages in the content area, you can check how a gallery looks in an external web browser application by clicking the Preview in Browser button (Figure 9.87), or use the *AITP (Mac) or Ctrl AITP (PC) shortcut. This creates a temporary export of the gallery and previews the result in whichever web browser program is set as the default browser on your computer system. The default web browser is the one set as the default by your operating system and there is no Lightroom preference for selecting this.

Image appearance in the Slideshow and Web modules

Lightroom uses a large, wide-gamut RGB space to carry out its image-processing calculations, but for screen presentation work, the color space needs to be tamed to something that is more universally recognizable. When you create a slideshow, Lightroom utilizes the JPEG previews that have already been generated to preview the catalog images onscreen. These preview images are created in the Adobe RGB space, which is particularly optimal for screen presentations because it prevents any unexpected shifts in the colors or contrast. In the case of non-raw (rendered) files such as TIFF, JPEG, PNG, or PSD, the native RGB space is used to generate the previews; for Slideshow work, the onscreen previews are preserved in whatever that space happens to be.

When you output images for the web, you are usually heading into unknown territory. This is because, once images have been published on the web, you have absolutely no way of knowing how they will be seen. It is fair to assume that most people will be viewing them with displays that are uncalibrated. Some web browser programs, such as Apple's Safari browser, are able to color-manage images that have an embedded profile, but most don't. For these reasons, the Web module converts the image previews on the fly to the universal sRGB space, which is an ideal choice for all web-output images.

To get some idea of how your photos will look when converted to sRGB, you can use the soft-proofing method described on page 485, which allows you to preview a file in a selected destination space, before you carry out the actual conversion.

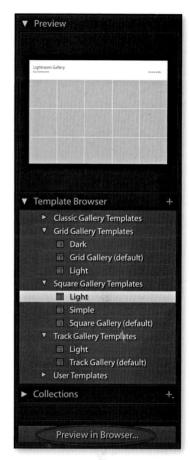

Figure 9.87 The Preview in Browser button.

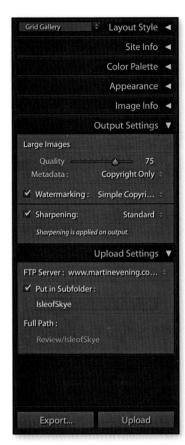

Figure 9.88 The Export and Upload buttons are located in the bottom-right corner of the Web module interface.

Upload Settings

Once you have finished preparing a web gallery, you can export or upload it as a complete website. Each method has its advantages. The question, as you'll see in the sections that follow, is how much you want to control manually versus automatically.

Exporting a web gallery

The Export option lets you save a complete version of the website to a folder on the computer. This then allows you to preview a web gallery in different web browser programs (not just the system default browser) and upload the web content manually using a dedicated FTP program.

To export a gallery, click the Export button (**Figure 9.88**), or use ***J** (Mac) or Ctrl (PC). This opens a system navigational dialog where you can choose a location to save the exported gallery to (such as the Desktop), type in a name for the exported gallery folder, and click Save to start the export process.

If you are familiar with FTP software, you can then manually upload the saved site folder to the desired server location. There are various file transfer protocol (FTP) programs you can choose from. Fetch from fetchworks.com is a popular program for the Mac. If you are working on a PC, I recommend using WS_FTP Pro (ipswitch.com) or FlashFXP (flashfxp.com). Whichever computer platform you use, the same steps will be used to establish an FTP connection. You need to enter the server URL, username ID, and password. Your Internet service provider (ISP) will be able to supply you with all the necessary information (assuming your Internet account includes server space).

Uploading a web gallery

The Export option is preferable should you need to manually edit a site before uploading it, or if you want to store a backup copy of a website offline. But for all other circumstances, you can use the Upload button to simplify the process of uploading the files to your server space directly. But first, you'll need to configure the FTP Server settings in the Upload Settings panel.

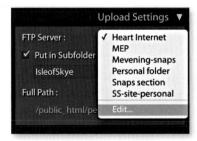

1. In the Upload Settings panel, I clicked the FTP Server preset menu and selected Edit.

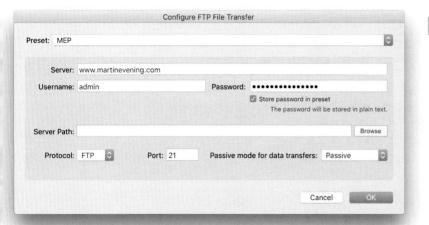

NOTE

When you point a web browser program at a web link, it automatically searches for a web page with the name index.htm or index.html. If you want to specify a published subdirectory link, you must place a forward slash (/) before the directory folder name and another forward slash at the end to tell the web browser to search for an index.htm or index.html page.

2. To create a new custom preset, I entered all the information that was required to access my server space. The server address is usually the first part of the URL, and the username and password can sometimes be the same as those used for your email account. The server path is used to enter the root folder on the server. Consult with your ISP, because there may well be a root-level name that has to first be entered to access the server space allocated to you; otherwise, the connection will not work. With this particular server, it was not necessary to enter anything here.

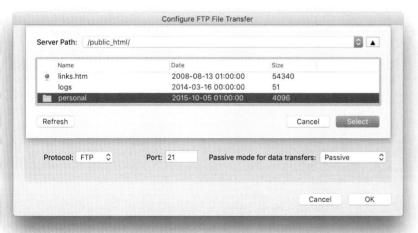

3. You do not necessarily have to memorize the structure of your server directory or the name of the server path. Here, I just clicked the Browse button in the Configure FTP File Transfer dialog, and Lightroom scanned the server to reveal a folder view of the server directory. I then clicked to select the *personal* folder and clicked the Select button to make this the server path.

NOTE

SFTP stands for secure file transfer protocol and is a network protocol that provides both file transfer and manipulation across a reliable network connection.

TE

If you are uploading web gallery files to an existing web server space that already contains your website, be careful that the subdirectory you choose does not conflict with existing folders. For example, it is not a good idea to upload new web galleries to a folder called *images*, because it is highly probable that your website already uses a folder of that name. Try using more unique and descriptive names for the folder locations, such as *client-review*, *personal* or *snaps*.

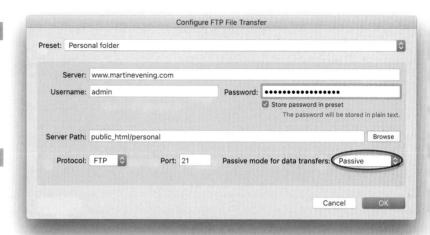

4. You can now see that the server path directory had been automatically updated to point to the *personal* folder. You can use the Browse feature in this way to access different folders or subfolders on the server and save them as different upload presets. If you experience problems getting a connection when you click the Browse button (or later when you try to upload), it could be because of firewall software on your computer system or router. If this is the case, try selecting Passive from the "Passive mode for data transfers" drop-down (circled). Once I was done, I chose Save Current Settings as New Preset, named it *Personal folder*, and clicked OK.

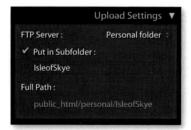

field needed to be completed. The folder name entered here completes the server path directory; this section is left blank because you *must* apply a unique name to the website folder you are about to create. Because the currently selected FTP Preset pointed to */personal,* all I needed to do was type a name for this particular web gallery. In this example, I typed *IsleofSkye* as the next part of the server directory and clicked outside the box to update the Full Path below. There was no need to add a forward slash at the beginning or end of this section of the path. Lightroom adds the slash automatically, because the complete path I had created was, in fact, */personal/IsleofSkye/*. I then clicked the Upload button, and Lightroom automatically uploaded the gallery files to this location on the server.

Managing your uploads

Lightroom makes it simple to upload websites, but doesn't provide you with an easy way to remove them. Bear in mind that server space costs money and there may be a capped limit on how much space you have available, or there may be a surcharge if you exceed your limit. You will therefore still need access to FTP software in order to carry out general housekeeping maintenance of the server space and delete web galleries that no longer need to be hosted.

Template Browser panel

You can easily end up putting a lot of time and effort into designing a customized web gallery template, so it makes sense to save any template designs that you work on via the Template Browser panel in the Web module (**Figure 9.89**). To add a new preset, click the Add button, or press (Mac) or Ctri (PC), and enter a new name for the template. To delete a preset, highlight the name in the Template Browser and click the Remove button. Most likely, you will continue to refine the design of your templates, so do not forget that as you select a preset, you can right-click to access the context menu and select "Update with current settings." When you hover over the presets in the list, the Preview panel shows previews of the gallery page layout presets. The previews display the gallery showing the layout and colors used.

Creating a web collection

You can save web settings and the associated image selections as a web collection (**Figure 9.90**). Click the + button in the Collections panel (circled), name the collection, and click Create to save (**Figure 9.91**). You can also choose Web ⇒ Save Web Gallery Settings, or press **★S** (Mac) or CtrlS (PC), to save the current web settings as a web collection. When doing so, you can choose to include all the photos in the Filmstrip or just those used in the current web gallery.

Figure 9.91 The Web module Create Web Gallery dialog and Web module Create bar.

Figure 9.89 The Web module Template Browser panel.

Figure 9.90 The Web module Collections panel.

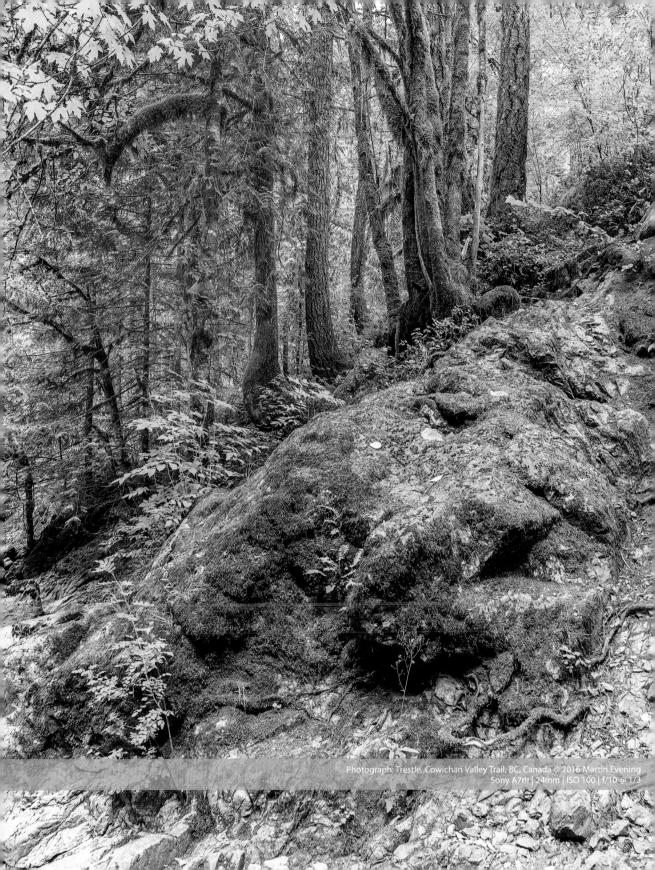

10

Managing your photos in Lightroom

How to use the metadata tools in Lightroom to manage your catalogs

Here is a quick test for you: Can you remember all the things you photographed last month? Were there any particular shots that stood out? Okay, so how about that same month five years ago? Many photographers think they can successfully rely on their memory when accessing pictures from their photo archives. The fact is, as we shoot more and more photographs, this kind of approach is doomed to failure, and as time goes by, it will only get worse.

Lightroom can help you organize and catalog your images from the very first moment you import your images. It provides a flexible system of file management that can free you from the rigid process of having to organize your images within system folders.

On the face of it, image management might seem like a chore, but the time you invest now in rating your photos and adding custom metadata such as keywords can easily bring its own rewards and justify the time spent doing this. Adding custom metadata to your photos will add value. For working photographers, this can mean adding commercial value by making such photos more easily accessible to someone carrying out a keyword search. Even adding just a minimal amount of metadata to your personal photos can help prevent precious photographs of friends, family, and places visited from being lost among an ever-growing catalog of images.

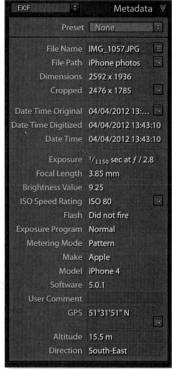

Figure 10.1 When I took this image, the iPhone recorded the time and date it took the photo, as well as the GPS coordinates. I used the Keywording panel to add the following keywords:

Olympics < Symbols, metal < Objects, circle < Shapes, train station < Transportation, Kinds Cross < London < UK.

Working with metadata

In the early days of digital photography, many photographers relied solely on a folder-based organizational system. Even today I come across photographers who use named folders to manage their entire image library. With a folder-based organizational system, the degree to which you can successfully retrieve specific images depends on your ability to memorize the folder structure and know where everything is stored. Anyone who is responsible for maintaining a large image archive knows that this method of file management can soon become unwieldy. What is needed is a cataloging program that can help you keep track of everything. Therefore, the trend these days is to use file management by metadata, where you search for a file by searching its attributes rather than by trying to remember which folder you put the picture in.

At the heart of any digital asset management (DAM) system is the ability to manage the files stored on that system through the use of metadata. A good DAM system should allow you to filter files using the metadata that is already embedded, as well as add custom metadata tags that can be used to carry out refined file searches and organize files into custom groupings. Some examples have already been shown in this book, such as how the Filmstrip filter can narrow down a selection of photos and display only those images with ratings of one star or higher, or two stars or higher, and so on. We have also looked at how to use the Folders panel to manage the image library. But the real power behind Lightroom is the database engine, which lets you carry out specific searches and quickly find the photos you are looking for. **Figure 10.1** shows an example of metadata applied to a personal photograph, while **Figure 10.2** shows an example of metadata applied to a commercial photograph.

It is in no way mandatory you follow all the advice offered in this chapter, as everyone will have their own particular image-management requirements. You may find you just want to use the Folders panel to catalog your library images, and that is enough to satisfy your needs. But, hopefully, one of the key things you will learn in this chapter is that the time invested in cataloging an image collection can pay huge dividends in terms of the time saved when tracking down those pictures later. The image-management tools in Lightroom are far from being a complete asset-management solution, but they do offer something for nearly everyone. Some may find the cataloging tools in Lightroom insufficient. But even so, the data you input via Lightroom will be fully accessible in other image-asset-management programs. Once you start adding metadata to your images and grasp the benefits of doing so, the process can become addictive.

The different types of metadata

Metadata is usually described as being data about data, which is used to help categorize information. Most of us carry out metadata searches on a daily basis.

Every time you use an Internet search engine such as Google, you are using metadata to find what you are looking for. For example, if you type in a search for "elephants" and then click the Images filter, you can quickly locate lots of photographs of elephants (over 11 million of them). But if you were to refine the search criteria to "Indian elephants ceremonial," you could start to narrow the search down further. If you need to find an email that was sent to you a year ago, you can use the search tools in your mail program to quickly find what you are looking for. An MP3 player such as an iPod is able to make use of embedded metadata to help you locate specific music, and a cable TV system will typically allow you to search for movies in a variety of ways. You can probably search for a specific film title by genre, release date, or director.

Lightroom also lets you organize your image files by metadata. All digital image files will contain a certain amount of camera data (known as EXIF metadata) to describe things like the camera and lens used, along with other technical information such as the lens settings and image file type. The thing is, the information that we would consider most important, such as who or what was in the picture when the photograph was shot, cannot be included automatically (although the Lightroom Faces feature can sometimes help). For the most part, photographers have to add such custom metadata information manually by entering keywords that help describe the image. Keywords can be used to categorize the photos in your catalog, and if you are skilled at keywording, this can really help you manage your photos efficiently, as well as improve sales if you are in the business of supplying photos to an agency.

It is true that you will need to spend time entering all this metadata information, although there are various tips coming up in this chapter that will show you how to avoid repetitively entering this data for every single image. The trade-off is that the time invested in cataloging your images in the early stages can help reap rewards later in the time saved retrieving your files. In most cases, you need to configure essential metadata only once to create a custom metadata template. You can then apply this bulk metadata automatically to a set of imported photos. You can take the metadata cataloging further and add extensive custom metadata information to individual images. It all depends whether this is important for the type of work you do. Basically, the amount of effort spent adding metadata should always be proportional to how useful that information may be later. There is no point in going overboard doing this. How much time you should devote to this task and the amount of detailed information you record will all come down to how important that information will be to you personally and/or the people you are supplying your images to.

There is a lot of detailed content coming up in this chapter about how to apply, edit, and use metadata. Therefore, I thought the best way to introduce this subject would be to provide a quick example of how metadata can be used to carry out a search of the Lightroom catalog.

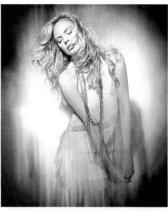

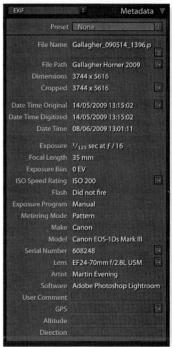

Figure 10.2 The Metadata panel shows the EXIF metadata for this studio shot. To this I added the following keywords: Brian Gallagher < Hair stylists, Camilla Pascucci < Makeup artists, Gallagher Horner < Jobs, Harriet Cotterill < Clothes stylists, M&P < Model agencies, Veronica < Models

A quick image search using metadata

One of the key features in Lightroom is the Filter bar, which can be accessed at the top of the content area whenever you are in the Library Grid view mode. The Filter bar combines text search, file attribute, and metadata search functionality all in one. The following steps suggest just one of the ways you can use a metadata filter search to find photos quickly and thereby demonstrate the usefulness of tagging your photos with keywords. I will begin by outlining the main aspects of the Metadata panel followed by the Keywording and Keyword List panels.

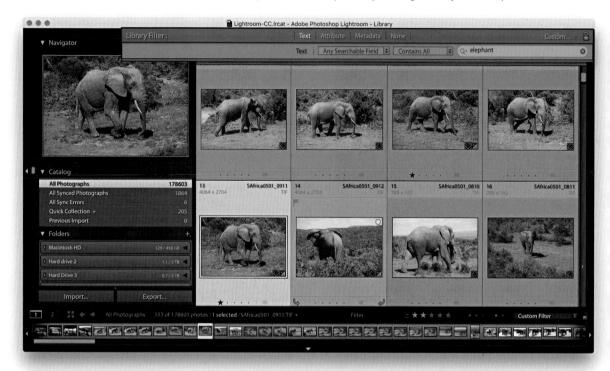

1. Let me start by showing how you can search for photos quickly, without needing to refer to the folders the images are kept in. In the example, I selected all of the photos in the catalog and used **F (Mac) or Ctrl F (PC) to reveal the Library Filter bar with the Text search field activated. Here, I typed "elephant" and I allowed the search to search within Any Searchable Field using Contains All search criteria. This filtered the catalog view to reveal 271 images with a text match for "elephant." This could be wherever there was a match in a keyword, caption, or filename. A filtered selection of 271 images was obviously a lot easier to sort through than a Google search that produced over 11 million results, but there are ways you can use Lightroom to further narrow down a search.

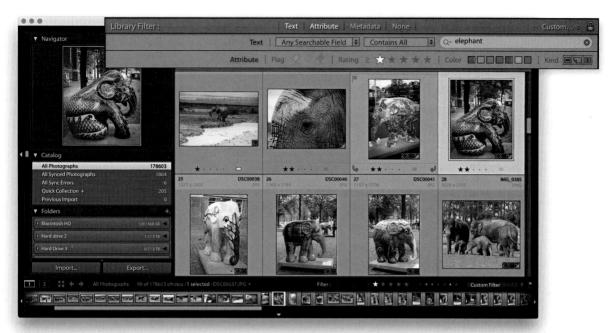

2. I then clicked the Attribute tab in the Filter bar and clicked the one-star button to narrow the search to elephant images with a rating of one star or higher. This reduced the selection to a more manageable 59 images.

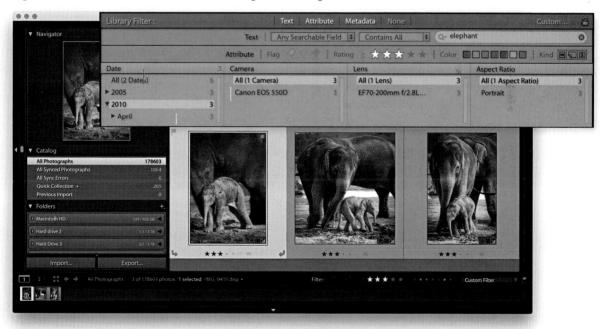

3. Lastly, I clicked the Metadata tab in the Filter bar and, in the Date column, clicked to select just those images that were shot in 2010. I also clicked the three-star button to display just those images with a rating of three stars or higher.

Figure 10.3 The Metadata panel, showing the default view.

Figure 10.4 The Metadata view options.

Metadata panel

Let's now look at the Metadata panel. Figure 10.3 shows the default Metadata panel view, which displays a condensed list of the file and camera information. At the top is the Preset menu with the same options as those found in the Import dialog Apply During Import panel (see also page 568 for more about creating and applying metadata presets). Below this are fields that show basic information about the file such as the File Name and Folder. Underneath that are the Title. Caption (elsewhere also referred to as "Description"), Copyright, Creator, and Location fields. These fields are all editable, and when you click a blank field, you can enter custom metadata, such as the image title and copyright information. Below this are Rating and Label, followed by the basic EXIF metadata items. This data is informational only and shows things like the file-size dimensions, camera used to take the photograph, camera settings, lens, and so forth. Some of the items in the Metadata panel have action arrows or other buttons to the right of the metadata item. These provide additional functions. For example, if you click the action arrow button next to Folder (circled in Figure 10.3), this takes you directly to a Grid view of the source folder contents.

Metadata panel view modes

If the Metadata panel in your version of Lightroom looks different from the one shown in Figure 10.3, this is probably because you are using one of the 11 other Metadata panel layout views. If you click on the View menu shown in Figure 10.4, this lets you access any of the alternative Metadata panel view options. In Figure 10.5, you can see a comparison of some of the main Metadata panel view modes. Each photo can contain a huge amount of metadata information, so if you want to see everything, you can select the EXIF and IPTC view. But if you want to work with a more manageable Metadata panel view, I suggest you select a Metadata panel view more suited to the task at hand. For example, the EXIF view mode displays all the non-editable EXIF metadata, whereas the IPTC view mode concentrates on displaying the IPTC custom metadata fields only and the IPTC Extension view can be selected to display additional IPTC Extension data. The Large Caption view mode displays a nice, large Caption metadata field, which gives you lots of room in which to write a text caption (the large caption space here does at least make the Caption field easy to target—click anywhere in the Caption field and you can start typing). While you are in data entry mode, pressing ←Return allows you to add a return in this field section instead of committing the text.

The Location panel mode provides a metadata view that is more useful for reviewing travel photographs. The Minimal and Quick Describe view modes are suited for compact Metadata panel viewing, such as when working on a small screen or laptop. And the DNG mode reveals specifics about the DNG data for selected DNG images. This lets you see specific DNG file information, such as whether lossy compression has been applied.

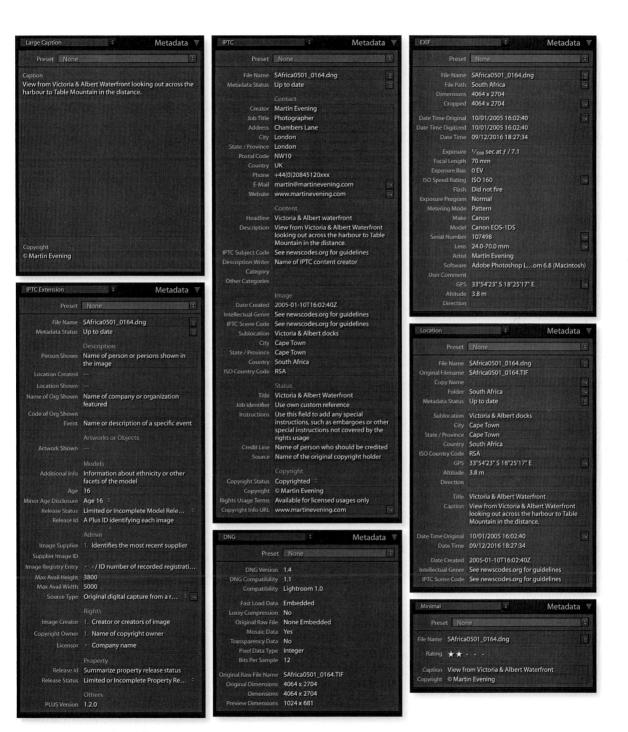

Figure 10.5 Some of the different Metadata panel view modes.

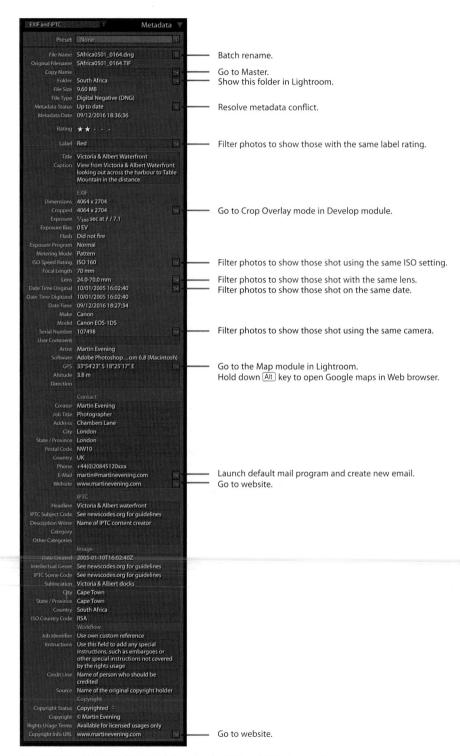

Figure 10.6 *The Metadata panel showing the EXIF and IPTC view mode.*

General and EXIF metadata items

Let's now look in more detail at the items that can be displayed in the Metadata panel. **Figure 10.6** shows a complete list of the items you might see listed when using the EXIF and IPTC view mode. Many metadata items can be displayed here and most are fairly self-explanatory. As you roll over the items listed in the Metadata panel, the tooltips provide extended explanations of how to use each of the fields. You might not see everything listed here in your version of Lightroom; certain items require the metadata to be present before they can be displayed. For example, only if there is an audio sidecar present will it appear as a metadata item just below Metadata Status. If you click the action button next to this, you'll be able to listen to the audio annotation. If no audio sidecar file is attached, you won't see anything listed.

File Name

This displays the filename for the currently selected photo. If you need to change the name of a file, click inside this field to make any name changes. If you want to carry out a batch-rename action, select the photos you want to rename and click the button to the right to open the Rename Photos dialog.

Sidecar Files

The Sidecar Files item shows up whenever a sidecar file is found associated with an image. Sidecar files are always hidden from view, so this extra item in the Metadata panel lets you know whether an XMP sidecar is present.

Copy Name

The Copy Name field refers to virtual copy images made in Lightroom. Each virtual copy image can provide an alternative version of the original master (or negative as it is sometimes described in Lightroom). By making virtual copies, you can apply different crops or color treatments. But because virtual copies all refer to the same master, they all share the same root filename. Whenever you create a new virtual copy, Lightroom labels each one as Copy 1, Copy 2, etc., but you may want to edit this name. In **Figure 10.7**, I renamed the virtual copy name *Black and white*. Virtual copy images can quite often end up being separated from the master, because you may have assigned a different star rating to the virtual copy version, they may be grouped in a collection, or they may have been removed from the master parent image. If you click the action button next to the copy name field (circled in Figure 10.7), you can quickly trace the master version of any virtual copy.

Making audio notes via the camera is useful should you wish to record information, such as the name of a person you have just photographed or other information that you might want to write up later as a caption.

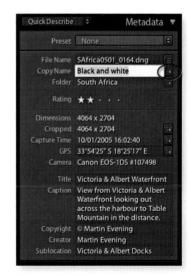

Figure 10.7 The Metadata panel with the Copy Name field active.

In **Figure 10.8**, you can see Grid view showing a master DNG image with two virtual copies to the right (see the page curl-icons circled in the bottom-left corners). The one on the right was renamed *Black and white*.

Figure 10.8 A master photo with two virtual copies (the one on the right has been renamed).

Metadata Status

If there is no metadata status conflict, the Metadata Status field will say "Up to date." If the metadata for the photo has been altered since it was last saved to the file's XMP space, it will say "Has been changed." Clicking the action button opens a dialog prompting you to save the changes to disk. If the metadata has been edited externally in Bridge, but the settings have not yet been read in Lightroom, it will say "Changed on disk," while a "Conflict detected" message indicates the metadata has been changed both in Bridge and Lightroom. In both cases, clicking the action button opens the metadata status dialog shown in **Figure 10.9**, where you can choose Import Settings from Disk, Overwrite Settings, or Cancel. The ins and outs of metadata saving, XMP spaces, and Lightroom settings are quite a complex subject. For a more detailed explanation, see pages 626 to 632.

Figure 10.9 The Metadata panel Metadata Status field with a "Changed on disk" warning. Clicking the action button opens the dialog shown here.

Cropped photos

If a photo has been cropped, the Cropped measurement will appear in the Metadata panel, showing the crop dimensions in pixels. If you click the action arrow next to it, this takes you directly to the Crop Overlay mode in the Develop module.

Date representation

Date Time Original and Date Time Digitized mean the date that a photo was captured or was first created, whereas the Date Time field indicates the time the file was last modified (such as a DNG conversion). **Figures 10.10** through **10.12** explain the differences between these bits of metadata information.

Next to Date Time Original is the Go to Date action button (this applies only to digital capture images). Clicking this button filters the catalog view to show only those photos that have matching capture dates. To exit this filter view, use the <code>\(\mathbb{H}\)</code> (Mac) or $(\mathbb{Ctrl}\)$ (PC) shortcut, which toggles the catalog filters on or off.

Capture time editing

Maintaining a capture time record of the photos you shoot should be more than just a matter of idle curiosity. A lot can depend on having your photos accurately time-stamped. For example, when importing photos from more than one camera, it is important that the internal clocks of both cameras are in sync. Doing so means the photos will be correctly ordered when sorted by the capture time. Perhaps the internal clock in your camera is wrong. Did you remember to set the internal clock correctly when you first bought your camera? For critical, time-sensitive work such as GPS tagging via a separate GPS device, you may want to keep a regular check on your camera's internal clock to ensure it is accurate.

If you know that the camera time and date settings are incorrect, you can address this by choosing Metadata ⇒ Edit Capture Time while working in the Library module. The Edit Capture Time dialog (**Figure 10.13**) lets you amend the Date Time Original setting for an individual image or a group of images.

If you find out too late that the date and time are wrong, the Edit Capture Time feature can help you restore the correct time to your captures. If you are editing the capture time for a selection of images, the "Adjust to a specified date and time" option lets you set the date for the current most selected image (the one shown in the dialog preview) and the remaining selected images will all reset their dates and time relative to this image. If the internal camera clock is correct but you simply forgot to adjust the camera clock to a new time zone, you might want to select the "Shift by set number of hours (time zone adjust)" option and adjust for any time-zone difference. At the bottom of the dialog, there is a warning that "This operation cannot be undone." However, if you later go to the Metadata menu in Lightroom, you can choose Revert Capture Time to Original. This allows you to reset the capture time metadata. Also, the "Change to file creation date for each image" option allows you to change the capture time for the capture time setting in the camera EXIF data back to the original creation date.

When you use the Edit Capture Time dialog to edit the original capture time settings for raw files, the changes made are applied to the XMP data only. If you go to the Metadata tab in the Lightroom Catalog Settings and go to the EXIF

Date Time Original 03/12/2016 16:17:13
Date Time Digitized 03/12/2016 16:17:13
Date Time 03/12/2016 16:17:13

Figure 10.10 For camera capture files that have not been converted to DNG, the Date Time Original, Date Time Digitized, and Date Time entries will all agree.

Date Time Digitized 24/09/2010 18:09:46
Date Time 24/09/2010 18:12:19

Figure 10.11 A scanned photo shows near enough identical Date Time Digitized and Date Time fields: i.e., the date the scan was made.

Figure 10.12 Date Time Original and Date Time Digitized refer to the time the photo was captured. The Date Time setting refers to the date the TIFF derivative file was made.

TIP.

On the Mac, there is an application called A Better Finder Attributes to reset the Date Original and Date Time Digitized back to their actual times: publicspace.net/ ABetterFinderAttributes. It works for a number of camera raw formats.

section at the bottom, you will see the option "Write data or time changes into proprietary raw files." When this is checked, it lets you hardwire date changes into the EXIF field contained in the proprietary raw file (as opposed to simply writing to the XMP space). It is not normal practice to risk editing the internal metadata fields of undocumented proprietary raw files, so use with caution. The reason for having this preference is that when some workflows rely on external programs, it may be necessary to edit the EXIF field inside the actual raw file (for example, you may need to externally synchronize the raw files with a GPS log).

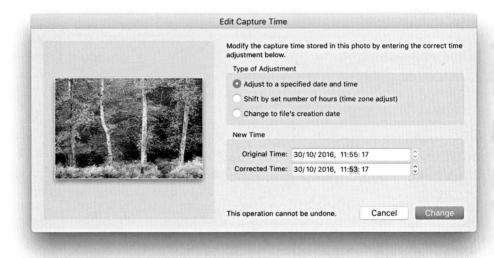

Figure 10.13 The Edit Capture Time dialog.

Camera model and serial number

These items instantly tell you which camera model and specific serial number were used to take a particular photograph. If you shoot using more than one digital camera body or have photos in the catalog taken by other photographers using the same camera type, this data can prove really useful, especially if you want to track down exactly which camera was used. Let's say there is a problem with one of the cameras—there may be damage to the sensor or a camera focusing problem. Using this data, you can pinpoint which specific body is responsible.

Artist EXIF metadata

The Artist EXIF metadata will only show up if you have applied this as a custom user setting for your camera. This can be done quite easily on most cameras by searching for the Copyright menu item, where you can enter your personal copyright details (**Figure 10.14**). If there isn't a Copyright menu item, you may find your camera comes with utility software. Connect it to the computer using a tethered connection and navigate to the section that allows you to enter and edit the Artist copyright field.

Embedding your name as the owner in the camera settings seems like a pretty good idea. This ensures the copyright name is always embedded in the capture file EXIF data. Just remember that if you borrow someone else's camera or rent one, always check what the owner name metadata says. Once the owner metadata is embedded in the raw capture files, you will not be able to edit the EXIF data that easily. If you are feeling brave, it can be changed using an EXIF editor such as ExifTool by Phil Harvey (sno.phy.queensu.ca/~phil/exiftool), but this is a command line-based editor and not particularly easy to use. While you can't edit the Artist EXIF field directly, you can use Lightroom to edit the IPTC Creator field, which will work superficially because the two fields are linked in Lightroom.

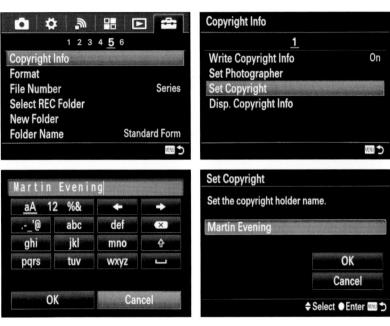

Figure 10.14 The sequence of screens you would select on a Sony A7 camera in order to add your name to the Artist EXIF metadata.

Custom information metadata

So far, I have mostly described the fixed, embedded camera metadata that is displayed in the Metadata panel. We are now going to look at working with custom metadata, which is data that you can use to add image-specific information. This can broadly break down into information about the image, such as the caption, headline, and location details of where the picture was shot. You can also add custom metadata that includes contact information about who created the photograph, such as your name, address, phone number, email, and website. This information can also include how the photo might be classified and what copyright licensing restrictions might be in force. As you start applying metadata to individual photos or groups of images, you gain the ability to differentiate them further and can reap the benefits of having a carefully catalogued image database.

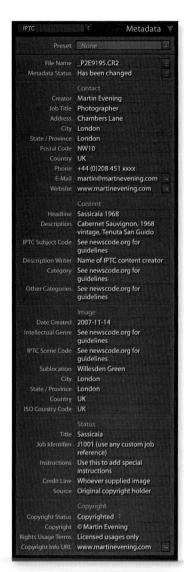

Figure 10.15 The Metadata panel in IPTC mode.

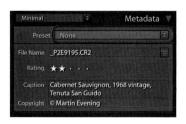

Figure 10.16 The Metadata panel with the Preset menu highlighted.

Applying such metadata now will help you in the future. Not only can it allow people to contact you more easily, but it can also help when you are working in Lightroom and need to make a targeted image search.

Figure 10.15 shows the Metadata panel in the IPTC view mode. You can see here that I have filled in the editable sections with examples of how you might use this panel to add descriptive information to a photo. You could, for example, select all the photos in a particular folder from the same shoot and add custom information to categorize them. Most of the items in this panel, such as Creator, Job Title, and Address, are self-explanatory, and this is data you would probably want to apply to nearly every photo. However, the Headline and Caption fields can be used to add image-specific information. The Headline field might be used to describe a photo shoot, such as Xmas catalog shoot 2016, or White-on-white fashion shoot, while the Caption field can be used to provide a brief description of a scene, such as Crowds line the streets at local festival to celebrate the Chinese New Year. These custom bits of information are essential when submitting images to a picture library, and they are particularly useful when you take into account that the value of an individual image is increased as more information is added. Even with a small-scale setup, you'll find it rewarding to methodically catalog your photographs with basic metadata information in the Contact and other IPTC sections.

Metadata presets

You certainly do not want to spend too much time entering repetitive metadata. This is where the metadata presets (also known as metadata templates) come in handy, because you can use them to apply the metadata information that needs to be input on a regular basis. To create a new metadata preset, click the Preset menu shown in **Figure 10.16** and select Edit Presets. This opens the Edit Metadata Presets dialog (**Figure 10.17**). The fields here will be populated with the IPTC metadata already applied to the currently selected photo, which you can use as the basis for a new preset. You can then edit the fields in this dialog as well as check the individual boxes for the items you wish to include. Having done that, click the Done button at the bottom to open the Save Changes dialog, where you can select Save As to save these settings as a new metadata preset.

Metadata presets provide a useful way to batch-apply informational metadata either at the import stage or later via the Metadata panel. You might therefore find it useful to create several metadata templates for the different types of shoots you normally do. Let's say you are a sports photographer and are often required to photograph the home football team whenever the team plays a game at the local stadium. You could save yourself a lot of time by creating a template with the name of the football team and the location information and apply this template every time you photograph a home game. Even though the Lightroom Metadata panel cannot display all the items that can be included in a Metadata preset, other programs may be able to do so.

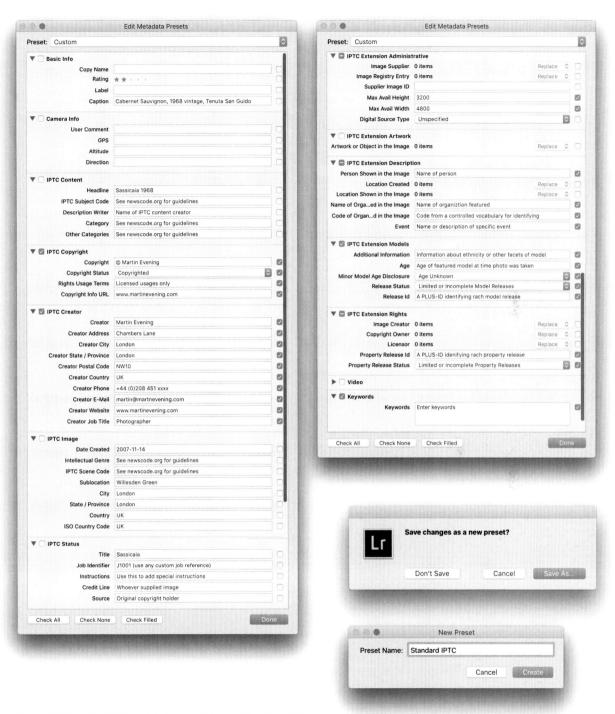

Figure 10.17 The Edit Metadata Presets dialog and New Preset dialog.

TE

If nothing else, make sure that every photo you create contains your contact details, is marked as copyrighted, and has a copyright notice. Photographers should always take steps to ensure that any photographs they release into the public domain do not become classified as orphan works.

If a photograph has no identification as to who shot it and it is "found" by someone on the Internet, that photo becomes classified as an orphan work. Currently, this does not give anyone the legal right to use such images. However, in some countries, there have been recent attempts to change the law so that orphan works can be legitimately used without needing to trace the owner.

The message here is to make sure everything you create is marked with your copyright and beware of uploading photos to sites that may strip the copyright metadata from your images.

Editing and deleting metadata presets

If you want to edit an existing preset, first choose the preset you want to edit and then select Edit Presets. Apply the edit changes you want to make, and click the Done button. This opens the Save Changes dialog, where you will have to select Save As and choose a new name for the preset (it must be a new name—you cannot overwrite an existing preset). To remove a metadata preset, choose Edit Presets and select Delete Preset.

IPTC metadata

The items listed in the Edit Metadata Presets dialog are not as comprehensive as those found in Photoshop, Bridge, or Phase One Media Pro, but the editable items you see listed in Figure 10.17 do conform with the latest International Press Telecommunications Council (IPTC) standard file information specifications, as used worldwide by the stock library and publishing industries. For help in understanding how to complete some of the advanced IPTC fields (such as the IPTC Subject Codes), I suggest you try visiting newscodes.org. Therefore, the metadata information you input via Lightroom will be recognizable when you export a file for use in any of these other programs. Conversely, Lightroom is able to display only the metadata information it knows about. It will not be able to display all the data that might have been embedded via Bridge or Media Pro. Should this be a cause for concern? For those who regard this as a shortcoming in Lightroom, it may well prove to be a deal breaker. But for others, the metadata options that are available should be ample. Figure 10.17 provides a useful overview and suggestions on how to complete the Basic and IPTC fields, and Figure 10.18 shows a practical example of a metadata preset that would be suitable for everyday use.

It is not mandatory all the listed fields be completed; just fill in as many as you find useful. For example, the IPTC Content section can be used to enter headline information and details of who wrote the description. The Description Writer field refers to the person who entered the metadata information: This might be a picture library editor, a photographer's assistant, or a work colleague. This type of information is not something that you would necessarily want to add as part of a metadata preset. However, the IPTC Copyright section can list information about who owns the copyright plus Rights Usage Terms. The IPTC Creator section can also contain contact details such as your address, telephone, email, and website. This information will most likely remain the same until you move or change email accounts. The IPTC Image section allows you to enter information that is more specific to the image, such as the intellectual genre. The remaining fields can be used to describe when and where the photograph was shot, job reference (such as a client art order), and so on.

Once you are done, you can save this template as a new metadata preset and apply it whenever you import new images into the catalog. Essentially, metadata presets are available and editable via the Import Photos dialog. You therefore

Preset: UK Basic IPTC		
▼ Basic Info		
Copy Name		C
Rating		
Label		
Caption		
Camera Info		
▶ ☐ IPTC Content		
▼ Ø IPTC Copyright		
Copyright	© Martin Evening	8
Copyright Status	Copyrighted	8
Rights Usage Terms	Licensed usages only	6
Copyright Info URL	www.martinevening.com	E
▼ ☑ IPTC Creator		
Creator	Martin Evening	8
Creator Address	Deer Reach	6
Creator City	Northchurch Common	6
Creator State / Province	Hertfordshire	6
Creator Postal Code	HP4	8
Creator Country	UK	8
Creator Phone	01442 860000	6
Creator E-Mail	martin@martinevening.com	8
Creator Website	www.martinevening.com	8
Creator Job Title	Photographer	- 6
▼ ☐ IPTC Image		
Date Created		(
Intellectual Genre		
IPTC Scene Code		
Sublocation		
City		
State / Province		
Country		

Figure 10.18 In this metadata preset, only some of the fields have been filled in and the corresponding check boxes selected.

have the choice of applying metadata presets either at the import stage or via the Metadata panel Preset menu. This way, you can ensure that after each new import, all newly added photos carry complete copyright and contact information (**Figure 10.19**).

In Figure 10.18, you will notice I did not enter data into all the fields, and for those that were empty, I deliberately left the check boxes deselected. This is because a selected check box is saying "Change this metadata." When you create a metadata preset, you will often want to devise a preset that is general enough to cover

Figure 10.19 A Metadata panel view with the Figure 10.18 Metadata template applied to an image.

certain types of shoots but without including terms that will make a preset too specific. Also, if you create a metadata preset that is designed to add metadata to specific IPTC fields, you may not want to overwrite any of the other fields that contain important metadata.

When a field in the Edit Metadata Presets dialog is checked but left blank, its description will turn red. The placeholder text in the field will say "Type to add, leave blank to clear," reminding you that if you check the box and do not add any text, it will act as an eraser, deleting any data for that field. Let's say I had an image where the Caption, Color Label, and Rating information had already been added. If I applied the metadata preset shown in Figure 10.18 but with all the boxes checked, it would overwrite these existing metadata settings with null content, thereby erasing the Caption, Color Label, and Rating data. So, when you create a new preset, it is always worth confirming that you select only those items that you intend to change; otherwise, your metadata presets can soon start messing up the photos in the catalog rather than enhancing them. Of course, you can always edit an existing preset and deliberately set the preset to erase older metadata if you think that would be useful. Configure these presets carefully, and always test them to make sure they behave exactly as you expect them to.

IPTC Extension metadata

Lightroom incorporates the IPTC Extension Schema for XMP, which is a supplemental schema to the IPTC Core. It provides additional fields with which to input metadata that can be useful to a commercial photography business. If you refer back to the example shown in Figure 10.17 on page 569, you will see brief explanations of how these fields may be utilized. Basically, the IPTC Extension schema can provide additional information about the content of the image, such as the name, organization, or event featured in a photograph. It provides you with further fields to improve administration, whereby you can apply a globally unique identifier (GUID). It offers fields for precisely defining the licensing and copyrights of a particular photograph. For example, instead of just saying "This photo is copyrighted by so and so," it allows you to specify the name of the copyright holder, as well as whom to contact to obtain a license. This might well be a picture library or a photo agent rather than the photographer. The image supplier can also be identified separately. Again, it might be a photo library that supplies the image rather than the photographer directly. For more information, visit the PLUS website: useplus.com.

If you photograph people, you can record specific model information such as the age of the model, which might be particularly relevant if the subject was a minor when the photo was shot. You can also provide a summary of the current model release status. The same thing applies to photographs of private properties where, under some circumstances, a property release may be required.

A more efficient way to add metadata

One of the things that continues to irk me about Bridge is that if you select a photo, make the Description field active in the Metadata panel, and enter new text, you have to press —Enter to commit, select the next image, and then retarget the Description field all over again to add a new description for the next photo.

Fortunately, this process is made a lot easier in Lightroom. **Figure 10.20** shows a Library Grid view of photographs that were taken at a model casting. I tend to shoot model castings with the camera tethered to the computer and update the Caption field with the model's name and model agency as I go along. In Figure 10.20, you can see that the Caption field is currently active and I have typed in the model's details. Instead of pressing —Enter to commit this data entry, I could use the \Re key (Mac) or \mathbb{C} trl key (PC), and a right or left arrow to progress to the next or previous image. This step commits the text entry and takes you directly to the next photo. It also keeps the metadata field active so you are now ready to carry on typing in new information for the next selected photo.

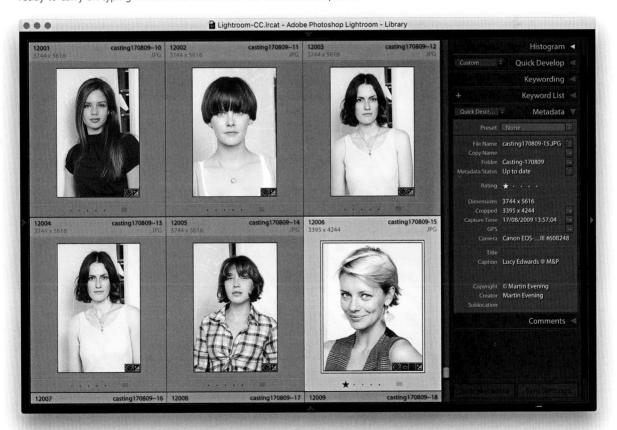

Figure 10.20 Here is an example of how to update the metadata for a series of photos without losing the focus on the field that is being edited in the Metadata panel.

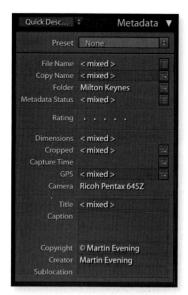

Figure 10.21 The Metadata panel when multiple photos are selected and all have different metadata information.

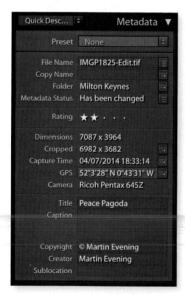

Figure 10.23 The Metadata panel with Multiple photos selected and Show Metadata for Target Photo Only is active.

Metadata editing and target photos

If you have a group of photos currently selected and go to the Metadata panel, whenever there are varied file attributes for the selected images, the metadata information will display <mixed> values (**Figure 10.21**). Only those values that are common to all the selected photos (such as the copyright information) will be displayed. When you are in this default mode of operation, you can edit individual fields in the Metadata panel to update the metadata you wish to be common to all the selected files. So, for example, if you want to apply the same title to everything, you can edit the Title field, and this will update all the selected images and apply to all.

Figure 10.22 The Show Metadata for Target Photo Only menu item.

However, if Show Metadata for Target Photo Only is selected in the Metadata menu (**Figure 10.22**), the Metadata panel display will look like the version shown in **Figure 10.23**, which displays the metadata information for the most selected or target photo only, even though you may have more than one photo selected.

To show you how this feature might be used, in **Figure 10.24**, I selected all of the photos from a folder in the catalog. The Metadata panel displayed the information for the photo that was the most highlighted (the target photo). By using the ## + arrow keys (Mac) or Ctrl + arrow keys (PC), I was able to navigate from one photo to the next without deselecting the active photo selection and read the metadata information for each individual image as I did so.

With the Show Metadata for Target Photo Only mode, the one thing you need to be aware of is that you will now only be able to edit the metadata on a per-image basis. This is a good thing, because it means that you can keep an image selection active and edit the metadata for each of the individual photos without losing the selection. However, many people will be accustomed to making image selections and then using the Metadata panel to edit the settings globally. So, just be aware that although this menu item can prove useful, you probably will not want to have it enabled all the time, as it could lead to confusion if you forgot this option was switched on.

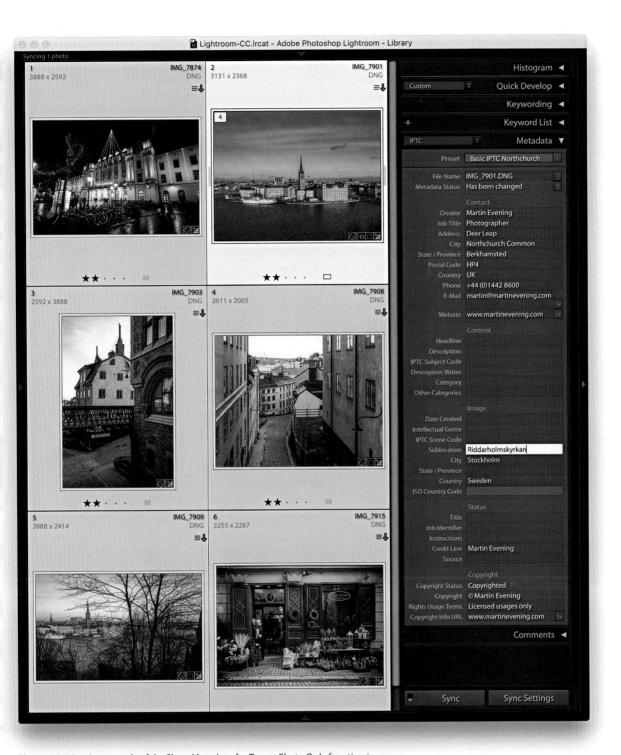

Figure 10.24 An example of the Show Metadata for Target Photo Only function in use.

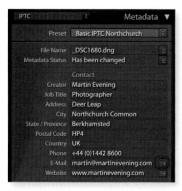

Figure 10.25 In this view of the Metadata panel, you can see the action buttons next to the E-Mail and Website items.

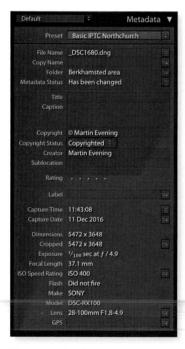

Figure 10.26 You can set the Copyright status by clicking the menu highlighted here in the Metadata panel.

Mail and web links

You can use the E-mail field to enter your email address. Other Lightroom users viewing your photos can simply click the action button circled in **Figure 10.25** to create a new mail message to this email address using the default mail program on their computers. If the email program is not currently running, Lightroom launches it automatically.

Similarly, clicking the action button next to the Website field launches the default web browser program and takes you directly to that website. The Website field can be used to enter your usual website address. But if you wanted to, you could use this field to enter a URL that takes people to a specific page on your website. For example, you could direct people to a specific web page informing people of the types of rights that are available for certain types of images. For instance, I could broadly divide the photos in my catalog collection as photos that have been exclusively licensed, those that have non-exclusive licenses (and are available for purchase), and those that are not for sale.

Copyright status

In the Copyright Status field (**Figure 10.26**), you can set the copyright status as being Unknown, Copyrighted, or Public Domain. You can edit the copyright status via the Metadata panel, or go to the Metadata panel Presets menu, choose Edit Presets, and create a new custom metadata preset via the Metadata Presets dialog where Copyrighted is selected by default (**Figure 10.27**). If you choose to use the Copyright field only to indicate this is your copyright, this statement should be clearly understood in nearly all countries and is all that you need to do to enforce your ownership rights. You will notice that whenever you open an image in Photoshop that is marked as being copyrighted, a © symbol appears at the beginning of the filename in the document window title bar.

When viewing a photo using the IPTC Metadata panel view, the action arrow next to the Copyright Info URL takes you directly to the website link entered into the accompanying Copyright URL field.

I highly recommend that, wherever appropriate, you mark all your images as being copyrighted. You can do this by applying a metadata preset during the import process (see Chapter 2). Unfortunately, marking an image as being copyrighted will not fully protect it from becoming an orphan work. For example, if you upload your images to certain social networking sites, the copyright tag is automatically stripped, so beware. For advice on how to format a copyright notice, go to en.wikipedia.org/wiki/copyright notice.

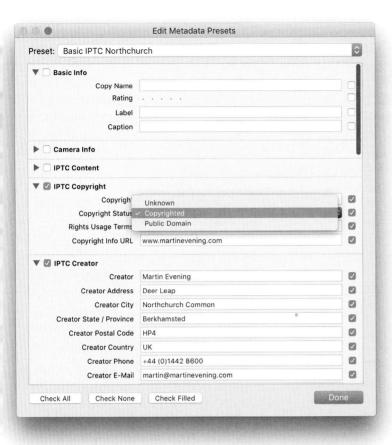

Figure 10.27 The Edit Metadata Presets dialog, showing the Copyright Status options.

Keywording and Keyword List panels

Keywording provides one of the easiest and most flexible ways to annotate your photos. In order to gain the maximum benefit, you will do well to apply a certain degree of discipline and consistency to the way you keyword your images. As I showed at the beginning of this chapter, keywording images can add value to any catalog. For professional photographers who sell photographs for a living, good keywording is essential for achieving maximum sales. For amateur photographers who are maintaining an archive of personal photographs, keywording can still add value in terms of making special photographs more easily accessible. It has taken a while to convince everyone of the importance of keywording, but now that many of us are shooting tens of thousands of photos each year, it is more important than ever to do what we can to keep our photo catalogs manageable. So, how much should you keyword? Professional colleagues of mine, such as Seth Resnick, claim that each image they supply to a picture library should have at least

Figure 10.28 A personal landscape image showing the associated keywords.

NOTE

Lightroom Classic CC does not sync keywords to the cloud servers, so they won't appear in Lightroom CC/
Lightroom mobile. Similarly, keywords added via Lightroom CC will not show up in Lightroom Classic CC either.
The only way to get keywords from Lightroom Classic CC to Lightroom CC is to migrate the catalog (as described in Chapter 11). During this one-time process flattened keywords are migrated to Lightroom CC.

50 keywords attached if it is to achieve any sales success. Seth generally carries out careful research to look for as many terms and related topics as possible for each of the images he submits. He will consider checking for variations in spelling, as well as looking out for hot topic words that might be relevant to something he has just shot. If you are not focused on library sales, then this kind of approach may seem like overkill. There is no point in overdoing things, and the key is to spend only as much time on the process of keywording as you are likely to benefit from in the future through the time saved when carrying out a file search. Okay, so it is hard to know exactly how much keywording is going to be necessary. I have to confess that I am still kind of catching up with the keywording of some of the older photos in my catalog, but I am at the stage now where every photo has at least one keyword term associated with it. But adding a few keywords that are relevant can add significant value to each image you annotate—even if it is just the photos you keep in a personal archive (**Figure 10.28**).

You can add keyword metadata via the Import Photos dialog as you import your images. The **Figure 10.29** example shows relevant keywords being added to the Keywords field, which would be applied to all the photos as they were imported. Lightroom can auto-complete keywords if it recognizes that the word you are typing might already belong to the keyword list.

Or, you can add or edit the keywords at any time via the Keywording panel (Figure 10.30). I normally organize my keywords in the Keyword List panel into a hierarchy of keyword categories (also referred to as a controlled vocabulary). For example, in the Keyword List panel *Places* keyword category, I have a keyword subcategory called *Europe*. In Figure 10.30, I clicked in the highlighted Enter Keywords field (where it says "Click here to add keywords") to add keywords to an image. In this instance, I wanted to add a subcategory of Europe titled *Norway*, and within that a subcategory: *Bygdøy peninsula*. The full keyword path here was: *Bygdøy peninsula* < *Norway* < *Europe* < *Places*. The keyword metadata is always entered in this hierarchical order, placing the child keyword before the parent. You will find that it pays to establish a proper keyword hierarchy that suits the content of your library and give some careful thought as to how you wish to structure a controlled vocabulary. For example, also included here were other keywords such as *Seascapes* < *Nature subjects* and *Boats* < *Transportation*.

Keywords can be used to describe anything you like. But do not forget that there are also IPTC fields that can and should be used to enter data, such as the location where a photo was shot. While keywords provide a single place for entering informational data, the fields in the IPTC data section are regarded as the formally correct place for entering such data. If you sell photos for a living, it makes sense to follow industry conventions and make sure you also fill out these sections rather than rely solely on keywording to do this.

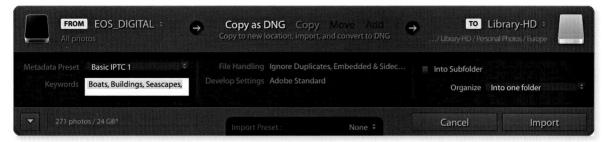

Figure 10.29 The Import Photos dialog with the Keywords field active.

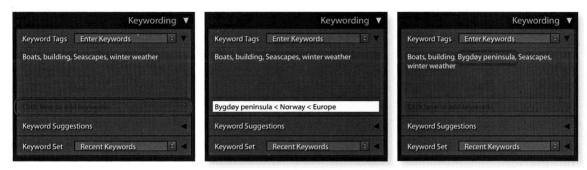

Figure 10.30 The Keywording panel with the Enter Keywords field highlighted (left), keywords being added (middle), and how the entered keyword appeared once added (right).

You can add keywords by clicking the plus button in the Keyword List panel, which is circled in **Figure 10.31**. Here, you can see I also right-clicked on the Norway keyword to reveal the context menu and chose Create Keyword Tag inside *Norway*. This opened the Create Keyword Tag dialog (**Figure 10.32**), where I added *Bygdøy peninsula* as a child of Norway.

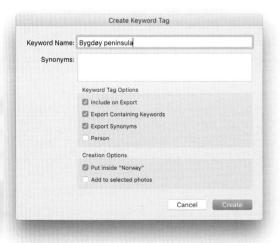

Figure 10.32 The Create Keyword Tag dialog.

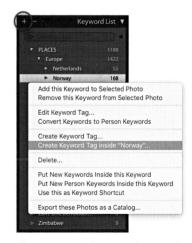

Figure 10.31 The Keyword List panel context menu.

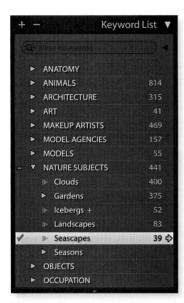

Figure 10.33 The Keyword List panel with a keyword tag selected and the box checked to apply this keyword to the selected image or images.

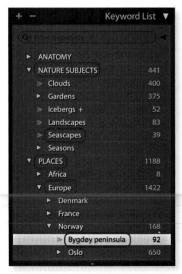

Figure 10.34 Notice that the Bygdøy peninsula keyword is a subset of Places > Europe > Norway and the Seascapes keyword is a subset of Nature Subjects.

When you roll over a keyword in the Keyword List panel, a check box appears to the left of the keyword. If you click this box, it adds a check mark and the keyword is added to the selected image or images (**Figure 10.33**). If you click the arrow to the right of the keyword count number, Lightroom filters the catalog to show all photos that share the same keyword.

If need be, you can use the Keyword List panel to manually edit the keyword list hierarchy, remove keywords that are no longer applicable, or create new hierarchy groupings. After a keyword has been added to the Lightroom keyword list, Lightroom will auto-complete keywords as you start typing in the first few letters for a new keyword entry. Apart from making it quicker to enter new data, this helps you avoid duplicating keyword entries through careless spelling or typos. Lightroom also auto-assigns the correct hierarchy. For example, the next time I might choose to add the keyword Seascapes, the Seascapes keyword will be automatically applied to the image using the Seascapes < Nature subjects keyword path (Figure 10.34). I will be coming back to this point later, but basically when you enter a keyword, Lightroom is able to auto-complete the keyword and at the same time knows to assign the correct keyword hierarchy. The only problem that can arise here is when a single keyword can have more than one context and therefore appears listed in more than one hierarchy.

Keeping metadata private

What about metadata you might wish to keep private? As you create new keyword tags or edit existing keywords, you can uncheck the Include on Export option in the Create Keyword Tag dialog (**Figure 10.36**). This lets you prevent specified keywords from being exported. Let's say I used the keyword tag *heavily manipulated > Private metadata* to tag photos that I edited in Photoshop. I might find this useful whenever I want to filter out the images that have had a lot of work done to them in Photoshop, but my clients would most likely prefer I didn't include this particular keyword at the export stage.

Imagine you were in the business of supplying location services to clients.

Figure 10.35 shows an example of an image of a holiday property, for which you might want to keep the location metadata hidden. After all, it would not be in your interests to include the exact location details within the metadata. If you use the Export dialog to export your photos, you can check the Remove Location Info box in the Metadata section to remove all GPS and IPTC location metadata. Similarly, you can also check the Remove Person Info box to exclude including People keywords (I'll be discussing People keywords later on page 590).

Synonyms: The hidden keywords

Within keywords, it is possible to include synonyms (Figure 10.36). Synonyms are basically alternative terms that can be used in place of the main keyword, which may or may not overlap with other keyword terms. The key difference between

synonyms and keywords is that synonyms, although they are searchable the same way as keywords, actually remain hidden from view in the Keywording List panel. This may seem odd, but there is a good reason for this. Basically, keeping synonyms hidden can help keep the keyword list less cluttered. However, one issue with synonyms is that when you import an image that contains a synonym (and when Export Synonyms was checked), it will be treated as a separate keyword and appear orphaned in the Keyword List panel.

In the Figure 10.36 example, the keyword car uses the following hierarchy: car < automobile < land transportation < TRANSPORTATION. Because Export Containing Keywords was checked, when any file using this keyword is exported, the full keyword hierarchy will be included. However, there are other search terms that people might want to use when searching for cars, such as auto, motor, or vehicle. These can be added as synonyms. Consequently, any image that's tagged using the single keyword car will be discoverable using any of the following search terms: car, automobile, land transportation, transportation, auto, motor, or vehicle. The benefit of using synonyms is that they allow you to include more potential keyword search terms within a single keyword in the keyword list, but without cluttering up the entire list with lots of different keywords that are essentially variations of a single keyword term. When creating keywords for locations, if it is important that other people find your photos, there are good reasons to consider including foreign-language versions of a name in order to reach a maximum audience. For example, English speakers might search "Venice," whereas the Italians will (correctly) search "Venezia." When I was photographing in Scotland recently, many of the places I photographed had both English and Gaelic names. Therefore, the Gaelic versions might be suitable for inclusion as synonyms.

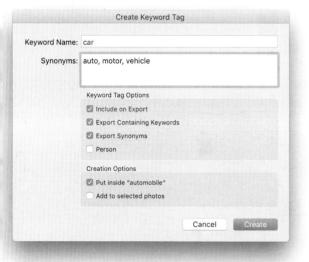

Figure 10.36 The Create Keyword Tag dialog for the keyword car, along with entered synonyms in the Synonyms field.

Figure 10.35 An example of an image for which, in some instances, you might like to keep the location metadata private.

Figure 10.37 Highlight the images you want to apply a keyword to, and then drag the keyword from the Keyword List panel to the image selection.

Figure 10.38 Make a selection of images, and then drag the selection to the keyword in the Keyword List panel.

Applying and managing existing keywords

You can apply keywords to photos in the catalog in a couple of ways.

Figure 10.37 shows how you can apply a keyword to a selection of images by dragging a keyword to the image selection. The good thing about this method is that it is easy to hit the target as you drag and drop the keyword. The other option is to make a selection first in the content area, and then drag the selection to the keyword. In **Figure 10.38**, I selected the same group of images and dragged the selection to the keyword *Las Vegas*.

When you select an image in the Library module, you will see all keywords associated with the photo listed in the Keywording panel, each separated by a comma. As you roll over the applied keyword box, you will see a tooltip indicating the number of keywords currently applied to the image. If multiple images are selected, the Keywording panel displays all the keywords that are active in the image selection. Those keywords that are common to all images in the selection are displayed as normal, while those keywords that apply only to a subselection of the images will be marked with an asterisk (**Figure 10.39**). If you want to unify a particular keyword across all the selected images, simply highlight the asterisk and press the Delete key. This ensures all the selected images are now assigned with that keyword. If you want to change a particular keyword, you can always highlight it and type in a new word or press Delete to remove it completely from the selection.

Figure 10.39 The Keywording panel with multiple images selected, showing all the applied keywords.

Auto-complete options

As you enter metadata for keywords and other editable metadata fields, it can save time to have the "Offer suggestions from recently entered values" option checked in the Catalog Settings dialog (Figure 10.96 on page 626), where you can also click the Clear All Suggestion Lists button to reset the memory and clear all memorized words. If you type in a keyword when there are two or more possible sources, Lightroom will offer them as choices. I will discuss the reasons for this later in the implied keywords section on page 586.

Most of the time, auto-completion is a useful thing to have active. Sometimes, however, it can become a pain. For example, when I do a model casting and enter the names of models in the Caption field of the Metadata panel in the Library module, I don't find auto-completion particularly helpful. What is useful with the Mac version is the ability to spell-check. The Edit ⇒ Spelling submenu in the Library module contains the options Show Spelling and Grammar, Check Spelling, and Check Spelling as You Type. This can help you avoid mistakes as you add new metadata.

Figure 10.40 *Keywords can be used to categorize the images in ways that are meaningful to your business.*

Removing keywords

It is easy enough to remove keywords. You can go to the Keyword List panel, select the keyword or keywords you want to delete, and click the – button at the top of the panel. This deletes the keyword from the Keyword List panel's hierarchical list and also removes it from any photos that have had the keyword assigned to them. If you just remove a keyword via the Keyword List panel, you will be deleting it from the Lightroom database only. If keyword metadata has already been saved to the file's XMP space and you need to maintain compatibility with Bridge, you will want to force-save the metadata change (the keyword deletion) back to the file's XMP space by choosing Metadata \Rightarrow Save Metadata to Files. By the same token, if specific keywords are removed using an external program, those keywords will not appear removed when you view the photo in Lightroom until you explicitly read the revised metadata back from the image.

As photos are removed from the catalog, keywords that were formerly associated with those images will consequently become unused. You can remove these by selecting and deleting as I have just described, or clear them from the Keyword List panel. To do this, go to the Metadata menu and choose Purge Unused Keywords. Just so you don't remove these keywords by accident, a warning dialog will ask you to confirm this action.

Keyword hierarchy

It is important to plan the keyword hierarchy you are going to use by adopting what is known as a controlled vocabulary of keywords. You can edit the keyword list by dragging and dropping the keywords into different keyword categories. It is possible to have several tiers of subcategories. For example, you could organize place name keywords in the following order: Town/City < State < Country < Places. When you are working in the Keywording panel, you can enter new keywords and assign a hierarchy by including a < character after the keyword, followed by the category. So, if you wanted to add a new keyword called *elephants* as a subcategory of mammals, vertebrates, and ANIMALS, you would type elephants < mammals < vertebrates < ANIMALS (or you could type ANIMALS > vertebrates > mammals > elephant). When you press (-Enter), you will see the elephants keyword appear as a new subset keyword in the Keyword List panel. There are a few things to point out here. One is that you always enter new keywords using the above path directory methods. Second, once you have established a basic hierarchy, there is no need to type a complete path each time. In other words, once you have created the above path hierarchy to add, say, cat as a keyword, you do not have to type cat < mammals < vertebrates < ANIMALS. All you will need to type is cat or maybe cat < mammals and Lightroom will know how to complete the remaining hierarchy.

How you categorize library images is entirely up to you, but if you submit work to an external photo library, you will most likely be given guidelines on the acceptable keywords and categories to use when keywording photographs to be sent in for submission. These guidelines are normally supplied privately to photographers who work directly with the picture agencies, but there are online resources you can refer to that describe how best to establish and work with a controlled vocabulary. These ensure the keyword terms you use to describe your images conform to prescribed sets of words that are universally used by others working in the same branch of the photo industry. When you get into complex keywording, it is important to be methodical and precise about which terms are used and the hierarchy they belong to.

Keyword categories can also be used to catalog images in ways that are helpful to your business. For commercial shoots, I find it is useful to keep a record of who has worked on which shot. Some catalog programs let you set up a custom database template with user-defined fields. In Lightroom, you can set up keyword categories for the various types of personnel and add the individual names as a subset (or child) of the parent keyword category. **Figure 10.40** shows how I have created keyword categories for *Clothes stylists, Hair stylists,* and *Makeup artists*. Within these categories I created subcategories of keywords listing the people I have worked with regularly. As I start typing in someone's name as a new keyword entry, if Lightroom recognizes this as a possible match to one of the existing keywords in the keyword database, Lightroom auto-completes the keyword metadata entry in addition to correctly placing the keyword within the established hierarchy. This type of organization is also useful for separating library images by job/client names. When the keyword names are in place, you should find it fairly easy to keep your catalog of images updated.

Keyword filtering

The Keyword List panel can easily grow to contain hundreds of keywords. You can simplify the navigation by typing the keyword you are searching for in the Filter Keywords section at the top of the panel. Even if you type just the first few letters, this can help narrow the selection of keywords to choose from. You can use this feature to check if a keyword exists in more than one place and edit the keyword list accordingly. The filter options allow you to filter by All keywords, by People keywords, or by Other (exclude People keywords). If you click on the down arrow beside the magnifier in the Filter Keywords box (circled in **Figure 10.41**), you can select Show Keywords Inside Matches. This is helpful when you also want to show all the child keywords of the ones you have filtered.

You can also use the Keyword List panel to filter the photos that appear in the content area. As you roll over a particular keyword, you will see an arrow appear next to the keyword count number. When you click the arrow, this displays all the photos in the Lightroom catalog containing that keyword, regardless of whatever photo filter view you have currently active.

Figure 10.41 An imported D-65 keyword list, which was created by Seth Resnick for attendees of his D-65 workshops.

Figure 10.42 The Keywording panel with Keyword Tags set to Enter Keywords.

Figure 10.43 The Keywording panel showing the Keyword Tags menu including Keywords & Containing Keywords and Will Export.

Figure 10.44 When a keyword can have more than one context, you will see a choice of keyword paths to select.

Importing and exporting keyword hierarchies

You can create your own keyword hierarchy from scratch or import one that has already been created (as in the Figure 10.41 example). To import keywords into Lightroom, you'll need to do so from a tab-delimited keyword file. This is a plain text file with a tab between each indented level in the text so the data is arranged in a hierarchical format. David Riecks runs a website with tips and guidelines on how to work with a controlled vocabulary at controlledvocabulary.com, where you can purchase a ready-made vocabulary that is compatible with Lightroom. To install, download the file, launch Lightroom, choose Import keywords from the Metadata menu, and select the file. That's it—these keywords will be added to the Keyword List panel. Similarly, you can export a keyword hierarchy for sharing on other computer systems or catalogs by choosing Metadata \Rightarrow Export Keywords. Likewise, this exports the keyword list as a text file using a tab-delimited format.

Implied keywords

The Keywording panel lists keywords that have been applied explicitly to images via the Keyword Tags section. But as I mentioned, some of the keywords you enter will already have implicit keywords associated with them. So, if in the future, I apply the keyword *Bygdøy peninsula*, it will automatically include the implicit keywords: *Places, Europe,* and *Norway.* I don't have to type in *Bygdøy peninsula* < *Norway* < *Europe* < *Places* if there is already a keyword with such a hierarchy in the database. It should only be necessary to type in the first few letters, such as *Byg*, and Lightroom will auto-complete the rest. If the Keyword Tags menu is set to display Enter Keywords (**Figure 10.42**), you can edit the keywords in this mode, but the implicit keywords will be hidden (although they will nonetheless remain effective when conducting searches). If you select Keywords & Containing Keywords or Will Export (**Figure 10.43**), you will see a flattened list of keywords that includes the implicit keywords, but you will not be able to edit them in the Keywording panel when using these two modes.

When you enter a new keyword, you use the < key to signify that this keyword is a child of the following keyword (such as train < land transportation < Transportation). This establishes the hierarchy, and as I explained, when you use the Enter Keywords mode, all you will see is the first keyword, and the parent keywords will be hidden. However, if you apply a keyword that is identical to another keyword but both have different parents, you will then see the full keyword path hierarchy appear in the Keywording dialog. For example, in Figure 10.44, you have two options for the Keyword Camilla Pascucci. This is because I added the keyword Camilla Pascucci in two separate contexts. In one context, Camilla Pascucci is a makeup artist I work with, but she is also my wife (so she can also be listed as a subset of PEOPLE as someone I know!). This is why when you type in certain keywords, you will sometimes see more than one keyword path suggestion. It also explains why, when after you press Enter to okay the choice, you may see a full keyword path directory in the Keywording panel rather than a single keyword.

Keyword suggestions

Expanding the Keyword Suggestions section reveals a grid of suggested keywords. You can click on any of the keywords displayed here to add these to a selected photo or photos. When you select an image, Lightroom adapts the list of keywords that are available for use based upon the keywords already in neighboring images. that have been captured around the same time. The suggested keywords are also prioritized based on how soon before or after the current photograph they were taken. The system works well when trying to guess what other keywords you might like to add to a particular photograph. In Figure 10.45, the selected image had the keywords Las Vegas, night, and Paris Hotel. From this the Keyword Suggestions section was able to suggest adding other keywords such as Bellagio Hotel, Luxor Hotel, and MGM Hotel. These were common keywords that had been assigned to photos taken close to the time the selected image had been captured. The more keywords you have in the source photo or neighboring photos, the more accurate the suggested keywords will be. The diversity of your keywording will also count. If all the keywords in a set of images are nearly identical, there is not much Lightroom can do when it comes to suggesting alternative keywords.

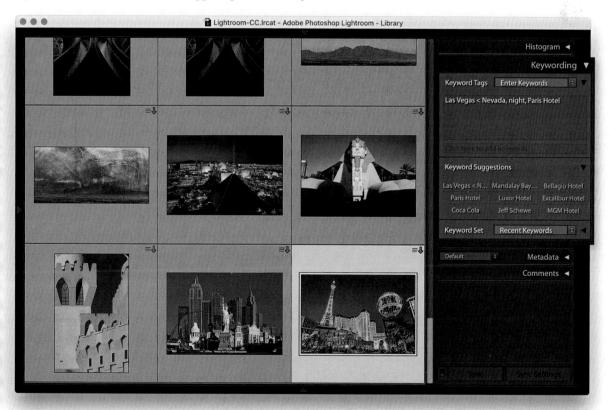

Figure 10.45 A selected image and the keyword suggestions in the Keywording panel.

Figure 10.46 The Keywording panel with the Outdoor Photography keyword set selected.

Keyword sets

The Keywording panel can also be used to display sets of keywords. When keywording certain types of photo projects, it can save you a lot of time to have commonly used keywords made quickly accessible. Keyword sets offer a quick method for adding commonly used keywords to selected images. To access a keyword set, click the disclosure triangle (circled in Figure 10.46) to reveal the Keyword Set section options. This will normally display the Recent Keywords keyword set, which, as I just showed, can be useful for most keywording jobs. Or, you can select one of the supplied keyword set presets such as Outdoor Photography, Portrait Photography, or Wedding Photography. In Figure 10.46, the Outdoor Photography keyword set was selected, offering suitable, outdoor keyword suggestions such as Landscape and Wildlife. Clicking the keyword set shortcuts is a toggle action. You can click once to add a keyword and click again to remove it. You can also use the Alt key plus a number as a shortcut for assigning keyword set keywords. If you hold down the Alt key, the number shortcuts will appear next to each keyword. So, for example, if I wanted to assign a Flowers & Plants keyword, I would use the Alt -9 shortcut (Figure 10.47).

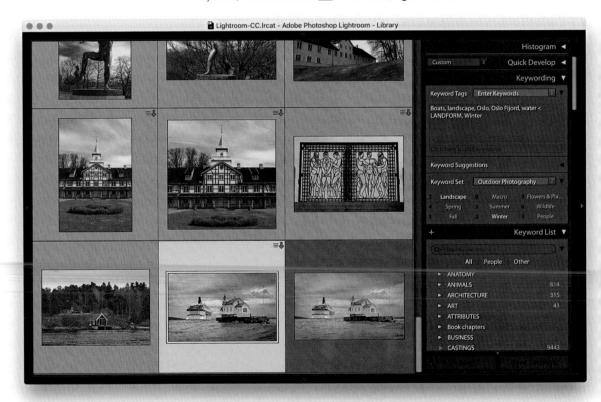

Figure 10.47 Here is an example of the Outdoor Photography keyword set in use. With this loaded, you have a set of nine keywords at your disposal with which to annotate your photos.

Creating your own custom keyword sets

If you have lot of photos to edit from a specific trip or you photograph certain types of events regularly, you may find it useful to create your own keyword sets for these types of shoots.

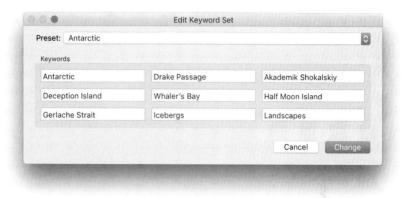

1. To create a custom keyword set, go to the Keyword Set section of the Keywording panel and click "Edit set." This opens the Edit Keyword Set dialog using the current keyword set list. Just replace these with the keywords you would like to use when keyword-editing a particular project. Here, I created a keyword set that I could use when editing photographs taken in Antarctica.

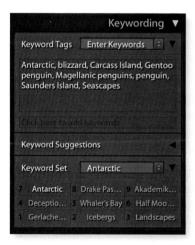

2. After you create a new custom keyword set, the keywords appear listed in the Metadata panel in the Keyword Set section. You can hold down the Alt key to preview the keyboard shortcuts and use the Alt key plus a number to quickly assign any of these keywords to selected photos.

ΠE

When the Painter tool is set to Target Collection mode, it can be used to add photos to whatever is the current target collection. This is normally the Quick Selection in the Catalog panel, but you can change this to any collection you like.

Figure 10.49 The Painter tool's appearance varies according to which type of setting is being applied.

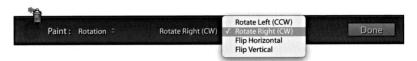

Figure 10.48 With some of the Painter tool options such as Rotation, you will have menu options to choose from.

The Painter tool

The Painter tool is located in the Library module Toolbar (**Figure 10.48**). It can be activated by clicking the tool, which will float it from its docked position in the Toolbar. You can also access the Painter tool by going to the Metadata menu and choosing Enable Painting, or use the ******Alt K (Mac) or Ctrl Alt K (PC) shortcut. You can then select which type of settings you want to apply with the Painter tool.

The Painter tool is ideal for those times when you may want to repeatedly apply a keyword or combination of keywords to photos in the Library module Grid view. You can do this by clicking with the Painter tool on a photo, or you can click and drag over a number of photos at once. But that's not all; you can also use the Painter tool to paint using labels, flags, ratings, metadata, Develop settings, or rotation settings, as well as add to the target collection. You can also load keywords from any of your keyword sets. To do this, hold down the Shift key with the Painter tool selected to pop open the keyword sets list, select a desired keyword set, and then click individual keywords to add these to the keyword painter list. In Keywords mode, you can enter more than one single keyword into the Paint field. You will also notice in the Keyword List panel that keywords entered this way will appear with a + sign next to them.

The Painter tool appearance varies according to which mode you have selected. Figure 10.49 shows examples of all the different styles. As you can see, there are lots of potential uses for this tool—not just applying keywords, but other tasks such as painting with a saved Develop setting. To undo a Painter tool—applied setting you need to hold down the Alt key as you click to switch to the Eraser mode (), which will undo a setting. Also keep in mind that you have to be careful to target the thumbnail and not just the cell area. For jobs where you are constantly applying the same instruction, like "rotate this photo 90 degrees" or "apply this set combination of keywords," the Painter tool does have its uses, but it can often be much easier to just select the photos first and then apply a setting to all the photos in one step.

People view mode

The face-tagging feature automatically identifies faces in the catalog images, adding face regions to individual photos. It can be trained to recognize named individuals and then to create and automatically add Person keywords to the Keyword List panel inside a designated parent keyword.

Before Lightroom can identify and recognize face shapes in each image, however, the photos in the catalog (or Filmstrip selection) must be indexed. During this stage, Lightroom builds a record of each image in a form that the face-recognition engine can use to detect and analyze faces in images. Indexing can be turned on for the whole catalog by checking the "Automatically detect faces in all photos" option in the Catalog Settings Metadata section, or you can click the Identity Plate to open the Activity Center and enable Face Detection. If indexing is turned off, Lightroom will only index the selected source when you enter the People view or you activate the Draw Face Region tool in the Loupe view for the current photo. For photos that are currently offline, Lightroom automatically indexes them the next time they come back online and Lightroom is launched.

When the initial indexing is complete, you can click the People button in the Library module Toolbar to go to the People view mode (click again to toggle returning to the Grid view). Once in the People view mode, Lightroom displays face thumbnails in the Unnamed People section showing all the possible face matches for that particular selection of images. From there, it is up to you to identify the faces and enter the names manually. As you identify each face, Lightroom will attempt to identify similar faces. You can then click to approve the name suggestions as being correct, or rename them correctly.

In Loupe view with the Draw Face Region tool active, face regions overlay each recognized face. For a photograph with a group of people, Lightroom will not just suggest the names of the people featured in the photo, but will identify each face individually. Lightroom seems mostly able to spot faces. On the other hand, it can still miss obvious matches, or include all kinds of picture elements as faces, but you can always choose to delete the face region for such photos to remove them from the equation. In practice, you will have to decide whether the effort of all this training work is worth it compared to the manual method of visually identifying people and manually entering keywords. Ultimately, face-tagging requires a significant amount of user input in the early stages in order to familiarize Lightroom with the people you photograph most often. The more you use this feature, though, the easier it becomes for Lightroom to automatically recognize the people seen in your photographs and name and keyword them automatically.

You can monitor the indexing progress via the Activity Center. The indexing process involves reading the raw data from disk, so if you happen to be doing something else that involves reading the raw data, such as converting to DNG, or building Smart Previews, the indexing process can happen simultaneously and get a free ride. Plus, the index will build faster if you have Smart Previews available. Failing that, if there are embedded previews that are sufficiently large enough (greater than 1024 pixels along the longest edge), Lightroom will use those. Face info search data is also included when importing from another catalog and when creating a virtual copy. Let's now look at a step-by-step example of the facetagging process in use.

To trigger a face detection run again, select the photos, do a batch rotation, and then rotate them back.

Here is a Library module Grid view of photographs taken of people connected with D-Lab in Berkhamsted. The photographs at this stage were untagged.

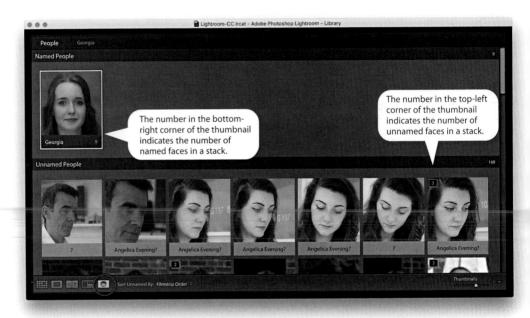

2. I switched to the People view by clicking the People view button (circled). Alternatively, I could have chosen View ⇒ People or used the ⊙ shortcut. So far, Lightroom had recognized Georgia. I clicked to confirm and added her to the Named People section. If you hold down the Alt key and pan the pointer over a face stack, it shows a preview of all the faces that are in that stack.

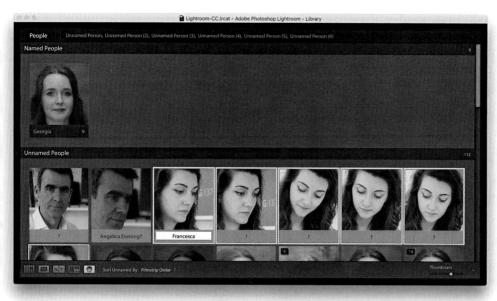

3. Here, I made a selection of matching faces in the Unnamed People section and clicked in the text field below (you can also use the ♠Shift) shortcut) to enter text to identify Francesca as a new person and add her to the Named People section. Lightroom auto-completes as you type. When you are editing single faces, pressing Return automatically selects the next face and highlights the text field. You can also use (Mac)/Ctrl (PC) plus an arrow key to progress from one face to the next.

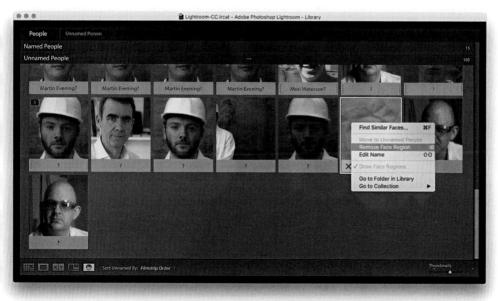

4. Lightroom will very likely produce some false results. You can manage these by pressing Delete, clicking the X button on the bottom of the thumbnail, or making a selection and using the context menu to select Remove Face Region.

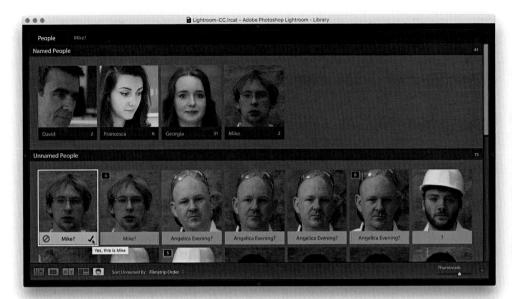

5. Having begun to train Lightroom to recognize certain faces, I could hover over a face in the People view and click the cancel icon to reject and delete the face region or click the check mark icon to confirm the named-face suggestion and add this face to the Named People section.

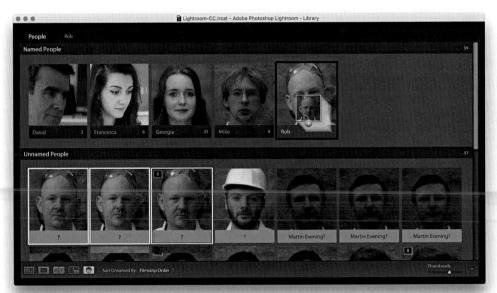

6. Another way to manage faces in the Unnamed People section is to make a selection of faces and drag these across to a named face in the Named People section. This names the selected photos. You can also drag photos between sections to take, say, a photo from the Named People section and drag it to the Unnamed People section (where it will become Unnamed again).

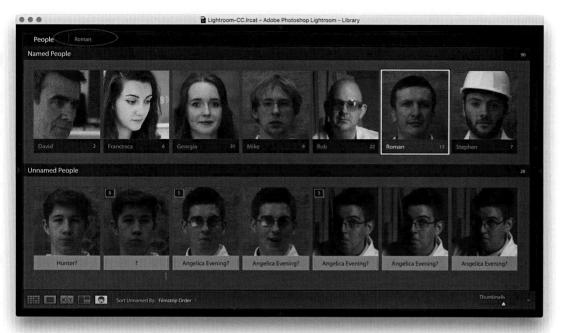

7. At this point, I had carried out most of the naming, but there were still some thumbnails left over in the Unnamed People section.

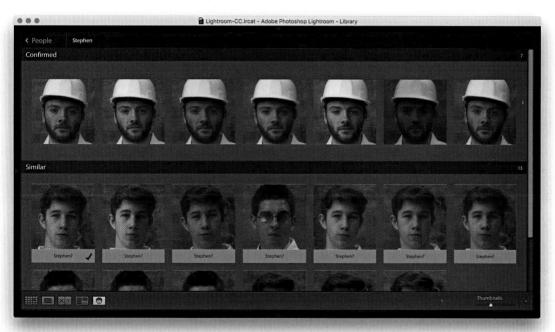

8. Here, I double-clicked a named face to go to the Single Person view. You can also do this by clicking the keyword name that appears at the top (circled in Step 7). Lightroom suggests similar face suggestions in the section below.

9. I then double-clicked a face in the Single Person view to switch to the Loupe view in the Library module to reveal the face regions, which as you can see, identifies individual faces and lets you confirm that keywords have been added. Here, the Draw Face tool button is activated (circled). Clicking again allows you to hide face regions and revert to the regular Loupe view mode zoom behavior. The draw face region bounding box is compliant with the Metadata Working Group standard specifications for face regions. So, faces metadata information can be exported from or imported into Lightroom. In fact, some cameras already encode detected faces this way.

Figure 10.50 The top bar in the People view mode.

Single Person view mode

As you manage photos in the People view mode, the name of the person (or persons) you have selected in the Named People section appears in the top bar (**Figure 10.50**). Clicking a name takes you to the Single Person view mode, where you can see the full number of confirmed faces (**Figure 10.51**). You can then click the arrow (circled) to return to the People view mode again. Below this is a Similar section, where, as you roll over the faces, you can click the Tick button to add a face to the Confirmed section (even if there is no name suggestion for the face).

Right-clicking a face in People view opens a context menu (**Figure 10.52**). You can use this to choose Find Similar Faces (**#F** [Mac] or Ctrl F [PC]), Move to Unamed

Figure 10.51 The Single Person view with the Similar section below.

People, Remove Face Region, Go to Folder in Library, or Go to Collection (the collection that contains the photo). The Find Similar Faces item is great as a tool for getting Lightroom to quickly locate similar-looking people even if you haven't had a chance to keyword or face-tag them yet.

Expanding and collapsing stacks

You can use the S key to expand or collapse a stack in the People view, or click and hold S to expand and release to collapse again. Use the Undo command to revert.

People view mode Toolbar

The People view Toolbar is shown in **Figure 10.53**. The Sort menu can be used to manage how the faces are organized. From the menu here, you can choose to sort by Suggested Name, Filmstrip Order, Stack Size, or Popular Names.

Figure 10.52 The Faces context menu.

Figure 10.53 A close-up of the People view Toolbar Sort menu options.

Figure 10.54 The Keyword List panel with person keywords inside the PEOPLE keyword.

Person keywords

As you add face names, you simultaneously create person keywords. These are a special class of keyword, which by default are added at the root level to the keyword list inside the PEOPLE keyword (**Figure 10.54**). With the default settings, all person keywords you create automatically become children of the *PEOPLE* keyword, and an asterisk appears after the target keyword name listed in the Keyword List panel. If you want, you use the context menu shown in **Figure 10.55** and select "Put New Person Keywords Inside this Keyword" for any other specific keyword.

You can drag a face from the People view mode to the Keyword List panel as a shortcut for applying a correct people keyword. Similarly, you can drag a person keyword to a face in the People view mode to apply.

You will also notice in the context menu shown in Figure 10.55 that you can choose Convert Keywords to Person Keywords. This means if you have previously assigned a keyword with someone's name, you can convert this to a person keyword. You can do this for single or multiple selected keywords. You can even select a parent keyword, convert it into a person keyword, and all the associated child keywords will also be converted. This step adds the keyword to the person keyword list, but will not necessarily always add face regions to the photos. But where a face region does get added and you enter the first few letters of that person's name, Lightroom will now know to auto-complete this as a known person keyword.

Figure 10.55 *The Keyword List context menu.*

1. In this example, I wanted to convert an existing, regular keyword to become a person keyword. First, I clicked the arrow next to the keyword *Joel* to load all of the photos with this keyword into Library Grid view. Next, I right-clicked the regular keyword to access the context menu and selected Convert Keywords to Person Keywords.

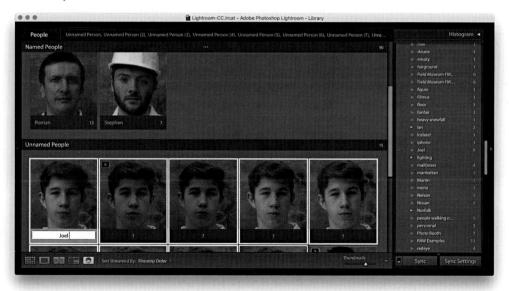

2. I then clicked the People button to switch to People view. At this stage in People view mode, Lightroom had assigned face regions to the photos, which now needed confirming. I selected all, typed *Joel* for one of the selected faces, and pressed Return.

As you use the Face tagging feature to identify people, you can train it to become better at recognizing people you photograph regularly. However, this only happens when there are clearly recognizable facial features. Photos you assign person keywords to that don't happen to have recognizable features won't confuse things. Therefore, if the subject you add a person keyword to happens to be wearing dark sunglasses or a mask, this won't deprecate the Lightroom face-recognition process.

Exporting Person keywords

When you export photos from Lightroom (as discussed in Chapter 7), you have the option to exclude exporting the person keywords you have added. It does not matter how you choose to organize your keyword list hierarchy, because Lightroom identifies the (face-tag generated) person keywords as a separate class. By default, Lightroom does not include person keywords in an export. If you wish to override this privacy mode, you can do so by unchecking the Remove Person Info option shown in **Figure 10.56**. When this option is turned off, Lightroom saves the metadata as a keyword as well as to the Person Shown section of the IPTC metadata.

Figure 10.56 The Metadata section of the Lightroom Export dialog.

Photo filtering and searches

So far, we have looked at how to manage images by using folders to group the images in the catalog, and how to apply flags, star ratings, and color labels. I have also shown how to add metadata information, including keywords to add context. Now I will show you how to use the Library module to search for specific photos.

Filtering photos in the catalog

Once you have edited your photos using the star rating system, you can use these ratings in conjunction with folders, collections, keywords, and other types of metadata to refine an image selection. **Figure 10.57** illustrates how the catalog contents can be seen as having a pyramid-shaped structure in which the zero-rated images are the most numerous, fewer images will have a one-star rating, and even fewer images will have a three-star or higher rating. The files in the catalog can be further filtered by first selecting a specific folder or collection or applying a keyword filter. Therefore, if you combine a ratings search with a

Figure 10.57 This schematic diagram that represents how image searches of the Lightroom catalog can easily be narrowed by combining these different types of search criteria.

specific collection/folder or keyword filter, you will always be able to quickly narrow down a selection of images from the catalog and find the specific photographs you are looking for.

When a filter is in effect, you can use Library

Enable Filters to toggle it on and off, or use the **XL** (Mac) or Ctrl L (PC) keyboard shortcut (**Figure 10.58**). You can also manage filter behavior via the File

Library Filters menu (shown in Figure 10.59). The reason for this duplication is so that you can access the same filter options when working in modules other than the Library module. Selecting the Lock Filters item makes a library filter persistent across all sources (i.e., all folders and collections). You then have to remember to use \(\mathbb{R} \mathbb{L} \) (Mac) or \(\mathbb{Ctrl} \mathbb{L} \) (PC) to toggle this sticky library filter setting on or off. When Lock Filters is checked, you can also check the Remember Each Source's Filters Separately option. This allows you to make library filters sticky per folder/collection. When enabled, the filter settings are remembered for each specific folder or collection. There are times when this kind of behavior can be desirable, as long as you are aware when a filter is active and you know how to toggle the library filter setting on or off. Incidentally, if you select the "Show message when loading or rendering photos" option in the Loupe View options, a status message will remind you when a filter is currently active.

Figure 10.58 The Library menu showing the Filter options.

Figure 10.59 The File ⇒ Library Filters submenu.

Three ways you can filter the catalog

I will focus on metadata and metadata filtering a little later, but for now let's look at the filter options as they relate to flags, ratings, and color labels. **Figure 10.60** shows the Library module Library menu where you can filter by things like Flag, Rating, or Color Label. These options are identical to those found in the Filters section of the Filmstrip (**Figure 10.61**) and the Attribute section of the Filter bar, which is accessible from the top of the content area whenever you are in the Library Grid view (**Figure 10.62**). For example, you could filter the photos displayed in the content area by choosing Library ⇒ Filter by Rating ⇒ One Star and higher, to make only those photos with a one-star rating or greater visible (Figure 10.60). Or, you could simply click the one-star button in the Filmstrip and select the "rating is greater than or equal to" option to make only the one-star or higher photos visible (Figure 10.61). Or, click the one-star button in the Filter bar and select the "rating is greater than or equal to" filter option (Figure 10.62).

Figure 10.60 The Library module Library menu and Filter by Rating submenu.

Figure 10.61 The Filmstrip, showing the Filter section options.

Figure 10.62 The Filter bar Attribute section and filtering options.

Filtering photos via the Filmstrip

Now let's look at the top section of the Filmstrip in more detail, and in particular, how you can use the Filmstrip controls to filter images according to their rating, pick status, or label color. You can toggle between hiding/showing the Filmstrip by clicking the arrow at the bottom of the interface or by using the F6 function key (Figure 10.63). The Folder/Collection section displays the current folder path directory or collection name. Click anywhere here to view a list of recent sources, such as a recently visited folder, collection, or favorite source. The Filter section can be expanded or collapsed by clicking the word *Filter* (circled in red). This section contains the "Filter based on flag status" selectors, which can filter by showing "all picked images only," "all unflagged images only," or "all rejected images only" (click the flag icons again to undo). To use the "Filter based on rating," click the icon circled in blue to reveal the star rating filter menu.

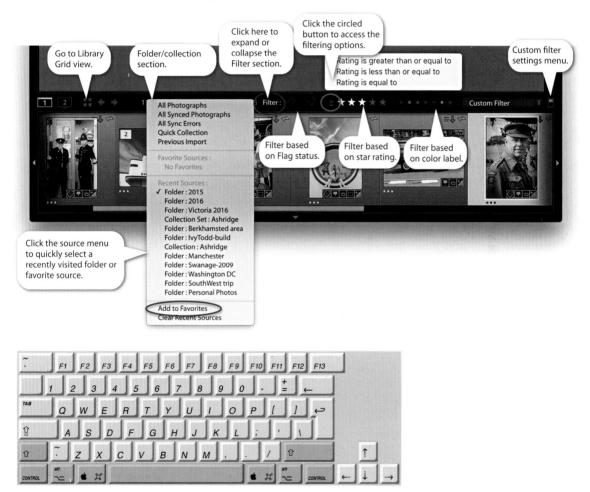

Figure 10.63 The Filmstrip. Use the left/right arrow keys to navigate through the photos.

TIP

The flag buttons in the Filmstrip can take a little getting used to. Start with all the flag buttons unchecked. Click the first pick flag () to filter the photos to display the picks only. Then click it again to turn off the filtering and reveal all the photos. Now click the middle flag () to show the unflagged images only, and click it a second time to once more reveal all the photos. Next, click the reject flag () to display the rejects only, and click again to return to the all-photos view. Now try clicking both the pick and reject flag buttons. This reveals both the picks and rejects, but not the unflagged images.

Adding folders as favorites

You can add folders as favorites via the Filmstrip source menu so that you can use this same menu to quickly locate favorite sources. To save a favorite, go to the source menu and select Add to Favorites (highlighted in Figure 10.63). The folder or collection will now appear in the Favorite Sources section at the top of the list.

Flagged photos filter options

You can click the Filter Picks Only button in the Filmstrip () to view the Pick photos only. Likewise, you can use the Filter Rejects Only button () to view the rejects only. This raises the question of what you do with the reject photos. Some people suggest the rejects could then be deleted, but I strongly advise against this because you never know when a reject photo may be useful. Perhaps there is an element in the shot you may find handy later? Finally, the Unflagged Photos Only filter button () allows you to filter the unflagged photos.

Star rating filter options

If you click the icon to the left of the star rating symbols (**Figure 10.64**), you can choose from one of the following options to decide what the filtering rule should be: "Rating is greater than or equal to," "Rating is less than or equal to," or "Rating is equal to."

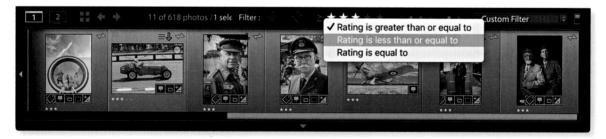

Figure 10.64 The Filmstrip rating menu options.

Creating refined selections via the Filmstrip

You can also use the Filmstrip buttons to create image selections based on the flag and color label status. If you hold down the \Re key (Mac) or Ctrl key (PC) as you click any of the flag, rating, or color label buttons, instead of filtering the photos, you can create an image selection based on the buttons clicked. If you hold down the Ctrl key (Mac) or Ctrl shift key (PC) as you click, you can add further photos to the selection. To remove photos from a selection, use Ctrl (Mac) or Ctrl Alt (PC) as you click the flag, rating, or color label buttons.

Color label filter options

To filter photos by color label, you can choose File ⇒ Library Filter by Color Label, go to the Library ⇒ Filter by Color Label menu, or click the color label buttons in the Filmstrip. The color label buttons in the Filmstrip (**Figure 10.65**) allow you to make quick selections based on color labels. The buttons work independently: Click the red button to display all red label images, click the yellow button to add yellow label images, and click the red button again to remove the red label images from the filter selection. The Filmstrip also includes Other Label and No Label filter options. If you apply an Other Label filter, it filters out the photos where the label color and label color text do not match the current color label set. There is also a No Label filter option that lets you quickly filter the unlabeled photos only. If you go to the Toolbar (T), just above the Filmstrip, you can use the Sort menu to sort photos by Label Color or Label Text (**Figure 10.66**). This can also help you locate files where the color label and label text may differ from the current color label setup and address the problem of mismatched Lightroom/ Bridge color label descriptions (see page 129).

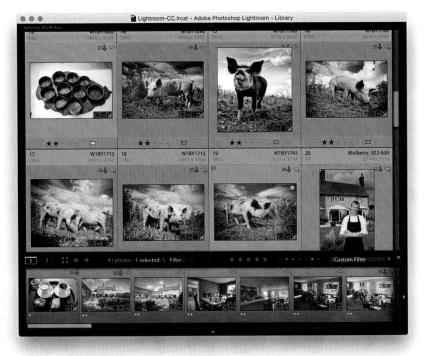

1. In this example, you can see a collection of photos from a location shoot in which I assigned a red color label to the interior and exterior shots, yellow to the black-and-white kitchen shots, green to the staff portraits, blue to the outdoor farm photos, and purple to the final food still-life shots. Because I had not yet applied any filters, all the images were visible in the Library module Grid view.

Figure 10.65 The Filmstrip color label buttons. This includes two extra color label filtering options: Other Label and No Label.

Figure 10.66 The Sort menu in the Toolbar allows you to sort photos by the Label Color or Label Text description.

2. I clicked the yellow filter button in the Filmstrip to filter just the yellow-labeled photos.

3. Next, I <u>Alt</u>-clicked the yellow swatch to display all the photos except for the yellow-labeled ones. An inverted swatch selection such as this excludes those photos that do not have a color label.

Virtual copy and master copy filtering

Most of the photos in the catalog will be master copy images. These are the original source files, of which there can be only one version of each in the catalog. However, you can create virtual copy versions of the masters, which allows you to edit the virtual copy versions as if they were separate originals, but without having to create a physical copy of the master. For more about working with virtual copies, see page 334.

The Master Photos and Virtual Copies filters can therefore be used to filter the display to show or hide the master copy photos only and show or hide the virtual copy photos only. To do this, go to the Library module Library menu, choose Filter by Kind, and choose All, Virtual Copies, Master Photos, or Videos (Figure 10.68). But it is actually far simpler to use the Virtual Copies and Master Photos filter buttons that are located in the Attribute section of the Filter bar (Figure 10.69).

Figure 10.68 The Library \Rightarrow Filter by Kind menu (or File \Rightarrow Library Filters \Rightarrow Filter by Kind menu.

Figure 10.69 The Filter by Master Copy and Filter by Virtual Copy buttons are circled here in the Filter bar.

Figure 10.70 The Folders panel showing the menu options.

Subfolder filtering

The Show Photos in Subfolders filter (highlighted in yellow in Figure 10.68) lets you determine whether to include or hide photos contained in subfolders. This menu item is also located in the Folders panel menu (**Figure 10.70**).

Deselecting Show Photos in Subfolders modifies the photo display in all folders. If there are no photos outside the subfolders, you will see a message that says, "No photos in selected folder, subfolders not shown." This makes it clear why a folder view may appear empty. Let me give you an example of how this works. In the Folders panel view in **Figure 10.71**, I selected a folder called *London* that contained 13,982 photos, of which 10,881 photos were contained in 56 subfolders, which meant there were 3101 photos floating around in the London folder that were not assigned to any of the London subfolders. In this instance, I deselected Show Photos in Subfolders in the Library menu. Therefore, when I clicked the *London* folder, it showed a photo count of 3101 photos and excluded the images contained in the subfolders.

Figure 10.71 A view of my London folder in which I disabled "Show Photos in Subfolders."

Making filtered image selections

The Edit menu contains a series of "Select by" submenu items. These let you make filtered selections of photos from the current catalog view. For example, in **Figure 10.72**, I went to the Edit menu "Select by" submenu item and chose Edit ⇒ Select by Rating ⇒ two stars. I then opened the Edit menu again and chose Select by Flag ⇒ Intersect with Selection ⇒ Flagged. This selected just those photos with two stars or higher that were also marked as being flagged.

The general idea here is that you can use successive Add to Selection commands to build lots of different kinds of filter selections. For example, you can use the Select by Color Label menu to add yellow label images to a red or yellow photo selection. You can also use the Select by Rating \Rightarrow Intersect with Selection menu to create selections of photos that have matching criteria only. Or, you could use this method to select all the one-star-rated photos that have a red or yellow label. The Edit \Rightarrow "Select by" menu options can be used in this way to create any number of selection rules, which may be useful when managing large collections of photos.

MOTE

Remember, you can also use the Filmstrip buttons to create image selections based on the flag and color label status. If you hold down the # key (Mac) or Ctrl key (PC) as you click any of the flag or color label buttons, instead of filtering the photos, you can create an image selection based on the buttons clicked. If you hold down the 黑公Shift keys (Mac) or Ctrl 公Shift keys (PC) as you click these Filmstrip buttons, you can add further photos to the selection. To remove photos from a selection, use #(Alt) (Mac) or Ctrl Alt (PC) as you click the buttons.

Figure 10.72 An example of how to create an intersected selection of photographs.

Figure 10.73 The File ⇒ Library Filters menu with Remember Each Source's Filters Separately checked and made active.

Filter bar

The Filter bar is the main place to go to whenever you need to make refined filter selections of photos in the catalog (although you can still use the Filmstrip controls to filter by ratings and labels). The Filter bar therefore groups together the filter controls in order to make the filtering process more centralized and flexible. It lets you filter the photos shown in the catalog using Text, Attributes (like those in the Filmstrip), Metadata, or a combination of all three. There is a lock button in the top-right section of the Filter bar (circled in Figure 10.74). Clicking this button locks the filter settings and has the same effect as selecting Lock Filters in the File \Rightarrow Library Filters submenu.

The Filter bar lock behavior is also governed by the Remember Each Source's Filters Separately option that is highlighted in **Figure 10.73**. If this item is checked, enabling the lock in the Filter bar allows you to lock filters for specific view sources. If it is unchecked, enabling the lock in the Filter bar allows you to lock filters globally. Remember, you can also use the Enable Filters shortcut (**#L** [Mac] or Ctrl [PC]) to toggle a filter search on or off.

To summarize, locking a filter allows you to lock the filter settings for a specific folder or collection view or to lock the filter settings globally. The Enable Filters command allows you to turn filters on or off (however they might be applied).

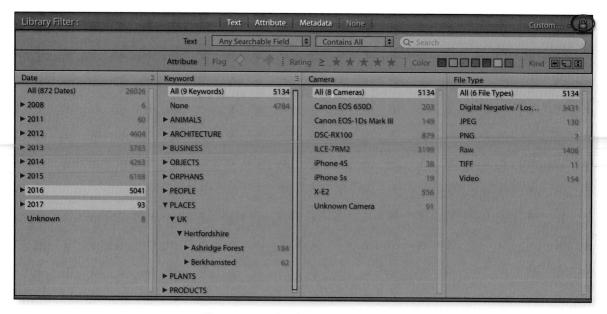

Figure 10.74 The Filter bar.

The Filter bar layout

There are three components to the Filter bar: Text, Attribute, and Metadata. They can be used to make a filter search of the entire catalog or a subset of catalog images. For speedier, targeted searches, I suggest you make a subselection of photos beforehand, but if you want to conduct a search of the entire catalog, you must remember to first go to the Catalog panel and select All Photographs to carry out a global search. It is so easy forget this important rule; there have been many times when I have gone to the Filter bar intending to carry out a global search, yet forgotten I had a subselection of photos active. So if a Filter bar search does not seem to be working properly, check that you have All Photographs selected. To combine two or more types of filter searches, you need to hold down the Shift key as you click the Text, Attribute, or Metadata tab.

Figure 10.75 A text search for "ann" included this photo of my mother-inlaw. Hannah.

Text filter searches

To carry out a text search, you can choose Library ⇒ Find, click the Text tab in the Filter bar, and click the Search field (Figure 10.76), or use the HF (Mac) or Ctrl F (PC) shortcut to enable a text search and at the same time highlight the Search field in the Filter bar. From there, you can type in a text term that can be used to filter the photos in the current catalog view, looking for terms that match. For example, a general text filter search of my Lightroom catalog using the term "ann" for any searchable fields yielded 720 results. I could then narrow this down by searching within keywords only. This would result in 110 photos being filtered, including the photograph shown in **Figure 10.75** of my mother-in-law, Hannah. The problem with this approach is that a general search for a phrase like "ann" can yield any number of matches—probably too many to be really useful. There are ways, though, that you can limit a search and restrict the number of results you get when filtering the catalog contents. To start with, you can select an appropriate search target. Rather than search using Any Searchable Field, you can narrow down a search target by choosing one of the following options: Filename, Copy Name, Title, Caption, Keywords, Searchable Metadata, Searchable IPTC, or Searchable EXIF data.

Figure 10.76 Filter bar text-search target options.

Filename searches can be fairly straightforward. For instance, I often search specifically by Filename using a Contains rule and type the filename I am looking for in the Search field. I use this filter method when clients have made their final image selection and sent me a list of filenames of the photos they want me to retouch. All I need to do then is make a general selection of the client's photos and type in the last four digits of the selected filenames. This is usually enough to quickly locate each of the photos I am looking for. I discussed Copy Name earlier in the Metadata panel section. Basically, you can use this to search the copy names that have been used for all your virtual copy images. All the other types of searches enable you to narrow the range of a text search to concentrate on the selected metadata type only, such as captions or keywords. If you are unsure precisely where to search, the easiest option is to revert to using the more general Any Searchable Field approach, but doing so might mean you end up with too many matches to choose from.

Search rules

You can further limit a filter search via the Rule menu in the Text filter section (Figure 10.77). Here, you can choose rules such as Contains. This carries out a search for text that partially matches anywhere in a text phrase. In the Figure 10.77 example, a search for "ann" could yield results such as Ann. anniversary, or banner. If you enter two or more words when carrying out a Contains search, it will mean photos that match partially or fully are filtered. A Contains All rule is more specific and looks for an exact match, such as Ann. If you enter two or more words when carrying out a Contains All search, it will be like carrying out an "and" search where only photos that match both terms are filtered. For example, if I were to carry out a keyword search using "Cape Town," Lightroom would show only photos for which both terms (Cape and Town) were found. The Doesn't Contain rule excludes files that match the text entered. Using a Starts With rule for an "ann" search yields only words like Ann or anniversary, and an Ends With search filters results for anything ending with "ann" like Portmann (or also Ann). These further search refinements ensure you have full control over the filtering process and that you don't end up with too many text filter matches.

Figure 10.77 The Filter Bar text search options, showing the Rule menu.

Combined search rules

Clicking the Search field icon circled in **Figure 10.78** opens a combined menu containing all the Search Target and Search Rules options. You can navigate this single menu to choose the desired settings. If you click the X icon on the right of the text field box, you can clear a text filter term and undo the current text filter.

Figure 10.78 The combined Search Target and Search Rule menu.

Fine-tuned text searches

You could apply the "Start with" rule when searching, but it is handy to know that you can conduct a search for anything that begins with a specific search term by typing + at the beginning of the term. In my Lightroom catalog, if I were to type +cape in the Search field, this will display photos with any keywords that begin with cape, such as Cape Point or Cape Town, and exclude keywords like Landscape (Figure 10.79). Inverse searches can be made by typing an exclamation point before the search term. For example, in Figure 10.80, I again entered +cape to search for all terms that start with the word cape, but combined this with !USA to exclude any USA locations that start with the word cape. This excluded all the keywords that referred to the USA, such as Cape Canaveral or Cape Fear, but did include non-USA locations such as Cape Town, South Africa (Figure 10.81).

Figure 10.79 Example of refined text search using a + in the Search field.

Figure 10.80 Example of refined text search using an exclamation mark (!) in the Search field.

Figure 10.81 The search criteria entered in Figure 10.80 resulted in a search that just included photos taken in Cape Town, South Africa.

Attribute filter searches

The Filter bar Attribute section (**Figure 10.82**) makes it easier to integrate a refined filter search based on criteria such as the flag status, the star rating, the color label, or whether you wish to filter the master files, copy files, or video files only. Everything here is the same as the attribute filter controls in the Filmstrip; you can click the buttons to apply a filter and click the star rating options to specify whether to filter for photos with a star rating that is the same and higher, the same and lower, or the same rating only.

Figure 10.82 The Attribute section of the Filter bar showing the rating options menu.

Metadata filter searches

The Metadata section (**Figure 10.83**) integrates some Keyword filter functionality of the Keyword List panel, but goes further by giving you access to a wide range of metadata attributes (not just keywords) that you can combine to accomplish different kinds of metadata information searches. The Metadata filter section provides customizable columns. The example below uses the default four-column view, and you can see how it is possible to combine a metadata search by Date combined with a search that included a *Places* keyword and Raw file type. There probably are not that many instances where you would want or need to combine quite so many search criteria in a single search, but the functionality is there to allow you to do this (and more).

Figure 10.83 The Metadata section of the Filter bar. This shows a metadata filter based on files created in 2016 that contained the Places keyword and were also raw files.

Metadata filter options

The Metadata section can be adjusted in height by dragging the bar at the bottom up or down. When the Filter bar is expanded in height, it can consume a lot of valuable space in the Grid view content area, which is a problem if all you are interested in doing is applying a filter using one panel only. This is another reason why it is important to remember the \(\bigcup\) keyboard shortcut, which toggles hiding and showing the Filter bar. This gives you the convenience of being able to move the Filter bar out of the way when it is not needed.

The individual panels can be customized by clicking the panel header and selecting one of the many metadata search criteria that are available (Figure 10.84). The default view gives you four panels to work with, but you can customize this layout by clicking the button in the top-right corner of each panel (Figure 10.85) to either add extra columns (up to eight in total) or remove columns. The menu circled in Figure 10.85 can be used to add or remove columns from the Metadata section. When filtering by Date, Keyword, or Location, there are also options to choose a Hierarchical or Flat list for the Metadata list views. When filtering by Date, there are also Ascending and Descending date options. Because you are able to customize the layout of the panels, this can provide you with lots of ways to filter the catalog photos. Selecting multiple items within a single panel allows you to include more terms in a filter selection, where you can use the Shift or the Key (Mac) or Ctrl key (PC) to select more than one search term in each panel. Selecting search items from other, separate panels will allow you to "intersect" a photo filter selection and narrow a search.

Figure 10.85 This menu lets you add or remove a column in the Filter bar Metadata section.

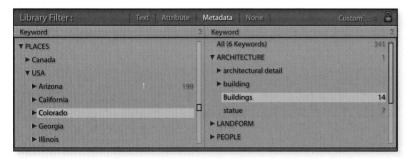

Figure 10.86 In the first column, a keyword filter was used to filter photos with the keyword Colorado. In the second column, a secondary Keyword filter filtered all Colorado keyworded images that also contained the keyword buildings.

Figure 10.84 The expanded list of options for a Filter bar Metadata search, which now also includes a Snapshot Status category.

Figure 10.87 The Color Label metadata filter category.

Figure 10.89 An example of the Lens filtering options.

Metadata filter categories

The Date categories let you progressively filter by date. For example, you can search first by year, and then expand the year folders to search by month and then by day.

The File Type section can be used to separate images by file format and make it easy to quickly filter out images, such as the TIFF masters or the raw DNG images. The Keyword category is one that you will probably want to use most of the time when searching the catalog, and in **Figure 10.86**, you can see an example where I used two Keyword filter columns to narrow a keyword search.

The Label category (**Figure 10.87**) almost amounts to the same thing as clicking a color label swatch in the Filters section of the Filmstrip. The main difference is that the Label filters used here allow you to distinguish between the color of a label and any text associated with that label. To understand what I mean by this, please refer to the section on sorting color labels on page 635.

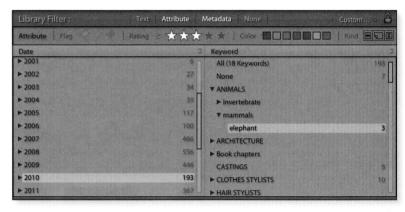

Figure 10.88 A combined Filter bar search.

Figure 10.88 shows an example of a Filter bar search that achieves the same filter result as the combined filter search described at the beginning of this chapter. The Filter bar search applied here was based on a three-star filter for photographs taken in 2010, using the keyword *elephant*.

The Camera filter option can be used to filter by camera model, and the Camera Serial Number option by serial number. Imagine, for example, that you suspect a fault has developed on one of your camera bodies. Inspecting the images by camera type can let you filter out the images shot using that specific camera. The Lens filter (**Figure 10.89**) is great for filtering the catalog by lens type, which can be handy when you are searching for shots that were taken using a specific lens. Flash State refers to whether the on-camera flash was fired or not. With the Shutter Speed filter, you can filter photos according to the shutter speed the photos were shot at. Likewise, the Aperture filter lists every aperture setting that has been used, which might be useful for shortlisting pictures shot at a particular

lens aperture. With ISO Speed Rating, you can quickly filter the high-ISO shots from all the rest, and the GPS Data filter lets you filter according to whether GPS data is embedded or not. If you select the Map Location filter, you can filter by the saved location names saved in the Map module.

The next few sections require that you have entered custom metadata in the catalog photos. The Location and Creator categories can be useful if you are in the habit of editing the associated IPTC fields via the Metadata panel. If so, you can quickly filter the catalog photos by any of the IPTC metadata items you see here. Location, City, State/Province, and Country all refer to the Location IPTC metadata used to describe where a photo was shot (you may use keywords to do this as well, of course, but only the IPTC data is referenced here). The Creator section filters photos by who was the creator. With some camera systems, you can configure the camera settings so that the creator name is always embedded at the capture stage for each and every shot. The Copyright Status and Job reference are also further examples of IPTC metadata that first has to be entered by the user.

The Aspect Ratio filter lets you filter according to whether the photos are landscape, portrait, or square. The Smart Preview Status filter allows you to filter photos that have or do not have Smart Previews. Snapshot Status lets you separate images that do and do not have snapshots. Treatment refers to photos that are in color or have been converted to black and white. The Develop Preset filter filters according to the Develop module presets that may have been applied to the photos in the catalog, including those that have just had the default settings applied. This is a useful filter for tracking down photos that have had a particular type of treatment, such as a favorite black-and-white conversion or split-toning technique (Figure 10.90). Are you looking for inspiration? You could select All Photographs to view the entire catalog and use this filter category to check out certain Develop preset effects as applied to various images. You could then copy the develop setting from one of these filtered photos or make a note to apply this particular Develop preset to other images. And lastly, the Metadata Status lets you filter photos according to whether the metadata is up to date, has been changed. has been changed on disk only, or there is a metadata conflict.

Figure 10.90 An example of the Develop Preset filter options.

Locating missing photos

It is inevitable that photos in the catalog will become misplaced; folders may appear grayed out in the Folders panel, or individual files will show exclamation-point badges. In either case, this indicates that the photos are either offline or missing. It may be a simple matter of checking to reconnect a missing hard-drive volume, or it could be because you have deleted or moved the original photos at the system level. If you need to locate all the currently missing files in the catalog, you can do so by going to the Library menu in the Library module and choosing Find All Missing Photos. This gathers together all the missing files and groups them as a temporary collection in the Catalog panel (Figure 10.91).

Figure 10.91 A Missing Photographs temporary collection in the Catalog panel.

Figure 10.92 The Custom Filters menu options, where you can save a Filter bar setting as a new preset.

Custom filter settings

Some filter selections you are likely to apply again and again. It therefore makes sense to save these as custom filter settings, which you can do via the Filter bar Custom Filter menu, shown in **Figure 10.92**. Here, I have saved a custom filter setting called *Client select masters*. This filters photos that match the keyword *Jobs* (to select all client job photos) and where the file type is a TIFF file (which is what I always use when saving retouched master images). I am then able to use this custom filter whenever I need to see a shortlist of all my client retouched master images. Custom filter settings can also be accessed via the Custom Filter menu in the Filmstrip. Also, when saving filter settings, you can save the number of Filter bar columns that are required. For example, you can save a six-column Metadata filter setting if you wish.

Figure 10.93 The empty field text search rules.

Empty field searches

If you choose to search by caption in the Text filter section of the Filter bar, in the accompanying Rules section, you can apply Is Empty and Isn't Empty rules. And for keyword searches you can apply Are Empty and Aren't Empty rules (Figure 10.93). The purpose of these is to let you search for photos with no caption or keywords added, or alternatively, you can select only those photos that do have captions titles or keywords (when either of these rules is selected, the field search is overridden and the search field box dimmed). For example, the Is Empty and Are Empty rules can be used to filter out photos that have yet to have metadata added to them.

Advanced searches

Let's finish this section with an example of a complex search in which several different types of search criteria are combined together to create a precise, targeted filter of the catalog. All the tools you need to do this are located in the Filter bar, and the following step-by-step example will hopefully provide guidance and inspiration to help you get the most out of Lightroom's search abilities. Just to remind you once more: After a filter search has been made, you can use **IL* (Mac) or Ctrill (PC) to toggle the filter on or off.

1. I first selected All Photographs in the Catalog panel. I then went to the Filter bar, clicked the Text tab, and chose to search by keywords only using the Contain rule. I then typed in the name of one of my clients, *Gallagher*, to initiate a catalog search for photos that were keyworded with the word *Gallagher*. As I began typing in the first few letters, the search narrowed the selection of images in the Grid view to show all the photos where the keywords metadata contained this same sequence of letters. The Filter bar search filtered the photos in the grid to show 3769 photos that had been shot for this client. This included everything—the raw files as well as the TIFF masters. The next task was to whittle this selection down to something more specific.

2. I Ashift-clicked the Attribute tab and applied a three-star filter to show only the three-star or higher images. I also clicked on the Master files button to include master files only, excluding any virtual copy or movie files. Next, I Shift-clicked the Metadata tab to reveal the Metadata filter options and used a Date panel to search for photos that had been shot in 2011. I now had 276 images to choose from. Lastly, I used a File Type panel to search for TIFF Document File Types. This resulted in a filter selection that showed only the TIFF file format photos shot during 2011 for this client that had been rated with three or more stars. This resulted in a filter search of just 4 photos out of the original 3628.

Figure 10.94 The Publish Services panel.

Publishing photos via Lightroom

The Publish Services panel (**Figure 10.94**) can be used to publish collections of photos to sites such as Facebook and Flickr. When photos are published in this way, a constant link remains between Lightroom and the hosting website. Any subsequent changes you make to a photo in Lightroom are propagated to the server hosting the images online.

You can also publish photos to a hard drive directory on the computer. If designing a book, you can use the Publish panel to generate resized TIFF files for use in the book and publish these to the folder that is linked to by the page-layout program. If changes need to be made to any of the images, you can edit them in Lightroom, and then simply republish them to generate new TIFF masters that will remain automatically linked in the page-layout program. You can also use this mechanism to maintain off-site backups of important original images. It is also possible to create multiple folders via the Publish Services panel.

The following steps show how I configured the settings for the Photoshelter Archive, a third-party publish services plug-in, I have installed in Lightroom.

1. To start with, I clicked the Plus button in the top-right corner of the Publish Services panel and selected Go to Publishing Manager. This opened the Lightroom Publishing Manager dialog shown here. I then clicked on the Photoshelter Archive publish service and entered my account details. Here, I configured the remaining Export settings to establish what size I would like the large images to be and chose to add watermarks to images uploaded to this service.

NOTE:

There is a PDF on the book's website showing how you can use Lightroom to set up a Flickr publish service.

Downloadable Content: thelightroombook.com

2. The plug-in auto-detected the three main categories on my site: Hair, Landscapes, and Portraits. I was now ready to start adding photographs via the Photoshelter service. To do this, I made a selection of photos via the Library module and dragged these across to the appropriate category.

3. I was now ready to publish. The photos I had just added appeared under the New Photos to Publish section, meaning they had yet to be uploaded. To do this, I needed to click the Publish button (there is a Publish button in the bar at the top. as well as in the bottom-left corner) to publish them to my Photoshelter website. This instructed Lightroom to upload all the New Photos to Publish photos. As the photos were added, they emptied from the New Photos to Publish section and joined the Published Photos section. There, they would remain until I decided to do something else to them. For example, if I were to edit the IPTC metadata or the Develop settings for any of these photos, this would move the image out from the Published Photos group and into the Modified Photos to Republish section. This mechanism allows you to keep track of which photos have been published and which ones have been modified in some way or have yet to be published. Lightroom therefore always kept me informed whenever I needed to update the photos published on my website. Should you need to, you can right-click a photo in the Publish Services panel and select Mark to Republish to force move it to the Modified Photos to Republish group.

Saving and reading metadata

In your very first computer lesson, you would have learned how important it is to always save your work before you close down a program. Some Lightroom users become confused by the fact that there is no "save" item in the File menu and wonder if they will lose all their work after they quit the program. There is no need to worry because your work is always saved automatically in Lightroom. Even if Lightroom suffers a crash or there is a power failure, you should never lose any data.

It is important to remember that as you carry out any kind of work in Lightroom whether you are adjusting the Develop settings, applying a color label or star rating, or editing keywords or other metadata—such metadata edits are primarily stored in Lightroom's catalog file. Whenever you alter a photo in Lightroom, you are not manipulating the actual image data. This is because Lightroom is built around the principle that the imported images are the master negatives and these should never be edited directly. Lightroom therefore records the changes made as metadata information, and these edit changes are always stored at a central location in the Lightroom catalog. This is why Lightroom can be much faster at searching images compared to a browser program such as Bridge. You can add, search, and read metadata information more quickly because the metadata information is all stored in a central catalog file. However, it is also possible for the metadata information to be stored within the individual files themselves, by choosing to explicitly save the metadata to the files directly. In the case of JPEG, PNG, TIFF, PSD, or DNG images, there is a dedicated XMP space within the file header that can be used to store the metadata. However, with proprietary raw files, the metadata has to be stored separately in what is known as an XMP sidecar file. Basically, whenever you edit an image in Lightroom, whether you make adjustments in the Develop module or add keywords, everything you do is recorded directly to the Lightroom catalog file. At the same time, you also have the option to perform an explicit save, which saves the updated metadata to the files' XMP space. Or, you can configure Lightroom to do this for you automatically in the background when the program is idle.

The fact you can save metadata edits to the file as well as to the catalog may seem like a good thing. Doing so can provide you with an extra level of backup security, but there are a few things to bear in mind here. First, no matter how often you remember to save and update your files, the central catalog file will always contain the most up-to-date version of what has happened to the image files contained in the catalog. The catalog file should, therefore, always be regarded as the primary database—the truth is in the catalog. Second, a major benefit of having everything stored in the catalog file is that all the edit work you do is stored in a single, relatively lightweight database document. This means that backing up can be fast and easy because all you have to do is make a copy of the catalog file rather than make a backup copy of every single image that has been modified since the last time you backed up. Of course, in the case of proprietary raw files only the XMP

sidecar files need to be backed up, and this can be done very quickly without needing to back up the original raws. However, in the case of raw DNG, TIFF, PSD, PNG, and JPEG images, whenever you update the metadata for these types of files, the entire file has to be copied during the backup process.

A third point is that if you set up Lightroom to "Automatically write changes into XMP," a lot of disk activity has to take place as Lightroom tries to catch up with all the latest adjustments that have been made to the photos in the catalog. The same is true each time you manually choose to save edits to a large number of files. Following on from this, if you keep modifying files in this way over and over again, there is the added risk that these files may one day become corrupted. Let me stress that it is only a very small risk, but all the same, it's one worth avoiding.

So, when should you save metadata to the files? If you work with a browser program such as Bridge alongside Lightroom, the only way Bridge can read the metadata is from the file itself (because Bridge cannot read the metadata stored in the Lightroom catalog). So, if you want your Lightroom edits to show up in Bridge, it is necessary to first save the metadata to the file. And, if you are working with other types of cataloging programs in conjunction with Lightroom, it will again be necessary to save any metadata changes to the file so that these can be read. There are also some production workflows that may involve transferring files from one Lightroom catalog to another, where it may be easiest to save the current metadata changes to the files so these can be read when they are imported to another Lightroom catalog. Consequently, we sometimes have to ask ourselves whether the "truth is in the database" (the Lightroom catalog) or the "truth is in the file." I will return to this question shortly.

For most of the time that you are working in Lightroom, it should not really matter if the metadata information is stored only in the catalog. The main thing is to remember to make regular backups of the catalog, such as once a week, as well as carrying out scheduled system backups. It helps too that Lightroom has a built-in catalog backup feature, as well as diagnostics and self-repair functions, to help keep your catalog file protected. If Lightroom detects on launch that the catalog database file has become corrupted, there is a Repair Catalog option (Figure 10.95).

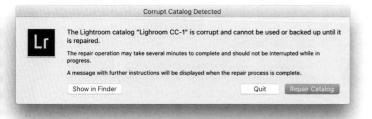

Figure 10.95 Corrupt catalog warning dialog.

You can use the Filter bar to search the catalog by Metadata Status.
This allows you to filter those files that have up-to-date metadata from those where the XMP metadata has been changed but not saved yet. You can also create a Smart Collection that filters files according to their metadata update status.

MOTE

Although you can save metadata to the file's XMP space, collections, flags, virtual copies, stacks, and history data are stored only in the central Lightroom catalog database.

Saving metadata to the file

Let's first look at how you can automatically save changes to the files. If you go to the Lightroom menu (Mac) or Edit menu (PC) and choose Catalog Settings (MAIT), [Mac] or Ctrl (AIT), [PC]), you will see the dialog shown in Figure 10.96, which includes an "Automatically write changes into XMP" option. When this is enabled, Lightroom automatically writes changes to the catalog files' XMP space, but only when it is convenient to do so and without affecting the program's performance too much. Checking this option ensures that all the files in the Lightroom catalog will eventually get updated. If you want to be sure that a file's XMP space gets updated right away or you have "Automatically write changes into XMP" switched off, you can choose Metadata

⇒ Save Metadata to File command in the Library module (or the Photo ⇒ Save Metadata to File command, if working in the Develop module). This forces an immediate export of the metadata information from the Lightroom catalog to the image file's XMP space. Easier still is to use the \(\mathbb{R} \) (Mac) or \(\text{Ctrl } \) (PC) shortcut any time you need to immediately update any metadata changes made to a photo or group of selected photos.

Turning on the "Automatically write changes into XMP" option is useful if you wish the metadata updating to always take place in the background. You could regard this as a way to perform an additional metadata backup. For example, if you were to find yourself in the unfortunate position of having a damaged catalog file, you could open the most recently saved backup and choose Metadata \Rightarrow Read Metadata from Files command to read in and restore the most recent missing metadata.

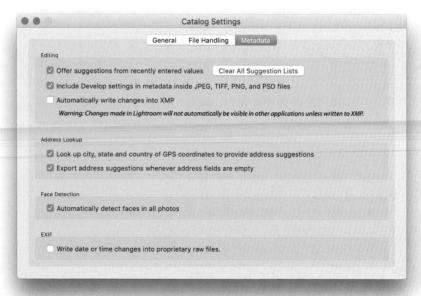

Figure 10.96 The Catalog Settings dialog.

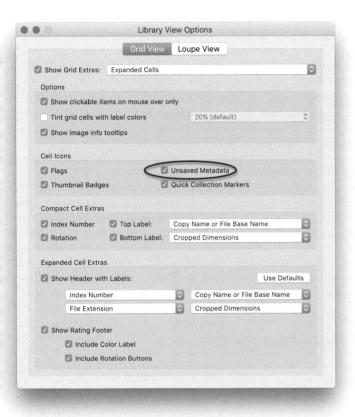

Figure 10.97 The Library View Options dialog.

Tracking metadata changes

In order to keep track of which files have been updated and which have not, Lightroom does offer some visual clues. If you choose View \Rightarrow View Options (MJ [Mac] or CtrlJ [PC]), there is a check box in the Cell Icons section of the Library View Options dialog called Unsaved Metadata (circled in **Figure 10.97**). When this is checked, you may see a "calculating metadata" icon (MJ) in the top-right corner of the grid cells as Lightroom scans the photos in the catalog, checking to see if the metadata is in need of an update. You will also see this when Lightroom is in the process of saving or reading metadata from a file. If the metadata in the catalog and the file are in sync, the icon soon disappears. If there is a metadata status conflict, you will see either a down arrow, up arrow, or exclamation mark.

A down arrow in the top-right corner of a grid cell (**Figure 10.98**) indicates the metadata information embedded in the photo's XMP space is now out of date compared to the current Lightroom catalog file. This means you need to choose Metadata \Rightarrow Save Metadata to File (******S) [Mac] or Ctri (**) [PC]) if you want to update the metadata saved to the file. Choosing Save Metadata to File pops open

Figure 10.98 The down arrow icon in the top-right corner indicates the metadata is out of date.

Figure 10.99 The Save Metadata to files confirmation dialog.

the dialog shown in **Figure 10.99**, which asks if you wish to continue. If you are uncertain what to do, you can click the down arrow icon, which opens the dialog shown in **Figure 10.100**. This dialog asks if you want to save the metadata changes to disk (which could also be described as "Do you wish to confirm saving the metadata changes to the photo's XMP space?").

Figure 10.101 An up arrow indicates that the settings have been edited externally.

Figure 10.102 The metadata conflict warning icon.

Figure 10.100 Clicking the down arrow button opens the dialog shown here.

The up arrow in **Figure 10.101** indicates the metadata information embedded in the image file's XMP space is out of sync and more recent than the current Lightroom catalog file. This can occur when you have edited a Lightroom catalog file in Bridge or Camera Raw and the externally edited image has a more recently modified XMP than the Lightroom catalog. If you are confident you do want to read the externally applied edit changes, then choose Metadata ⇒ Read Metadata from File.

If there is a metadata status conflict because the settings have been modified both in Lightroom and another external program, you will see the warning icon shown in **Figure 10.102**. This situation can occur when the Lightroom catalog photo may have been modified in Lightroom (without saving the metadata to the file) and has also been edited by an external program, resulting in two possible "truths" for the file. Is the truth now in the Lightroom catalog, or is the truth in the externally edited file XMP metadata? Clicking the icon opens the dialog shown in **Figure 10.103**,

Figure 10.103 *The "metadata status conflict" dialog.*

1238

where you can choose either to Import Settings from Disk (if you think the external settings are right) or Overwrite Settings (if you think the Lightroom catalog settings are the most truthful and up to date).

In the Metadata panel (**Figure 10.104**), there is an item called Metadata Status. If anything has been done to edit the photo metadata settings since the last time the metadata was saved to the file, Metadata Status will list "Has been changed." This is basically telling you the same thing as the metadata status icon that appears in the Library Grid cells.

XMP read/write options

Let's now take a closer look at what exactly XMP settings are. The XMP space is the hidden space in an image document (such as a JPEG, PNG, TIFF, PSD, or DNG file) that the metadata settings are written to. In the case of proprietary raw files, it would be unsafe for Lightroom to write to the internal file header, so XMP sidecar files are used instead to store the XMP metadata. This includes everything that is applied in Lightroom, such as the IPTC information, keywords, file ratings, flags, and color labels, as well as the Develop settings that have been applied via the Quick Develop panel or Develop module.

In the Metadata section of the Catalog Settings (**Figure 10.105**), the "Include develop settings in metadata inside JPEG, TIFF, PNG, and PSD files" option lets Lightroom distinguish between writing the Develop settings metadata to the XMP space for all files, including JPEG, TIFF, PNG, and PSD files, or to raw and DNG files

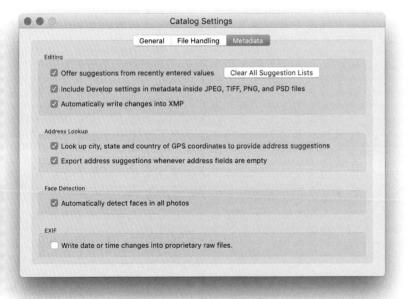

Figure 10.105 The Catalog Settings dialog in which all the Metadata section Editing options have been checked.

Figure 10.104 The Metadata Status item in the Metadata panel.

NOTE

If you are working with the latest version of Lightroom and the latest version of Photoshop, everything will work seamlessly. If you are working with Lightroom Classic CC and an earlier version of Photoshop, such as CS4, CS5, or CS6, there are limitations you need to be aware of. Edits carried out using Version 3/Version 4-specific controls in Lightroom will not be recognized in any version of Camera Raw prior to version 6.7. Edits carried out in Lightroom using Version 1 and Version 2 will be compatible with Photoshop CS4 and Camera Raw 5.7, but you will need to restrict yourself to Version 1/Version 2 adjustments only if sharing with older versions of Photoshop and Bridge.

only. This preference predetermines what gets written to the XMP space when you explicitly save the Develop settings metadata to the file. But the ability to save Develop settings into non-raw files can be a mixed blessing. If you are sharing images with another Lightroom user, but are not exporting them as a catalog, you will most likely want to save the metadata settings to the XMP space. But for Creative Cloud customers sharing files from Lightroom with Bridge, this can lead to some unexpected file behavior when you open non-raw files via Bridge. Basically, raw and DNG images whose Develop settings have been modified via Lightroom will open in Camera Raw via Bridge exactly as you expect to see them, because Bridge is able to read the settings that were created in Lightroom. However, where you have non-raw files, such as JPEGs, TIFFs, or PSDs that have been edited via the Lightroom Develop module, and the Develop settings have been written to the file's XMP space, Bridge may now consider such files to be like raw files and open them via Camera Raw rather than open them directly in Photoshop. That is what I mean by a "mixed blessing." If you want Lightroom to retain the ability to modify the XMP space of non-raw files for data such as file ratings, keywords, and labels but exclude storing the Develop settings, you should uncheck the "Include develop settings in metadata inside JPEG, TIFF, PNG, and PSD files" option. Do this and the Lightroom Develop settings for non-raw files will only get written to the Lightroom catalog and will not be exported to the files when you choose Save Metadata. Meanwhile, raw and DNG files will be handled as expected. On the plus side, you will never face the confusion of seeing your non-raw images such as JPEGs unexpectedly default to open via Camera Raw when you had expected them to open in Photoshop. The downside is that if you modify a non-raw image in Lightroom using the Develop module, these changes will be seen only in Lightroom and not by Bridge. Personally, I prefer to turn off "Include develop settings in metadata inside JPEG, TIFF, PNG, and PSD files."

Let me explain the settings and how they affect image files after being modified in Lightroom. If a photo in Lightroom is modified using the settings shown in Figure 10.105 with "Automatically write changes into XMP" and "Include develop settings in metadata inside JPEG, TIFF, PNG, and PSD files" enabled, then all the adjustments made to the image will automatically be saved to the Lightroom catalog and also saved to the original image file. In the case of proprietary raw files, the XMP metadata will be written to an XMP sidecar file and when opened via Bridge will, as you would expect, open via the Camera Raw dialog with the same Develop settings that were applied in Lightroom. In the case of DNG files, the XMP metadata will be written internally to the file and these, too, will open in Camera Raw. In the case of JPEG, TIFF, PNG, and PSD files, because you are including the Lightroom Develop settings in the export to the XMP space, they will also default to opening in Bridge via the Adobe Camera Raw dialog. However, just to add to the confusion, this does assume that the Camera Raw preferences are set to "Automatically open JPEGs with Settings" and "Automatically open TIFFs with Settings."

If the "Automatically write changes into XMP" option is disabled, as shown in Figure 10.106, the metadata edits will only be saved to the Lightroom catalog. Raw and DNG files will open via Bridge in Camera Raw, but won't show the most recent Develop module edits. If you were to open a JPEG, TIFF, PNG, or PSD image via Bridge that had previously been edited in Lightroom, it will open directly in Photoshop and not open via Camera Raw. But at the same time, any image ratings, metadata keywords, or other information that may have been entered while working in Lightroom will not be visible to Bridge or any other external editing program either (this assumes you are not manually saving the metadata to the file). In this example, the "Include develop settings in metadata inside JPEG, TIFF, PNG, and PSD files" option is still switched on, so if you did want the metadata edits to be saved to the files' XMP metadata space, you would have to do so manually using the Save Metadata command (ISS) [Mac] or Ctrl [S] [PC]). But in doing so, you would once again be saving all the Lightroom settings to the files' metadata space (including the Develop settings), and we are back to the same scenario as in Figure 10.105 where non-raw files may default to opening via Camera Raw, which is perhaps not what was wanted.

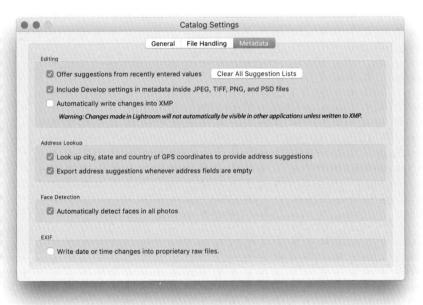

Figure 10.106 In this example, "Automatically write changes into XMP" has been disabled.

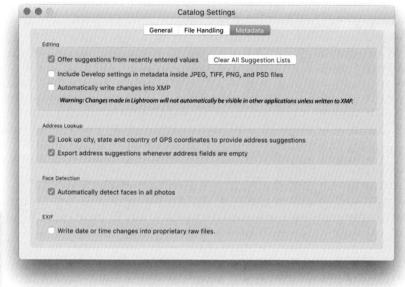

Figure 10.107 In this example, "Include Develop settings in metadata inside JPEG, TIFF, PNG, and PSD files" and "Automatically write changes into XMP" have both been disabled.

Now let's look at what happens when "Include develop settings in metadata inside JPEG, TIFF, PNG, and PSD files" and "Automatically write changes into XMP" are both disabled (**Figure 10.107**). As before, any edit changes you make in Lightroom will be saved to the Lightroom catalog only. If you do choose to explicitly save the metadata, this saves everything to the raw and DNG files, but in the case of JPEG, TIFF, or PSD files, this saves all the metadata to the file *except* for any Develop module edits. When such files are opened from Bridge, they will open in Photoshop directly instead of via the Camera Raw dialog. With this configuration, a Lightroom save saves the informational metadata edits to the file but only saves the Develop settings to raw and DNG files. JPEG, TIFF, PNG, and PSD files will not contain the Develop edits and will always open directly in Photoshop.

MG_3601.CR2

*

Figure 10.108 This shows how

a raw image adjusted in Lightroom

might look after it has been edited in

Figure 10.109 This shows how the same raw image would look in Bridge where the metadata has not yet been saved to the file's XMP space.

Where is the truth?

The most up-to-date, or "truthful," settings can reside either in the Lightroom catalog or in the files themselves. If you work only in Lightroom, the truth will always be in the catalog. But if you adopt a more complicated workflow where the files' Develop settings and other metadata can be edited externally, the truth may sometimes be in the file. For example, **Figure 10.108** shows how a photo might appear in Lightroom with Lightroom edits applied, while **Figure 10.109** shows what the same image might look like when viewed in Bridge without the edits saved to the file's metadata. The "Automatically write changes into XMP," Save Metadata to File, and Read Metadata to File options, therefore, allow you to precisely control how the metadata is updated between the Lightroom catalog and the image files.

496 3456 x 5184

Lightroom.

IMG 3601

Synchronizing metadata settings

You may often want to apply or synchronize metadata settings between photos. To do this, make a selection of images and click the Sync button (circled below). This opens the Synchronize Metadata dialog (Figure 10.110). The check boxes let you select the items you want to synchronize. You can then click the Synchronize button to synchronize the IPTC metadata information (including the keyword metadata) in the most selected image with all the others in the selection. Checked items that have no content will be highlighted in red. You will want to pay careful attention here not to overwrite existing metadata with blank metadata when synchronizing the metadata or using a template. A checked blank item effectively erases metadata fields when you sync the metadata. You can also select an image and press **Alt **\text{\Omega} Shift** (Mac) or **Ctrl** Alt **\text{\Omega} Shift** (PC) to apply the Copy Metadata command, and then use ***(Alt *\text{\Omega} Shift** (V) (Mac) or **Ctrl** (Alt *\text{\Omega} Shift** (V) (PC) to paste those settings to another selected image or group of images.

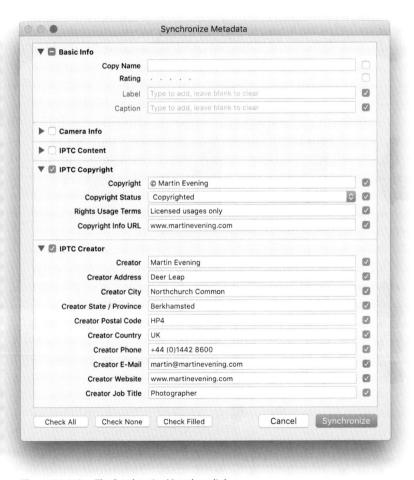

Figure 10.110 The Synchronize Metadata dialog.

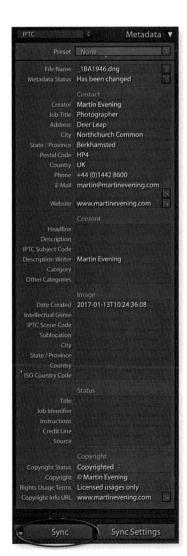

NOTE

The sort order is numerically sensitive. This means that Lightroom reorders number sequences correctly: 1, 2, 3, 4, 5, 6, 7, 8, 9, 10, 11, 12, 13 as opposed to 1, 10, 11, 12, 13, 2, 3, 4, 5, 6, 7, 8, 9.

Figure 10.111 The Library module Toolbar sort order buttons.

Sorting images

You have the option of sorting images in Lightroom by Capture Time. Added Order, Edit Time, Edit Count (for sorting Edit versions of master images in the order in which they were created), Rating, Pick, Label Text, Label Color, File Name, File Extension, File Type, or Aspect Ratio. Next to the Sort menu is the Sort Direction button. This lets you quickly toggle between ordering the images in an ascending or descending sort order (Figure 10.111). Capture Time is set by default and is probably the most useful sort-order setting. For example, if you come back from a shoot with several cards full of images, there is a high probability that the order in which you import the photos may not match the order in which they were shot. If the files are renamed at the time of import, you may want to correct this later, making sure the files were sorted by Capture Time in descending order and batch rename them in this order (Library ⇒ Rename Photos). The descending sort order is useful when shooting in tethered mode, when you may want the most recent images to always appear at the top of the filter view in the content area. You can easier method is to use the Sort menu in the Toolbar (Figure 10.112).

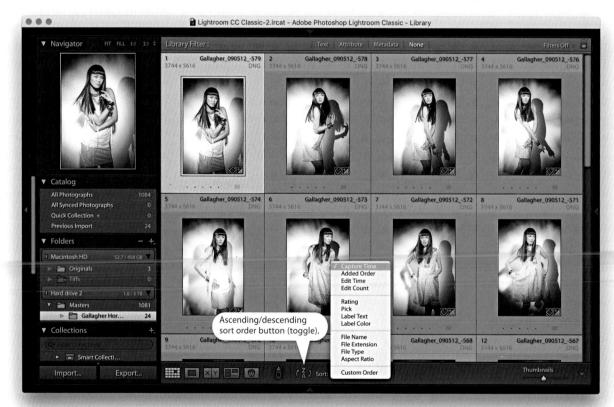

Figure 10.112 The Library module Toolbar Sort menu options.

Sort functions

If you are viewing a folder or a collection source, you can manually adjust the image sort order by dragging and dropping photos either within the Grid view or via the Filmstrip. However, it is possible to drag and drop photos in the Library grid or a Filmstrip view only when a single folder view or a collection is selected. You cannot drag and drop grouped folder views or filter views that span more than one folder. Sorting the photos manually defaults the sort order menu to the User Order sort setting, and the User Order sort will remain in force after you have exited a particular folder or collection view. As soon as you switch to any other sort order menu option, such as Capture Time, the previous User Order sort will be lost.

Color label sorting

You will notice that instead of having a single sort option for sorting by color labels, there are in fact two options: Sort by Label Color and Sort by Label Text. This can help resolve some of the possible contradictions in the way color labels are identified in Bridge and Lightroom; both use different default label-naming sets (Figure 10.114). The Sort by Label Color option can be used to sort photos (alphabetically) by the color labels applied in Lightroom and Bridge (where the Bridge color label text also matches). The Sort by Label Text option is a "catch-all" option that allows you to sort *all* color-labeled photos regardless of whether the color-label settings between Lightroom and Bridge match. Also, if you go to the Metadata panel (Figure 10.113), you will notice the Metadata panel displays the color-label text data only. This means that, although Lightroom will not necessarily be able to display the color labels that might have been applied in Bridge as a color tint, you still have a way to filter and sort them based on the color-label text metadata.

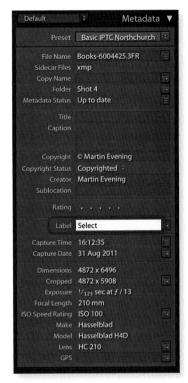

Figure 10.113 The Metadata panel displays the color-label information using the color-label text data.

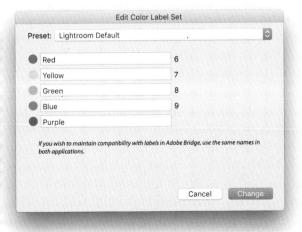

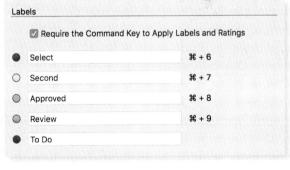

Figure 10.114 The Lightroom default Color Label set scheme (left) and Bridge default Color Label set scheme (right).

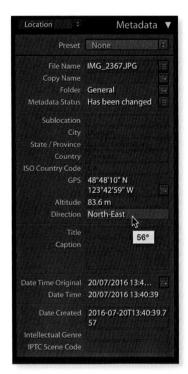

Figure 10.115 The Metadata panel in Location mode displaying the GPS metadata.

Figure 10.116 The AMOD AGL 3080. This unit can record GPS coordinates several times per minute and saves the GPS time-stamped trackpoints to a log file.

Geotagging images

In this section, we are going to be looking at ways to add GPS location metadata to your photographs, a process known as *geotagging*. A number of cameras are now able capable of automatically recording and embedding GPS data in capture images. For example, smartphones are capable of embedding GPS coordinates in photos. Alternatively, you can use a GPS receiver to record the GPS data and use separate software to take the tracklog data and "geocode" the captured image files to specify the exact point where a photograph was taken at a particular time. If an image has been geocoded, you will see the precise GPS coordinates in the GPS field in the Library module Metadata panel (**Figure 10.115**). The Altitude field displays the known altitude, while the Direction field displays one of eight compass points. To see the precise degree value, roll the pointer over the Direction field. You can click the arrow next to the GPS field to go directly to the Map module.

GPS devices

To geocode images successfully, you need to take several things into account. First is your choice of GPS device. One option is a standalone device, and there are a number of affordable choices for around \$100 or less. For example, I regularly use the AMOD AGL3080, which is shown in Figure 10.116. The cheaper devices tend to have a rather low sensitivity, however, and may fail to work when the cloud cover is heavy or you are inside a building. They also tend to consume a lot of battery power. So, it may be a good idea to consider using rechargeable batteries and always carry a spare set with you when you are out on location. As an alternative, many smartphones, such as the iPhone, automatically embed GPS data in the photos you shoot with them, or you can use the Geotag Photos app (geotagphotos.net) to record GPS coordinates via your smartphone every 30 seconds. At the end of a trip, you'll need to upload the recorded GPS Exchange (GPX) file to your account page on the Geotag Photos website. If you are prepared to spend more money, GPS recording units with higher sensitivity can provide continued recording in overcast weather conditions or when you are down in a deep valley. Such devices offer the benefit of on-screen display controls and can be useful for other activities as well, such as personal navigation (especially in remote areas).

As with raw file formats, there are currently a large number of different proprietary formats for storing GPS coordinates, not all of which are compatible with the different software solutions that utilize GPS data. Of these, the GPX format has emerged as an industry standard, and only tracklogs written in this format can be loaded into the Lightroom Map module. Therefore, it is desirable to use a GPS device able to export data using GPX. If yours doesn't, you can still rely on third-party software to read the recorded GPS data, match it with your photos, and geocode the images.

The various hardware options you can buy will most likely already come with supplied software for a Mac or PC, which you can use to geocode your photos. The problem is that many of these programs are designed to write GPS data to JPEG capture images only. You need to make sure the software you use is able to geocode the GPS data to raw files using XMP sidecar files. This will then allow Lightroom to read in the geocoded metadata. For Mac users, I recommend HoudahGeo 5 (houdah.com/houdahgeo) and GPSPhotoLinker (earlyinnovations.com). For PC users, I recommend GeoSetter (geosetter.de/en).

On a cautionary note, be aware that some geocoding software either does not use the correct EXIF field to store the data or stores the GPS data within its own database only, thereby forcing you to use only that software to make use of the recorded data. Remember also, that if the software you use is able to edit the EXIF data of a proprietary raw file, you should take extra care that this does not affect the integrity of the file. It is generally not a good idea to mess with the XMP data of an undocumented raw file format. You never know if this may cause problems reading other data that's stored in the file. For example, when reviewing one of the geocoding products shown in an earlier version of this book, I had to point out that the lens data in the lens data EXIF field would appear truncated after modifying the raw files. No real harm was done to the image data, but it was unnerving all the same to see this happen.

Embedding GPS metadata in a photo

Now that I have explained how GPS metadata can be useful, let's look at how you can capture and embed GPS metadata in a series of photos. Firstly, for the geotagging to be accurate, the internal clock in your camera must show the correct time. It does not matter so much whether the camera clock is set to the correct time zone (although it may help if you remember to do this), but it should at least be accurate to a time zone somewhere in the world. GPS timestamp data is recorded using something very similar to UTC (Coordinated Universal Time), a standard time that is measured irrespective of the different time zones in effect around the world. When it comes to geocoding your images, all you need to do is tell the software which time zone the camera clock was using at the time the photos were taken.

With the right equipment and good timekeeping, you can make an accurate record of where a photograph was taken from at a particular point in time. Such data may prove helpful to historians in the future, although given the inaccuracy of many of the photos you currently see placed on Google Earth, I wonder if the data recorded today will be seen as being that valuable? I find that most are wildly inaccurate. But even so, it does amaze me that the photos I have shot using my iPhone mostly have very precise GPS coordinates.

Figure 10.117 A view of the Metadata panel using the Location view mode. The IPTC location fields are auto-filled.

Figure 10.118 Here, I clicked each location name header in turn to select and confirm the location metadata.

Reverse-geocoding

Reverse-geocoding is the process of reverse-coding a GPS point to an actual address or place name. A number of software programs can match a GPS coordinate to a range of known geographic locations and calculate which one is nearest or most relevant. For example, iPhones are able to reverse-geocode the GPS data and show on a map where your photos have been taken.

To reverse-geocode in Lightroom, you need to open the Catalog Settings and enable "Look up City, state and country of GPS coordinates to provide address suggestions" (When you first create a new catalog in Lightroom, you will be asked if you wish to enable this feature). Once done, geocoded images will display the location name metadata in the Metadata panel (**Figure 10.117**). To apply location field names, manually click on the location header names circled in **Figure 10.118**. This reveals a pop-up menu from which you can select and confirm the name for each location name field.

Unsurprisingly, this has brought about some concerns, such as whether it is appropriate to include GPS and other location data when releasing photos into the public domain. For example, there have been panic stories about photos of children taken by their parents at home, which have then been uploaded to a social network site, and the embedded GPS data shows the exact address where the family lives. I can imagine news documentary photographers who might not always want to reveal information about where their photos were taken. Fortunately, the Library module Publish Services panel and Export dialog give you the option to exclude all location metadata. As GPS embedding becomes more widely available, professional photographers have to take extra care to make sure they are not breaking any laws or inadvertently breaking client confidentiality by leaving any GPS data embedded.

The Map module

The Map module (**Figure 10.119**), lets you view and manage geotagged images. The main content area displays a map view of the world, and you can change the style of this view via the Map Style menu in the Toolbar Map (**Figure 10.120**). As with the Web module, the map preview is built using Google's Chromium Embedded Framework. You can quickly switch map views using keyboard shortcuts: **I1* (Mac) or Ctrl1* (PC) for Hybrid, **I2* (Mac) or Ctrl2* (PC) for Road Map, and so on. To view catalog images on the map, you first need to make a photo selection either from the Library module or via the Filmstrip. The Metadata panel on the right can confirm whether GPS data is present, and, when it is, it displays the GPS coordinates (Figure 10.119). For those images that have previously been geocoded with GPS data, clicking the arrow next to the GPS data field (circled) centers the map location on the selected image, as does double-clicking an image in the Filmstrip.

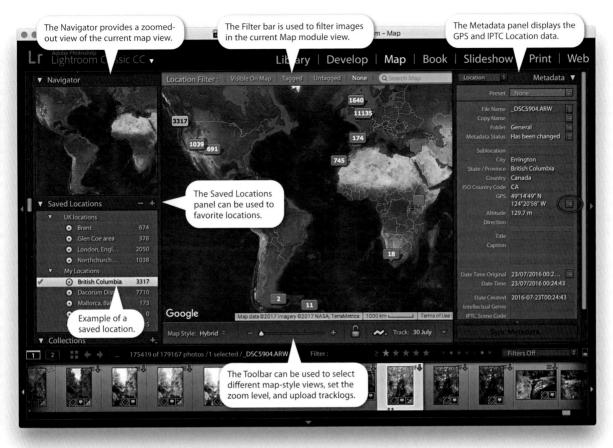

Figure 10.119 The Lightroom Map module.

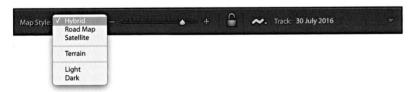

Figure 10.120 The Lightroom Map module Toolbar (T) and available map view options.

Navigation

To navigate the Map module, use the Zoom slider in the Toolbar to zoom in or out, and click and drag to scroll the map view. You can also use the + and – keys to zoom in and out and can control the level of the zoom with the Toolbar Zoom slider. The Navigator panel (**Figure 10.121**) provides a slightly more zoomed-out map view, where you can double-click to zoom in and click-drag to scroll the map. You can also hold down the Att key and drag to define an area to zoom in to. You can scroll with a mouse or trackpad to quickly zoom in and out of the Navigator panel view as well as in the Map view.

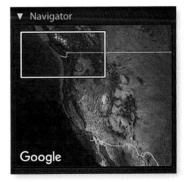

Figure 10.121 The Navigator panel.

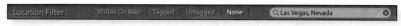

Figure 10.122 The Location Filter bar. Use backslash $(\ \)$ to toggle on or off.

Location filter bar

The Map module Filter bar (\subseteq) (**Figure 10.122**) can be used to filter the Filmstrip contents and create a filtered subselection. The default None option applies no filter to the Filmstrip and lets you see all the Filmstrip images. The Visible on Map option populates the Filmstrip with just those photos that are geocoded and appear within the current map view. As you zoom in, fewer photos will be selected; as you zoom out, more photos will be selected. The Tagged option filters the Filmstrip to select the geotagged photos only, dimming the untagged photos. The Untagged option selects all images that have yet to be geotagged within the current selection and dims all the rest. This is particularly useful if you wish to filter the photos that are yet to be geotagged.

The Search field can be used to search the Google Maps database to find a specific place. Very often, a single place name will suffice when making a search. Otherwise, use a comma when entering a place name hierarchy. So, for example, you might want to specify searching for *Las Vegas, New Mexico*, if you did not want the search to default to *Las Vegas, Nevada*. If you are not sure of an exact location, or there might be more than one place associated with a specific search, you will see a popup list of suggestions after you press —Enter). This allows you to select whichever is the correct, desired location (**Figure 10.123**).

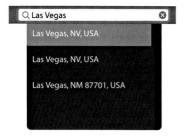

Figure 10.123 A location search can offer suggestions where more than one location is associated with a specific search.

Loading GPX tracklogs

You can import tracklogs (GPX only) via the tracklog icon in the Toolbar (circled in **Figure 10.124**) or by going to the Map menu and choosing Tracklog ⇒ Load Tracklog. Once a tracklog has been loaded, Lightroom searches to see if any photos in the current catalog selection have date times that match with the times recorded to it. Where matches are found, Lightroom gives you the opportunity to auto-tag the matching photos so they can be geotagged. It is best to make sure you have the correct time set on your camera to match that on your computer and, if necessary, time-shift the GPS data as you load a tracklog. Alternatively, you can drag a photo from the Filmstrip to a point on the tracklog you believe to be the right location for that photo. Do this and all the other photos will auto-tag accordingly (**Figure 10.125**). This lets you quickly auto-tag photos regardless of any time-zone differences and is most useful for resolving time discrepancies between the camera and the tracklog. This does depend on you being able to recognize a particular location on the map of course.

TIE

Lightroom is only able to read GPS logs recorded using the GPX format. If a tracklog has been recorded in some other format, you will first need to convert it to the more universal GPX format. Check out gpsvisualizer.com for help converting tracklog files to GPX.

Figure 10.124 An example of loading files to a tracklog.

Figure 10.125 If you are unsure of the time-zone difference, you can also drag a photo to a known point on a tracklog, and then select other photos to auto-tag to the tracklog.

Editing pins

Figure 10.126 shows examples of the types of pins displayed in the Map module. The pin marker for a single, unselected image is an empty orange pin marker. As you roll the pointer over the pin, it changes, adding four arrows, indicating you can drag to alter the pin's position. Doing this overwrites the original GPS metadata, however, which might be a problem if you end up removing the original recorded GPS position. It is possible to lock solo pins by clicking the lock button in the Toolbar (or use 黑区 [Mac] or [Ctrl 区], but you will not then be able to edit the positions of any of the other solo pins until you remove the lock. If you click a pin to select it, the pin turns yellow, indicating the image is selected in the Filmstrip. If more than one image is geotagged at a specific location, the number of photos are displayed within the pin marker. The number in the pin and number of pins will vary according to the Map module magnification view. To reposition a pin group, you need to click it to select the photos in the Filmstrip. You can then drag those photos from the Filmstrip to reposition them on the map. A yellow rectangle with a number inside and no pointing arrow indicates a cluster of selected nearby photos. An orange rectangle with a number and no pointing arrow indicates a cluster of unselected nearby photos. A pin with a black dot represents the result of a Map search. If you click a pin, you'll see the thumbnail or thumbnails associated with that pin. When there is more than one photo, click the arrows in the thumbnail preview to view the images associated with that particular pin position (Figure 10.127).

You can use the Recent Tracklogs submenu to select other previously loaded tracklogs. And, at the bottom is an option to turn off tracklogs.

Figure 10.126 Examples of pin appearance in the Map module.

Figure 10.127 Clicking or hovering over a pin reveals the thumbnail or thumbnails associated with that location.

Matching photos to a recorded tracklog

The following steps show an example of how I was able to load a GPX tracklog and ensure that the photos matched correctly when auto-tagging them.

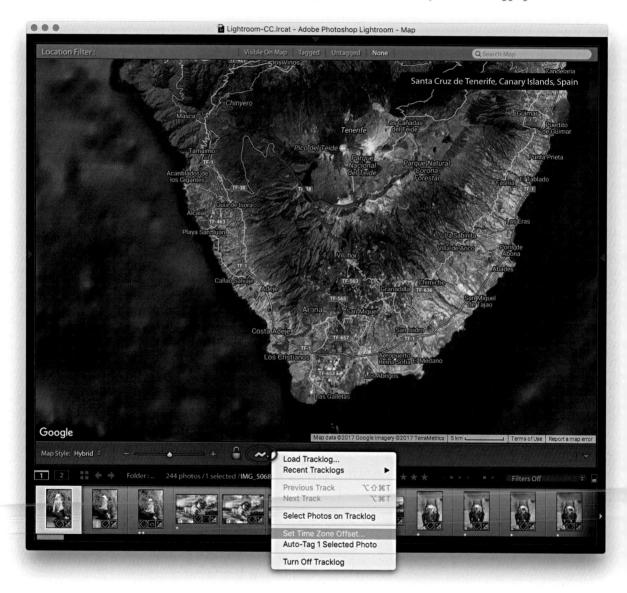

1. To begin, I clicked the tracklog button (circled above) and loaded a GPX tracklog. The GPS tracklog route then showed up in the Map module map view as a blue route. Before I used this to tag the photos in the Filmstrip, I wanted to ensure the selected photos matched the same time zone as had been recorded by the tracklog.

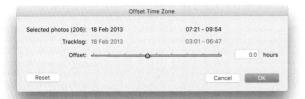

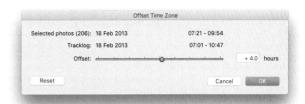

2. Essentially, the tracklog is always correct. What is not always correct is the date time set in the camera and, thus, the date time that is embedded in the capture image files. The objective here is to work out just what that time difference might be. If you think your camera is set correctly, taking into account daylight-saving time, you can proceed to Step 3. Otherwise, go to the Tracklog menu shown open in Step 1 and select Set Time Zone Offset. If the camera times appear not to match, the tracklog time will appear in red. As you adjust the Offset slider, you will know when you are close to the correct setting when the tracklog time is displayed in black.

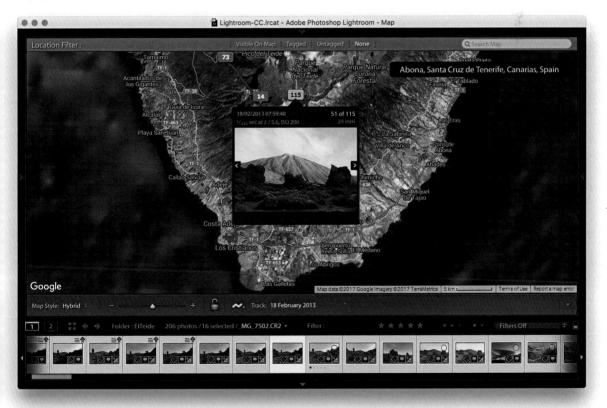

3. Once the time zone was set correctly, all I had to do was to select the photos in the Filmstrip and choose Auto-Tag Selected Photos from the Tracklog menu. This successfully matched the photos to the tracklog.

TP

If you disabled the "Look up City, state and country of GPS coordinates to provide address suggestions" option in the Metadata section of the Catalog settings and then enabled it again, you will need to restart Lightroom for this to kick in.

Manually geotagging photos in the Map module

What about the photos in your catalog that can't be geocoded using recorded tracklog files? You can manually geocode these by dragging individual photos or selections of photos from the Filmstrip to a location on the map, or hold down the <code>(Mac)</code> or <code>(Ctrl)</code> (PC) key and click the map to geotag them. As you do so, you will see that a pin marker is added to the map view (**Figure 10.128**). This is a quick and easy solution for geotagging photos that do not have any recorded GPS data. However, I would urge you to think carefully when manually tagging photos this way. For the data to be useful and conform with the way GPS data is normally recorded, you need to tag as near as possible to the location the photo was taken from and not the location of the subject in the photo.

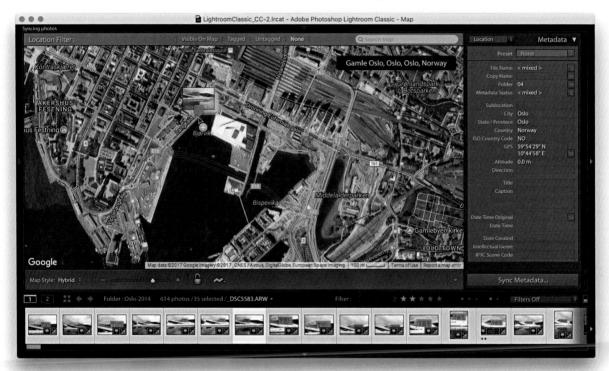

Figure 10.128 Geocoding photos manually via a drag and drop from the Filmstrip.

When you geocode images manually in this way, the IPTC location fields in the Metadata panel are filled automatically, but only if none of the location fields is empty to begin with and only if you have the "Look up City, state and country of GPS coordinates to provide address suggestions" option enabled in the Metadata section of the Catalog Settings. If any of the fields already has information, Lightroom will not auto-populate them with new location data (even though the new data might be more accurate). If you need to update the location, you will have to do so manually.

If you right-click anywhere in the Map module, you will see an Add GPS Location to Selected Photos menu option. This allows you to manually geotag photos by making a selection in the Filmstrip first and then using the context menu to geotag the selected photos. You can also use this context menu to select a Delete GPS Coordinates option.

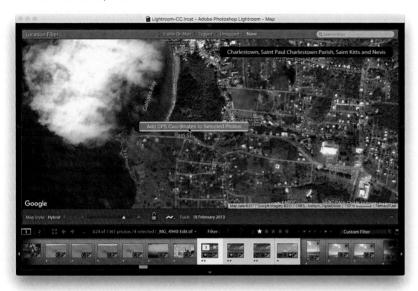

1. In this example, I made a selection of photos via the Filmstrip and right-clicked in the Map view to select Add a GPS Location to the selected Photos.

2. The selected photos were now geotagged to this location.

Figure 10.129 The Saved Locations panel.

Saved Locations panel

The Saved Locations panel (**Figures 10.129**) can be used to store favorite locations and thereby makes managing the Map module easier. All you have to do is click the arrow to the right of a saved location, and the Map module will instantly switch to display the location in the map view (**Figure 10.130**). Use ① to toggle the circumference display on or off. To create a new location, make sure the current map view is centered on an area of interest and click the + button at the top of the panel. This opens the New Location dialog shown in **Figure 10.131**, where you can set a radius for the location and choose a folder to save the new location to. Once a location has been saved, you can edit the radius by dragging on the circumference pin. Photos can be dragged directly to Saved Locations, and Saved Locations can be dragged to photos in the Filmstrip.

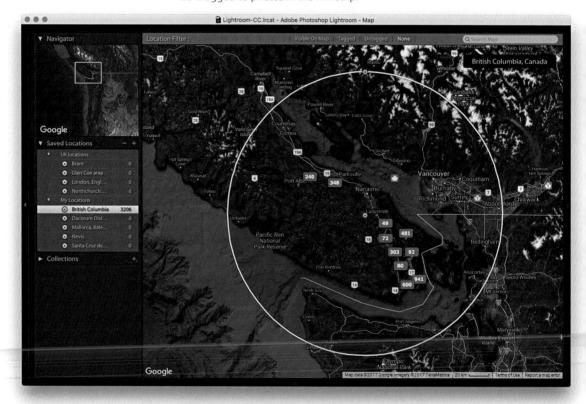

Figure 10.130 The radius of a saved location in the main Map view.

Exporting GPS-encoded files

Whenever you export a photo from Lightroom, the GPS data is normally saved with it, along with all the other XMP data that's associated with the image. However, there are ways you can specifically strip the GPS and IPTC location metadata. One way you can do this is to check the Private box in the New Location

dialog when creating a new location (Figure 10.131). Or, you can right-click the Saved Locations panel to reveal the context menu, and choose Location Options to open the (similar) Edit Location dialog and enable the Private GPS data option. When you do this, the GPS data will from then on be excluded on export from all photos contained within that radius. In the Metadata section of the Export dialog (**Figure 10.132**), you will see a Remove Location Info check box. This too strips the IPTC location and GPS metadata from all photos included in a Lightroom export.

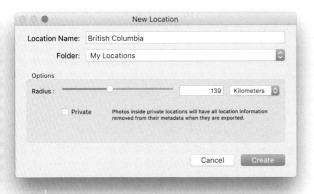

Figure 10.131 The New Location dialog.

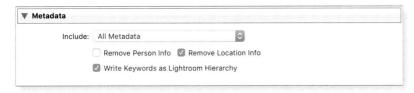

Figure 10.132 The Metadata section of the Export dialog, where you can check the Remove Location Info option to exclude all Location EXIF metadata on export.

Filtering geocoded images

Figure 10.133 shows the GPS metadata filtering options. This includes a GPS Data filter to filter according to the GPS status. Next to this is the Map Location filter. Both are available as filter options in the Library module Filter bar.

Figure 10.133 The GPS metadata filtering options.

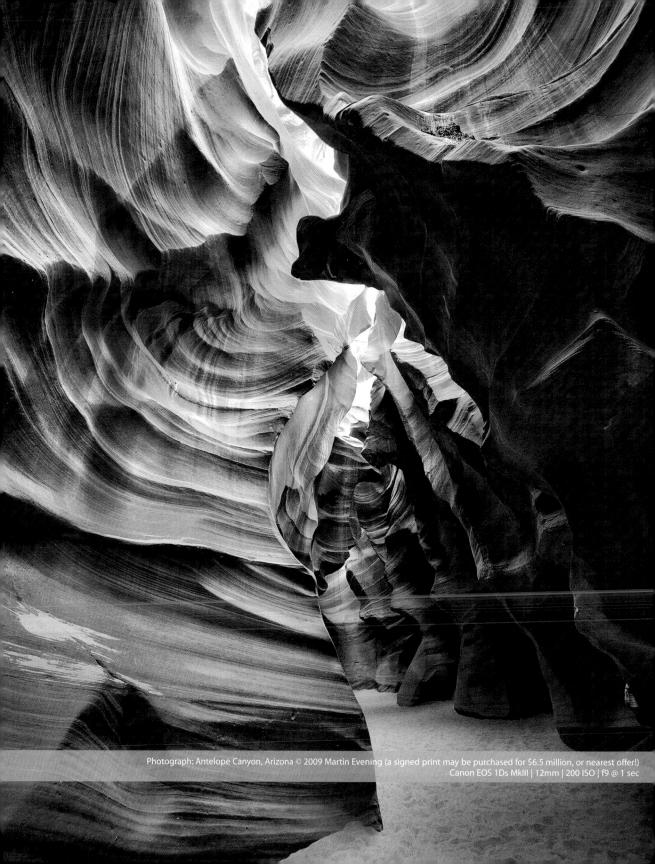

Lightroom CC/mobile

How to synchronize your files with the Lightroom CC/mobile ecosystem

Smartphones can now be used to do so many things. Your phone can connect to the Internet, take photographs, record audio, recognize a fingerprint, or even be used as an impromptu incendiary device. So it is only natural that Lightroom should now allow you to extend what you can do in Lightroom to a mobile environment. Lightroom mobile (which is now known as Lightroom CC) lets you take Lightroom beyond the confines of a desktop or laptop computer.

It all started off on a small scale with the introduction of Lightroom mobile for iPads and iPhones and later Android devices. Since then Lightroom CC has extended to include Lightroom web for sharing collections/albums with friends and clients, Lightroom web view for remote editing via a Web browser, Lightroom for Apple TV, and now the Lightroom CC application, a self-contained Lightroom-lite program with full synchronization to Lightroom CC/mobile apps and a master Lightroom Classic CC catalog.

This chapter gives you an overview of the Lightroom CC/mobile family and explains how the different elements integrate with each other. If you already understand how Lightroom Classic CC works, you will find most of the controls self-explanatory. This chapter provides a useful guide to working with Lightroom CC/mobile and explores the various components.

NOTE

Lightroom Classic CC customers who are subscribed to the Photography plan will have access to Lightroom CC included along with 20GB of storage. This allows you to dip your toes in the water and try out Lightroom CC. Should you wish to extend the storage space limit to 1 TB a further plan is available. Or, you can choose to subscribe to Lightroom CC only with 1 TB of storage.

Lightroom CC/mobile workflow

Lightroom mobile for the iPad and then the iPhone first came about in response to user requests for a mobile app version of the Lightroom desktop program. Since its first introduction, the Lightroom mobile (now Lightroom CC) features have expanded to offer more ways to edit and share photos synced to the cloud and linked to a master Lightroom Classic CC catalog. You can view synced images via an iPhone, iPad, Android device, or any web browser. You can capture photos directly using a smartphone camera, and some specific devices will let you capture in DNG and carry out HDR merges. When using the Lightroom CC program or Lightroom CC for mobile on one of the latest iPad Pro devices, you can import raw files directly and have these sync directly to the cloud from wherever you are in the world. This has the potential to let you travel light with the security of knowing that backups will automatically be uploaded to the cloud and synced to the synced Lightroom catalog back home, or in the office. Meanwhile, you can edit photos on your devices while you are on the road and the edits you make will be synced back to the Lightroom Classic CC catalog and Lightroom CC application, as well as to collections/albums on other devices that are running Lightroom CC/mobile.

That in theory is how things should work, but this will be very much dependent on the speed and availability of your Internet access. While you may have a nice fast connection at home or at work, what matters more is the Internet access that's available to you when you are out and about, which can often be patchy and slow. Furthermore, many hotels place a cap on the amount of data you can download or upload each day. In reality, a high bandwidth workflow is something currently only a few photographers have access to on a regular basis. It may one day become a reality as high bandwidth speeds and high volume data access become more widely available. Certainly, a lot may change over the coming years and it is no bad thing for Lightroom CC/mobile to be ahead of the game at this stage with a mobile ecosystem that's ready for a globally connected world. To help overcome such problems, I recommend you sync photos to the cloud during those times when you do have good Internet access. That way you can work more efficiently in places where the Internet connection is not so great. In these situations the Lightroom CC application and Lightroom CC/mobile components only need to download proxy versions for you to work with and the edits you make are uploaded as metadata only.

You can use the Lightroom CC program and Lightroom CC/mobile system to quickly share photos with others via social media, share photos using weblinks, or simply to access Lightroom Classic CC catalog photos on a personal device. I particularly like the ability to share Lightroom CC albums via a Lightroom web view link. As you update individual images these are updated automatically on the album's Lightroom web view page. Therefore, when you share a selection of images with someone, you can continue to edit the photos in Lightroom Classic CC, or any of the Lightroom CC components, and the edits are

continuously updated on the web page. Also, using Lightroom web view, friends or clients can leave feedback by liking or adding comments.

While Lightroom CC/mobile gives you the freedom to work with your photos on personal devices, you can use Lightroom web to access Lightroom mobile shared albums from any computer or device that's connected to the Internet and upload files to the Adobe cloud via the web browser interface.

Ultimately, the Lightroom CC/mobile workflow is all about making the catalog syncing process as robust as possible so whether you capture photos on your phone, import them from a personal device or laptop or desktop computer, your photos can be shared everywhere. It's also about helping photographers to manage their photos better. Lightroom CC/mobile users will find the Adobe cloud-based servers provide a powerful search engine that can help you find the photos you are looking for by using descriptive terms, just as you would when carrying out a regular Internet search.

Figure 11.1 shows a summary of the Lightroom CC/mobile family workflow illustrating the data upload/download paths. The high-bandwidth data transfer for the master files is represented by the wide green arrows. The medium-bandwidth Smart Preview data transfer is represented by the medium brown arrows, and the low-bandwidth metadata data transfer is represented by the thin purple arrows.

NOTE

To sum up, Lightroom Classic CC is a disk storage-based computer application, whereas Lightroom CC/ mobile is an integrated cloud storage-based, mobile system. Lightroom CC consists of Lightroom for mobile, Lightroom web view, Lightroom web, Lightroom for Apple TV, and a Lightroom CC computer application. The above Lightroom CC/Lightroom mobile components can all link to a single, master Lightroom Classic CC catalog. When you work with Lightroom CC, the cloud is central to everything you do in Lightroom.

Figure 11.1 The Lightroom CC/mobile workflow.

NOTE

The preview files use the P3 display space, which is designed to match the gamut of wide-gamut displays such as the 5K iMac and iPad Pro, where incidentally, iOS10 has introduced system-level color management. This provides the necessary hooks for app-based color management, such as X-Rites ColorTRUE app. For images that are viewed on a web page, Lightroom CC/mobile relies on the browser to carry out the color conversion to the monitor profile (which will usually be sRGB) except for certain browsers running on older iOS devices and Android devices. You also need to take into account that you can adjust the hardware display controls on Android devices, which makes this even more of a guessing game.

What Lightroom CC/mobile can and cannot do

Essentially, all the Lightroom CC/mobile elements let you interact with your synced Lightroom Classic CC catalog via compatible mobile devices and work remotely. To interact with the synced catalog data, you will need to be online and have adequate space to download the required proxy files/JPEG previews to your device (proxy/ Smart Preview files are essentially low-resolution compressed raw files). This can be described as a "leaning back" workflow that integrates seamlessly with your synced Lightroom catalog. Lightroom CC/mobile for iPad, iPhone, or Android is useful for those who want to work on their catalog images without having to carry around a laptop computer, turning a commuter journey into productive reviewing or editing time, for instance. With Lightroom CC for mobile, you can also add files directly from the Camera Roll, shoot photos using the Lightroom CC for mobile camera mode, or copy files from a camera card to the device. This can be described as a "road warrior" workflow, where Lightroom CC for mobile on a mobile device can replace the use of a laptop.

You have the means to share images via text message, email, or social media. You can present images in a slideshow form, although it helps if you have previously selected the images to work offline and allowed time to download the proxy data.

When it comes to making tone and color edits, you are limited, of course, to the color gamut of the display on your mobile device. A mobile device won't be able to match the gamut of your usual desktop display. So, while it is cool that you can work on images outside the office and stream the edit changes via the cloud, the edits you apply may well look quite different when viewed back at the office on your regular display. Such color management limitations are likely to prove a stumbling block for some time. The Apple iOS or tablet hardware in general may become more sophisticated and provide a more reliable viewing environment, but these are still primarily consumer devices. However, you can calibrate an iPad screen though using the X-Rite ColorTRUE app (see Note).

If you view using Lightroom CC for web, the JPEG proxy files (which use the Display P3 color space) will match the color space used by the latest wide-gamut Retina iMacs. Display P3 is roughly the same size as Adobe RGB. It isn't an exact match, but it can contain most of the same colors. Therefore, the color management should be effective if you are working in Lightroom CC for web on a remote computer that has a similar wide-gamut, calibrated display.

Lightroom CC for Apple TV

To access Lightroom CC for Apple TV, you need an Apple TV (4th generation) running tvOS 9.0 or later. Download Lightroom CC for Apple TV from the App store and open it. When you sign in, note down the code that appears, then visit

lightroom.adobe.com/tv in your computer's web browser and enter the authorization code. If successful, Lightroom CC for Apple TV can display your Lightroom CC albums on the TV screen as slideshows.

Setting up Lightroom CC/mobile

When you install Lightroom Classic CC, your Adobe account will automatically be activated. If for some reason you are signed out, you can sign in again via the Lightroom Help menu and enter your account details using the dialog shown in **Figure 11.2**. The Lightroom CC preferences (**Figure 11.3**) show your current Adobe account status and can be used to manage the Lightroom CC settings.

Adobe Lightroom

Foll Adobe ID

Sign in

martin@martinevening.com

Sign in

Forgot password?

Not a member yet? Get an Adobe ID

Want to use your company or school account?
Sign in with an Enterprise ID

Or sign in with

Facebook G Google

Cancel

Figure 11.2 The Adobe Creative Cloud login dialog.

Figure 11.3 The Lightroom CC preferences.

Figure 11.4 The Identity Plate menu options.

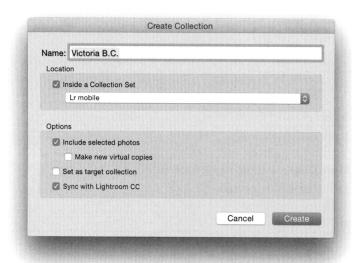

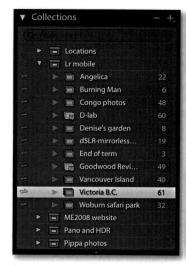

Figure 11.5 When creating a new collection, you can sync it with Lightroom CC/mobile by checking the Sync with Lightroom CC option in the Create Collection dialog.

Figure 11.6 The Catalog panel showing photos being added to All Synced Photographs.

Pending Sync Activity tells you how many photos are in the process of uploading and downloading. Clicking the expansion triangle will give you specific information about which files are uploading, as well as information about any sync errors. You can pause Lightroom CC synchronization via the Identity Plate menu by clicking the pause button (circled in **Figure 11.4**).

Photos can be synced from Lightroom Classic CC to Lightroom CC/mobile by creating collections and enabling these to be synced with Lightroom CC/mobile. If you click the plus button at the top of the Collections panel to create a new collection, you can check the Sync with Lightroom CC option (Figure 11.5). This ensures the selected photos in the collection are saved as a new collection and synced to Lightroom CC/mobile. After you click the Create button, Lightroom Classic CC starts the synchronization process whereby Lightroom creates Smart Preview proxy versions of the master images and uploads these to the Adobe cloud servers. Meanwhile, in the Collections panel you will see a sync badge appear in the left column next to the synced collection (Figure 11.5). This indicates a collection is currently set to sync with Lightroom CC/mobile (as an album). Clicking on this opens a dialog that allows you to turn off syncing for that collection. However, doing so will remove all the mobile sync data for that collection/ album, including photos stored on the cloud and any comments. Alternatively, you can sync photos with Lightroom CC/mobile without having to add them to a specific Lightroom CC/mobile collection/album first. Just simply drag photos to All Synced Photographs in the Catalog panel (Figure 11.6).

The overall sync status can be seen in the Identity plate area (Figure 11.4), where you can click on the pause button to pause the sync process. Sync activity is

also shown in the Lightroom CC preferences (Figure 11.3). Synchronizing a large number of files can take time, which is why you'll often see a list of pending activities in the Sync Activity section. Even if your Internet access is good this can all take time, which is why there is a "Prevent system sleep during sync" option, to allow syncing to complete fully before letting the computer to go to sleep mode. The synchronization process works in both directions, syncing not just the selected photos in the Lightroom Classic CC catalog to Lightroom CC/mobile, but also syncing (downloading) photos that have been added via Lightroom CC/ mobile. This means you can sync original files that have been captured or imported via a mobile device. So, if you add photos to a mobile device via the Camera Roll, capture via Lightroom CC for mobile directly, or import files from a camera to a device, these are synchronized to the cloud and synced back to Lightroom Classic CC. This works with only a single Lightroom catalog at a time. If you attempt to sign in to a different Lightroom catalog, Lightroom Classic CC will display an alert if the catalog you're signing in from is not the one it is already synced to. Also, be warned that if you click the Delete All Data button, this removes everything you have currently synced to Lightroom CC/mobile and will return you to a "stopped" state where sync is switched off.

Essentially, photos that are synced from Lightroom Classic CC to Lightroom CC/ mobile are synced to the cloud as Smart Preview proxies of the desktop originals. Synced devices, such as an iPhone or an Android device, can access first of all the JPEG previews and then download proxies on demand for editing on your device. In the case of Lightroom CC for web view and Lightroom CC for web, the proxy images are higher resolution JPEGs.

Images that are uploaded via a device running Lightroom CC for mobile, or a computer running Lightroom CC for web, or Lightroom CC are uploaded as original files to the Adobe cloud servers whether these are JPEGs or raw files. The synchronization process ensures copies of master files captured or imported to a device are eventually all synced back to Lightroom Classic CC (providing sync is enabled). In the case of Lightroom CC/mobile, the process is one-way. Imported or captured files are only synced as proxies to computers or devices running Lightroom CC/mobile, i.e., Lightroom CC for web, Lightroom CC for mobile, or Lightroom CC.

How Lightroom CC/mobile edits are synchronized

With everything synced via the cloud, edits made to an image on a computer running Lightroom Classic CC, Lightroom CC, or Lightroom CC for web, or on a device running Lightroom CC for mobile are synced automatically to all the other Lightroom CC synced components. This can happen very quickly because only the file metadata is being synced. However, if there is a conflict, such as an edit change made in Lightroom Classic CC clashing with an edit change previously made on a Lightroom CC for mobile device, the mobile device changes are preserved as a Develop Snapshot.

Where Lightroom CC/mobile photos are kept

Photos synced from Lightroom Classic CC to Lightroom CC/mobile are copied to the Adobe cloud servers as Smart Preview proxy images, where they are stored permanently. Once the photos are uploaded to the cloud, the Adobe cloud servers create JPEG previews that are downloaded first to the Lightroom CC for mobile devices or Lightroom CC for web view/web pages (with Lightroom CC for web view and Lightroom CC for web the JPEG previews are used to view only and not downloaded to the computer used to view them). This is followed by downloading the Smart Preview proxies "on demand" to Lightroom CC for mobile devices or computers running Lightroom CC. The Smart Preview proxy files are limited in size to 2560 pixels across the widest dimension. This makes the proxies suitably big enough to make edits to and enlarge to see in more close-up detail, while not being so big they take ages to download. The Smart Preview proxy files are temporarily stored on each device and automatically cleared after a time in order to keep space clear on the device.

Original files that are imported via Lightroom CC for mobile devices, Lightroom CC for web, or the Lightroom CC program are immediately uploaded to the Adobe cloud servers as original masters, stored there permanently, and eventually deleted from the source device. Once the files are uploaded to the cloud, the Adobe cloud servers convert the files to Smart Preview and JPEG proxies that can be accessed via other Lightroom CC for mobile devices, or Lightroom web pages. However, the uploaded originals are always automatically downloaded to the synced Lightroom Classic CC catalog and copied to the designated Lightroom Classic CC images folder. The default location is the Pictures/My Pictures folder. If you intend to sync a large number of files, this may use up a lot of precious space on the main computer hard drive. You can physically move the files from this folder location and place them on other drives and the link with the Lightroom mobile versions will be maintained. I would still be concerned about the linking becoming broken though. A better solution is to go to "Specify Location for Lightroom CC ecosystem's images" in the Lightroom CC preferences (Figure 11.3) and select a master folder location on a drive that has ample clear space.

To make the synchronized files easier to manage, there is a "Use subfolders formatted by capture date" option in the Lightroom CC preferences. So photos synced this way are automatically imported to Lightroom desktop and imported to the desired download folder using a dated folder configuration of your choice.

To summarize, master images that are synced via Lightroom Classic CC stay on the host computer and Smart Preview proxies are uploaded to the Adobe cloud servers. Originals imported via any Lightroom CC for mobile device are synced to the cloud, copied to the Lightroom Classic CC computer, and eventually removed from the device they were imported from. The cloud converts all imported originals to JPEG and Smart Preview proxies, which can be shared with Lightroom CC for mobile enabled devices, or the Lightroom CC program.

Creating a synchronized collection from Lightroom Classic CC

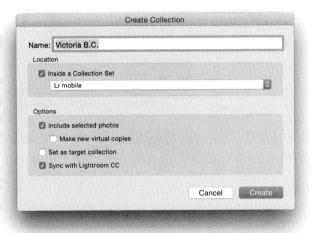

1 To set up a collection to synchronize with Lightroom mobile, I made a selection of images in Lightroom Classic CC and clicked the + button in the Collections panel to open the Create Collection dialog. Here, I created a new collection inside a collection set named Lr Mobile and made sure the Sync with Lightroom CC box at the bottom was checked.

Syncing 47 photos
Martin Evening

2. This initiated a synchronization between the Lightroom Classic CC desktop computer and the cloud, which, in turn synchronized with any synced devices using Lightroom CC/mobile.

NOTE

Lightroom CC for mobile can display the File Type badges shown here in the grid view to denote raw, DNG, or HDR photos. To change this, use a two-finger tap in Grid view to cycle through all the Info display options, including flags, ratings and EXIF Info.

Figure 11.7 The Organize menu options. The blue line indicates when a filter is active.

3. Over in Lightroom CC for mobile, the Lightroom CC collection I created in Lightroom Classic CC appeared as a new album. When I tapped on the album, it opened in a Grid view. I could swipe right to return to the album list view.

Working with Lightroom CC for mobile

Lightroom CC for mobile is available for iPhone, iPad, and Android devices (the iPad and Android screens will look slightly different from the iPhone-based examples shown here). It provides a limited range of controls to apply global and localized image edits and add flag or star ratings. You can use Lightroom CC for mobile from your phone or tablet while you are away from the computer running Lightroom Classic CC or Lightroom CC. You can edit your pictures and see the edits you apply updated when you get back to the main computer.

Essentially, once you have created a synced collection via Lightroom, you can view it as an album using any compatible device running Lightroom CC for mobile. Use a single-tap to open an album in a Grid view (see Step 3 above). Here, you can tap the Refine button at the top (circled in **Figure 11.7**) to reveal the filtering and sort order options. The Share options can be accessed via the button circled in **Figure 11.8**. For example, you can choose Save to Camera Roll, choose to open the files in a social media app or, say, Snapseed. Or, you can choose the "Edit in" option to edit in Photoshop Fix. In Figure 11.8, I tapped Share. I was then able to tap or swipe to select the photos to resize and share as a message, in an email, or send via social media, or to send direct to a printer.

Figure 11.8 The Share options menu (left), Image Size (center), and Share screen (right).

Tap on the three dots (circled in **Figure 11.9**) to access the Manage options, where you can choose to see a flat or segmented view sorted by Capture Date, Modified Date, Import Date, File Name, Most Liked, or Custom. Tap the Copy To or Move To options to copy or move select photos between albums. For example, you can make a selection and then select the destination to copy or move to (tap and hold to see the Select All and Deselect All options). Tap Present at the bottom to prepare the photos to be viewed as a slideshow. This reveals an arrow Play button (). Tap the three dots at the top of the screen while a slideshow is playing to access the slideshow playback options. You can also use a long press on a photo in Grid view to access the Manage and Share options.

Single image view

Use a single tap to go from the Grid view to the Single image view. **Figure 11.10** shows the four view modes that are available. In Review mode, the rating options can be used to apply flag ratings or star ratings. Swipe up or down on the left side to add or decrease the star rating. Swipe up or down on the right side to add or decrease the flag rating. Also included here is a Filmstrip mode, like you would have in the Lightroom Develop and Create modules so you can easily select other photos without having to exit the single image view mode. The Activity mode lets you review likes and comments made by people you have invited to view shared albums.

Figure 11.9 The Manage options.

TIP

If the device you are using has a pressure-sensitive screen, the brush also reacts to how hard or soft you press with your finger. Also, as you make a slider adjustment, you can increase the granularity of your finger adjustments by moving your finger farther away from the slider.

Double-tap to open the sharpening loupe at 100%. To see the sharpening mask, first start sliding the mask slider, then, while keeping your first finger on the slider thumb, add a second finger on top of the slider track. Double-tap to remove points from a parametric curve.

Figure 11.10 The Single view mode display options: Edit, Rate & Review, Activity, Keywords, and Info.

The Edit mode image-edit controls more or less match those in the Lightroom Develop module. For example, you can tap the Light option to access the Auto tone (see page 670), Tone Curve, and Tone slider controls (**Figure 11.11**). Use a two-finger slide on the Exposure, Highlights, Shadows, Whites, or Blacks sliders to see the clipping mask. There are Color editing, Crop options, Effects, Detail, and Optics lens corrections options, as well as Presets options offering various color, tone, and black-and-white effects. Use a tap-and-hold gesture to toggle between the before and after views. Double-tap sliders to reset.

To apply a selective edit, tap the Selective button (to the left of Crop). Next, tap the Plus button (+) to reveal the Selective tool options (). Here, you can tap to select either the Brush, Radial Gradient, or Linear Gradient tools. Selecting the Brush tool opens the Brush tool controls on the left, where you can tap and swipe up or down to change the Size (), Feather (), or Flow () attributes. Having done that, you adjust the Develop settings, tap on the photo, and drag to add a new brush adjustment. After adding an adjustment, you can remain in the Add brush mode () to add to adjustments or tap the Erase tool () to erase adjustments. With the Radial Gradient, you first tap on the screen to add a Filter adjustment (Figure 11.12), and then adjust the Develop settings. Next, you can edit the Filter overlay handles to adjust the extent of the Radial Gradient adjustment. Tap the Feather button () and swipe up or down to change the Feather setting. Tap the Invert button () to switch between an inside and an outside adjustment. In the Add and Erase modes, you also have Size, Feather, and Flow attribute sliders to adjust the brush edit settings. With the Linear Gradient tool, you tap and drag to add an adjustment and edit the Develop settings. You can then tap and drag the overlay controls to set the extent and angle of the Linear Gradient adjustment. As with the Radial Gradient, you can switch between the Add and Erase mode and edit the Erase brush edit settings.

Tap the Undo button () to toggle between the last state and the current.

Tapping the Settings button () lets you choose to copy, move, delete, or copy and paste settings or to present a slideshow. When you are in Selective Edit mode, however, this menu reveals options to duplicate an adjustment, remove, or reset. You can also choose to automatically show or never show the red overlay.

The single-screen Info mode (Figure 11.10) displays Title, Caption, Copyright, rating, and basic EXIF metadata. When adding titles and captions to your photo, you can type them or use iOS voice recognition (tap the microphone key next to the Spacebar to record). Auto text correction helps with spelling. In Single image view mode, the Cloud icon indicates the download status: whether a preview or Smart Preview is available. Tapping the Cloud icon reveals more information telling you the status of the local and cloud storage, as well as the download status.

In all these modes you can swipe left or right to navigate through the images. A single tap can be used to toggle the data information display on and off, and a two-finger tap can be used to cycle through the information display options (displaying the file information or histogram, or none).

Figure 11.11 When editing the Edit controls, you can tap on the bar (circled) to hide the sliders.

Figure 11.12 *Editing the Selective edit Radial Filter settings.*

Figure 11.13 The Lightroom mobile preferences.

Lightroom CC for mobile preferences

Tap the Lr button in the top-left corner to access the Lightroom CC for mobile preferences shown in **Figure 11.13** (the main menu is outlined in red). The *Send Usage Info* option is on by default. This collates non-personal data about how you use Lightroom mobile on your device and sends this back to Adobe to help improve product features. You can deselect if you are uncomfortable with this.

The Cloud Storage & Sync section indicates how many photos and how much cloud storage you have left available. Disabling the Use Cellular Data option restricts uploads to Wi-Fi only. This lets you avoid cellular network usage for data transfers and thereby avoid hitting cap limits on your cellphone plan. Selecting Only Download Smart Previews is best for customers who have limited bandwidth and restricts downloads to Smart Previews only. Note you can also pause sync when tapping the cloud button. This, too, can be helpful when you have limited Internet access. The Prevent From Sleep mode stops Lightroom CC for mobile from going to sleep when a power cable is connected. The Local Storage section lets you monitor the overall storage space taken up by locally stored copies plus the cached files. The Clear Cache button clears the cache data stored on the device without deleting the master photos. In the General section, when Auto Add Photos is enabled, photos shot using the device camera are automatically added to Lightroom mobile. The same applies to video files when Auto Add Videos is enabled. Select the Add Copyright option to automatically add your copyright notice. If Lens Profile Corrections is enabled, you can choose to have these applied to All Files or Raw only. The Show Touches option is one instructors might want to select if recording a demo movie that incorporates the finger gestures used when working with Lightroom CC for mobile. The Metadata Sharing section lets you choose whether metadata will be saved when you share images via Lightroom CC for mobile. When it is enabled, you can more specifically choose whether to include the Caption, Camera and Camera Raw info, or Location Info. Mobile devices such as the iPhone store GPS metadata automatically, so you need to think carefully whether this data should be included when you share files. The Gesture Shortcuts section provides information about the various gesture shortcuts you can use in Lightroom CC for mobile.

Album/folder options

Tap the plus sign in the Albums header section (**Figure 11.14**) to add a new album or folder. Albums can be nested within folders (think collection sets). Tapping on the three dots next to an album opens the Album options shown in **Figure 11.15**. Here, you can share a Web gallery, rename, clear the cache, or delete. Use the Move To option to move the selected album to a destination folder, as you would moving files between albums. If you are about to board a plane, or travel to a region with poor Internet access, you can tap the Store Locally option. This ensures Smart Previews are downloaded locally for that album. An interim dialog informs you how much storage space will be required. Having done this, you can continue to edit these photos while your device is offline.

Figure 11.14 Tapping the three dots next to an Album opens the Album options below.

Figure 11.15 The Album options menu.

HE

When using the iOS system, Lightroom CC for mobile can be added as a Widget, which can be seen when you swipe right after launch to reveal the Widget screen.

NOTE

In Pro mode, Exposure compensation is selected by default. Drag up or down in landscape mode, or left to right in portrait mode to vary the setting. Likewise, you can select other parameters, such as WB or ISO, and tap and slide to adjust.

Adding photos directly via a device

Photographs can be added via the device you are using. You can do this using the blue floating action button (and an addicking the Camera Roll button. This will take you to the Camera Roll on the device where you can single-tap or swipe to select the photos you wish to add. Once done, these will appear as Recently Added photos in Lightroom CC for mobile and in All Synced Photographs in the Catalog panel in Lightroom Classic CC.

Lightroom CC for mobile camera

When you click the Camera button, this opens Lightroom CC for mobile in camera mode, allowing you to capture photos and add them automatically to Lightroom CC for mobile. In Auto mode, the options are limited, while the Professional capture mode (**Figure 11.16**) offers manual camera controls that you can tap to manually control the individual settings. Tap the three dots (top left) to reveal the additional options shown below in Figure 11.16. If you tap the Focus button (just below Reset), you can adjust the opacity of the focus peaking overlay.

You can also capture using the Volume buttons. Click one of the buttons to capture a photo, or click and hold to capture photos in camera burst mode. Mobile devices running iOS 10 with a 12-megapixel sensor (and higher) can capture in DNG mode direct. However, to date, DNG capture is only supported on the iPhone 6S and later and iPad Pro models. When using such devices, the Settings menu gives you the option of shooting in JPEG or DNG mode. An HDR capture mode is also available for iPhone 7 devices and later.

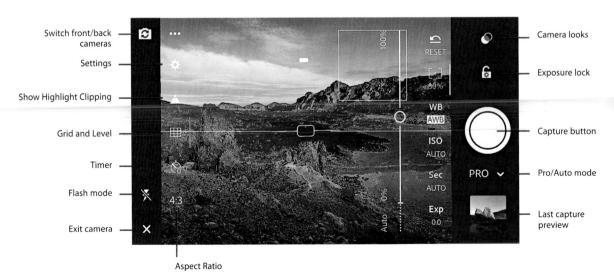

Figure 11.16 The Lightroom CC for mobile camera interface and camera file format options.

Lightroom CC for mobile searches

To carry out an image search, tap the Search button (circled in **Figure 11.17**). This reveals the keypad where you can type in a search term to search the current selected photos. You can search a specific Album or all Lightroom photos (as selected below). When entering a search, it works best if you use a singular term, such as "house" or "car," rather than plural. You can do a combined search by separating with a comma ("tree, water"). Predictive texting can help you select correct terms, and the microphone button can be used to carry out a verbally recorded search.

Lightroom CC for mobile searches are localized to whatever language you have the program set to. When you carry out such searches, the Adobe server uses a powerful search engine that can match images based on textual criteria. This is the same thing as carrying out a web search, in which a search for a specific term will show relevant image matches. When searching your images, the server utilizes knowledge it has of lots of other images to optimally filter your photos. At the same time, the search engines also make use of any available embedded metadata, such as album names, GPS coordinates, IPTC metadata, and keywords.

Figure 11.17 A Lightroom CC for mobile search.

Lightroom CC for web view

Lightroom CC/mobile synced albums can be made available to view on a web page. To do this, you need to use Lightroom Classic CC to select a Lightroom CC synced collection/album and click the Make Public button in the Toolbar at the top of the screen (**Figure 11.18**). This reveals a URL link you can use to share with friends or clients, which will let them view the photos in a Lightroom CC for web view page using a regular web browser much in the same way as they would a Lightroom-generated web gallery (**Figure 11.19**). When viewing a Lightroom CC for web view page, visitors have the opportunity to add likes and comments, which you can then view via the Lightroom Classic CC Library module Comments panel. As you update individual photos, the contents of Lightroom CC for web pages will update automatically. In this respect, Lightroom CC for web is more dynamic than regular Lightroom web galleries created via the Web module.

Figure 11.18 The top bar controls and the Make Public/Make Private buttons.

Figure 11.19 A Lightroom CC for web view page viewed in a web browser.

If you wish, you can click the Make Private button to make an album private again. Essentially, this allows you to share Lightroom CC/mobile synced albums via a web page on any computer that has Internet access. Anyone you share the link with can view the page, but visitors must have an Adobe ID, or use a Facebook or Google account, to log in before they will be able to interact with a Lightroom web album. They can then mark photographs with likes or add comments. You can also use the following shortcuts to navigate the Lightroom CC for web view interface: Use (a) to return to the Grid track view. Use (b) to toggle filename info display in the Grid track view and toggle the Activity Info panel in Loupe view. Use (c) to toggle the Photo Info panel in Loupe view.

Lightroom CC for web view can be extremely useful for working photographers. They can share collections/albums of photos, and allow clients to monitor the latest changes or additions as they happen. Let's say you are working on a series of photographs that are being retouched in Photoshop and cataloged in Lightroom. By managing these images in Lightroom and syncing them to Lightroom CC/mobile, the collection/album data will be continuously updated to show the latest updated versions. This all happens in the background and means you don't have to manually create a new website —the image-edit changes are updated automatically.

When someone adds a like or a comment, you can see who has added it via the Lightroom CC for web view page or via the Comments panel in Lightroom Classic CC (**Figure 11.20**). Notifications will also appear in the Lightroom Classic CC Grid view and Collections panel (**Figure 11.21**). A yellow comment badge in the Grid view indicates that one or more people have made a comment. Similarly, in the Collections panel, new comments are flagged with a yellow badge. To locate photos in Lightroom that have recently been commented upon, you can select a collection and choose Library ⇒ Review comments. Or, you can choose Sort Order ⇒ Last Comment Time.

Figure 11.21 The Grid view and Collections panel showing the badge icons that indicate a

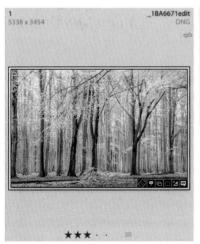

photo has been commented on.

Figure 11.20 Comments made via a Lightroom CC for web view page can be seen when viewing the Web page itself (top), as well as in the Library module Comments panel (below).

NOTE

Lightroom CC for Web is a good example of how machine learning and Artificial Intelligence (AI) opens up new opportunities in the cloudnative, Lightroom CC workflow. If you click on the Lr icon and go to the Technology Previews section you can enable the new Best Photos and Auto Tone features. The Best Photos feature is particularly interesting as it can analyze photos in a selected album and filter photos based on 'aesthetic' criteria such as depth of field, symmetry, rule of thirds, sharpness and lighting. It also places emphasis on people and faces to come up with an overall score for each image. This is followed by a de-duplication process to remove photos that are close together in capture time and similar in content to help you narrow down the best results when dragging the slider to select Fewer or More photos.

Lightroom CC for web

Lightroom CC/mobile synced images can also be accessed using the Lightroom CC for web interface. Lightroom CC for web is kind of hidden though. Start by going to the Help menu in Lightroom Classic CC and selecting "Lightroom online." This opens the Adobe Photoshop Lightroom CC page shown in **Figure 11.22**. Click your account button (circled) to open the Lightroom Product page and then click the Lr Photos button. This launches the Lightroom CC for web page, at which point, I suggest you bookmark the page for future use. Lightroom CC for web shares some of the same Lightroom shortcuts, such as pressing (a) for Grid view and using (b) to go to Develop. Use (c) to access the Crop overlay, and (c) to convert to black and white.

Figure 11.22 The Lightroom Online web page and below that, the account web page options. The Lr Photos link to the Lightroom CC for web page is circled.

Figure 11.23 The Lightroom web page interface in Master Collections view mode.

The Lightroom CC for web page provides an alternative way to manage files synced with Lightroom CC/mobile, whether these have been synced as collections/ albums or simply added as synced photographs. Click on the Share button (circled red in **Figure 11.23**) to open the share options and access the Share Settings (**Figure 11.24**). This is similar to sharing photos from Lightroom Classic CC with Lightroom CC for web view, and the options here include allowing file downloads, showing metadata, and showing location info.

The interface lets you edit your photos in the same way as you can in Lightroom CC for mobile. The left track panel shown in Figure 11.23 is currently in Master Collections/Albums mode and the selected photos can be seen in the main content area. The other option is Shared Collections/Albums mode (circled in blue). When viewing a single image (**Figure 11.25**), you can click the Edit This Photo button (top left) to access the Develop edit controls, or click the Info button (circled in red) to reveal the Info tab shown in Figure 11.25. Here, you can title and caption images and check viewer comments. The Download button (circled in blue) can be used to download files as Originals or Latest Version (which will be a JPEG with a maximum dimension of 2048 pixels). The rating options are available just below the image view.

Figure 11.24 The Lightroom Web Share options.

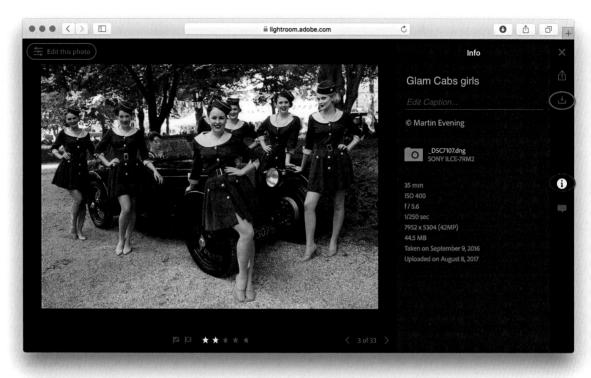

Figure 11.25 *Lightroom CC for web single page interface.*

Figure 11.26 The Lightroom CC for web Sort order options.

To carry out an image search, click in the Search all photos field (Figure 11.23) and enter a search term. As with Lightroom CC for mobile, Lightroom CC for web interrogates the master images stored on the Adobe cloud server and displays the results in the main content area. The search results are displayed with the most relevant images placed at the top. Therefore, as you scroll down the list, you'll most likely start to see results that don't match the search criteria so closely. This feature is also part of the Lightroom CC program, which also makes that a powerful program for managing synced images. Click on the eyeball icon on the right, just below the account button (circled in **Figure 11.26**), to access the sort order options. These let you filter photos based on their flag status and choose to order by capture time toggling between most recent or oldest first.

Auto tone

When you are in Edit Photo mode and click the Auto button in the Light panel (**Figure 11.27**), you are currently given two auto-tone previews to choose from. This is part of an ongoing process using artificial intelligence to determine what are optimal auto-tone adjustments. The new Auto Tone method uses machine learning and artificial intelligence trained using large data sets to achieve better auto tone outcomes. Here, you don't know which preview uses the new and which uses the old auto method. However, the auto options in Lightroom CC for mobile do give you a clear choice between the old and new methods.

Uploading files via Lightroom CC for web

Lightroom CC for web can also be used to upload files remotely. This means you can, in effect, add photos to the synced Lightroom Classic CC catalog via the Lightroom CC for web interface from any computer. The supported file formats include: proprietary raw, DNG, TIFF, JPEG, PSD, and PNG. As you do this, photos are added to the Adobe cloud server, where they are synchronized to the Lightroom Classic CC catalog on the desktop computer. Photos synced in this way will be copied to the Lightroom CC/mobile folder selected in the Location section of Lightroom Classic CC's Lightroom mobile preferences. If you select an image in Lightroom Classic CC that's been imported this way, the Metadata panel can be used to locate the specific, dated subfolder into which the file has been segregated. Or, you can use the context menu, or choose Photo \Rightarrow Show in Finder (\mathbb{H}\mathbb{R}\mathbb{R}) [Mac] or \mathbb{Ctrl}\mathbb{R}] [PC]). If the file you have synchronized already exists in the catalog, it will still be added, but it will be synced to the original file in the master catalog as a virtual copy rather than be added to the Lightroom CC/mobile folder. The following steps show how to upload files via Lightroom CC for web.

Figure 11.27 The Auto option in the Light panel.

1. To begin with, I clicked on the Collections plus button in Lightroom CC for web (circled) to create a new collection/album and named it *Eric Portraits*. With the new empty collection selected, I clicked on Select Files to choose the files to upload. You can also drag and drop photos directly to a collection to initiate an upload.

2. After I had done this, the top bar showed an upload was in progress.

3. The collection/album in Lightroom CC for web now showed the photos had been added. If you return to the Collections view and click the gear wheel settings button (circled), the options appear on the left, allowing you to rename a collection, remove a collection, or change the cover image.

4. Meanwhile, in Lightroom Classic CC, the photos that had recently been added via Lightroom CC for web view showed up in the Collections panel. They also appeared listed under All Synced Photographs in the Catalog panel.

Managing photos via Lightroom CC for web

The Lightroom CC for web manage options are shown below in Figure 11.28.

Figure 11.28 The Lightroom CC for web manage options.

When viewing photos in the Grid view, you can select the photos you wish to manage by clicking in the top-right corner of each thumbnail. As you roll over this area, you will see a tick icon. Click this to select or add to a selection (as shown in Figure 11.28). Once a selection has been made, you will see the manage options above. You can use the Set as Cover button to replace the cover image of an album using a single selected photo. The Remove button can be used to remove photos from Lightroom mobile. To delete master files from the synced Lightroom Classic CC catalog, you'll need to click on the trash button next to this. Click the Copy To or Move To buttons to copy or move to an existing album or to a new album. The Move Photos and Copy Photos options are shown in Figure 11.29. You can also drag a selection to copy to another album, or drag to the + icon to create a new album. Click the Share button to open the Share options shown in **Figure 11.30**. Start by giving the photo or photos you wish to share a title and check Allow Downloads if you wish to allow the photos to be downloaded. Click on the Display tab for more web page format options. Click Save to go to the next screen, where you can copy and paste the URL shown, or click on one of the social media buttons on the right.

Click the x at the end of the manage options in Figure 11.28 to cancel and deselect a selection.

Figure 11.29 The Lightroom CC for web Move and Copy Photos options.

Figure 11.30 *The Lightroom CC for web Share options.*

Lightroom CC program

NOTE

Lightroom CC requires Mac OS X 10.10 or later, or Windows 10.

The Lightroom CC program (which I refer to from here on as Lightroom CC) provides the security of cloud-based storage, a simplified user interface (**Figure 11.31**), and the ability to sync photos across multiple devices, other computers running Lightroom CC or Lightroom Classic CC. It might suit photographers who find Lightroom Classic CC too intimidating and overcomes two of the major hurdles of image management: knowing how and where to import your images and how to keep them secure.

Figure 11.31 *The Lightroom CC interface.*

Lightroom CC has a new code base that enables it to sync to the cloud with an ease that is not available in Lightroom Classic CC. This makes it more adaptable to the future of cloud-based management. Lightroom CC assumes no prior knowledge of Lightroom and simplifies the process by making sure everything is synced to the cloud and therefore synced to your other copies of Lightroom CC for mobile devices (as well as to the synced Lightroom Classic CC catalog). Ultimately, once an import/upload process is completed, your files are safe on the Adobe server even if they are yet to be downloaded elsewhere. If a laptop computer running Lightroom CC, your tablet, or your phone were to be stolen, all you would need to do is get the computer or device replaced, log in to the Adobe Creative Cloud, and access all your master files again.

Migrating from Lightroom Classic CC

Migrating a catalog is a one-time process for adding photos, videos, and related metadata from Lightroom Classic to the Lightroom CC/mobile ecosystem.

Go to the File menu in Lightroom CC and choose Migrate Lightroom Catalog (\(\mathbb{R}\)\Cappa\Shift\(\mathbb{M}\)\) [PC]). Here, you can select as many Lightroom catalogs as you want to migrate (Figure 11.32).

Figure 11.32 The catalog selection options for Migrate Lightroom Catalog.

How long the migration process takes depends on the size of your catalog, size of the files, and specs of your computer. You are strongly advised to plug in your computer while migrating rather than rely on battery power. If you see warnings about missing files during migration, you will be prompted to go back and find them. For example, this can happen if you've moved the catalog, you left an external drive disconnected, or a Windows drive took on a different drive letter when plugged back in. To fix this, open Lightroom Classic CC, look in the Folders panel for folders marked with question marks. Right-click and choose Find Missing Folder to help locate the folders on your drive. Then, quit Lightroom Classic CC and try the migration again. For more information on how to locate missing files, see tinyurl.com/nlbvg9f.

1012

Lightroom Classic CC only uploads Smart Previews to the cloud, not originals. So don't get fooled into thinking this is a viable backup. Lightroom CC, on the other hand, always sends originals.

Figure 11.33 A migrated Lightroom Classic CC catalog as it appears in the Lightroom CC program.

After migration, the contents of each catalog will be added under a folder (similar to a collection set in Lightroom Classic CC) identified by the catalog's name (**Figure 11.33**). Collection hierarchies will be maintained but limited to five levels, with the top level going to the catalog name. It is also possible some images may get imported twice, in which case they will be added multiple times.

By default, the migrated catalog files are all copied to a temporary location within the *Lightroom Library.Irlibrary* file inside the *Pictures/My Pictures* folder on your computer. Over time, as they are backed up to the cloud, Lightroom CC may remove these large, original files and replace them with smaller Smart Previews to save disk space, but this initial copy can require a lot of space. If there is not enough storage space available on your local system drive, you'll see an error message that gives you the option to direct Lightroom CC to store original files on a separate drive. In Lightroom CC, go to Edit \Rightarrow Preferences (Win) or Lightroom CC \Rightarrow Preferences (Mac) (see **Figure 11.53** on page 688), and select the Local Storage panel. Click the Change Location button to select a drive with at least the amount of space recommended in the error message.

The migration process provides a solution to the problem of how to copy keyword metadata from Lightroom Classic CC into Lightroom CC. However, what gets migrated along with the images is limited. Folders and folder hierarchies will not be preserved. Nor will Smart Collections or snapshots. Keyword hierarchies will be flattened and face name data and color labels converted to keywords (**Figure 11.34**). After you complete migrating a catalog to Lightroom CC, you can still access and use the catalog in Lightroom Classic CC and it is possible to continue syncing in Lightroom Classic CC. You can import new photos, create a synced collection, and these will sync to Lightroom CC as new albums outside the migrated catalog folder. Or, you can drag new photos to All Synced Photographs, and these will sync to

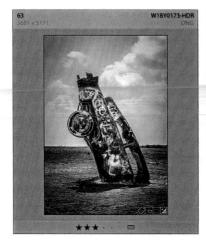

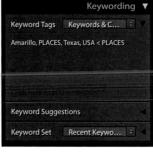

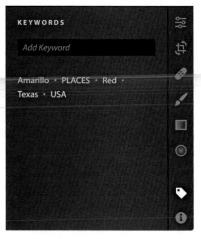

Figure 11.34 This shows how a Lightroom Classic CC photo with a mix of color label and hierarchial keyword metadata will appear in the Lightroom CC program after migration. The red color label simply becomes a regular keyword Red.

Lightroom CC. You can continue to edit all photos in Lightroom Classic and Develop settings updates will propagate to Lightroom CC. Likewise, editing the Develop settings on photos in Lightroom CC will be updated to Lightroom Classic CC. If you add new photos to the original Lightroom Classic CC catalog, you can also export these as a separate catalog, which can then be migrated into Lightroom CC.

Lightroom CC program layout

Animated slides can help you learn about Lightroom CC. The content also varies depending on whether you have Lightroom Classic CC installed. The Lightroom CC interface displays recently added files plus a dated list of files on the left with a list of albums (Lightroom mobile synced collections) below. To keep your albums nicely ordered, these can be arranged into folders and subfolders. You can do this by selecting Create Folder from the Albums fly-out menu shown in **Figure 11.35**.

The Edit, Keyword, and Info options are on the right. Use **(G)** to toggle between Grid and Working Grid view modes. To filter the images displayed in the content area, use the filter controls in the left panel to filter by date, folder, or album. Or, click the Search field that's circled in **Figure 11.36**. The cloud-based search engine is one of the key attractions of Lightroom CC. As with Lightroom CC for mobile and web, when you enter a search term, Lightroom CC queries the cloud-based files and displays the search results. Using the left panel, you can cross-reference a text search with a specific date or album search. Use the Refine bar to refine by keywords, camera model, or location information.

10112

If migrating from Lightroom
6.x/2015.5, you can migrate any single catalog, after which syncing will be disabled. Once you have upgraded to Lightroom Classic CC, you can continue to sync files to the cloud and can migrate further Lightroom Classic CC catalogs. If these include duplicates, however, duplicate files will be added to Lightroom CC.

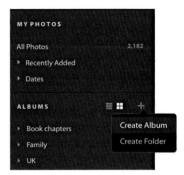

Figure 11.35 The Create Album/ Create Folder menu.

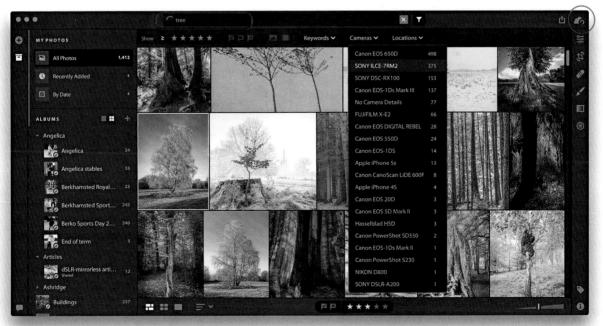

Figure 11.36 A Lightroom CC program file search.

Importing files via the Lightroom CC program

When you click the Add Photos button (), the Import interface shown in Figure 11.37 opens. If a camera card or more than one card is inserted, you'll first see a list of cards to import from. You will then be prompted to browse the computer to select a folder to import from and add to the Catalog. If a camera card is connected, you can choose to copy from the card. In Figure 11.37, I checked the Select All option. But you can also manually select the files to import. The imported files are initially stored in the *Pictures/My Pictures/Lightroom Library.Irlibrary* file. This import process is carried out in the background, freeing you to get on with other tasks. The thumbnail images will show up fairly quickly in the content area, but it will take longer for a full upload to take place, as Lightroom CC also needs to copy the original files to the Adobe cloud server. From there, the files are processed as JPEG and Smart Preview proxies ready to be accessed by other Lightroom CC/mobile clients, Lightroom CC for web, and so on. Incidentally, Mac computers with Retina displays will need to pull down higher-res previews, which can add to the time it takes to load Smart Previews.

Figure 11.37 The Lightroom CC program Import interface.

You can have two or more computers running Lightroom CC accessing the images stored on the Adobe cloud servers and have these synchronized with the synced Lightroom Classic CC catalog. **Figure 11.38** shows how this might work with a laptop running Lightroom CC and a desktop computer running Lightroom Classic CC plus a second Lightroom CC program. In this example, original files imported to a laptop computer running Lightroom CC are copied to the Adobe cloud server and stored on the cloud, where JPEG previews and Smart Preview proxies are created. Meanwhile, the originals are copied to the computer that's running Lightroom Classic CC and added to the (synced) catalog. Here, the original files are copied to the designated Lightroom CC/mobile images folder.

When you click to edit an image in Lightroom CC, preview proxies and originals are downloaded on demand from the Adobe cloud server. So, in this example, when editing an image in Lightroom CC on the original laptop computer, JPEG previews and proxies are downloaded to the Lightroom CC program. And similarly, when editing a photo in the Lightroom CC program on the desktop computer, previews and proxies are downloaded there, too. Lightroom Classic CC and Lightroom CC don't have to be on the same computer. You could have a scenario in which Lightroom CC is on a laptop, Lightroom Classic CC is on a desktop computer, and a second version of Lightroom CC is on another, separate computer.

As original files are uploaded from Lightroom CC to the cloud, these will over time be deleted from the host computer to clear disk space. How this happens depends on the Target Available Disk Space Usage setting in the Lightroom CC preferences. If you have a large catalog of images, the chances are you won't need to access most of the original images again or only very rarely. But you will need to access favorite photos or those shot in the last year more frequently. One terrabyte of storage is made available on the Adobe Cloud servers. This should be enough space to store around 40,000 raw originals, or more, depending on the size of the raw files, although other storage plans are available. At the same time, Lightroom CC routinely downloads proxies so these are accessible on the local machine if and when it needs them. This mechanism allows Lightroom CC to remove the originals more aggressively, freeing up space, and lets you continue working should the originals be offline. The Target Available Disk Space Usage setting currently does not allow for additional storage demands of Smart Previews, so you may, therefore, see the disk usage increase beyond this set threshold.

If you choose Lightroom CC to manage your imports, how and where these are stored is less relevant. The target market is for those who prefer things be made simple. But it is also important for more advanced users to be aware of Lightroom CC's features and how it fits in to the current Lightroom CC/mobile workflow.

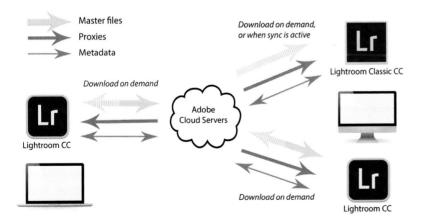

Figure 11.38 A Lightroom CC program to Lightroom Classic CC and/or Lightroom CC program hosted on a separate computer workflow.

MOTE

After your trial or subscription expires, Lightroom CC can work in a residual mode. This means you can browse and output them, but you won't be able to edit them any longer, or upload new photos to the cloud. This is kind of the same as the policy for Lightroom Classic CC, where you can continue to access your photos after your subscription expires.

To view the Lightroom CC sync status, click the cloud icon circled blue in Figure 11.36. This also allows you to pause syncing.

NOTE

To open and edit a photo in Photoshop, choose File ⇒ Edit in Photoshop (ﷺE [Mac] or Ctrl E [PC]). This opens a rendered version as a 16-bit image in ProPhoto RGB. Save and close the photo in Photoshop to see the photo added to Lightroom CC and the preview updated.

Editing photos in the Lightroom CC program

To switch from the Grid view to the Detail view, double-click or use D. The Edit controls (E) are accessed from the right panel track (Figure 11.39) and the Edit panels are summarized in Figure 11.40. These are all mostly similar to those found in Lightroom desktop, except some of the groupings and names are slightly different. For example, the Basic panel tone controls (第1 [Mac], Ctrl 1 [PC]) are grouped under Light, where the Auto button utilizes the most recent artificial intelligence auto-tone method. The advanced controls are accessed by clicking on the disclosure triangle to reveal more options. For example, the Detail panel (第4 [Mac], Ctrl 4 [PC]) contains a single Sharpness slider. Click the disclosure triangle next to it to reveal all four sharpening sliders. Despite these user interface differences, the slider settings all correspond with those in Lightroom Classic CC. Lightroom CC does require all images to be converted to Version 4. Therefore, when you select a photo to edit, you may see a warning if a photo needs updating to the current process version.

The Color panel (#2 [Mac], Ctrl 2 [PC]) can be used to edit the White Balance, Vibrance, and Saturation settings. Click the color wheel (circled) to disclose the Color Mix options. Clicking the B&W button reveals instead the black and

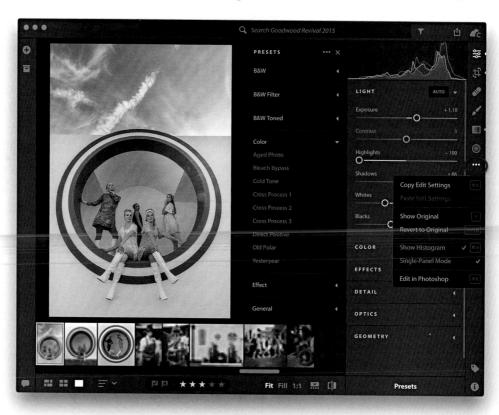

Figure 11.39 The Lightroom CC program image-editing controls.

white mix options. The Clarity slider is moved to the Effects panel (#3 [Mac], Ctrl 3 [PC]), where it joins the Dehaze and Vignette sliders. The Detail panel contains Sharpening, Noise Reduction, and Grain effect sliders. Lens Corrections controls are grouped under the Optics panel (#5 [Mac], Ctrl 5 [PC]), and the Transform panel Upright adjustment options are grouped in the Geometry panel (#6 [Mac], Ctrl 6 [PC]).

The Crop and Healing Brush panels are shown in **Figure 11.41**. The Crop panel options (©) are the same as Lightroom Classic CC, except you also have Horizontal and Vertical flip buttons, which are just below the Straighten slider. Use (黑[[Mac], [Ctrl] [PC]) to rotate left and (黑] [Mac], [Ctrl] [PC]) to rotate right. The Healing Brush panel (H) lets you select Clone and Heal modes.

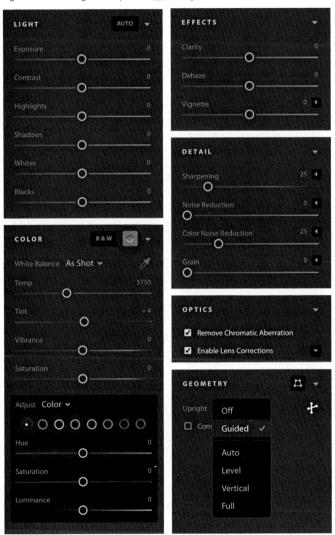

Figure 11.40 The Edit panels.

Figure 11.41 The Crop and Healing Brush panels.

Localized adjustments include the Brush, Linear Gradient, and Radial Gradient tools. **Figure 11.42** shows a Radial Gradient (R) adjustment being applied to an image (Press O to cycle the Overlay visibility). Here, I had the Eraser tool selected (A), which can be used to brush edit the adjustment effect, erasing the mask. Hold down the Alt key to toggle to add to mask mode. When any localized adjustment is active, a right-click on any slider reveals a Reset All Sliders option.

To see a Before/After preview, click the Show Original button on the bottom right of the Toolbar (circled in red in Figure 11.42), or use the $(\ \)$ key shortcut (in the Before view mode the controls are grayed out). At the bottom is a Presets button. Click this to access the various preset options, which will then appear in a column next to the Edit controls (Figure 11.39). As you roll over the preset previews, the Edit sliders adjust to show the settings used.

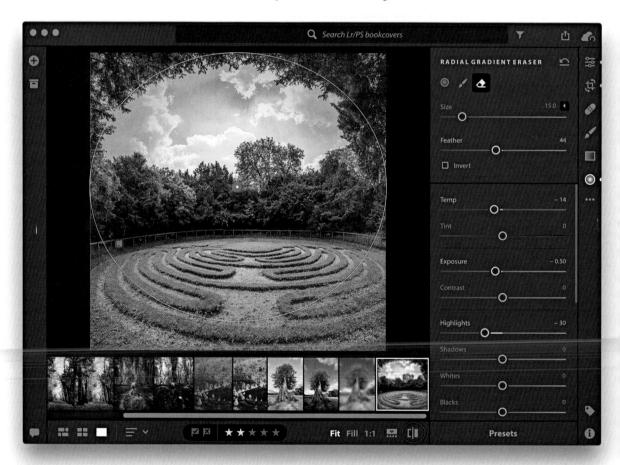

Figure 11.42 The Radial Gradient edit controls.

Stacking photos

To stack photos in Lightroom CC, create a photo selection and choose Edit

Stacks

Group Into Stack. Or, you can right-click to reveal the context menu shown in **Figure 11.43** and select Group Into Stack.

On the face of it, stacks in Lightroom CC are similar to stacks in Lightroom Classic CC. However, Lightroom Classic CC stacks don't actually correspond with Lightroom Classic CC, or vice versa. They are only similar in that you can group photos into a stack to compact series of photos and have them represented as a single Grid thumbnail. You can click on a thumbnail Stack badge to see the stacked photo contents (**Figure 11.44**). The square thumbnail on the left of the group (circled below) shows the cover image. You can drag and drop any image from the stack to replace this.

The main difference is that stacks in Lightroom CC are global and more like "assets." For example, you can click and drag a stack to copy it to another album. A stack is therefore like an entity that can exist in more than one album. This means ungrouping the stack in one location ungroups the stack elsewhere.

Figure 11.43 The context menu showing the Group Into Stack option.

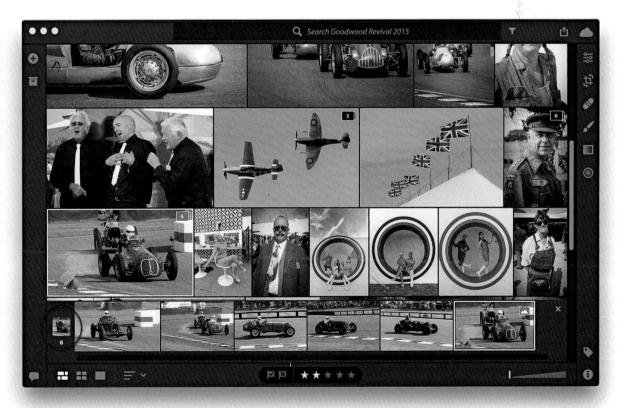

Figure 11.44 An example of photos stacked in the Lightroom CC program.

Figure 11.45 The Edit Settings menu.

Edit Settings options

The Settings menu (the three dots circled in Figure 11.39) can be used to access the options shown in **Figure 11.45**. Here, you can select Copy Settings and Paste Settings. Currently, these carry out a full copy. There are no options to select which specific settings are copied and pasted. The Show Original option can be toggled to show a before or after view. Revert to Original undoes all Develop adjustments. You can use **XZ** (Mac) or Ctrl **Z** (PC) to undo and **Shift** (Mac) or Ctrl Shift (PC) to redo. Choose Show Histogram to display the histogram seen here. Select Single-Panel Mode if you want the panel header to collapse when you click to select another panel. Click Edit in Photoshop to open in Photoshop (you can also right-click an image and choose Edit in Photoshop). Once you have finished editing in Photoshop, choose Save, and a saved version will appear added to Lightroom CC.

Managing photos in the Lightroom CC program

The Info panel view is shown in Figure **11.46**. This displays a basic subset of IPTC metadata information plus EXIF data in the camera placard section. If the file contains GPS or IPTC location metadata, you'll also see the accompanying map view.

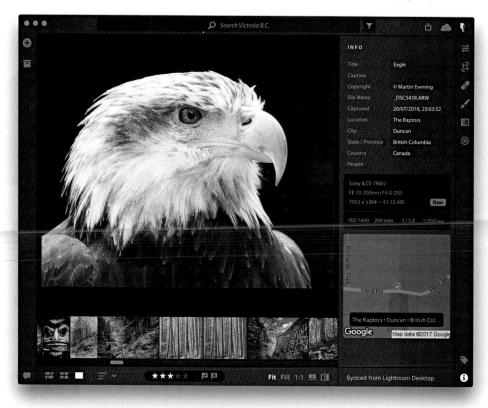

Figure 11.46 The Lightroom CC program Info panel view.

Selecting and rating images

You can multi-select albums using the Shift, or the ∰ (Mac) Ctrl (PC) keys. If an album is currently empty, a help message will appear reminding you to click the Add Photos button to add new photos to the album. Use Edit ⇒ Select None to deselect (∰D [Mac], Ctrl D [PC]). To rate images, use the number keys 1 to 5. You can also use the Z key to flag images, X key to mark as a reject, and U to unflag. Incidentally, as you flag photos or add star ratings, these photos are prioritized when uploading files to the cloud.

Creating copies

To create a copy image in Lightroom CC, Choose Edit ⇒ Make a Copy. Or, right-click on a photo and choose Make a Copy from the context menu. When you create a copy in Lightroom CC, there is no master copy or virtual copy. All copies have equal status. Therefore, you can create a copy, apply separate edits to the copy image, and delete the first version should you wish to. One thing to be aware of, though, is that Lightroom CC copies are indistinguishable from duplicate photos, i.e., a photo that has been imported twice. As I mentioned earlier, this isn't allowed in Lightroom CC, but it is possible when migrating files from Lightroom Classic CC.

Keywording

In the Keyword panel view (**Figure 11.47**), you can use the Add Keyword field to add keywords. As you enter keywords, they appear listed below. When you have a selection of images active, you can see those keywords that are applied to just some and those that are applied to all the selected images. As you roll the pointer over the "Applied to Some" section keywords, these will change to blue and, if you click, be applied to all selected images. As you roll over the "Applied to All" section keywords, they will change color to red and be removed from all selected images.

There is no requirement that you comply to a particular controlled vocabulary. You just type the keywords you wish to assign and these are added as a flat list. Keywords entered in Lightroom CC on one computer will be synced to the cloud and appear in Lightroom CC on another computer. But crucially, keywords added in Lightroom CC to synced photos will *not* appear listed in Lightroom Classic CC. However, while keywords that have been added via Lightroom Classic CC don't appear in Lightroom CC, they'll be there all the same, but are simply hidden from view.

The overall intention has been to make keyword entry simple for Lightroom CC users, as there is no keyword list hierarchy to manage. At the same time, this has resulted in a necessary disconnect with Lightroom Classic CC. The one way to get keywords to copy over and appear listed in Lightroom CC is to use the migration process described on page 675.

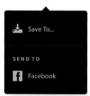

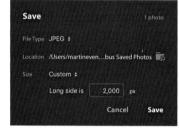

Figure 11.48 The Lightroom CC program Share (above) and Save To (below) options.

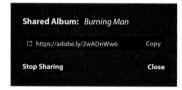

Figure 11.49 Right-clicking an Album pops open the Shared Album dialog.

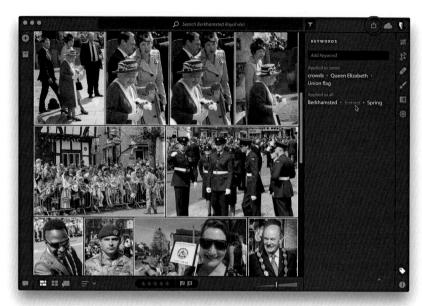

Figure 11.47 The Lightroom CC program Keyword panel view.

Lightroom CC program file sharing

Click on the Share button (circled in Figure 11.47) to open the Save To options shown in **Figure 11.48**. The Save To options are so far limited to exporting photos from Lightroom CC as JPEGs either as small (maximum 1024 pixels), full-sized, or at a custom size of your choosing. Or, you can save as Original files. If you right-click on any album and choose Share Album, this opens the dialog shown in **Figure 11.49**, where a publicly accessible URL is generated.

Removing/deleting photos

To remove a photo from an album, press the Delete key. This opens the Remove Photos dialog shown in **Figure 11.50**. If you confirm, this simply removes a photo from the Album, but it will remain in All Photos. To permanently delete photos, press Alt Delete. This opens the Permanently Delete Photo dialog also shown in Figure 11.50, warning that the photo you are about to delete will be deleted permanently. It is important to bear in mind that with Lightroom CC, there is no fail-safe backup to recover photos from the trash. Be *absolutely sure* before you delete anything.

Figure 11.50 The Lightroom CC program Delete and Remove Photos warning dialogs.

Lightroom CC program preferences

Click the cloud button shown in **Figure 11.51** to view the cloud status and settings. This informs you how much data space you have used up so far and confirms if your data has been synced and backed up successfully. To open the Preferences dialog, click the gear wheel button (circled) or use the use \Re , (Mac) or \mathbb{C} trl, (PC) shortcut.

The Account Preferences (Figure 11.52) show the status on your current cloud account usage. The Local Storage preferences (Figure 11.53) can be used to manage the available free disk space on your computer to cache the original files along with copies of the Smart Previews, as space allows. If you select a low setting, you can save on disk space. However, Lightroom CC will store less permanent cache data and, therefore, rely more heavily on your Internet connection to access the cache data. Without a fast Internet connection, this can result in a slower user experience. Originals are then only downloaded for editing and exporting. You can select which drive to store local files. This can be an internal or external drive. If the drive gets disconnected, files are stored temporarily and copied across the next time the drive is connected. Or, if anything gets deleted from the local drive, copies are downloaded from the cloud to restore. The General preferences (Figure 11.54) can be used to manage the interface appearance. In Manual Panel Management mode, you can open the left and right track panels simultaneously and choose to enable or disable graphics support or reset all warning dialogs and tips. Use 公Shift Alt to reset the preferences at launch.

Figure 11.52 The Lightroom CC program Account preferences.

Figure 11.51 The Lightroom CC program cloud status and settings.

Figure 11.53 The Lightroom CC program Local Storage preferences.

Figure 11.54 The Lightroom CC program General preferences.

1 2 Lightroom preferences and settings

I have reserved this final chapter to go into more detail about certain aspects of Lightroom, including how you can customize the program to suit specific ways of working. The first part of the chapter provides a more detailed summary of the Lightroom preferences. The options described here can be accessed by choosing Lightroom ⇒ Preferences (Mac) or Edit ⇒ Preferences (PC) (or use the <code>M</code>, [Mac] or <code>Ctrl</code>, [PC] keyboard shortcut). Where relevant, I have included references to earlier chapters in the book. The latter portion of the chapter provides information and details on the Lightroom settings, such as the template settings files and catalog folder.

I decided to keep these topics separate, mainly because I did not want to clutter the earlier chapters with information that might have been too distracting. This is an unashamedly technical section aimed at advanced users, although I have tried to keep the explanations as clear and simple as possible.

Figure 12.1 The main Lightroom Classic CC startup splash screen.

Figure 12.2 The About Adobe Photoshop Lightroom Classic CC splash screen.

TIP

You can reset the Lightroom application preferences by holding down the Alt & Shift keys as you launch Lightroom. However, resetting the preferences at launch clears only the user preferences and not the startup preferences.

General preferences

Let's begin with the General preferences (Figure 12.3).

Show splash screen

At the top, you can select the desired language you wish to use. If you deselect "Show splash screen during startup," you can avoid seeing the Lightroom splash screen (**Figure 12.1**) each time you launch Lightroom. This is just a cosmetic thing, and it depends on whether you want to see the splash screen as the program loads. After the program launches, if you select About Adobe Photoshop Lightroom Classic CC from the Lightroom menu (Mac) or Help menu (PC), you will see the **Figure 12.2** splash screen, where you can read the full credits for the Lightroom team who worked on the program.

Check for updates

When you first installed Lightroom, you had the option to choose whether to be notified automatically of any updates to the program. In case you missed doing this, you can check the "Automatically check for updates" option.

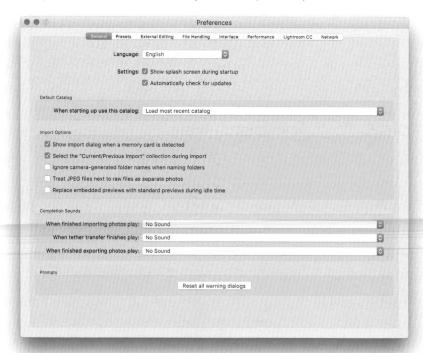

Figure 12.3 The Lightroom General preferences.

Catalog selection

In the Default Catalog section, you can choose which catalog should be used each time you launch Lightroom, such as "Load most recent catalog" or "Prompt me when starting Lightroom." You can also jump directly to the Catalog Settings by clicking the Go to Catalog Settings button at the bottom of the dialog. As the text message here points out, this allows you to apply catalog-specific settings. For more information about these settings and working with catalogs in Lightroom, refer to Chapter 3.

Import options

When the "Show import dialog when a memory card is detected" item is checked, this forces the Import dialog to appear automatically whenever you insert a camera card into the computer. The "Select the 'Current/Previous Import' collection during import" option is checked by default, meaning that the Current/Previous Import collection is always shown whenever you import new files. This is what most people will expect to see happen. But if you prefer to have the import process happen in the background, then deselect this option. The "Ignore camera-generated folder names when naming folders" option can help shorten the import process if you wish to import everything directly from a camera card into a single Lightroom folder. For example, maybe you have a camera card with photos that were shot using more than one camera and they have ended up in several different folders. When this option is checked, the card folder contents are all grouped into one folder ready to be imported.

Some cameras are able to capture and store JPEG file versions alongside their raw capture files. If you shoot with the camera in the raw + JPEG mode, the "Treat JPEG files next to raw files as separate photos" option governs the import behavior for such files. If left unchecked, Lightroom treats raw and JPEG photos as a combined import and displays them as a single raw + JPEG import in the catalog (Figure 12.4). This option effectively treats the JPEGs as if they were sidecar files, and if you move or rename the catalog photo in Lightroom, the associated JPEG is moved or renamed, too. If this item is checked, Lightroom imports the raws with accompanying JPEGs and displays them as separate photos. If you have already imported raw + JPEG photos with "Treat JPEG files next to raw files as separate photos" switched off, it is possible to view the JPEGs as separate photos. First, go to the General tab of the Preferences dialog and turn the "Treat JPEG files next to raw files as separate photos" option on. Then choose Library ⇒ Synchronize Folder. This will then carry out a search for the JPEG photos and allow you to import them separately. Conversely, if you have imported raw + JPEG photos as separate photos, you can uncheck the "Treat JPEG files next to raw files as separate photos" option and synchronize the folder. This will give you the option to "Remove missing photos from catalog," removing the JPEGs and leaving you with combined raw + JPEG catalog photos.

MOTE

The Import dialog can recognize almost any USB or FireWire device as something to import from, such as a connected iPhone or iPad.

Figure 12.4 If "Treat JPEG files next to raw files as separate photos" is unchecked, raw and JPEG photos appear as a single import in the Lightroom catalog.

Where embedded previews are present in place of Lightroom-built previews, you can enable "Replace embedded previews with Standard previews during idle time" to have Lightroom update and replace these.

Completion sounds and prompts

In the Completion Sounds section, you can choose an alert sound to play after completing an import or export from Lightroom or tethered transfer. You will often see warning dialogs with a "Don't show again" check box at the bottom. If you click the "Reset all warning dialogs" button, you can restore all default warning alerts.

Presets preferences

The Lightroom Presets preferences are shown in **Figure 12.5**. You will notice the "Apply auto tone adjustments" and "Apply auto mix when first converting to black and white" settings have gone. Mainly because these options were never used much, most people found the auto-tone setting to be too hit and miss to be enabled as a default.

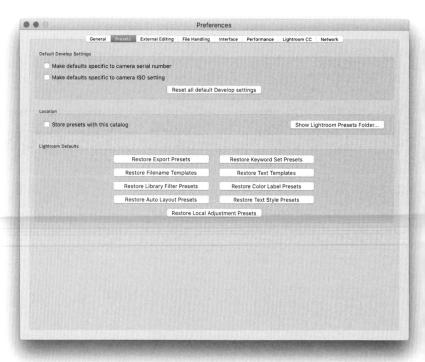

Figure 12.5 The Lightroom Presets preferences.

Camera-linked settings

The Default Develop Settings section are linked to a feature found in the Develop module Develop menu called Set Default Settings, discussed on page 352.

Basically, if you check "Make defaults specific to camera serial number" and "Make defaults specific to camera ISO setting," you can use these check boxes to determine whether certain default settings can be made camera-specific and/or ISO-specific. The "Reset all default Develop settings" button lets you revert all the Develop settings to their original defaults.

Location section

If you would like Lightroom to save the custom presets you have created within the main catalog folder, you can check the "Store presets with this catalog" option. This is useful if you are migrating library images from one computer to another because it saves having to transfer the custom settings (such as your Develop settings) separately, should you wish to share your custom settings with other users. But then again, you might prefer not to also share your custom presets. This preference item gives you that choice. There is also a Show Lightroom Presets Folder button, which conveniently opens the Lightroom presets folder (wherever it is stored) so you can quickly access the folders that contain your Lightroom presets.

There are some negative implications when storing presets with the cata-

log (see page 13 for more detail).

Lightroom Defaults section

The other buttons in this section are all reset buttons that can be used to restore various Lightroom settings. For example, the Restore Export Presets button restores the preset list that is used in the File ⇒ Export dialog (see page 430), and clicking Restore Keyword Set Presets resets the Keyword Sets template list. To explain this in more detail, if you go to the Library module Keywording panel (**Figure 12.6**), you will notice that Lightroom provides a few Keyword set templates that can be used for keywording photos such as Portrait Photography, Wedding Photography, and Outdoor Photography (**Figure 12.7**). If you click the Keyword Set menu in the Keywording panel (or choose Metadata ⇒ Keyword Set

Figure 12.7 The Edit Keyword Set dialog.

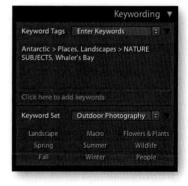

Figure 12.6 The Keywording panel, showing the Keyword Set section.

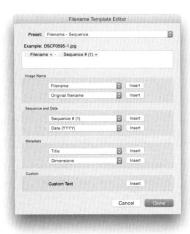

Figure 12.8 The Filename Template Editor dialog.

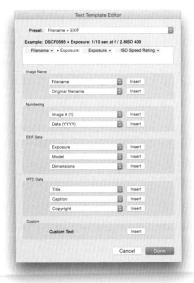

Figure 12.9 The Text Template Editor dialog.

⇒ Edit), you can customize the default Keyword Sets. Restore Keyword Set Presets therefore restores the original Keyword Sets.

The Restore Filename Templates button restores the default file rename templates used in the Export dialog and Filename Template Editor (**Figure 12.8**). However, this does not affect any of the custom templates you may have added here; it merely resets the settings for the default templates that you may have edited. The same thing applies to the Restore Text Templates button—this restores the default settings in the Text Template Editor dialog (**Figure 12.9**), which is used in the Slideshow, Print, and Web modules.

You can save Filter presets that include things like "Filter by one star or higher," and also things like the column layouts in the Metadata Filter bar (see page 618). The Restore Library Filter Presets button can therefore be used to reset the Filter Presets in case you inadvertently update the default settings with a new (and incorrect) setting. On page 635, I mentioned the potential confusion that can be caused through using color label text descriptions that do not match the text descriptions used in Bridge, or by another Lightroom user who sends you images labeled using another label description system. The Restore Color Label Presets button resets the label text descriptions to the default setting: Red, Yellow, Green, Blue, Purple.

The Restore Auto Layout Presets and Restore Text Style Presets buttons relate to the Book module. The Restore Local Adjustment Presets button resets the pop-up menu settings and all other default tool presets for the Adjustment Brush, Graduated Filter, and Radial Filter tools.

External Editing preferences

See page 414 in Chapter 7.

File Handling preferences

The File Handling preferences are shown in Figure 12.10.

Import DNG Creation

The Import DNG Creation options in the File Handling preferences refer only to the DNG settings that are used whenever you choose to import photos using the Copy as DNG option. First, we have the File Extension options, which can use lowercase dng or uppercase DNG.

As the Camera Raw specifications have been updated, so has the DNG file format. Because of this, you have the option to specify which versions of Camera Raw you wish your DNG files to be compatible with. If you are using Lightroom with

			Prefere	nces				
General	Presets Exte	rnal Editing	File Handling	Interface	Performance	Lightroom CC	Network	
Import DNG Creation								
	File Ex	tension:	dng		0			
	Comp	atibility:	Camera Raw 7.1	and later	0			
	JPEG	Preview:	Medium Size		0			
			Embed Fast L	oad Data				
			Embed Origin	al Raw File				
Reading Metadata								
Treat " as a keyword s			rt or when reading m					
Treat "/" as a keyword	separator h	ierarchies	I slash, and backslas instead of flat keywo as a hierarchy separa	ds. The vert	keywords as key ical bar is auton	word atically		
	,	ecognizea	as a nierarchy separa	itor.				
File Name Generation								
Treat the following char	acters as illegal:	1:		0				
Replace illegal file name	Replace illegal file name characters with:		(-)	٥				
When a file na	me has a space:	Leave A	ks-Is	٥				

Figure 12.10 The Lightroom File Handling preferences.

Photoshop CS6 or later, then you would want to select the "Camera Raw 7.1 and later" option. If, on the other hand, you are working with an older version of Photoshop, you might want to select one of the other options. For example, if you select the "Camera Raw 2.4 or later" option, this means that when you choose Copy as DNG at the import stage, the DNGs you create will be compatible with Lightroom 1.0 or Photoshop CS. When I say "compatible," I mean the DNG files can be opened in older versions of Lightroom or Photoshop's Camera Raw. However, this will not allow you to see or access any settings adjustments that are specific to a later version of Camera Raw. So, suppose you edited a DNG image in Lightroom using Process Version 3 or Version 4 using the updated noise-reduction adjustments or applying a Radial filter and adding IPTC Extensions metadata information. An older version of Lightroom or Camera Raw would be able to open the image, but it would only be able to read the image and metadata settings that were understood by that older version of Lightroom or Camera Raw. If you can assume this will not be a problem and you are not bothered about maintaining backward compatibility, selecting a later version allows you to create DNG files that can take advantage of the latest DNG specifications. If you import your files as DNG using the older compatibility specification and change your mind later, you can always export your photos as DNGs and select a later compatibility version.

NOTE

The DNG 1.3 specification that coincided with the release of Camera Raw 5.4 saw the addition of correction and enhancement parameters, known as "opcodes." These allow complex processing such as geometric distortion correction to be moved off of the camera hardware and into a DNG reader program. In the case of Lightroom and Camera Raw, this enhancement enables the DNG 1.3 format to read optical lens correction metadata that has been embedded in the raw files of certain camera systems and to store this in the DNG format. For instance, the lens correction data contained in the Panasonic DMC-LX3 raw camera files can be read when using Camera Raw 5.4 or Lightroom 2.4 or later. A lens correction adjustment is then applied at the Camera Raw processing stage after the demosaicing stage. If you refer back to Chapter 4, you will see an example of a message that appears in the Lens Corrections panel where a lens profile correction has already been applied automatically.

Next is the JPEG Preview section, which can be set to None, Medium Size, or Full Size. DNG previews are based on the Lightroom Develop settings applied at the time a DNG file was created, such as at the import stage using the assigned import Develop settings. But these previews will no longer be valid once anything further is done to alter the settings associated with the DNG, or when a DNG file is viewed in a different raw editor program (unless that other program is Bridge and is using the latest version of Camera Raw). It so happens that Lightroom takes no chances when it encounters a new DNG, because Lightroom always rebuilds the preview cache based on the embedded Develop settings rather than the embedded preview. However, if you import DNG photos into Lightroom using the Embedded & Sidecar option for generating the initial previews, Lightroom makes use of any embedded previews. The previews may, of course, eventually get updated, but the initial DNG previews are the ones used at the time the DNG files are imported.

If you wanted to trim the file size, you could choose not to embed a preview, knowing that new previews would be generated again when DNG files are managed elsewhere. A medium-sized preview economizes on the file size and is suitable for standard library browsing. After all, most of the photos in your catalog probably have only medium-sized JPEG previews. But if you want the embedded previews (and remember, these are the previews embedded in the file and not the Lightroom catalog previews) to always be accessible at full resolution and you do not consider the resulting increased file size to be a burden, then choose the Full Size preview option. This has the added benefit that, should you want to view these DNGs in other applications, you can preview the DNGs at full resolution using a preview that was generated by Lightroom. Photos processed in Lightroom as DNGs should preview exactly the same when viewed in other applications (but only after you have exported them). Generating full-sized previews in a DNG file also means that high-quality prints can be made via external programs based on the Lightroom-rendered settings.

The Embed Fast Load Data option will dramatically improve the image-loading performance in the Develop module compared to proprietary raw files. It embeds data inside the DNG file so that it loads faster when adjusting settings, but it does increase the file size slightly. It also allows you to store derivative versions of raw originals more efficiently on cloud servers (where space may be limited). Incidentally, loading proprietary raw cache files is now also on a par with fast-load previews in DNG.

Embed Original Raw File embeds a copy of the original proprietary raw file inside the DNG file. This option lets you preserve the original raw file data within the DNG file format but with the ability to reverse the process in order to access the original raw file format. The penalty for doing this is increased file sizes, and I do mean a *big* increase, because you will be storing two versions of the raw file data in a single file. One argument in favor of doing this is that by preserving the raw file in its original form, you can still access the original raw file and process it in

the proprietary raw processing program. For example, the proprietary CR2 raw files produced by Canon cameras allow the storing of dust-spotting data that can only be written or read using Canon's own software. If you choose not to embed the original raw file, you lose the means to extract the original raw file and process your photos using the camera manufacturer's software.

Convert and export DNG options

The Import DNG Creation settings discussed here can also be found in the Export dialog, as well as in the dialog that results from choosing Library ⇒ Convert Photo to DNG (**Figure 12.11**). In the case of the Convert Photos to DNG dialog, you have an option to "Only convert raw files." Check this option to filter the conversion process so that it applies only to raw originals and not JPEGs or other non-raw photos. You can also check the "Delete originals after successful conversion" option if you wish to clear all the original raw files from the folders. I always check this because I am usually comfortable with removing the original raws after I have converted everything to DNG.

DNG compression

The standard DNG file format applies what is known as *lossless compression*. This method compresses the file size without incurring any data loss. And by this I mean no loss of image data and no loss of metadata or any other secret source data that is embedded in the original proprietary raw file. DNG compression usually results in a file that is slightly smaller than the original. The DNG compression method is often more efficient than that used by the camera manufacturers—but not always, as it may sometimes yield slightly bigger files.

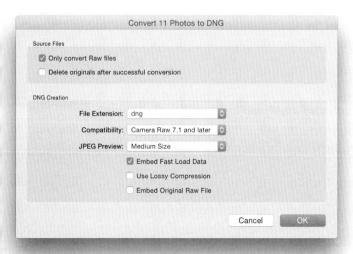

Figure 12.11 The Convert Photo to DNG dialog shares the same settings options as those listed in the Import preferences, but it does include a Use Lossy Compression option.

NOTE

In Lightroom, there is support for multi-core reading of tiled DNG images. The DNG format has, for a while now, been arranging the raw data into distinct tiled sections that are each compressed separately. As a consequence, Lightroom is able to read the raw data stored in such DNGs faster, which will be particularly noticeable when you are reading from files stored on solid-state drives (SSDs). As far as I know, cameras that create native DNG files are not yet saving tiled DNGs, but they should do so in the future.

DNG with lossy compression

The Use Lossy Compression option allows you to create lossy DNGs and is only contained in the Convert to DNG and Export dialog settings. When this option is selected, the DNG conversion produces a linearized demosaiced version of the raw file adding lossy compression, making the saved file size significantly smaller. However, because the raw file data is kept in its linear form, it responds just like a regular DNG when making Develop adjustments. Such files read quicker because they are smaller, and because they are already demosaiced, which means the early-stage raw processing can be skipped. This, in turn, speeds up the raw image processing. The compression applied here is quite safe (equivalent to, say, a quality 10 JPEG setting), but having said that, it is nonetheless lossy and is *not* advised for use as a regular raw archive format. In the Export dialog, you also have the option to export files as lossy DNGs at reduced pixel dimensions (see page 436).

The lossy DNG format offers significant advantages over some small raw formats like Canon's sRAW and mRaw, in which much, including the white balance, is baked into the demosaiced sRAW or mRaw file. However, while it is possible to convert standard DNG files to lossy DNG, once you have applied the conversion, you cannot remake a proper raw DNG by converting a lossy DNG back to the non-lossy DNG format. Lossy DNGs offer a number of interesting possibilities. For example, lossy DNGs allow you to archive raw files as economically as possible (making the saved file size a lot smaller). But bear in mind that this does involve baking in the Camera Raw demosaic processing. JPEGs can be converted to lossy DNG without further degradation to the image and without increasing file size. So, lossy DNG can bring some benefits when used as a container for JPEG originals. I have found it useful for archiving a sequence of time-lapse captures that had been shot using raw. It has also made it possible for me to supply raw images as downloads for this book. Will camera manufacturers be willing to support lossy DNG? It could certainly offer an alternative to shooting JPEG—vou could end up with the same size capture file, but with raw characteristics. This could revolutionize workflows for photographers who need to upload files guickly and who would normally shoot JPEG.

Updating DNG previews for third-party viewing

The DNG file format has been around for a number of years now and widely adopted as a preferred format for archiving raw camera files. One snag, though, is that the DNG-created previews may not always be up-to-date. This is not necessarily a problem if you are using DNG in Bridge or Lightroom, because the previews can easily be rebuilt when transferring DNG files from one Lightroom/Bridge setup to another. However, it is less convenient when working with other DNG-aware programs such as Phase One Media Pro that are unable to rebuild a Camera Raw-generated preview. To get around this, you can go to the Library module Metadata menu and choose Update DNG Previews & Metadata. This does two things: It updates the metadata the same way as the Save Metadata to Files command does and rebuilds the JPEG previews contained within the DNG files.

Validating DNG files

A Validate DNG Files feature is located in the Library module Library menu. This can be used to carry out a check on the health of the DNG files, though be warned that it can take a long time to process a large batch of files. Running a DNG validation check should not disrupt your work in Lightroom. You can either select a small number of files in the Library module first, or if you want to check the entire catalog, do so overnight. If no errors are found, you'll see the dialog shown in **Figure 12.12**. If errors are found when running a Validate DNG check, you will see the dialog shown in **Figure 12.13**, which will include a more accurate report as to which DNGs may be suspect. When there are bad DNGs, these files will be added to a temporary Bad DNG Files collection that will be added to the Catalog panel. This could just mean a broken link between the catalog photo and the actual original, not that the source file (wherever it might be) is broken.

NOTE

Only DNG files that have been created using Adobe software can be properly validated in this way. Unfortunately, DNG files that have been created in-camera at the capture stage cannot be validated because they do not contain the necessary checksum.

Figure 12.12 The Validate DNG summary dialog.

Figure 12.13 The Validate DNG Results dialog.

Checking DNG metadata status

There is a DNG view mode for the Metadata panel. This lets you see all the settings associated with a DNG file that would previously have been hidden. For example, this panel view mode can inform you as to whether lossy compression has been used (see page 561). You can also use the Filter bar to filter by file type, which can distinguish between DNG files that are lossy or lossless.

MD

In order to take advantage of recent speed improvements in Lightroom, you can do two things. Make sure all new DNGs contain "fast load data." In addition, you can increase the Camera Raw cache size. This helps speed up the raw processing for proprietary raw files and older DNGs that have not been saved with "fast load data."

Figure 12.14 The Small Flourish panel end mark.

Reading Metadata options

If only there could be agreement on common standards for the way metadata information is handled between different programs. Adobe's open-source XMP specification has certainly gone a long way toward providing the industry with a versatile standard format for storing metadata information. But there are still a few gotchas that can prevent the smooth integration of informational data from one program to another. The Reading Metadata section in the File Handling preferences (Figure 12.10) is there to help resolve such inconsistencies. If you check "Treat': as a keyword separator" and "Treat'! as a keyword separator," this enables Lightroom to better interpret the keyword hierarchy conventions used in other programs.

Filename generation options

Filenames that contain illegal characters can also cause hiccups when you import such files into Lightroom. The "Treat the following characters as illegal characters" item can be set to recognize "/:" as an illegal character, or you can select the extended list of characters to encompass more potential bad characters that would need to be replaced. In the "Replace illegal file name characters with" section, you can then choose a suitable replacement character to use, such as a hyphen (-), an underscore (_), or similar characters. Some database and FTP systems may prefer spaces to be removed from filenames. For example, when I upload files to my publisher, the FTP server does not allow files with spaces in the filenames to be uploaded. This is where the "When a file name has a space" item can come in useful, because you can choose to replace a space with a hyphen (-) or underscore (_) character.

Interface preferences

The Interface Preferences are shown in Figure 12.15.

Panel end mark

The panel end mark is a squiggly symbol that can be made to appear at the bottom of the panel list in the Lightroom modules (**Figure 12.14**). You can access the panel end mark options via the End Marks menu in the Interface preferences (Figure 12.15). Or, you can right-click the end of the panels list, navigate to the Panel End Mark submenu, and select the Small Flourish panel end mark option. Lightroom no longer installs a selection of panel end marks. As a consequence, there remains just one panel end mark (Small Flourish), and the default option for now is None, unless you are upgrading directly from Lightroom 4 or earlier.

			Pref	erences				
	General Presets	External Editing	File Handling	Interface	Performance	Lightroom CC	Network	
Panels								
End Marks:	None (default)	0	Font Size:	Small (defau	it)	٥		
Lights Out								
Screen Color:	Black (default)	0	Dim Level:	80% (default)	٥		
Background								
	Main Winde	ow	Second	ary Window				
Fill Color:	Medium Gray (defau	ılt) 😊	Medium Gray	(default)	٥			
Keyword Entry								
Separate keyw	ords using: Comma	S	٥		Spaces are	allowed in keywor	ds	
Auto-compl	ete text in Keyword Ta	ags field						
Filmstrip								
Show badge	es			Show p	hotos in navig	gator on mouse	-over	
gnore click:	s on badges			Show p	hoto info tool	tips		
Show rating	s and picks							
Show stack	counts							
Tweaks								
Zoom clicke	ed point to center			Use typ	ographic frac	tions		
Swipe between	een images using mo	use/trackpad						

Figure 12.15 The Lightroom Interface preferences.

Custom panel end marks

Would you like to create your own panel end mark design? Well, it is actually not that difficult to do. To start with, take a screen shot of one of the Small Flourish panel end marks to get an idea of the scale of the design and how it will look against the panel background color. Next, create a new custom design in Photoshop scaled to the correct size on a transparent layer, and save this graphic using the PNG file format (which supports transparency). Now go to the Panel End Mark menu and select Go to Panel End Marks Folder (from the Interface preferences End Marks menu). This reveals the folder in the Finder/Explorer location where the panel end mark image files need to be stored. Place the PNG file you have just created in there and reopen the Preferences dialog. You will now see your custom design listed in the Panel End Mark menu.

Creating a custom splash screen

If you want, you can replace the standard Lightroom splash screen with your own design. To do this, you will first need to create a design in Photoshop and save it as a PNG. Once you have done that, go to *Username/Application Support/Adobe/Lightroom* (Mac) or *Username\AppData\Roaming\Adobe\Lightroom* (PC), and place it inside the *Splash Screen* folder. The next time you launch Lightroom, you will see this as the new splash screen. To revert to the standard splash screen, make sure the *Splash Screen* folder is empty.

Panel font size

There are two font size options: Small (which is the default setting) and Large. If you refer to **Figure 12.16**, you can see how the difference between these two settings is actually quite subtle. By choosing the Large setting, you can make the panel fonts more legible when viewing on a large screen at a distance. Notice how the Large panel font size setting also makes the panels slightly bigger in size. This change does not take effect until after you have relaunched Lightroom.

Figure 12.16 A comparison between the default Small panel font size setting (left) and the Large panel font size setting (right).

Lights Out

The Lightroom Interface preferences let you customize the appearance of the interface when using the Lights Out and Lights Dim mode. Bear in mind that these preference settings also allow you to create a "Lights up" setting. So, instead of using black as the Lights Out color, you could try setting it to light gray or white. I find using Lights Out with white is a handy alternative to selecting the Soft Proofing option as a way to quickly check how an image appears against white.

Background

The Background section lets you customize the background appearance in the Lightroom modules. You can set the fill color to several different shades of gray, as well as white or black. Lightroom also provides preference options for those working with a two-display setup, letting you customize the background options for both displays independently.

Keyword entry

Spaces are normally allowed when entering keywords in the Keywording panel, and you separate keywords by typing a comma between the keywords. If you prefer to use spaces to separate the keywords, this is now an option. If you do this, however, you have to remember to type quotes around any keywords that contain spaces. For example, the keyword Cape Fear would need to be entered as "Cape Fear." If you don't use quotes, you'll end up with two keywords: Cape and Fear. The "Auto-complete text in Keyword Tags field" option is on by default and assists auto-complete as you enter keywords in the Keywording panel. If you occasionally go to the Catalog Settings Metadata tab section and click "Clear all suggestion lists," this clears the cached keywords and flushes out misspelled keywords.

Filmstrip options

In the Filmstrip section you have the "Show badges," "Ignore clicks on badges," "Show ratings and picks," "Show stack counts," "Show photos in Navigator on mouse-over," and "Show photo info tooltips" options. Some examples of badges are shown in **Figure 12.17**. With these items checked, you have fuller access to Library module functions while working in other modules. For example, let's say you are working in the Develop module. You can use the Filmstrip to see at a glance all the current filtered images, with their labels, ratings, and pick status. You can hover over individual images to see a slightly larger preview in the Navigator panel, and the tooltip floating window can be used to quickly reveal the filename, time of capture, and pixel dimensions. The badge icons indicate whether keyword metadata has been added or the Develop settings have been edited. Clicking a metadata badge,

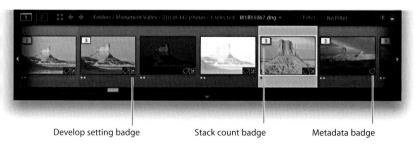

Figure 12.17 The Lightroom Filmstrip extra view options.

MOTE

Lightroom will use the comma as a delimiter, even when spaces is selected. In these instances, the comma effectively overrides spaces. It was decided to strip commas from keywords when spaces is used as delimiter. Doing this manages to make the use of spaces as a delimiter function work, although this will not please people who use commas in words and numbers.

The "Use typographic fractions" option is not present in the Windows version; instead, you will see "Use system preference for font smoothing." On a PC, you will also see an Enable Open GL for Video option. If the video card for your computer supports OpenGL, I suggest you leave this option checked.

for example, immediately takes you to the Keywording panel in the Library module, highlighting the keywords so they are ready to edit. Clicking the Develop edit badge takes you to the Develop module, where you can resume editing the Develop settings. On the other hand, you may want to prevent accidental clicking, which is why there is now an "Ignore clicks on badges" option. Lastly, the "Show stack counts" badge displays a badge for image stacks along with a stack count number. These Filmstrip options extend the usefulness of the Filmstrip as a way to manage the Lightroom catalog photos.

Interface tweaks

When "Zoom clicked point to center" is checked, the Loupe view uses the click point as the center for its magnified view. To understand how this works, try clicking the corner of a photo in the standard Loupe view. If "Zoom clicked point to center" is checked, the corner zooms in to become centered on the screen. When this option is unchecked, the photo zooms in with the corner point positioned beneath the pointer. Personally, I find that deselecting this option provides you with a more logical zoom behavior.

The "Use typographic fractions" option affects the way the fractions are presented in the Metadata panel in the Library module. When checked, Lightroom uses proper fraction characters or superscript and subscript characters. For example, **Figure 12.18** shows how a shutter speed is displayed when this option is checked and unchecked.

When the "Swipe between images using mouse/trackpad" option is checked, you can use a single-finger swipe gesture to navigate photos in the Library module viewed in the Loupe view mode.

Figure 12.18 The Metadata panel view (left) shows the shutter speed displayed when "Use typographic fractions" is switched off. The Metadata panel view (right) shows the shutter speed displayed when "Use typographic fractions" is switched on.

Performance preferences

The Performance preferences (Figure 12.19) are mostly covered in Chapter 1.

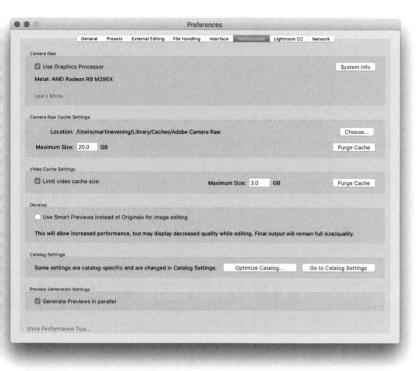

Figure 12.19 The Lightroom Performance preferences.

Camera Raw and video cache settings

Whenever you attempt to view an image in the Develop module, Lightroom builds full, high-quality previews direct from the master image data. In the case of raw files, the early-stage processing includes the decoding and decompression of the raw data, as well as the linearization and demosaic processing. All this has to take place first, before getting to the stage that allows you to adjust things like the Basic panel Develop controls. The Camera Raw cache is therefore used to store the unchanging, early-stage raw processing data that is used to generate the Develop module previews so that this initial processing step can be skipped the next time you view that image. If you increase the Camera Raw cache size, more image data can be held in the cache. This, in turn, will result in swifter Develop module preview generation when you load these photos. Since version 3.6, the Camera Raw cache has been making the Camera Raw cache files more compact. This means you can now cache a lot more files than was the case before within the limits set for the Camera Raw cache size. The revised 5 GB cache limit should ensure better performance. The Camera Raw cache used to have an upper

NOTE

The Camera Raw cache folder is stored in the Adobe Camera Raw folder located in the Library/Caches folder (Mac) or Username\AppData\
Local\Adobe\Camera Raw folder (PC).
Note that the Camera Raw cache folder shares its data between Camera Raw in Photoshop/Bridge and Lightroom.

limit of 50 GB, but this has now been removed so that you can set the cache limit as high as you like. Bear in mind here that the Camera Raw cache file sizes have been much reduced in size. Consequently, you no longer need to devote quite so much disk space to the Camera Raw cache as was previously the case. For example, these days, a 20 GB cache should allow you to store around 20,000 cache files.

The "Limit video cache size" option lets you set a precise limit for the size of the video cache. This is all to do with the video playback performance when viewing and editing video files in the Library module.

Selecting "Use Smart Previews instead of Originals for image editing" can certainly speed up performance in the Develop module, but at the expense of working with a lower-resolution Smart Preview image with lesser image quality.

Other settings that affect performance are located in the Catalog Settings, which you can quickly access by clicking on the Go to Catalog Settings button. You will also find that choosing Optimize Catalog can help improve the overall Lightroom performance.

Lightroom CC preferences

The Lightroom CC/Lightroom mobile preferences are discussed in Chapter 1.

Lightroom Network preferences

The Lightroom Network preferences are shown in **Figure 12.20**. If you are using a proxy authentication server to access the Internet, you are advised to go to the Network preference section and enter your proxy authentication username and password. Lightroom can then use this information to get you out to the external Internet.

Figure 12.20 The Lightroom Network preferences.

Lightroom settings and templates

The Lightroom preference file keeps a record of all your custom program settings. On a Mac, the preference file is named *com.adobe.LightroomClassicCC7*. *plist* and is located in the *Username/Library/Preferences* folder (**Figure 12.21**). On Windows, the *Lightroom ClassicCC7 Preferences.agprefs* file is located in the *Username\AppData\Roaming\Adobe\Lightroom\Preferences* folder (**Figure 12.22**). If the Lightroom program is behaving strangely and you have reason to believe that the preferences might be corrupted, then try resetting the preferences. To reset the Lightroom preferences, hold down Shift Alt as you restart Lightroom and select Reset Preferences from the dialog box.

Figure 12.21 The Adobe Lightroom preferences file location (Mac).

Figure 12.22 The Adobe Lightroom preference file location (PC).

MOTE

You can install custom settings simply by double-clicking them. This opens a dialog asking you to confirm if you wish to add the preset to Lightroom. You can also import presets using the contextual menu in the Presets or Template Browser panels.

NOTE

Once you have established your Lightroom settings the way you like, I suggest making a copy of the Lightroom preference file. If the preference file should ever become corrupted, you can simply replace the corrupted file with the saved copy. This saves you from having to reconfigure the Lightroom preferences all over again. This tip can be applied to working with Photoshop as well.

Incidentally, a few of the critical preferences have been moved out of the main preference file. As a consequence of this, when you delete the Lightroom preferences, this does not make it forget essential things, such as which catalog you were using or which catalogs you had already successfully upgraded.

NOTE

The startup preference file is located here: Username/Library/Application Support/Adobe/Lightroom/
Preferences/Lightroom Classic CC 7
Startup Preferences.agprefs (Mac) and Username\App Data\Roaming\Adobe\ Lightroom\Preferences\Lightroom Classic CC 7 Startup Preferences.
agprefs (PC).

TIP

Richard Earney hosts a website called Inside Lightroom that offers various Develop module presets: insidelightroom.com.

Accessing saved template settings

When you save a setting in any of the Lightroom modules, the saved template settings are normally stored in the Lightroom template settings folder. For Mac OS X, use the *Username/Library/Application Support/Adobe/Lightroom* folder (**Figure 12.23**). On Windows, use the following path directory: *Username\AppData\Roaming\Adobe\Lightroom* folder (**Figure 12.24**). Inside these folders, you will see a set of subfolders that contain the default and custom settings for the various Lightroom modules. For example, in Figure 12.24, you can see a list of all the various settings folders, including the *Develop Presets* folder that is highlighted. You can make copies of these files and distribute them as preset settings for other Lightroom users to install on their computers, which they can do by dragging and dropping presets into the folder directories shown below.

The quickest way to locate the Lightroom presets folder is to go to the Lightroom Presets preferences and click the Show Lightroom Presets Folder button.

Figure 12.23 *The Adobe Lightroom template settings folder (Mac).*

Figure 12.24 The Adobe Lightroom template settings folder (PC).

Note that the *AppData* folder on a PC computer is normally hidden. To reveal the folder on Windows, go to the Control Panel, select Appearance and Personalization, choose Folder Options, and click the View tab. Here, you will see the option "Show hidden files and folders." On a Mac, the user's *Library* folder is normally hidden. To reveal it, hold down the Alt key as you click the Go menu in the Finder. Similarly, on a PC, the file extensions are often hidden by default, so you may not always see the file extensions, such as *Irtemplate* and *Ircat*.

Customizing the Lightroom contents

The Adobe Lightroom application consists of modular components (i.e., the Library, Develop, Map, Book, Slideshow, Print, and Web modules). If you want to peek inside the Lightroom application folder, follow the instructions shown in **Figures 12.25** and **12.26**. After you have revealed the package contents, you will see the various folders and files that make up Lightroom. In Figure 12.25, I expanded the *PlugIns* folder to reveal the individual module components. Now that you know where the modules are kept, you know how to customize Lightroom.

Hacking the Lightroom contents

Advanced Lightroom users may already be aware that it is possible to hack into the program contents to remove modules from Lightroom. This can lead to some cross-module behavior problems. For example, if you remove the *Slideshow*. *Irmodule* file from the *PlugIns* folder shown in Figure 12.26, the Slideshow module will be missing after you launch Lightroom and the Impromptu Slideshow menu will also be disabled in the Window menu. Likewise, if you remove the Export module, the Export menu commands will be omitted from the File menu.

If all you really want to do is to edit the module picker menu to hide certain modules, it is a lot easier to right-click in the top bar of the Lightroom interface and uncheck the modules you would prefer to be hidden (see page 23). This method is safer, too, because hacking Lightroom by physically removing modules is more likely to cause Lightroom to crash.

The Mac package contents even let you access the graphic files (these are located inside the various *Resources* folders), giving you the opportunity to sneakily customize the interface. Obviously, you want to be careful when playing around with the program components, because it is quite easy to damage or remove files that should not be messed with. If you are not careful, you can create problems that can be addressed only by carrying out a fresh reinstall of the program.

Figure 12.25 On the Mac, you can reveal the package contents by right-clicking or Ctit -clicking the Adobe Lightroom icon and selecting Show Package Contents from the menu. This opens a separate folder window, which allows you to access the program files and modules.

Figure 12.26 On a PC, go to Program files\Adobe\ to locate the Adobe Photoshop Lightroom folder. There you will find the Lightroom application program along with the program files and modules.

Lightroom previews data

The Lightroom Previews.Irdata file is a self-contained file that holds all the previews and thumbnail data. In **Figure 12.27**, I used the context menu to show the package contents of the Lightroom Previews.Irdata file. This particular package was just over 117 GB in size and contained lots of .Irprev files. These are the thumbnail and preview cache files that are used by Lightroom to display the photos in the Library module and Filmstrip. The size of the thumbnail cache depends on how you set the File Handling preferences in the Catalog Settings dialog (**Figure 12.28**). If you want to keep the Lightroom Previews.Irdata size to a minimum, select Automatically Discard 1:1 Previews, and then choose the After One Day or After One Week option. If you do not mind it growing in size, select After 30 Days or Never. The choice is yours, but because hard drive space is now so cheap, if you can spare the disk space, you might as well set this to Never. Otherwise, Lightroom will have to constantly re-render the 1:1 previews for the most commonly visited folders.

Figure 12.27 The .lrprev files contained in my Lightroom Previews. Irdata file.

Figure 12.28 The File Handling section in the Catalog Settings dialog.

I say hard drive storage space is cheap, but this is not so true if you have the Lightroom catalog stored on an internal SSD. There are definite benefits to using an SSD to store the Lightroom catalog data, but it does come at a cost, and the storage space on such drives is usually more limited.

System information

If you ever need to see an overview of your system setup, you can choose Help \Rightarrow System Info. This opens the dialog shown in **Figure 12.29**.

If you look closely, you will notice a new line: "Camera Raw SIMD optimization." This provides information about whether your system has a recent-generation Intel chip (either Sandy Bridge or Haswell), which if present, should make working in the Develop module faster. Just about every computer that supports Lightroom should at least list SSE2. However, if you see AVX listed, then your system will support this new Develop module performance improvement. If your computer lists AVX2, then you should see an additional small improvement over AVX.

Figure 12.29 The Lightroom System Info dialog can be accessed via the Help menu.

The ideal computer for Lightroom

The ideal computer setup for Lightroom depends on the size of the files you intend on working with. The raw file captures you will be working with may range in size from 6 to 60 megapixels, and the larger files will certainly place more demands on your computer resources. So, when looking for an ideal computer to run Lightroom, you definitely need to take the typical image file sizes into account. The most important factors affecting Lightroom performance are the processor speed and the amount of RAM that is available for Lightroom to use. These are followed by the speed and size of the hard disk and, to a lesser extent, the processing power of the graphics card. Lightroom is optimized to run on the latest Intel computer processors; at a minimum, you need a Mac featuring an Intel processor with 64-bit support with 2 GB of RAM and running Mac OS X 10.10 or later. And on the PC side, you need an Intel Pentium 4 or AMD Athion 64 processor with 2 GB of RAM, running Windows 7, Windows 8, or Windows 10 64-bit versions.

RAM

You will benefit from having as much RAM as possible, but you should take into account that the operating system and any other open applications will also consume some of that RAM. For example, if you happen to have just 2 GB of RAM installed on your computer, the operating system will use about 200 MB, while another 50 MB might be eaten up by various utilities. These days, 4 GB is a more realistic minimum starting point and most computers ship with at least 4 GB of RAM. But you should see significant improvements in performance if you install more than this, especially now that Lightroom is able to run as a 64-bit program and can therefore access RAM beyond the previous 4 GB limit.

Graphics card

Until recently, the graphics card did not play such a vital role in Lightroom's overall performance. All you needed was a card capable of running the screen display at its native resolution. However, Lightroom is able to take advantage of GPU support to offer faster Develop module performance. Currently, this applies to interactive image editing only, providing improved navigation and slider adjustment response. The GPU performance improvements will be most noticeable on bigger displays, especially high-pixel-density displays, and are also dependent on the video card, of course. So, the advice now is to select a fast video card for optimum Lightroom Develop performance when configuring your computer.

NOTE

From time to time, Adobe may need to temporarily disable GPU support for some graphics cards due to compatibility issues and driver bugs that result in poorer performance than expected when GPU support is enabled.

Hard drives

On both the Mac and the PC, a default Lightroom installation installs the Lightroom catalog folder (which contains the catalog and previews files) inside the user's *Pictures* or *My Pictures* folder. As your catalog grows bigger, these catalog files will increase in size, although there are options in the preferences to limit how long the 1:1 previews are preserved, automatically deleting them after a certain number of days. Don't forget that the Camera Raw cache can also be allowed to grow, and this, too, can consume more disk space (though not as much as was the case with earlier versions of Lightroom). Another factor is multiple saved History states, which can cause the catalog to become bloated.

The main considerations when selecting a hard drive are the interface type, hard-drive configuration, speed, and buffer memory. All these factors will affect the overall speed. Let's start with the interface connection. Internal drives usually offer a fast SATA interface connection, and one option would be to add extra-fast internal drives. However, the trend now is for smaller desktop machines that rely on external storage. The latest external interface connections include Thunderbolt (Mac) and USB 3 (both Mac and PC), which can offer suitably fast data access to rival a SATA or USB-C interface.

TIP

When assessing your overall storage requirements, do not try to build a system to last you the next five years. Buy the storage system you need today, but make it expandable for the future.

The hard-drive spindle speed determines how fast data can be written to and retrieved from the disk drive unit. Most 3.5-inch desktop drives have a spindle speed of 7200 RPM, whereas the smaller 2.5-inch drives found in laptops and portable bus-powered drives mostly run at a speed of 4200 to 5400 RPM. You can get 7200 RPM 2.5-inch drives, but they are more expensive and are usually offered only as a custom option when buying a laptop. SSDs are increasingly popular these days. The maximum storage for an SSD is currently 2 TB; these are expensive, but they are really fast, and I use these drives as the main hard drive on my desktop and laptop computers. There have been horror stories about hardware failure with SSDs, so do your homework before leaping to make a purchase.

Drive configurations

Multiple hard drives can be configured in a variety of ways, using various RAID methods. You need a minimum of two disks to configure a RAID system, and most off-the-shelf RAID solutions are sold as a bay dock that can accommodate two or more drives with a built-in RAID controller. For some people, RAID is the perfect solution, but for small photography businesses, it can be overkill.

Just a bunch of disks

There are varied opinions about which is the best way to manage a photography archive storage system. In my view, RAID storage is great but not the best solution for all photographers. A perfect solution would be to have a high-capacity RAID drive system that is capable of storing all your images securely on a single RAID unit. I have seen photographers work with such setups, but even so, it is quite costly to have a multidrive unit that holds all your data running continuously and consumes lots of power just so that once or twice a year you can dig up a photo you shot six years ago. If you analyze your storage requirements, you will most likely find that the majority of files you access are those that have been shot in the last few years and you don't need to have instant fast access to everything you have shot all the time.

A simpler solution is known as the "just a bunch of disks" solution, or JBOD for short. With a JBOD setup, you can have a file storage system that is scalable to meet your expanding storage needs, which is economical to maintain, as well as reliable (provided that you maintain a proper backup strategy). In my office, I use four 3 TB drives to store all the current catalog files and back these up to alternating sets of four external 3 TB drives. I also have other drives that are used to store all my older raw and master file images that date back over the last 22 years, plus matching drives that are used for backing up to. Most of the time, I do not need to have these drives running. Whenever I need to access any of the older images, I can switch on the necessary hard drive, as directed by Lightroom. JBOD can never be as foolproof as a RAID system, but it may be more appropriate for those photographers who think it would be an acceptable-enough solution for their storage needs.

HE LEARNING CENTRE CITY & ISLINGTON COLLEGE 444 CAMDEN ROAD LONDON N7 0SP TEL: 020 7700 8642

Index

434, 549

albums 1:1 previews, 108-109, 110, 385, 403 В options for folders and, 663 8-bit vs. 16-bit images, 435 B&W panel (Develop module), removing photos from, 686 16-bit printing option, 478 356, 359 sharing on the web, 666-667 64-bit operating systems, 17 Auto button, 356, 361 See also collections manual adjustments, 362-364 AMOD AGL3080 GPS unit, 636 Α slider controls, 358, 361, 366 Amount slider actions, export, 442-444 See also black-and-Post-Crop Vignetting, 270 Activity Center, 37-38 white conversions Sharpening controls, 386-387 Back Up Catalog dialog, 70 Address Lookup option, 37 Aperture Importer plug-in, 58-59 Adjustment brush, 298-313 Backdrop panel (Slideshow module), aperture information, 616-617 Auto Mask option, 302-303, 306 512, 522-523 Appearance panel (Web module), 534, brush stroke editing, 300 background operations in 542-543 Clarity adjustments, 304, 312-313 Lightroom, 38 Apple TV Lightroom CC app, 652 Color effect, 306-307 Background panel (Book module), Apply During Import panel, 50-52 exposure dodging, 301 510, 511 artist EXIF metadata, 566-567 initial options, 298-300 backgrounds aspect ratios, 170, 171, 515, 617 moiré reduction, 409-411 book, 510, 511 attribute filter searches, 614 pin position/edits, 300 module interface, 703 Auto Align option, 200 previewing stroke areas, 304 print layout, 460 Auto Dismiss option, 174, 175 saving effect settings, 300 slideshow, 522-523 Auto Import Settings dialog, 60 selective noise reduction, 408-409 backups Auto Layout option Shadows adjustments, 310-311 bucket system, 92 Book module, 494, 498-499 Sharpness adjustments, 312–313 catalog, 70-72 Picture Package, 466-467 Soften Skin effect, 304-305 imported photo, 47 Auto Layout Preset Editor, 498–499 Temp and Tint adjustments, software for, 72 Auto Mask feature, 302-303, 306 308-309 strategies for, 71-72 auto straightening option, 168-169 Adobe Bridge. See Bridge program badges, thumbnail, 94, 137, 658 Auto Sync mode, 294, 336 Adobe Camera Raw. See Camera Raw bandwidth considerations, 650, Auto Text options, 507 Adobe cloud servers, 3, 656 651, 663 Auto Tone setting, 184, 200, 202, 217, Adobe Color CC, 541 Basic panel (Develop module), 345, 670 Adobe Creative Cloud, 8, 653 174-215 Auto White Balance setting, 176 Adobe IDs, 9, 10 Auto Tone setting, 184 automatic program updates, 690 Adobe Photoshop. See Photoshop Blacks slider, 182-183, 187, 195, Auto-Stack by Capture Time feature, 199, 237 Adobe Reader, 530 130-131 Adobe RGB color space, 111, 189, 418, Clarity slider, 210-213

Contrast slider, 181, 186

burning CDs/DVDs, 445-446 Exposure slider, 180, 185, 193, auto calculation, 182-183 Bury, Joshua, v 194, 195, 198 Basic panel, 182-183, 187-188, Highlights slider, 181-182, 186, 195, 199, 237 C 193, 236 blur effect, 400-401 Cadman, Rob, vi Histogram panel used with, Blurb photo books, 494 calibrating the display, 155-158 190-191 Bombich, Mike, 72 devices used for, 155-156 image adjustment workflow, Book module, 494-511 steps in process of, 157-158 185-188 Auto Layout panel, 498-499 white point and gamma, 156-157 keyboard shortcuts for, 191 Background panel, 510, 511 Calvert, Terry, vi overexposed image correction, Book Settings panel, 496-497 Camera Calibration panel (Develop 192-193 Cell panel, 506, 510 module), 274-275, 373, 375 Saturation slider, 214-215, 372 Guides panel, 505 Camera Raw Shadows slider, 181-182, 187, 194, interface overview, 494-495 cache size for, 700, 705-706 195, 236 Page panel, 504-505 DNG 1.3 specification, 695 Temp slider, 178, 179, 360 Preview panel, 497 Lightroom compatibility with, 161, Tint slider, 178, 179, 360, 365 Text panel, 506-507 340-343, 419 Tone Curve adjustments and, 181, Toolbar, 498 processing images in, 5 234-237 Type panel, 508-510 See also raw files underexposed image correction, Book Preferences dialog, 507 cameras 194-195 Book Settings panel, 494, 496-497 black-and-white mode on, 358 Vibrance slider, 214-215, 373 books, 494-511 connecting to computers, 61, 62 White Balance tool, 174-179, backgrounds for, 510, 511 default Develop settings for, 185, 235 covers for, 502-503 352-353, 693 Whites slider, 182-183, 187, creating new, 495-496 importing files from, 33-36 198, 237 editing, 500-503 lens correction data from, 250 beauty retouching, 304-305 guides used for, 505 Lightroom CC/mobile interface Before/After viewing modes, 276-281 multi-page view of, 498 for, 664 keyboard shortcuts, 277, 278, 280 page layout options, 504-505 metadata info about, 566. PDF or JPEG, 497 managing previews in, 278-281 616-617 soft-proofing feature, 486-489 presets for, 498-499 previews generated by, 110 bit depth, 13, 418, 435 previewing, 497 profiles for, 274-275 Black & White button, 356 publishing, 511 tethered shooting with, 61-65 black-and-white conversions, 355-375 setup options, 496-497 transmitting photos from, 61 desaturating color for, 372-375 text options, 506-510 Campagna, Matthew, 539 Develop module controls, 356-357 type controls, 508-510 Canon EOS Utility, 62 infrared effect and, 365-367 borders, 462-463, 464 captions manual adjustments for, 362-364 Boundary Warp slider, 208-209 viewing in Metadata panel, 560 overview of options for, 358 Bridge program, 5, 68, 129, 414, 573, web gallery, 544-547 refining B&W images, 368-375 630-631 capture sharpening, 378-380 Split Toning panel for, 356, 367, brush spots, 287-290, 291 capture time editing, 565-566 368-371 bucket system backups, 92 Carbon Copy Cloner, 72 Temp and Tint sliders for, 360 Build Previews menu, 43 Catalog panel (Library module), 19, See also B&W panel Build Smart Previews option, 43, 148 78, 133, 654

Blacks adjustment

Basic panel (Develop module) (cont.)

Saturation slider, 214-215 Catalog Settings dialog, 11-12, 15, 69, circle spots, 284, 285, 291 Clarity adjustments selective color darkening, 242-243 626, 629 Split Toning panel, 370-371 Adjustment brush, 304, 312-313 catalogs, 67, 68-75 Vibrance slider, 214-215 Basic panel, 210-213 about, 68-69 color gamut considerations, 483-484 negative, 212-213, 304 backing up, 70-72 color labels, 128-129 corrupted, 72-73, 625 Quick Develop panel, 218 creating new, 74 Classic Gallery style, 536 assigning to photos, 128, 129 filtering photos with, 129, exporting, 143-145, 147 clipping 605-606, 616 filtering photos in, 600-607 gamut, 244-245 sort options for, 635 highlight, 180, 188, 198 folders and, 56, 88-89 Color Management settings, 472, 479 importing, 145-147 shadow, 188, 198-199 Clone mode, Spot Removal tool, 284 Color Palette panel (Web module), migrating to Lightroom CC/mobile, 534, 541 close-up Loupe view, 97, 102, 103 675-677 Color panel controls, 240 cloud storage, 656, 663, 687 opening existing, 75, 145 color picker dialog, 516, 541 CMYK images, 45, 161, 444, 486 optimizing, 71 Color Priority vignette, 270, 271 recovering Sync, 73 collections, 133-141 Color Range Masking, 324-325 removing photos from, 142 book. 495-496 Color Smoothness slider, 406-407 creating new, 134-135 selecting default, 691 color spaces, 13, 189, 418, 434-435 deleting, 139 sharing between computers, color themes, 541 149-151 duplicating, 137 Color Wash controls, 522, 523 Smart Previews for, 144, 145, editing, 138-139 importing photos to, 43 ColorChecker chart, 176 147-151 module-specific, 135-138, 494 ColorSync option, 472, 475, 479 storage location for, 11, 12 print, 454 Compact Cells view, 93, 94 upgrading, 11 publishing, 620-623 comparing images CD/DVD exports, 445-446 Before/After viewing modes for, Quick, 133-134, 139 Cell panel (Book module), 494, removing photos from, 138 276-281 506, 510 renaming, 139 Compare view for, 114-117, Cell Size/Spacing sliders, 456 saving creations as, 494 121, 122 cells Reference view mode for, 282-283 sets of, 140 Book module layout, 506, 510 sharing on the web, 666-667 compression options, 31, 531, Custom Package layout, 468 697-698 Picture Package layout, 466-467 slideshow, 512, 529 computers Single Image/Contact Sheet layout, Smart, 11, 140-141 connecting cameras to, 61, 62 455, 456-457, 458 synchronized, 19, 657-658 setup for running Lightroom on, 8, Cells panel (Print module), target, 139, 590 712-714 466-467, 468 web gallery, 553 sharing catalogs between, 149-151 Collections panel, 19, 135, 140, Chan, Eric, v. 380 See also Macintosh computers; character controls, 508-509 496, 553 Windows computers Charles-Will, Charlene, v color adjustments Configure FTP File Transfer dialog, Check All button, 40, 337 Adjustment brush, 306-307 Choose Profiles dialog, 479 desaturated color, 372-375 551-552 HSL controls, 240-245 Constrain Aspect Ratio Lock, 170 chromatic aberration removal, hue-shift effects, 243-244 Constrain to Image option, 168 250-251 noise reduction, 404, 405-407 contact sheets, 458-459 See also Defringe adjustments content area, 24, 40-42 ChronoSync backup program, 72

Basic panel, 181, 186 709-710 Basic panel controls, 174–215 Detail panel, 403 Cut Guides option, 469 Before/After viewing modes, Tone Curve panel, 239 276-281 controlled vocabularies, 578, 584, D Blacks adjustment, 182-183, 585, 586 187-188, 199 DAM Book, The (Krogh), 92 Convert Photos to DNG dialog, Camera Calibration panel, date/time information, 565-566, 616 31, 697 274-275, 373, 375 Davis, Nancy, v Copy as DNG option, 30, 36 Camera Raw compatibility, 161, dead pixels, 380 Copy Name field, 563-564 340-343 defaults Copy Settings dialog, 338 camera-specific settings, camera Develop setting, copying 352-353, 693 352-353, 693 Before/After view settings. Clarity adjustments, 210–213 restoring in Lightroom, 693-694 278-281 color adjustments, 240-245 Defringe adjustments, 252-257 Develop module settings, 338-339 Contrast adjustments, 181, 186 Eyedropper tool for, 253 importing photos by, 30 copying and pasting settings, global, 254-256 copyright information, 438, 570, 338-339 localized, 257, 258 576-577 cropping procedures, 164-173 process for making, 252-253 corruption Detail panel, 378, 385-395 Deghost Amount options, 201, 202 catalog, 72-73, 625 display calibration, 155-158 Dehaze adjustments, 272-273 file, 36, 47 Effects panel, 268-273 deleting Cotterill, Harriet, vi Exposure adjustments, 180, collections, 139 Create bar, 136, 454, 553 192-195, 198 history steps, 330 Create Collection dialog, 135, Graduated Filter tool, 314-318 metadata presets, 570 139, 654 HDR image adjustments, 200-201 photos from hard drives, 142 Create Keyword Tag dialog, 579, 581 highlight adjustments, photos in Lightroom, CC, 686 Crop Marks option, 464 181-182, 186 templates, 491 Crop Overlay mode, 164, 170, 268 Histogram panel, 188-191 See also removing Crop Overlay tool, 164, 165, 168 History panel, 19, 329-330 demosaic processing, 378-380, 402 cropping photos, 164-173 HSL controls, 240-245 Density slider, 299 aspect ratios for, 170, 171 image-processing engine, 153, 154 desaturated color adjustments, auto straightening and, 168-169 interface overview, 162-163 372-375 basic steps for, 166-167 Lens Corrections panel, 246-258 Destination panel (Import dialog), canceling crops, 172 localized adjustments, 298-328 52-54 Constrain to Image option, 168 Loupe Overlay view, 104-107 Detail panel (Develop module), 378 guide overlays for, 171, 172 Match Total Exposures command, default settings, 380-381 metadata info about, 564 196-197 Noise Reduction controls, 402-407 post-crop vignettes, 268-271 presets used in, 344-351 Sharpening controls, 378, 385-395 Quick Develop options, 173 process versions, 159-161 Detail slider repositioning crops, 170-171 Radial Filter tool, 319-322 Noise Reduction controls, 403 rotating and, 164 Range Mask options, 323-328 Sharpening controls, 390-392, 393 custom filters, 618-620 Red Eye Correction tool, 295-297 Develop module, 5, 153-353 custom metadata, 567-573 Reference view mode, 282-283 Adjustment brush, 298-313 Custom Package layout, 468-469 retouching tools, 284-333 Auto Tone setting, 184, 345 custom profile printing, 479 Saturation adjustments, 214-215 B&W controls, 356-375

customizing Lightroom, 20-21,

Develop module (continued)

Contrast adjustments

Shadow adjustments, 181–182, 187 Dropbox.com website, 150 Expanded Cells view, 93, 94 Export as Catalog dialog, 143 Export dialog, 430, 431, 432, 446, 485–490 Spot Removal tool, 284–294 Synchronizing settings, 221, DVD/Blu-ray disc backups, 92 Export dialog, 430, 431, 432, 446, 448, 647 exporting, 430–449 actions for, 442–444
Soft Proofing option, 483, dual-display setup, 120–123, 425 Export dialog, 430, 431, 432, 446, 485–490 duplicates, checking for, 43 448, 647 Spot Removal tool, 284–294 Dutton, Harry, vi exporting, 430–449 synchronizing settings, 221, DVD/Blu-ray disc backups, 92 actions for, 442–444
485–490 duplicates, checking for, 43 448, 647 Spot Removal tool, 284–294 Dutton, Harry, vi exporting, 430–449 synchronizing settings, 221, DVD/Blu-ray disc backups, 92 actions for, 442–444
Spot Removal tool, 284–294 Dutton, Harry, vi exporting, 430–449 synchronizing settings, 221, DVD/Blu-ray disc backups, 92 actions for, 442–444
synchronizing settings, 221, DVD/Blu-ray disc backups, 92 actions for, 442–444
-,,,,,,,,,,
336–337 DVD/CD exports, 445–446 books as PDFs or JPEGs, 497
Tone Curve panel, 226–239 catalogs, 143–145, 147
Tool Overlay options, 172, 291 E to CDs or DVDs, 445–446
Transform appel 350, 367
Vibrance adjustments 214–215 Earney, Richard, 708 as email attachments 446–447
edge sharpening, 321–322 file settings for 434–435
White Palance tool 174–179, 185 Edit in Photoshop command, 415, 419 GPS-encoded files, 646–647
Whites adjustment 182-183 Edit Keyword Set dialog, 589 keywords 439-586-600
Edit Metadata Presets dialog, 51, 569, location options for, 431–433
Develop Presets panel, 275 Develop Presets panel, 275 Develop Presets panel, 275
Povelop Settings many 50 438–439 600
digital asset management (DAM) paming files for 434
brush strokes, 300 output sharpening for 438
Capture time into, 565–566
collections, 138–139
external editor options for,
414–421 presets for 431
choosing 155 images in Photoshop, to the same folder 432–433
dual display setup 120–123 / 125 sizing images for 437
soft-proofing considerations slideshows 530–533
483–485 video files. 449, 532
DNG files 8 694_699 metadata presets, 570–572 watermark options for 439–441
viaeo Tiles, 221–225 web galleries 550
compression for 31 697–698 Edwards, Lucy, VI
converting raw files to 30–32 697 Adjustment Brush for dodging 301
200-Z/3
694_697 Denaze adjustments, 2/2=2/3
exporting images as, 436–437, 697 Rest Grap Viscottics controls Histogram panel and, 190
Post-Crop Vignetting controls, metadata status for, 699 268–271 Match Total Exposures command,
Photo Merge 200 201 203 196–197
erridii overeynosed image correction
exporting photos for, 440–447
well adjustments, validating, 699 metadata links to, 576 validating, 699 Quick Develop panel adjustments,
VMP metadata and 624 630 632 216 217
DPX video format, 449 empty field searches, 618 underexposed image correction,
Draft Mode Printing option, 458, 477 Eraser mode, 300, 590 Draft Mode Printing option, 458, 477 EVIE motodata, 51, 246, 247, 546 194–195
drag and drop import 57 Existing function (247, 340, 247, 340, 540, 540, 540, 540, 540, 540, 540, 5
Draw Face Region tool, 99, 102, ExifTool editor, 567
591, 596

external editing options, 414-421 component layout, 611 system, 82-83, 84 file format/settings, 418 custom settings, 618-620 template settings, 708-709 naming/renaming files, 418 Metadata section, 614-617 Folders panel (Library module). Photoshop editing option, 415, 419 searching with, 558-559, 611-620 6. 79-92 preference settings, 13, shortcut for toggling, 610 Foster, Nadia, vi 414-415, 418 Text section, 611-613 fractions, typographic, 704 preset creation, 417 filtering photos, 600-620 Fraser, Bruce, vi, 272, 378, 393, 438 program selection, 416-417 attribute searches, 614 Friedl, Jeffrey, 448 steps for using, 420-421 catalog options for, 602 FTP programs, 550 Evedropper tool, 253 collections based on, 140-141 color labels for, 129, 605-606 G F custom settings for, 618-620 galleries. See web galleries Filmstrip options for, 603 Face Detection control, 37 gamma setting, 156-157 Filter bar for, 610-620 face-tagging feature. See People gamut clipping, 244-245 flags used for, 124, 604 view mode General preferences, 12, 690-692 GPS data used for, 640, 647 favorite folders, 604 GeoSetter software, 637 keywords used for, 585 Feather slider Geotag Photos app. 636 Library menu options for, 601, 610 Adjustment brush, 298 geotagged images, 636-647 master copy filtering, 607 Post-Crop Vignetting, 268 creating, 636-637 metadata searches, 614-617 Spot Removal tool, 292 exporting, 646-647 rules defined for, 612-613, 618 Fetch FTP software, 550 filtering, 640, 647 selections used for, 604, 609 file format compatibility, 45-46 manually tagging, 644-645 star ratings for, 126, 127, 604 file handling reverse geocoding of, 638 subfolder filtering, 608 imported photos and, 43-48 viewing and managing, 638-647 text searches, 611-613 setting preferences for, 14, 46, See also Map module virtual copy filtering, 607 694-700 Google Maps, 10 finding. See searching File Handling panel (Import dialog), Gorman, Greg, 199 flagged photos GPS metadata, 636-647 deleting rejects, 142 File Renaming panel (Import dialog), embedding into photos, 637 filtering picks/rejects, 124, 604 48-50 exporting files containing, 646-647 Flag icons indicating, 94 File Type filtering, 616 filtering photos by, 640, 647 rating picks/rejects, 124-125 Filename Template Editor, 48, 49, options for recording, 636-637 FlashFXP software, 550 418, 694 reverse geocoding of, 638 Flow slider, 298-299 files See also geotagged images folders catalog, 68-69 GPSPhotoLinker Software, 637 catalogs and, 56, 88-89 corruption of, 36, 47 GPU processing, 16, 17 exporting to same, 432-433 organization of, 41-42 GPX tracklogs, 640-643 favorite, 604 saving metadata to, 624-626 Graduated Filter tool, 314-318 hierarchy of, 39, 79-81 Filmstrip, 27 Brush option, 317-318 importing to, 34-35, 53, 54 filtering photos via, 603 examples of using, 314-316, 401 links to, 84-85 navigating photos via, 118-119 Grain effect sliders, 272 managing, 6, 79-81 setting preferences for, 703-704 graphics card, 17, 713 naming/renaming, 84, 552 Filter bar, 24, 92, 610-620 grayscale conversions. See black-andorganizing, 90-92 advanced searches, 619-620 white conversions synchronizing, 86-87, 341 Attribute section, 614 grayscale previews, 386, 393

Grid Gallery style, 536, 538, 541 grid overlays, 104, 105 Grid view, 40, 93–96 in Lightroom CC/mobile, 658–659 navigating, 95–96	Highlight Priority vignette, 270, 271 highlights clipping, 180, 188, 198 detail recovery, 186, 192 reflective vs. nonreflective, 198	Hue sliders HSL panel, 240, 241, 242, 243 Split Toning panel, 368
options available in, 93–94 secondary displays and, 121, 122, 123 shortcuts for, 96, 103 videos displayed in, 221, 222 working in, 100, 101 grouping photos, 130–131 guide overlays crop, 171, 172 Loupe Overlay view, 104, 105 Guided Upright option, 265–267 guides book, 505 print, 457, 466 Guides panel Book module, 494	Highlights adjustment Basic panel, 181–182, 186, 193, 236 Tone Curve panel, 232 high-pixel-density display support, 6 Histogram panel Develop module, 188–191 Library module, 216 History panel (Develop module), 19, 329–330 Hogarty, Tom, v Holbert, Mac, 451 HoudahGeo 5 software, 637 HSL / Color / B&W panel (Develop module), 240, 356 HSL controls (Develop module), 240–245	ICM Color Management, 472, 475, 479 identity plate customizing, 20–21 Lightroom CC menu options, 653 photo border technique, 462–463 slideshow options, 518, 519 steps for creating, 460–461 web gallery options, 540 Identity Plate Editor, 20–21, 461, 463, 519, 524 Image Info panel (Web module), 534, 544–547 Image Settings panel (Print module), 453, 454, 466 image-processing engine, 153, 154
H H.264 video format, 449, 532 halo suppression, 390 Hamburg, Mark, iv, v, 196 hard drives configuring multiple, 714 considerations for selecting, 713–714 deleting photos from, 142 Harvey, Phil, 567 HDR image creation, 200–203 Deghost Amount options, 201, 202 Photo Merge process for, 200–201, 202–203 Heal mode, Spot Removal tool, 284 Help menu, 22, 25, 162	B&W conversion method, 373, 374–375 desaturated color adjustments, 372–375 false color hue adjustments, 243–244 overview of sliders and, 240 reducing gamut clipping with, 244–245 selective color darkening, 242–243 HSL panel, Luminance sliders, 240, 242, 244, 245 HTML galleries, 536, 537 Appearance panel settings, 542 Color Palette panel settings, 541 Site Info panel settings, 540 Title/Caption information, 544, 545	implied keywords, 586 Import dialog, 28–29, 39–54 Apply During Import panel, 50–52 compact mode, 29 content area, 40–42 Destination panel, 52–54 expanded mode, 28, 29 File Handling panel, 43–48 File Renaming panel, 48–50 Import Presets menu, 54 Source panel, 39 Import DNG Creation options, 694–697 Import Photos dialog, 86, 87, 108, 579 importing photos, 27–65 Add method for, 56 Auto Import feature, 60 backing up and, 47
hiding/showing panels, 76 Toolbar, 24 hierarchy folder, 39, 79–81 keyword, 439, 584–585	HTML5 galleries, 536, 538 Appearance panel settings, 543 Color Palette panel settings, 541 Site Info panel settings, 540 Title/Caption information, 544, 545	camera card imports, 33–36 catalog imports, 145–147 Develop settings and, 50 DNG conversion options, 30–32 drag-and-drop method for, 57 file handling options for, 43–48

importing photos (continued)	J	Kost, Julieanne, v
folder options for, 34-35, 53, 54	Jardina Caarga vii	Krogh, Peter, 91, 92
Import dialog options, 28–29,	Jardine, George, vi	
39–54	JBOD storage system, 714	L
keyword imports, 586	JPEG files	Lab color values, 191
Lightroom CC/mobile for,	books exported as, 497	labeling photos. See color labels
678–679	external editing options, 417	
metadata info and, 35, 51-52,	moiré removal on, 411	Layout Image overlay, 106–107
570–571, 578	photos exported as, 434	Layout panel
organizing and, 41–42, 52, 53	print jobs saved as, 478	Print module, 453, 455–457
from other programs, 58–59	raw + JPEG imports and, 48	Slideshow module, 512, 515
plug-ins for, 58-59	slideshows exported as, 531	Layout Style panel (Print module),
preferences for, 32-33, 691-692	web gallery images as, 548	453, 454
presets created for, 35, 54	XMP metadata and, 629–632	Custom Package layout, 468–469
previewing and, 32, 43, 44–45,		Picture Package layout, 466–467
108–109	K	Single Image/Contact Sheet layout,
problems with, 47	kerning, 509	454–465
raw + JPEG options for, 48	keyboard shortcuts, 2, 25, 162	Layout Style panel (Web module),
renaming options for, 48–50	Keyword List panel (Library	534, 536–540
storage locations for, 52–54	module), 578, 579-580, 582,	HTML gallery (default) layout,
tethered shooting and, 61–65	584–585, 598	536, 537
importing video files, 55	Keywording panel (Library module),	Lightroom Grid (HTML5) gallery
information	578, 579, 583, 586, 587,	layout, 536, 538
camera, 566, 616–617	588–589	third-party gallery styles, 539–540
copyright, 438, 570, 576-577	keywords, 577–589	Lens Corrections panel (Develop
date/time, 565–566, 616	adding to photos, 52, 579–580	module), 246–258
photographic, 465, 616–617	applying existing, 582, 583	chromatic aberration removal,
title/caption, 544–547	auto-completion of, 583	250–251
See also metadata	entry preferences for, 703	Defringe adjustments,
infrared effect, 365–367	exporting, 439, 586, 600	252–257, 258
inkjet printers, 451	filtering, 585	lens profile corrections, 246–249
Inside Lightroom website, 708	hierarchy of, 439, 584–585	Vignetting sliders, 257
installing/upgrading Lightroom, 9–11	implied, 586	lenses
interface, 3	importing, 586	metadata info on, 246, 247, 616
compact, 78	Lightroom CC/mobile, 685–686	profiles for, 246–249
overview of, 23–25	migrating, 578	Library module, 67, 76–151
preferences, 14–15, 700–704	Painter tool and, 590	Catalog panel, 78, 133
interpolation methods, 437	person, 598–600	Compare view, 114–117
inverse searches, 613	private, 580	dual-display setup, 120–123
iPhoto Importer plug-in, 58	removing, 584	Filmstrip, 118–119, 603
IPTC metadata, 51, 560,	sets of, 588–589	Filter bar, 24, 92, 610–620
570–572, 578	suggested, 587	Folders panel, 6, 79–92
ISO settings	synonyms of, 580–581	Grid view, 93–96
metadata info on, 617	See also metadata	Histogram panel, 216
noise reduction and, 404	Knoll, John, 7	Keyword List panel, 578, 579–580,
,	Knoll, Thomas, v, 7	582, 584–585, 598

mobile camera interface, 664 Keywording panel, 578, 579, 583, Loupe Overlay view, 104-107 586, 587, 588-589 overview of, 650-651, 674-675 Grid and Guides, 104-105 Loupe Overlay view, 104-107 photo storage, 656 Layout Image feature, 106-107 Loupe view, 97-103 preferences, 18-19, 662-663, Loupe view, 40, 97-103 Metadata panel, 560-576 687-688 navigating, 102-103 Navigator panel, 78 program layout, 677 options available in, 98-99 overview of, 76-77 removing/deleting photos secondary displays and, 120, Painter tool, 139, 590 from, 686 122, 123 panel controls, 76 search options, 665 shortcuts for, 96, 98, 103 previews, 108-111 setting up, 653-655 videos displayed in, 221, 222 Publish Services panel, 620-623 sharing photos from, 686 working in, 101 Quick Collections, 133-134 Single image view, 659-661 zoom views, 103 Quick Develop panel, 173, stacking photos in, 683 Luminance Range Masking, 326-328 216-225 syncing to/from, 19, 654-655 Luminance slider rating images in, 124-129 workflow for, 651, 652 Detail panel, 402-403 selection options, 132 Lightroom Classic CC, 1, 8, 651, HSL panel, 240, 242, 244, 245, shortcuts for, 25 666, 675 373, 375 Sort menu, 634-635 Lightroom Publishing Manager, 621 Lyons, lan, v stacks, 130-131 Lightroom RGB workspace, 154, 189 Survey view, 112-113 Lightroom Settings folder, 69 M Toolbar, 78-79 Lights Out/Lights Dim modes, 702 Macintosh computers video functions, 221-225 links keyboard preferences on, 96, 120 Library View Options dialog, 93, email and web, 540, 576 Lightroom preferences on, 98, 627 folder and file, 84-85 11-12, 707 Lightroom CC for Apple TV, 652 volume, 85 printer settings on, 470, 473, Lightroom CC for web, 668-674 localized adjustments, 298-328 476, 480 Auto Tone method, 670 Adjustment brush, 298-313 system requirements for, 8 interface overview, 668-670 Clarity slider, 304, 312-313 Time Machine backups on, 72 managing photos via, 673-674 Color effect, 306-307 magnification options, 102, 103 uploading photos via, 671-672 Defringe controls, 257, 258 Managed by Lightroom print settings, Lightroom CC for web view, 666-667 Dehaze slider, 273 480-481 Lightroom CC/mobile, 1, 649-688 Graduated Filter tool, 314-318 Managed by Printer settings, 472, adding device photos to, 664 Moiré slider, 409-411 473-475, 479 album/folder options, 663 Noise slider, 408-409 Mangalick, Sharad, v creating copies in, 685 Radial Filter tool, 319-322 Map module, 638-647 Edit Settings menu, 684 Range Mask options, 323-328 GPX tracklogs, 640-643 editing photos in, 661, 680-682 Shadows slider, 310-311 Location Filter bar, 640 features and limitations, 652 Sharpness slider, 312-313, manual geotagging, 644-645 Grid view, 658-659 398-399 navigating, 639 importing files via, 678-679 Temp and Tint sliders, 178, pin markers, 641 keywords added in, 685-686 308-309 Saved Locations panel, 646 Lightroom CC for web and, Location Filter bar, 640 See also geotagged images 666-674 lock files, 69 margin settings, 455, 456-457 managing photos in, 684-685 lossy DNGs, 31, 698 Masking slider, 393-395 migrating catalogs to, 675-677 master images, 334-335, 607

Match Total Exposures command,	information displayed in, 560,	Network preferences, 706
196–197	563–568	New Develop Preset dialog, 344,
McCormack, Sean, v, vi, 462, 532	view modes, 560–562	352, 372
megapixels, 712	migrating catalogs, 675–677	noise reduction, 402-409
memory cards, 33–36	Mirror Image mode, 98	color, 404, 405-407
menu bar, 23	missing photos, 617	luminance, 402-403
metadata, 4, 556-589, 624-633	mobile version of Lightroom. See	selective, 408-409
artist EXIF, 566-567	Lightroom CC/mobile	tips for, 404
camera info, 566, 616-617	modules	nonreflective highlights, 198
capture time, 565–566	collections specific to,	numbering sequences, 50
copyright status, 570, 576-577	135–138, 494	
custom information, 567–573	Lightroom design using, 2–3	0
displayed in Metadata panel, 560, 563–568 DNG view mode for, 699 editing for multiple images, 574 efficient way of adding, 573 export options for, 438–439, 600 face-recognition, 596, 600 filter options for, 614–617 GPS coordinates as, 636–647 imported photos and, 35, 51–52, 570–571, 578	menu for selecting, 23, 709 removing from Lightroom, 709 shortcuts for, 2, 162 See also specific modules moiré reduction, 409–411 monitor. See display screen movies. See video files/clips multiple cell printing, 458–459 music for slideshows, 525, 526, 533 Music panel (Slideshow module), 525 My Pictures folder, 11, 12	O'Hare, Sam, 400 optimizing catalogs, 71 Options panel (Slideshow module), 512, 516–517 organizing folders, 90–92 imported photos, 41–42, 52, 53 orphan works, 570, 576 Output Settings panel (Web module) 534, 548
keywords and, 577–589, 600		output sharpening, 380, 438
lens info, 246, 247, 616	N	overexposed image correction,
mail and web links, 576 presets, 51, 568–572 private, 580 saving to files, 624–626 searching with, 558–559, 614–617 setting preferences for, 700 status info, 341, 343, 564, 629 synchronizing, 633 target photos and, 574–575 tracking changes to, 627–629	naming/renaming collections, 139 exported photos, 434 externally edited photos, 418 folders, 84, 552 illegal characters for, 700 imported photos, 48–50 photo files, 48–50, 563 presets, 348	192–193 overlays crop guide, 171, 172 Grid and Guides, 104–105 identity plate, 518, 519 Layout Image, 106–107 Loupe Overlay, 104–107 text, 518, 520–521 Overlays panel (Slideshow module), 512, 518–521
types of, 556–557	snapshots, 330 Nash, Graham, 451	Р
virtual copies and, 334 web gallery, 546–547, 548 XMP space and, 624, 626, 629–632 Metadata panel (Library module), 560–576 customizing data in, 567–573 editing data in, 574–577	Navigator panel (Library module), 78, 103 negative Clarity adjustments, 212–213 negative sharpening effect, 400–401 negatives exporting catalogs with/without, 143–144 importing catalogs without, 147	Page Bleed view, 456, 457 Page panel Book module, 494, 504–505 Print module, 460–465, 469 Page Setup dialog, 470, 471, 472 Paint Overlay vignette, 268, 270 Painter tool, 139, 590 Pan and Zoom option, 526

end mark options, 702	panels	PhotoKit SHARPENER plug-in,	Interface, 14-15, 700-704
font size options, 702 Photoshelter Archive, 621, 623 662-663, 687-688 hiding/showing, 76 Photoshop, 6-7, 413, 414-429 Network, 706 solo mode for, 162 droplet creation, 442-444 Performance, 16-17, 705-706 working with, 24 editing images in, 414-429, 680 Presets, 13, 353, 692-694 paper pancars creation, 204-209 Lightroom integration with, 7, 161, 205-207, 208 Propection of Merge process for, 204, 205-207, 208 414-415, 418 web gallery, 534-553 Projection options, 205, 206 Smart Objects used in, 426-429 potos, 498-499 presets presets paper steps for working with, 422-425 potok, 498-499 presets presets photo book, 496 picks and rejects acarea-specific, 352-353 printer profiles for, 481 deleting rejected photos, 142 Develop module, 344-353 size settings for, 470 filtering photos flagged as, 124-125 export, 431 Pacucci, Camilla, vi, 586 124, 604 external editor, 417 PDF documents Flag icons indicating, 94 how they work, 347 exporting books as, 497 flagging photos as, 124-125 HS. desaturate, 372, 373 print files output as, 458	end mark options, 700–701	438, 477	Lightroom CC/mobile, 18-19,
solo mode for, 162 droplet creation, 442–444 Performance, 16–17, 705–706 working with, 24 editing images in, 414–429, 680 Presets, 13, 353, 692–694 See also specific panels extended editing in, 426–429 resetting, 11, 690, 707 panorama creation, 204–209 Lightroom integration with, 7, 161, presentations, 493–553 book, 494–511 Boundary Warp slider, 208–209 414–429, 630 book, 494–511 Photo Merge process for, 204, 205–207, 208 A14–415, 418 web gallery, 534–553 Projection options, 205, 206 Smart Objects used in, 426–429 presets paper steps for working with, 422–425 book, 498–499 photo book, 496 picks and rejects camera-specific, 352–353 printer profiles for, 481 deleting rejected photos, 142 Develop module, 344–353 sace settings for, 470 filtering photos flagged as, external editor, 417 PEDF documents English just as, 458 keyboard shortcuts for, 40, 124 HSL desaturate, 372, 373 Pair files output as, 458 keyboard shortcuts for, 40, 124 HSL desaturate, 372, 373 Peace, James, vi Pictures folder, 11, 12 metadata, 51, 568–572	font size options, 702	Photoshelter Archive, 621, 623	
working with, 24 editing images in, 414–429, 680 Presets, 13, 353, 692–694 See also specific panels extended editing in, 426–429 resetting, 11, 690, 707 Boundary Warp slider, 208–209 414–429, 630 book, 494–511 Boundary Warp slider, 208–209 414–415, 418 resetting, 11, 690, 707 Projection options, 205, 206 Smart Objects used in, 426–429 resets paper steps for working with, 422–425 book, 498–499 photo book, 496 picks and rejects picks and rejects book, 498–499 printer profiles for, 481 deleting rejected photos, 142 Develop module, 344–353 size settings for, 470 filtering photos flagged as, export, 431 external editor, 417 PBPD documents Flag icons indicating, 94 how they work, 347 HSL desaturate, 372, 373 exporting books as, 497 flagging photos as, 124–125 HSL desaturate, 372, 373 print files output as, 458 keyboard shortcuts for, 40, 124 metadata, 51, 568–572 Peacre, James, vi Picture Folder, 11, 12 names for, 348 People view mode, 590–600 pin markers, 300, 314, 319, 641 preferences for, 13, 692–694	hiding/showing, 76	Photoshop, 6-7, 413, 414-429	Network, 706
working with, 24 editing images in, 414–429, 680 Presets, 13, 353, 692–694 See also specific panels extended editing in, 426–429 resetting, 11, 690, 707 panorama creation, 204–209 Lightroom integration with, 7, 161, 900, 707 presentations, 293–553 Boundary Warp slider, 208–209 414–429, 630 book, 494–511 Projection options, 205, 206 Smart Objects used in, 426–429 sideshow, 512–533 Projection options, 205, 206 Smart Objects used in, 426–429 presents paper steps for working with, 422–425 book, 494–499 photo book, 496 picks and rejects picks and rejects book, 494–499 pinter profiles for, 481 deleting rejected photos, 142 Develop module, 344–353 size settings for, 470 filtering photos flagged as, export, 431 external editor, 417 Pascucci, Camilla, vi, 586 124, 604 how they work, 347 exporting books as, 497 flagging photos as, 124–125 HSL desaturate, 372, 373 pint flies output as, 458 keyboard shortcuts for, 40, 124 metadata, 51, 568–572 Peace, James, vi Picture Package layout, 466–467, 469 present showed	solo mode for, 162	droplet creation, 442–444	Performance, 16-17, 705-706
See also specific panels extended editing in, 426–429 resetting, 11, 690, 707 panorama creation, 204–209 Lightroom integration with, 7, 161, 2630 presentations, 493–553 Boundary Warp slider, 208–209 414–429, 630 book, 494–511 Photo Merge process for, 204, 205–207, 208 setting preferences for, 3ideshow, 512–533 web gallery, 534–553 Projection options, 205, 206 Smart Objects used in, 426–429 presets paper steps for working with, 422–425 book, 498–499 photo book, 496 picks and rejects camera-specific, 352–353 printer profiles for, 481 deleting rejected photos, 142 people pmodule, 344–353 size settings for, 470 filtering photos flagged as, 225, 246 export, 431 PDF documents Flag icons indicating, 94 how they work, 347 exporting books as, 497 flagging photos as, 124–125 HSL desaturate, 373, 373 print files output as, 458 keyboard shortcuts for, 40, 124 metadata, 51, 568–572 pearce, James, vi Picture Package layout, 466–467, 469 metadata, 51, 568–572 Pearce, James, vi Pictures folder, 11, 12 names for, 348 People view mode, 590–600 </td <td>working with, 24</td> <td>editing images in, 414–429, 680</td> <td></td>	working with, 24	editing images in, 414–429, 680	
panorama creation, 204–209 Lightroom integration with, 7, 161, 800, 494–511 presentations, 493–553 book, 494–511 Photo Merge process for, 204, 205–207, 208 414–429, 630 book, 494–511 sideshow, 512–533 Projection options, 205, 206 Smart Objects used in, 426–429 presetts web gallery, 534–553 paper steps for working with, 422–425 book, 498–499 book, 498–499 photo book, 496 picks and rejects camera-specific, 352–353 printer profiles for, 481 deleting rejected photos, 142 book, 498–499 portice, Camilla, vi, 586 124, 604 export, 431 PBDF documents Flagi cons indicating, 94 external editor, 417 exporting books as, 497 flagging photos as, 124–125 HSL desaturate, 372, 373 print files output as, 458 keyboard shortcuts for, 40, 124 import, 35, 54 Sideshows exported as, 530–531 Pictures folder, 11, 12 names for, 348 Pearce, James, vi Pictures folder, 11, 12 names for, 348 People view mode, 590–600 pin markers, 300, 314, 319, 641 preferences for, 13, 692–694 stack controls, 597 plug-ins watermark, 440	See also specific panels	extended editing in, 426-429	
Boundary Warp slider, 208–209 414–429, 630 book, 494–511 Photo Merge process for, 204, 205–207, 208 414–415, 418 web gallery, 534–553 Projection options, 205, 206 Smart Objects used in, 426–429 presets paper steps for working with, 422–425 book, 498–499 photo book, 496 picks and rejects camera-specific, 352–353 printer profiles for, 481 deleting rejected photos, 142 Develop module, 344–353 size settings for, 470 filtering photos flagged as, export, 431 exporting books as, 497 flagoging photos as, 124–125 how they work, 347 PBFD documents Flag icons indicating, 94 how they work, 347 HSL desaturate, 372, 373 print files output as, 458 keyboard shortcuts for, 40, 124 import, 35, 54 sildeshows exported as, 530–531 Picture Folder, 11, 12 names for, 348 Peace, James, vi Picture Folder, 11, 12 names for, 348 People view mode, 590–600 pin markers, 300, 314, 319, 641 steps for using, 381–383 person keywords, 598–600 Playback panel (Slideshow module), 590–597 steps for using, 592–596 plug-in Manager, 448 video clip, 225 pe		Lightroom integration with, 7, 161,	
205-207, 208 414-415, 418 web gallery, 534-553 paper steps for working with, 426-429 presets photo book, 496 picks and rejects book, 498-499 printer profiles for, 481 deleting rejected photos, 142 Develop module, 344-353 size settings for, 470 filtering photos flagged as, export, 431 PBCF documents Flag icons indicating, 94 external editor, 417 PDF documents Flag icons indicating, 94 how they work, 347 exporting books as, 497 flagging photos as, 124-125 HSL desaturate, 372, 373 print files output as, 458 keyboard shortcuts for, 40, 124 import, 35, 54 sideshows exported as, 530-531 Picture Fackage layout, 466-467, 469 metadata, 51, 568-572 Pearce, James, vi Pictures folder, 11, 12 names for, 348 People view mode, 590-600 pin markers, 300, 314, 319, 641 preferences for, 13, 692-694 how it works, 590-591 pixel limit, 47 sharpening, 381-383 person keywords, 598-600 Playback panel (Slideshow module), steps for using, 348-351 totoe curve, 228 stack controls, 597 Pug-in Manager, 448 v	Boundary Warp slider, 208–209		
205-207, 208 414-415, 418 web gallery, 534-553 paper steps for working with, 426-429 presets photo book, 496 picks and rejects book, 498-499 printer profiles for, 481 deleting rejected photos, 142 Develop module, 344-353 size settings for, 470 filtering photos flagged as, export, 431 PBCF documents Flag icons indicating, 94 external editor, 417 PDF documents Flag icons indicating, 94 how they work, 347 exporting books as, 497 flagging photos as, 124-125 HSL desaturate, 372, 373 print files output as, 458 keyboard shortcuts for, 40, 124 import, 35, 54 sideshows exported as, 530-531 Picture Fackage layout, 466-467, 469 metadata, 51, 568-572 Pearce, James, vi Pictures folder, 11, 12 names for, 348 People view mode, 590-600 pin markers, 300, 314, 319, 641 preferences for, 13, 692-694 how it works, 590-591 pixel limit, 47 sharpening, 381-383 person keywords, 598-600 Playback panel (Slideshow module), steps for using, 348-351 totoe curve, 228 stack controls, 597 Pug-in Manager, 448 v	Photo Merge process for, 204,	setting preferences for,	slideshow, 512–533
Projection options, 205, 206 Smart Objects used in, 426–429 presets paper steps for working with, 422–425 book, 498–499 photo book, 496 picks and rejects camera-specific, 352–353 printer profiles for, 481 deleting rejected photos, 142 Develop module, 344–353 size settings for, 470 filtering photos flagged as, export, 431 Pascucci, Camilla, vi, 586 124, 604 external editor, 417 PDF documents Flag ions indicating, 94 how they work, 347 exporting books as, 497 flagging photos as, 124–125 HSL desaturate, 372, 373 print files output as, 458 keyboard shortcuts for, 40, 124 import, 35, 54 sideshows exported as, 530–531 Picture Folder, 11, 12 names for, 348 Pearce, James, vi Pictures folder, 11, 12 names for, 348 People view mode, 590–600 pin markers, 300, 314, 319, 641 preferences for, 13, 692–694 how it works, 590–591 pixel limit, 47 sharpening, 381–383 person keywords, 598–600 Playback panel (Slideshow module), steps for using, 348–351 Toolbar, 597 export, 448 presets panel (Develop module), 344, <td></td> <td></td> <td></td>			
paper photo book, 496 picks and rejects camera-specific, 352–353 printer profiles for, 481 size settings for, 470 filtering photos flagged as, export, 431 pascucci, Camilla, vi, 586 124, 604 printer profiles for, 481 exporting books as, 497 print files output as, 458 slideshows exported as, 530–531 pricture Package layout, 466–467, 469 perace, James, vi people view mode, 590–600 pin markers, 300, 314, 319, 641 person keywords, 598–600 pingle Preson view mode, 596–597 stack controls, 597 stack controls, 597 stack controls, 597 steps for using, 592–596 plug-ins performance preferences, 16–17, 705–706 Point Curve editing mode, 228–229 person keywords, 598–600 perspective corrections, 259–267 Post-Crop Vignetting controls, preferences, 11–19, 689, 690–706 perspective corrections, 259–267 profit files, 465 Photo Merge feature, 200–203 panorama creation, 204–209 Photographer's Toolbox website, 448 Import, 56, 996–692 plingling, 13, 144–415 photographer's Toolbox website, 448 Import options, 32–33, 691–692 printer profit in profit and profit of preferences, 11–19, 689, 690–706 panorama creation, 204–209 photographer's Toolbox website, 448 Import options, 32–33, 691–692 printer profit in profit and profit of preferences, 144, 46, 694–700 person degree feature, 200–203 panorama creation, 204–209 person degree feature, 200–209 person degree feature, 20	Projection options, 205, 206	Smart Objects used in, 426-429	
photo book, 496 printer profiles for, 481 printer profiles for, 481 printer profiles for, 481 printer profiles for, 481 printer profiles for, 470 printer profiles for, 470 printer profiles for, 470 print files output as, 458 print files output, 466-467, 469 print	paper		book, 498-499
printer profiles for, 481 size settings for, 470 filtering photos flagged as, export, 431 Pascucci, Camilla, vi, 586 124, 604 external editor, 417 PDF documents exporting books as, 497 print files output as, 458 slideshows exported as, 530–531 Picture Package layout, 466–467, 469 Pearce, James, vi People view mode, 590–600 pin markers, 300, 314, 319, 641 person keywords, 598–600 pin markers, 300, 314, 319, 641 person keywords, 598–600 pin markers, 300, 314, 319, 641 person keywords, 598–600 playback panel (Slideshow module), steps for using, 381–383 steps for using, 592–596 plug-ins toolohar, 597 export, 448 performance issues, 4–5, 71, 700 Performance preferences, 16–17, 705–706 Performance preferences, 16–17, Transform sliders for, 267 Post-Crop Vignetting controls, Transform sliders for, 267 Post-Processing export options, 441 Pet Eye mode, 297 Photo Merge feature, 200–203 panorama creation, 200–203 panorama creation, 204–209 Photographer's Toolbox website, 448 Import options, 32–33, 691–692 Photographer's Toolbox website, 448 Import options, 32–33, 691–692 Import options, 32–33, 691–692 Imported photo, 32, 43, 44–45,	photo book, 496	picks and rejects	camera-specific, 352–353
Pascucci, Camilla, vi, 586 124, 604 Pascucci, Camilla, vi, 586 124, 604 Por documents Plag icons indicating, 94 Por documents Pascucci, Camilla, vi, 586 Plag icons indicating, 94 Por documents Plag icons indicating, 94 Por documents Plag icons indicating, 94 Por print files output as, 458 Por print files output, 450 Por print files output, 450 Por print files output, 450 Por print files output as, 458 Por print files output, 450 Por print files output as, 458 Por print files output as, 450 Por print files output as, 458 Por print files output, 448 Por print files output as, 458 Por print files output as, 458 Por			Transcendential state and a majoritation state and state
Pascucci, Camilla, vi, 586 124, 604 external editor, 417 PDF documents Flag icons indicating, 94 how they work, 347 exporting books as, 497 flagging photos as, 124–125 HSL desaturate, 372, 373 print files output as, 458 keyboard shortcuts for, 40, 124 import, 35, 54 sildeshows exported as, 530–531 Picture Package layout, 466–467, 469 metadata, 51, 568–572 Pearce, James, vi Pictures folder, 11, 12 names for, 348 People view mode, 590–600 pin markers, 300, 314, 319, 641 preferences for, 13, 692–694 how it works, 590–591 pixel limit, 47 sharpening, 381–383 person keywords, 598–600 Playback panel (Slideshow module), steps for using, 381–383 person keywords, 598–607 Plug-in Manager, 448 video clip, 225 stack controls, 597 export, 448 Presets panel (Develop module), 344, 191 Performance issues, 4–5, 71, 700 slideshow, 533 presharpening images, 377 Performance preferences, 16–17, 705 PNG files, 5, 106, 417, 629–632, 701 pressure-sensitive screens, 660 person keywords, 598–600 portrait sharpening, 382 Preview Target tool, 385 perspecti			, 100000
PDF documents exporting books as, 497 flagging photos as, 124–125 print files output as, 458 slideshows exported as, 530–531 Pearce, James, vi People view mode, 590–600 pin markers, 300, 314, 319, 641 person keywords, 598–600 pinwarkers, 300, 314, 319, 641 person keywords, 598–600 plug-ins stack controls, 597 steps for using, 592–596 plug-ins performance issues, 4–5, 71, 700 performance preferences, 16–17, 705–706 person keywords, 598–600 portrait sharpening, 382 person keywords, 598–600 plug-ins performance preferences, 16–17, 705–706 portrait sharpening, 382 person keywords, 598–600 portrait sharpening, 382 person view mode, 596–597 portrait sharpening, 382 performance preferences, 16–17, 705–706 portrait sharpening, 382 person keywords, 598–600 portrait sharpening, 382 preview Target tool, 385 preview, 108–111 photo galleries. See web galleries predictive caching, 4 brush stroke area, 304 camera vs. Lightroom, 110 data file for, 149, 711 photo galleries. See web galleries preferences, 11–19, 689, 690–706 camera vs. Lightroom, 110 data file for, 149, 711 photo lafte gature, 200–209 file for storing, 707 embedded, 43, 44–45 embedded, 43,			
exporting books as, 497 flagging photos as, 124–125 HSL desaturate, 372, 373 print files output as, 458 keyboard shortcuts for, 40, 124 import, 35, 54 slideshows exported as, 530–531 Picture Package layout, 466–467, 469 metadata, 51, 568–572 names, vi Pictures folder, 11, 12 names for, 348 preferences for, 13, 692–694 how it works, 590–600 pin markers, 300, 314, 319, 641 preferences for, 13, 692–694 how it works, 598–600 Playback panel (Slideshow module), steps for using, 348–351 stack controls, 597 Plug-in Manager, 448 video clip, 225 stack controls, 597 Plug-in Manager, 448 video clip, 225 watermark, 440 preformance issues, 4–5, 71, 700 slideshow, 533 presharpening images, 377 preformance issues, 4–5, 71, 700 slideshow, 533 presharpening images, 377 preson perferences, 16–17, PNG files, 5, 106, 417, 629–632, 701 pressure-sensitive screens, 660 portact sharpening, 382 prespective corrections, 259–267 Post-Crop Vignetting controls, preview panel (Book module), 497 preforms sliders for, 267 268–271 Before/After, 276–281 Upright adjustments for, 259–267 Post-Processing export options, 441 Book module, 497 Pret ge mode, 297 predictive caching, 4 brush stroke area, 304 Pfiffner, Pamela, v preferences, 11–19, 689, 690–706 camera vs. Lightroom, 110 data file for, 149, 711 export for templates, 465 External Editing, 13, 414–415 exporting calleries. See web galleries accessing, 11–12 data file for, 149, 711 export ganger for, 204–209 file for storing, 707 exporting catalogs with, 144–145 panorama creation, 204–209 file for storing, 707 exporting catalogs with, 144–145 panorama creation, 204–209 General, 12, 690–692 grayscale, 386, 393 imported photo, 32, 43, 44, 44–45, processing export options, 32–33, 691–692 imported photo, 32, 43, 44, 45, 694–700 generation of, 109–110 grayscale, 386, 393 imported photo, 32, 43, 44, 45, 694–700 generation of, 109–110 grayscale, 386, 393 imported photo, 32, 43, 44–45, 694–700 generation of, 109–110 grayscale, 386, 393 imported photo, 32, 43, 44–45, 694–700 generation of, 109–110 gray		Flag icons indicating, 94	
print files output as, 458 keyboard shortcuts for, 40, 124 import, 35, 54 slideshows exported as, 530–531 Picture Package layout, 466–467, 469 metadata, 51, 568–572 names, vi Pictures folder, 11, 12 names for, 348 preferences, 590–600 pin markers, 300, 314, 319, 641 preferences for, 13, 692–694 how it works, 590–591 pixel limit, 47 sharpening, 381–383 person keywords, 598–600 Playback panel (Slideshow module), Single Person view mode, 596–597 512, 526–527 tone curve, 228 video clip, 225 steps for using, 592–596 plug-ins watermark, 440 Presets panel (Develop module), 344, Perceptual rendering intent, 482 import, 58–59 345, 381 presharpening images, 377 performance issues, 4–5, 71, 700 slideshow, 533 presharpening images, 377 performance sissues, 4–5, 71, 700 Point Curve editing mode, 228–229 presoure preferences, 16–17, Point Curve editing mode, 228–229 presoure beywords, 598–600 portrait sharpening, 382 prespective corrections, 259–267 Post-Crop Vignetting controls, Transform sliders for, 267 268–271 Before/After, 276–281 Upright adjustments for, 259–267 Post-Processing export options, 441 Book module, 497 Pet Eye mode, 297 predictive caching, 4 brush stroke area, 304 Pfiffner, Pamela, v preferences, 11–19, 689, 690–706 camera vs. Lightroom, 110 photo galleries. See web galleries accessing, 11–12 data file for, 149, 711 embedded, 43, 44–45 Photo Info templates, 465 External Editing, 13, 414–415 embedded, 43, 44–45 ephoto generation, 200–209 file for storing, 707 exporting catalogs with, 144–145 panorama creation, 204–209 General, 12, 690–692 grayscale, 386, 393 imported photo, 32, 43, 44, 44–45, Import options, 32–33, 691–692 imported photo, 32, 43, 44, 44–45, Import options, 32–33, 691–692 imported photo, 32, 43, 44, 45, Imported photo, 32, 43, 44, 45, Import options, 32–33, 691–692 imported photo, 32, 43, 44, 45, Import options, 32–33, 691–692 imported photo, 32, 43, 44, 45, Imported	exporting books as, 497		
Picture Package layout, 466–467, 469 metadata, 51, 568–572 Pearce, James, vi Pictures folder, 11, 12 names for, 348 People view mode, 590–600 pin markers, 300, 314, 319, 641 preferences for, 13, 692–694 how it works, 590–591 pixel limit, 47 sharpening, 381–383 person keywords, 598–600 Playback panel (Slideshow module), steps for using, 348–351 tone curve, 228 vack controls, 597 Plug-in Manager, 448 video clip, 225 watermark, 440 Prosets panel (Develop module), 344, 597 Toolbar, 597 export, 448 Presets panel (Develop module), 344, 697 Performance issues, 4–5, 71, 700 slideshow, 533 presharpening images, 377 Performance preferences, 16–17, PNG files, 5, 106, 417, 629–632, 701 pressure-sensitive screens, 660 portrait sharpening, 382 preside corrections, 259–267 post-Crop Vignetting controls, preview James (Book module), 497 Pet Eye mode, 297 predictive caching, 4 Pet Eye mode, 297 predictive caching, 4 Pfiffner, Pamela, v preferences, 11–19, 689, 690–706 camera vs. Lightroom, 110 photo galleries. See web galleries accessing, 11–12 data file for, 149, 711 embedded, 43, 44–45 Photo Merge feature, 200–209 file for storing, 707 exporting catalogs with, 144–145 panorama creation, 204–209 General, 12, 690–692 grayscale, 386, 393 imported photo, 32, 43, 44–45, processing export options, 32–33, 691–692 imported photo, 32, 43, 44–45, processing exported photo, 32, 43, 44–45, processing exported photo, 32, 43, 44–45, import options, 23–33, 691–692 imported photo, 32, 43, 44–45, processing export options, 32–33, 691–692 imported photo, 32, 43, 44–45, import options, 32–33, 691–692 imported photo, 32, 43, 44–45, import options, 32–33, 691–692 imported photo, 32, 43, 44–45, import options, 32–33, 691–692 imported photo, 32, 43, 44–45, import options, 32–33, 691–692 imported photo, 32, 43, 44–45, import options, 32–33, 691–692 imported photo, 32, 43, 44–45, import options, 32–33, 691–692 imported photo, 32, 43, 44–45, import options, 32–33, 691–692 imported photo, 32, 43, 44–45, import options, 32–33, 691–692 imported photo, 32			
Pearce, James, vi Pictures folder, 11, 12 names for, 348 People view mode, 590–600 pin markers, 300, 314, 319, 641 preferences for, 13, 692–694 how it works, 590–591 pixel limit, 47 sharpening, 381–383 person keywords, 598–600 Playback panel (Slideshow module), Steps for using, 348–351 tone curve, 228 stack controls, 597 Plug-in Manager, 448 video clip, 225 watermark, 440 rolbar, 597 export, 448 presets panel (Develop module), 344, Perceptual rendering intent, 482 import, 58–59 ay 5, 381 preformance issues, 4–5, 71, 700 slideshow, 533 presharpening images, 377 performance preferences, 16–17, PNG files, 5, 106, 417, 629–632, 701 pressure-sensitive screens, 660 portrait sharpening, 382 preview panel (Book module), 497 person keywords, 598–600 portrait sharpening, 382 preview Target tool, 385 perspective corrections, 259–267 Post-Crop Vignetting controls, Transform sliders for, 267 268–271 Before/After, 276–281 Berore/After, 276–281 Book module, 497 preferences, 11–19, 689, 690–706 camera vs. Lightroom, 110 photo galleries. See web galleries accessing, 11–12 data file for, 149, 711 embedded, 43, 44–45 Photo Info templates, 465 External Editing, 13, 414–415 embedded, 43, 44–45 Photo Merge feature, 200–209 file for storing, 707 exporting catalogs with, 144–145 panorama creation, 204–209 General, 12, 690–692 grayscale, 386, 393 imported photo, 32, 43, 44–45,	slideshows exported as, 530–531	Picture Package layout, 466–467, 469	metadata, 51, 568–572
how it works, 590–591 pixel limit, 47 sharpening, 381–383 person keywords, 598–600 Playback panel (Slideshow module), Single Person view mode, 596–597 512, 526–527 tone curve, 228 stack controls, 597 Plug-in Manager, 448 video clip, 225 steps for using, 592–596 plug-ins watermark, 440 Toolbar, 597 export, 448 Presets panel (Develop module), 344, Perceptual rendering intent, 482 import, 58–59 345, 381 performance issues, 4–5, 71, 700 slideshow, 533 presharpening images, 377 Performance preferences, 16–17, PNG files, 5, 106, 417, 629–632, 701 pressure-sensitive screens, 660 705–706 Point Curve editing mode, 228–229 Preview panel (Book module), 497 person keywords, 598–600 portrait sharpening, 382 Preview Target tool, 385 perspective corrections, 259–267 Post-Crop Vignetting controls, Transform sliders for, 267 268–271 Before/After, 276–281 Upright adjustments for, 259–267 Post-Processing export options, 441 Book module, 497 Pet Eye mode, 297 predictive caching, 4 brush stroke area, 304 Pfiffner, Pamela, v preferences, 11–19, 689, 690–706 camera vs. Lightroom, 110 photo galleries. See web galleries accessing, 11–12 data file for, 149, 711 Photo Info templates, 465 External Editing, 13, 414–415 embedded, 43, 44–45 Photo Merge feature, 200–209 file for storing, 707 exporting catalogs with, 144–145 Photo Merge feature, 200–209 File Handling, 14, 46, 694–700 generation of, 109–110 panorama creation, 204–209 General, 12, 690–692 grayscale, 386, 393 Photographer's Toolbox website, 448 Import options, 32–33, 691–692 imported photo, 32, 43, 44–45,	Pearce, James, vi	Pictures folder, 11, 12	names for, 348
person keywords, 598–600 Single Person view mode, 596–597 Sit2, 526–527 stack controls, 597 Plug-in Manager, 448 video clip, 225 steps for using, 592–596 plug-ins watermark, 440 Presetts panel (Develop module), 344, Perceptual rendering intent, 482 performance issues, 4–5, 71, 700 slideshow, 533 performance preferences, 16–17, PNG files, 5, 106, 417, 629–632, 701 person keywords, 598–600 portrait sharpening, 382 perspective corrections, 259–267 Post-Crop Vignetting controls, Transform sliders for, 267 Upright adjustments for, 259–267 Pet Eye mode, 297 Photo Info templates, 465 External Editing, 13, 414–415 Photo Merge feature, 200–209 Flie for storing, 707 Flags and service in tone curve, 228 tone curve, 228 video clip, 225 tone curve, 228 video clip, 225 video clip, 240 presetts panel (Develop module), 344, 497 presetts panel (Develop module), 344, 497 Pet Eye mode, 228–229 Preview panel (Book module), 497 Pet Eye mode, 297 predictive caching, 4 brush stroke area, 304 camera vs. Lightroom, 110 data file for, 149, 711 embedded, 43, 44–45 embedded, 43	People view mode, 590-600	pin markers, 300, 314, 319, 641	preferences for, 13, 692-694
Single Person view mode, 596–597 stack controls, 597 Plug-in Manager, 448 video clip, 225 steps for using, 592–596 plug-ins watermark, 440 Presets panel (Develop module), 344, Perceptual rendering intent, 482 import, 58–59 345, 381 performance issues, 4–5, 71, 700 slideshow, 533 performance preferences, 16–17, 705–706 Point Curve editing mode, 228–229 Preview panel (Book module), 497 person keywords, 598–600 portrait sharpening, 382 Preview Target tool, 385 perspective corrections, 259–267 Post-Crop Vignetting controls, Transform sliders for, 267 Upright adjustments for, 259–267 Post-Processing export options, 441 Pet Eye mode, 297 Pet Eye mode, 297 Preview balleries accessing, 11–12 Photo Info templates, 465 External Editing, 13, 414–415 Photo Merge feature, 200–209 file for storing, 707 exporting catalogs with, 144–145 photographer's Toolbox website, 448 Import options, 32–33, 691–692 imported photo, 32, 43, 44–45,	how it works, 590–591	pixel limit, 47	sharpening, 381–383
Single Person view mode, 596–597 stack controls, 597 Plug-in Manager, 448 video clip, 225 steps for using, 592–596 plug-ins watermark, 440 Presets panel (Develop module), 344, Perceptual rendering intent, 482 import, 58–59 345, 381 performance issues, 4–5, 71, 700 slideshow, 533 performance preferences, 16–17, 705–706 Point Curve editing mode, 228–229 Preview panel (Book module), 497 person keywords, 598–600 portrait sharpening, 382 Preview Target tool, 385 perspective corrections, 259–267 Post-Crop Vignetting controls, Transform sliders for, 267 Upright adjustments for, 259–267 Post-Processing export options, 441 Pet Eye mode, 297 Pet Eye mode, 297 Preview balleries accessing, 11–12 Photo Info templates, 465 External Editing, 13, 414–415 Photo Merge feature, 200–209 file for storing, 707 exporting catalogs with, 144–145 photographer's Toolbox website, 448 Import options, 32–33, 691–692 imported photo, 32, 43, 44–45,	person keywords, 598-600	Playback panel (Slideshow module),	steps for using, 348-351
steps for using, 592–596 plug-ins watermark, 440 Toolbar, 597 export, 448 Presets panel (Develop module), 344, Perceptual rendering intent, 482 import, 58–59 345, 381 performance issues, 4–5, 71, 700 slideshow, 533 presharpening images, 377 Performance preferences, 16–17, 705–706 Point Curve editing mode, 228–229 Preview panel (Book module), 497 person keywords, 598–600 portrait sharpening, 382 Preview Target tool, 385 perspective corrections, 259–267 Post-Crop Vignetting controls, Transform sliders for, 267 268–271 Before/After, 276–281 Upright adjustments for, 259–267 Post-Processing export options, 441 Book module, 497 Pet Eye mode, 297 predictive caching, 4 brush stroke area, 304 Pfiffner, Pamela, v preferences, 11–19, 689, 690–706 camera vs. Lightroom, 110 photo galleries. See web galleries accessing, 11–12 data file for, 149, 711 Photo Info templates, 465 External Editing, 13, 414–415 embedded, 43, 44–45 Photo Merge feature, 200–209 file for storing, 707 exporting catalogs with, 144–145 HDR image creation, 200–203 File Handling, 14, 46, 694–700 generation of, 109–110 panorama creation, 204–209 General, 12, 690–692 grayscale, 386, 393 Photographer's Toolbox website, 448 Import options, 32–33, 691–692 imported photo, 32, 43, 44–45,	Single Person view mode, 596–597	512, 526–527	
Presets panel (Develop module), 344, Perceptual rendering intent, 482 import, 58–59 345, 381 presformance issues, 4–5, 71, 700 slideshow, 533 presharpening images, 377 Performance preferences, 16–17, PNG files, 5, 106, 417, 629–632, 701 pressure-sensitive screens, 660 point Curve editing mode, 228–229 preview panel (Book module), 497 person keywords, 598–600 portrait sharpening, 382 preview Target tool, 385 perspective corrections, 259–267 post-Crop Vignetting controls, Transform sliders for, 267 268–271 Before/After, 276–281 Upright adjustments for, 259–267 Post-Processing export options, 441 Book module, 497 Pet Eye mode, 297 predictive caching, 4 brush stroke area, 304 preferences, 11–19, 689, 690–706 camera vs. Lightroom, 110 photo galleries. See web galleries accessing, 11–12 data file for, 149, 711 embedded, 43, 44–45 embedded, 43, 44–45 photo Merge feature, 200–209 file for storing, 707 exporting catalogs with, 144–145 photo mage creation, 200–203 File Handling, 14, 46, 694–700 generation of, 109–110 panorama creation, 204–209 General, 12, 690–692 grayscale, 386, 393 imported photo, 32, 43, 44–45, limport options, 32–33, 691–692 imported photo, 32, 43, 44–45,	stack controls, 597	Plug-in Manager, 448	video clip, 225
Perceptual rendering intent, 482 import, 58–59 345, 381 performance issues, 4–5, 71, 700 slideshow, 533 presharpening images, 377 Performance preferences, 16–17, PNG files, 5, 106, 417, 629–632, 701 pressure-sensitive screens, 660 705–706 Point Curve editing mode, 228–229 Preview panel (Book module), 497 person keywords, 598–600 portrait sharpening, 382 Preview Target tool, 385 perspective corrections, 259–267 Post-Crop Vignetting controls, previews, 108–111 Transform sliders for, 267 268–271 Before/After, 276–281 Upright adjustments for, 259–267 Post-Processing export options, 441 Book module, 497 Pet Eye mode, 297 predictive caching, 4 brush stroke area, 304 Pfiffner, Pamela, v preferences, 11–19, 689, 690–706 camera vs. Lightroom, 110 photo galleries. See web galleries accessing, 11–12 data file for, 149, 711 Photo Info templates, 465 External Editing, 13, 414–415 embedded, 43, 44–45 Photo Merge feature, 200–209 file for storing, 707 exporting catalogs with, 144–145 HDR image creation, 200–203 File Handling, 14, 46, 694–700 generation of, 109–110 panorama creation, 204–209 General, 12, 690–692 grayscale, 386, 393 Photographer's Toolbox website, 448 Import options, 32–33, 691–692 imported photo, 32, 43, 44–45,	steps for using, 592-596	plug-ins	watermark, 440
performance issues, 4–5, 71, 700 slideshow, 533 presharpening images, 377 Performance preferences, 16–17, PNG files, 5, 106, 417, 629–632, 701 pressure-sensitive screens, 660 705–706 Point Curve editing mode, 228–229 Preview panel (Book module), 497 person keywords, 598–600 portrait sharpening, 382 Preview Target tool, 385 perspective corrections, 259–267 Post-Crop Vignetting controls, previews, 108–111 Transform sliders for, 267 268–271 Before/After, 276–281 Upright adjustments for, 259–267 Post-Processing export options, 441 Book module, 497 Pet Eye mode, 297 predictive caching, 4 brush stroke area, 304 Pfiffner, Pamela, v preferences, 11–19, 689, 690–706 camera vs. Lightroom, 110 photo galleries. See web galleries accessing, 11–12 data file for, 149, 711 Photo Info templates, 465 External Editing, 13, 414–415 embedded, 43, 44–45 Photo Merge feature, 200–209 file for storing, 707 exporting catalogs with, 144–145 HDR image creation, 200–203 File Handling, 14, 46, 694–700 generation of, 109–110 panorama creation, 204–209 General, 12, 690–692 grayscale, 386, 393 Photographer's Toolbox website, 448 Import options, 32–33, 691–692 imported photo, 32, 43, 44–45,	Toolbar, 597	export, 448	Presets panel (Develop module), 344,
Performance preferences, 16–17, 705–706 Point Curve editing mode, 228–229 Preview panel (Book module), 497 person keywords, 598–600 portrait sharpening, 382 Preview Target tool, 385 perspective corrections, 259–267 Post-Crop Vignetting controls, Transform sliders for, 267 268–271 Before/After, 276–281 Upright adjustments for, 259–267 Post-Processing export options, 441 Book module, 497 Pet Eye mode, 297 predictive caching, 4 brush stroke area, 304 Pfiffner, Pamela, v preferences, 11–19, 689, 690–706 camera vs. Lightroom, 110 photo galleries. See web galleries accessing, 11–12 data file for, 149, 711 Photo Info templates, 465 External Editing, 13, 414–415 embedded, 43, 44–45 Photo Merge feature, 200–209 file for storing, 707 exporting catalogs with, 144–145 Photo generation, 204–209 General, 12, 690–692 grayscale, 386, 393 Photographer's Toolbox website, 448 Import options, 32–33, 691–692 imported photo, 32, 43, 44–45,	Perceptual rendering intent, 482	import, 58–59	345, 381
Point Curve editing mode, 228–229 Preview panel (Book module), 497 person keywords, 598–600 portrait sharpening, 382 Preview Target tool, 385 perspective corrections, 259–267 Post-Crop Vignetting controls, previews, 108–111 Post-Processing export options, 441 Preferences, 11–19, 689, 690–706 Post-Processing export options, 441 Preferences, 11–19, 689, 690–706 Post-Processing export options, 441 Preferences, 11–19, 689, 690–706 Post-Processing export options, 441 Porush stroke area, 304 Priffner, Pamela, v preferences, 11–19, 689, 690–706 Preferences, 11–19, 689, 690–706 Post-Processing export options, 441 Porush stroke area, 304 Preview Target tool, 385 Post-Processing export options, 441 Book module, 497 Post-Processing export options, 441 Book module, 497 Preview Target tool, 385 Pre	performance issues, 4–5, 71, 700	slideshow, 533	presharpening images, 377
person keywords, 598–600 portrait sharpening, 382 Preview Target tool, 385 perspective corrections, 259–267 Post-Crop Vignetting controls, previews, 108–111 Transform sliders for, 267 268–271 Before/After, 276–281 Upright adjustments for, 259–267 Post-Processing export options, 441 Book module, 497 Pet Eye mode, 297 predictive caching, 4 brush stroke area, 304 Pfiffner, Pamela, v preferences, 11–19, 689, 690–706 camera vs. Lightroom, 110 photo galleries. See web galleries accessing, 11–12 data file for, 149, 711 Photo Info templates, 465 External Editing, 13, 414–415 embedded, 43, 44–45 Photo Merge feature, 200–209 file for storing, 707 exporting catalogs with, 144–145 Photo Info templates, 200–203 File Handling, 14, 46, 694–700 generation of, 109–110 panorama creation, 204–209 General, 12, 690–692 grayscale, 386, 393 Photographer's Toolbox website, 448 Import options, 32–33, 691–692 imported photo, 32, 43, 44–45,	Performance preferences, 16–17,	PNG files, 5, 106, 417, 629-632, 701	pressure-sensitive screens, 660
perspective corrections, 259–267 Post-Crop Vignetting controls, Transform sliders for, 267 Upright adjustments for, 259–267 Pet Eye mode, 297 Pet Eye mode, 297 Predictive caching, 4 Priffner, Pamela, v Priffner, Pamela, v Photo galleries. See web galleries Photo Info templates, 465 Photo Merge feature, 200–209 HDR image creation, 200–203 Photographer's Toolbox website, 448 Post-Crop Vignetting controls, Post-Crop Vignetting controls, previews, 108–111 Before/After, 276–281 Book module, 497 Brush stroke area, 304 camera vs. Lightroom, 110 data file for, 149, 711 embedded, 43, 44–45 exporting catalogs with, 144–145 generation of, 109–110 grayscale, 386, 393 Import options, 32–33, 691–692 imported photo, 32, 43, 44–45,	705–706	Point Curve editing mode, 228–229	Preview panel (Book module), 497
Transform sliders for, 267 Upright adjustments for, 259–267 Post-Processing export options, 441 Book module, 497 Pet Eye mode, 297 Predictive caching, 4 Priffner, Pamela, v Preferences, 11–19, 689, 690–706 photo galleries. See web galleries Accessing, 11–12 Photo Info templates, 465 External Editing, 13, 414–415 Photo Merge feature, 200–209 HDR image creation, 200–203 File Handling, 14, 46, 694–700 Photographer's Toolbox website, 448 Import options, 32–33, 691–692 Before/After, 276–281 Before/After, 276–281 Beok module, 497 Book module, 497 B	person keywords, 598–600	portrait sharpening, 382	Preview Target tool, 385
Upright adjustments for, 259–267 Post-Processing export options, 441 Book module, 497 Pet Eye mode, 297 predictive caching, 4 brush stroke area, 304 Pfiffner, Pamela, v preferences, 11–19, 689, 690–706 camera vs. Lightroom, 110 photo galleries. See web galleries accessing, 11–12 data file for, 149, 711 Photo Info templates, 465 External Editing, 13, 414–415 embedded, 43, 44–45 Photo Merge feature, 200–209 file for storing, 707 exporting catalogs with, 144–145 HDR image creation, 200–203 File Handling, 14, 46, 694–700 generation of, 109–110 panorama creation, 204–209 General, 12, 690–692 grayscale, 386, 393 Photographer's Toolbox website, 448 Import options, 32–33, 691–692 imported photo, 32, 43, 44–45,	perspective corrections, 259-267	Post-Crop Vignetting controls,	previews, 108–111
Pet Eye mode, 297 predictive caching, 4 brush stroke area, 304 Pfiffner, Pamela, v preferences, 11–19, 689, 690–706 camera vs. Lightroom, 110 photo galleries. See web galleries accessing, 11–12 data file for, 149, 711 Photo Info templates, 465 External Editing, 13, 414–415 embedded, 43, 44–45 Photo Merge feature, 200–209 file for storing, 707 exporting catalogs with, 144–145 HDR image creation, 200–203 File Handling, 14, 46, 694–700 generation of, 109–110 panorama creation, 204–209 General, 12, 690–692 grayscale, 386, 393 Photographer's Toolbox website, 448 Import options, 32–33, 691–692 imported photo, 32, 43, 44–45,	Transform sliders for, 267	268–271	Before/After, 276–281
Pfiffner, Pamela, v preferences, 11–19, 689, 690–706 camera vs. Lightroom, 110 photo galleries. See web galleries accessing, 11–12 data file for, 149, 711 embedded, 43, 44–45 embedded, 43, 44–45 embedded, 43, 44–45 photo Merge feature, 200–209 file for storing, 707 exporting catalogs with, 144–145 HDR image creation, 200–203 File Handling, 14, 46, 694–700 generation of, 109–110 panorama creation, 204–209 General, 12, 690–692 grayscale, 386, 393 Photographer's Toolbox website, 448 Import options, 32–33, 691–692 imported photo, 32, 43, 44–45,	Upright adjustments for, 259–267	Post-Processing export options, 441	Book module, 497
photo galleries. See web galleries accessing, 11–12 data file for, 149, 711 Photo Info templates, 465 External Editing, 13, 414–415 embedded, 43, 44–45 Photo Merge feature, 200–209 file for storing, 707 exporting catalogs with, 144–145 HDR image creation, 200–203 File Handling, 14, 46, 694–700 generation of, 109–110 panorama creation, 204–209 General, 12, 690–692 grayscale, 386, 393 Photographer's Toolbox website, 448 Import options, 32–33, 691–692 imported photo, 32, 43, 44–45,	Pet Eye mode, 297	predictive caching, 4	brush stroke area, 304
Photo Info templates, 465 External Editing, 13, 414–415 embedded, 43, 44–45 Photo Merge feature, 200–209 file for storing, 707 exporting catalogs with, 144–145 HDR image creation, 200–203 File Handling, 14, 46, 694–700 generation of, 109–110 panorama creation, 204–209 General, 12, 690–692 grayscale, 386, 393 Photographer's Toolbox website, 448 Import options, 32–33, 691–692 imported photo, 32, 43, 44–45,	Pfiffner, Pamela, v	preferences, 11–19, 689, 690–706	camera vs. Lightroom, 110
Photo Merge feature, 200–209 file for storing, 707 exporting catalogs with, 144–145 HDR image creation, 200–203 File Handling, 14, 46, 694–700 generation of, 109–110 panorama creation, 204–209 General, 12, 690–692 grayscale, 386, 393 Photographer's Toolbox website, 448 Import options, 32–33, 691–692 imported photo, 32, 43, 44–45,	photo galleries. See web galleries	accessing, 11–12	data file for, 149, 711
HDR image creation, 200–203 File Handling, 14, 46, 694–700 generation of, 109–110 panorama creation, 204–209 General, 12, 690–692 grayscale, 386, 393 Photographer's Toolbox website, 448 Import options, 32–33, 691–692 imported photo, 32, 43, 44–45,	Photo Info templates, 465	External Editing, 13, 414–415	embedded, 43, 44-45
panorama creation, 204–209 General, 12, 690–692 grayscale, 386, 393 Photographer's Toolbox website, 448 Import options, 32–33, 691–692 imported photo, 32, 43, 44–45,	Photo Merge feature, 200–209	file for storing, 707	exporting catalogs with, 144-145
Photographer's Toolbox website, 448 Import options, 32–33, 691–692 imported photo, 32, 43, 44–45,	HDR image creation, 200–203	File Handling, 14, 46, 694–700	generation of, 109-110
	panorama creation, 204–209	General, 12, 690-692	grayscale, 386, 393
108–109	Photographer's Toolbox website, 448	Import options, 32-33, 691-692	imported photo, 32, 43, 44-45,
			108–109

previews (continued)	Print Sharpening options, 380, 477	tone adjustments, 216–218
Library module, 108–111	Print to JPEG File option, 478	typical workflow, 218–221
Masking slider, 394–395	printer profiles, 475, 479	video file editing, 221–225
missing, 111	Printer Properties dialog, 474, 481	
Photoshop-edited image, 425	printing, 451-491	R
secondary display, 122	16-bit, 478	Radial Filter tool, 319–322
size and quality settings, 111	contact sheets, 458-459	correcting edge sharpness with,
slideshow, 527	Draft Mode for, 458, 477	321–322
soft proof, 483-490	to JPEG files, 478	example of working with, 320
web gallery, 549	Lightroom procedure for, 472-475	Radius slider, 388–389, 393
See also Smart Previews	margin adjustments for, 455,	RAID systems, 71, 714
Print Adjustment controls, 475	456–457	RAM requirements, 713
Print button, 454, 472, 476	to PDF files, 458	Range Masking, 323–328
print collections, 454	profiles for, 475, 479	color, 324–325
Print dialog, 473, 476, 480	rendering intent for, 482	luminance, 326–328
print drivers, 472	resolution for, 457, 471, 477	process versions and, 324
Print Job panel (Print module), 453,	sharpening images for, 380, 438	rating photos, 124–129
472–482	soft proofing images for, 483-490	color label use and, 128–129
Color Management settings, 472	templates for, 474, 491	flagging picks/rejects, 124–126
Draft Mode Printing option, 477	private metadata, 580	Lightroom CC/mobile for, 685
Lightroom printing procedure,	process versions, 159-161, 217, 324,	star ratings for, 126–127
472–475	336, 338, 345	raw files
Print Adjustment controls, 475	profiles	converting to DNG, 30–32, 697
Print Sharpening options, 380, 477	camera, 274–275	Detail panel adjustments, 380–381
Print to JPEG File option, 478	lens, 246-249	editing in Photoshop, 415, 419
Profile list menu, 479	printer, 475, 479	external editor options, 416–417
rendering intent options, 482	Projection options, 205, 206	improved processing of, 378–380
Print module, 452–482	Promote subfolders dialog, 80	XMP metadata and, 624, 630, 632
Cells panel, 466-467, 468	proofing feature. See soft proofing	See also Camera Raw
Custom Package layout, 468–469	ProPhoto RGB color space, 154, 189,	raw + JPEG files, 48
Guides panel, 457	418, 434, 435	Real World Image Sharpening with
Image Settings panel, 454, 466	PSD files, 46, 417, 418, 629-632	Adobe Photoshop, Camera
interface overview, 452-454	public vs. private albums, 666, 667	Raw, and Lightroom (Fraser and
Layout panel, 455–457	Publish Services panel, 620–623	Schewe), 393
Layout Style panel, 454	publishing	Red Eye Correction tool, 295–297
Page panel, 460-465, 469	books, 511	Redo command, 330
Page/Print Setup dialog, 470-471	photos, 620-623	Reference view mode, 282–283
Picture Package layout,		Refine Photos dialog, 125
466–467, 469	Q	reflective highlights, 198
Print Job panel, 472-482	Quality slider, 548	rejects and picks. See picks and rejects
Rulers, Grid & Guides panel, 466	Quick Collections, 133–134, 139	Relative rendering intent, 482
Single Image/Contact Sheet layout,	Quick Develop panel (Library module),	Reload command, 536
454–465	216–225	removing
Template Browser panel, 491	cropping options, 173	keywords from the Keyword
Print Setup dialog, 470, 471, 474	synchronizing settings, 220–221	List, 584
	Sylicinoriality Settings, 220 221	2.54, 55.

photos from collections, 138	saving	sharing
photos from Lightroom CC	Develop presets, 344-346	catalogs, 149–151
albums, 686	effect settings, 300	collections, 666-667
photos from the catalog, 142	metadata to files, 624-626	from Lightroom CC/mobile, 686
red eye from images, 295–297	print templates, 491	sharpening, 377–401
spots on photos, 284-294	slideshow templates, 528-529	capture, 378–380
See also deleting	web gallery templates, 553	edges of photos, 321–322
Rename Photos dialog, 50	scenic sharpening, 383	effect sliders, 385-389
renaming. See naming/renaming	Schewe, Jeff, iv, vi, 393, 402, 438	evaluating at 1:1 view, 385
rendering intent options, 482, 486	screen display. See display screen	examples of applying, 396-397
Repair Catalog option, 625	searching	grayscale previews of, 386
Resize to Fit options, 437	advanced or complex, 619–620	improved features for, 378-380
resizing. See sizing/resizing	attribute filter for, 614	localized, 312-313, 398-399
Resnick, Seth, 577, 585	Lightroom CC/mobile option	luminance targeted, 385
resolution	for, 665	modifying controls, 390-395
image size and, 437, 477	metadata used for, 558-559,	negative, 400-401
print reproduction and, 457,	614-617	output, 380, 438
471, 477	for missing photos, 617	portrait, 382
resource info for book, v	rules defined for, 612-613, 618	presets for, 381–383
retouching photos, 284-333	text filter for, 611-613	print, 380, 438, 477
Adjustment brush for, 298-313	second copy backups, 47	sample image for, 384
Graduated Filter tool for, 314-318	Secondary Display submenu, 120	scenic, 383
Radial Filter tool for, 319–322	secure file transfer protocol	web gallery images, 548
Range Mask options for, 323–328	(SFTP), 552	Sharpening controls
Red Eye Correction tool for,	Select Catalog dialog, 12, 75	Adjustment brush, 312–313
295–297	selections	Amount slider, 386–387
Spot Removal tool for, 284–294	filtering photos using, 604, 609	Clarity slider, 304, 312–313
reverse geocoding, 638	instructions on making, 132	Detail panel, 378, 385–395
RGB curve editing mode, 230-231	Lightroom CC/mobile, 685	Detail slider, 390-392
Richmond, Eric, vi	saving as collections, 134–135	Masking slider, 393–395
Riecks, David, 586	Slideshow module, 528	Quick Develop panel, 218
Rotate to Fit option, 454, 466	sets	Radius slider, 388–389
rotating photos, 164, 454	collection, 140	Sharpness slider, 312–313,
rulers and guides, 457	keyword, 588-589	398–399
Rulers, Grid & Guides panel (Print	shadows	shortcuts, keyboard, 2, 25, 162
module), 466	clipping, 188, 198-199	shutter speed information, 616
	darkening, 199, 234	sidecar files, 563
S	lightening, 187, 195	Simulate Paper & Ink option,
	localized adjustments, 310-311	485, 488
Saturation adjustments	noise problems, 402, 403	Single image view mode, 659-661
Basic panel, 214–215, 372 HSL panel, 240, 242, 372, 373	Shadows adjustment	Single Image/Contact Sheet layout,
Quick Develop panel, 218	Adjustments panel, 310–311	454–465
1 1 2	Basic panel, 181–182, 187, 194,	Single Person view mode, 596–597
Split Toning panel, 368 Saved Locations panel, 646	195, 236	Site Info panel (Web module), 534
Saved Locations pariel, 040	Tone Curve panel, 234	

Size slider	Smart Previews, 4, 147–151	synchronized spotting, 292-294
Adjustment brush, 298	benefits of, 148	Tool Overlay options, 291
Spot Removal tool, 284	creating, 43, 148-149	undoing/deleting spots, 291
sizing/resizing	exporting catalogs with, 144, 145	Visualize Spots feature, 286–287
images for exporting, 437	face-recognition technology	sRGB color space, 189, 418
interpolation and, 437	and, 591	SSDs (solid-state drives), 149, 711
thumbnails, 95–96	Lightroom CC/mobile and,	stacking photos, 130-131, 683
skin tone corrections, 241	655, 656	star ratings, 126–127, 604
Skurski, Mike, 438	Performance preference for, 17	storage
sleep protection, 10	sharing catalogs using, 149–151	cloud, 656, 663, 687
Slide Editor view, 514, 520	size of data file for, 149	hard drive, 713–714
Slideshow module, 512–533	Snapshots panel (Develop module),	straightening photos, 167, 168-169
Backdrop panel, 522-523	330–333	subfolders
interface overview, 512–513	saving variations using, 330, 331	filtering, 608
Layout panel, 515	Sync Snapshots command, 330,	importing, 40, 56
Music panel, 525	332–333	organizing photos into, 52, 53
Options panel, 516–517	soft proofing, 483-490	showing photos in, 81
Overlays panel, 518–521	Before and After views, 486–489	Survey view, 112-113, 122, 123
Playback panel, 526-527	Before State options, 490	Sync Snapshots command, 330,
Preview mode, 527	display screen considerations,	332–333
Slide Editor view, 514, 520	483–485	Synchronize Folder dialog, 86–87
Template Browser panel, 528-529	practice guidelines, 485–486	Synchronize Metadata dialog, 633
Titles panel, 524	Soft Proofing panel, 485, 486	Synchronize Settings dialog, 221, 293,
Toolbar, 512, 528	Soften Skin effect, 304–305	336, 337
slideshows, 512–533	solo mode, 162	synchronizing
backdrops for, 522–523	Soni, Neil, vi	Auto Sync mode for, 294, 336
collection creation, 529	sorting photos, 634-635	with Camera Raw, 342–343
exporting, 530-533	color label options for, 635	collections, 19, 657–658
identity plates, 518, 519	tethered shooting and, 65	Develop settings, 221, 336-337
image processing for, 549	sound tracks, 525, 526, 533	folders, 86–87, 341
impromptu, 528	sounds, completion/alert, 692	with Lightroom CC/mobile, 19,
music for, 525, 526, 533	Source panel (Import dialog), 39	654–655
navigating, 528	Special Characters panel, 509	metadata settings, 633
PDF or JPEG, 530-531	splash screen options, 690, 702	snapshots, 330, 332-333
playback options, 526-527	Split Toning panel (Develop module)	spot removal settings, 292–294
plug-ins for, 533	black-and-white conversions, 356,	Upright settings, 261
previewing, 527	367, 368–371	system folders, 82-83, 84
selections for, 528	color image adjustments, 370–371	System Info dialog, 712
templates for, 528-529	Spot Removal tool, 284–294	system recommendations, 8, 712-714
text overlays, 520-521	auto-calculate behavior, 292	
titles for, 524	brush spot adjustments, 287–290	Т
video, 532–533	editing circle/brush spots, 291	
Smart Collections, 11, 140–141, 149	Feather slider, 292	Target Adjustment tool, 226, 232,
Smart Objects, 426–429	instructions for using, 284-285	240, 362, 363, 510

keyboard shortcuts, 284, 285, 291

target collections, 139, 590

Temp slider	Thumbhails slider, 40, 95, 498	U
B&W conversions, 360	TIFF files, 417, 418, 434, 629-632	Uncheck All button, 40
independent adjustments, 179	Time Machine backups, 72	
localized adjustments, 178, 308–309	time/date information, 565–566, 616 time-lapse videos, 532–533	underexposed image correction, 194–195
Template Browser panel	Tint slider	Undo command, 291, 300, 330
Print module, 453, 491	B&W conversions, 360, 365	Unsharp Mask filter (Photoshop), 378
Slideshow module, 528–529	independent adjustments, 179	updates
Web module, 534, 546, 553	localized adjustments, 178, 308	automatically checking for, 690
templates	titles	provided by book's author, v
Photo Info, 465	slideshow, 524	upgrading Lightroom, 11
print, 474, 491	web gallery, 544–547	Upload Settings panel (Web module),
settings folder for, 708–709	Titles panel (Slideshow module),	550, 552
slideshow, 528–529	512, 524	uploading
text, 546–547	tone controls	files via Lightroom CC for Web,
web gallery, 553	Basic panel, 180–188	671–672
Tethered Capture Settings dialog, 63	Quick Develop panel, 216–218	web galleries, 550–552
Tethered Shoot control panel, 64	Tone Curve panel, 226–239	Upright adjustments, 259–267
tethered shooting, 61–65	Tone Curve panel (Develop module),	guide lines for, 265–267
cable vs. wireless, 61	226–239	how they work, 259–260
connecting cameras for, 61, 62	Basic panel adjustments and, 181,	steps for applying, 261–264
Lightroom features for, 62–65	234–237	suggested order for, 260
Sort option for, 65	overview of controls in, 226-227	synchronizing, 261
steps in process of, 63-65	Point Curve editing mode,	USB connections, 61
text	228–229	user Lightroom folder, 69
book, 506-510	RGB curve editing mode, 230-231	W
photo info, 465	Tone Curve regions, 232–234	V
searching, 611–613	tone range split points, 227,	Validate DNG Files feature, 699
slideshow, 518, 520-521	238–239	Vibrance adjustments
Sort by Label option, 635	Tool Overlay options, 172, 291	Basic panel, 214–215, 373
web gallery, 544–547	Toolbar, 24	Quick Develop panel, 218
text box layouts, 506	Book module, 498	video drivers, 17
Text panel (Book module), 494,	Develop module, 291	video files/clips
506–507	Import dialog, 40	adding to slideshows, 526
Text Template Editor, 694	Library module, 78–79	editing, 221–225
Print module, 465	People view mode, 597	exporting, 449, 532
Slideshow module, 520, 521	Slideshow module, 512, 528	importing, 55
Web module, 545, 546	tracklogs, 640–643	presets for, 225
thelightroombook.com website, v, 25	Transform panel (Develop module),	slideshows as, 532–533
theturninggate.net website, 539	259–267	time-lapse, 532–533
third-party gallery styles, 539–540	Transform sliders, 267	view modes
thumbnails	Upright adjustments, 259–267	Develop module, 164, 276–281
badges displayed with, 94,	transparency preservation, 260	Lightroom CC/mobile, 658–661
137, 658	Type panel (Book module), 508–510	Metadata panel, 560–562
Library Grid view, 95–96	typographic fractions, 704	

View options (Library module) Compare view, 114-117 Grid view, 40, 93-96, 100, 101 Loupe Overlay view, 104-107 Loupe view, 40, 97-103 Survey view, 112-113 vignetting applying to photos, 268-271 correcting for lens, 257 virtual copies copy names for, 563-564 creating for photos, 334–335 external editing with, 423-424 filtering for, 607 snapshots vs., 334 soft proofing and, 487, 490 Visualize Spots feature, 286-287 volume links, 85

W

Warde, Benjamin, v
watermarks, 439–441, 460, 518
web browsers, 549, 551
web galleries, 534–553
captions for, 544–547
collection creation, 553
color themes for, 541
exporting, 550
HTML-style, 536, 537, 542
HTML5-style, 536, 538, 543
image processing for, 549
layout appearance, 542–543
metadata information,
546–547, 548
previewing, 549

quality settings, 548

sharpening images in, 548 site info for, 540 styles for, 536-540 templates for, 553 third-party, 539-540 titles for, 544-547 uploading, 550-552 Web module, 534-553 Appearance panel, 542-543 Color Palette panel, 541 Export and Upload buttons, 550 Image Info panel, 544-547 interface overview, 534-535 Layout Style panel, 536-540 Output Settings panel, 548 Preview in Browser button, 549 Site Info panel, 540 Template Browser panel, 546, 553 Upload Settings panel, 550, 552 web-based version of Lightroom. See Lightroom CC for web website links from metadata, 576 from web galleries, 540 Wendt, Max, v Weston, Stuart, vi white balance

Basic panel adjustments, 174–179, 185, 235 color checker chart, 176 creative adjustments, 177 display screen calibration, 156 independent adjustments, 179 localized adjustments, 178 Quick Develop panel adjustments, 217 White Balance tool, 174–179, 185, 235
white point, 156, 483
Whites adjustment
auto calculation, 182–183
Basic panel, 182–183,
187–188, 237
Windows computers
Lightroom preferences on,
11–12, 707
printer settings on, 470, 474,
476, 481
system requirements for, 8
workflow in Lightroom, 3, 6
WS_FTP Pro software, 550

X

XMP space, 624 read/write options, 629–632 saving metadata to, 626, 628 X-Rite/Gretag Macbeth ColorChecker chart, 176

Z

Zoom to Fill Frame option (Slideshow module), 516, 517
Zoom to Fill option (Print module), 454, 466
zooming
clicked point to center option, 102, 704
magnification options for, 102, 103